FREEBORN COUNTY

MINNESOTA

IMAGES of America

IMAGES of America
FREEBORN COUNTY
MINNESOTA

Freeborn County Historical Society

Copyright © 1999 by Freeborn County Historical Society
ISBN 978-1-5316-0199-7

Published by Arcadia Publishing
Charleston, South Carolina

Library of Congress Catalog Card Number applied for.

For all general information contact Arcadia Publishing at:
Telephone 843-853-2070
Fax 843-853-0044
E-mail sales@arcadiapublishing.com
For customer service and orders:
Toll-Free 1-888-313-2665

Visit us on the Internet at www.arcadiapublishing.com

Contents

Acknowledgments	6
Introduction	7
1. The Southeast: Albert Lea, Hayward, London, Oakland, Shell Rock	9
2. The Southwest: Alden, Freeman, Mansfield, Nunda, Pickerel Lake	33
3. The Northwest: Bancroft, Carlston, Freeborn, Hartland, Manchester	57
4. The Northeast: Bath, Geneva, Moscow, Newry, Riceland	81
5. The County Seat: Albert Lea	105
Map of Freeborn County: Towns, Railroads, Major Roads	126

ACKNOWLEDGMENTS

The Freeborn County Historical Society is proud to present *Images of America: Freeborn County, Minnesota*.

We wish to acknowledge Bev Jackson, FCHS Executive Director, for weaving these threads of history into narratives that educate and entertain, and for coordinating this project; and Linda Evenson, FCHS Librarian, for the archival research that provided the interesting images and little known bits of history, and for the assembly of the final product. Kathy Freese, FCHS Administrative Assistant, supplied unending patience as she processed our ideas, revised, and revised again. We also thank Georges Denzene, museum volunteer, who provided limitless hours in the photo selection process, valuable information, and editing skills; and Jonathon Green, member of FCHS Board of Directors, who assisted in the planning of the book, in photo selection, and with proofreading.

Equally as appreciated are the following: Irv Sorenson, whose *Hi-Lites & Shadows* entertained readers of the *Albert Lea Tribune* for many years; Grace Haukoos, owner of The Constant Reader, who encouraged us to tackle this project; Roger Lonning, FCHS member, who provided his copious notes of Freeborn County's history for our use; Ed Shannon, of the *Albert Lea Tribune*, for informative columns; Kathy Jensen, author of "Clarks Grove...A Place We Call Home;" Bidney Bergie, Freeborn County historian; Michael Cotter, farmer and storyteller; Freeborn County residents who donated photographs; and the numerous authors of the publications—*Histories of Freeborn County* (1882, 1911) and *Freeborn County Heritage* (1988); *The Hollandale Story 1918–1950*; *Historiography*; and *The Community Magazine*.

Each of these people, with their own significant contribution, has made possible this publication, and for this we are grateful.

Introduction

The history of Freeborn County, Minnesota is the story of people—their dreams, their hard work, their joys, and their disappointments.

Our history is: Lieutenant Albert Miller Lea of the First United States Dragoons, who surveyed and mapped these beautiful prairies; and it is Elizabeth Stacy, the first woman to graduate from the University of Michigan Medical School. It is George Ruble, the stubborn gentleman who built the dam and the lumber mill for the town he dreamed would become the county seat; and it is the indomitable spirit of the pioneers, who could not speak the English language, but knew they would make their homes on this fertile Minnesota soil. It is the child who lies buried in a shallow grave, and the mother who dried her tears and then prepared supper for her family.

In this book, we will introduce to you these ethnically diverse people, and we will attempt to explain the human natures that braved the hot, sticky summers and the sub-zero winters. In earlier years, Native Americans had built mounds and lived in villages along the shores of the lakes. The Europeans arrived later in covered wagons, and some of these earliest settlers lived in dugouts until they could build better homes. Then came the merchants, who believed in the future of these small farming communities; and the entrepreneurs, who platted sites for the villages. This complicated mix defines our history.

Many books have been written about Freeborn County. Most of them focus on Albert Lea, the largest city and the county seat. We have chosen a broader view for this work.

We have selected prints and photographs from each of the twenty townships that make up the county. In these townships, many communities have developed over the years. Some of them lived only a short time, and died because they were bypassed by the railroads that criss-crossed Southern Minnesota, providing transportation for new settlers and shipping for agricultural products. Other villages could not attract settlers. Those that survived grew, and to this day provide homes for descendants of the earliest pioneers, as well as newer residents, who were attracted by industry or the beauty of Southern Minnesota.

A history of Freeborn County could not be written without an emphasis on agriculture. Farming has been the mainstay of the area. Early records describe fertile fields, the abundance of crops, and numerous creameries. For many years the largest industry in the county, the meat packing industry, provided jobs for the townspeople as well as a market for the cattle, hogs, and sheep raised in the rural areas.

Albert Lea is the county seat—a picturesque community surrounding Fountain Lake and touching the shores of Albert Lea Lake. It is a city of a legend—the horse race that determined

its position as the county seat, and the mysterious man whose body was found hanging in the courthouse clock tower. It is the only city in Minnesota that was named after the United States Army Officer who served with the Dragoons out of Fort Des Moines; and then almost thirty years later, who fought on the side of the Confederacy during the Civil War.

The county's namesake was William S. Freeborn, who served in the Territorial Legislature from 1854 to 1857. He was a politician with an interest in land development, and with whose support neighboring counties were also created.

Most of the photographs in this book are from the files of the Freeborn County Historical Society. The others have been donated in an effort to further define the communities, past and present, that make up our rural Southern Minnesota landscape.

Historical research for the photo captions was done in the FCHS library and archives. This library contains an abundance of information—original accounts, as well as other articles written many years after the actual incidents occurred. Research efforts were based on the earliest information possible, keeping in mind that later accounts were often affected by misinterpretation, personal bias, and the prevailing public attitudes. Sometimes only the later information was available.

Although dates, locations, and names are occasionally missing from photo identification, the editors felt that some pictures were simply too good to be omitted. We ask the readers to provide their own interpretations, knowing that this particular situation did take place sometime in the history of Freeborn County.

This book, *Images of America: Freeborn County, Minnesota*, has been designed as a guide for an afternoon's drive through one of the quadrants of the county, or a visit to the county seat. Whether you are in your car, or in an easy chair, and no matter which section of the county you choose, in these pages you will find photos that represent the people, the landscape, the economic purpose, and the lifestyles of each area.

We hope you enjoy your trip!

One

THE SOUTHEAST

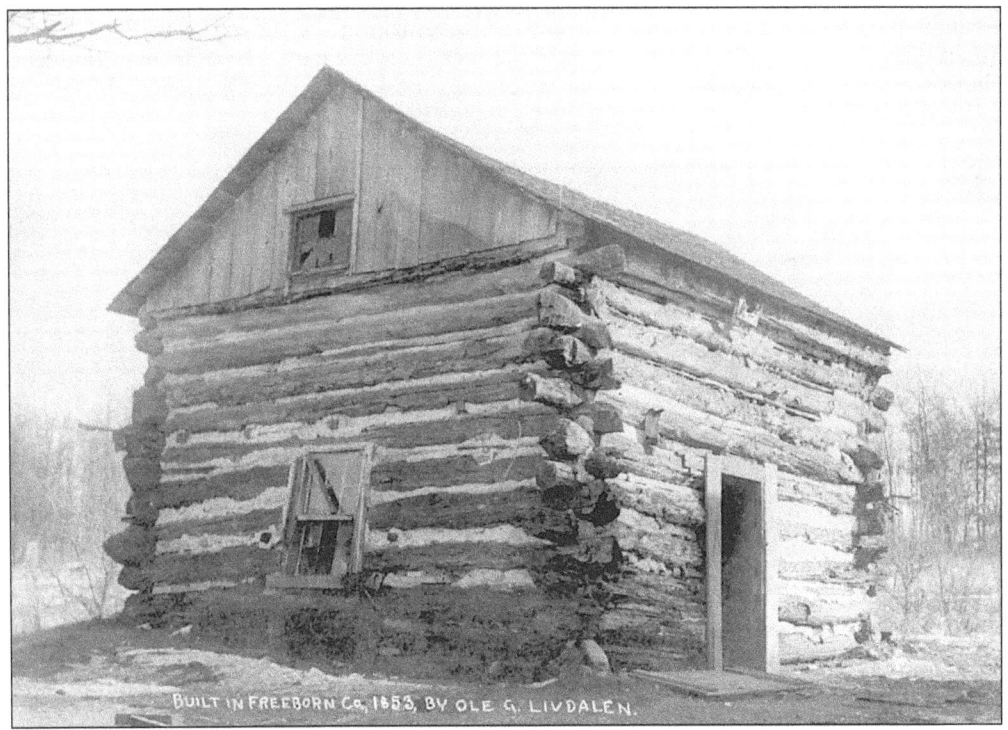

Resources show that this cabin was "rolled up" by Ole Gulbrandson and his wife Astri in 1853. One of the first homes built by a settler in Freeborn County, it was located on the southwest quarter of Section 33, Shell Rock Township. In 1856 Gulbrandson (sometimes called Livdalen) sold his claim to William Beighley who, in the next few years, raised the house several logs higher, put in floor boards and windows, and replaced the sod roof with cut oak shingles.

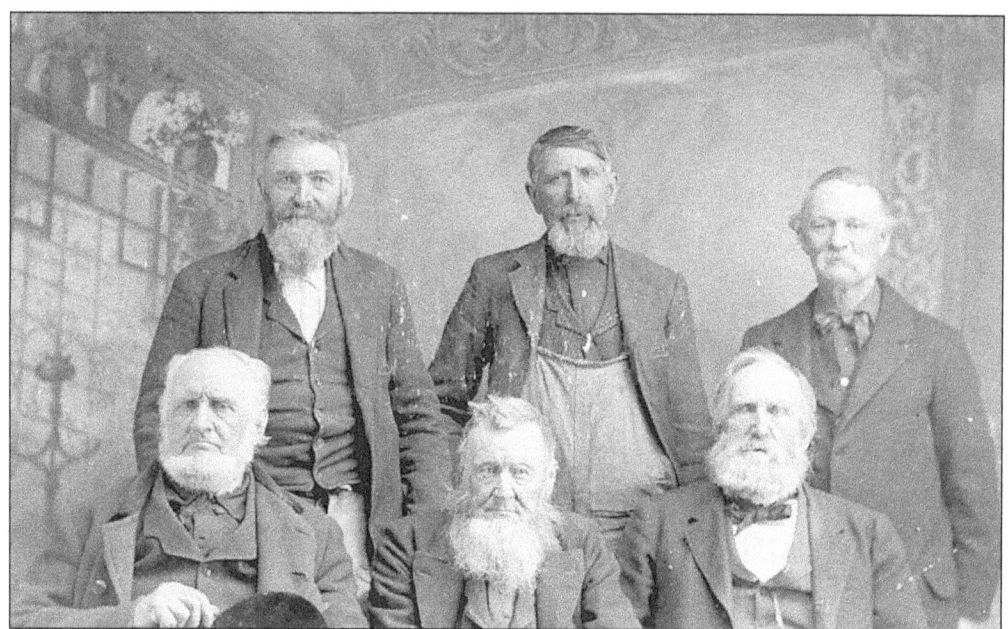

These distinguished early Freeborn County settlers pose for a group photograph in 1890 at the J.O. Booen Studio in Glenville. They are, from left to right, Charles T. Knapp (first to use a breaking plow in the county), Jacob Hostetter (spokesman at the funeral of two men found frozen during the blizzard of 1856), George Gardner (hotel owner), Mark Freeman (farmer), Henry Cottrell (who hauled supplies from McGregor, Iowa), and Edward Budlong (who farmed 230 acres).

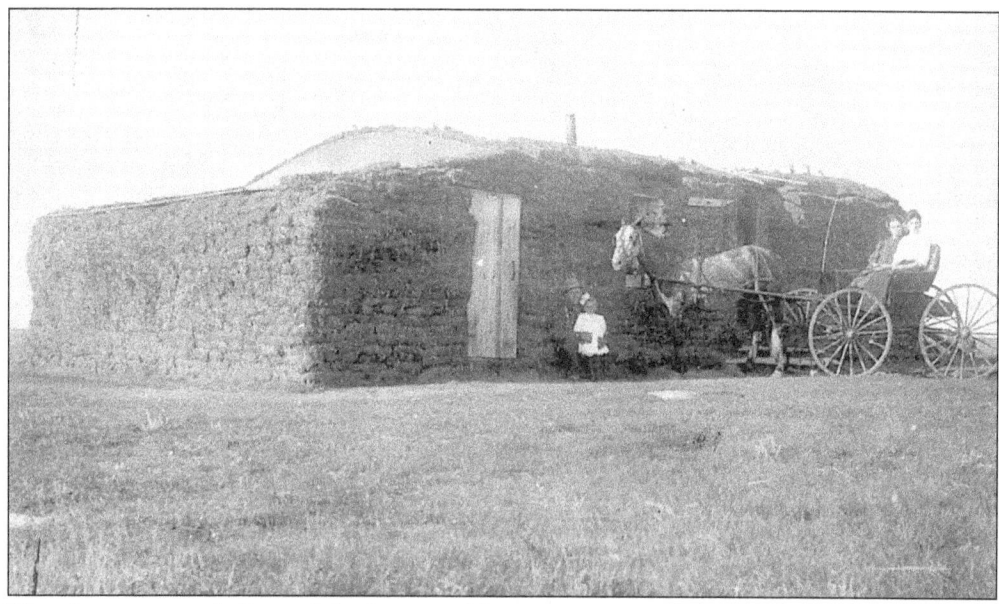

The elegant young ladies and the horse and buggy seem out of place in front of the John M. Turbett home. This sod house, made of huge chunks of thick prairie grass, was a temporary home for the family, until a permanent home could be built. J.M. Turbett was born in Pennsylvania in 1846 and died at Gordonsville in 1911, having been married twice and fathered 12 children.

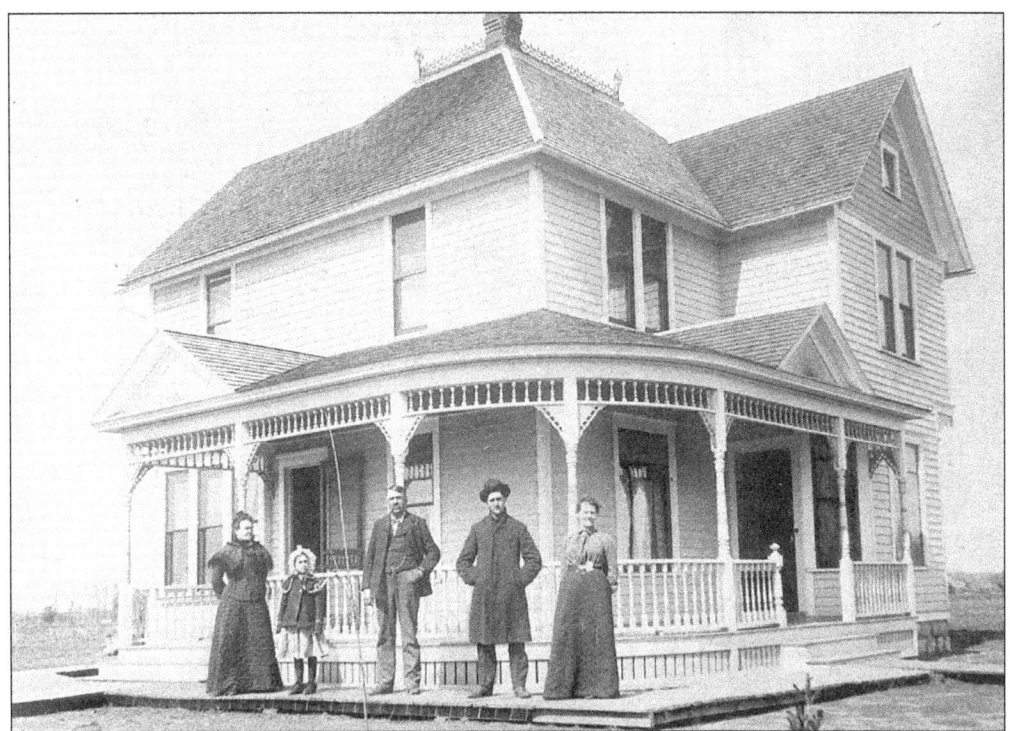

A photograph from the FCHS archives lists this beautiful Victorian home as the Lackey residence, on Skinner Street in Glenville. Shown here, from left to right, are: Ida Hull, Ida Lackey, Fred Morrison, Harry Morrison, and Mrs. Fred Morrison. No date is given. Other records show that Harry Morrison died in 1957, after several years of illness, remaining "strong in spirit, alert mentally, and interested in family and world news."

This typical 19th-century Minnesota farmhouse, with its steep-gabled roof and decorative porch, was the home of the Martin Nelson family from Gordonsville. For 40 years the Nelsons farmed, until Martin's death. He "sank quietly down in death," (*Albert Lea Tribune*, September 1930) while attending the funeral of an old friend, Aleck J. Lee, at Shell Rock Lutheran Church west of Northwood, Iowa.

Hi-Lites and Shadows of Yesterday and Today, drawn by Irv Sorenson in 1956, is pictured here.

This *Hi-Lites and Shadows of Yesterday and Today* was drawn by Irv Sorenson in 1960.

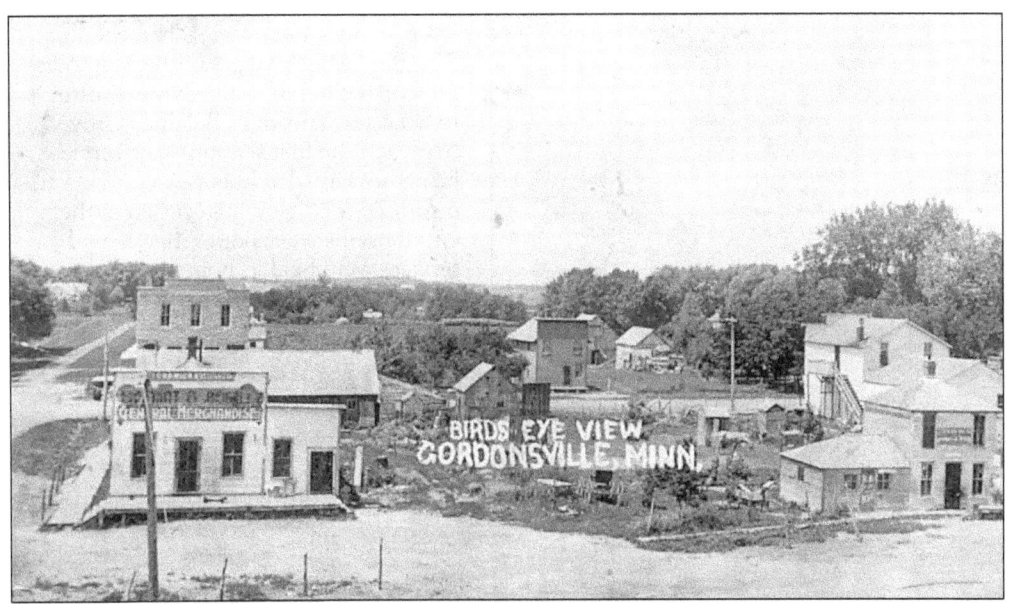

This 1910 view of Gordonsville shows the old bank building, one of the city's general stores, the Larson Cement plant, and the original home of the Pierce Harrows. The icehouse and the Methodist Parsonage are also shown. The 1904 city directory lists Samuel Beighley as the manager of the Long Distance Telephone Company. He also sold cigars, gum, and candy, with special attention given to oysters and ice cream when in season.

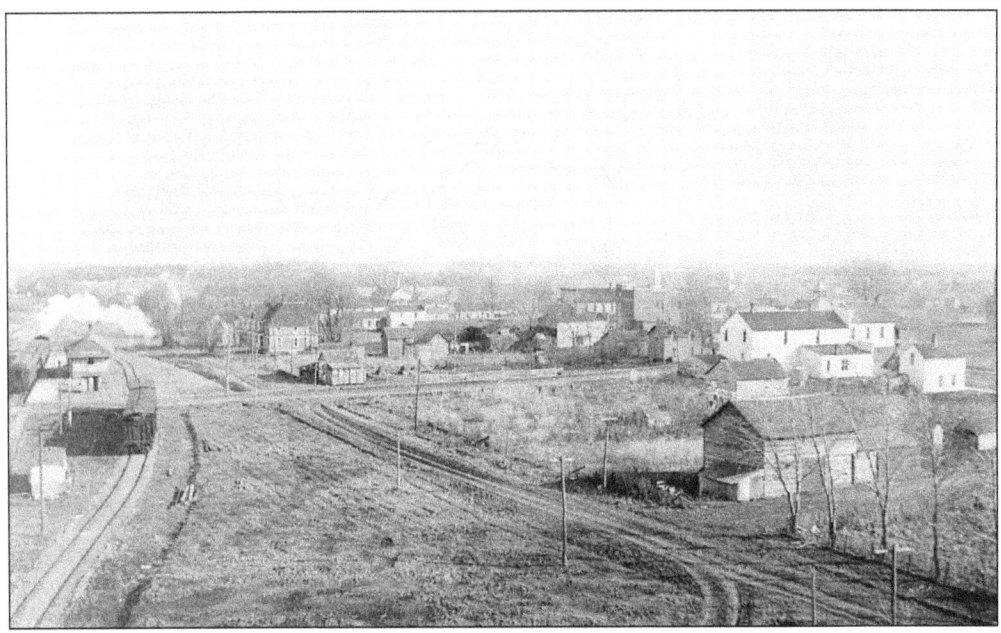

The village of Glenville was incorporated in 1898, and was a combination of two villages—Shell Rock and Woodside. By 1911, Glenville could boast of "four churches (Methodist Episcopal, Free Methodist, United Brethren, and Norwegian Methodist), a creamery, school, telephone system, a fine city hall, two banks, a fire company, a newspaper, and the usual business houses and residences." (*History of Freeborn County* [1911].)

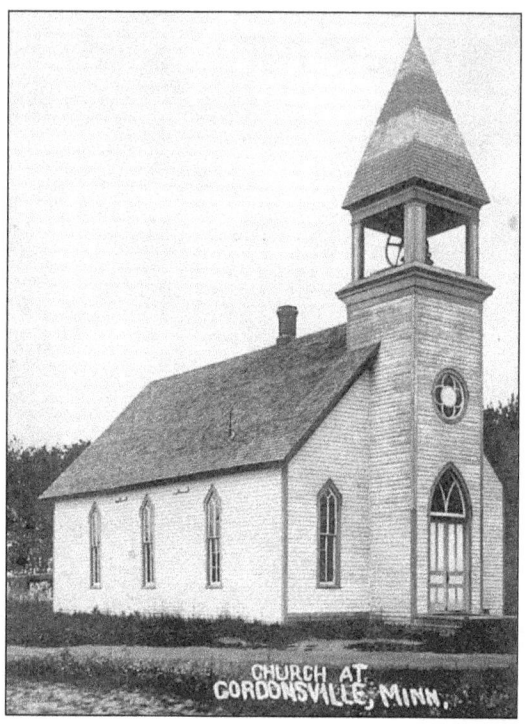

In 1857, an itinerant preacher, the Reverend Moses Mapes of the Methodist Episcopal Church, walked from Austin to what was known as Beighley Grove, to preach the first sermon—the service being held in a log home. A year later he organized the first congregation of the Gordonsville Methodist Church, and services were held in homes, and then in the schoolhouse, until this white-frame church was built in 1883.

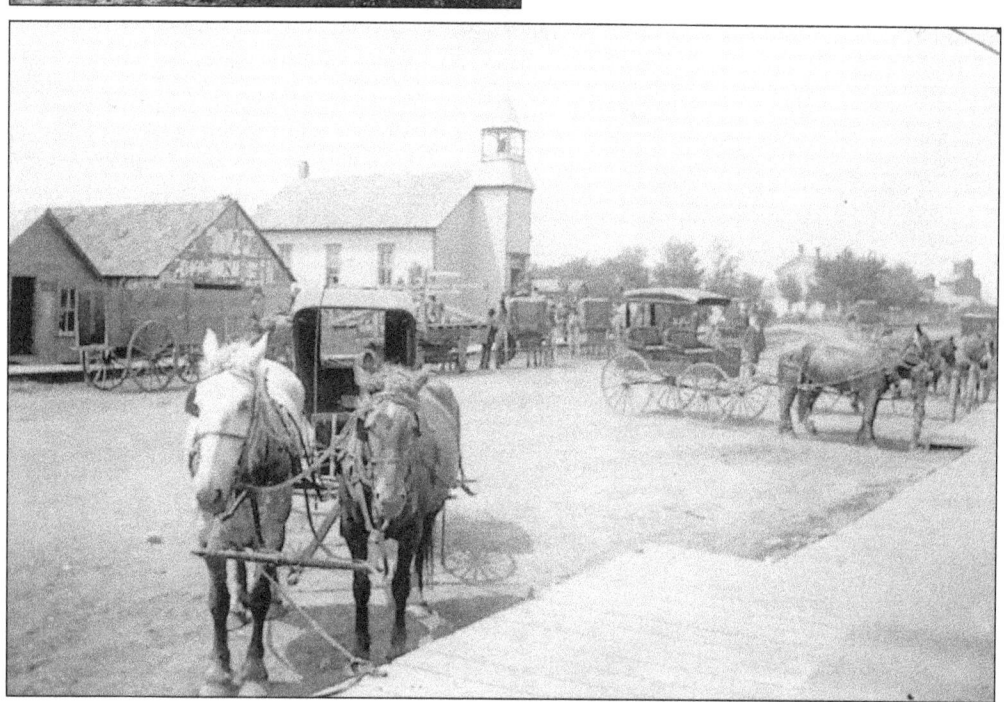

One wonders what event brought all these vehicles to Glenville on a day that was probably a weekday. In addition to the Glenville Free Methodist Church being open, Gillard's Blacksmith Shop also seemed to be busy. Note the iron rings on the sidewalk for tying horses, the single-seated buggies, the double-seated surreys, and the double-grain box and hay rack in front of the blacksmith shop.

John P. Larson (standing in the wagon), his wife Inger, and their children (in the auto) pose for the camera in 1906. Their farm, Shell Valley Farm, was located west of Gordonsville. He was born in Telemarken, Norway and immigrated to Freeborn County when he was 16 years old. The Larsons and their nine children were well known for their involvement in the church and the community.

"Through snow and rain and gloom of night," George McGrath carried the mail on Glenville's Rural Route No. 2 from its inception on October 1, 1902, until he died in 1921. He was known as one of Glenville's best citizens, a genial mail carrier who was a friend to those on the route, especially the children.

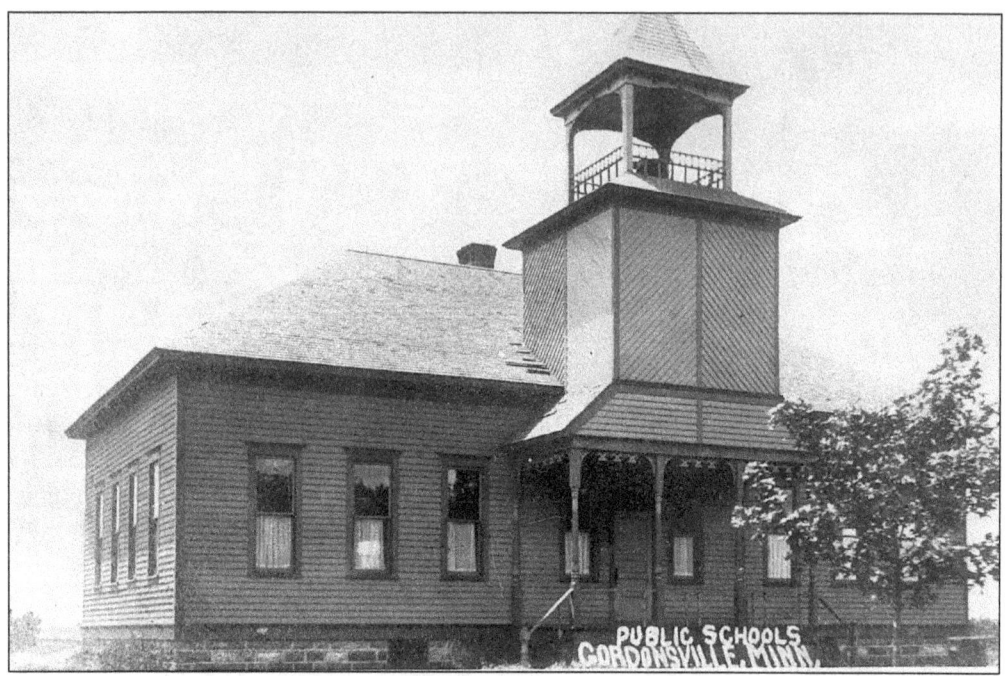

When this Gordonsville District 50 school was built in 1883, it was considered one of the best school buildings in the county. It contained two classrooms, a hallway, and a library with 150 volumes. Heat was provided by coal, which was kept in the basement and carried upstairs by the teachers and students to the two coal heaters. The building had no electricity or running water. It was destroyed by fire in 1900.

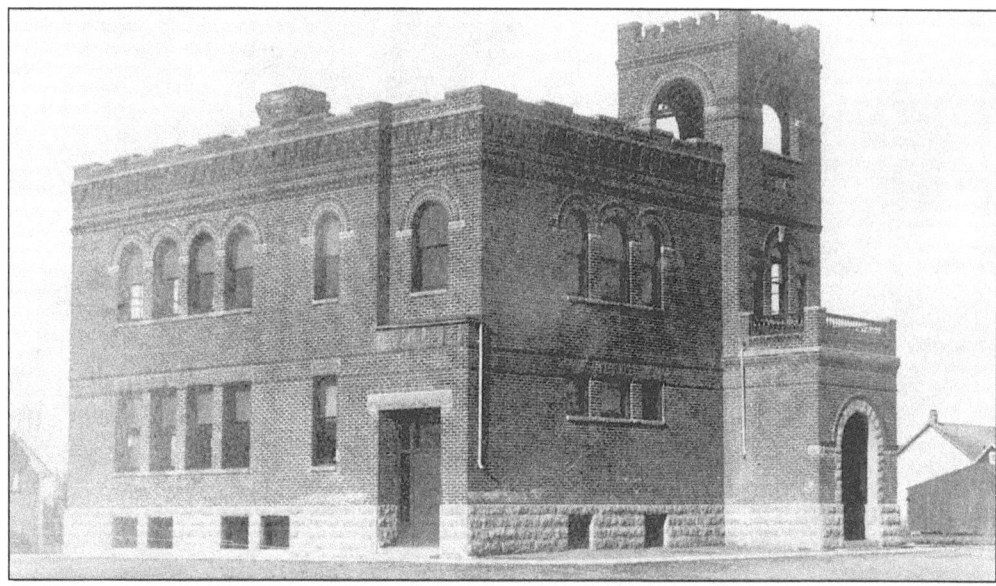

Glenville's third school was built in 1899, at a cost of $6,500. On a Monday morning in May, 1916, pupil Roy McGrath was working at the blackboard when he saw a puff of smoke and fire. He yelled, "fire," and then ran to the town hall to ring the fire bell. In less than three minutes, all the students were outside. They helped the firemen and neighbors with the bucket brigade, carrying water from nearby wells. Only the building interior was damaged.

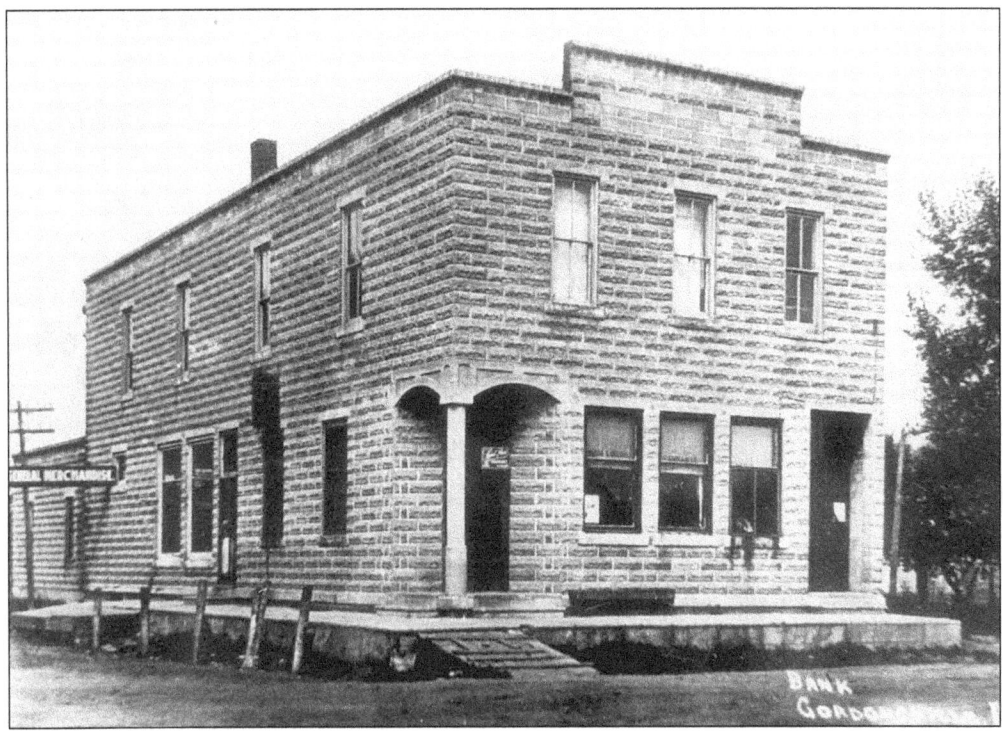

Old-timers spoke of the Gordonsville City Hall with pride and nostalgia. It not only served as an election site, but also a meeting place for organizations and the center for all community events, prize fights, dances, school programs, traveling shows, and church dinners. Built in the early 1900s from cement blocks made on the site, the building also housed the bank and the D.L. Klovis general store.

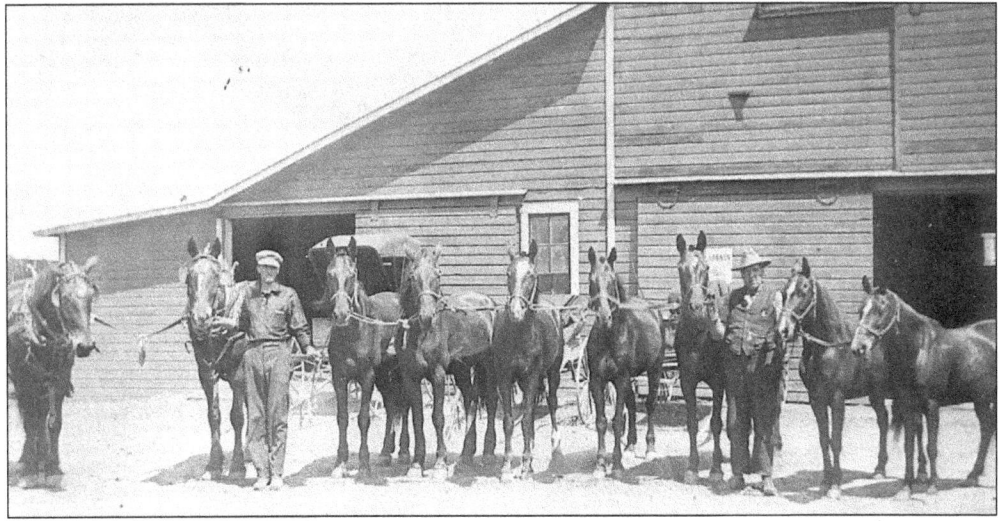

In 1910, George Pfiefer and Fred Holman sold the Glenville livery barn to S.T. Kirkpatrick, who modernized the building with a cement floor and force pump. The business was leased by Lester Abbott and Pardon "Pard" H. Cottrell. "Pard" later purchased Abbott's interest, and he is shown in this photograph with Con Olson. The livery was located one block north of Main Street, near the Illinois Central Railroad depot.

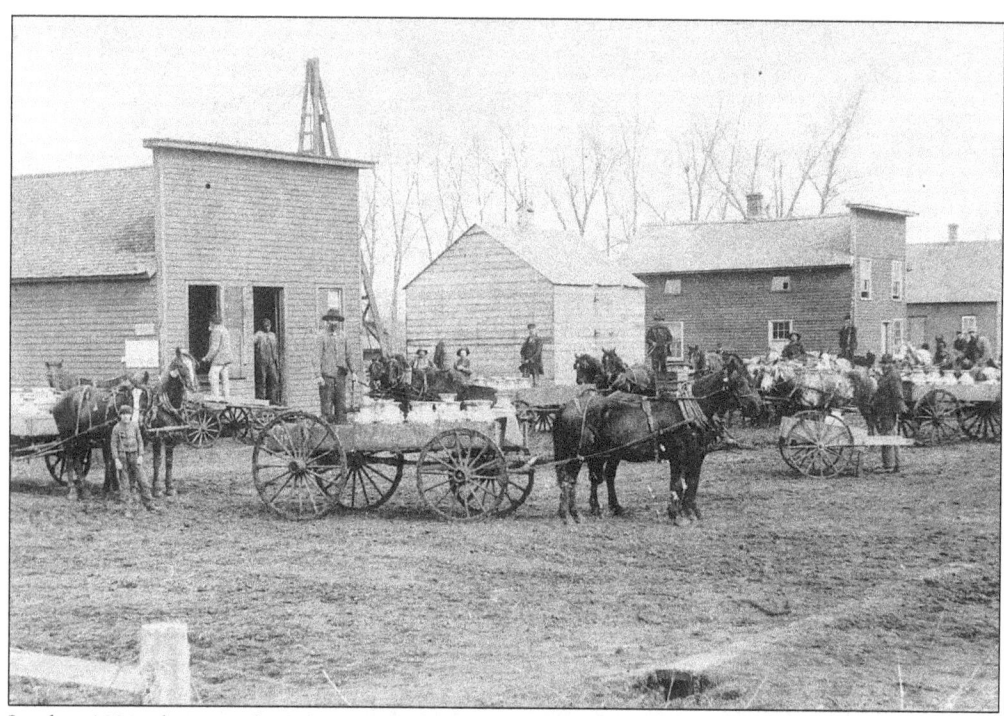

In this 1898 photograph, John C. Buley stands in the doorway (building on the left) of the milk skimming station of Gordonsville. Skimmed-off cream was hauled from this station to the Glenville Creamery to be churned. The second building was the icehouse, then the Forseth Hotel, and then the home of Fred Pierce, the blacksmith, whose business was across the street.

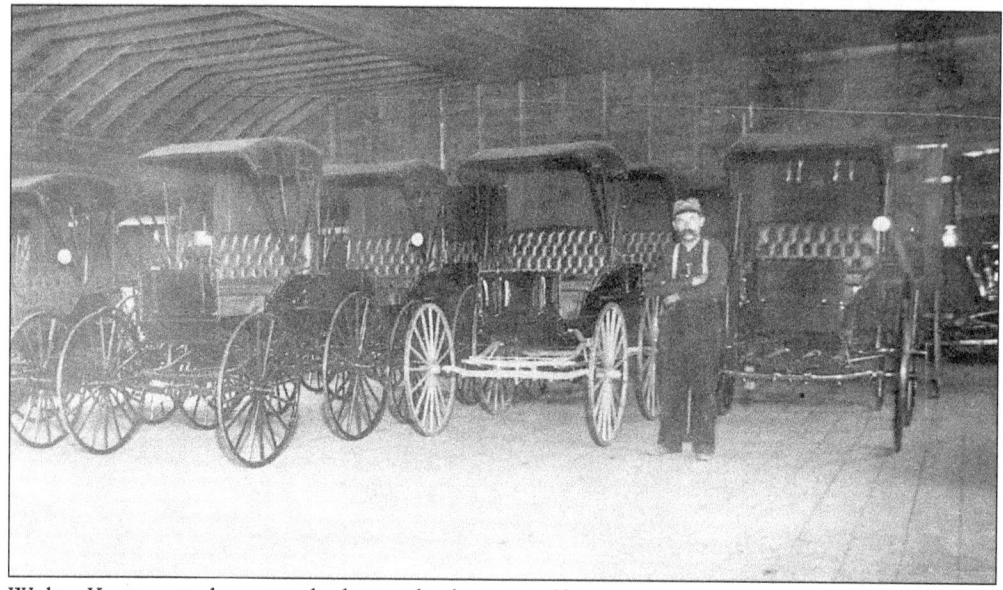

Walter Knutson is shown in the buggy display area of his farm implement business in Glenville. He was born in Denmark, came to the U.S. when he was 22, settled first in Austin, Minnesota, and a year later opened a blacksmith shop and implement business in Glenville. Twelve years later he moved to Albert Lea, going into a similar business. He was well known for his "right methods."

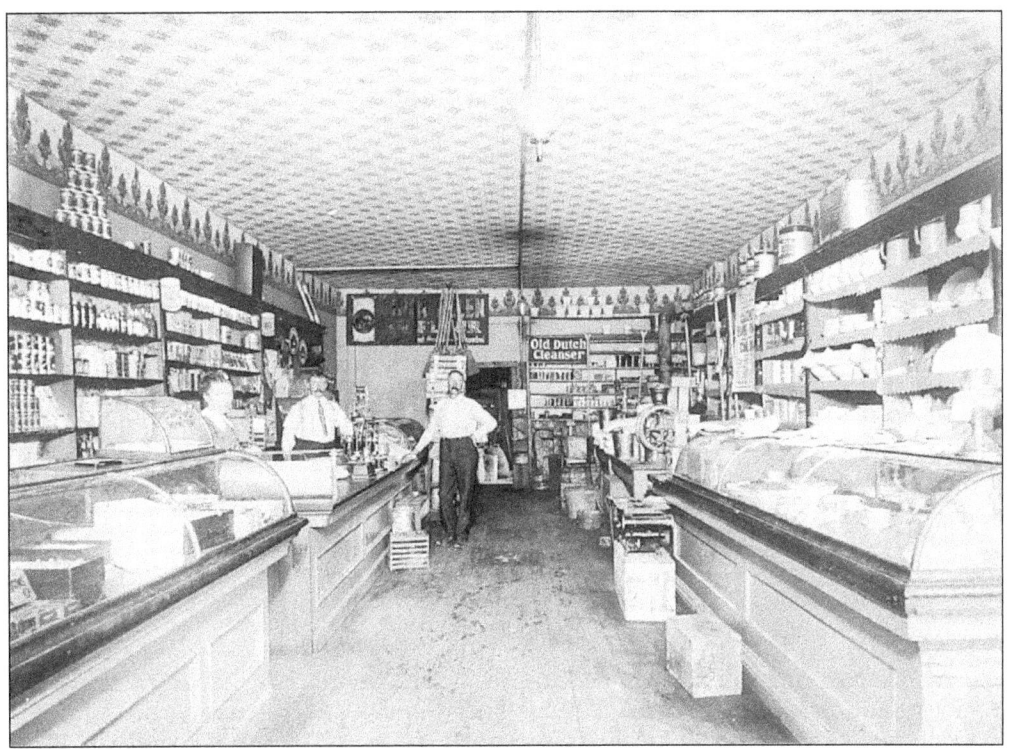

For many years, David J. Roberts owned the general store in Glenville. This photograph shows Roberts and his wife behind the counter and Anton Fields, the store clerk. The patterned tin ceiling, wooden floor, single electric light, wood counters with glass-domed display cases, and floor-to-ceiling shelving were typical of general store interiors in the years following the turn of the century.

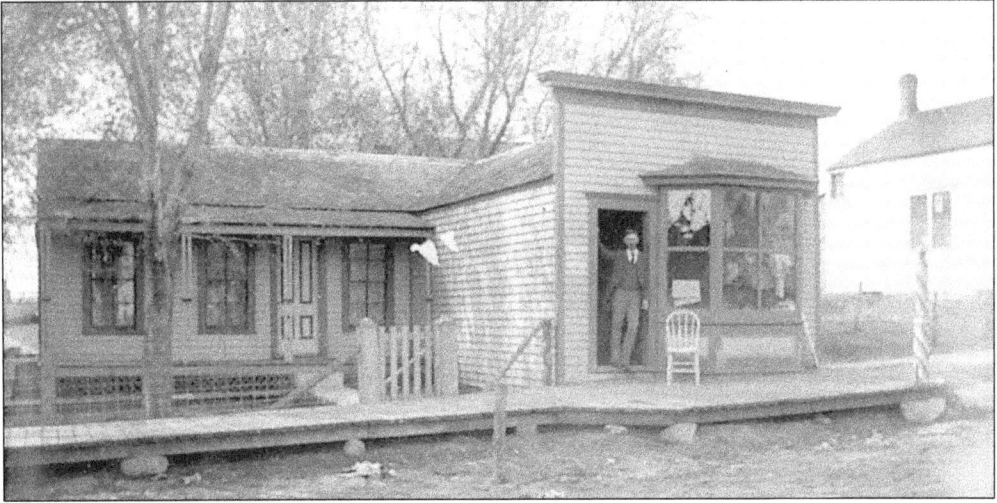

Incorporating his business and his home, James J. Egland's barber shop was located on the south side of Main Street in Glenville in 1896. Note the wooden sidewalks and the muddy streets. An 1890 listing of Glenville businesses also shows dry goods and machinery merchants, a hardware and lumber dealer, shoemaker, milliner, blacksmith, harness maker, butcher, grain and coal dealer, and a hotel owner.

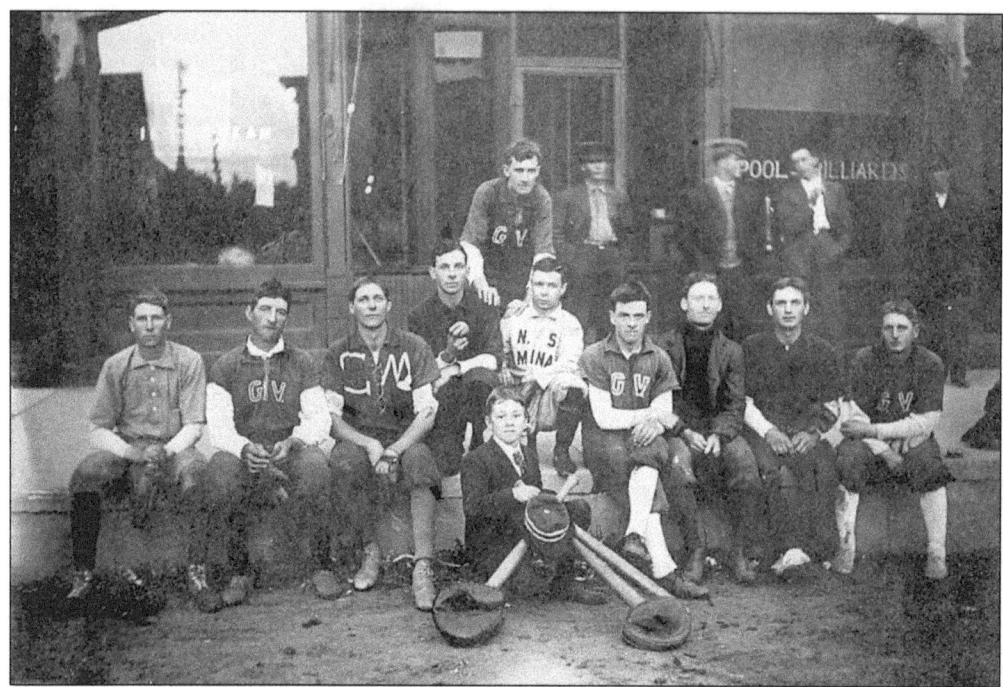

As four gentlemen stand near the Billiards Hall viewing the proceedings, the Glenville baseball team poses for a photograph. This picture, taken in 1908, shows, from left to right: Harry Kirkpatrick, Frank Brown, ? Franke, Gay Seuser, Mort Marcy, Ben Miller, Jess Seuser, unidentified, Jim Garner, George Lundberg, and Wendell "Pat" Seuser. For many years, almost every community had a baseball team that competed with teams from nearby towns.

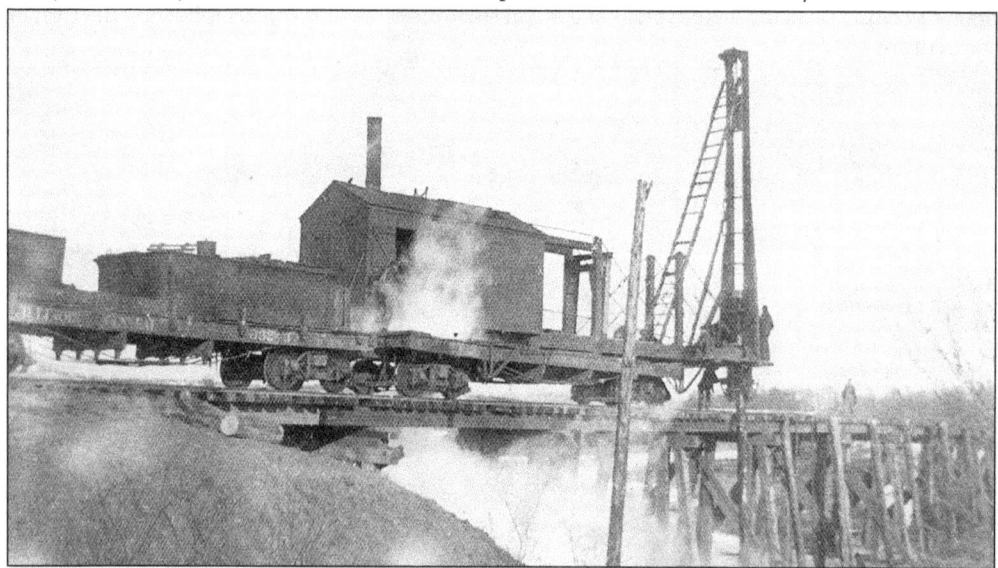

A steam-powered pile driver is being used in this 1900 photograph of bridge repair on the Illinois Central Railroad trestle over the Shell Rock River. In 1910, half of the bridge was destroyed by a fire, which was probably ignited by sparks from a train. The fire company and other citizens worked to prevent the fire from spreading to a nearby home. Both mail and passenger traffic were disrupted until repairs were made.

The Myrtle Post Office has had several locations, beginning at the H.N. Lane farm and operated by Miss Myrtle Lane, who became the town's namesake. In 1906, the post office was moved to the Hanson General Merchandise Store, operated by brothers Carl W. and Bill, where Carl W. Hanson served as postmaster until the store burned in 1927.

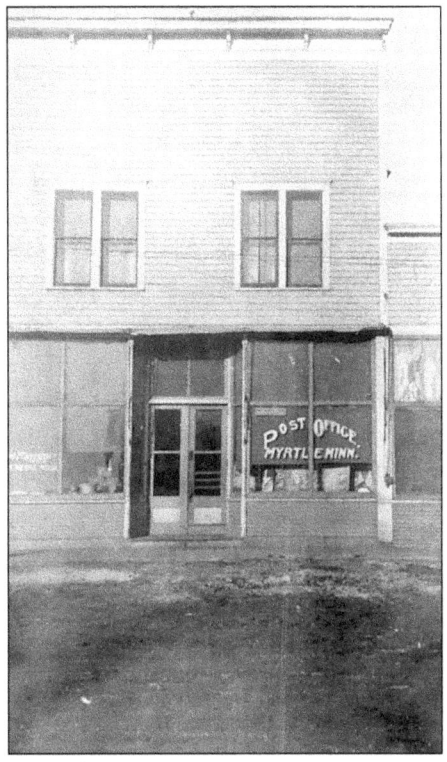

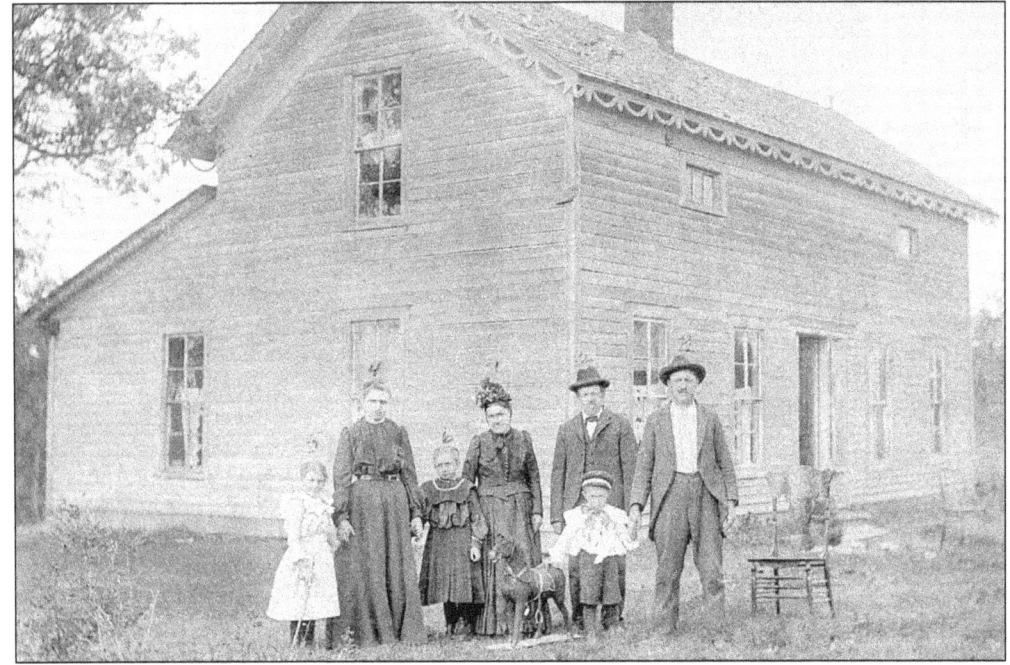

The Harrison Hotel and Grocery Store was located one mile east of Myrtle, and was operated by Frank Flusek from 1901 to 1907. This photograph shows his daughter Ella, wife Josefa, daughter Rose, parents Mr. and Mrs. John Flusek, and Frank Flusek Sr. His son, Frank Jr., is shown with the hobby horse.

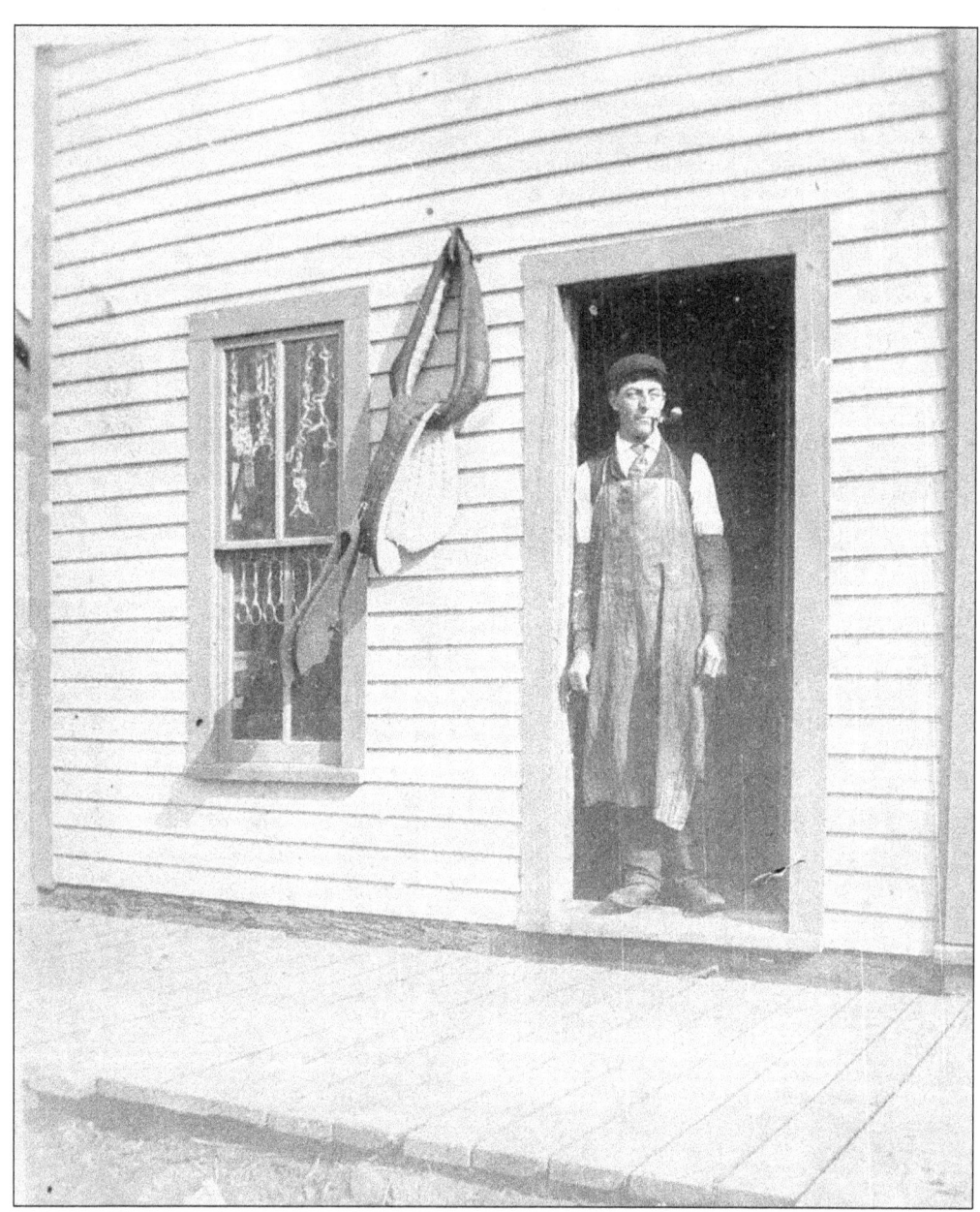

"John Belshan was born in London Township, Freeborn County, Minnesota on August 15, 1876, the son of John and Josefin Belshan. With the exception of four years spent in Wisconsin, he lived in this vicinity all his life. He grew to manhood at the old John Belshan homestead, north of Myrtle. He learned the trade of harness making in Glenville, where he established his shop in the spring of 1900. He was married to Anna Kral on March 27, 1901. To this union one child, Johnnie, was born on January 9, 1900. He passed away one year and 15 days later. Mr. Belshan came to Myrtle in 1909, where he resided until his death. A stroke, on July 23, 1937, incapacitated him to some extent, and he was later unable to continue his vocation. Besides his wife, he is survived by a sister, Mrs. Frank Kral, Route 1, Glenville, and two brothers, Albert J. and Louis J. of Austin, Minnesota. He passed away October 4, 1945, aged 69 years, 1 month, and 19 days. Peace be with him." (*Albert Lea Tribune*, October 22, 1945.)

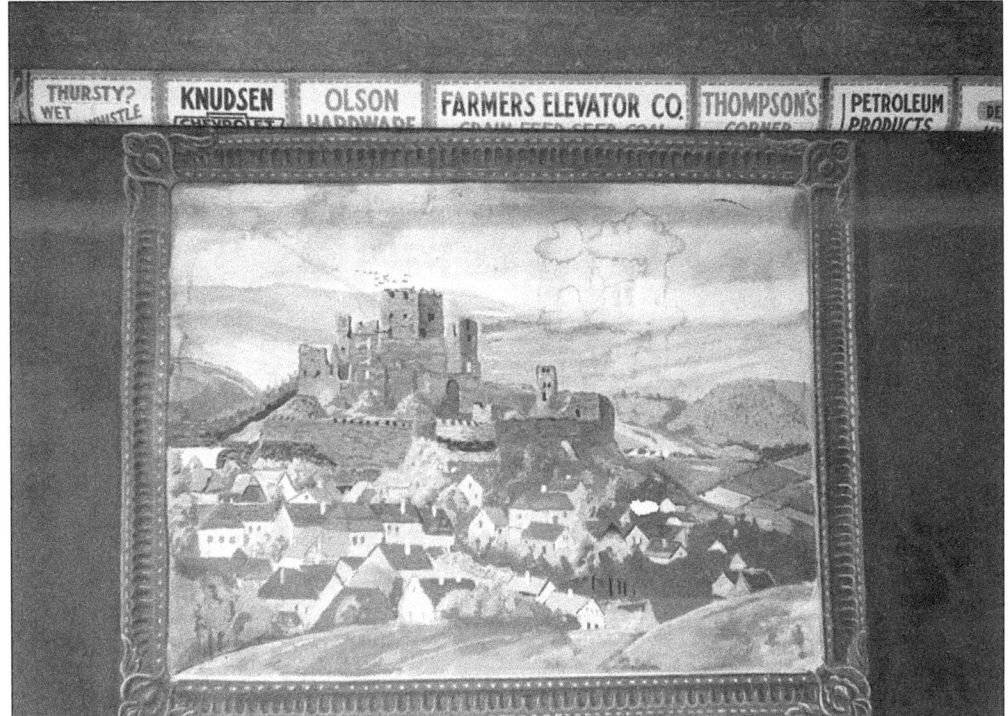

A castle in Bohemia, overlooking and protecting the village, is painted on one of the backdrops in Lodge Zare Zapadu No. 44 in Hayward Township. This painting, by a Mr. Avery, must have brought memories to many of the members of the Lodge fraternity, which, at one time, only admitted Czech people. The other backdrop, partially hidden, is bordered by advertisements of local businesses and products.

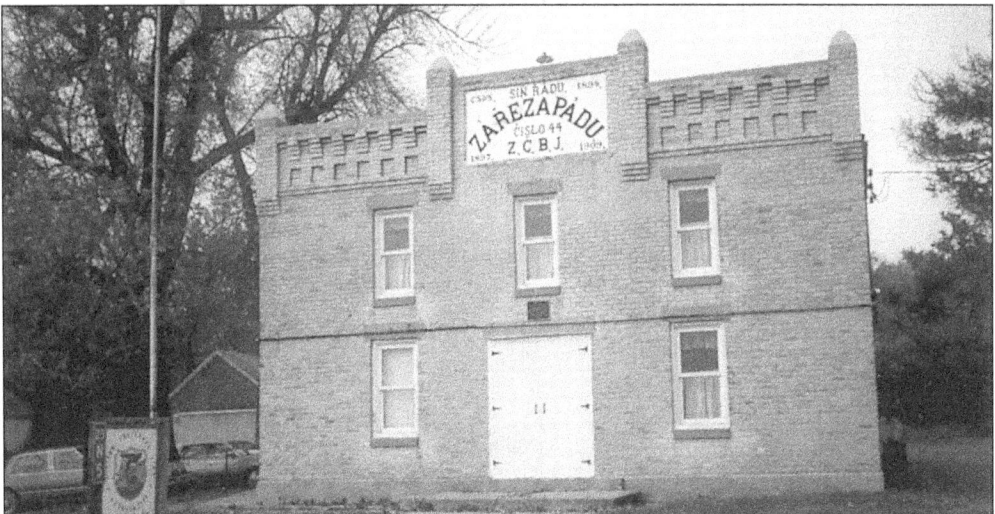

Lodge Zare Zapadu #44, Z.C.B.J., a fraternal organization in the Czech community, was organized in 1894. The name means the "Glow of the West." It has had three homes: two wooden buildings in 1878 and 1896, and the "Brick Hall" built in 1909. They have been the site of countless meetings, dances, reunions, festivals, and theatrical productions. The "Brick Hall" was placed on the National Register of Historic Places in 1986.

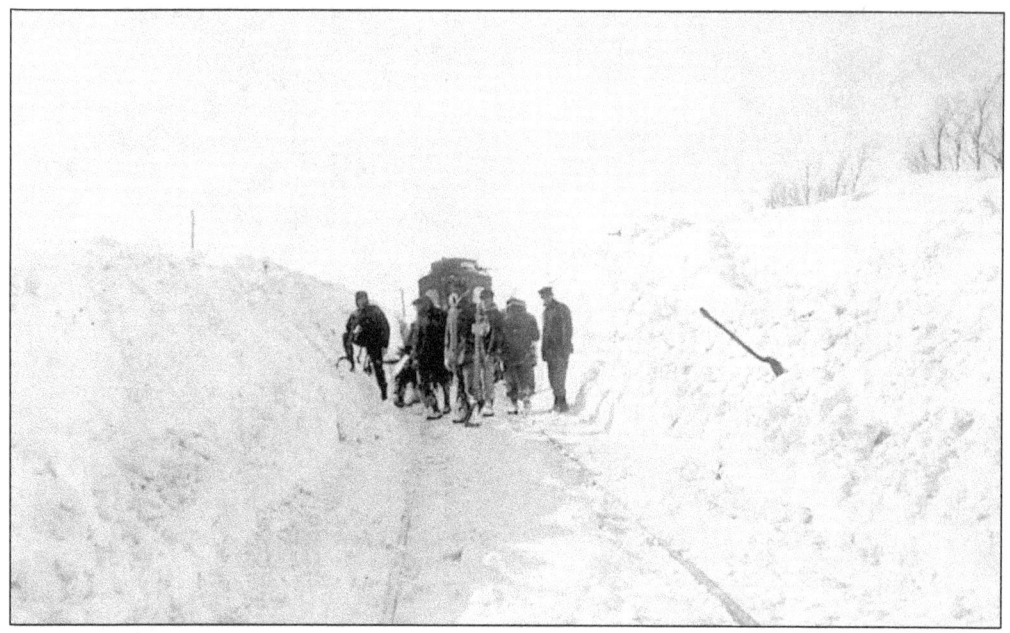

The blizzard of 1916 halted train service until this crew of men was able to shovel out one of the huge snow drifts that blocked the tracks of the Illinois Central Railroad west of Myrtle. Passengers, businessmen, and farmers all appreciated the resumption of service and the gang's hard work in the extreme February cold.

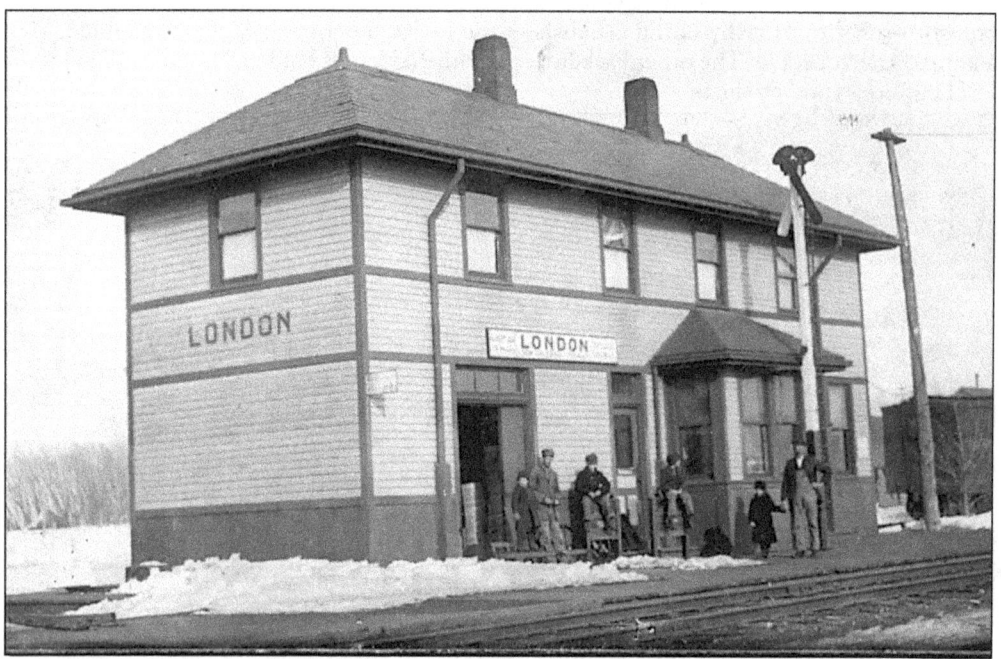

The Village of London was originally constructed about 2.5 miles north of its present location, but it moved when the Albert Lea & Southern Railroad was built across London Township in 1900. The Illinois Central took over ownership, connecting the village with Chicago, and it operated until 1984, when it became the Cedar Valley Railroad.

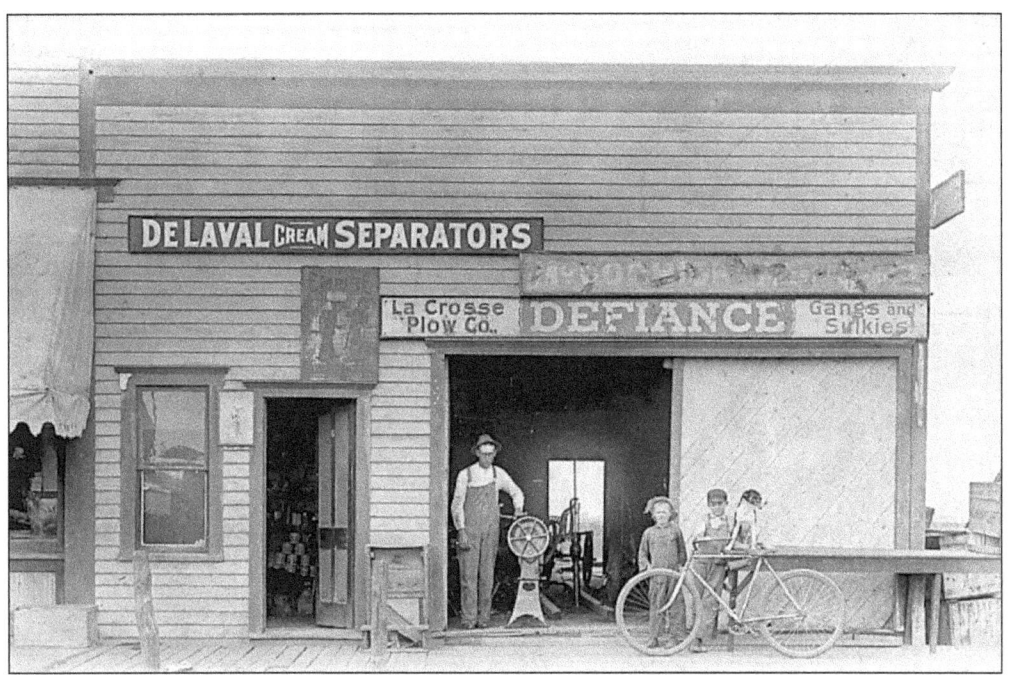

The 1906 Albert Lea/Freeborn County City Directory lists several businesses in the Village of London, among them Haldorson Implement (Christie and Haldorson). Swan H. Haldorson stands in the doorway of his business. The village also included the American Express Co., a bank, creamery, hotel, hardware store, railroad depot, general store, lumber company, blacksmith, and elevator.

At one time Oakland, shown here around 1910, was considered Freeborn County's Tow Head settlement. It was so named because of the tow, or cottony substance, from the poplar trees, and because of the white hair on the children who came with their families from Illinois. The first years were very difficult, with "An early Thanksgiving dinner containing only cracked corn, milk, one sweet cake, and rye coffee." (*Glenville Progress*, February 4, 1937.)

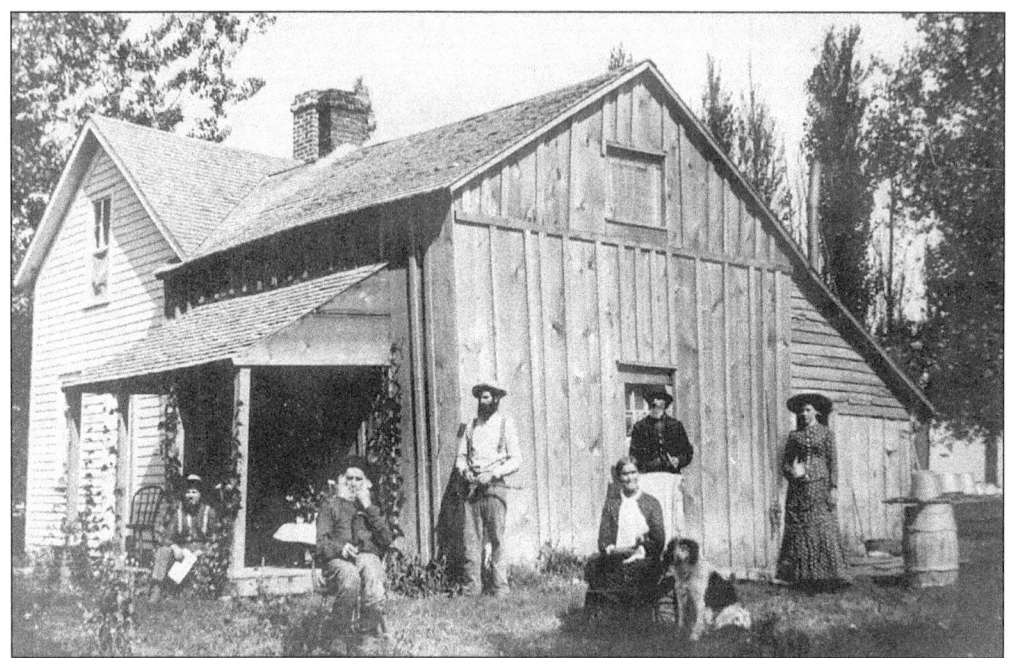

In 1861, the John W. Lightly family settled in Oakland Township on what became known as the "old homestead," as several generations of Lightlys farmed the land. His obituary stated, "He was highly respected by all who knew him, a man possessing an exalted sense of honor." (*Albert Lea Enterprise*, November 7, 1895.) Note the variety of materials used to build this farmhouse.

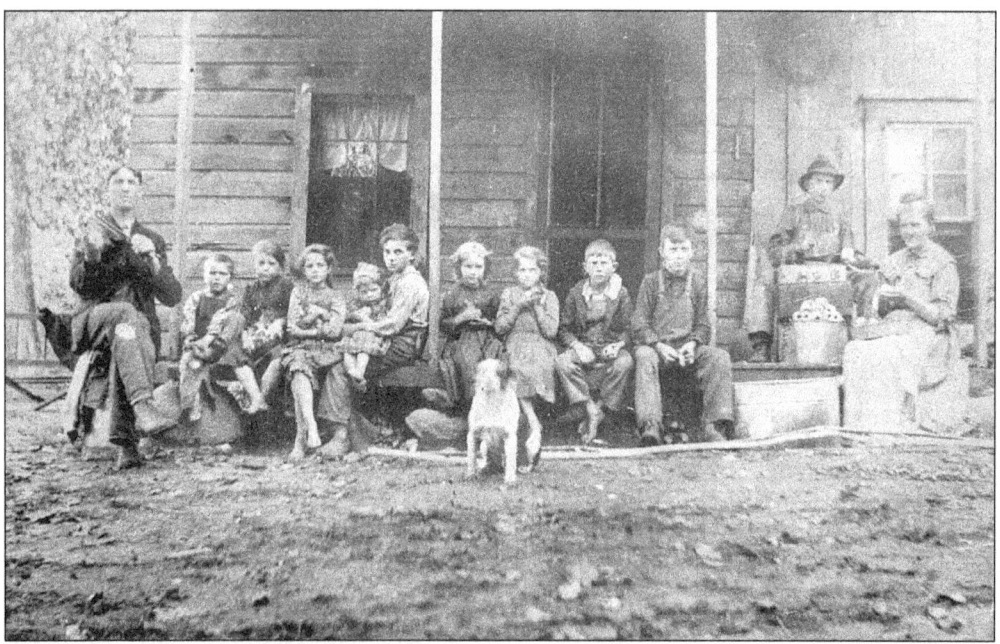

This unusual photograph was taken at the Hayes (possibly Lowry) place near Oakland around 1897. The couple on the right are coring apples, and the gentleman on the left is serenading the group with violin music. Are the children from one family, or are they neighbors or students? The only person identified in the picture is the third child from the left, Grace Lowry.

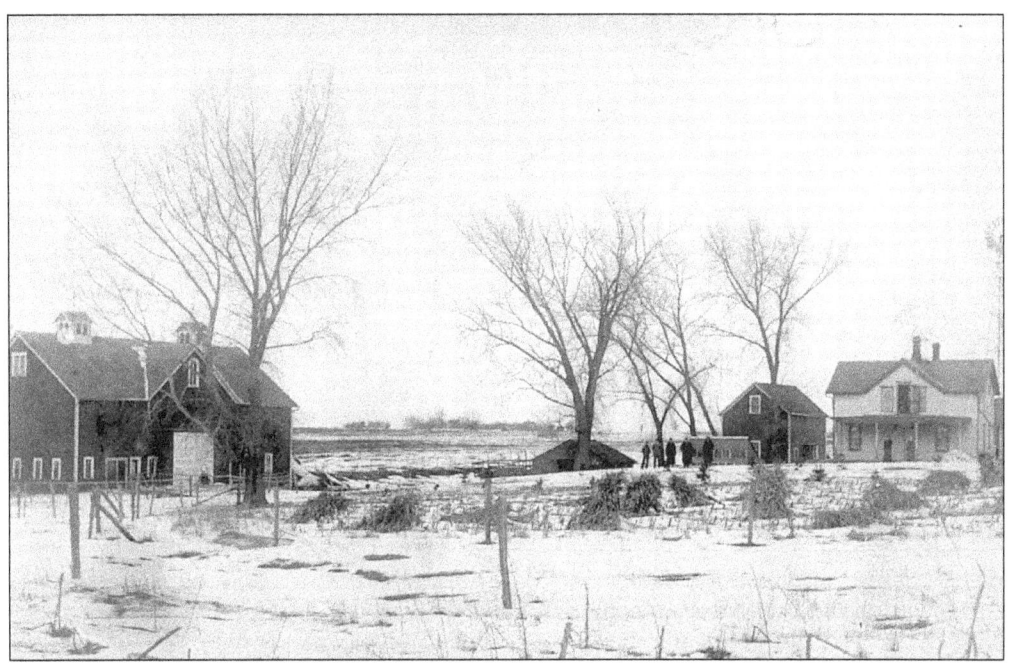

The Endre Gulbrandson farm, near Hayward, wears an air of quietude as it waits for the spring thaw and the busy season of preparation and planting. Gulbrandson was 40 years old and married when his family came from Norway, stopping in Wisconsin, and then moving on to Southern Minnesota and living in a dugout, until their log home was built in 1863.

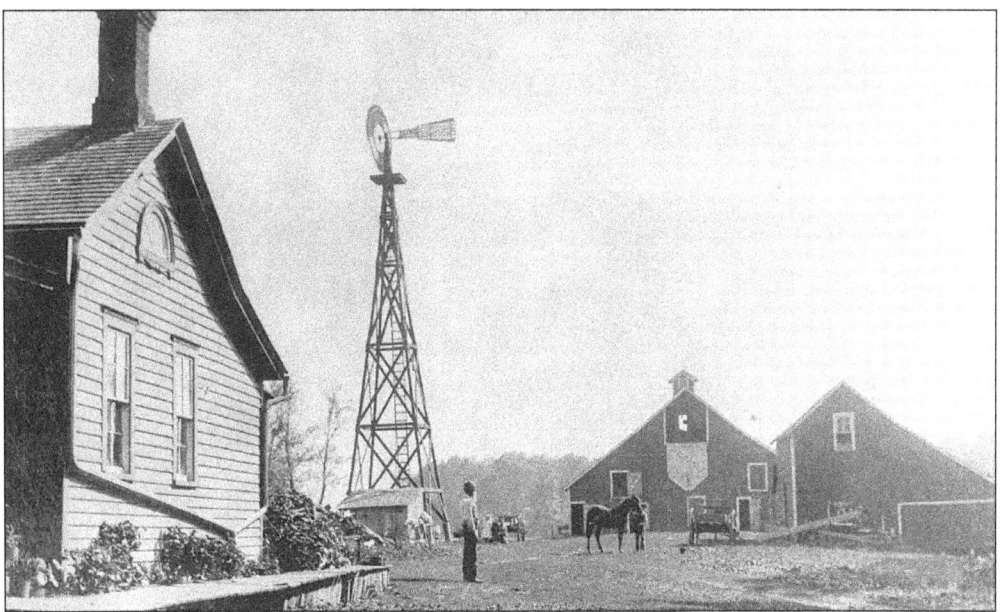

This farm place was located south of the Village of Hayward and typifies the pride and the care shown in the farming community in Hayward Township. Statistics for the year 1882 show that there were 87 farms under cultivation, growing wheat, oats, corn, barley, rye, buckwheat, potatoes, beans, sugar cane, hay, flax, apples, and grapes. There were also 243 milch cows and 135 sheep.

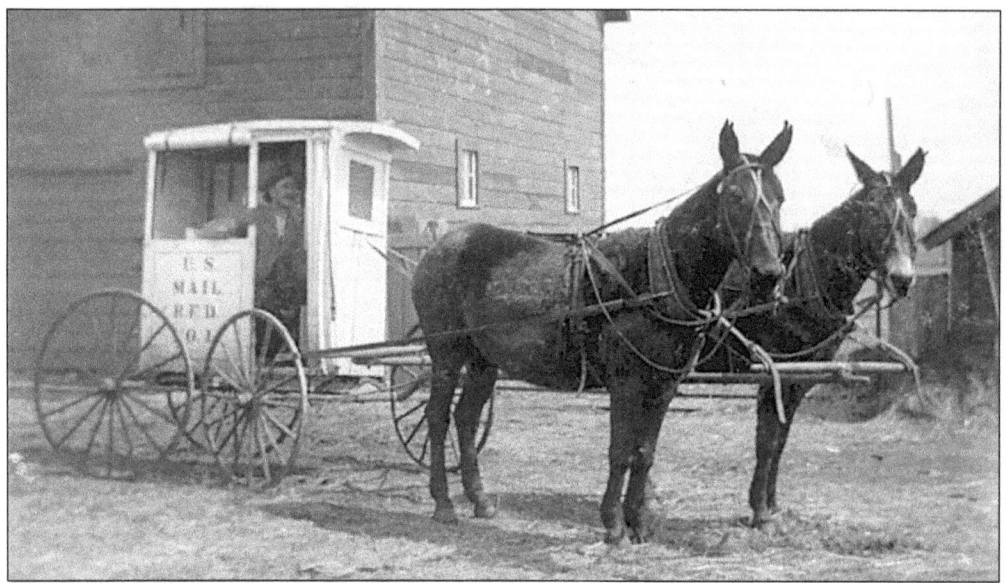

Henry Anderson, as the first rural mail carrier out of Hayward, made his first trip on January 2, 1905. The very first postmaster in Hayward was Nehemiha W. Campbell, who came to this township in 1858. The post office, which was in his home on the stage coach route between Austin and Blue Earth, was moved into the Village of Hayward in 1870.

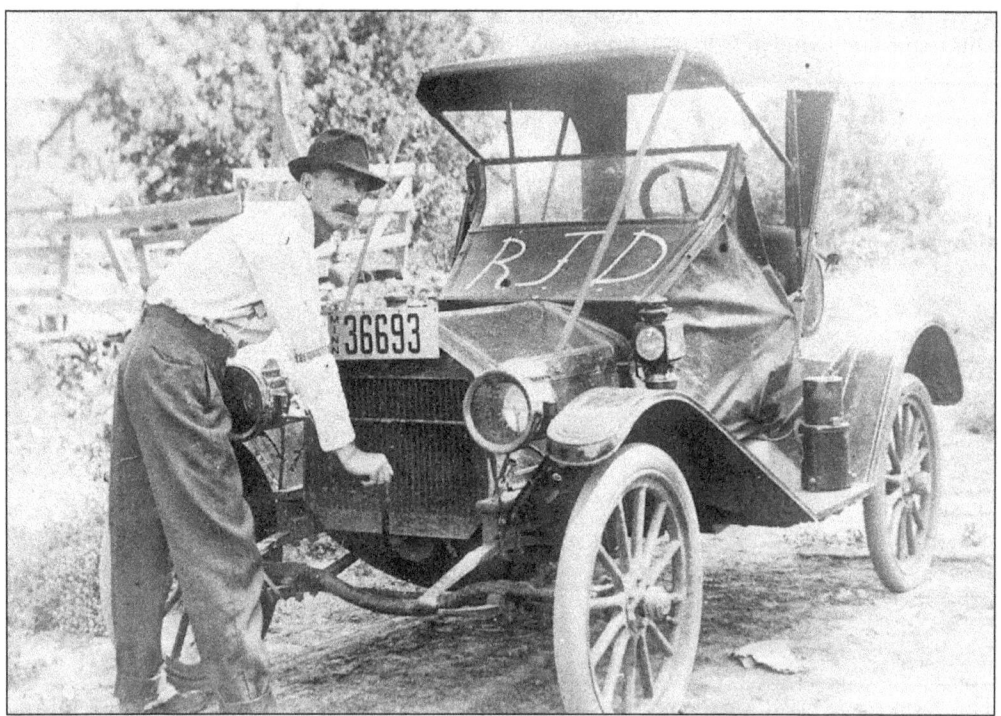

Henry Anderson, Hayward's first rural mail route driver, started in 1905, with a horse-drawn buggy. As rural routes expanded, and autos became the accepted method of transportation, he continued as mail carrier until 1931, serving also in the Lerdal area. An interesting note: On November 2, 1917, a war tax on letters went into effect, and it was repealed on July 1, 1919.

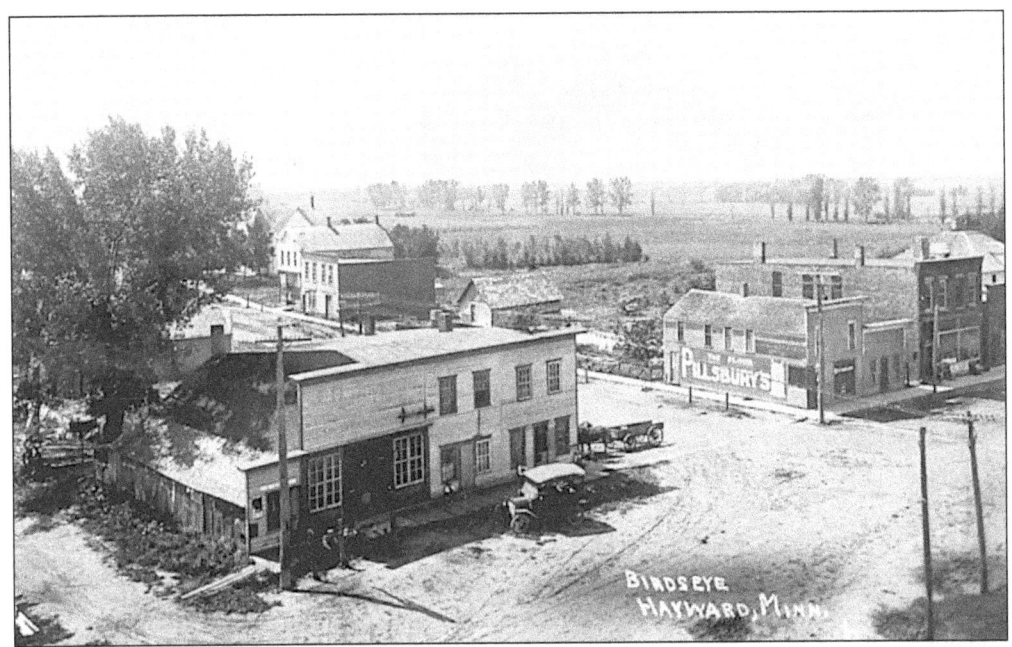

This view of the Hayward business district, in 1910, shows the blacksmith shop and Henry Anderson's store, which were both destroyed by fire in 1918. "The fire had gained considerable headway when discovered and was soon beyond control. . . . Albert Lea was called upon and the Fire Co. and engine made a record trip of six miles in 15 minutes, but not having sufficient water supply, could not do much." (*Glenville Progress*, October 3, 1918.)

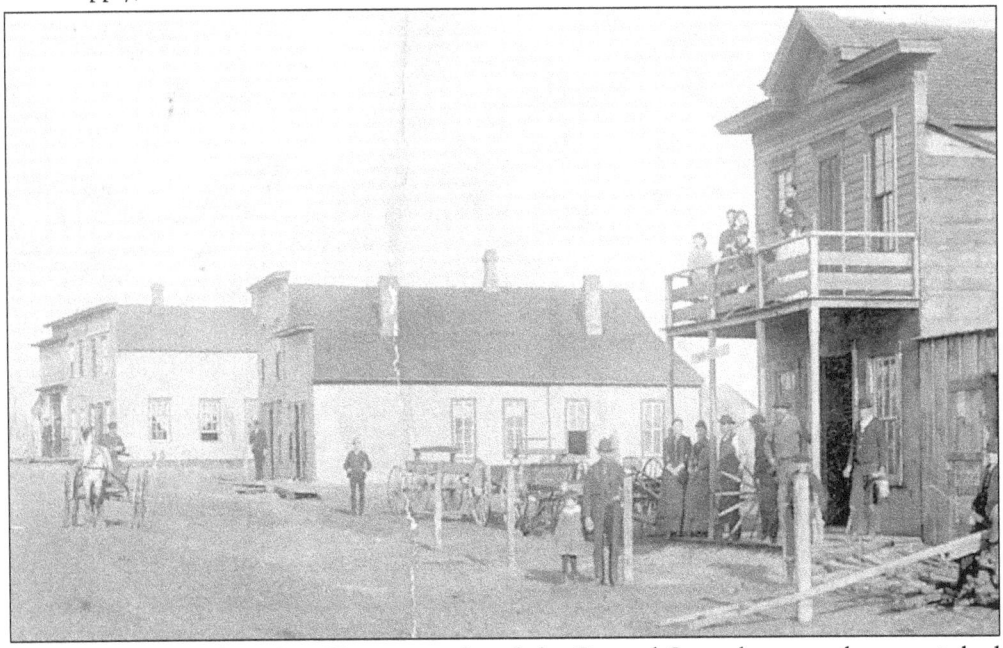

In 1880, Anton and Haakon Hanson purchased the General Store, but over the years it had several owners and was eventually destroyed by fire. The blacksmith and wagon shop was built by Halvor Halvorson in 1878, with living quarters upstairs. His family is on the balcony, and other townspeople are standing near the wagon wheel that is under construction.

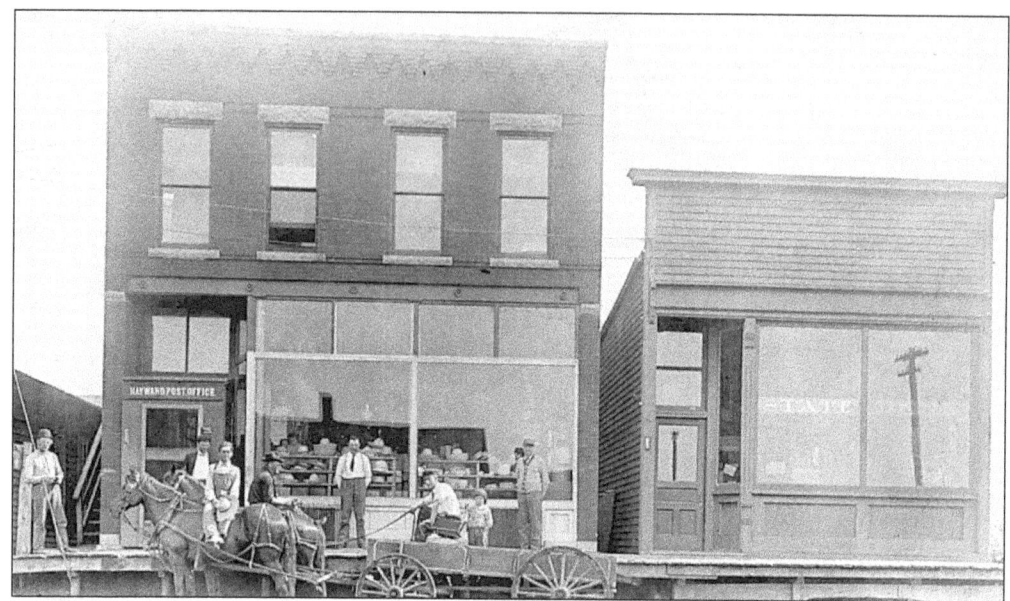

The Savre and Skaug General Store was in operation from 1909 to 1913, and then Elling Savre sold out to his partner Gilbert Skaug, who continued to operate the store until 1929. The post office was in the rear of the store. The wooden sidewalk was built at wagon-bed height, a handy convenience for customers. The State Bank was located next to the general store.

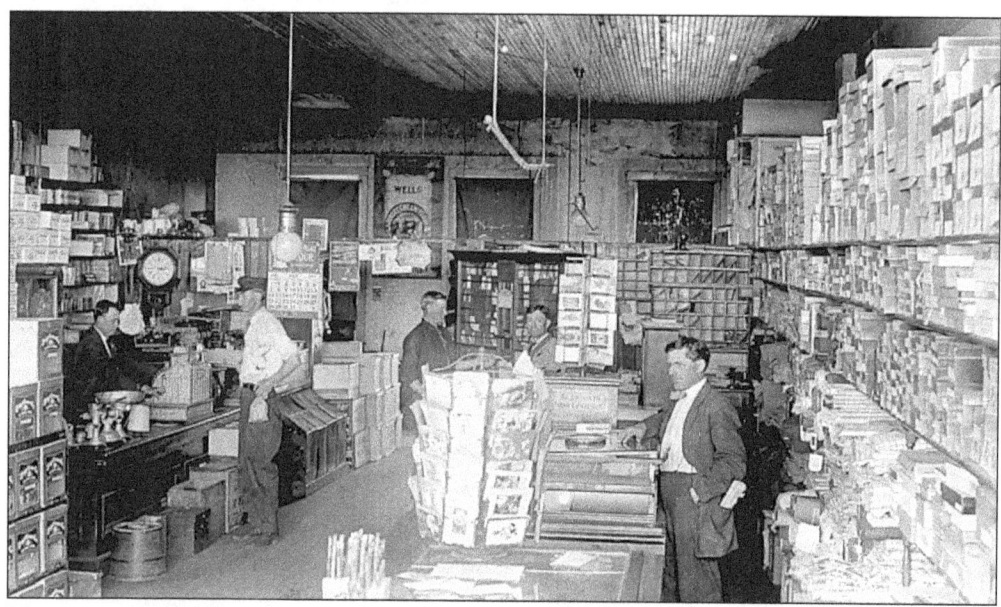

The Savre and Skaug General Store, 1909–1913, offered something for everyone—fabrics, greeting cards, shoes, kitchen wares, groceries, clothing—almost everything needed to provide for home and family. Four of the men in this photo are identified: G. Skaug, Elling Savre, Rolf Gulbrandson, and R.E. Dewey, who was postmaster. The town of Hayward and the township are named after David Hayward, who settled on Section 6 and remained there only two years.

Marie Jensen earned $30 per month as operator for the Hayward Telephone Exchange. Switchboards similar to this one were often located in private homes, so the operator was on duty 24 hours a day. Every telephone family had its own sequence of long and short rings, but because the phones rang in every home on the exchange, listening in on neighbors' calls (rubbering) was a popular pastime.

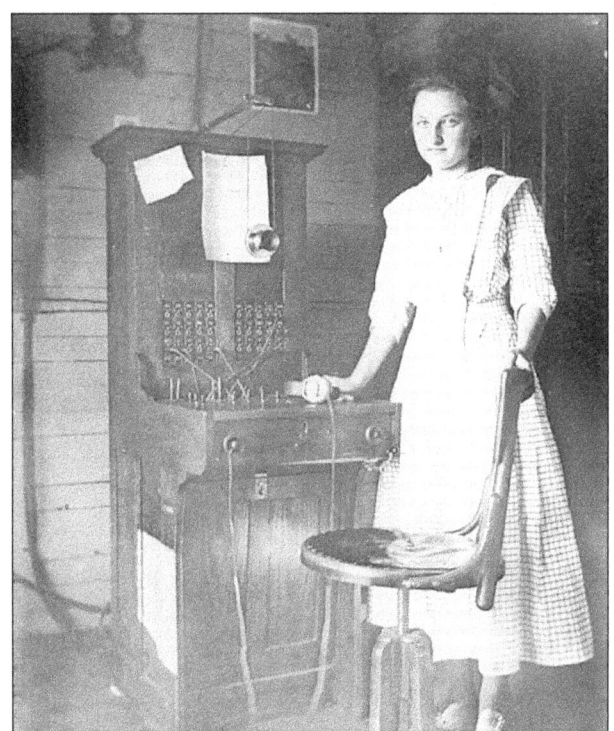

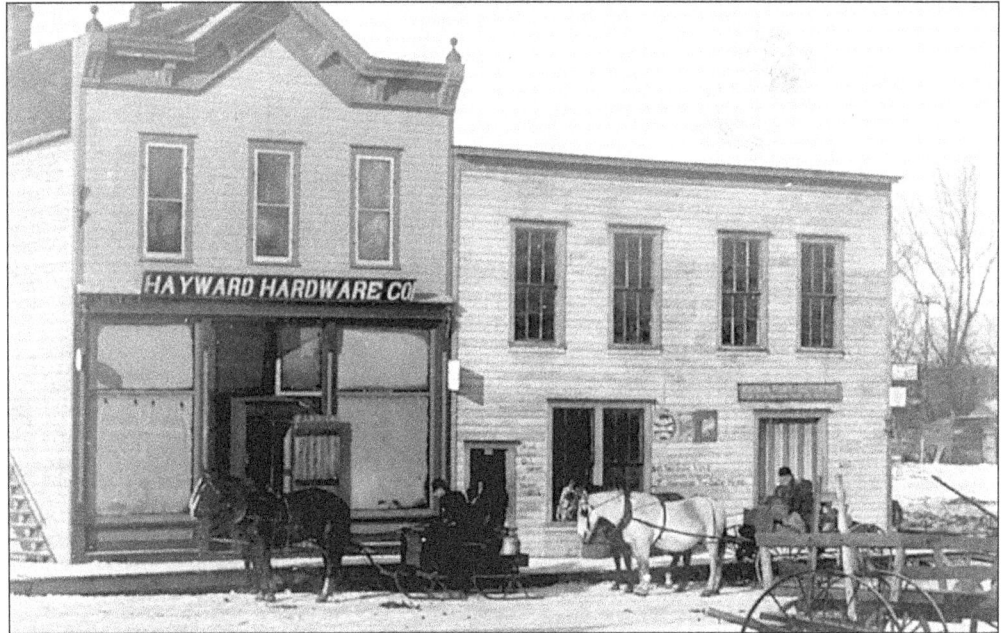

There were no buildings on the Hayward site until the railroad came through in 1869. The Hayward hardware store was built in 1906 by Vegger Gulbrandson. The building on the right advertises gasoline, kerosene, and fishing bait for sale. The teams belong to Vegger Gulbrandson and Lars Lunde. ("Platted 1886 by Morin and registered," *Centennial History of Hayward*, and "Platted 1869 by H.C. Lacey and recorded December 20," *History of Freeborn County* [1882].)

St. Nicholas

PLAT AS RECORDED THE 24th DAY OF NOVEMBER 1856 IN THE COUNTY OF FILLMORE, TERRITORY OF MINNESOTA.

HI-LITES and Shadows OF YESTERDAY and TODAY — by Irv Sorenson — 1963

*THIS SPELLING APPEARED ON MAP.

**THE N.E. ¼ SEC. 26 ALBERT LEA TOWNSHIP. ON THE SHORE OF LAKE ALBERT LEA THEY PROCEEDED TO LAY OUT ST. NICHOLAS. THEY ERECTED A LARGE LOG BUILDING AND OPENED A GENERAL STORE. THEY AT ONCE BEGAN THE CAMPAIGN TO MAKE ST. NICHOLAS THE COUNTY SEAT.

IN THE EARLY SPRING OF 1855, JACOB LYBRAND AND SAMUEL M. THOMPSON LOCATED IN AN AREA WHICH IS NOW

ST. NICHOLAS CLAIMS THE FOLLOWING "FIRSTS" IN FREEBORN COUNTY:— 1st. VILLAGE, 1st. POST OFFICE (OPENED 1855 and CLOSED 1858), 1st. HOTEL— Wm RICE-OWNER-1856, 1st. BLACKSMITH SHOP— Wm EDDY-1856.

THE LAND OFFICE WAS LOCATED AT BROWNSVILLE, MINN. UNTIL 1856 WHEN IT WAS MOVED TO CHATFIELD IN FILLMORE COUNTY WHERE THE ORIGINAL PLAT IS A PART OF THE RECORDS. (WOULDN'T THE SITE OF ST. NICHOLAS MAKE A WONDERFUL LAKESIDE COUNTY PARK?)

THANKS TO CURATOR "SKIPPER" BERG FOR A COPY OF THE ORIGINAL PLAT. HE'S DOING A GREAT JOB. GIVE HIM ALL THE HELP YOU CAN.

**FROM "FREEBORN COUNTY HISTORY." DESCRIPTION ON RECORDING MAP IS:
"LOT NO.4. OF SEC. 25 AND LOTS 1.2.1 S.E. ¼ OF N.W. ¼ OF SEC. 26 TOWNSHIP 102 N. OF RANGE 21 WEST."
— CHAS. C. COLBY SURVEYOR"

Hi-Lites and Shadows of Yesterday and Today was drawn by Irv Sorenson in 1963.

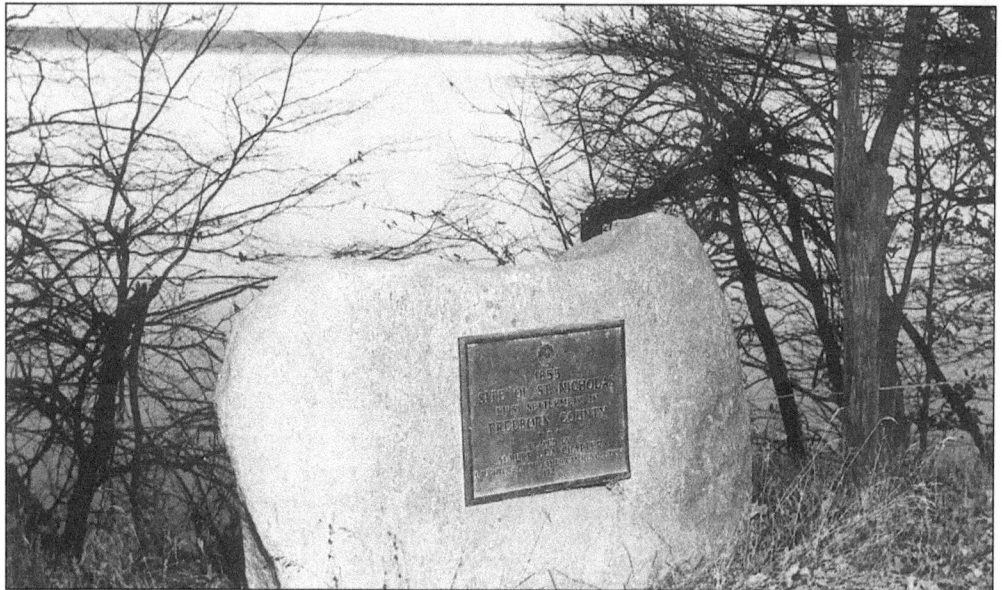

In the spring of 1855, Jacob Lybrand and Samuel M. Thompson, from Wisconsin, proceeded to lay out the village of St. Nicholas on the western shore of Lake Albert Lea. The location was beautiful, at the point of the broadest sheet of water in the county and with a fine gravel beach. Their dreams of attaining county-seat status for the village, however, were dashed by the powerful political machine in Albert Lea.

Two

THE SOUTHWEST

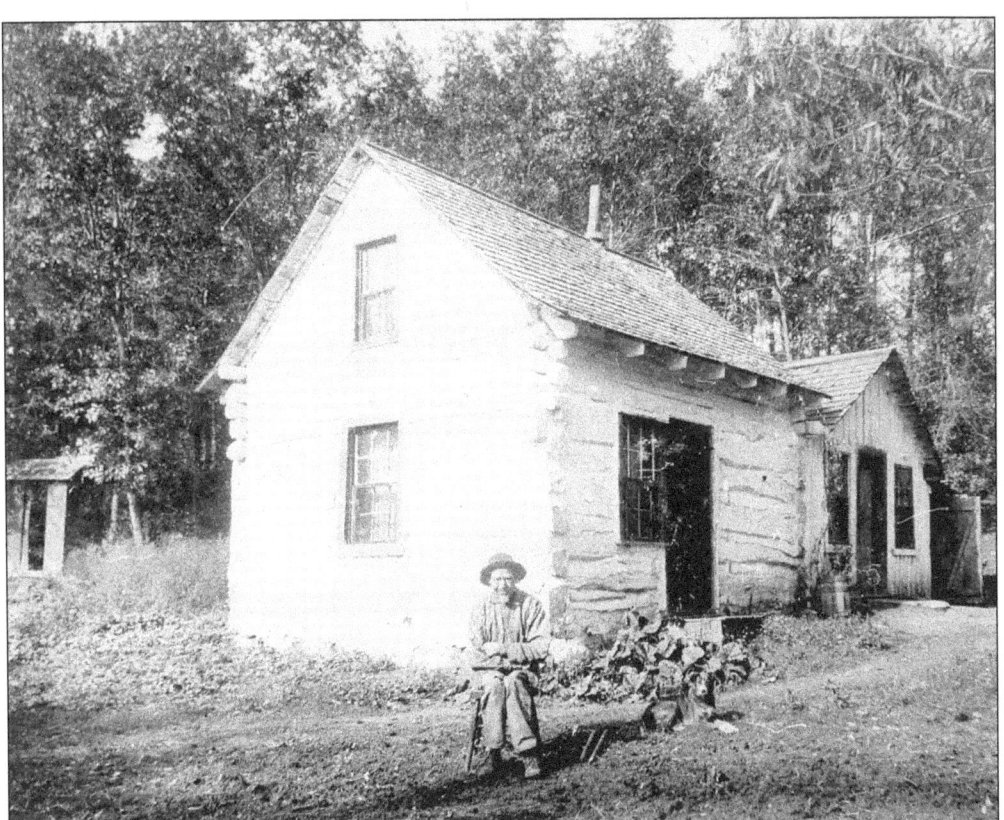

Olaf Torgeson, an early settler in Freeman Township, is shown sitting in front of his log home near Grass Lake. The lake was named for the grasses and sedges growing in its shallow water. The lake was eventually drained for farming. Notice the mortise and tenon cut of the lower logs on the building, and the rudimentary cut of the upper logs.

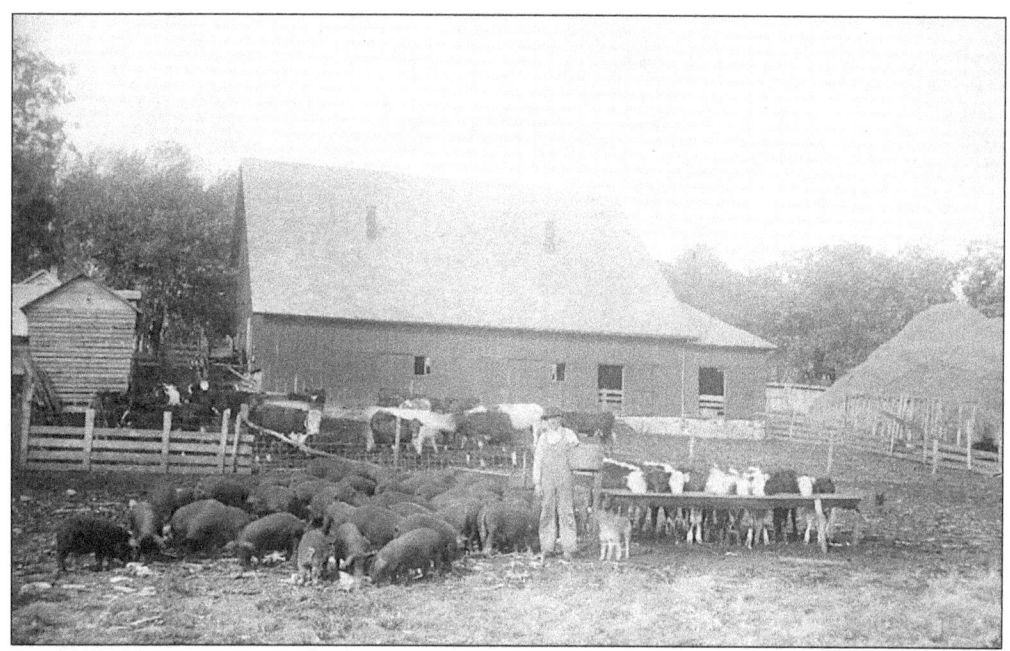

Early Southern Minnesota farms were almost totally self-sufficient. A variety of crops was grown, providing feed for the livestock. Cattle, hogs, chickens, ducks, sheep, and goats were not uncommon. A large vegetable garden was planted, and numerous fruit trees were tended—everything a family needed. This farm place was an example of that diversity. Lars Landaas is shown doing chores.

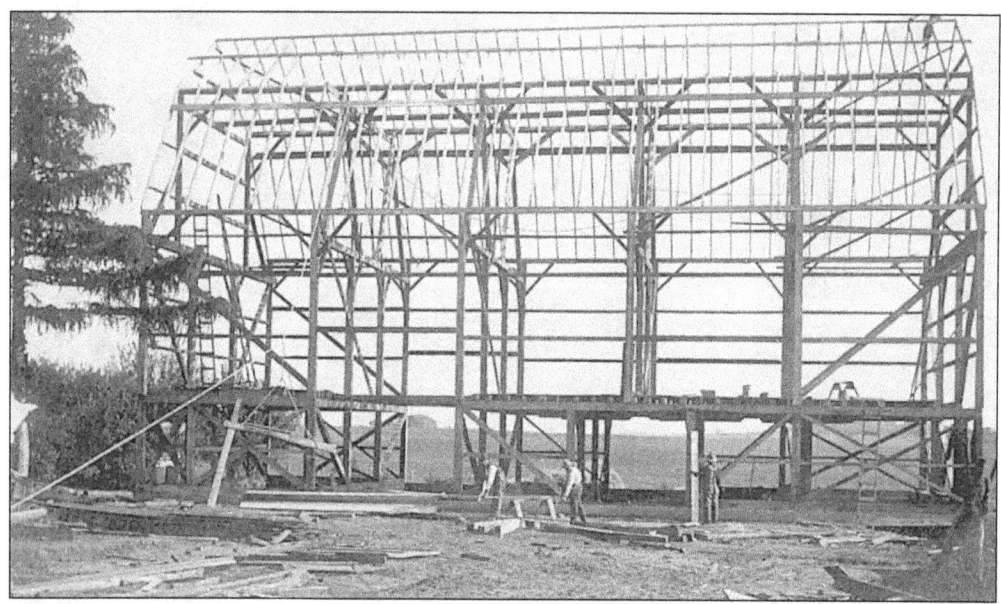

The Louis Leonhardi barn was built in 1909 in Nunda Township. Its gambrel roof design was popular on Southern Minnesota farms, and the large open space it provided was necessary for loose hay storage. Notice the man sawing lumber and the ladders propped against beams for easy access to the upper levels. How did the carpenter get to the roof ridge, and how were construction materials passed up to him?

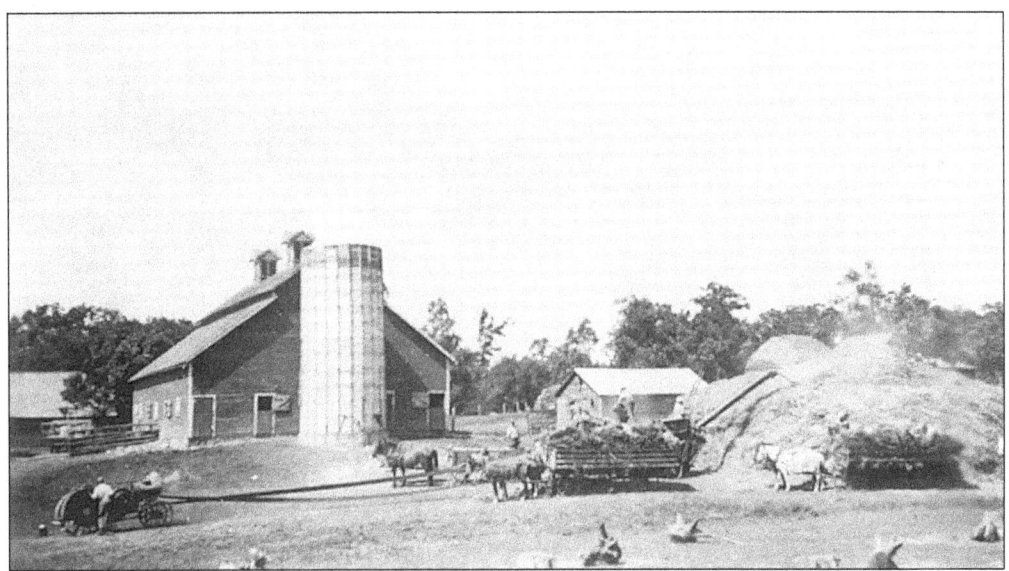

This threshing scene on the Joseph Wadsworth farm shows the manpower and the horsepower needed to operate the farm in Freeman Township. Wadsworth raised 60 acres of crops with the balance of his farm in pasture, and he was very proud of his thoroughbred Shorthorns and Poland China hogs. He and his wife Katherine had three children, he was active in several community organizations, and he was a staunch Republican.

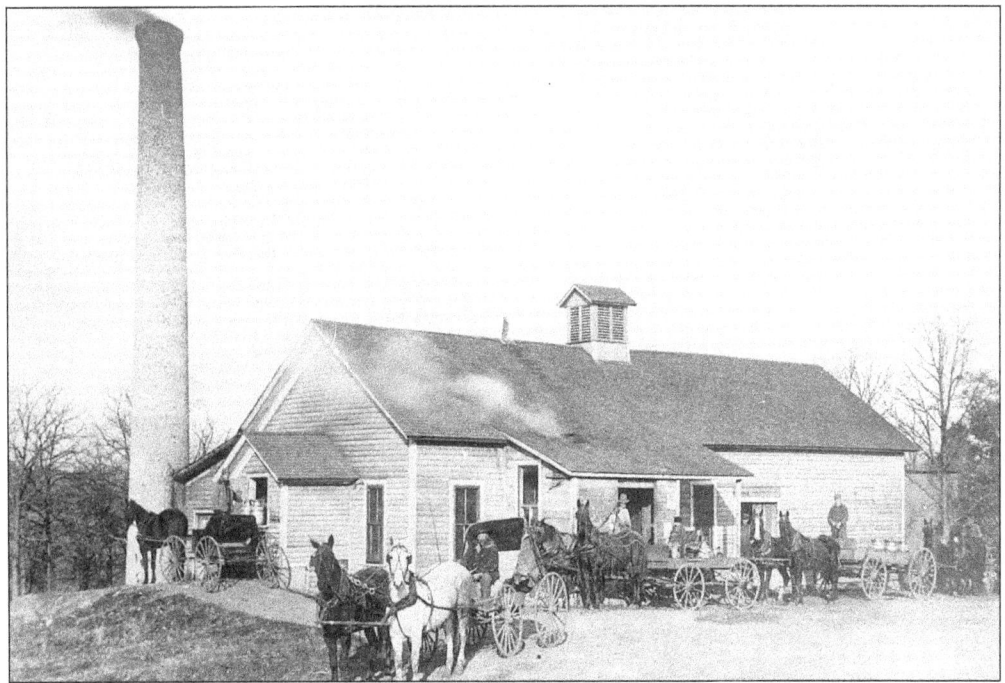

The Knatvold Creamery was operated from 1900 to 1914 by the Freeman Cooperative Creamery Association. The creamery first had a metal stack, which did not draw properly, and it was replaced with a brick chimney. Milk was brought in on Mondays, Wednesdays, and Fridays, and on busy days there might be 25 teams in the yard. Each creamery patron was responsible for two loads of ice for the icehouse.

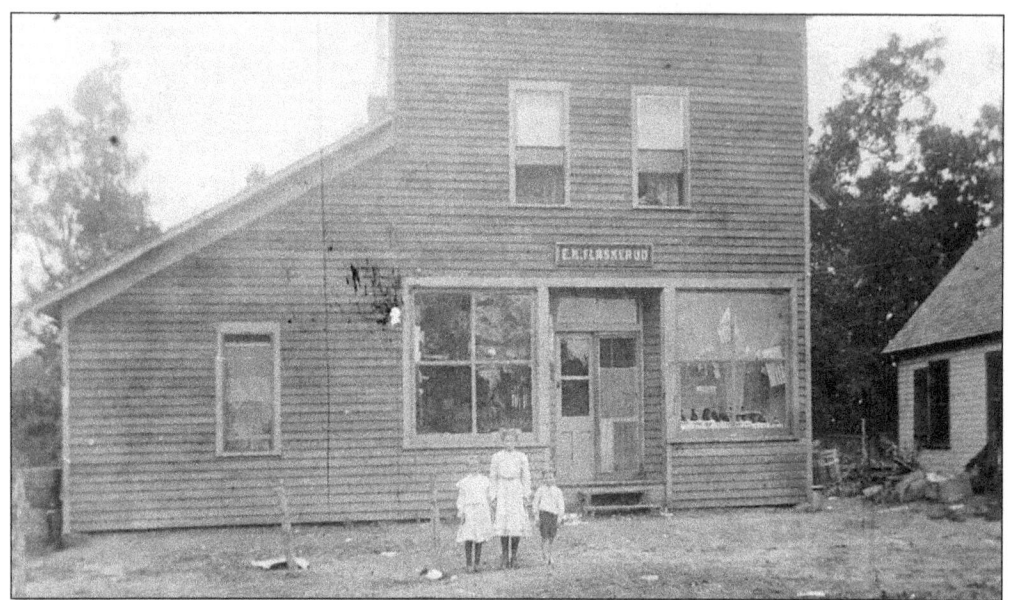

According to the *Freeborn County Standard*, January 3, 1900, it was decided that the new post office in Freeman would be changed to Knatvold in honor of Senator Knatvold. Thomas E. Flaskerud was commissioned as postmaster. The post office was in the H.Q. Angel General Store, which was later owned by Erick K. Flaskerud. The store had family living quarters upstairs and was in operation from 1900 to 1918.

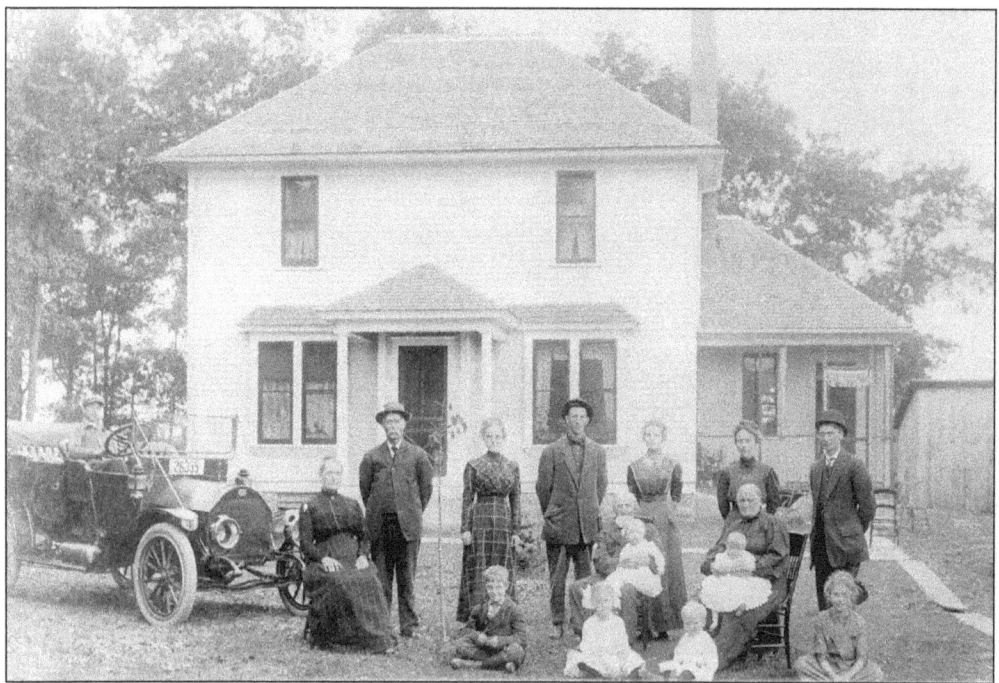

Everyone turned out for this intergenerational family photograph in the front yard of a home near Knatvold. While we cannot identify any of the people, it is interesting to speculate as to the reason for the gathering—a reunion perhaps? A chance to show off the new car? This photograph must have become a family treasure. Note the boardwalk leading to the side door.

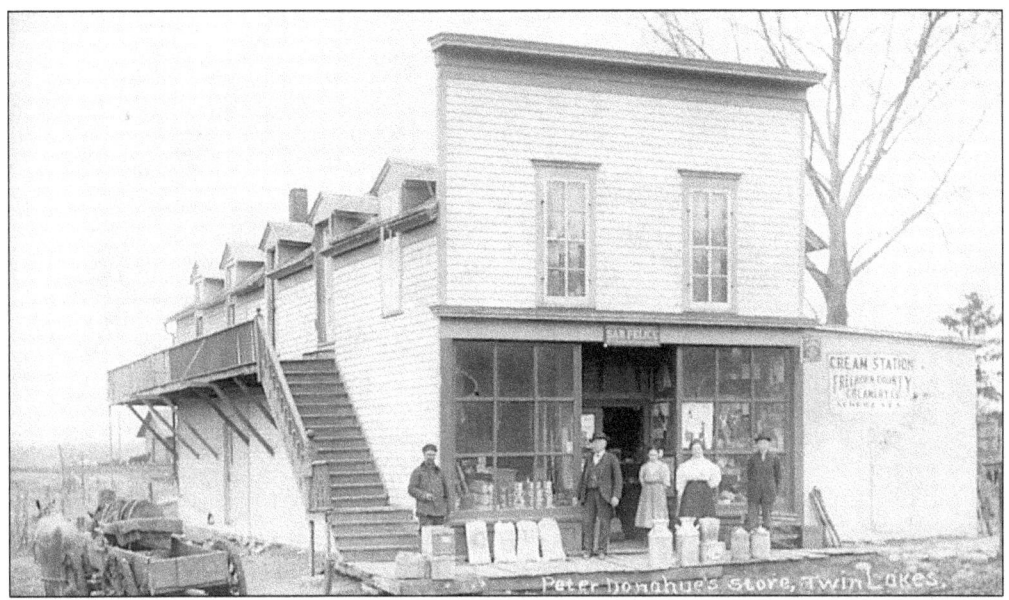

Peter Donahue is pictured here with his wife and daughter in front of their general store in Twin Lakes in 1908. The new addition to the building served as a cream station for the Freeborn County Creamery in Albert Lea. Donahue moved into this building in 1879 and operated the store for 50 years, until his death in May 1929. The man at the left is believed to be Alfred Olson.

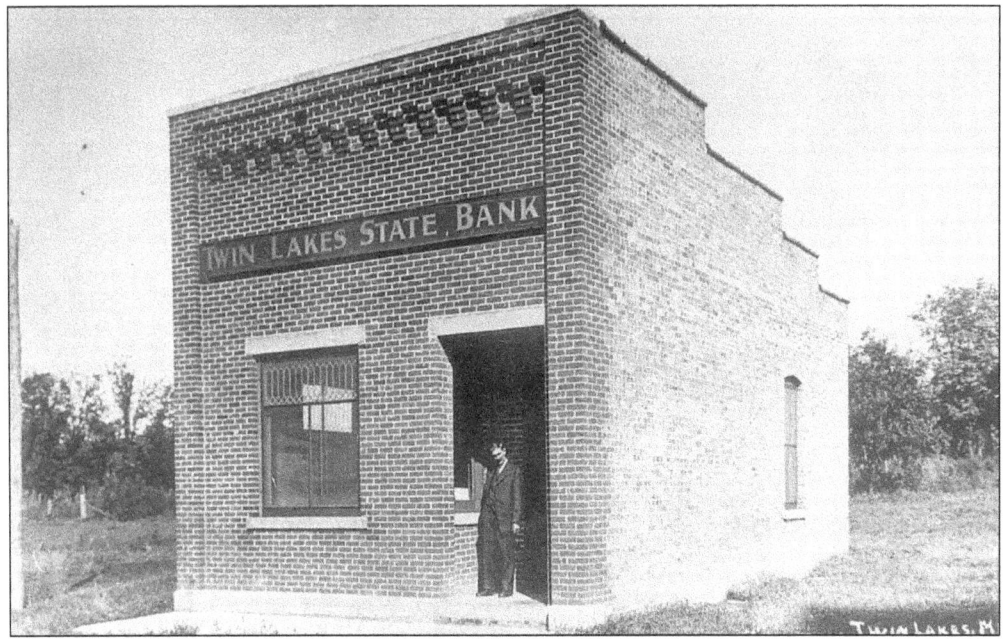

Constructed of brick, with ornate leaded-glass windows, the Twin Lakes State Bank was built in 1912, and was a valuable addition to the community. It was made a member of the Federal Deposit Insurance Corporation in 1933. The bank's interesting history includes a bank robbery in 1935, and another in 1938, with all but one of the 1938 "Milk Can Robbers" being captured.

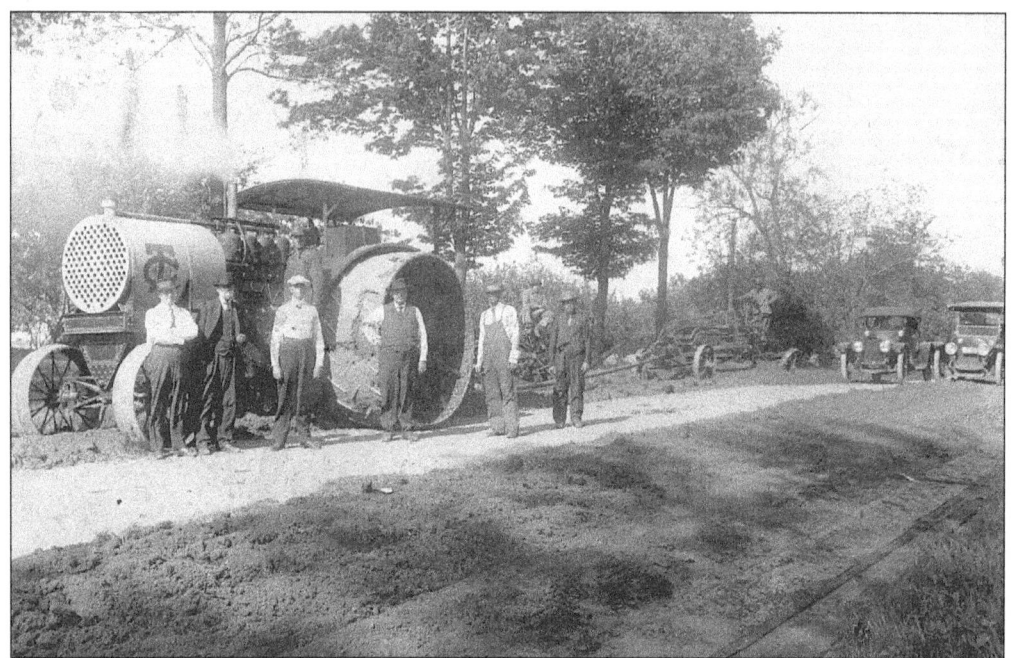

Road work near Emmons, around 1913, required some formidable equipment. This TC gas-powered tractor had four cylinders and one speed, forward and reverse (2 miles per hour). It had 84-inch rear wheels and weighed 23,700 pounds. The gentlemen in the picture are Carl Emmons, Ole Hammer, H.H. Emmons, Carl Olson, and ? Fitzgerald. The three members of the road crew are unidentified.

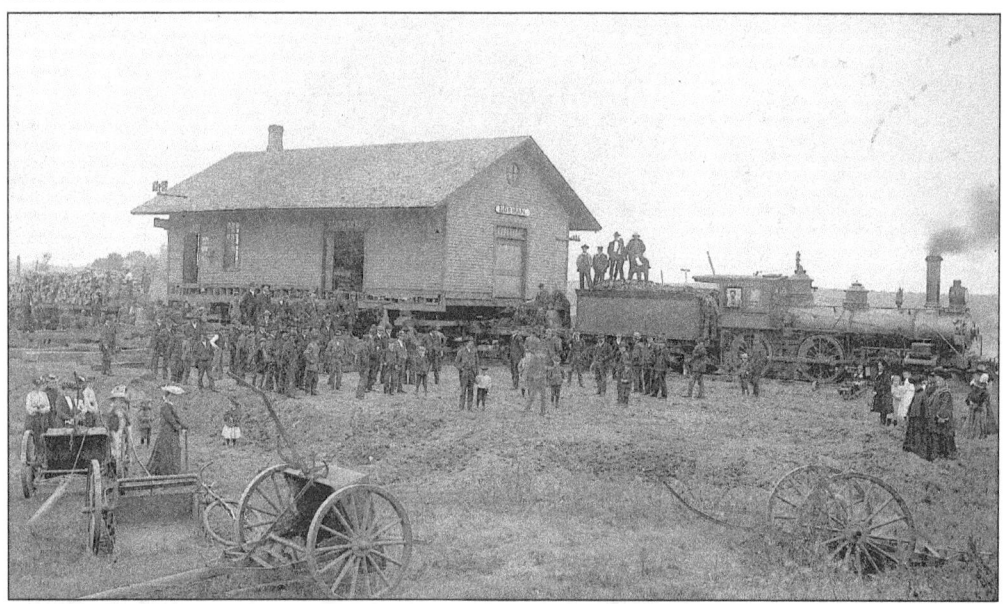

The people of Emmons had cause to celebrate in 1904. The Minneapolis & St. Louis Railroad had originally built its depot in Norman, Iowa, because the people of Winnebago County voted a 5% tax to aid in the cost of road construction. Emmons officials battled the decision all the way to the Supreme Court, and in 1904 the station was moved one mile north, just to the state line, where it was easily accessible.

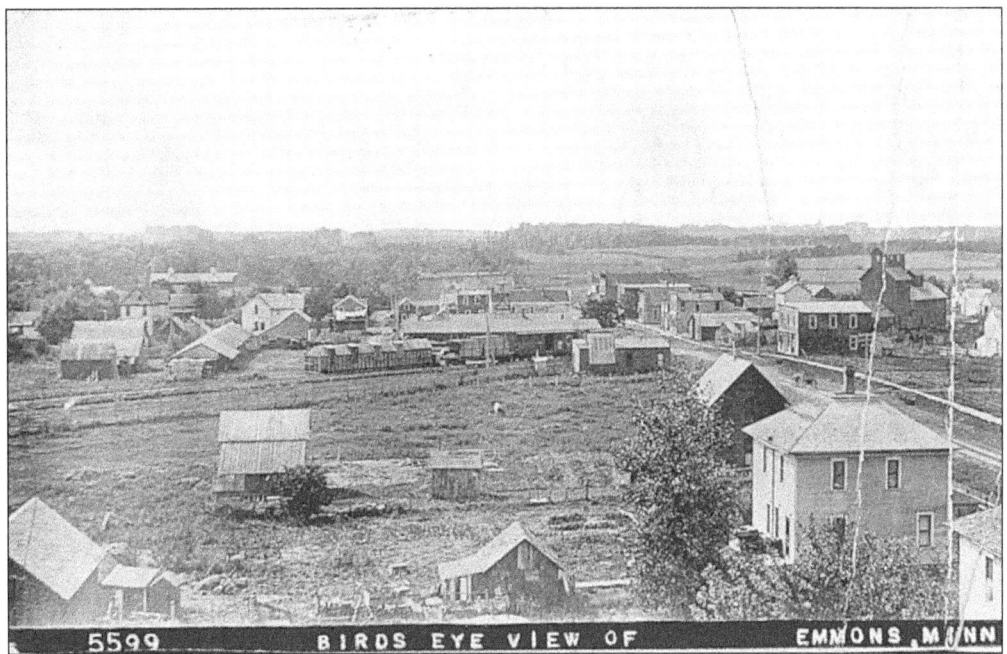

This bird's-eye view of Emmons was taken from the top of the schoolhouse in 1901. According to the 1899 city directory, Emmons is situated "exactly on the state line of Iowa and Minnesota. . . . The business men were all wide awake and prosperous and are always subordinating their own interests to those of the town. Emmons has a phenomenal record of growth and enterprise which cannot be equaled or surpassed."

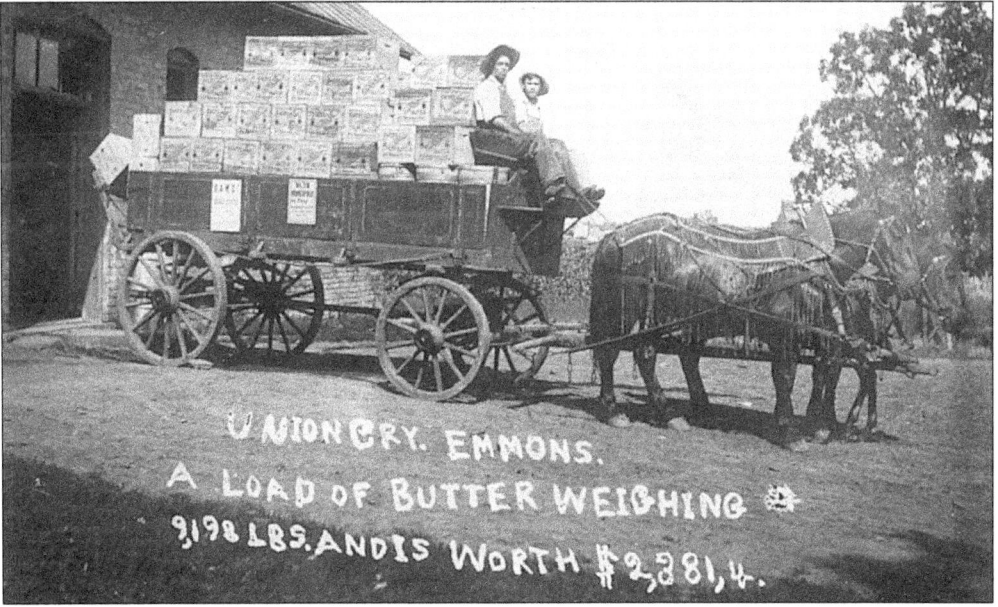

Doing greater business than any other creamery in the county, the Union Creamery Company received 3,075,269 pounds of milk and 498,800 pounds of cream in 1910. It produced 276,194 pounds of butter. Patrons were paid $69,145.06 for the milk and cream produced by their more than 1,500 cows. The creamery building was constructed with brick in 1903 at a cost of $8,000.

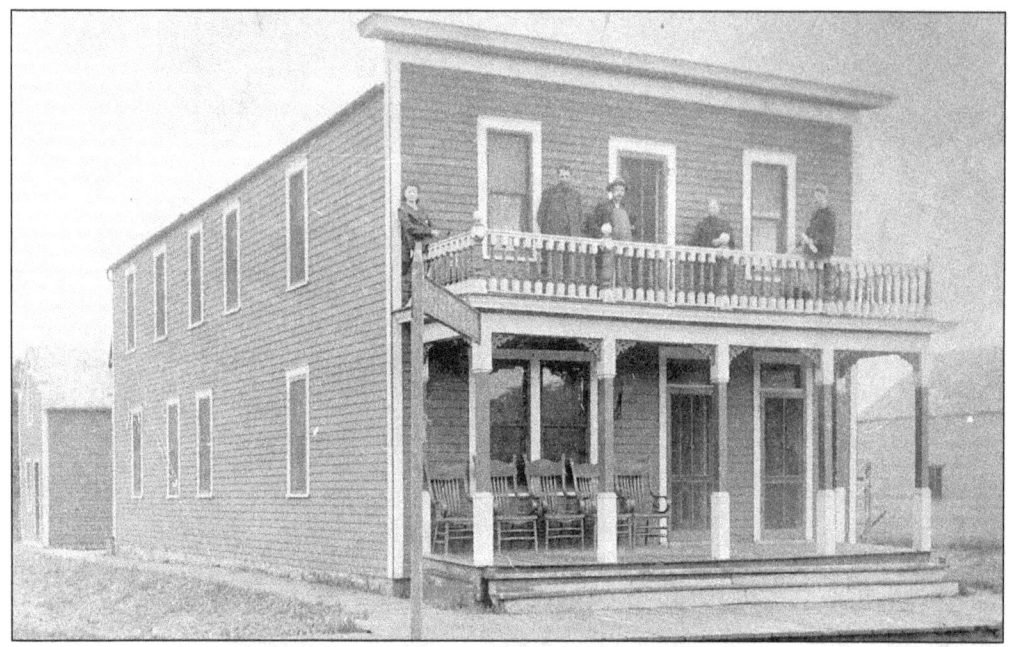

The Hotel Emmons received very little notice in articles on the history of the community; however, we do know the names of the people standing on the balcony. They are, from left to right: Hattie White, Mr. White, Bill Torry, Mrs. White, and Laura Lee. The name "White" surfaces often during research as a family prominent in the community, with service in the Union Army during the Civil War and involvement in many area organizations.

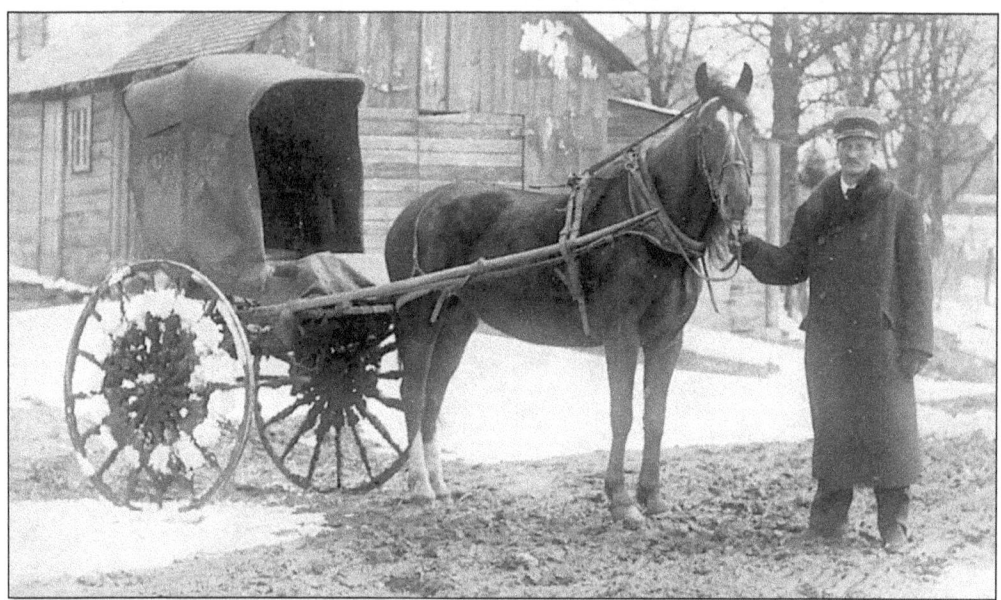

Long hours and cold weather were a basic part of George Rasmusson's day in 1908, as he delivered mail in his horse-drawn rig on RFD #1 near Emmons. Survival equipment included a sturdy snow shovel and a heated brick wrapped in a gunny sack to keep his feet warm. The first State Line post office was in the George Emmons farm home, until it was moved to the store in Emmons.

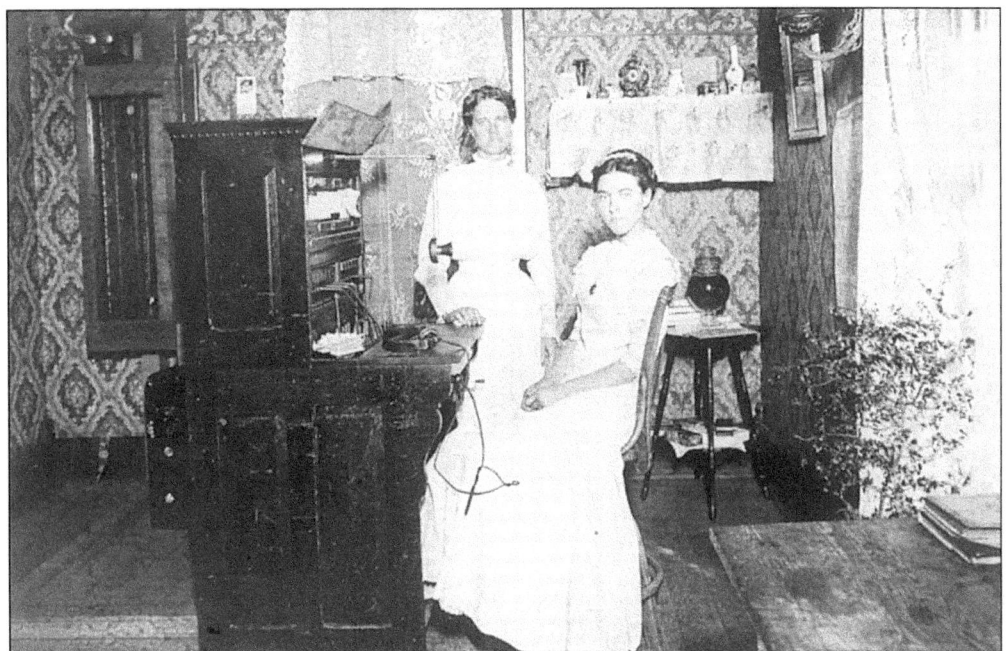

In 1908, Emmons telephone exchange operators were Bettie Engelsrud, seated, and Betsy Rasmusson, standing. At that time the telephone office was on the second floor of the barber shop. There were 15 farm lines, and the calls came in on different sounding rings, each needing to be memorized by the operator for efficient service. In 1910 Bettie Engelsrud and Andrew Rasmusson, the barber, were married.

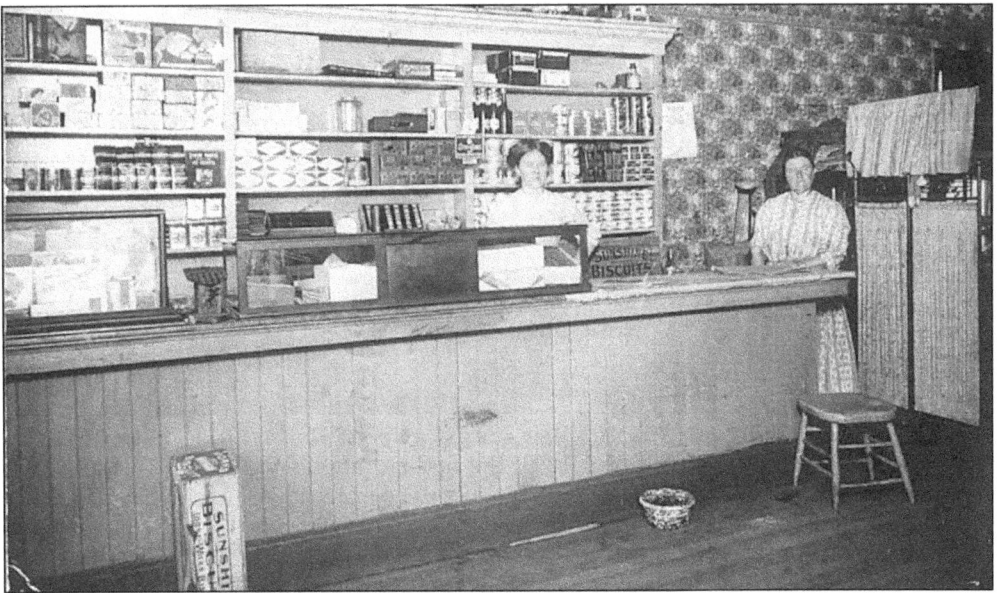

The enterprising Mrs. John Egland operated a cafe/boarding house/rooming house in Emmons in 1914. She is shown here with her daughter, who later became Mrs. Joe McGuire. Some of the other businesses in the community at that time were: a millinery run by Clara Kelly, a furniture and undertaking store owned by Gunder and Henry Clemmetson, and the Emmons Auto Company, Olson and Rasmussen owners.

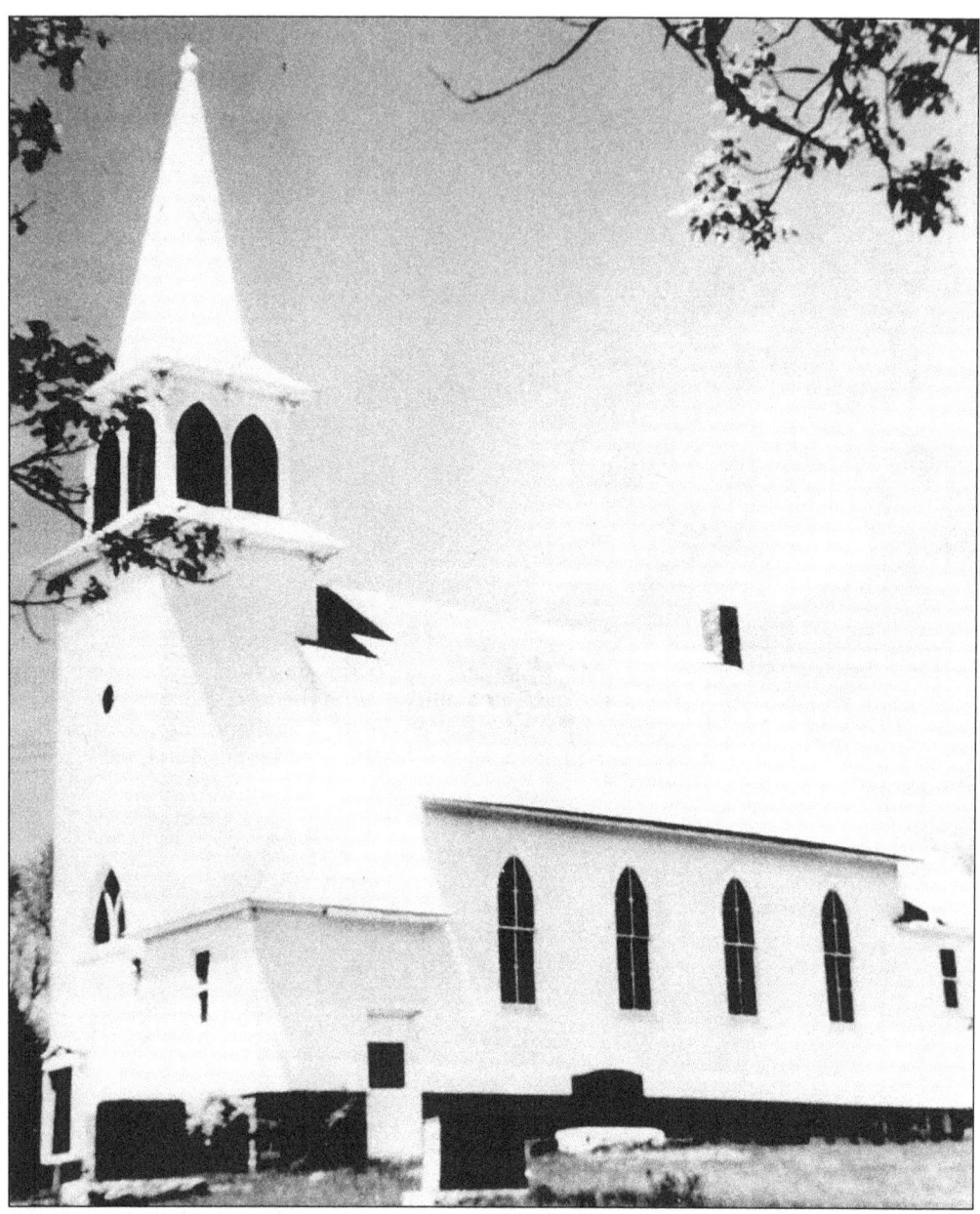

"The Mansfield Congregation of the Augustana Synod, a Swedish Evangelical Lutheran Church, was organized by Rev. S. Anderson in 1893, the first meetings being held and organization perfected at the home of Nels Johnson. . . . In 1894 the congregation was incorporated and a church built in the southeast corner of the southwest quarter of Section 20." In an unrelated article, an early pioneer family experienced difficult times. "The first settlers in Mansfield were the Tunell brothers, John and Henry, who came from Illinois by the way of Iowa with their families and with teams arriving June 23, 1856. . . . These brothers brought with them about one hundred head of cattle, and shortly after their arrival commenced putting up hay, securing enough to carry them safely through the winter; but a prairie fire destroyed it. . . . They finally managed to purchase enough hay from parties in Iowa to tide them over the winter, without a loss of more than half their stock." (*History of Freeborn County* [1911].)

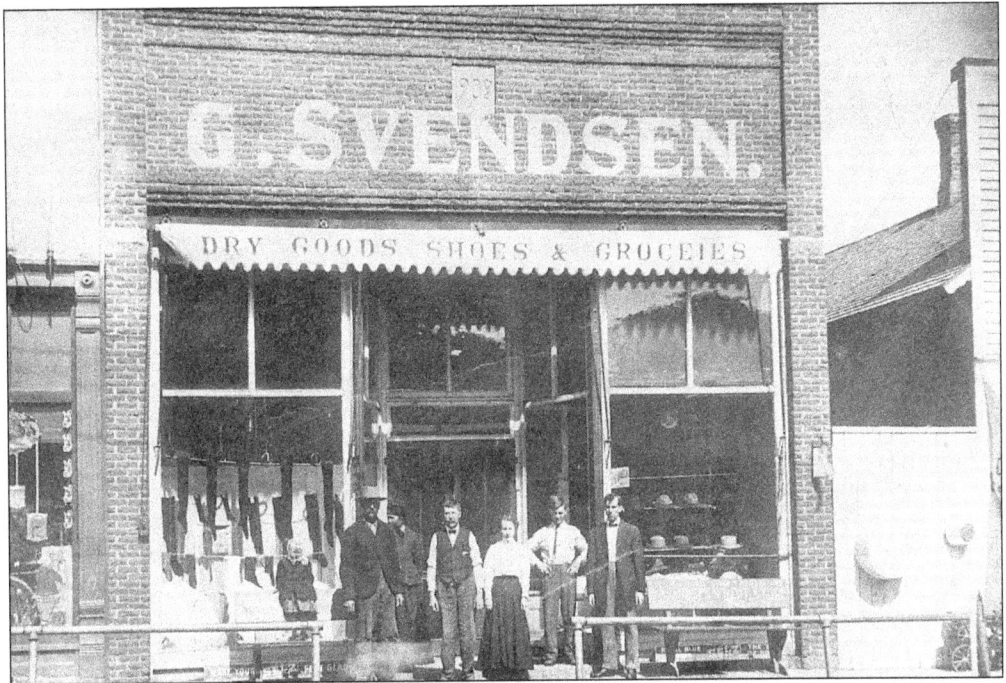

In 1911, G. Svendsen was the owner of one of the three general stores in Alden. The others being A.G. Hall & Son and the Cash Store, with J.E. Clayton as proprietor. Did the misspelled word on the awning help him to draw business from his competitors? The people standing in front of the store are, from left to right: unidentified, Nels Peterson, Gerhart Svendsen, Sadie Yates, unidentified, and Frank Wendt.

A Seventh Day Adventist School was located on the second story of the Henry Ernst home on the west shore of Gem Lake. The school started on December 15, 1870, with approximately 50 students, each paying $5 to $7 per term. Teachers were Henry Ernst and his sister Minnie. The house was later enlarged and became a residence after 1900.

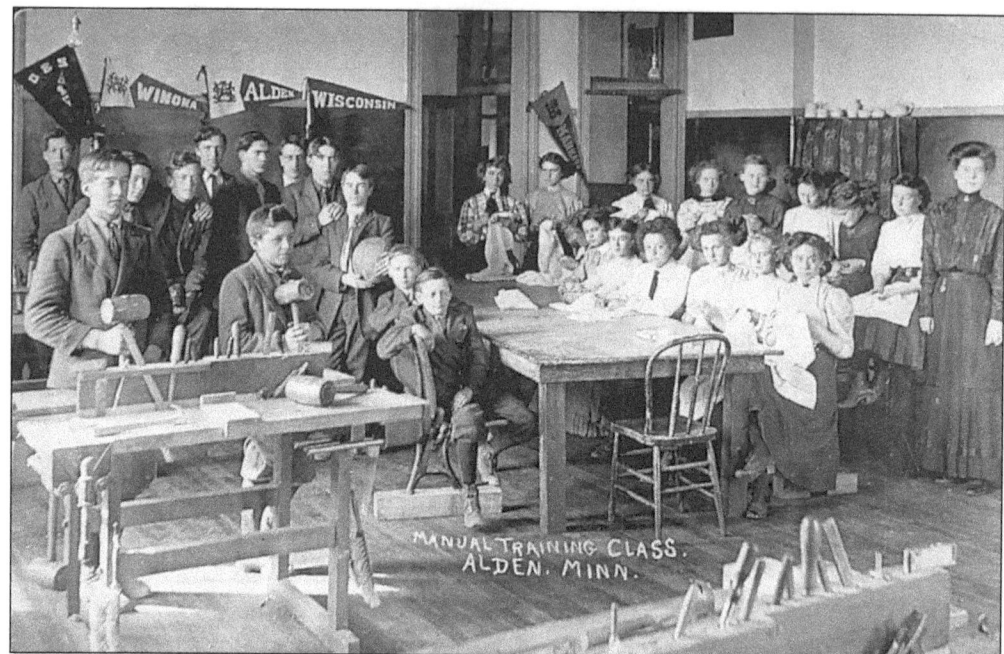

The Alden High School stressed not only the usual academic classes, but emphasized agriculture and manual training, "the institution being thoroughly modern in every respect." (*History of Freeborn County*.) Notice the carpentry tools held by the boys, and their work benches, and the girls learning the fine skills of sewing. Everyone in the picture seems to have dressed in their finest—probably not regular school-day wear.

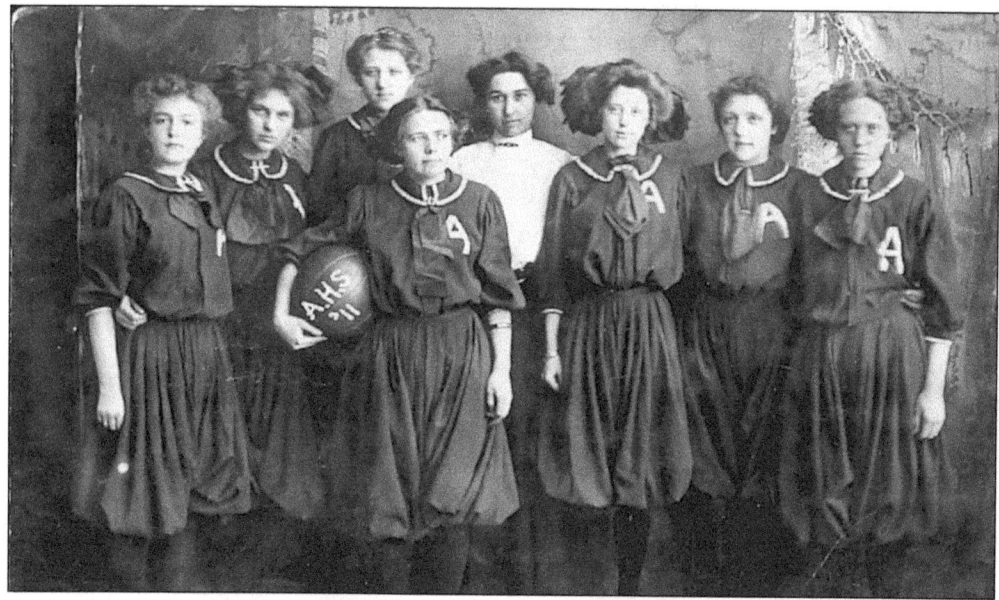

In 1911, the Alden girls basketball team became the Southern Minnesota League Champions. The girls are, from left to right: Hazel Lockwood, Isabell Mathison, Amelia Nielsen, Grace Robertson, Grace Sinderson (referee), Iris Howe, Ruth Anderson, and Alphreta Cottrell. They played against teams from Albert Lea, Jackson, Hartland, and Blue Earth. Their uniforms were dark blue, with white trim and red silk ties.

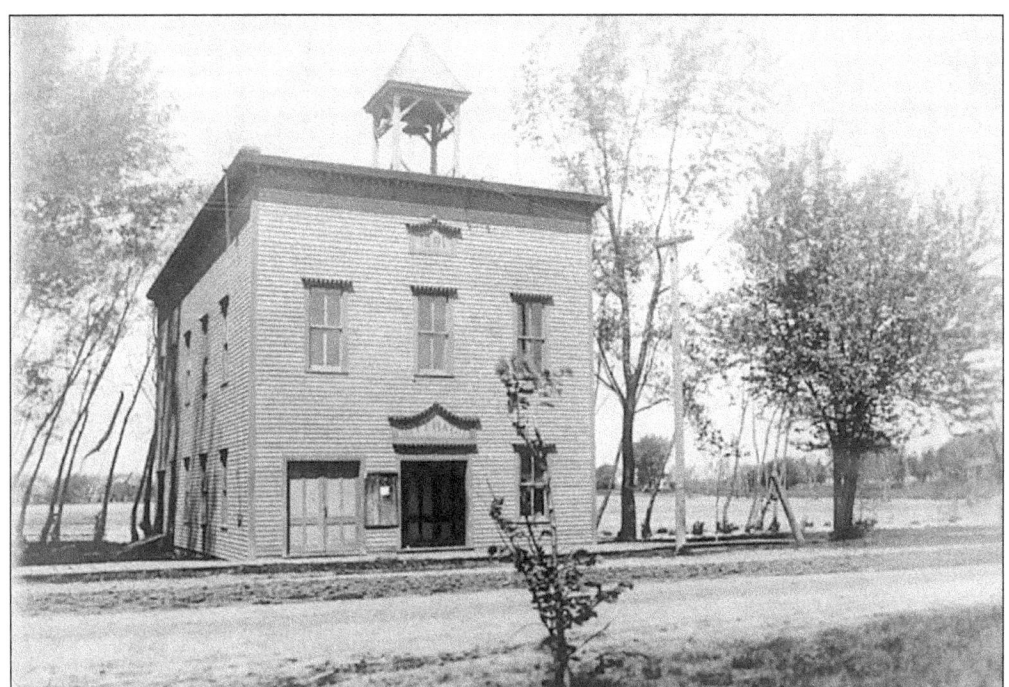

The Alden City Hall was erected in 1891. It was a two-story building, housing the fire department and the council chambers, and featuring a fine hall for entertainment and lectures. The Village of Alden was incorporated by a special act of the legislature in 1879, and the first meeting of the council was held on March 14th of that year.

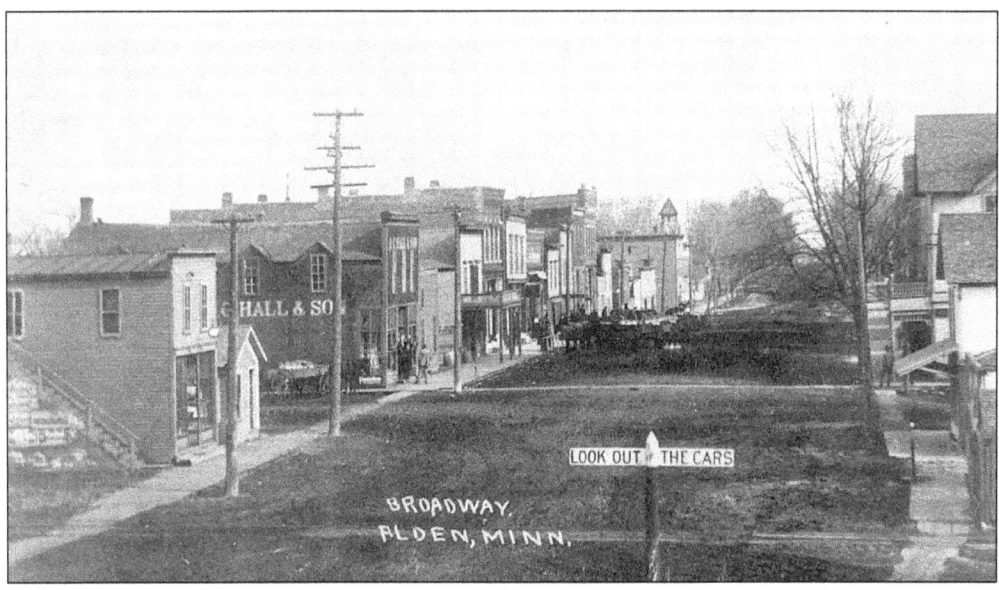

According to the *History of Freeborn County*, "Alden is called the ideal small village. It is situated on a beautiful body of water in the midst of a rich farming country, with neat buildings and well-kept streets, exceptional school opportunities and adequate church facilities. The village has advantages which make it an ideal place of residence." This 1900 Broadway photograph certainly shows this to be true.

45

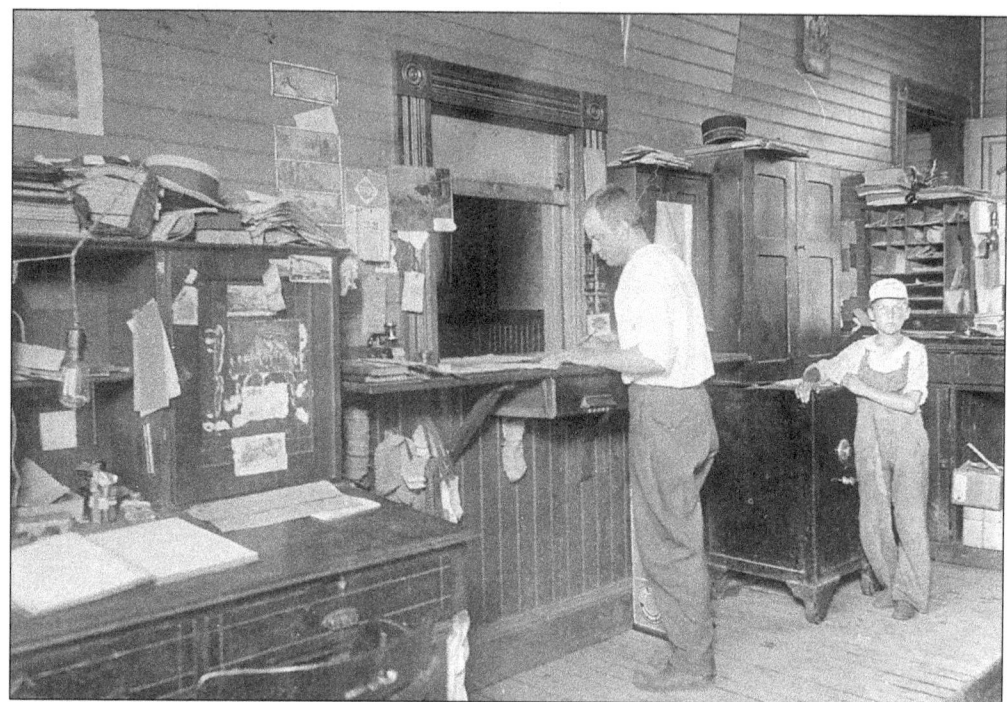

Hartwick M. Mathison is shown in the depot agent's office of the Chicago, Milwaukee, and St. Paul Railroad in Alden around 1914. The young boy in the picture is unidentified. *The History of Freeborn County* states that there were five railroad companies operating seven lines in the county, with the C M & St. Paul passing through Moscow, Oakland, Hayward, Albert Lea, Pickerel Lake, Alden, and Carlston Townships.

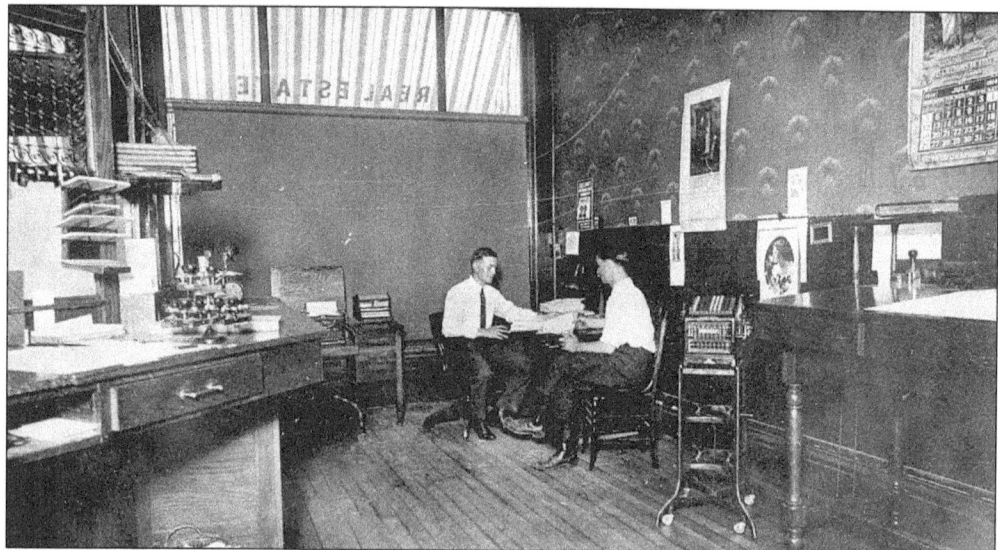

In 1916, the Security State Bank of Alden provided general banking loans, collections, and real estate. E.P. Greeley was president, and Arthur E. Erickson was vice president and cashier. The community also boasted of another bank, four churches, a steam flouring mill, three grain elevators, one creamery, and various other business enterprises. The population in 1916 was 800.

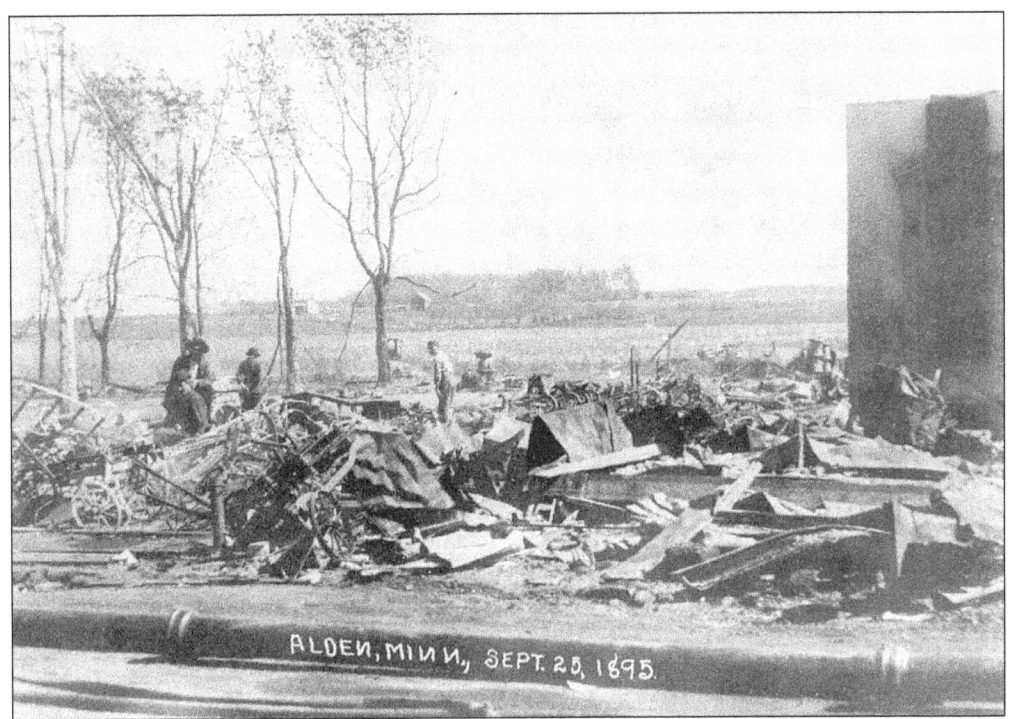

Fourteen Alden businesses burned to the ground on Thursday, September 19, 1895. Supposedly started by tramps in Walker and Valby's barn, the fire destroyed the Methodist Episcopal Church, P. Hemmingson's Store, J. Peterson's Saloon, a meat shop, drug store, furniture store, bakery, the State Bank of Alden, Niebuhr's Hardware and Machinery, Dr. Cowles office, the barber shop, the Chicago Fair Store, the Advance office, and numerous other business and personal properties.

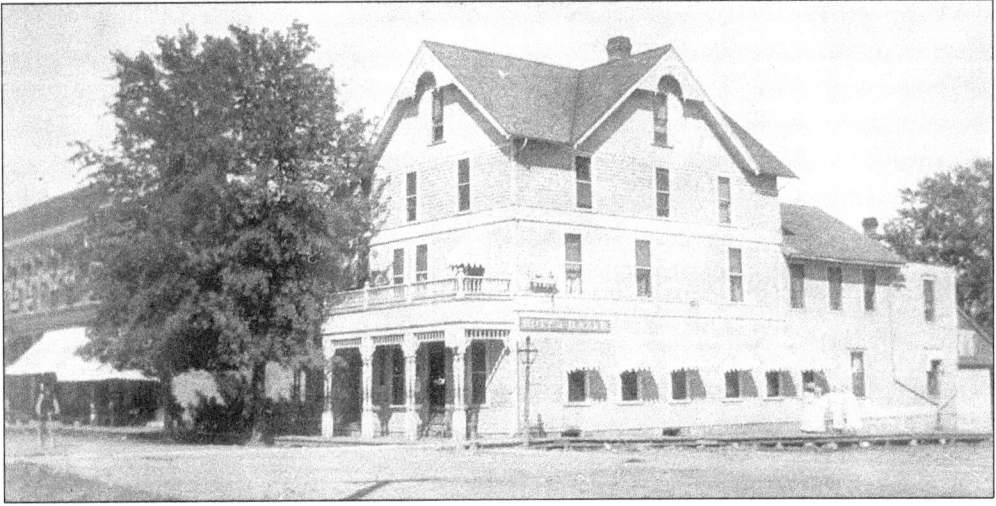

The Hotel Hazle was built around 1872, on the corner of Broadway and Main in Alden. The building was of frame construction, 24 by 40 feet, and its sills were hewn from oak logs cut in the woods just east of the village. The hotel was purchased in 1874 by J.A. Hazle and his wife. They built a 25- by 30-foot addition, which contained a dining room, sample rooms, parlor, kitchen, and several rooms on the second floor.

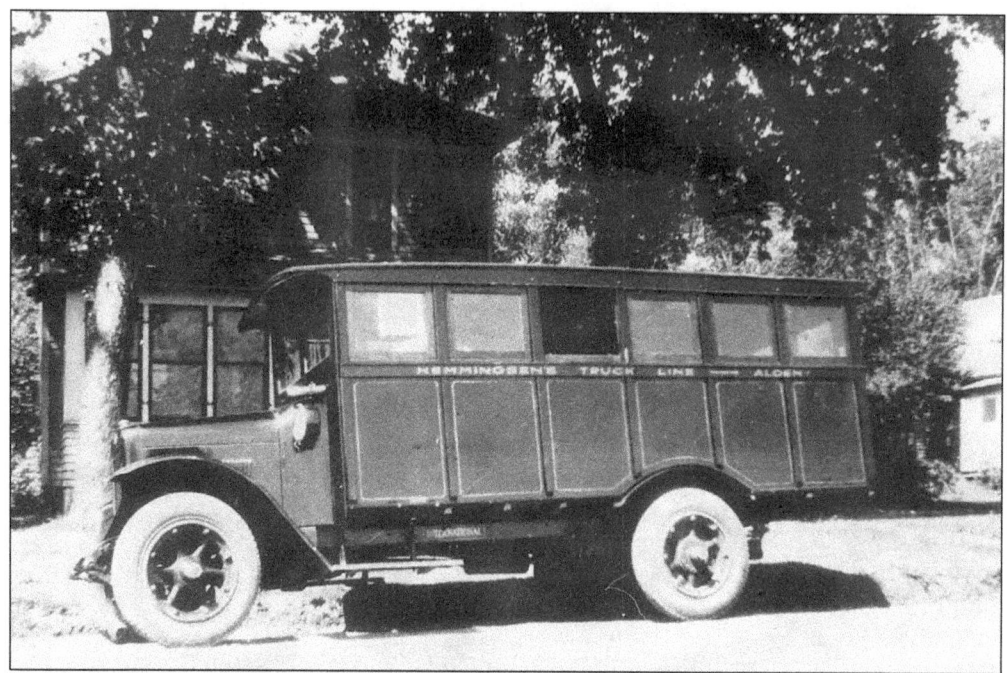

By 1902, Louis Hemmingsen had started a livery service. Traveling salesmen would arrive on the morning train, hire a Hemmingsen rig, transact the day's business, and leave on the evening train. With the advent of motor-driven vehicles, busses and trucks were added to the line. This photograph shows a 1927 school bus. The truck was an International, and the body was made in Albert Lea.

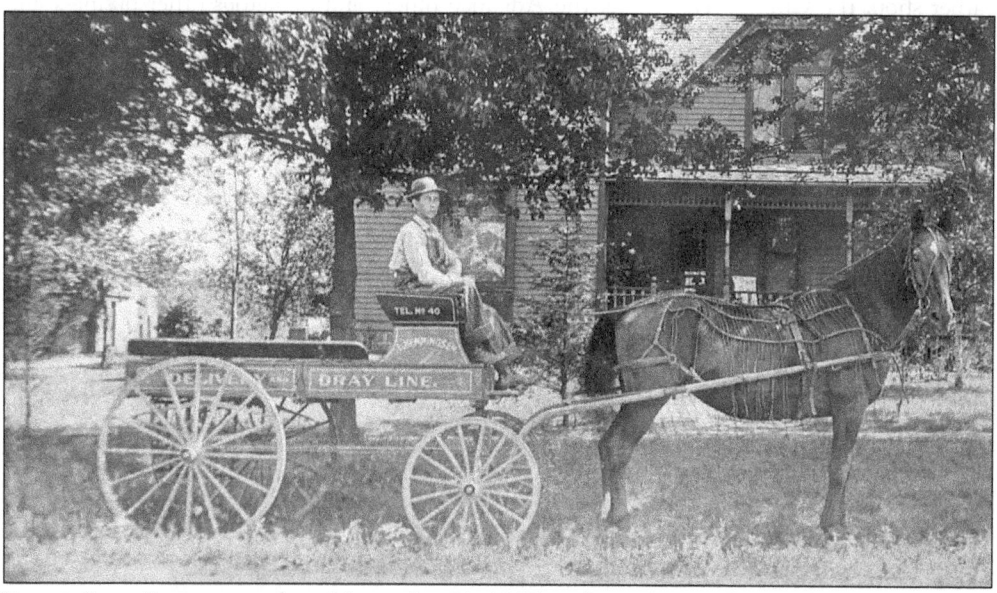

Francis Peter Peterson was born November 21, 1887, in Copenhagen, Denmark. He came to the United States in 1906 and settled at Alden. In 1911, when this picture was taken, Peterson was working for Hemmingsen Dray Line delivering groceries and freight. The horse, Pat, belonged to Peterson. They are shown in front of the Martin Clausen home by Alden Lake.

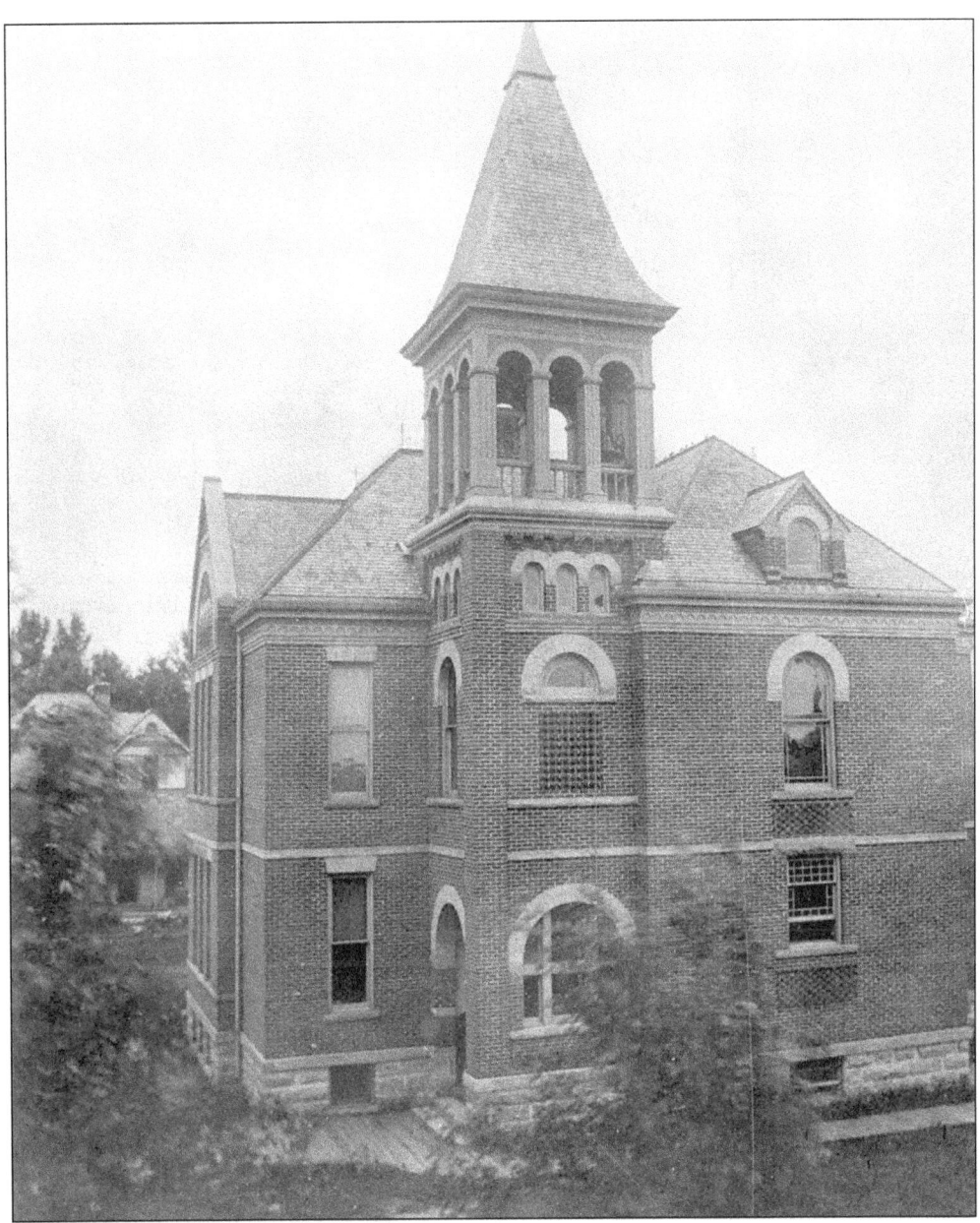

This beautiful brick school was the pride of the community when it was built in 1896. District 93 had several buildings on the same site, but most scholars were still attending country schools. Almost 30 years earlier, District 40 was organized, and Miss Maxson received $15 a month for her services. She had 11 pupils. District 80 was organized in 1866, but it was three years before a school was built at a cost of $600. E.J. Russell taught nine students that first year. In District 70, lessons were given in homes until 1869, when Angela Langdon received $12 per month for teaching 18 scholars; and in Section 27, Olivia Burdick taught for three terms in a sod house, until a schoolhouse was constructed with "patent seats and all necessary apparatus." Throughout the county, one-room schoolhouses were built with no running water or electricity; teachers received very little pay and served several roles, including custodian. The brick school in Alden was a major improvement on the earlier school scenario.

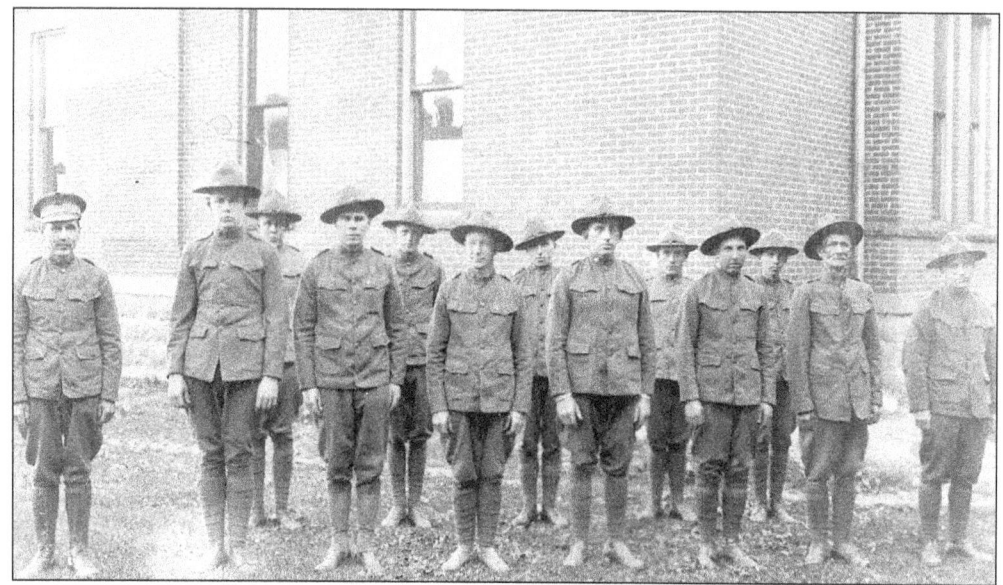

The Alden Company E 17th Battalion Minnesota Home Guard formed in 1918, eventually having 66 members. Pictured here are, from left to right: Captain Fred Holway, Verl Ebert, Harold Hanson, C.W. Nelson, Harold Cooper, Thorwald Svendsen, Wallace Hemmingson, V. Kennison, Fred Schaudt, Bob Sorenson, Burdette Wendt, Cornelius Ostrander, and Bert Hazle. Duties included farewell parades for servicemen, Home Guard Day at the county fair, Red Cross auctions, and helping with War Savings Stamps and Liberty Loan drives.

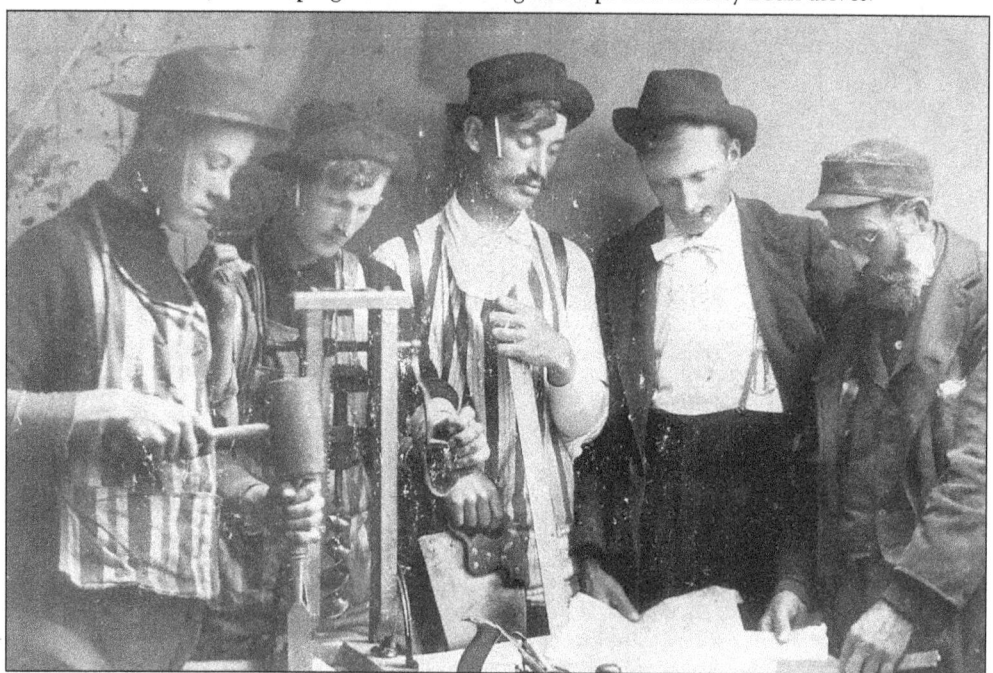

The only description available of this scene is, "photo of Alden men by Jensen Studio at Albert Lea—possibly a master carpenter and his apprentices. Note the striped aprons." What is the real story? Who are these men in this obviously posed photo? What skills and knowledge are being shared by the craftsman on the right, and who is the gentleman in the suit and bow tie?

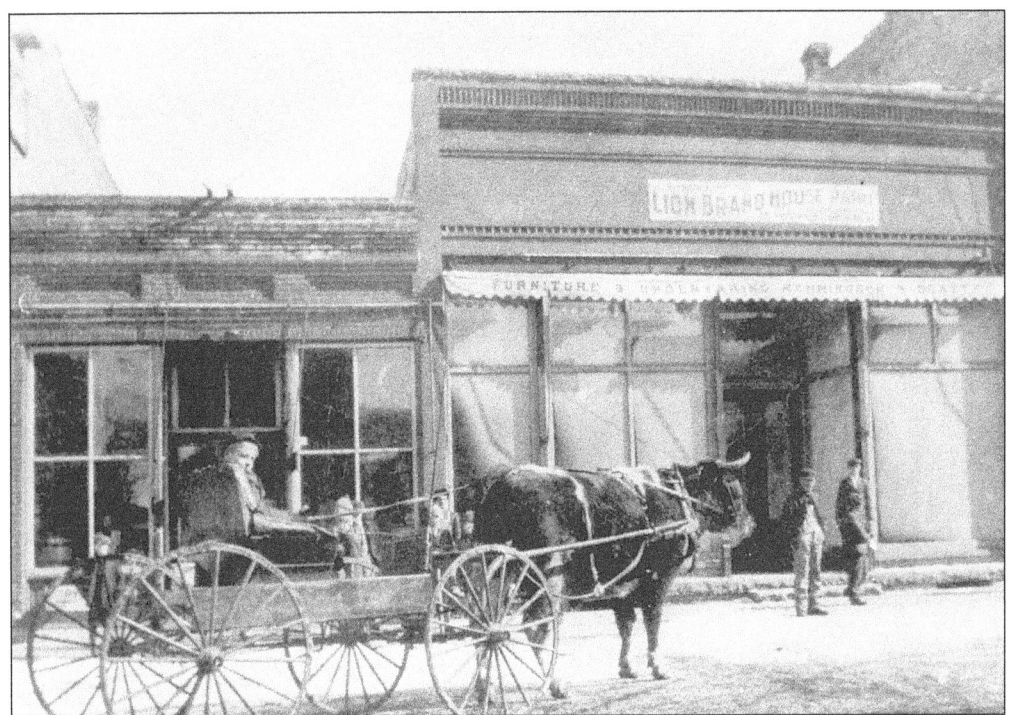

Russell Babbitt and his pet steer bring stares from on-lookers at Alden in 1908. He became a livestock breeder in the Conger area, and also served as Conger's mayor. Babbitt was also on the school board, on the Naeve Hospital board in Albert Lea, and had served as the president of the Minnesota Auction Markets Association. He died at age 64.

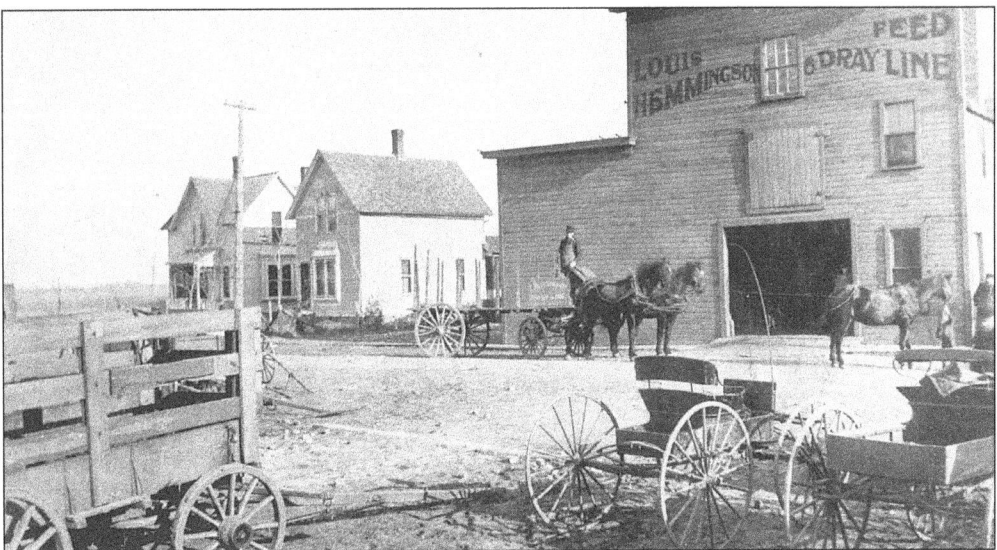

The Hemmingsen Transfer Company is one of the oldest firms in Alden, originating in 1900 with the purchase by Louis Hemmingsen of a feed barn, where farmers and other travelers could leave their horses to be fed and cared for while they were in town. A year later he purchased a draying service, and the horse-drawn wagon was added for the convenience of people who had items needing to be moved.

The German Methodist Episcopal Church of Pickerel Lake was built in 1873 on "one of the garden spots of the earth." E.H. Elickson and Besseson were the contractors. They built the church with stone blasters, men with ox and horse teams to dig and haul stones and lime, and stone masons to lay the walls. A year later the church was struck by lightning, but it was soon repaired.

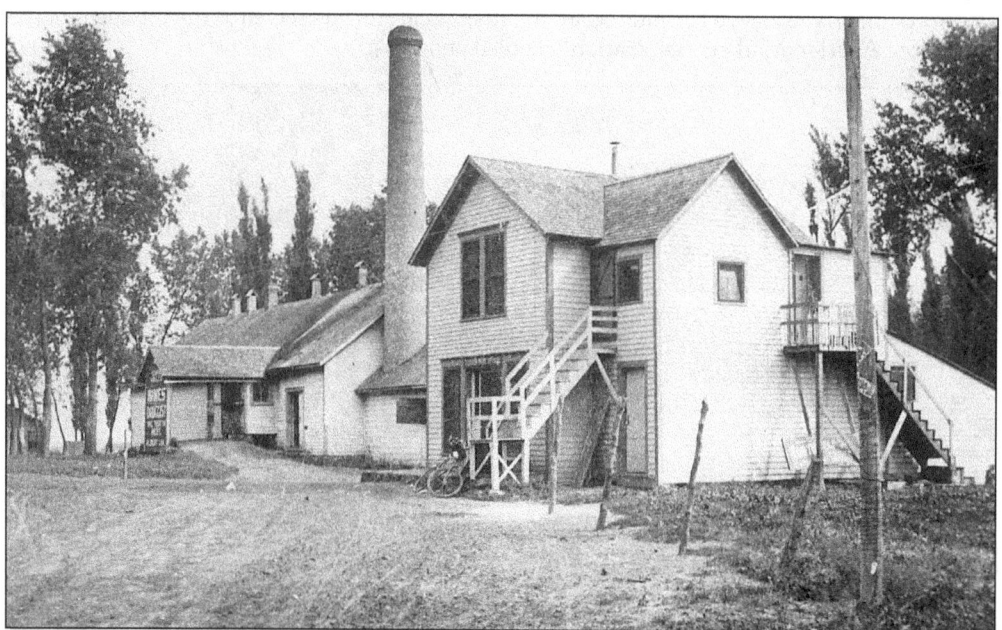

The Village of Clover existed from 1890 to 1915. It consisted of a creamery and a general store/post office, all built on land owned by William P. Pickle. The first directors of the Clover Valley Creamery were Charles Radke, George Hall, William Wohlhuter, Henry Drommerhausen, George Scherb, Fred Fink, and Herman Klukow. Postmasters were William Pickle, William Wohlhuter, Frank Yost, Peter Flesch, and George Enser.

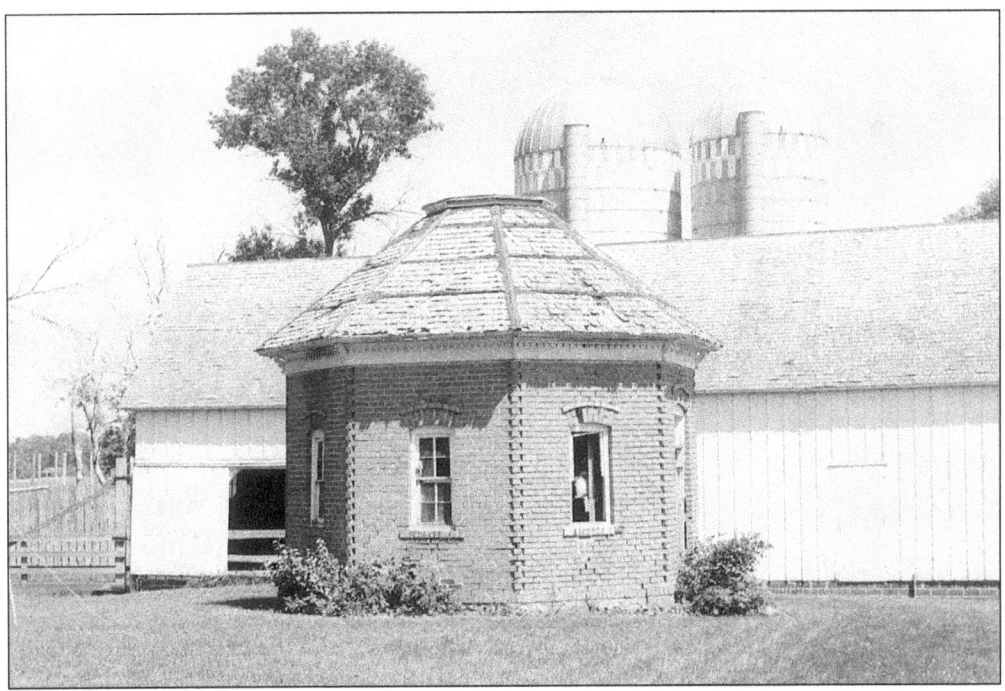

The octagonal brick chicken house was built on the Herman Klukow farm, north of Concordia Lutheran Church on the old Wilson Highway. The 1890 building had a concrete floor, plastered walls, and was of most unusual construction, reminding one of the European dovecote. In most recent years, it was used as a tool house.

This concrete-block silo was located on a Pickerel Lake Township farm in Section 21. It was built in 1914, with blocks cast and cured on the farm, which is east of the Concordia Lutheran Church. During the 1850s and 1860s, many Lutheran immigrants from Waldeck, Hannover, Pomerania, and other provinces in Northern Germany settled in the areas known as Pickerel Lake, Bear Lake, and Mansfield.

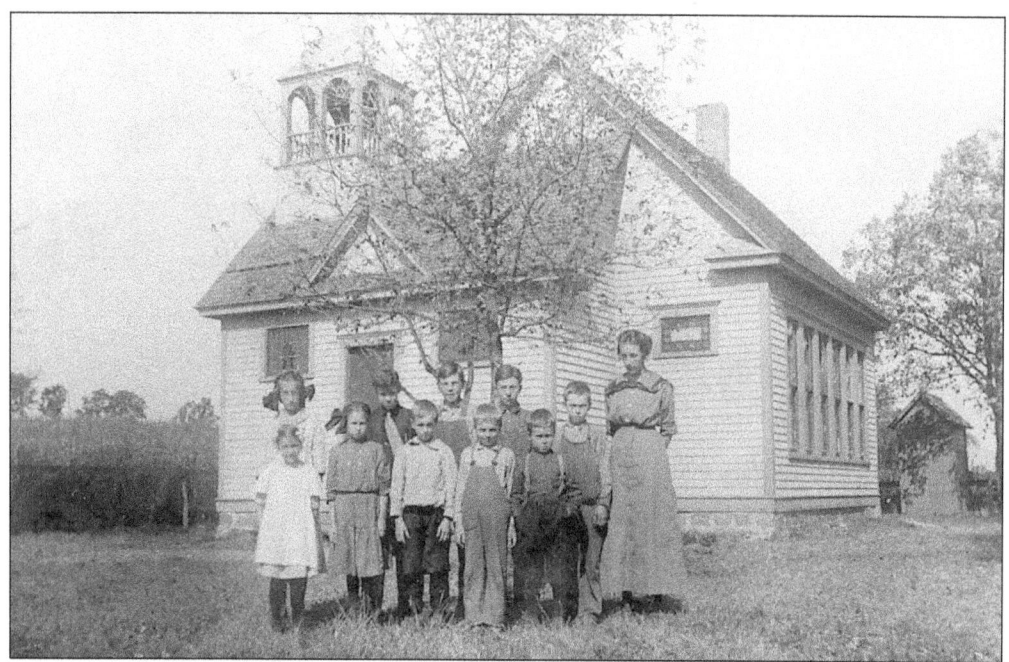

District 102 was first taught in the summer of 1876 in a carpenter shop on Mr. Widman's land. The teacher, Katie Eberhardt, had 18 or 20 scholars. The following year a neat frame building was erected at a cost of $300 in the southwest corner of Section 24. District organizers were George Widman, Mr. Jeklin, and F. Schneider. The photograph was taken in 1913. Elsie V. Lemke is the teacher.

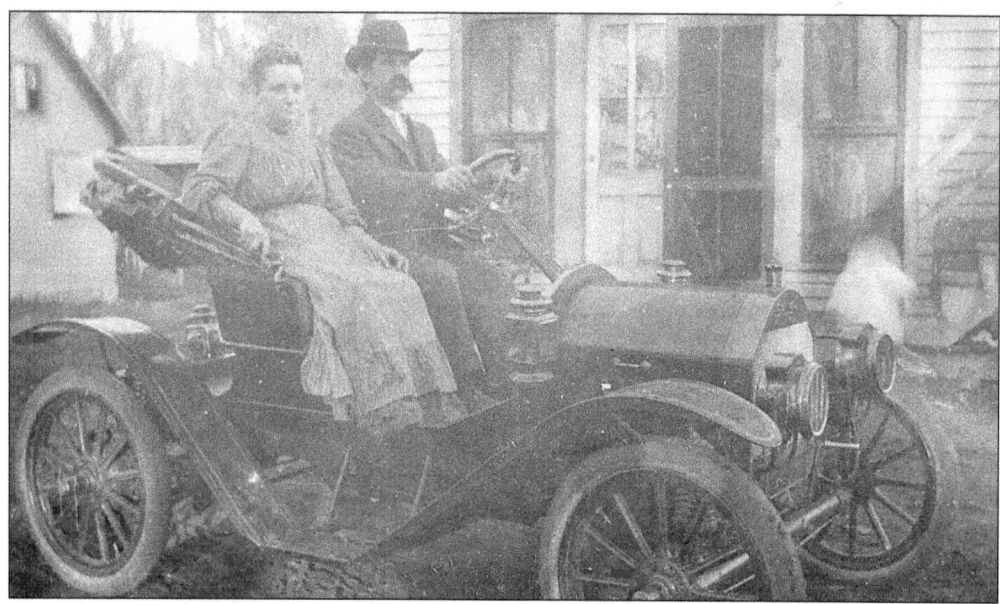

Mr. and Mrs. George Enser are shown seated in their 1910 automobile in front of the Clover General Store that he managed from 1904 to 1916. The Village of Clover was built on land owned by William P. Pickle. He built the general store in 1890, the same year that the post office was established. Originally the office was called Adair but, because of its resemblance to the word Adrian, the name was changed to Clover.

Hi-Lites and Shadows of Yesterday and Today, by Irv Sorenson in 1958, is pictured here.

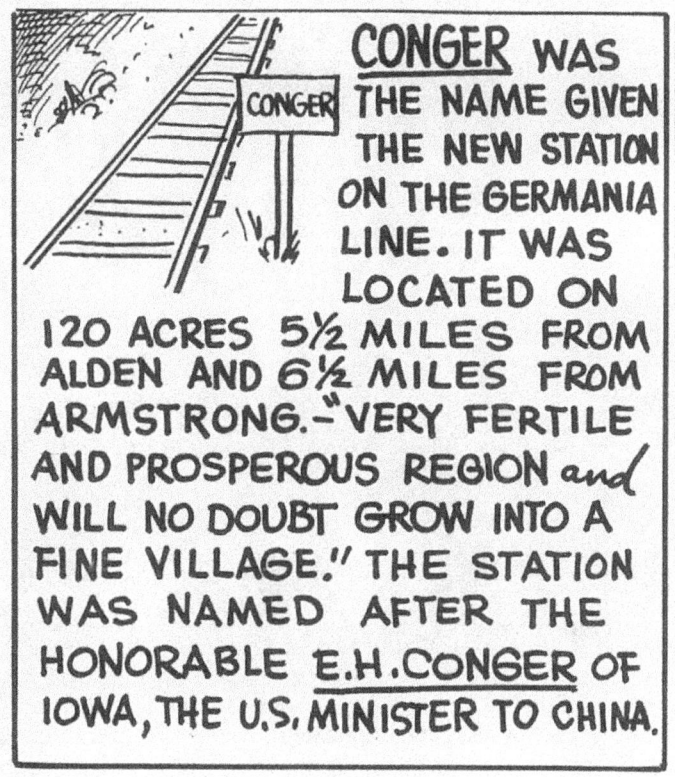

CONGER WAS THE NAME GIVEN THE NEW STATION ON THE GERMANIA LINE. IT WAS LOCATED ON 120 ACRES 5½ MILES FROM ALDEN AND 6½ MILES FROM ARMSTRONG. "VERY FERTILE AND PROSPEROUS REGION and WILL NO DOUBT GROW INTO A FINE VILLAGE." THE STATION WAS NAMED AFTER THE HONORABLE E.H. CONGER OF IOWA, THE U.S. MINISTER TO CHINA.

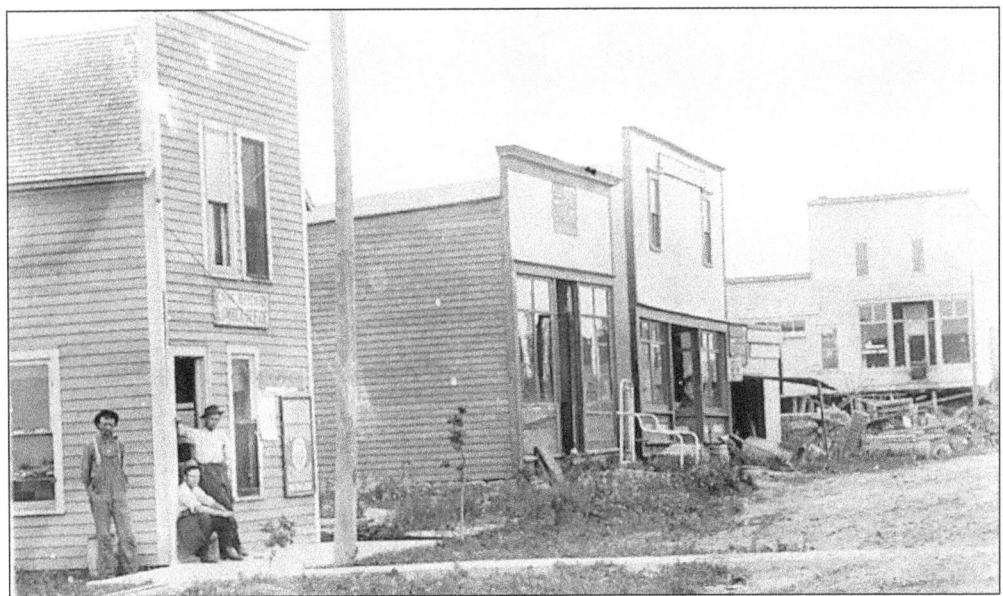

This 1914 view of the east side of Main Street in Conger shows Charles Sprenger standing in the door of his lumber yard and general store. Other businesses in town that year were the Conger Creamery Company, State Bank, blacksmith, hardware store, and the grain and coal company. Conger was located on the Chicago, Rock Island, & Pacific Railroad line 10 miles west of Albert Lea.

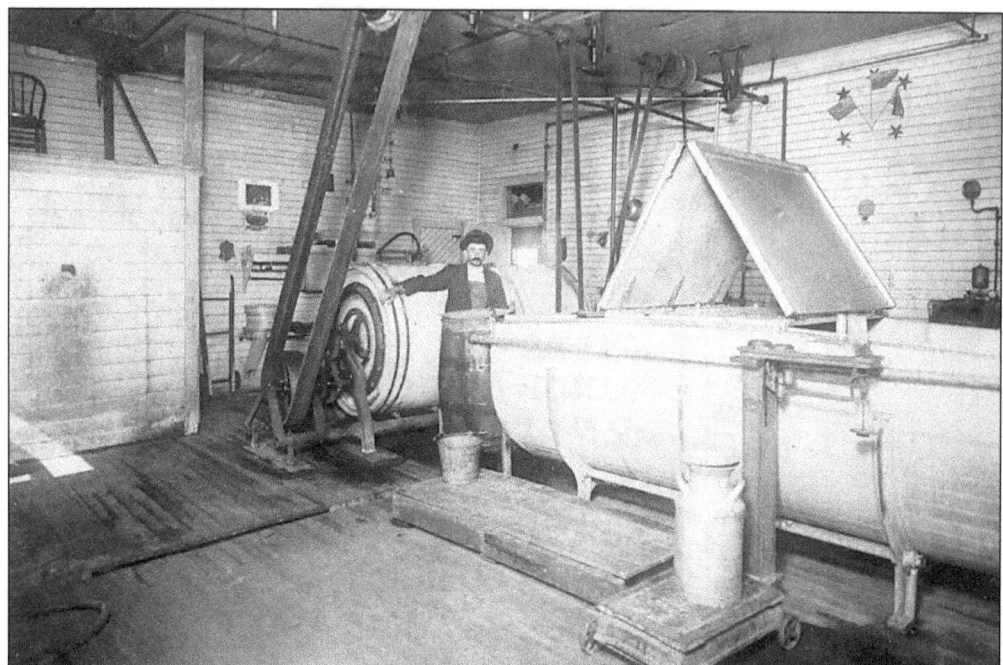

The Clover Valley Creamery Association was organized on June 2, 1890. Area farmers had been patronizing gathered cream wagons sent out from Albert Lea, Alden, and Emmons, and when the meeting was called to establish a modern separator creamery in Clover, there was not one dissenting vote cast. It was in operation until 1915. Note the patriotic flavor of the flags and stars on the interior wall.

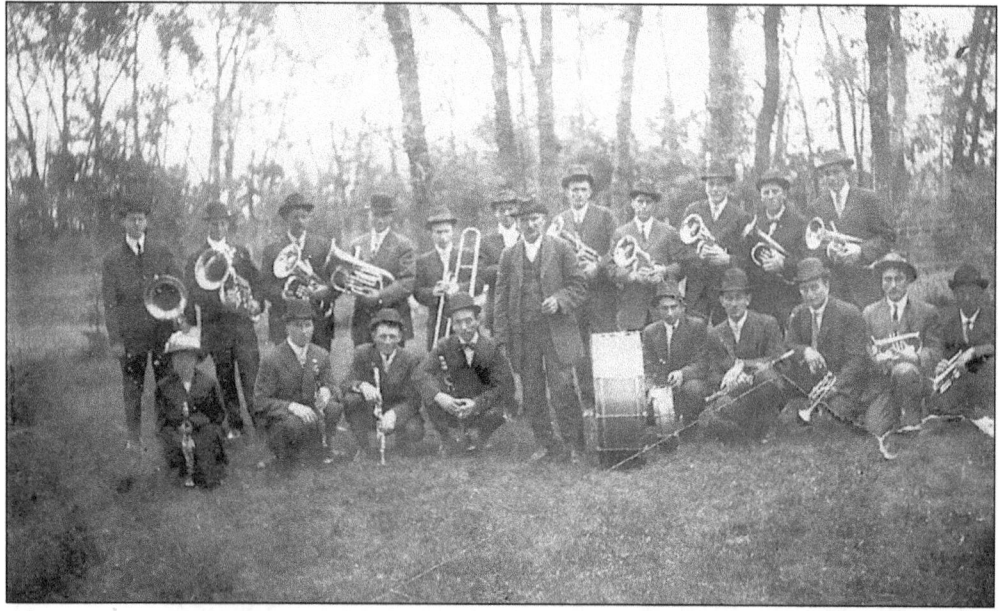

Almost every community, no matter how small, had its own band. Made up of local talent, they played for special events, parades, and Sunday afternoons in the city park. While some bands had their own special uniforms, the Pickerel Lake Band, with Henry Klose as director, posed for this photograph dressed in their Sunday best. Klose was also director of the Lerdal Cornet band.

Three

THE NORTHWEST

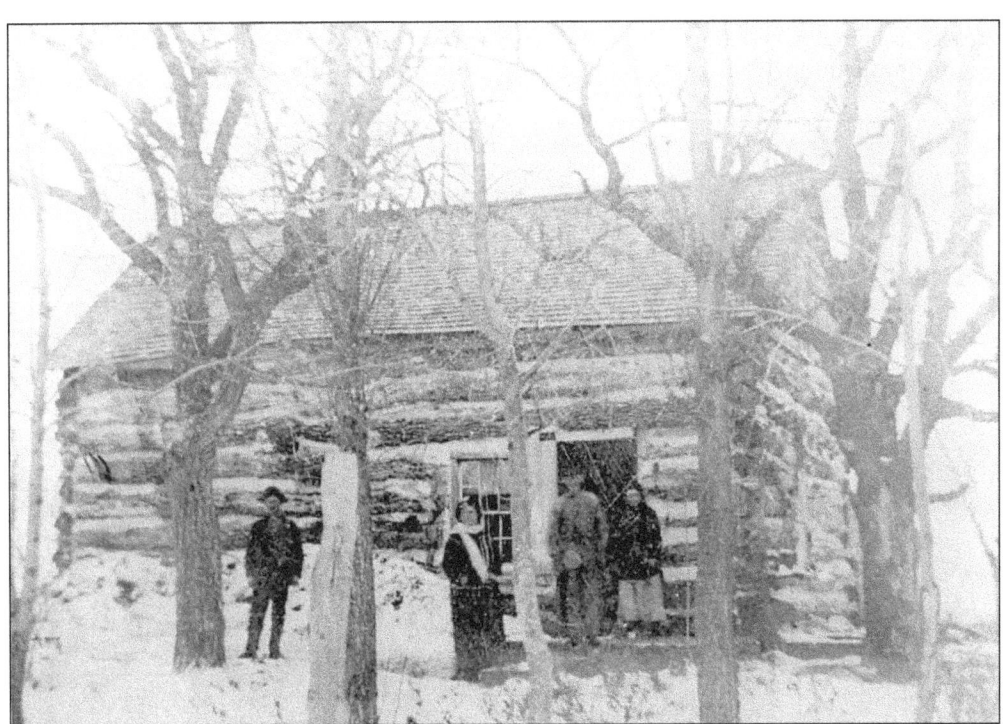

The first log house was built in Manchester Township by Smith Skiff on Section 26. In 1859, their sister Emily, and her husband George B. Chamberlain, arrived from New York, purchased adjoining land, and farmed for the next quarter of a century. The photograph information says, "The Old Homestead in Winter. Father and Eva standing in the door, Mother out in the yard, Karl Kittleson at one side."

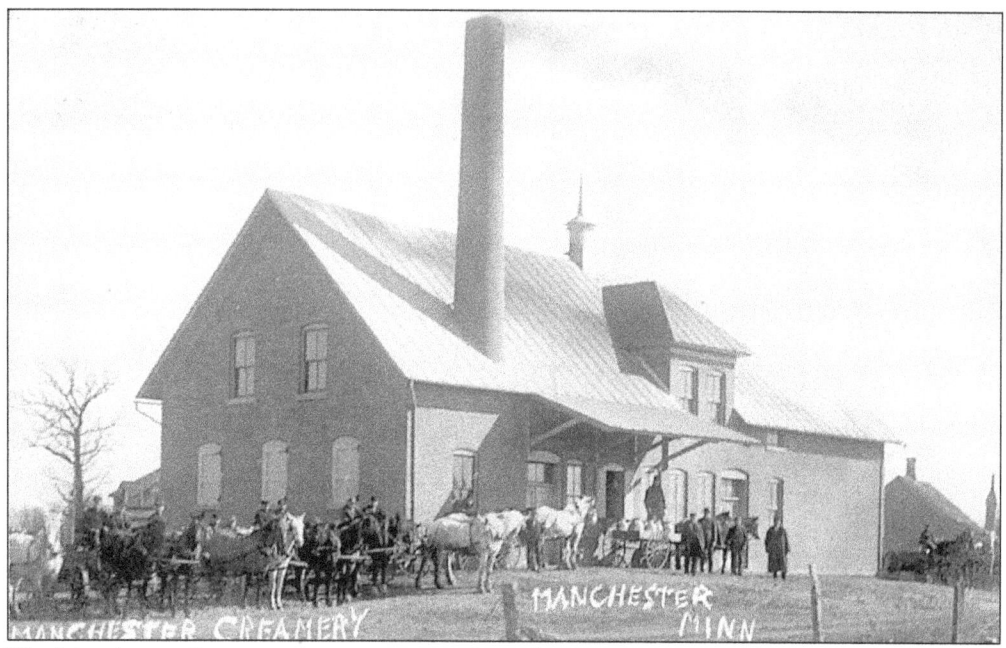

The Manchester Creamery Association was formed in January 1891, with C. Flindt as president and eight other directors chosen. By May the creamery was fully operational, with C.F. Meyer engaged as butter maker. After the original creamery was destroyed by fire, the brick creamery pictured was built in 1910. It was 32 by 84 feet, with 16-foot walls, a concrete ceiling, and a steel roof.

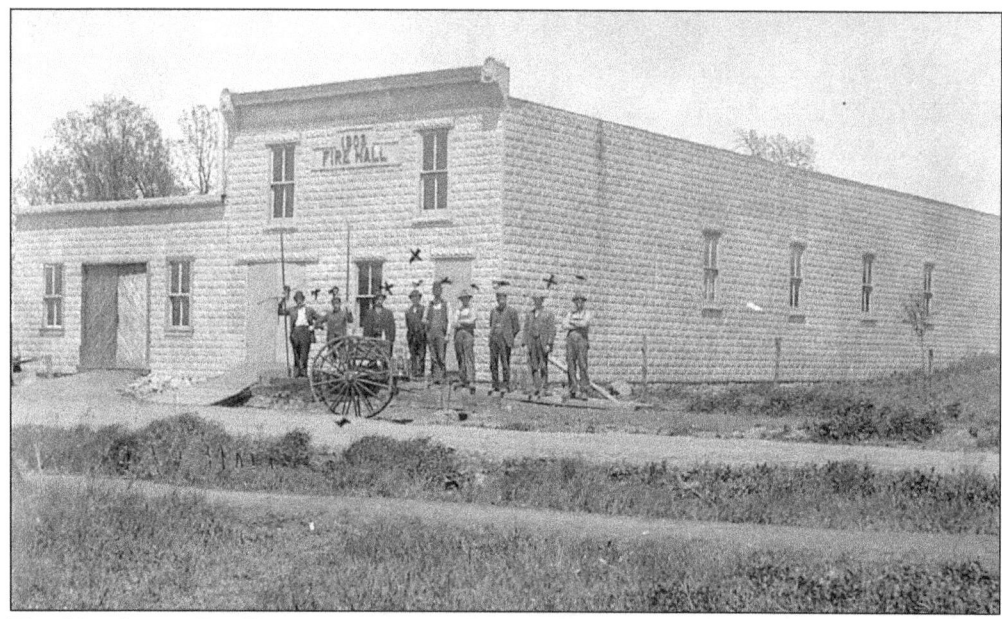

The Manchester Fire Department men and equipment are shown in front of the Fire Hall, which was built in 1909 and used also for theatrical and social purposes. According to the *History of Freeborn County*, another building in Manchester was the blacksmith shop, built by Anton Anderson in 1878, when he "commenced blowing the bellows." He later added a wagon shop and an engine house for his five-horse-power fire engine.

The original West Freeborn Lutheran Church was used by members of the congregation until 1876. It was a sod building with log interior walls and a log roof. In 1876, this frame church was erected at a cost of $5,700. Its imposing steeple contained an 800-pound bell that cost $300. This church was destroyed by fire in 1930.

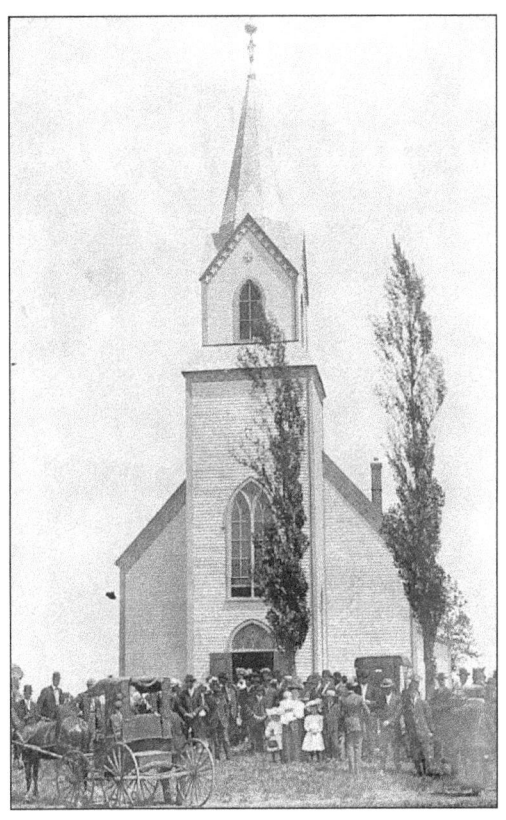

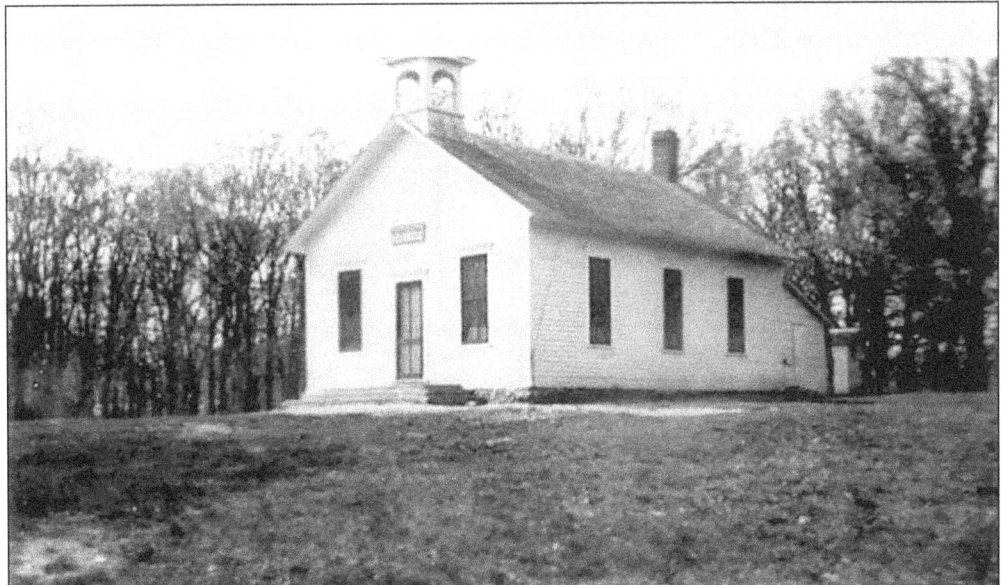

District No. 55 embraced the territory in the southeastern part of Manchester Township. It was organized in the fall of 1864 in the E.D. Hopkins house on Section 34, and the first school was taught by Maggie Colby in a log house belonging to A.M. Johnson. The following year a log house, 18 by 16 feet, was purchased for $100. District 55, or the Hopkins School, is shown as it appeared in 1918.

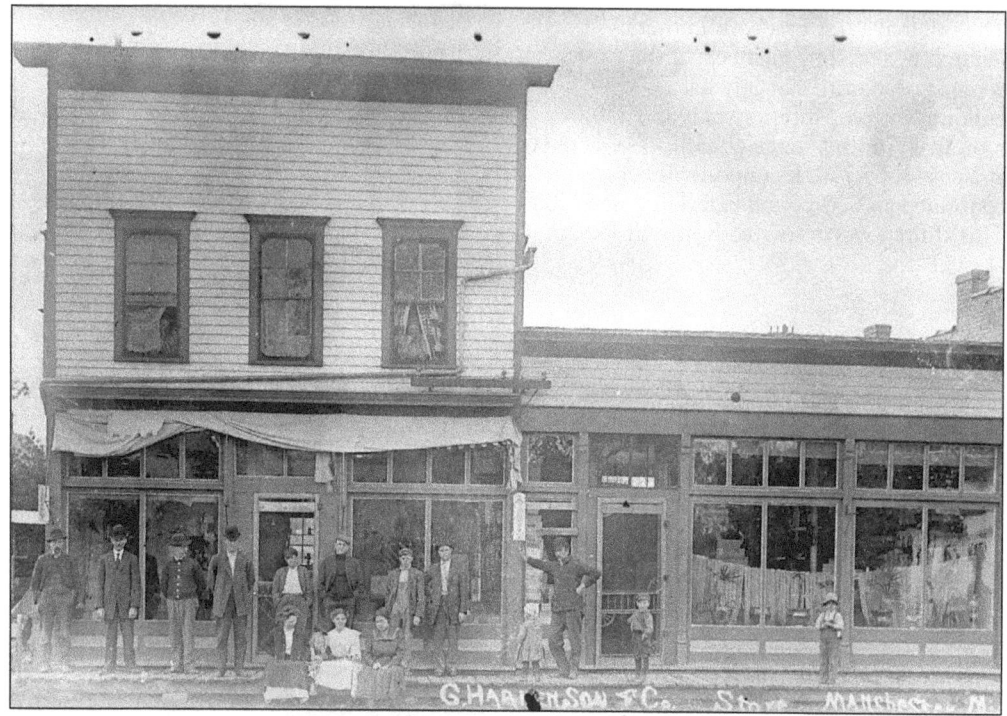

In 1911, the Manchester General Store was owned by Gunder Haakenson, Lyth O. Hartz, and John A. Thykeson. The 1914 city directory lists several names, mostly Haakensons, as employees; and it looks like they all gathered in front of the store for this photograph. The village of Manchester was platted in 1882, and was then re-platted and surveyed in 1898, although by that time there were several businesses in the community.

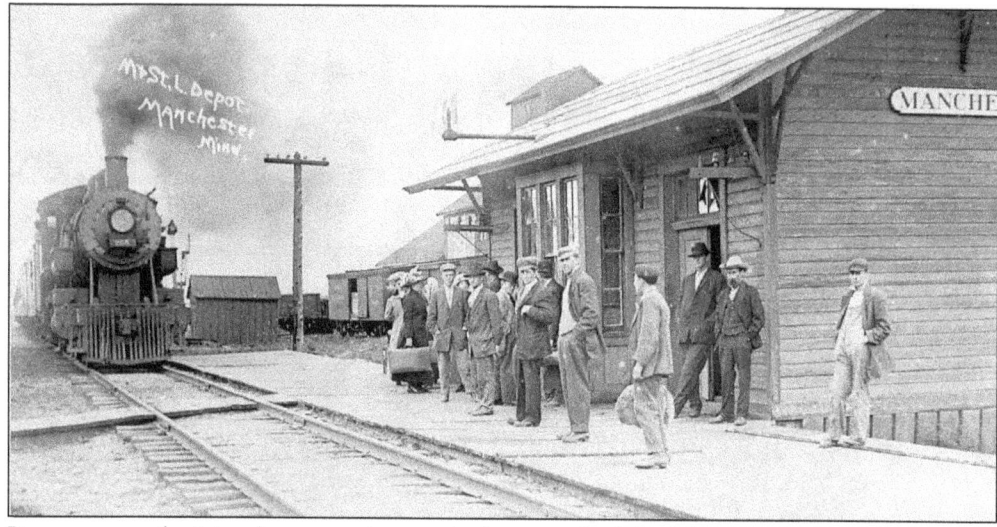

Passengers at the Manchester station await the arrival of the Minneapolis & St. Louis train in 1913. A year later the building burned to the ground. The body of depot agent, Mrs. Irene Coleman, was found in the ruins. She was one of the few women who attended Barry's Telegraph School in Minneapolis, and she had accepted the Manchester position three months earlier. Her husband had arrived only three weeks before the fire.

Hi-Lites and Shadows Yesterday and Today, was drawn by Irv Sorenson, 1956.

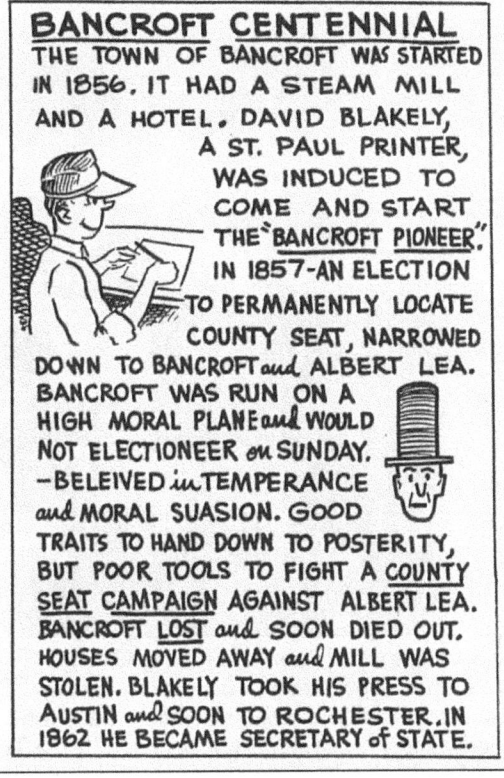

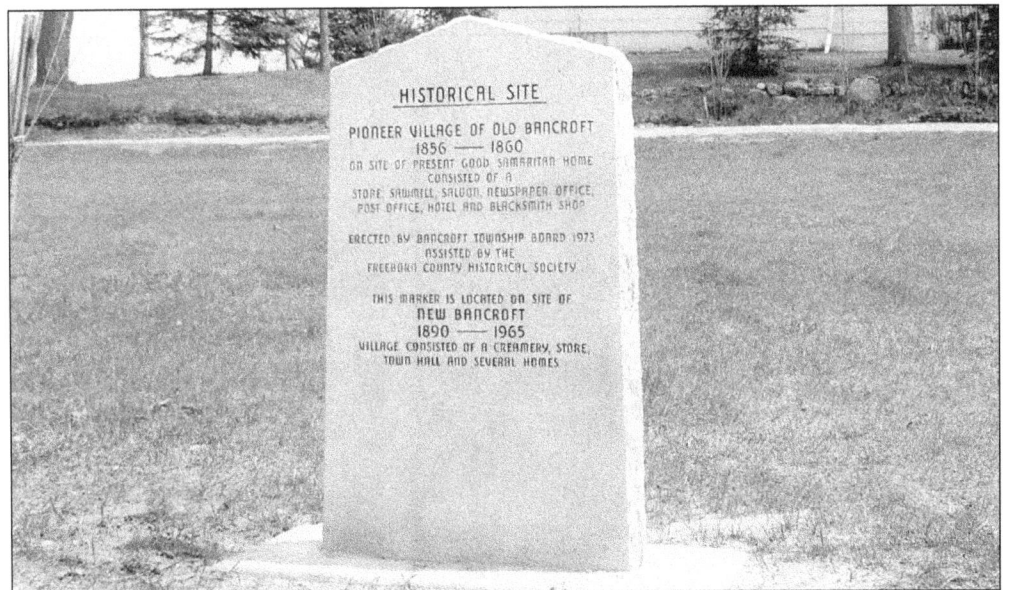

The original village of Bancroft was platted by Morton S. Wilkinson in 1856. The legislative bill enacting this process included a county seat clause, but this was repealed. An early account of the original buildings stated, "The store was removed. . . . Oleson first lived in a dugout. . . . Porter opened a blacksmith shop. . . . Perry started a law practice . . . a sawmill was set up—sold for taxes . . . hotel and saloon had brief existence."

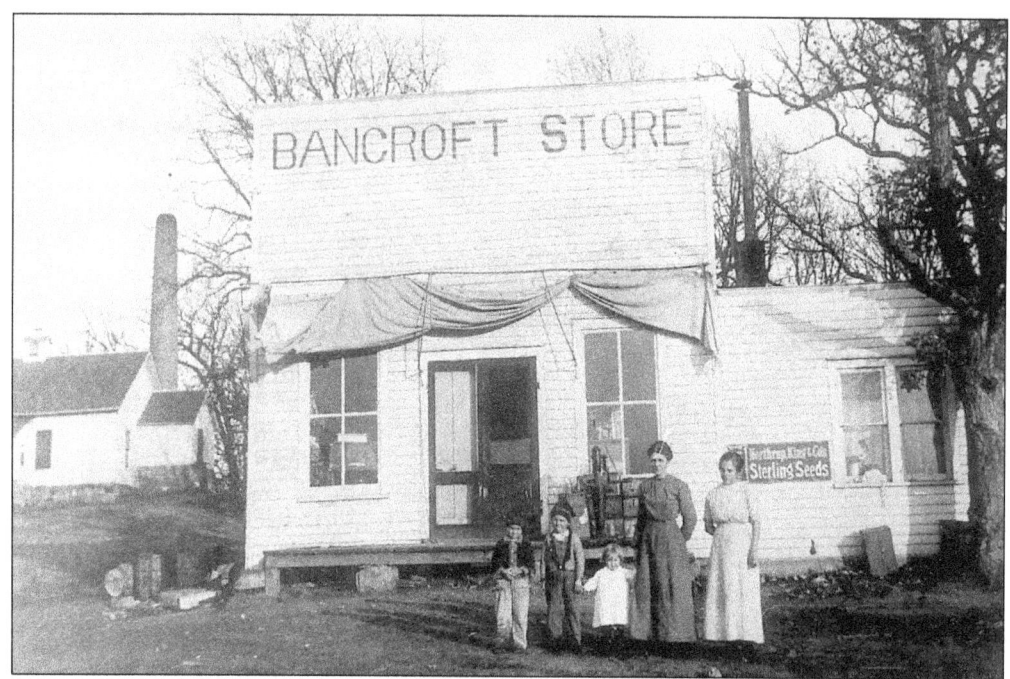

According to the *History of Freeborn County*, "Thomas Edgar erected the first Bancroft Store in the spring of 1857 and put in a stock of goods." The same source states, "A store (in 1857) was also erected, Charles Etheridge being the master builder." This photograph shows the store as it looked in 1912, when it was operated by the Torgeson family. Shown here, from left to right, are: Arnold Hendrix; Arnold, Cora, and Carolina Torgeson; and Gustina Larson.

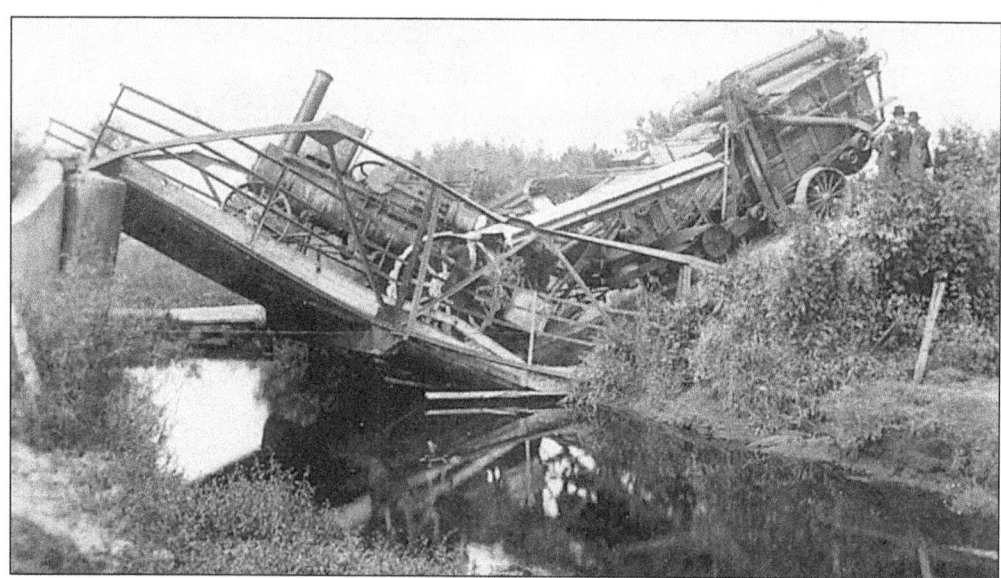

This steam engine and threshing machine was probably owned by one man, who hired out and worked for the neighboring farmers with a threshing crew. The schedule of this "threshing circle" was certainly disrupted when the weight of the equipment caused the Bancroft Creek Bridge to collapse. In 1920, these machines were the heaviest and most powerful equipment for miles around. How did they move them from the bridge?

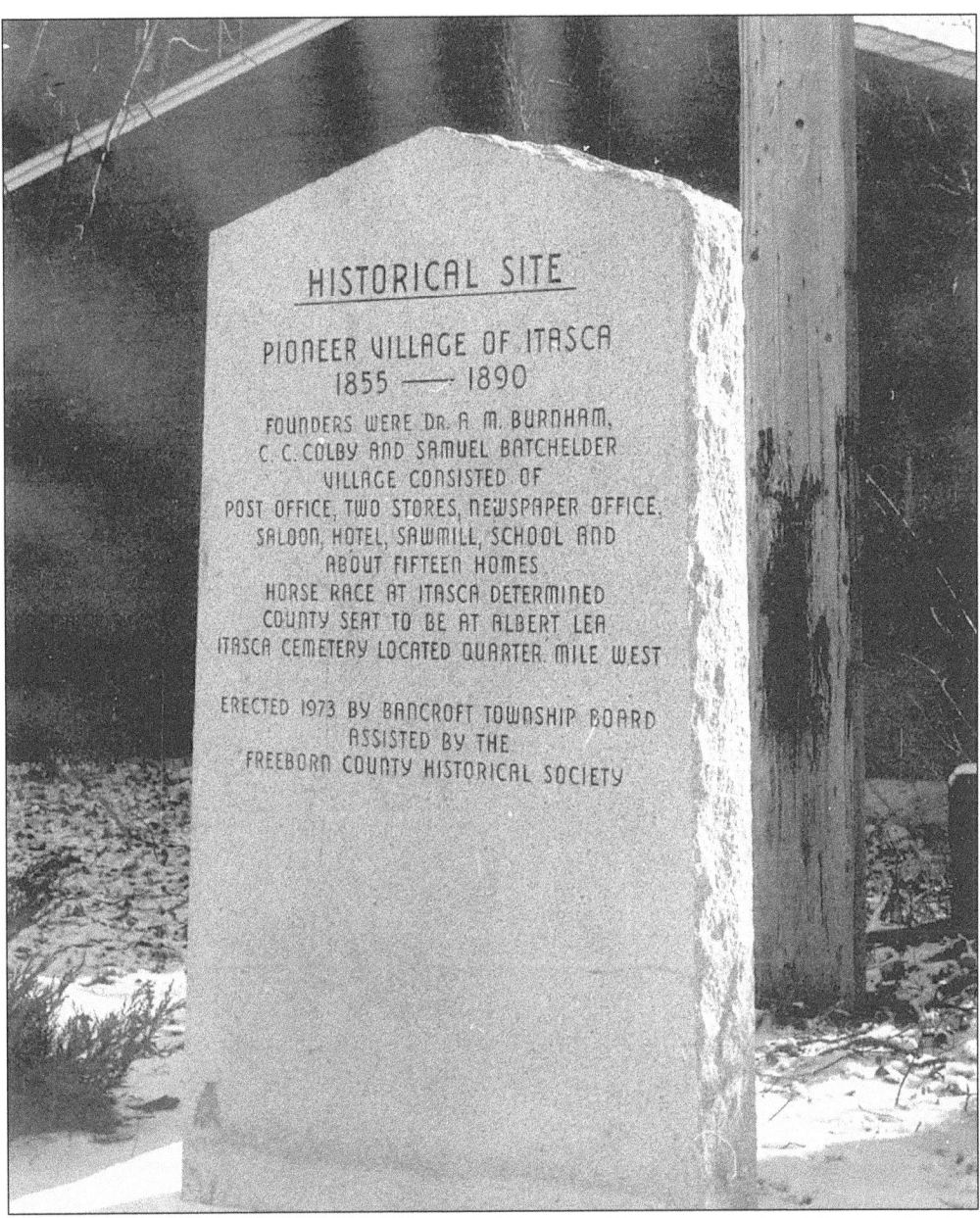

In 1855, Charles C. Colby settled in section 6, Albert Lea Township, and took land in Section 31, Bancroft Township, in which the village of Itasca was platted. Samuel Batchelder and A. M. Burnham arrived, and a post office and newspaper were established. Botsford, Hall, Dunbar, Pickett, and Longworth were also names identified with the village that hoped to become the county seat, but by 1911 it was occupied by Wedge Nursery. The following is from Ida Pickett Bell's 1930 letter, describing her trip to Itasca in the 1850s: "After we crossed the Mississippi River at McGregor (Iowa), our trials began. Roads were mostly cross country trails. Many times a wagon mired and father had to unload everything and sometimes go a long distance for a piece of timber strong enough to pry out the wheels. We had campfires and mother cooked. Sometimes it rained so we had nothing hot. We walked up the big hills, and as we met teams, the constant salutation was 'Hurrah for Lincoln'."

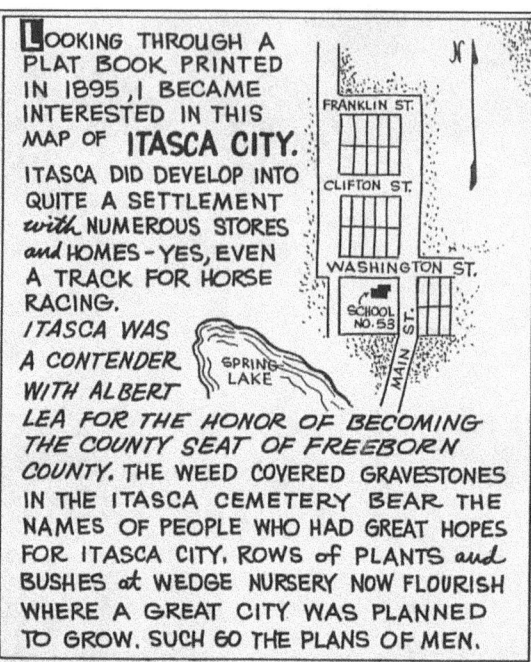

Looking through a plat book printed in 1895, I became interested in this map of ITASCA CITY. Itasca did develop into quite a settlement with numerous stores and homes – yes, even a track for horse racing. Itasca was a contender with Albert Lea for the honor of becoming the county seat of Freeborn County. The weed covered gravestones in the Itasca cemetery bear the names of people who had great hopes for Itasca City. Rows of plants and bushes at Wedge Nursery now flourish where a great city was planned to grow. Such so the plans of men.

Hi-Lites and *Shadows of Yesterday and Today* was drawn by Irv Sorenson in 1963.

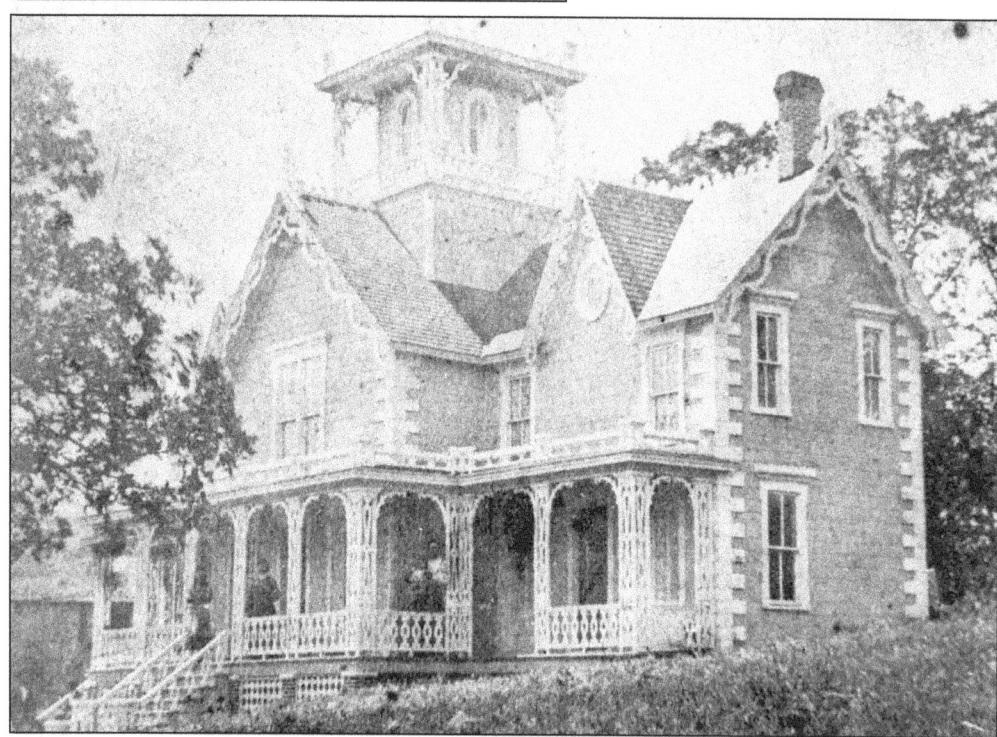

Dr. A. M. Burnham moved from Shell Rock in 1857 and started the "booming" in the village of Itasca (sometimes spelled Itaska, also known as Freeborn Springs). He built this beautiful home, painted pink and white, on the land that Lieutenant Albert M. Lea had called Paradise Prairie, one of the most beautiful spots he had ever seen. Burnham was prominent in the affairs of the community and an important voice in the county seat controversy.

This 1906 photograph of Freeborn shows the Methodist Church, Gilmore & Purdie Store, and the First State Bank. "In 1857, L.T. Scott erected a hotel on the lakeshore. . . . The first religious services in the village were held at this hotel by an itinerant preacher who chanced to stop . . . and was offered free accommodations if he would stay over Sunday and preach." (*History of Freeborn County* [1911].)

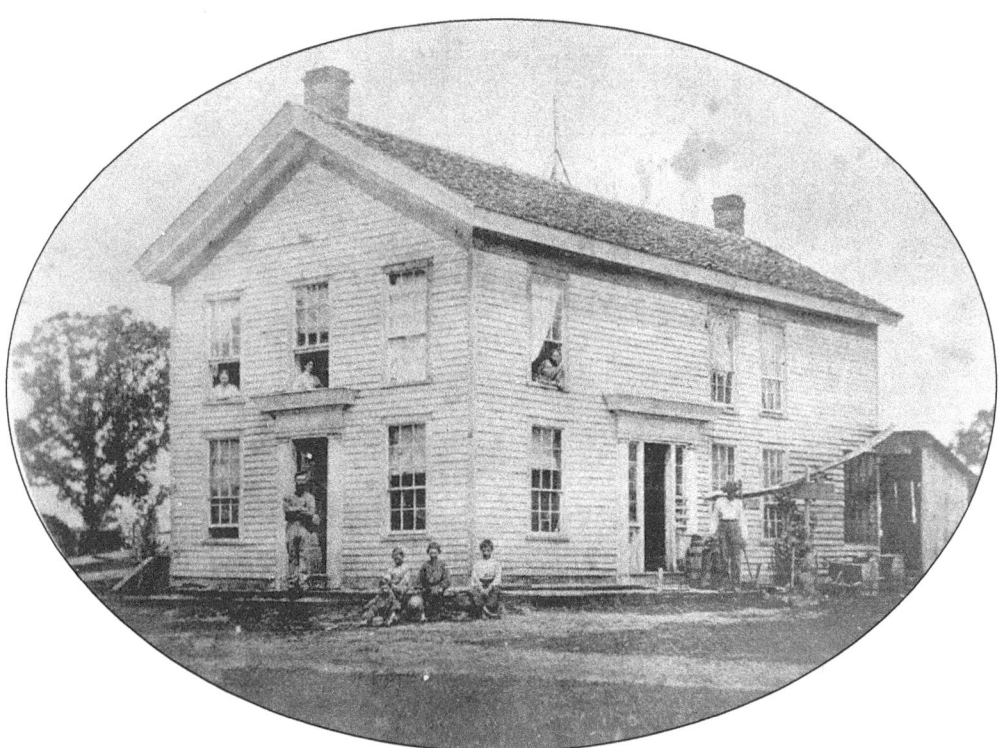

FCHS archives identify this building as the Chase Hotel, 1859–1899, located west of the Freeborn business area. L.T. Scott is said to have built Freeborn's first hotel, which also housed the first general store. Scott was prominent in community affairs and farmed, hauling his grain to Hastings, a six-day trip by ox team. At times he received only 35¢ a bushel for his grain.

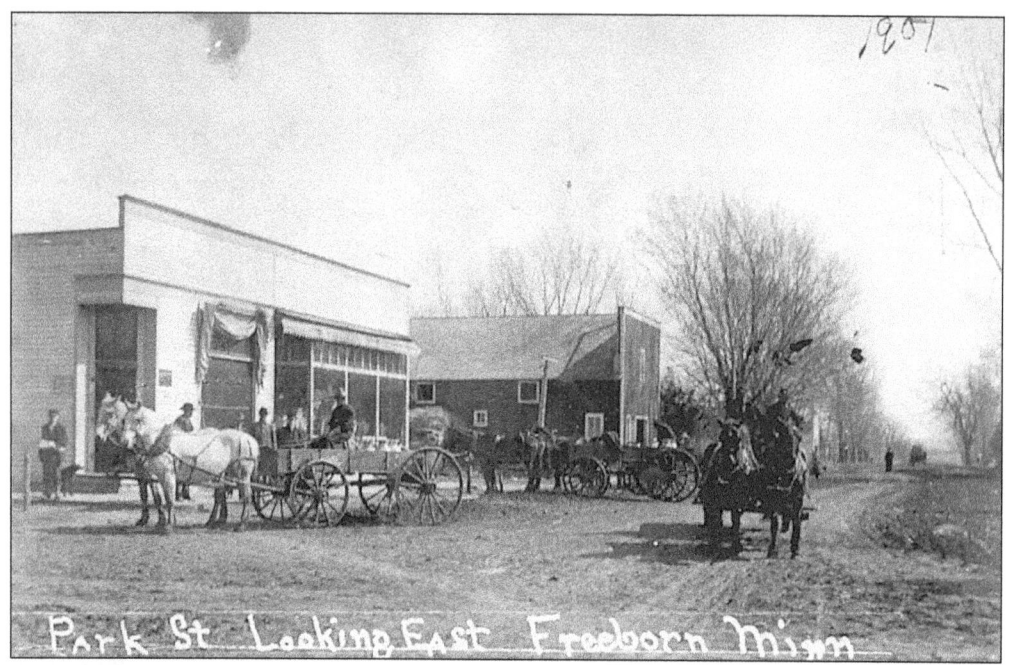

Dr. C.R. Butturff came to Freeborn in 1912 and opened his office and a drugstore in the building on the left side of this photograph. The livery stable is next to it. Other Freeborn businesses listed in the *History of Freeborn County* are: a bank, a creamery, two general stores, a blacksmith shop, an elevator, a hotel, a barber shop, and a meat market.

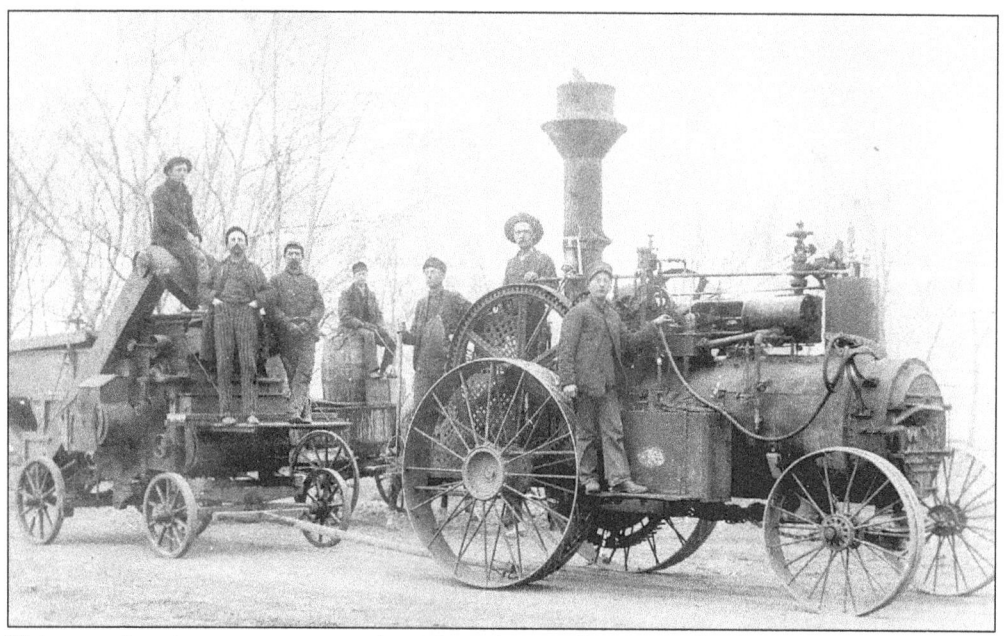

This straw-burning steamer required steady stoking, so keeping it fired was an endless job. The high smoke stack was needed because the burning straw sent out lots of sparks, so the stack was hinged for low clearances. The clover huller is similar to an early threshing machine. It would separate the seed from mature clover to be used for the next season's planting.

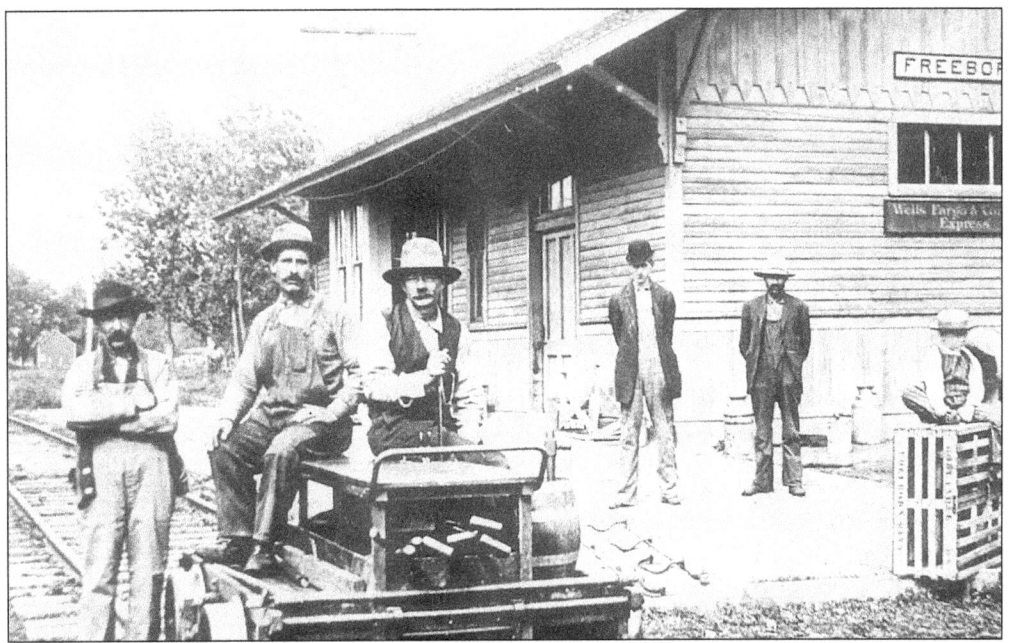

In March 1907, a line called the Duluth, St. Cloud, Glencoe, and Mankato Railroad was completed from Albert Lea, northwesterly through Freeborn, and on to St. Clair. In 1911, the line was sold to the Chicago and Milwaukee Company. It was known locally as "The Alphabet Line," and also "The Bug line." The Freeborn depot also housed the Wells Fargo Agency.

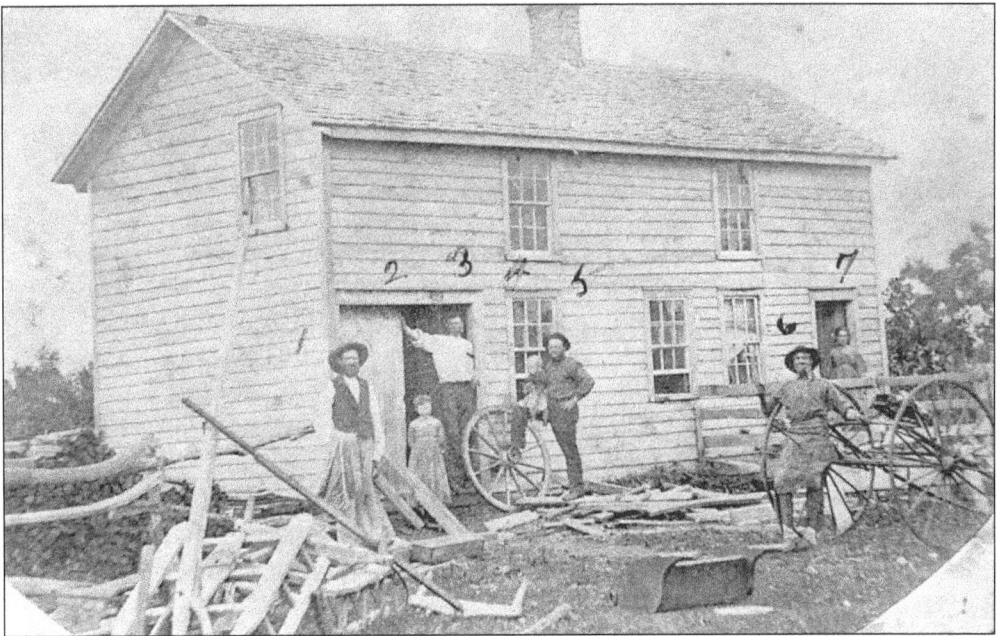

Blacksmith and wagon maker David Scoville (shown #5 holding his son Al) arrived from New York around 1865. He had the ability to cut rock, ash, and hickory trees from the shores of Freeborn Lake to make hubs and spokes of wheels. When moving west, he had shipped four wagons to Chicago by train. There he was offered a quarter of section of land, where Chicago now stands, in exchange for the wagons, but he chose to move on to Minnesota.

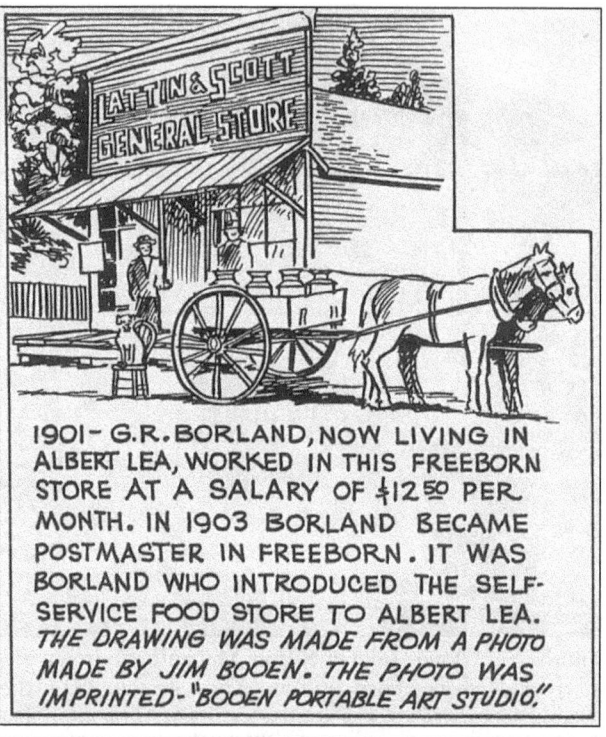

Hi-Lites and Shadows of Yesterday and Today drawn by Irv Sorenson in 1963.

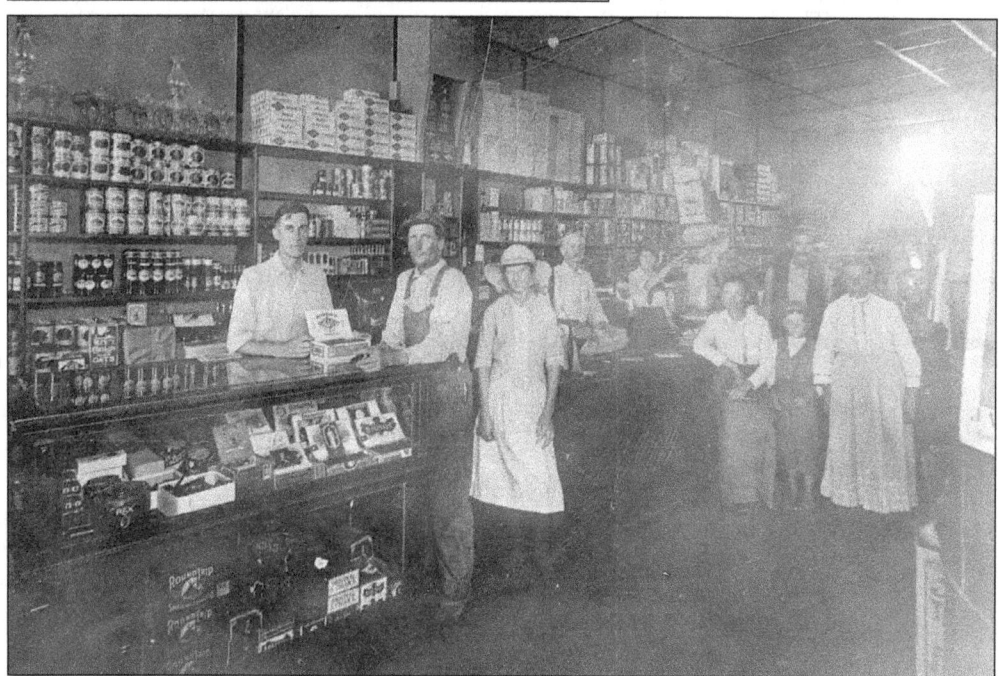

O.S. Gilmore, a Civil War Veteran, moved from Vermont to Minnesota in 1865. He was employed for two years in T.A. Southwick's store before opening his own general mercantile business. It eventually became known as O.S. Gilmore & Son and was operated in Freeborn for almost 30 years. Shown behind the counter are: Ansel S. Gilmore on the left, and John W. Bates and Mrs. Clara Hinkley, clerks, on the right.

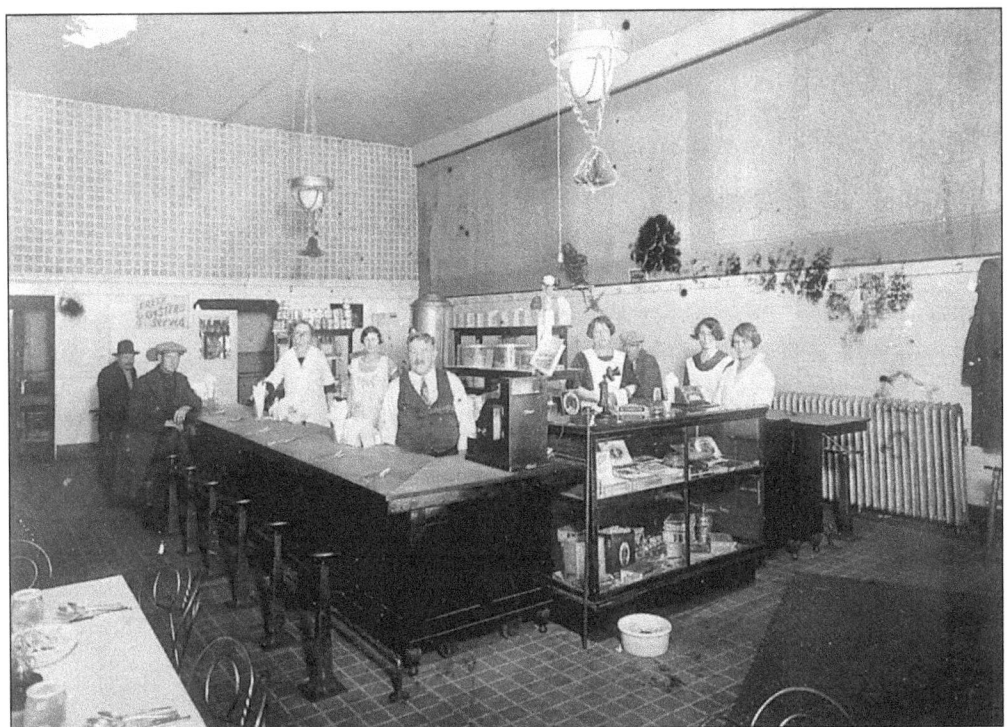

Paper Christmas bells decorate the light fixtures of the Freeborn Café, c. 1920. Caroline Rasmussen is the waitress shown directly behind the telephone. Notice the wooden counter tops and stool setting, the spittoon, the pegs for hanging coats on the far wall, the "fresh oysters served" sign near the kitchen door, and the bentwood chairs at the table.

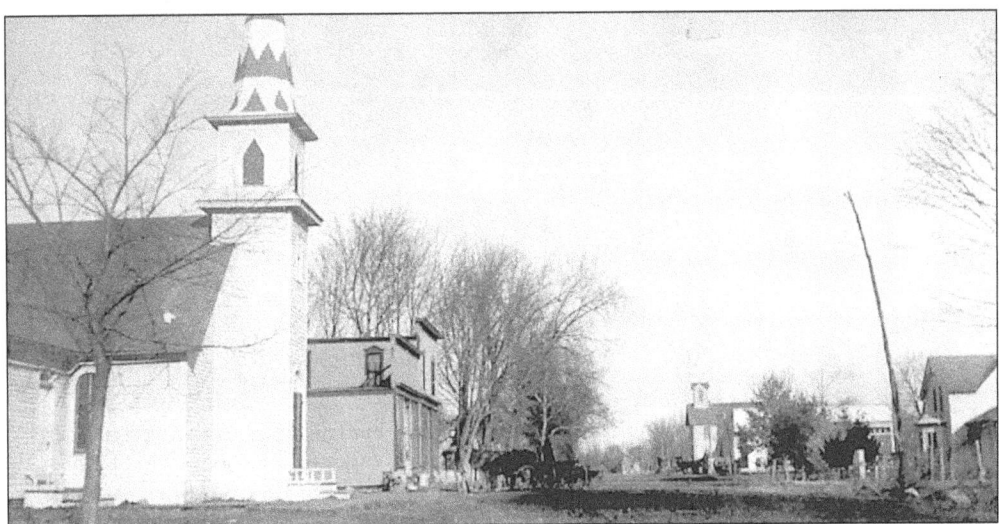

The religious service in Freeborn was held in the L.T. Scott Hotel in 1858. For several years the Baptists, Congregationalists, and Methodists shared the same church buildings, ministers, and church services. In 1919, the Ladies Aids merged, forming the Community Church Society. In 1932, the Methodist Church was struck by lightning and burned, and by 1936, 102 members of the Methodist Church joined the Congregational Church.

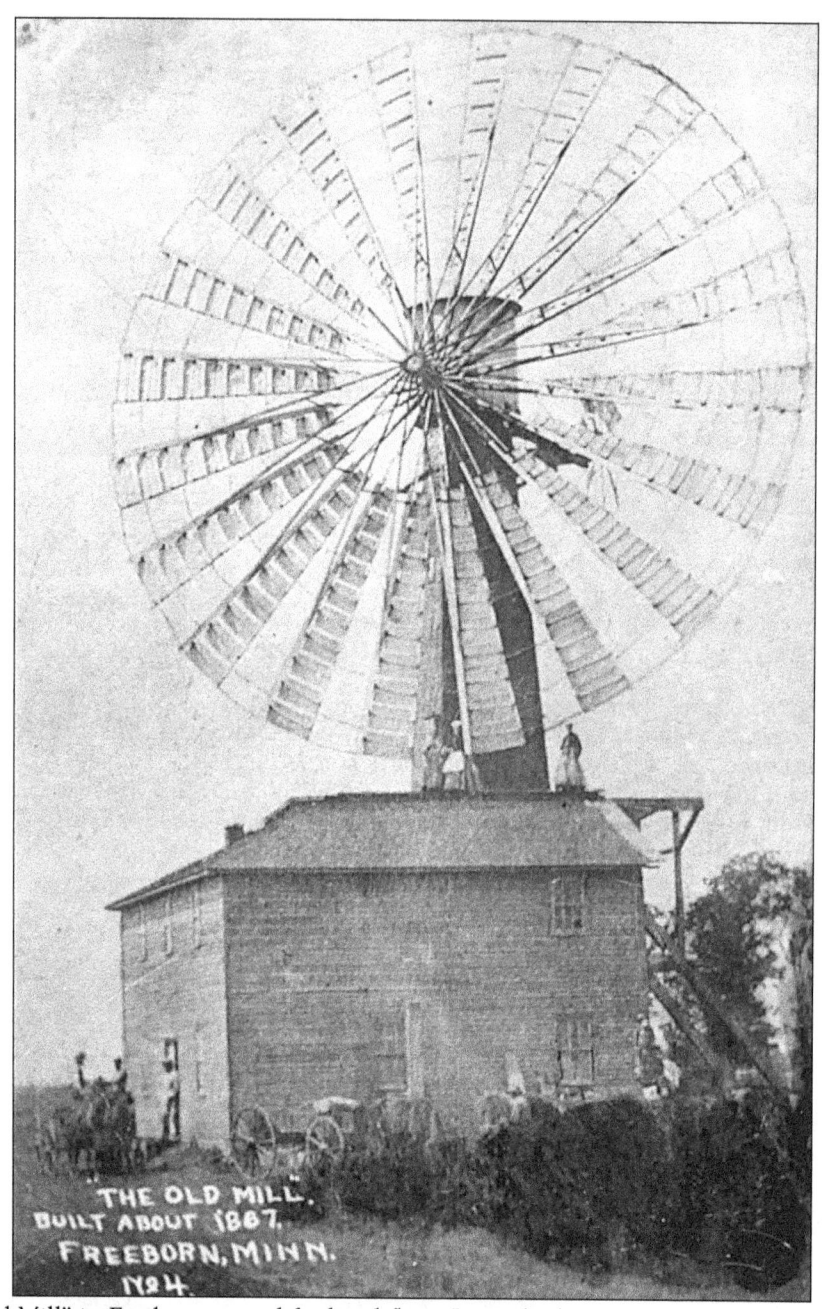

"THE OLD MILL".
BUILT ABOUT 1867.
FREEBORN, MINN.
No 4.

"The Old Mill" in Freeborn ground feed and flour. It was built in 1867 in the western part of town and operated until June 27, 1874, when the 50-foot windmill blew off. One of two such mills in Minnesota, it remained a county landmark for many years, but was finally torn down in 1898. In 1881, *The Graphic*, a London, England newspaper, printed a full page of drawings portraying the English perception of life on a prairie farm in Minnesota. Like this Freeborn windmill, the drawings had a definite European influence. The sketches show a turf house, hay stable, interior fireplace, farmer carrying an umbrella, and fine riding horses pulling farm equipment—all misconceptions of what pioneer life was really like. Immigrants brought these ideas to America and applied them. Some were very successful, and others were not.

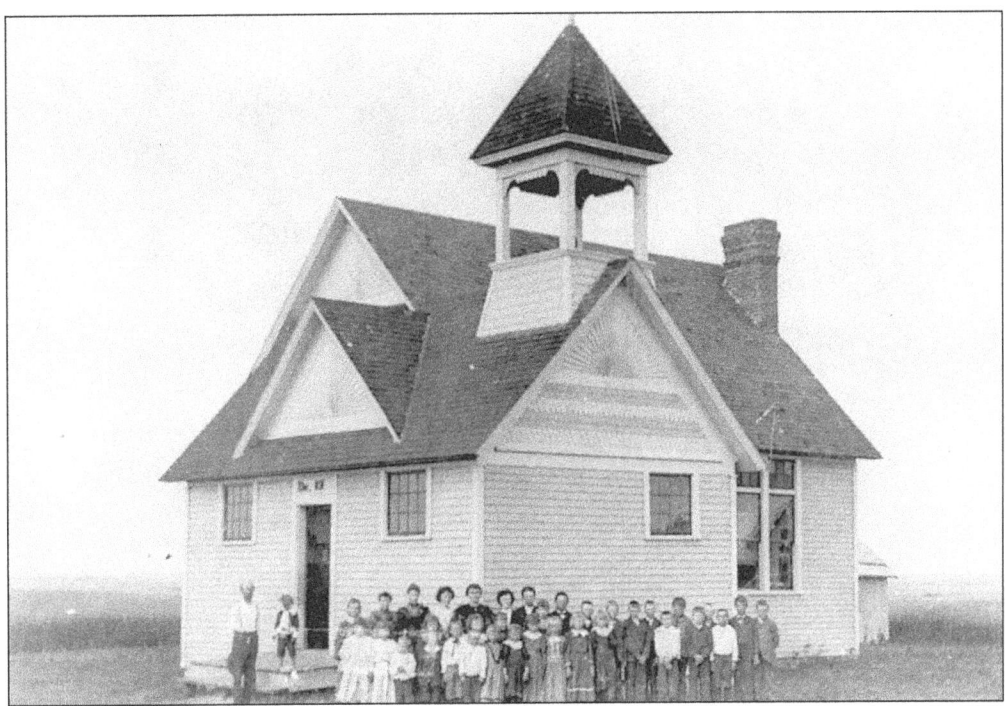

District No. 101 was organized in the spring of 1876, and a schoolhouse was erected in Section 28, at a size of 18 by 22 feet, and a cost of $450. The first teacher was Miss Emily Blighton, with ten scholars in attendance. District 101 joined with Districts 12 and 13 on December 18, 1919, when the first consolidation of country schools in Freeborn County took place.

District 15, Carlston Township, was organized in 1859, and in 1860 the first school was taught by Martha Stane in a log house. She had nine scholars and received $18 per month as compensation. A new schoolhouse was built in 1877. At a cost of $640, it was equipped with patent seats for 40 scholars. It was called the Melander School, after John L. Melander, one of the earliest residents of the township.

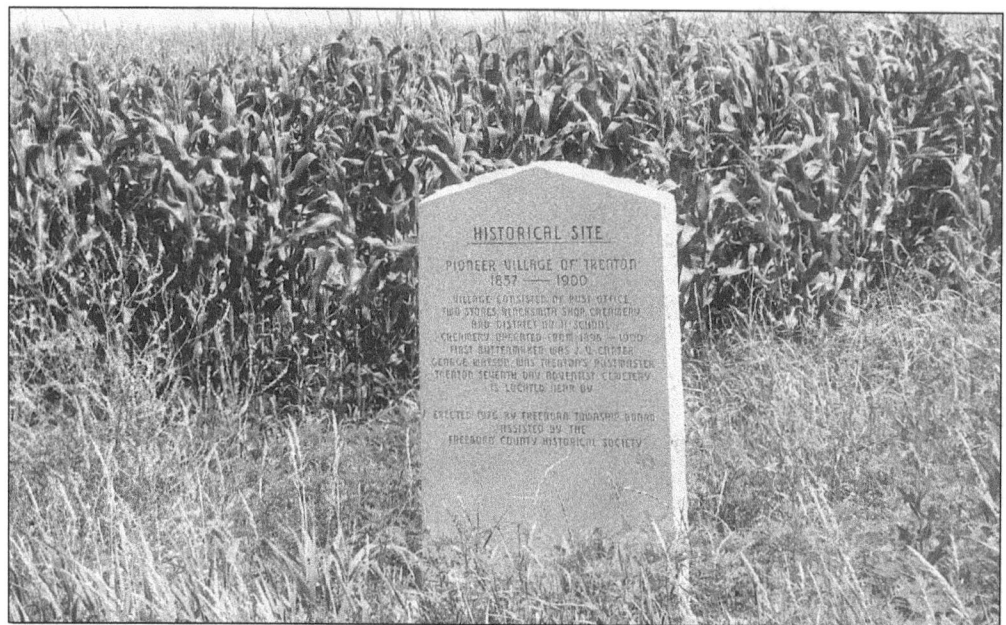

According to the *Freeborn County Heritage*, "On March 4, 1856, an advertisement appeared in a New Jersey newspaper. Written by John W. Ayers, it stated that he had visited Freeborn County, Minnesota and found an ideal spot [in Trenton] to make his home in the northwest corner of the township.... Several families were planning to start for Minnesota about the 10th of May, to choose their locations, and make their claims...."

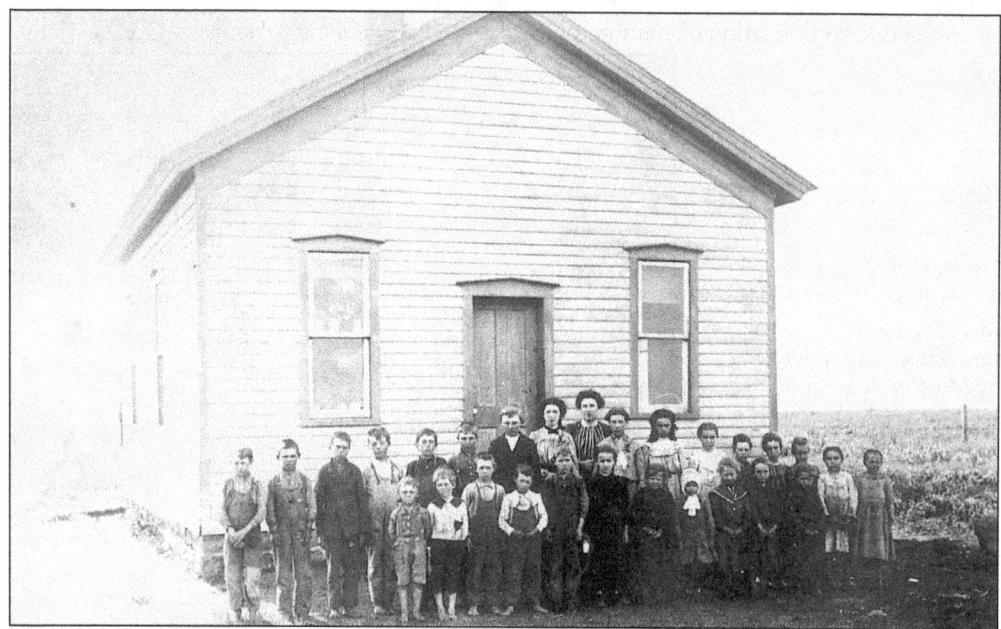

The Ayers party arrived in Freeborn Township in 1857. They immediately established a school (District 11, shown here) and a Seventh Day Baptist Church. John Ayers was an early Indian agent opening his home for the protection of settlers in 1862. He also served as postmaster with the office in his home near Trenton Lake. The mail arrived weekly for Alden by way of Freeborn.

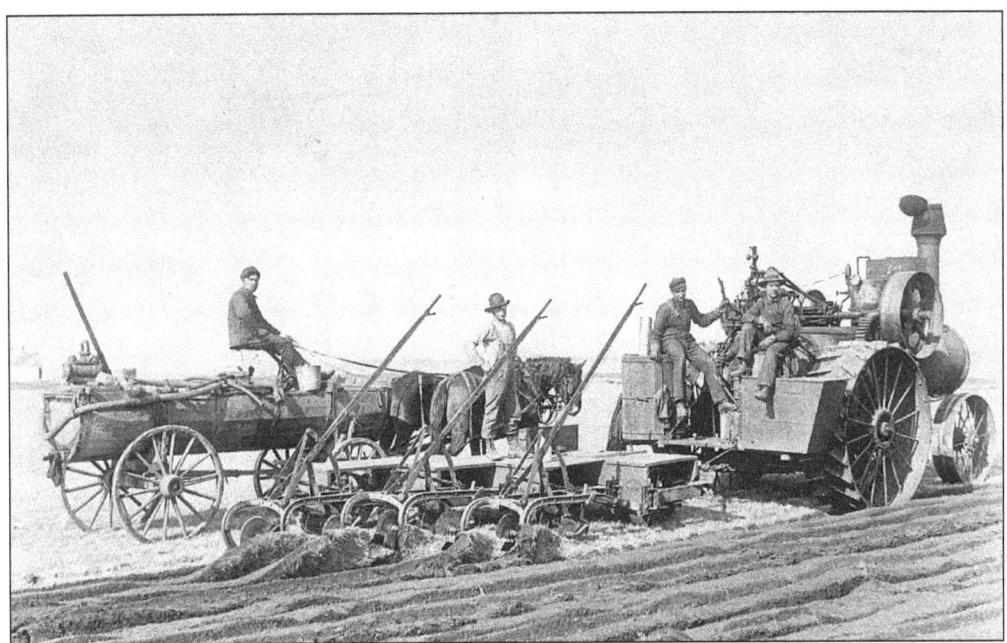

There had to be an air of excitement when prairie sod was turned for the first time—hard work for both man and machine. The steam engine, a brute for strength, moved about 1.5 miles per hour and was refilled from the hand-pumped water wagon. The six-bottom plow was controlled by three handles, requiring less manpower.

This peaceful, rural, winter scene is only identified in the FCHS archives as a parsonage near Hartland in 1914. The Midwest square architectural style of home building became popular after 1900 because it adapted well to the new plumbing and heating systems. The improvements were known only in the cities, as the windmill by the out building testifies to more traditional water access.

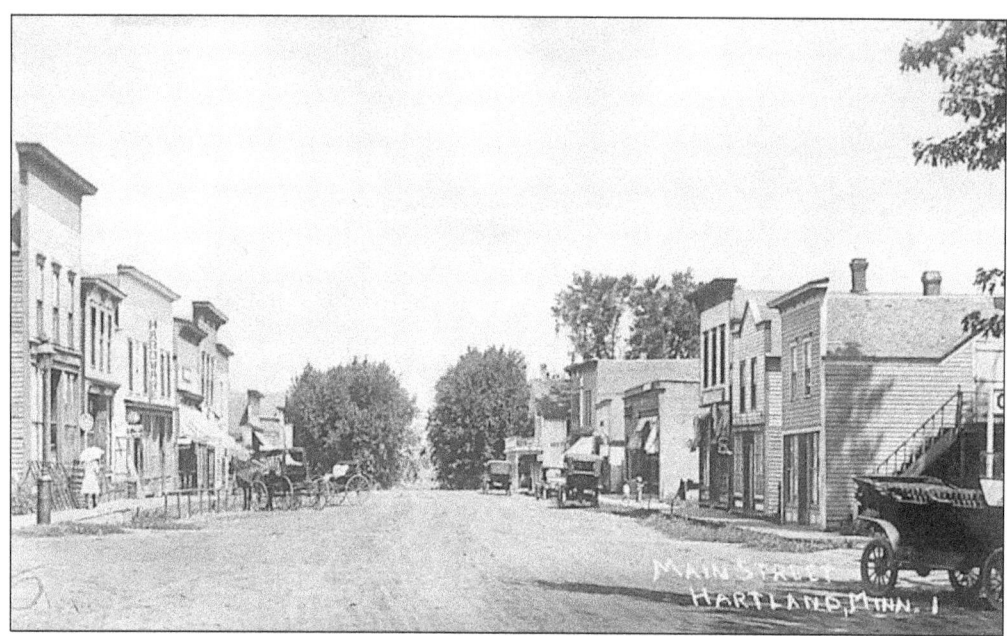

Hartland got its start in 1877. In its first three months $15,825 was spent for new buildings. This amount built 23 business places (many with living quarters on the second floor) and two dwellings. The most expensive building was the dry goods store at $1,500. Included were five saloons, ranging in cost from $400 to $1,000. The barber shop was $50. The dwellings cost $300 and $350. (*Hi-Lites and Shadows*, by Irv Sorenson, 1952.)

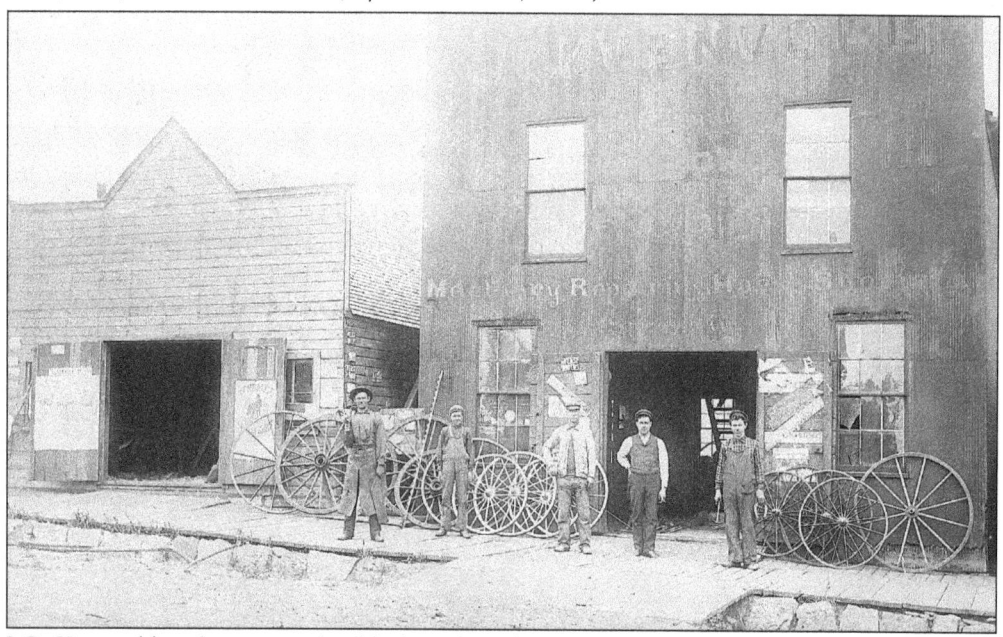

J.O. Kvenvold is shown near his blacksmith and wagon shop in Hartland (1889–1914), with three unidentified men and his helper on the far right. In 1901, the citizens of Hartland voted 39 to 33 to install a water system consisting of a 1,500-barrel tank—100-feet high and on iron supports—an eight-horse-power gasoline engine and engine house, 2,000 feet of water mains, and nine fire hydrants.

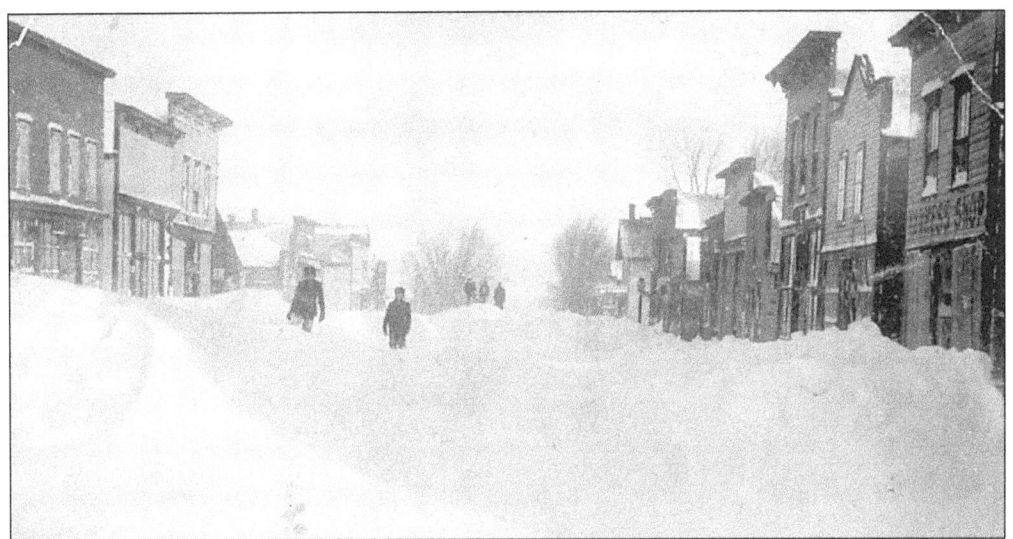

What kind of snow removal equipment did the village of Hartland have in 1909? One can only imagine the muscle power required to clear the streets so that the stores could open for business. Twenty years earlier, Hartland businesses were listed as: general store (3), saloon, temperance saloon and restaurant, carpenters (4), restaurant and hotel, blacksmith, shoemaker, hardware store, lumber yard, coal dealer, cattle buyer, hay barn, and wheat buyer.

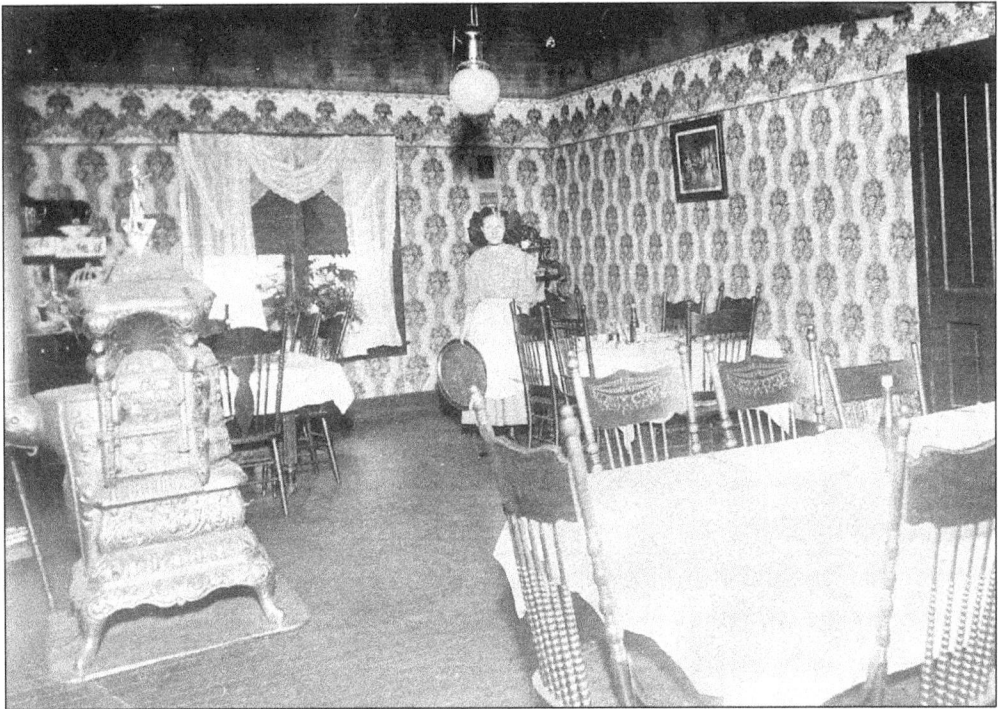

Waitress Alma Olson pauses with her serving tray in the dining room of the American House Hotel in Hartland around 1908. Notice the beautiful, hard-coal heater at the left. The 1899 city directory advertises, "American Hotel with modern improvements, rates $1.50 per day, long distance telephone office, under entire new management. Stop with us and we will try and please you. Thofson & Ackland Proprietors."

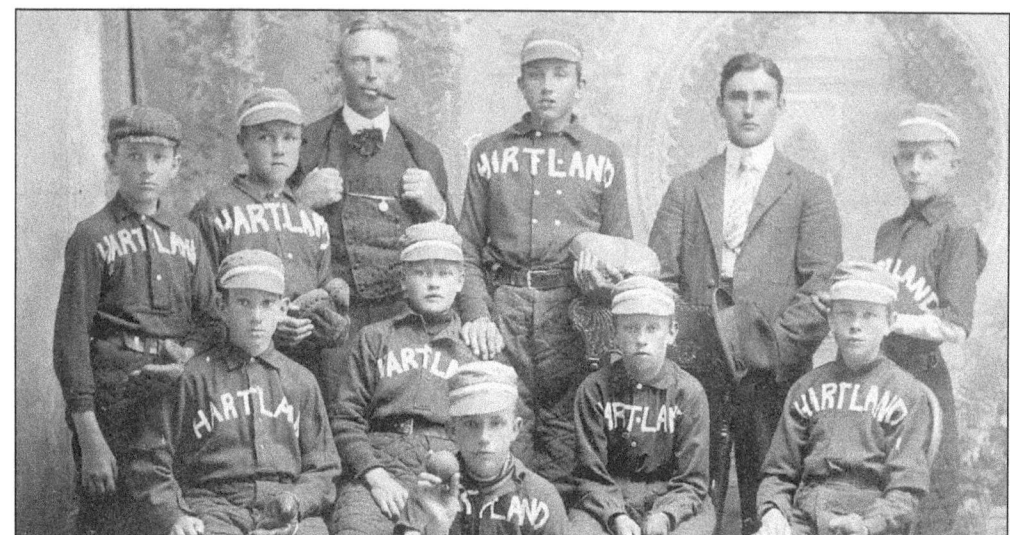

The Hartland boys baseball team members are pictured here from left to right: (in front) unidentified; (first row) Will Harris, Harry Borgen, and two unidentified boys; (second row) Jake Sorlie, Albert Gomsrud, Constable John Hooser, Theodore Gomsrud, John Laudert, and Edwin Stensrud. The names Gomsrud and Laudert surface in a *Hartland Herald* article dated October 13, 1910, which states, "The playing record is of such quality that we are not stretching it any when we claim the amateur championship of southern Minnesota."

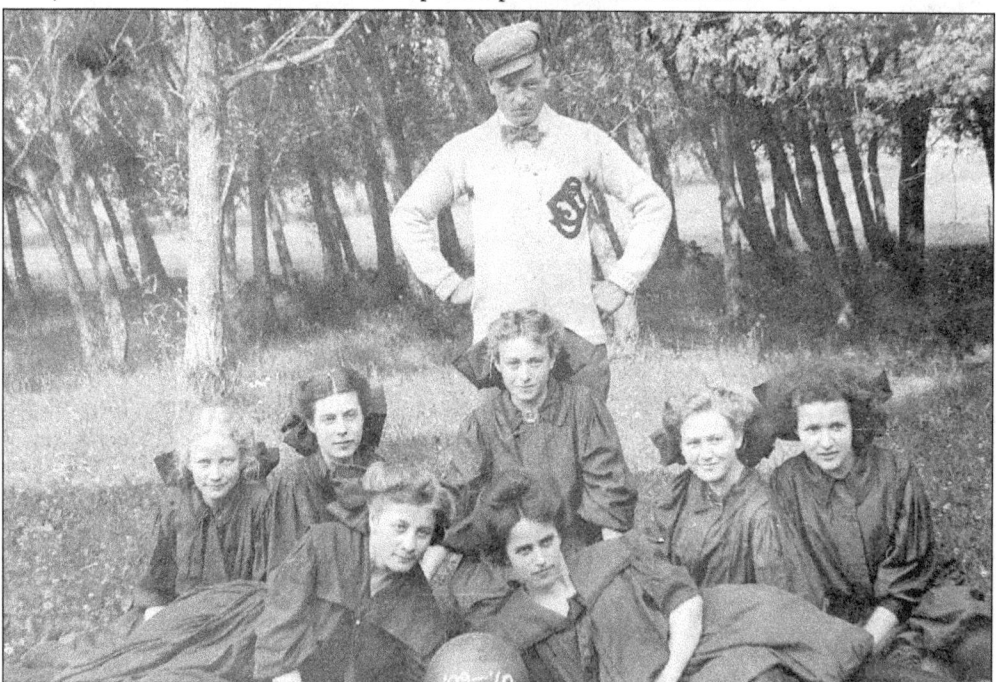

The hands-on-hips stance and the attempted serious look on the face of Coach Art Gaarder are reflected in the expressions on the faces of this 1909–1910 Hartland girls basketball team. When they posed for the camera man, each seemed to be interpreting their season in a different manner. Note their bloomer-skirt uniforms and big bows in their hair. Gaarder taught at both Hartland and Albert Lea Schools.

The Hartland bleachers are filled to capacity at this August 1910 ball game with Manchester. In September another game took place between the single and married men of Hartland. A *Hartland Herald* article states, ". . . the hen-pecks challenged the heart-frees to a duel to death . . . in the last death grapple a benedict (confirmed bachelor—newly married) busted the beak off the ball and dusted the doormat of victory. The count stood 10 to 9."

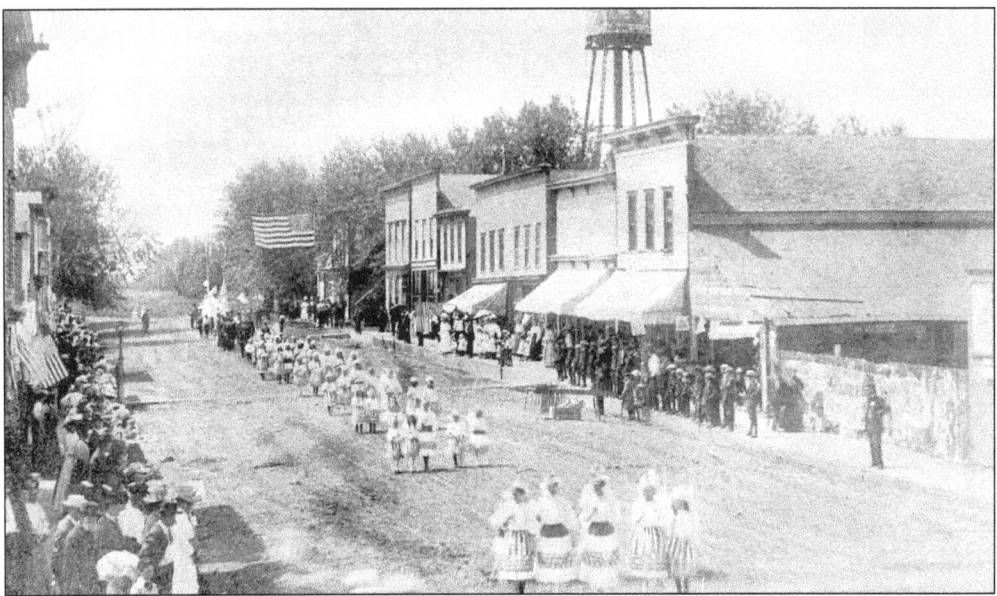

By the time of this patriotic parade in Hartland in 1910, early competitiveness had long been forgotten. In 1877, A.E. Johnson owned land on the west side of the railroad, and William Morin on the east. Both platted their land, beginning "a merry townsite fight" (*History of Freeborn County*). Buildings sprang up on both sides and, finally, Morin purchased land to the west of Johnson's, allowing business to center on the west side.

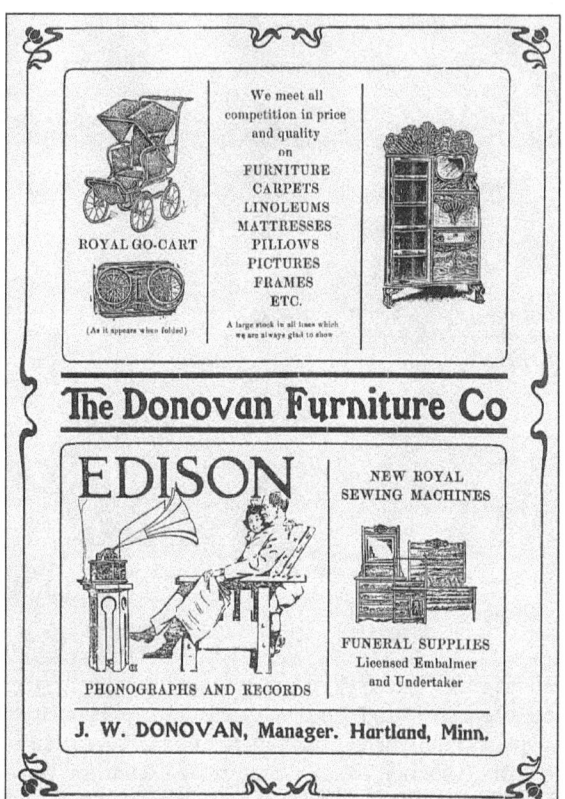

This Donovan Furniture Company advertisement is from the 1909 *Hartland Herald*.

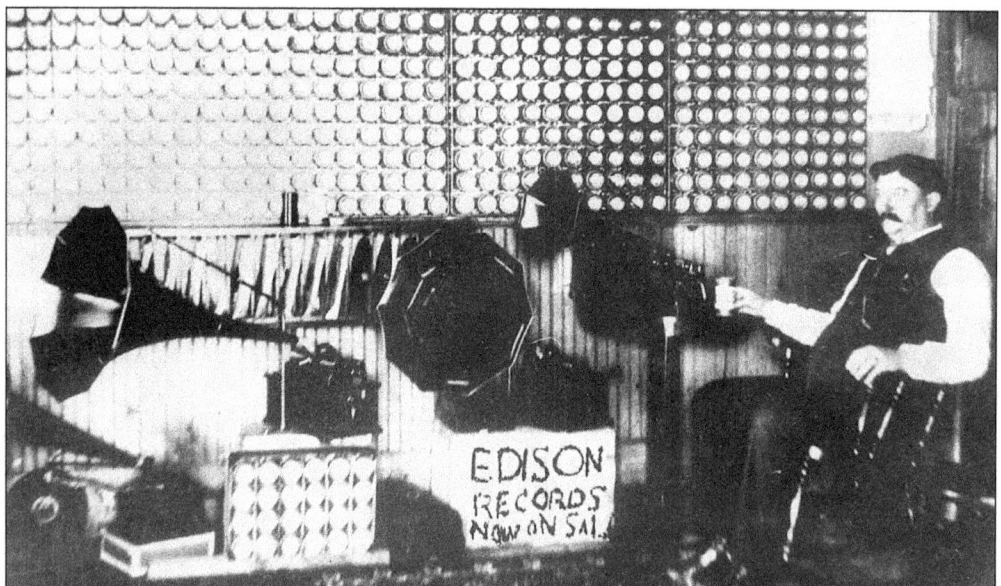

J.W. Donovan is shown with his large stock of Edison cylinder records displayed on a unique wall rack in his Hartland furniture store. He also sold phonographs, furniture, sewing machines, go-carts, mattresses, pictures, carpets, and linoleums. This multi-faceted business also offered funeral supplies and the services of a licensed embalmer and undertaker. His advertising stated, "A large stock in all lines which we are always glad to show." (*Hartland Herald*, 1909.)

Dr. Morton L. Head and R.H. Gardner opened this Hartland Drug Store in 1898, and in 1905 Dr. Head bought out his partner. In 1909 he advertised drugs, medicines, druggist supplies, and prescriptions accurately compounded. He also sold wallpapers, "the finest of this year's styles and designs," and, "paints for everything—interior decorating, house, barn, or buggy." Standing in front of the store, from left to right, are: Polly Sybilrud, Peter Sybilrud, unidentified, Helma Wulf, and Art Gaarder.

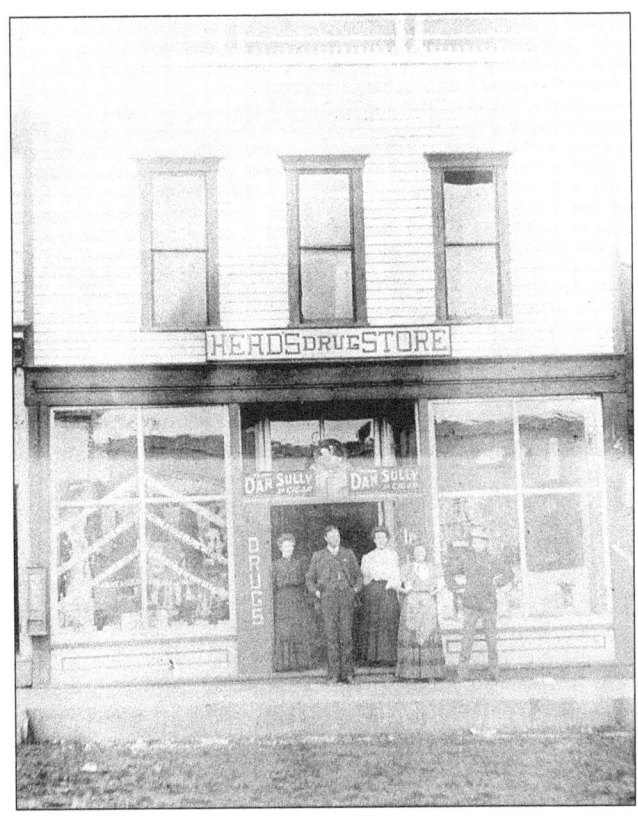

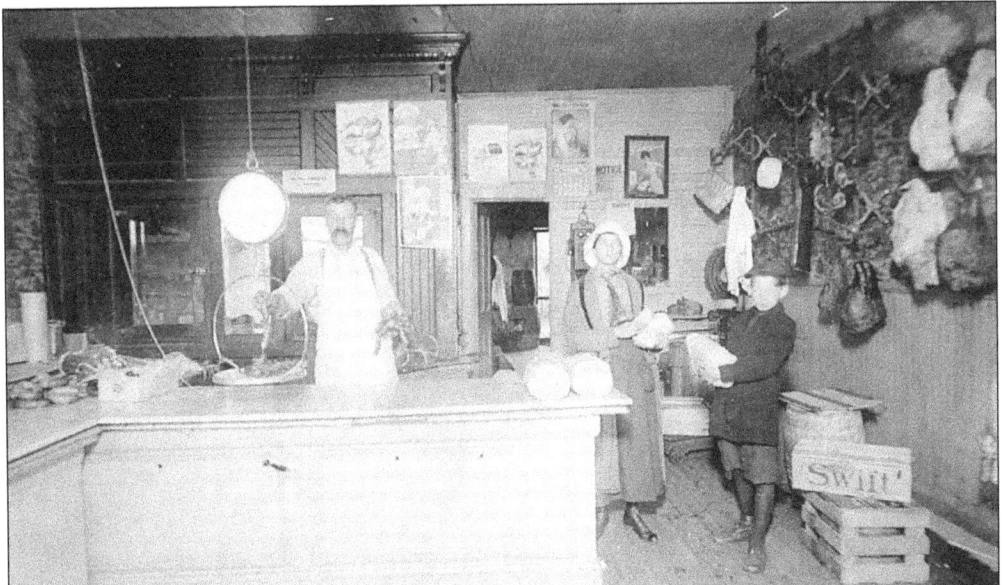

The Christopherson Brothers Meat Market was in operation in Hartland from approximately 1896 to 1915. The business was owned by brothers Carl, who in 1918 purchased Brundin Meat Market in Albert Lea, and Hans M., who was a stock buyer, one-time mayor of Hartland, and member of the school board. Owner Carl Christopherson and customers Edna Olson and George Brown are shown in the photograph.

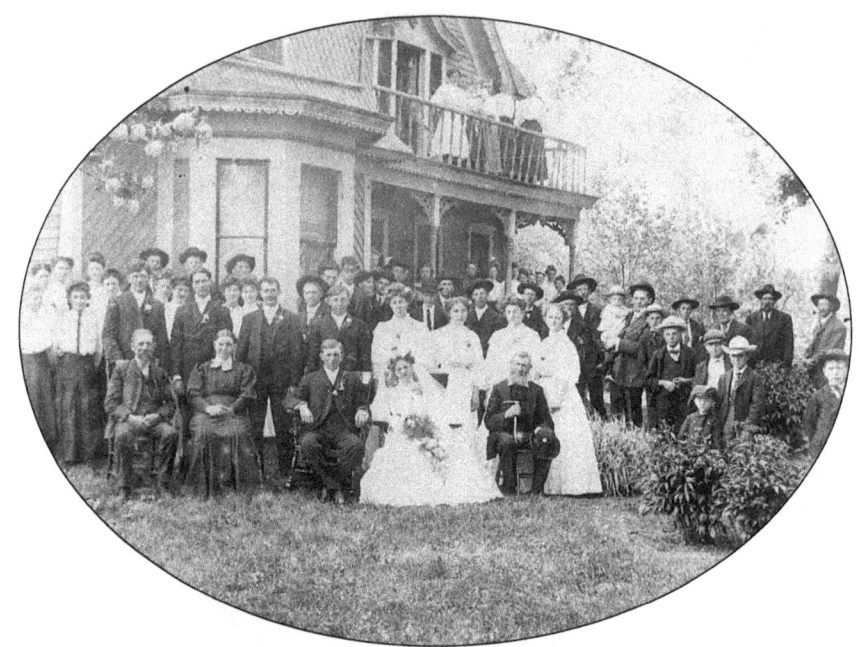

On June 2, 1906, the wedding of Miss Ida Knutson and Albert Miller took place at the synod church, and the reception was held at the home of B.L. Knutson. "The groom is a rising young man of sterling qualities and much ability. . . . That nothing but joy and prosperity may be the lot of this worthy young couple is the sincere wish of their many relatives and friends." (*Times-Enterprise*, June 6, 1906.)

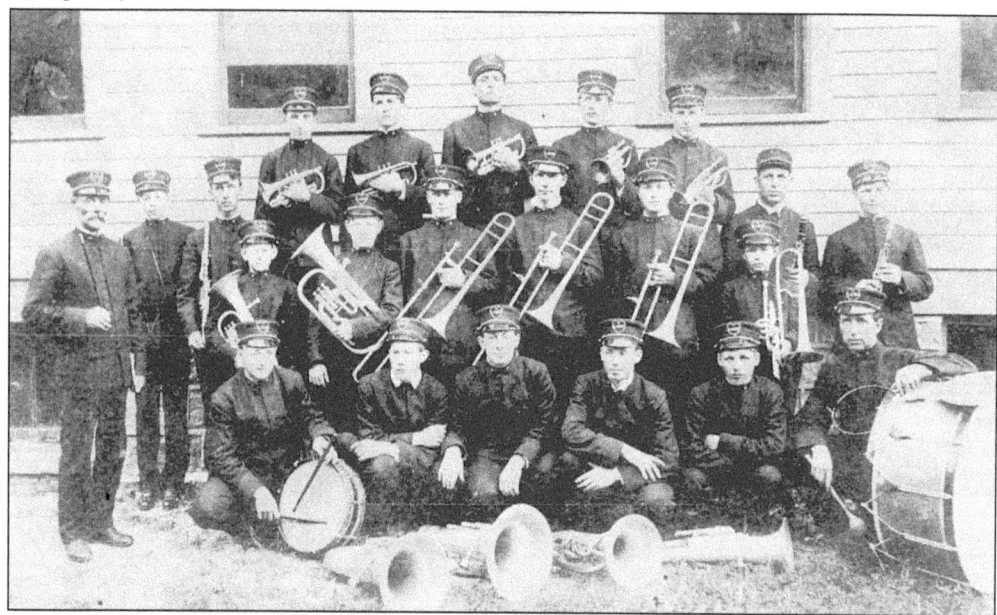

Members of the Hartland Band, organized in 1907, are, from left to right: (front row) Joe Grove, John Sybilrud, Louis Schultz, Oluf Olson, Helmer Hanson, and George Brown; (second row) Julius Sybilrud (conductor), Selmer Lee, Hjalmer Wolff, Harry Borgen, Johnny Cholette, Allie Raven, and Herman Sybilrud; (top row) Henry Slette, Selmer Anderson, Arthur Harris, Peter Hanson, Gerhart Hatle, Chris Sybilrud, Martin Sybilrud, Rudolph Stensvad, and Oscar Wulff.

Four

THE NORTHEAST

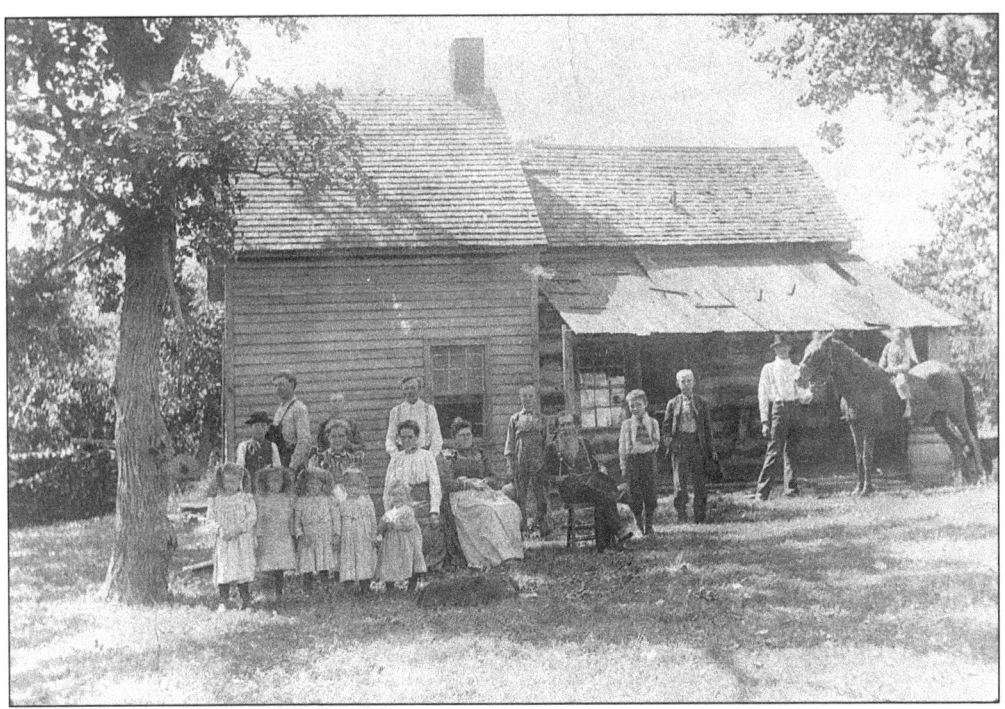

This undated photograph shows the Dearmin homestead near Moscow. The residence shows the original log house and an addition with wooden lap siding. Three Dearmin brothers and their mother and sister settled in Moscow Township in 1856. All three brothers, George, Robert, and Matthew, served in the Civil War. George and Robert were honorably discharged, and Matthew died in 1863 at Fort Abercrombie, Dakota Territory.

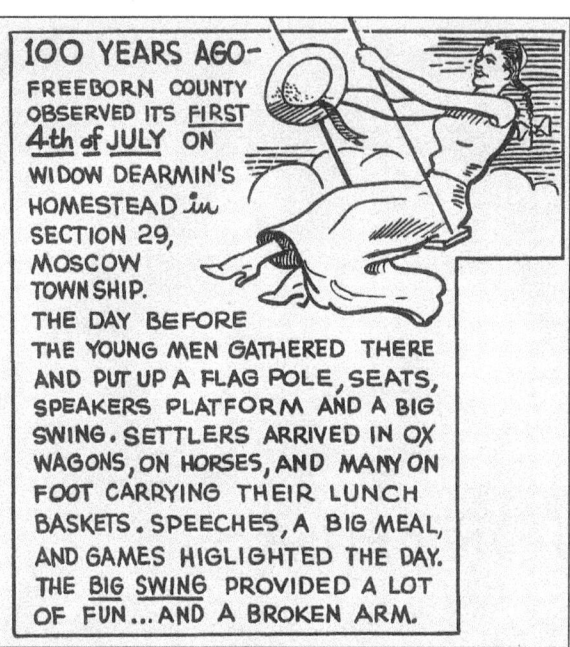

Hi-Lites and Shadows of Yesterday and Today drawn by Irv Sorenson - 1957.

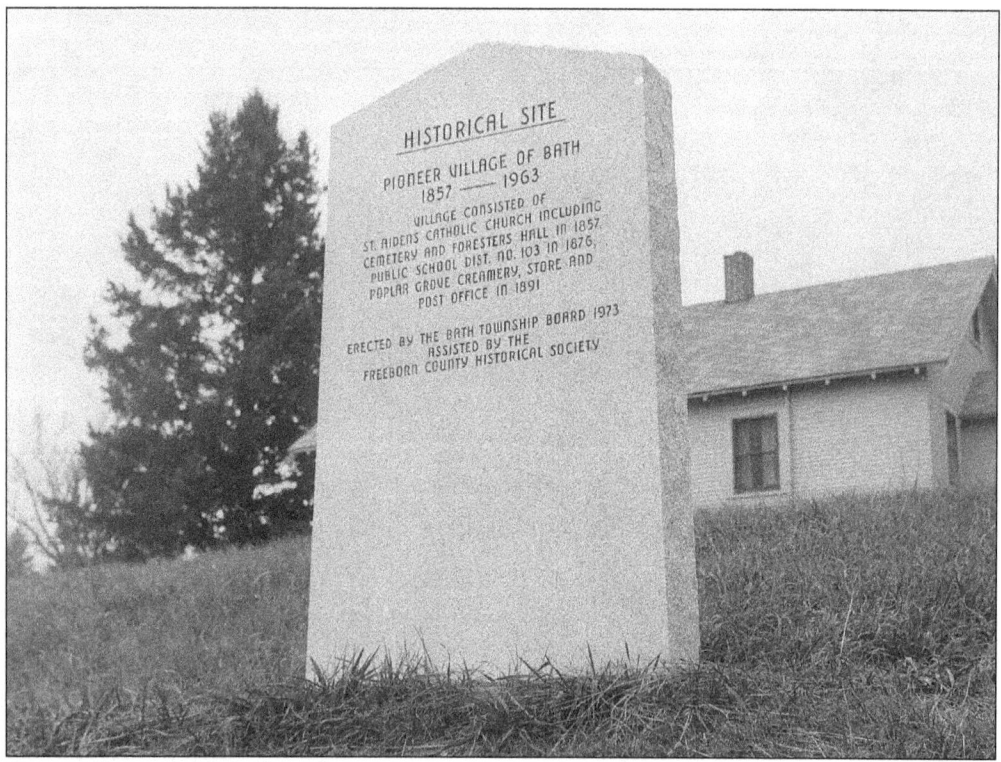

Bath Village was a small settlement located on the line between Sections 7 and 8 in Bath Township. It consisted of a store, post office, St. Aidens Catholic Church and cemetery, Foresters Hall, Public School District #103, and the Poplar Grove Creamery, which was originally called the North Star Creamery. Organized at an earlier date, the creamery began operations on May 20, 1892.

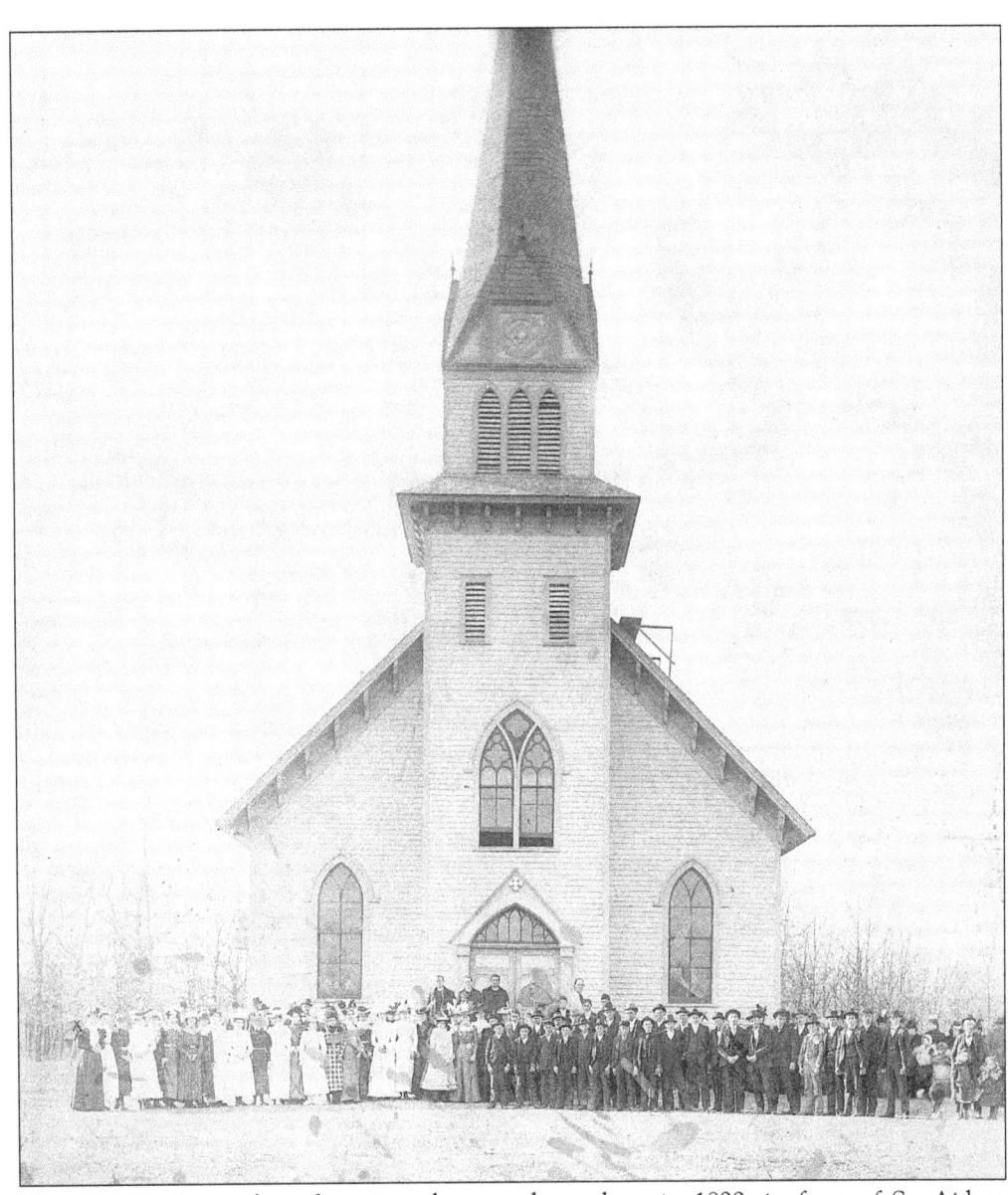

The congregation and confirmation class are shown here in 1899, in front of St. Aidens Catholic Church in Bath. The first St. Aidens was a log church built in 1857, and the second was a frame structure built in 1865. The third, according to the *Freeborn County Standard*, was built in August of 1882: "The Catholics of Bath, are about to commence the erection of a new church edifice in that town on Section 8, near the site of the old church. The main building will be 39 x 64, with a 16 foot octagon sanctuary in the rear, and a spire 85 feet high in front. The cost of the building will be about $4,000, which amount has been almost wholly raised by the liberality of the people of the neighborhood. The contract has been let to Thomas Walsh of this city, which insures a good job."

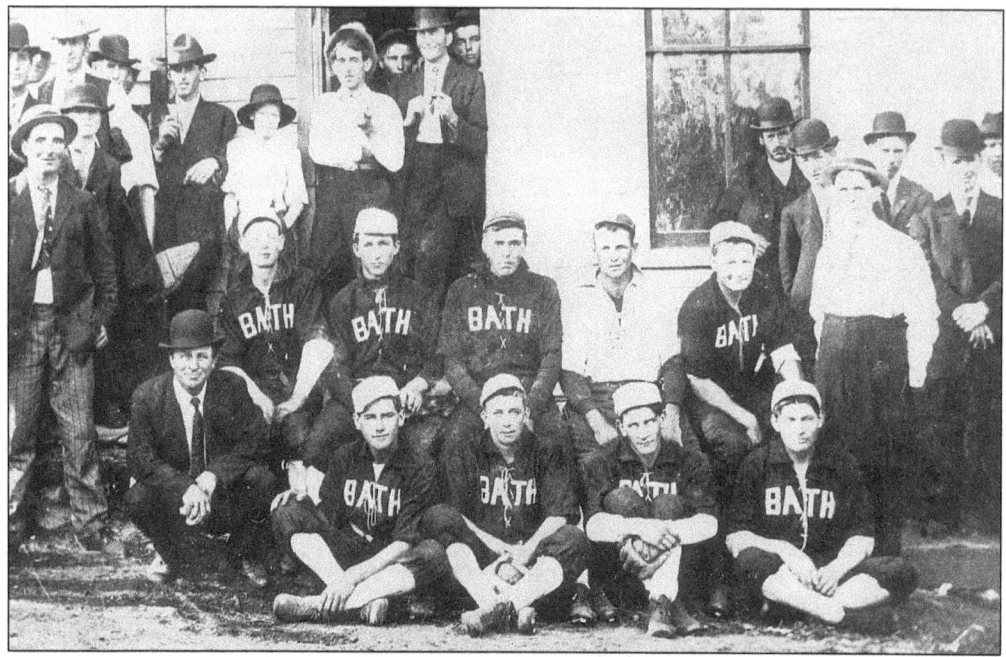

The 1908 Bath baseball team consisted of, from left to right: (front row) Roy Eustrom, unidentified, Frank Harty, and Tom Connor; (back row) Martin Bartness, George Laudert, Olaf Nygaard, Earl Pickering, and Henry Harty (manager). A 1908 *Freeborn County Standard* article describing a 4-to-3 game won by Bath-Hartland states, "the winning score was made through corner cutting, wrangling, and kicking on the umpire, leaving the grounds, returning, and leaving again . . . till Manchester gave in."

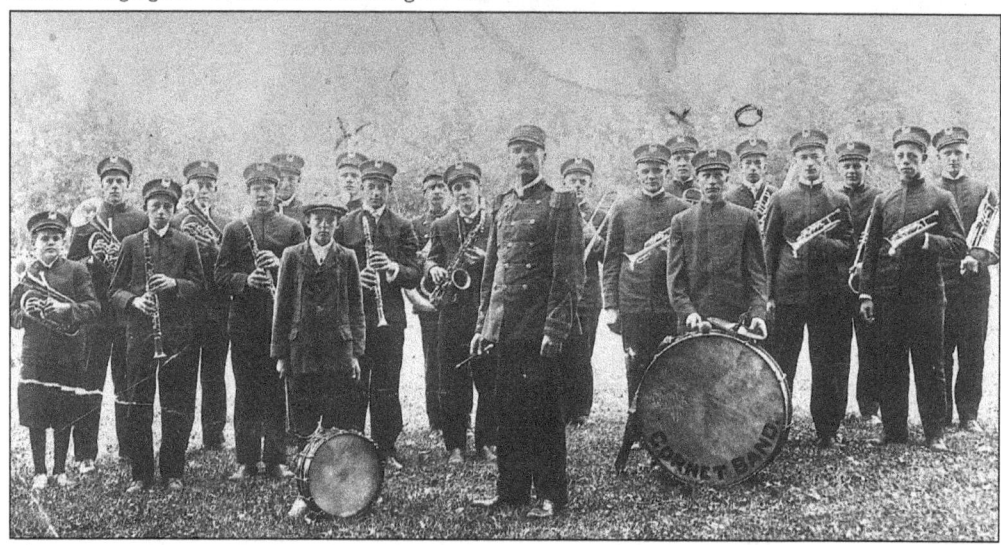

The Geneva Cornet Band was formed in 1916 and entertained the community and surrounding areas with Saturday-night concerts. Members were: Jens Wayne, Earl Jensen, Bill Benson, W.C. Gruetzmacher, Walter Johanson, Chris Wayne, Chris Nelson, Paul Skaug, Arthur Jensen, Carl Knudsen, Russel Rasmussen, George Gay, Henry Murray, Lars Swenson, Arnold Wayne, Irvin Wayne, Clifford Rasmussen, Abel Wayne, John Schad, Harvey Heegard, Olaf Olson, and Ray Rasmussen.

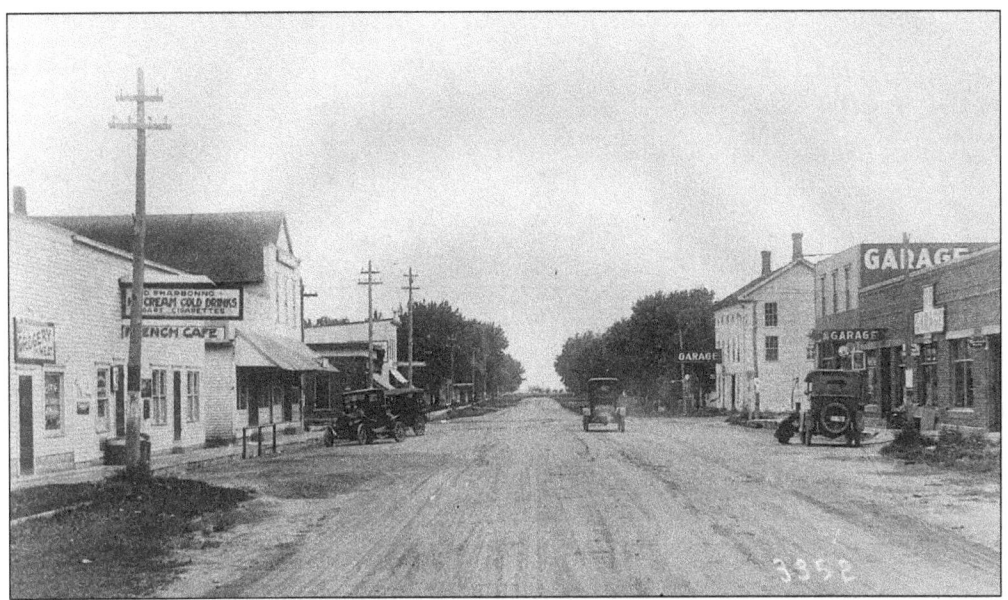

This view of Geneva in 1928 shows an up and coming rural community with a variety of businesses on either side of a graveled Main Street. The 1890 business listing included two general merchandise stores, a druggist and notary public, a physician and surgeon, a contractor and builder, a wagon maker, two blacksmiths, a butcher, two well drillers, a postmistress, and a hotel.

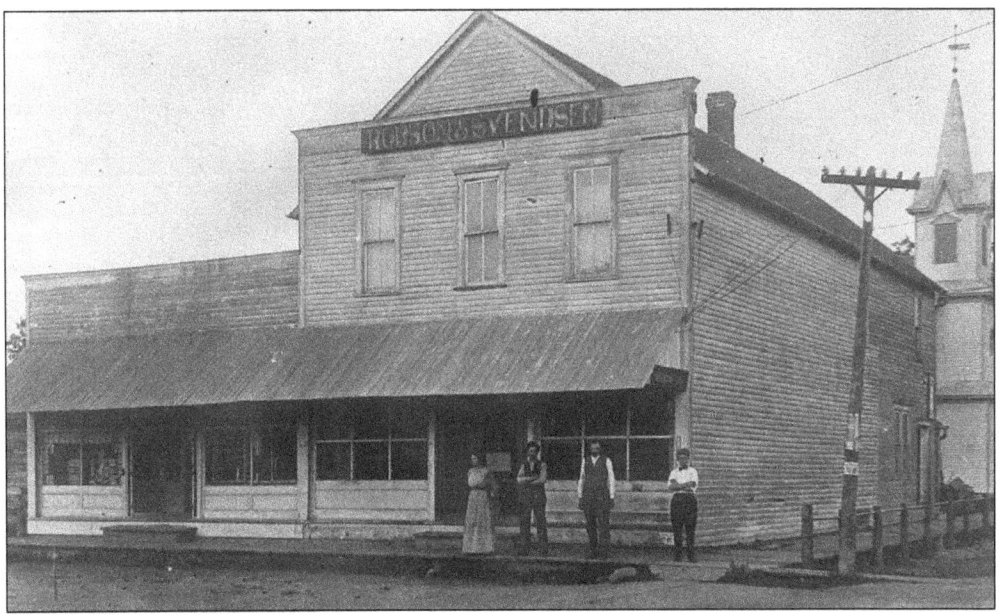

John T. Robson and Svend Svendsen operated the Geneva General Store until 1910, and then Svendsen continued ownership until 1919. It was said that he, a soft-spoken man of large build, once proposed to his childhood sweetheart, Libby Schad, who clerked in the store. She made no reply, and he never asked her again. They are buried side by side in the Geneva cemetery.

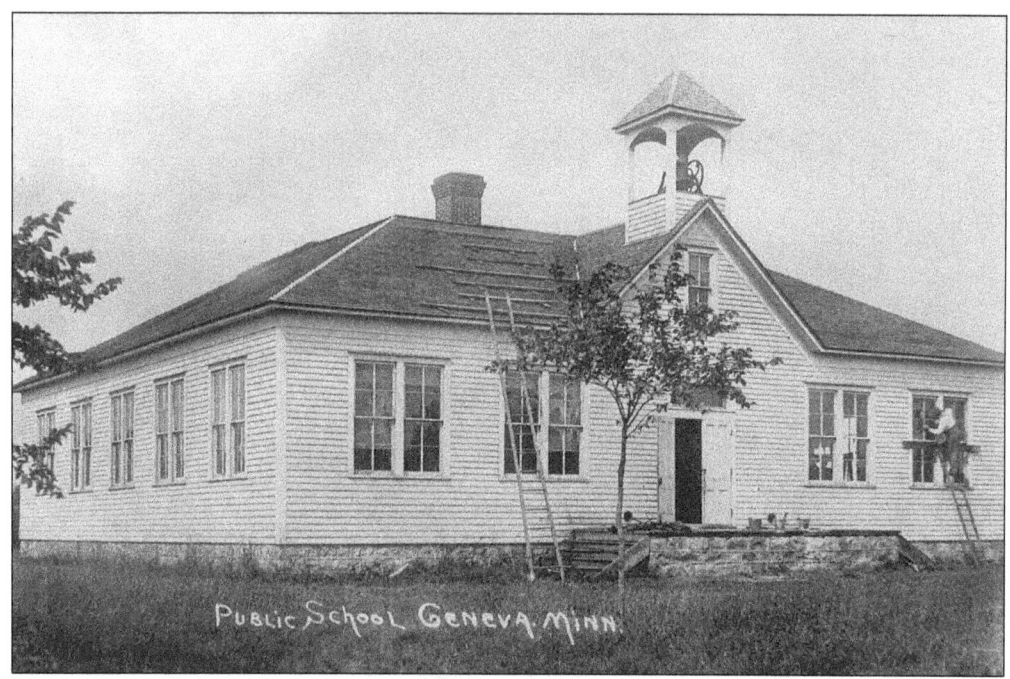

In Geneva, school classes were held first in a log shanty, then in a one-room school built in 1865. A two-story school built in 1888 burned to the ground in 1903, and in 1904 this large four-room school was built for eight grades and two years of high school. The eighth graders were allowed to take one or two subjects to prepare themselves for high school.

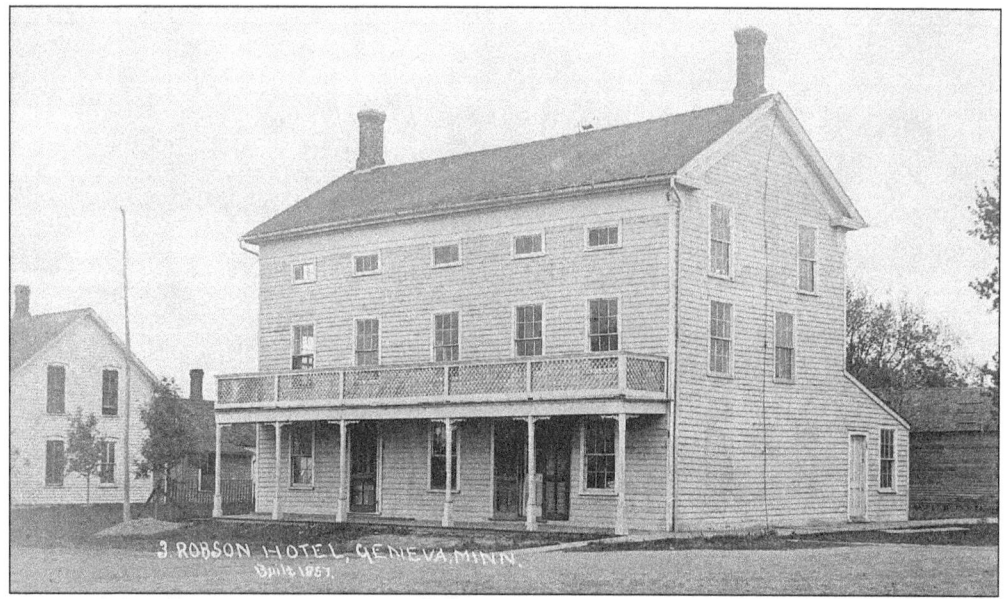

Built in 1857, the Robson Hotel was three stories high, with beautiful, black walnut interior trim. The first floor contained the gentlemen and ladies parlors, office, bar room, dining hall, and kitchen. The second floor was divided into parlors and bedrooms, and the third floor was a spacious hall. One thousand dollars worth of furniture was purchased for the hotel, and the opening included a grand ball.

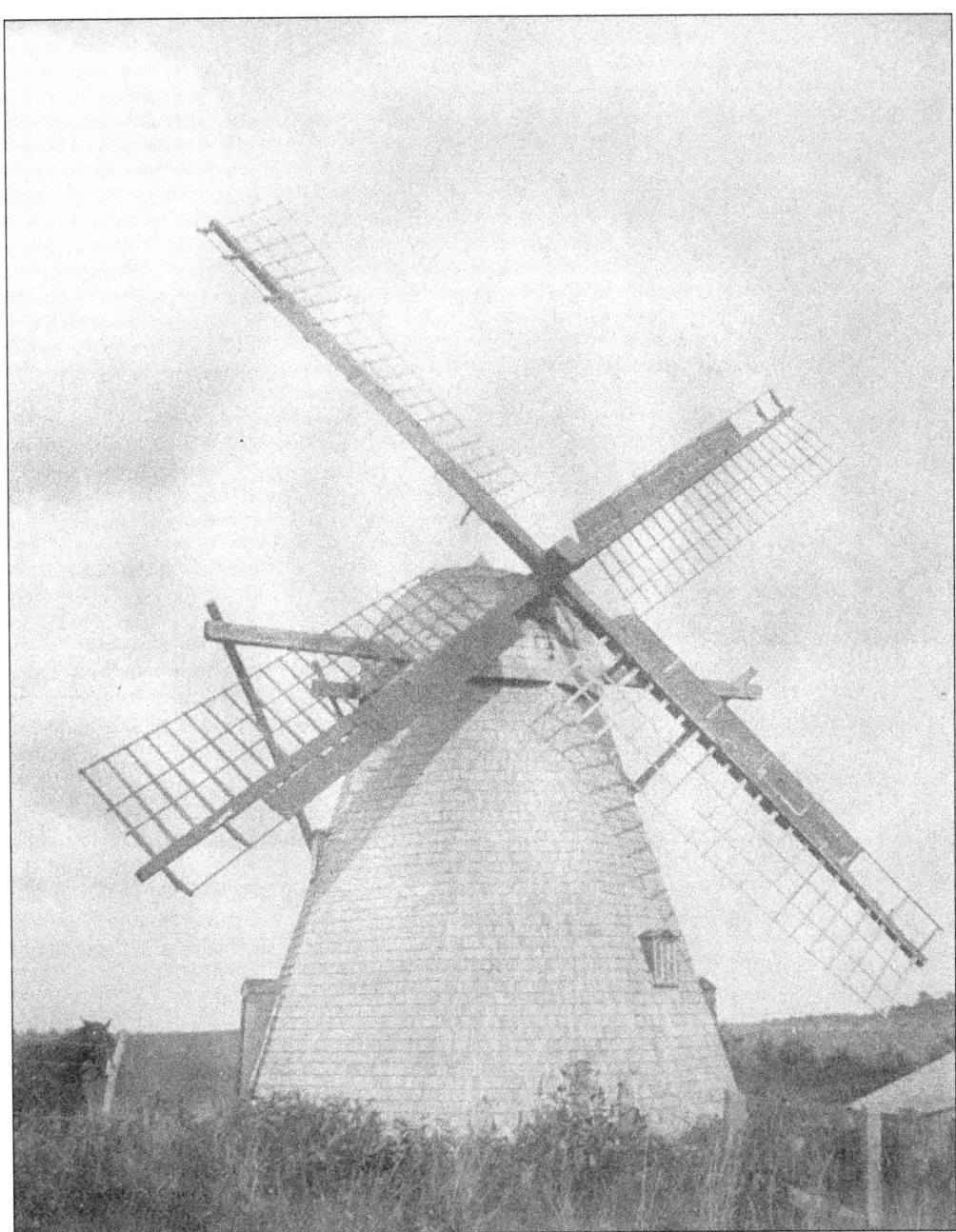
The Clarks Grove windmill, owned by William Frost, operated from 1898 to 1904, grinding rye, white, graham flour, cornmeal, and feed for farmers. The mill, completely dependent on wind power, operated only when the wind was blowing. There were times when Mr. Frost would wake his family in the middle of the night because he needed their help. During the busy times, farmers with horse-drawn wagons would be lined up on Main Street waiting for their turn. The farmers would bring their own sacks for feed, using wire or cord to tie the top of the sack. They came from Bancroft, Lerdal, Geneva, and the Hollandale/Clarks Grove area. Several times throughout the year, a government inspector from the State of Minnesota would pay a visit, checking the corn both before and after grinding.

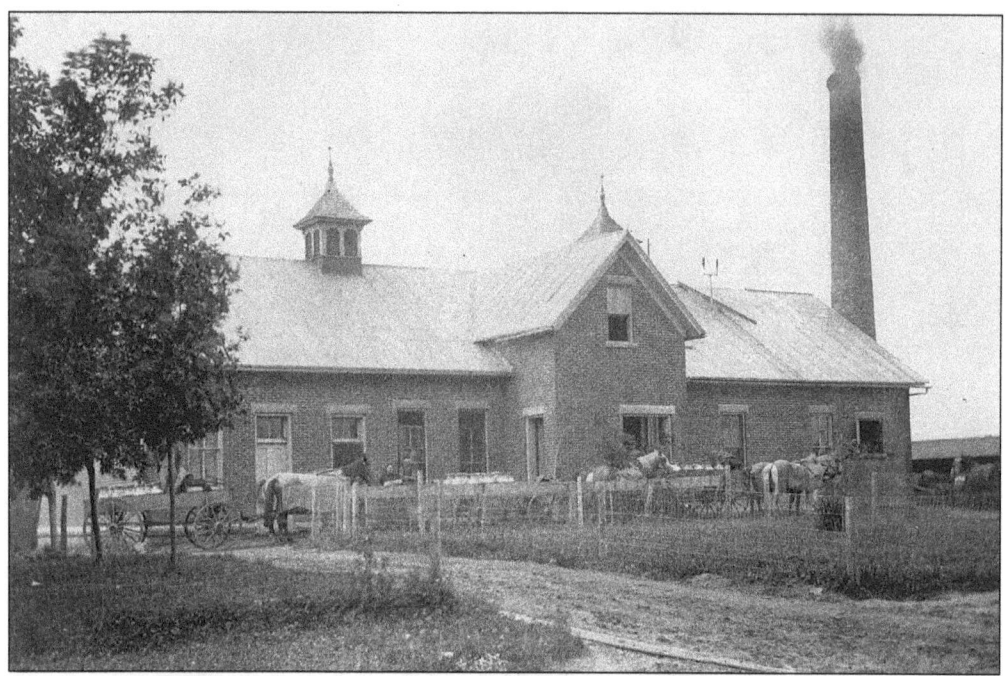

The Clarks Grove Creamery, the first cooperative creamery in Minnesota, opened its doors on May 15, 1890, with 82 area farmers as patrons. That year, 84,097 pounds of butter were manufactured. In 1895, this new, brick creamery was built at a cost of $9,000, which included materials, labor, equipment, well, and sheds. The building burned down in 1927, and a new creamery was built within eight months.

A third cooperative venture in Clarks Grove—the Lumber, Fuel, & Stock Company—was established in 1902. Its main purpose was to buy and sell building supplies, drainage materials, and fuel. Theodore Jorgenson was the company's first manager. In 1903, 26 train-car-loads of lumber, 21 car-loads of coal, and 2 car-loads of salt were sold. Mads Mortenson and "Grandpa" Jorgenson are shown in this 1910 photograph.

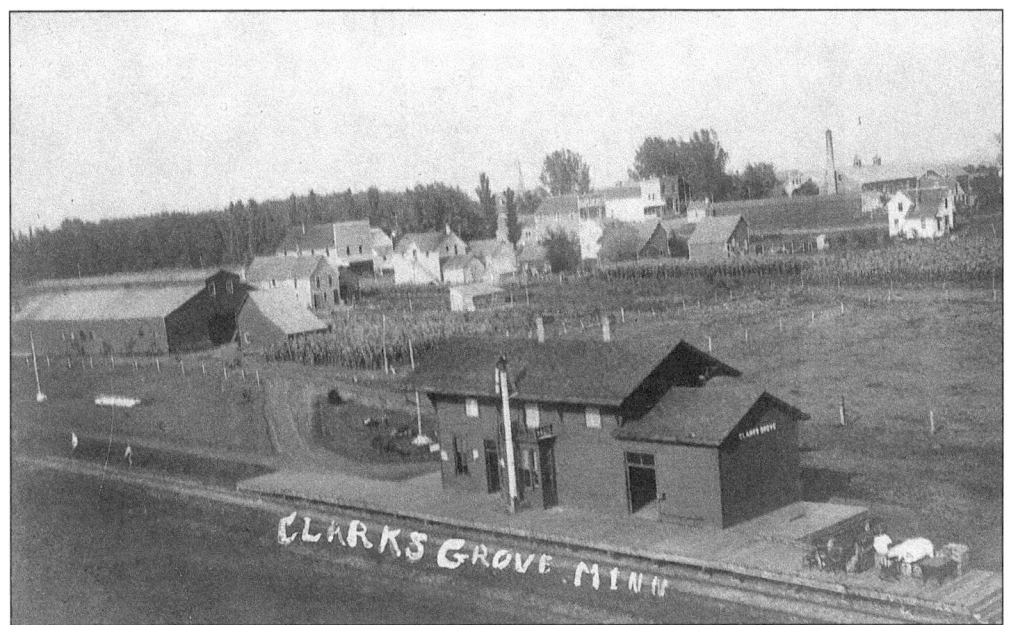

A postcard view of Clarks Grove, c. 1910, taken from the elevator, shows the depot, lumber yard (at the left), and the business district (upper right). The original Burlington, Cedar Rapids, and Northern Railroad depot was built 1 mile south of Clarks Grove at the proposed Village of Dorwart. Community resistance to this site eventually caused the depot to be moved north. In 1903, the B.C.R. & N. was taken over by the Chicago, Rock Island, & Pacific.

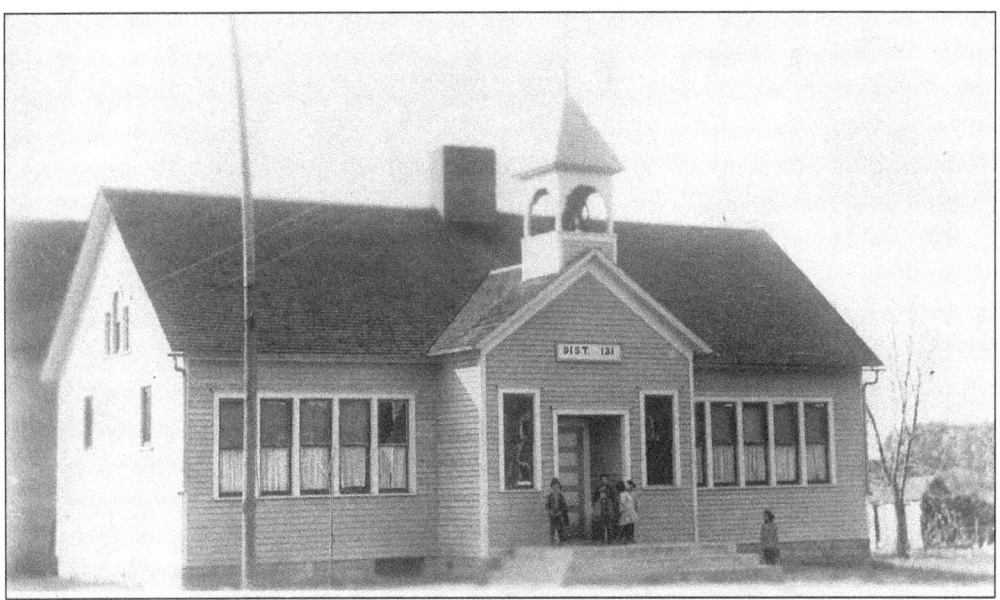

Clark Grove's School District #131 was created, and this building was erected in 1901, when Districts 5, 23, 82, and 7 consolidated. The school doors opened on December 11, 1901, with Olga Peterson as the first teacher. The slate blackboards arrived on February 5, 1902, and a community celebration was held on the schoolhouse lawn on April 2, the close of the first school year.

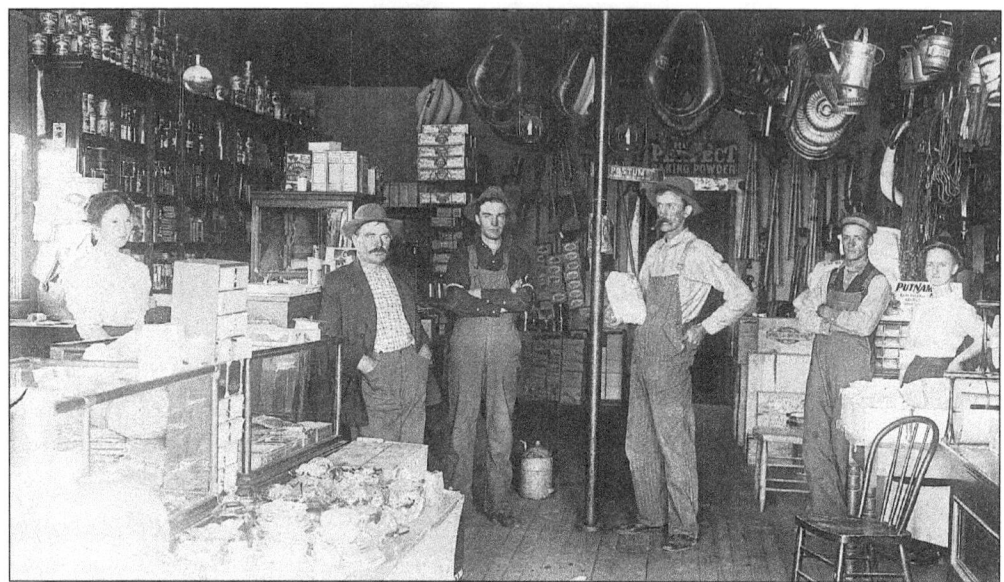

J.W. Peterson operated a general merchandise store in Clarks Grove from 1890 to 1917. Selling his first establishment, he then went into business with his brother, Charles, who also ran the post office. When his brother's health failed, J.W. Peterson continued the business. Merchandise included horse collars, bushel baskets, and kerosene cans. Shown in this photograph are, from left to right: Lola Peterson, Nels M. Jensen, Louis Larson, Chris A. Hanson, Henry Peterson, and Martha Peterson.

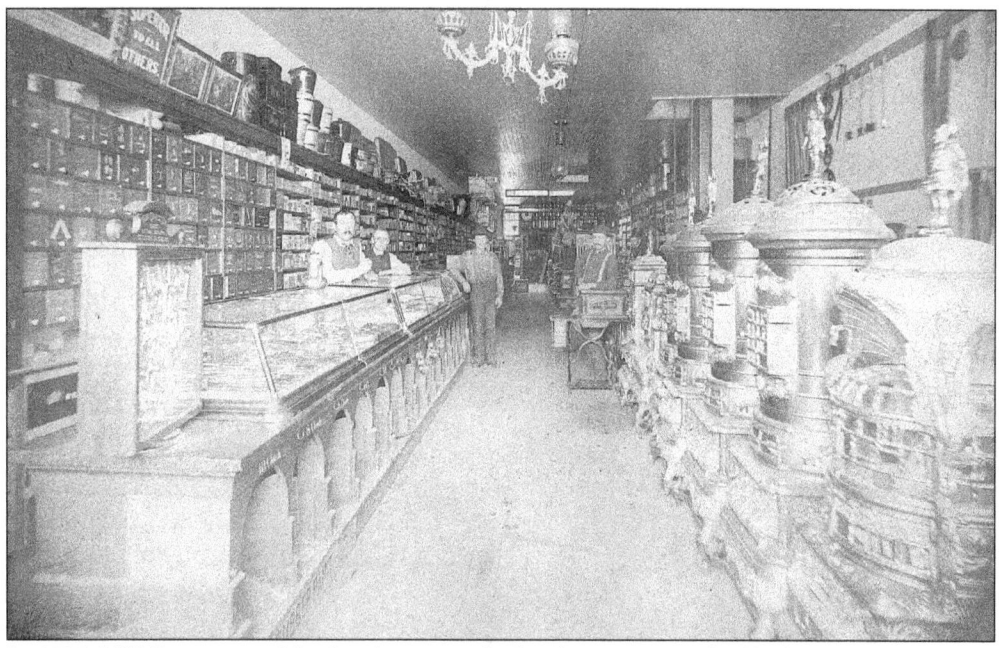

In 1896, J.W. Peterson and his brother opened a hardware store and a blacksmith shop, leasing the smithing business to H. Peterson of Albert Lea. They were known for shoeing as many as 30 horses a day. The Peterson Brothers carried a large inventory of hardware supplies and farm implements, including the Collins Plow and the McCormick Machine 'Extra'. In 1910, the Petersons sold out to a cooperative venture.

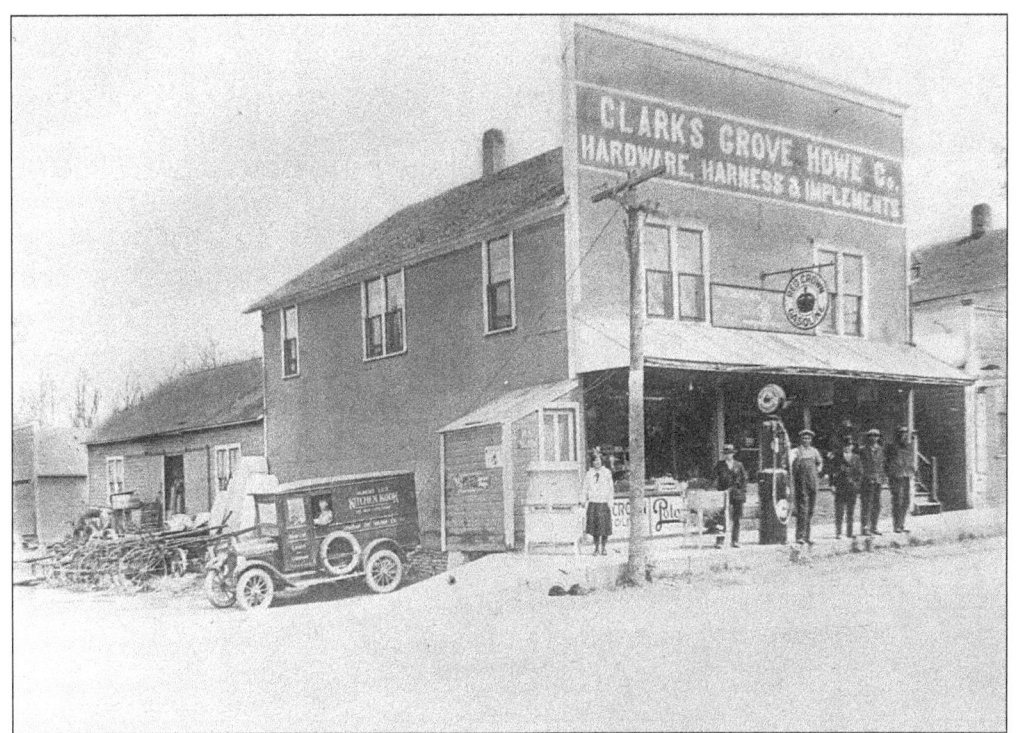

The Clarks Grove Hardware started in 1910 with the purchase of Peterson Brothers. This cooperative venture added several new lines of equipment, including LaCrosse manure spreaders and International F-12, 14, and 20s with steel wheels. They also sold New Idea and Minnesota equipment made by inmates at Stillwater State Prison, as well as Ford cars and Harley-Davidson motorcycles.

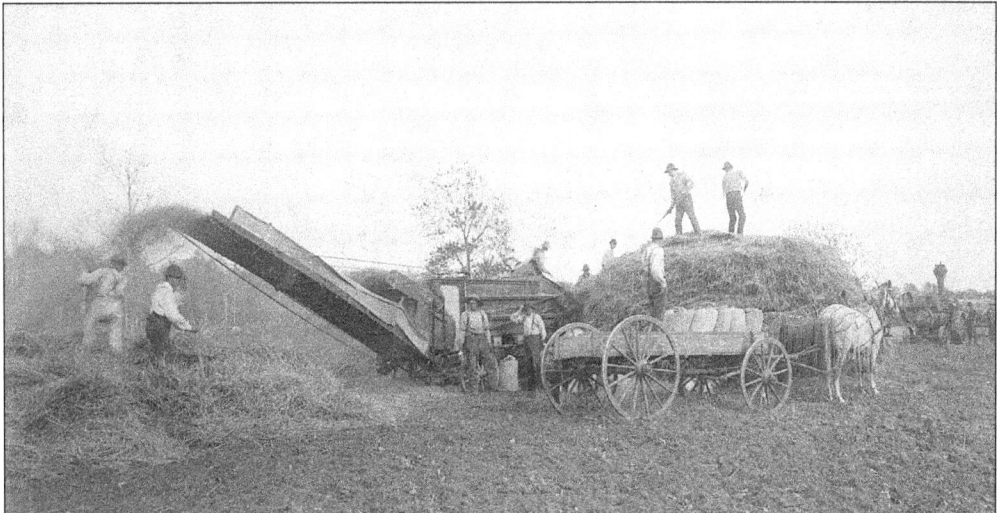

Even though the threshing machine owned by Tom Olson and Elling Hove was powered by a steam engine, several men and a lot of hard work were needed for the threshing process. Notice the men pitching the bundles from a stack into the thresher, and then others bagging the grain while the straw is carried by the elevator to another stack. This is a very early-model threshing machine, c. 1913.

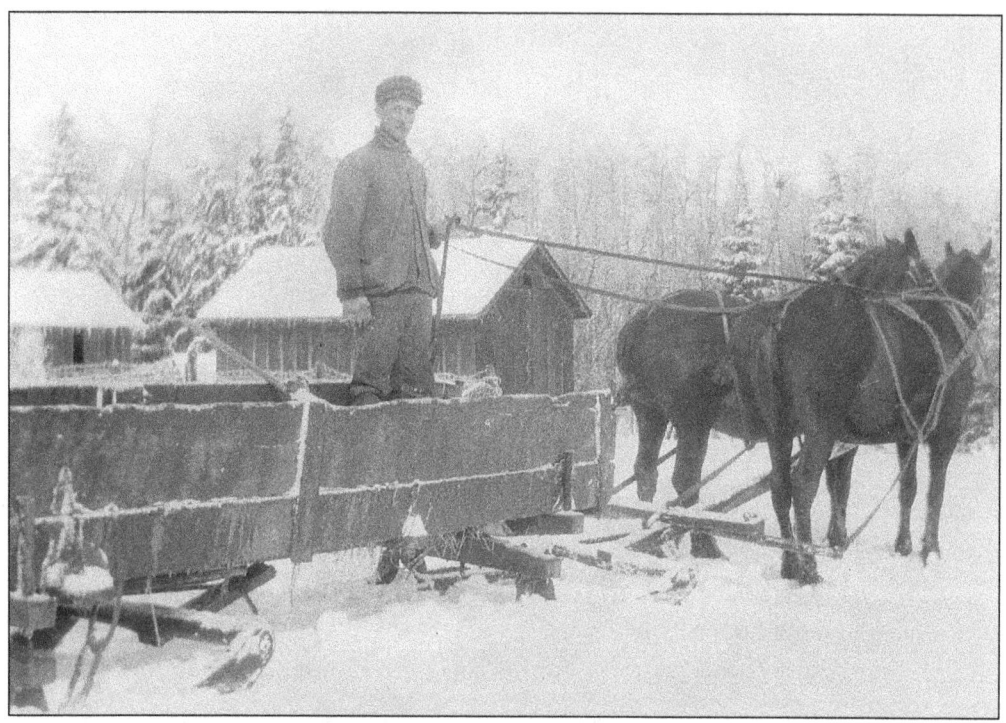

A Moscow Township farmer pauses for the camera on a busy winter day. His double box (two boards high) bob sled is typical of the equipment used for everyday farm chores. The sled was used for feeding livestock, cleaning barns, or hauling straw bedding and corn bundles. Its wide track made it less likely to tip. The well-cared-for, well-matched team of horses indicates a prosperous farm.

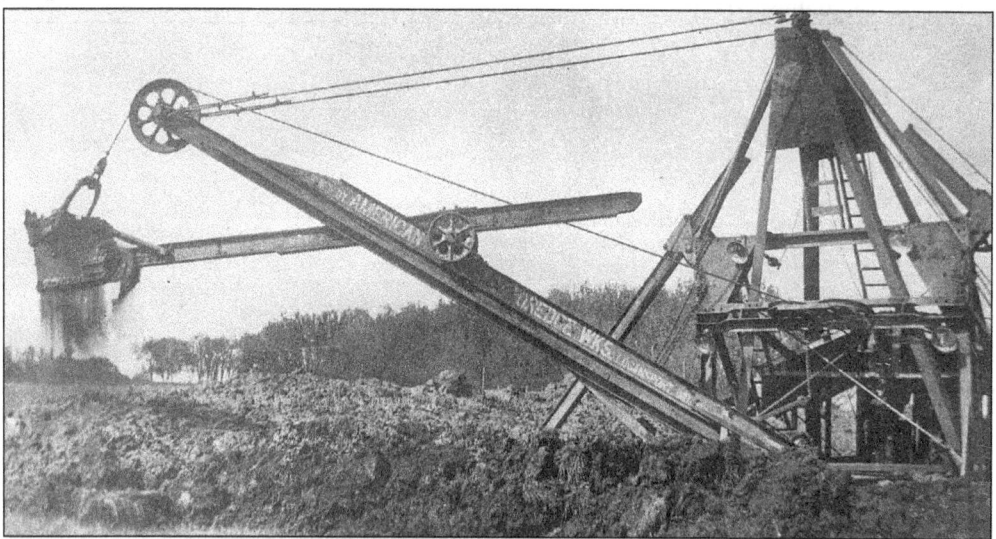

The *History of Freeborn County* states: "Turtle Creek is the principal water course in the town[ship], entering from Riceland by way of Sections 7 and 18, and taking a southeasterly course crosses the town[ship] and leaves Section 36 to enter Mower County. This stream furnishes an excellent waterpower in Section 22, which has been improved to some extent." This ditching machine is being operated on Turtle Creek near the Moscow Creamery in 1903.

The Village of Sumner in Moscow Township was laid out by Rufus King Crum in 1856, and a post office was established with George Watson as postmaster. In 1858, Mr. Crum erected a log house hoping to entertain prospective community residents, but to no avail. The stagecoach trail is still visible. The original livery barn was built with home-sawed lumber and square pegs, and was destroyed by a storm in 1998.

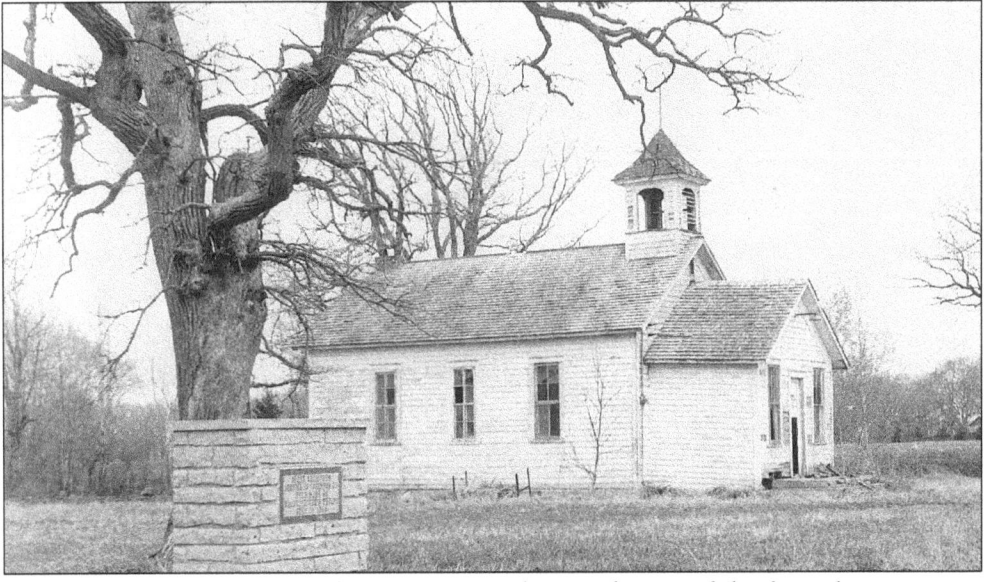

This marker in Moscow Township, Section 28, denotes the site of the first religious service to be held by an ordained minister in Freeborn County. Reverend Sylvester N. Phelps, of the Methodist Episcopal Church, was sent by his church to Austin, Minnesota, and, on August 31, 1856, he preached "the first gospel sermon ever heard within our borders" at the home of Rufus K. Crum. (*History of Freeborn County*.)

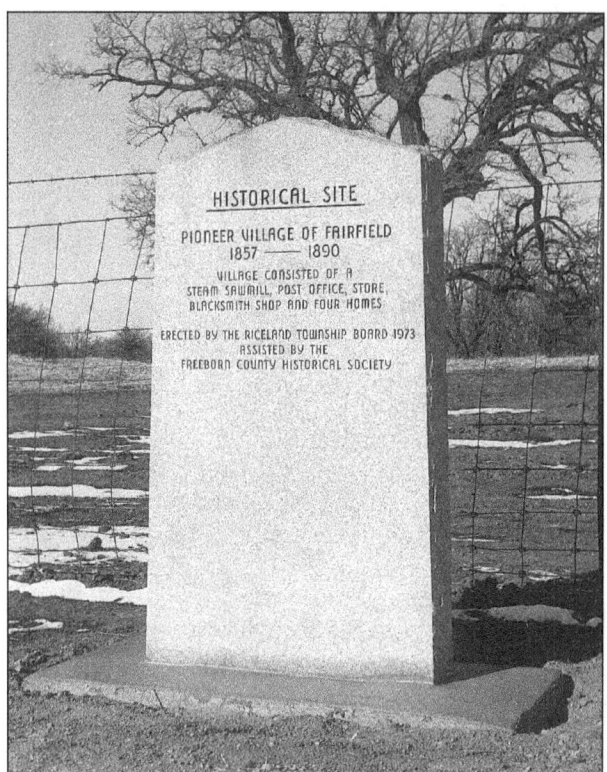

Fairfield was platted by Samuel Beardsley on the south shore of Rice Lake on a proposed road to Shell Rock. A post office was established, and there was a regular mail route; it was on the same section as the saw mill, and everything looked promising for rapid growth. However, the railroad never came, and the village became a thing of the past. (*History of Freeborn County.*)

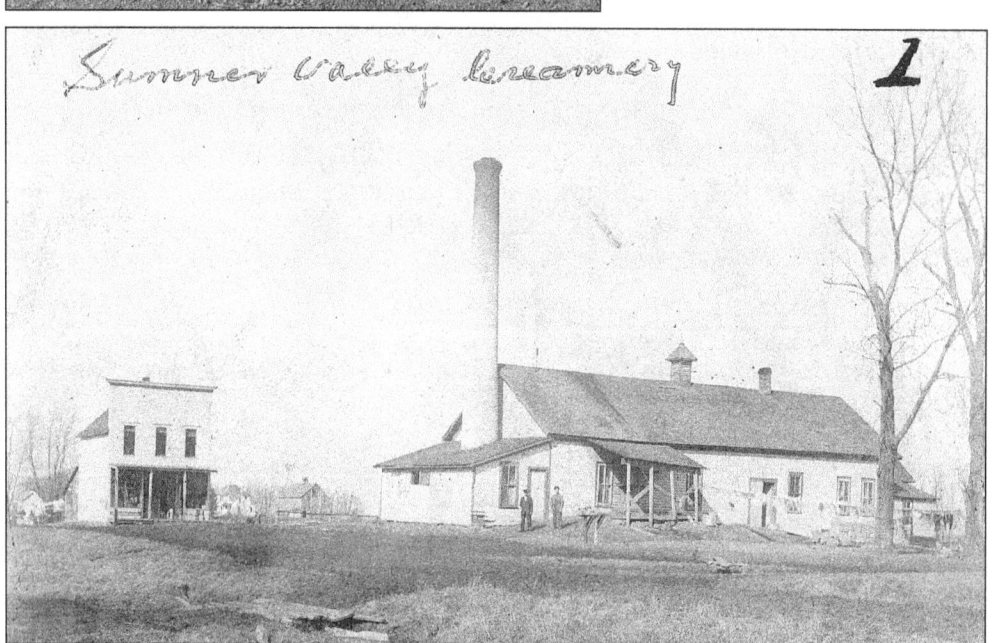

The Sumner Valley Creamery was organized in the summer of 1893 and began operations that fall. An attempt was made to manufacture cheese in addition to butter, but this was later abandoned. The creamery was named after a valley near the Oakland Lutheran Church, and was located on land owned by M.J. Tufte. The Sigsbee General Store is also shown in this photograph.

Charlotte Hanson enjoys an ice cream cone on the front porch of the Sigsbee General Store in 1928. Sigsbee was located in the southwest corner of Section 26, Riceland Township, and included the store owned by Martin Christopherson (and later Irvin Hanson), a post office, and the Sumner Valley Creamery. Sigsbee is another example of a small Freeborn County community that did not survive.

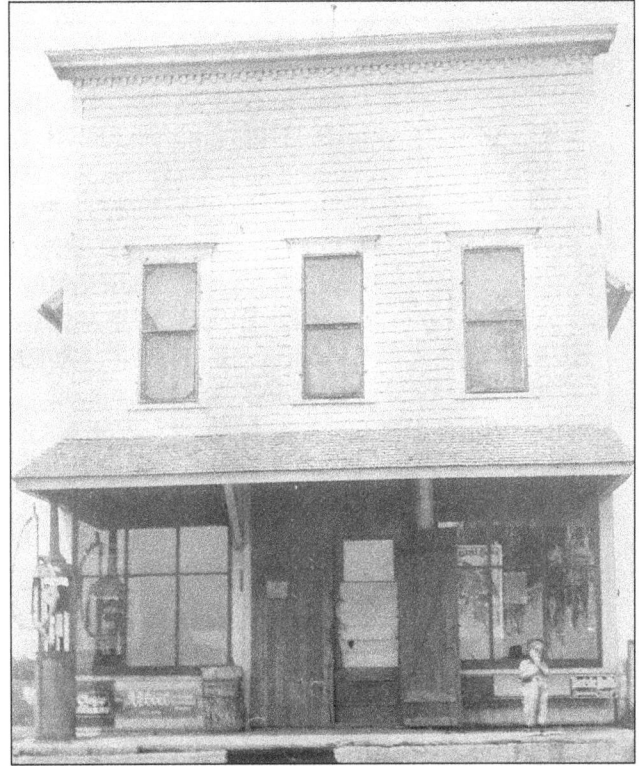

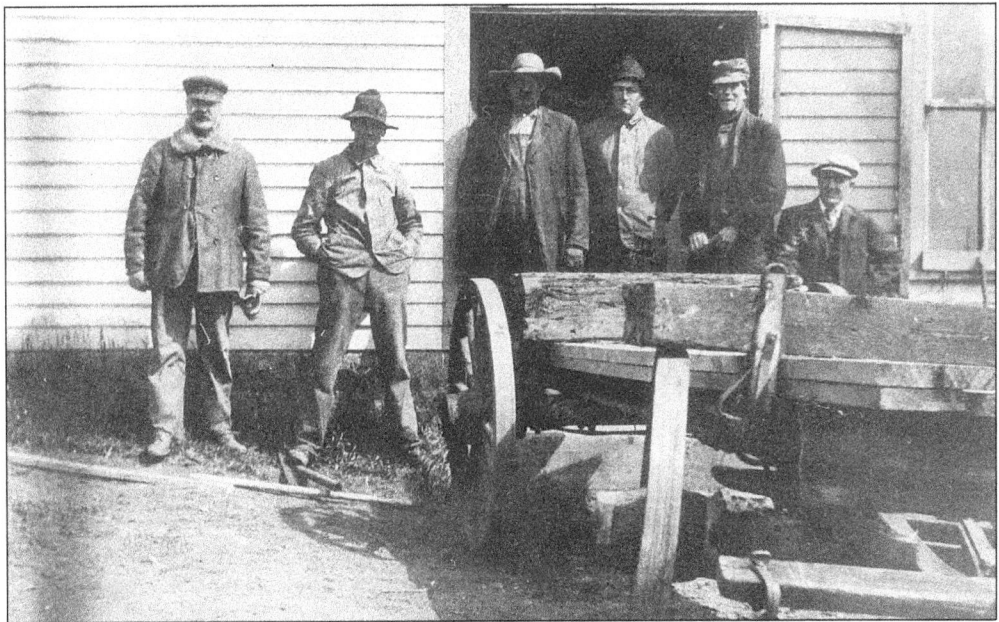

Severt Tufte, Ole Boe, three unidentified men, and Iver Tufte are shown here, from left to right, after delivering a new churn to the Sumner Valley Creamery at Sigsbee. This photograph, taken before 1920, exemplifies the pride and trust in the future of the dairy industry shown by the rural people in Freeborn County. At the turn of the century, there were 28 creameries and two cheese factories in the county.

A GREAT PEAT FIRE WAS BURNING IN 1889 IN THE BIG MARSH BETWEEN GENEVA AND MOSCOW. THE FIRE AREA WAS ABOUT 8 MILES LONG BY 2½ MILES WIDE. THE BURNING SOIL HAD BEEN FORMING FOR HUNDREDS OF YEARS IN WHAT FORMERLY CONSTITUTED A HUGE LAKE. THE LAKE HAD DRIED UP AND MADE THE LAKE AREA VALUABLE FOR PASTURAGE. "IT WOULD HAVE BECOME SUPERIOR FARMING LAND. IN A RAINY SEASON, THE BURNED LAND WILL BECOME A SHALLOW LAKE. AS DRAINAGE IS IMPOSSIBLE, IT WILL PERHAPS REMAIN A LAKE FOR HUNDREDS OF YEARS TO COME." IT WAS ESTIMATED THAT $100,000 DAMAGE WAS DONE TO THE 5,500 ACRES OF LAND AND THE 6000 TONS OF HAY BURNED WAS VALUED AT $30,000.

Hi-Lites and Shadows of Yesterday and Today drawn by Irv Sorenson in 1959.

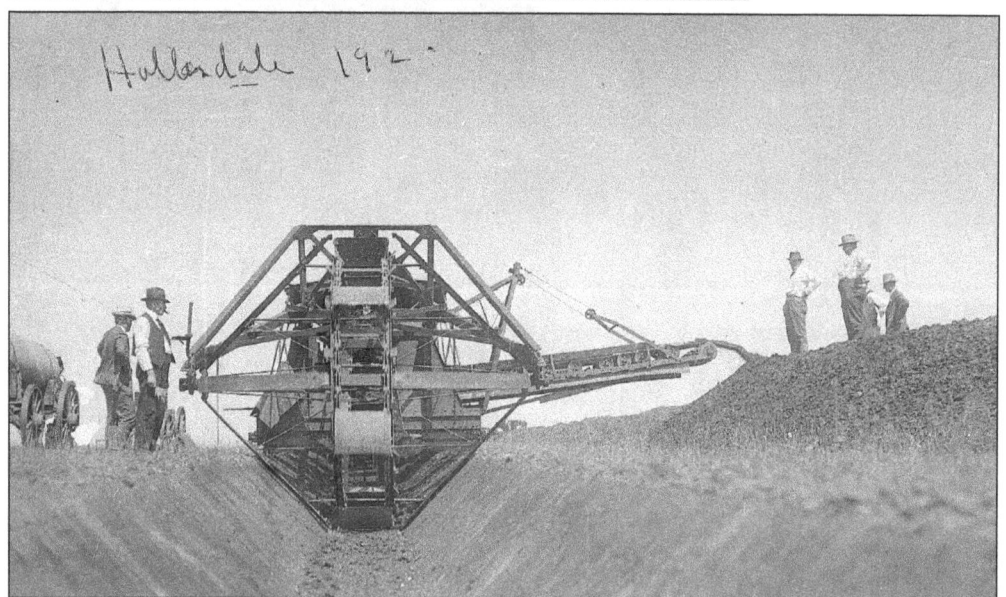

Rice Lake, once 15,000 acres of marsh, became 15,000 acres of fertile farmland thanks to the dream of George Payne, the Albert Lea Farms Investment Company, and the Buckeye ditching machine. With 120 horse power and weighing 76 tons, this machine could dig a ditch 12-feet wide at the top and 7-feet deep. The men who operated the digger lived in the house on top of the machine.

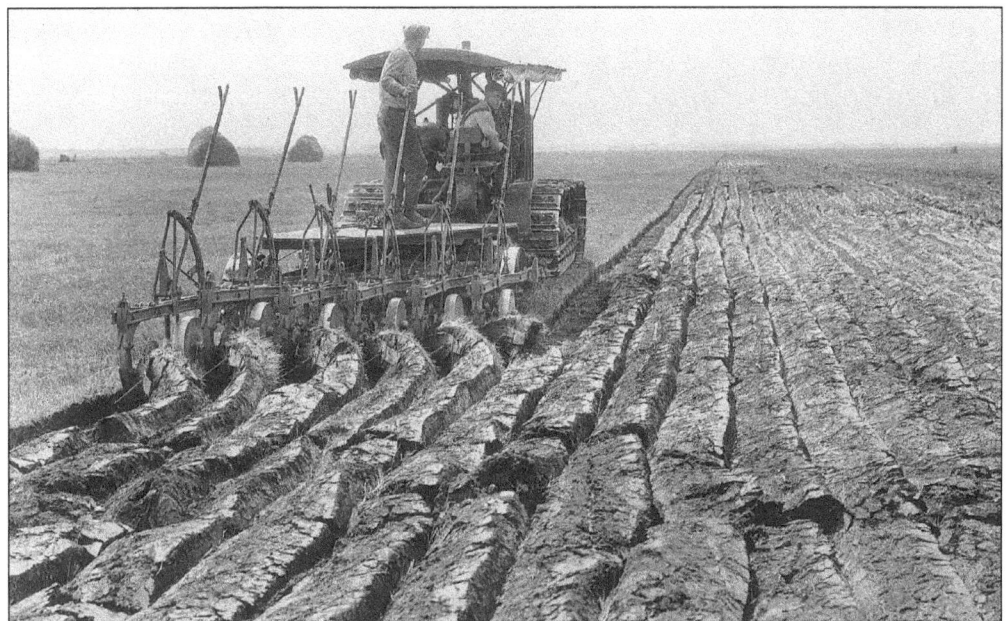

In spite of environmental concerns by citizens of Freeborn County, attempts were made to drain Rice Lake as early as 1907, although the most successful efforts began in 1919. This photograph shows the Bagley Brothers, with their caterpillar tractor, turning ribbons of sod—plowing land that had never grown anything but wild hay, and introducing to the next generations acres of fertile farmland.

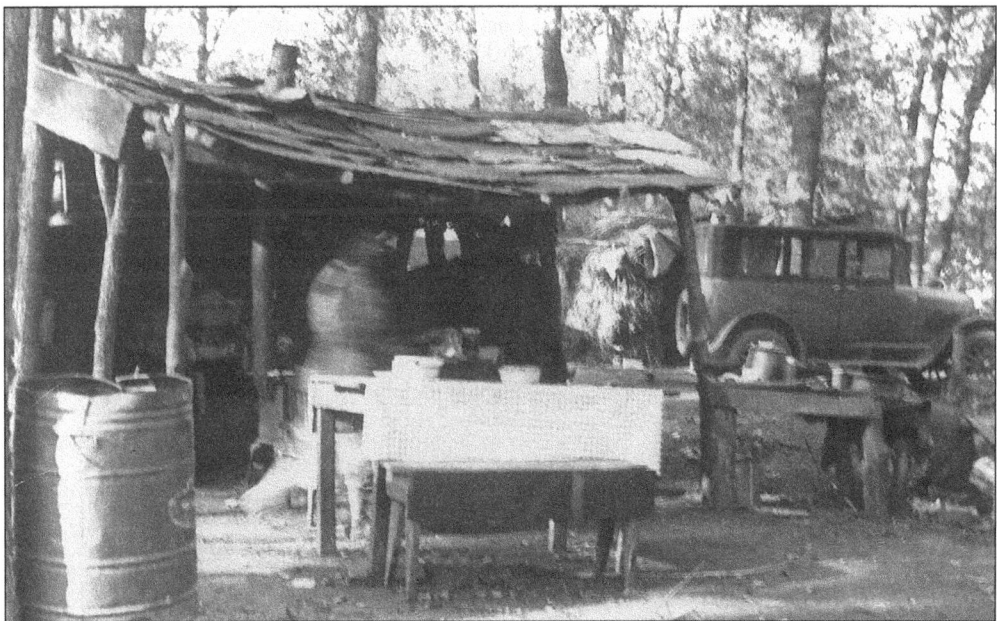

Migrant workers provided much of the labor, and they often worked alongside the farm owner and his family in the Hollandale-area vegetable fields. The migrants, many of whom came from Southern Texas, lived in housing provided by the farmers—some very adequate accommodations, and some very humble. Many chose to stay in Minnesota, to find permanent jobs, and to blend into established communities.

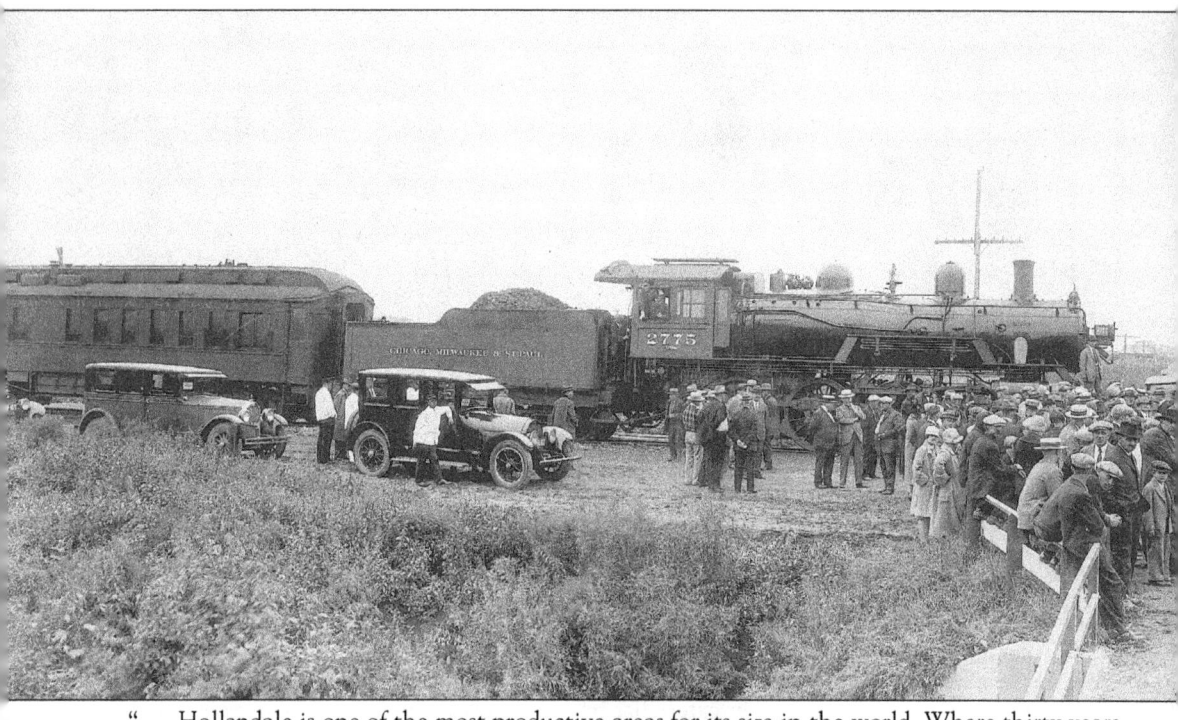

"... Hollandale is one of the most productive areas for its size in the world. Where thirty years ago there stood a cattail swamp under an average of four inches of water, today grows 80 square miles of the richest, most productive truck garden crops in the rich Midwest of America. From this 'useless swampland' growers this season harvested 15 to 30 tons of cabbage per acre . . . upwards of 750 bushels of onions per acre . . . 2,000 dozen of celery plants per acre . . . 15 to 30 tons of carrots per acre . . . and an average of 200-600 and more bushels of potatoes per acre. These figures are truly the basis for a miracle story, and that is exactly what Hollandale has proved to be. In spite of the bad years, financially and weather-wise, Hollandale has become certainly one of the miracle acreages in the world.

Early in the project, 25 years ago to be exact (1924), the need for marketing procedures was recognized. The Hollandale Marketing Association, a cooperative venture, was established to secure standards of quality which would find favor with buyers all over the nation; and to establish outlets which would buy Hollandale produce to the greatest advantage of the growers.

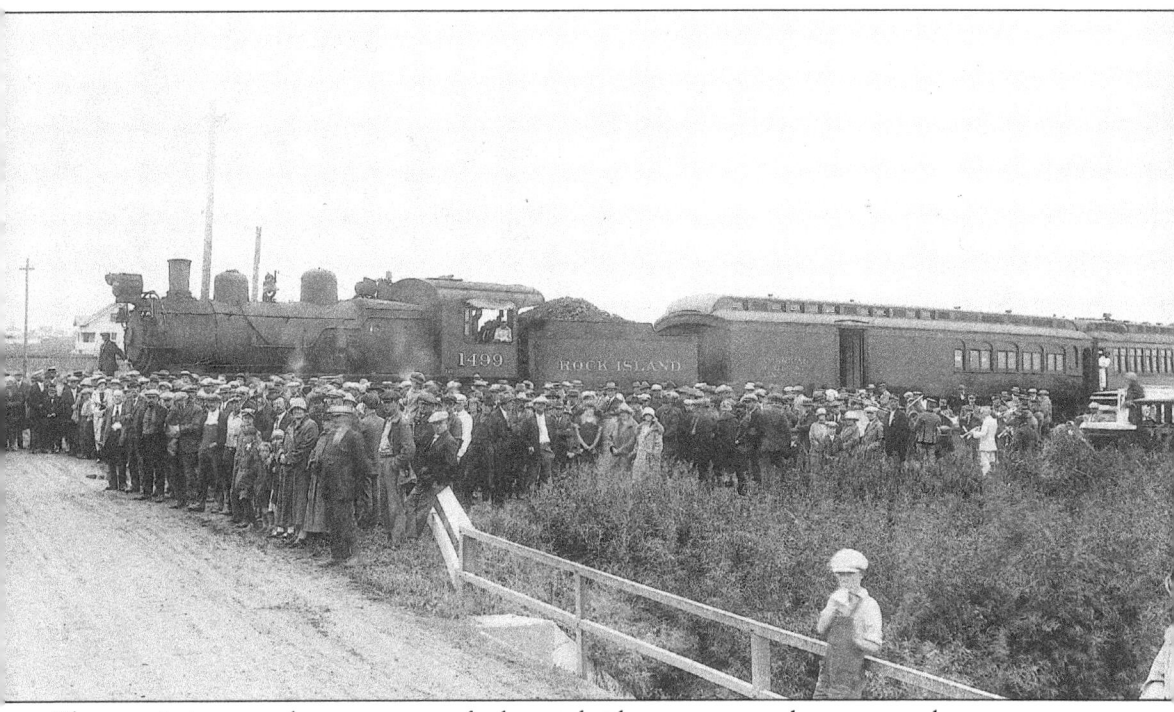

The association was also to go a step further and, when necessary, show growers how to get the most from their land. How well that job was done will be seen later. Even at the start, the value to top-quality crops was proved, when Hollandale seed potatoes commanded a premium of as much as 70¢ per bushel above the price of first-class table stock. Hollandale's tremendous production was such that, even at the start, it called for (and received) unique transportation facilities. These needs were satisfied when the Interstate Commerce Commission issued permits for two railroads (the Chicago, Rock Island, & Pacific and the Chicago, Milwaukee, & St. Paul) to build into Hollandale. The completion of that service was celebrated on September of 1926. The presidents of both of these railroads considered the connection of such importance that they personally attended the ceremonies of the opening of the line. It is said that no other tract of the same acreage in America is specifically served by two first-class railroads. Once begun, Hollandale was eventually destined to become a promised land for the farmers who came to participate in the benefits of the newly-opened acreage." (*The Community Magazine*, November 1949, an article titled "The Miracle Story of Hollandale.")

On September 4, 1926, hundreds of people flocked to Hollandale to celebrate the coming of the Rock Island and the Milwaukee Railroads and to recognize the entrepreneurial spirit and the hard work that made this dream a reality. Governors from two states, the presidents and officials of both railroads, the congressman from Minnesota's first congressional district, judges, lawyers, and ministers all joined with area residents to celebrate the event.

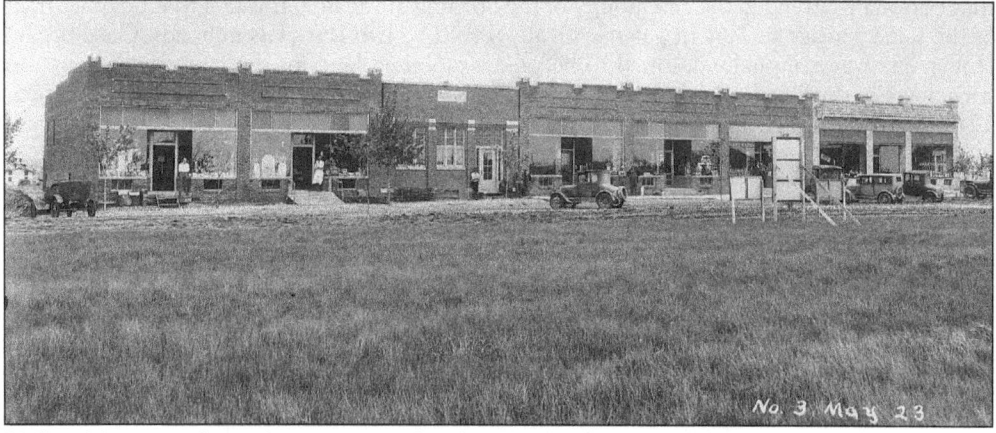

Hollandale was a planned community, developed according to the design of George Payne. His ideas on the homes, business district, and even the school showed a well-thought-out, balanced streetscape unlike any other rural Minnesota town. The view of Park Avenue West in 1927 shows the unique style of a business district built on a basic plan, rather than the haphazard growth of most urban areas.

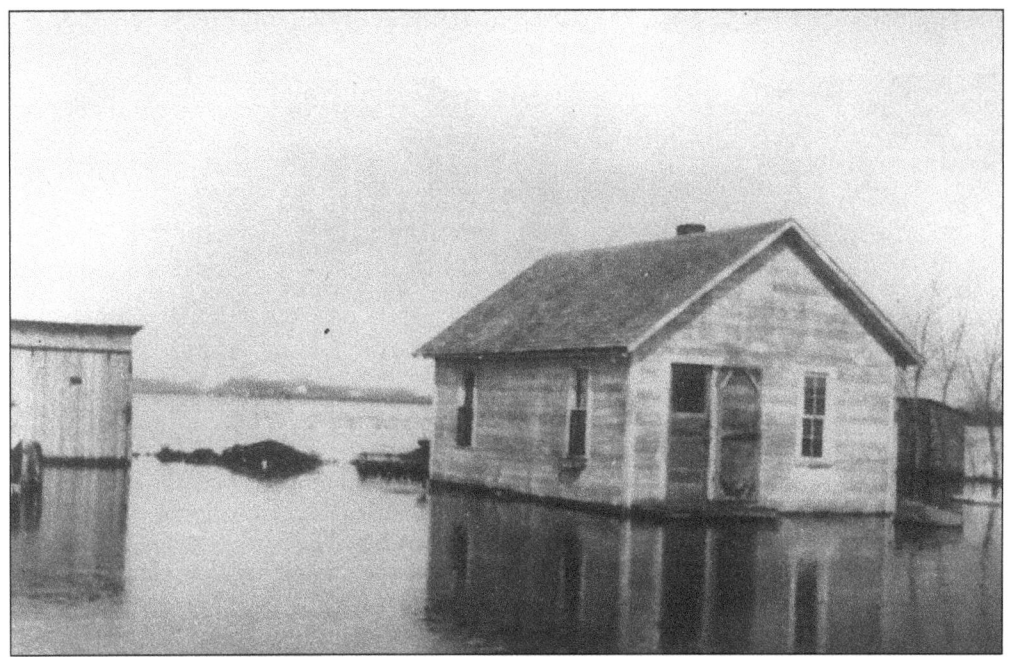

Miles and miles of drainage ditches could not keep up with the excessive rainfall in 1926, 1927, and 1928. It was as if nature was trying to reclaim her land. When the waters finally receded, the farmers found rotting crops in the fields. Many of them moved into Albert Lea and started new lives, giving up the dream of a prosperous farm life.

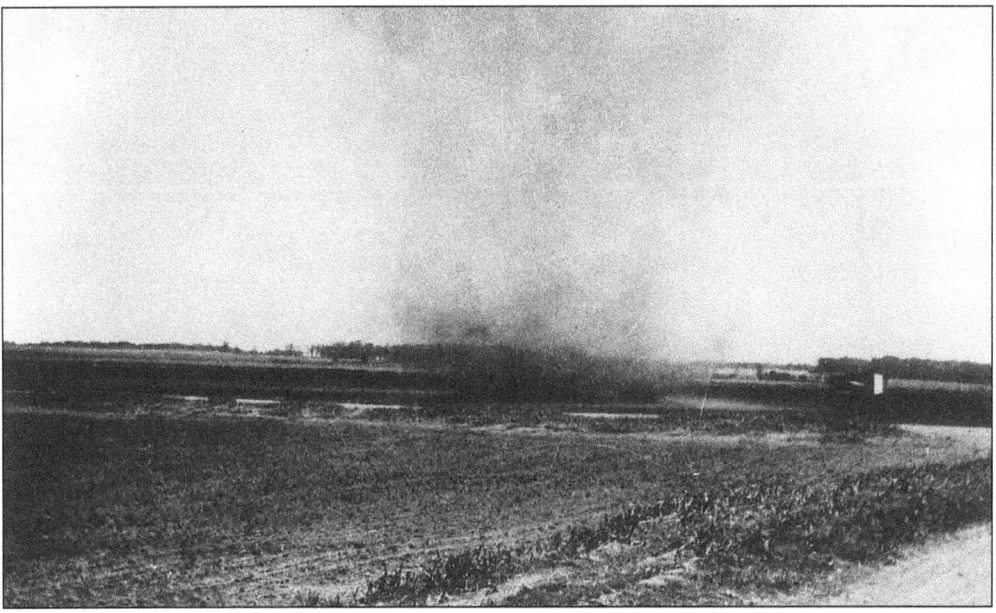

A strong wind and dry soil can be devastating to the farmer and frustrating to the farm wife. The fine, rich peat in the Hollandale area was formed by thousands of years of rank, jungle-thick vegetation decomposing in the swampy Rice Lake area. While it provides fertile soil for abundant crops, in the dry season it blows from the fields, settling in ditches and seeping into the finest cracks in buildings.

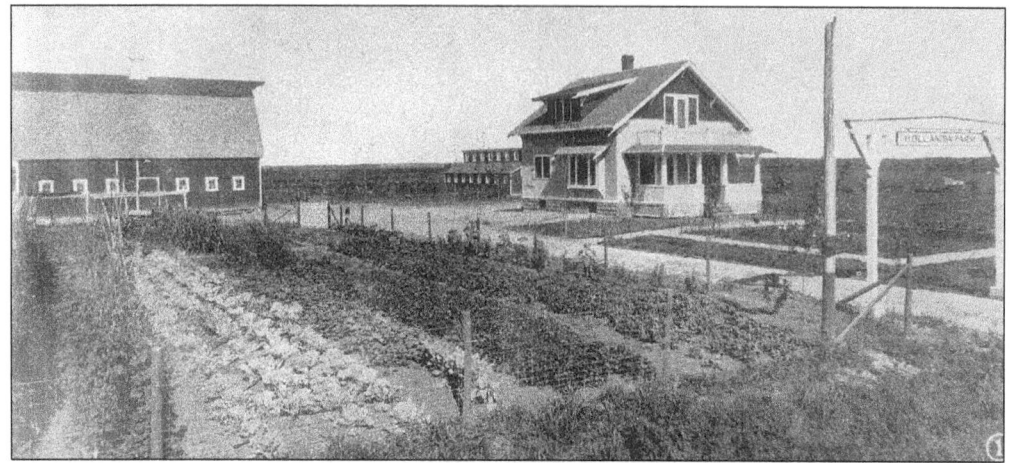

In 1921, because of high taxes and the possibility of another European war, Peter and Fenna Louters and their seven children emigrated to America. Stopping first in Iowa, in 1922 they became the first settlers in the Hollandale area. They purchased 80 acres of the newly drained land, farmed successfully on the Hollandale farm, and had the community's first church services in their living room.

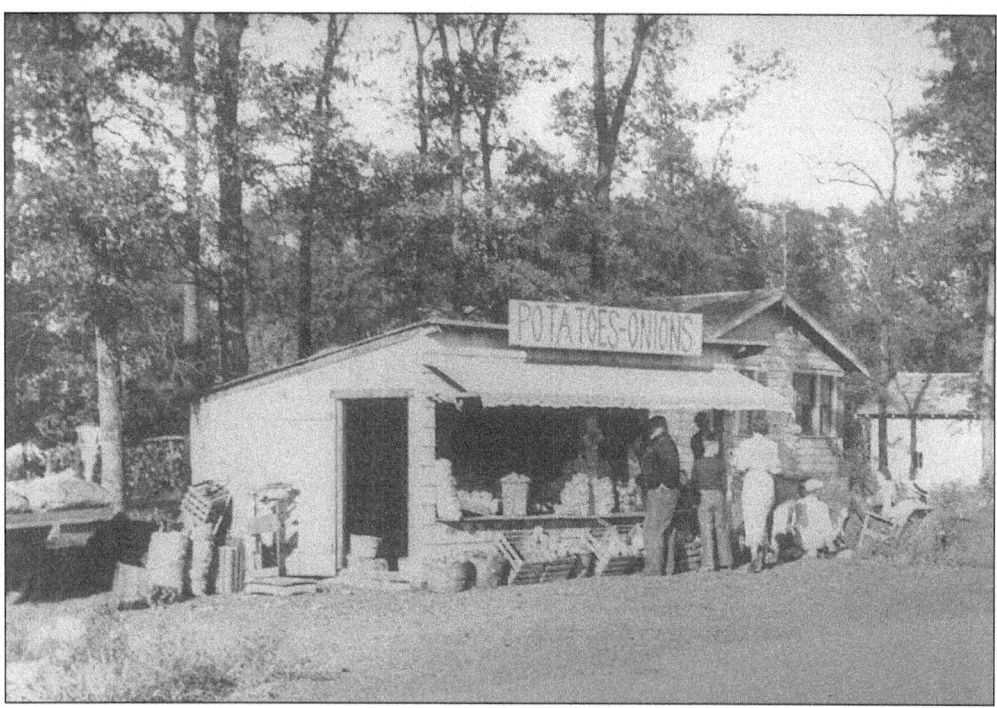

Cabbage, onions, celery, carrots, potatoes, asparagus, sugar beets—abundant vegetable crops that made dreams come true. Farms were paid off in five years, quality crops brought good prices, and success seemed assured for the Hollandale settlers. In addition to shipping vegetables to other parts of the country, city people from miles around came to the Hollandale/Maple Island-area to purchase fresh produce at road-side stands.

A Man in Hollandale
Has 31 Acres of Muck Land

Just one acre of onions last year made him enough money to pay all his annual installments and interest on his purchase. 30 acres for himself—one acre for us

Another Has 160 Acres of Mineral Land That Cost Him $200 an Acre

40 acres of sugar beets made him $100 an acre clear profit after paying for seed and hand labor—think of making half the cost of an acre in a single year!

This 40 acres more than paid his annual installment and interest on the whole 160 acres. Will he pay for his farm?

Is There a Single Farm in the Whole State Where You Live That Can Show Such a Record? There are Many Like These Two in

Hollandale
Come and talk with the men who did it

WRITE FOR FREE ALBUM OF PICTURES OF HOLLANDALE

Albert Lea Farms Co.	Payne Investment Co.
Owners	Selling Agents
HOLLANDALE, MINNESOTA	OMAHA, NEBRASKA

These are promotional materials from Payne's *Hollandale Enterprise* magazine of May 1924.

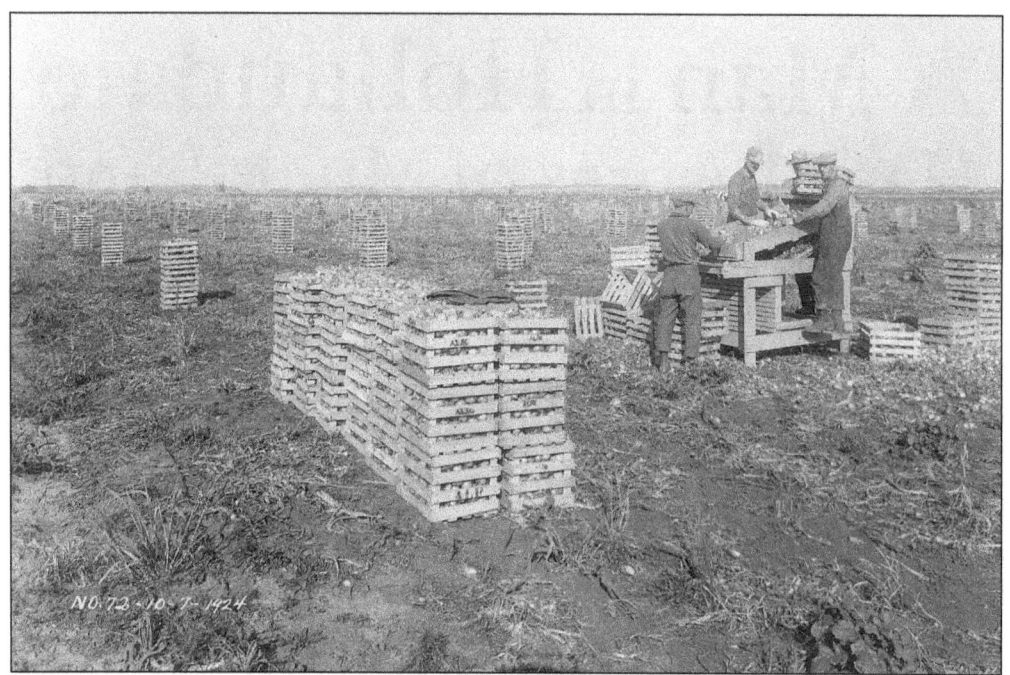

Onions were sorted in the fields by hand and then packed into wooden crates, each holding 50 pounds, before being loaded onto the truck to be taken to storage, or to the market. The size of this field and the number of crates gives you an idea of the amount of back-breaking labor involved in the planting, care, and harvest of a vegetable crop.

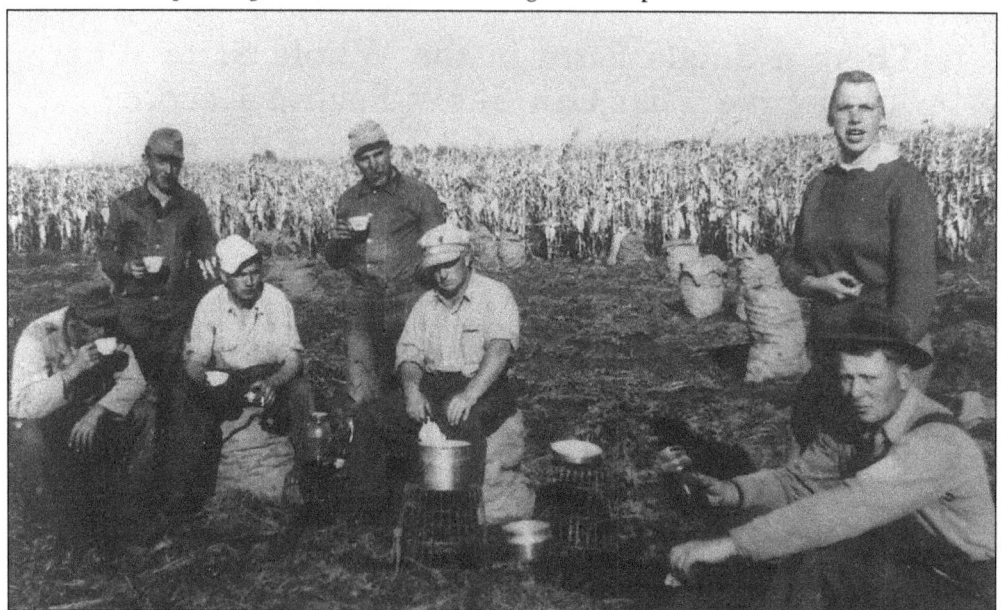

German prisoners of war, housed north of Owatonna in 1944 and 1945, were sent to Hollandale to live temporarily and to work in the fields during the harvest. This photograph shows Al and Doris Reynen, on the right, and five of the German workers. The Olin Hamer family also used the former members of the German military forces to help with the harvesting of sugar beets, potatoes, and onions.

Five

THE COUNTY SEAT

The Harry Gillrup house, surrounded by a picket fence, lives on in memory as a once-elegant home, owned by a prominent Albert Lea attorney. Located on the corner of Washington and Water Streets, the home, with its many additions, was built on the site of the Lorenzo Merry cabin, the first in Albert Lea. The Merrys called their place the "Strangers Hotel," and provided bread and sustenance for newcomers in the mid–1850s.

Albert Miller Lea was born in Richland, Tennessee in 1808. He planned to practice law, but because of his father's death, he left law school and entered the U.S. Military Academy at West Point. In 1835, Lieutenant Lea was a surveyor and a map maker with the U.S. Dragoons out of Fort Des Moines, Iowa, when they traveled through the area that was to become Southern Minnesota. Lea mapped "some of the most beautiful country he had ever seen." Though he named the largest lake in the area Fox Lake, the name was later changed to Lake Albert Lea by a cartographer in Washington, D.C. Twenty years later, the area's first settlers chose to name their village after the lake. When Tennessee seceded from the Union in 1861, Albert M. Lea served as a major in the Confederate Army. This caused much concern among the citizenry of Albert Lea, and there was talk about changing the name of the city. However, cool heads prevailed, and there was no name change. In 1879, Colonel (an honorary title) Albert M. Lea returned to Albert Lea, Minnesota to be honored at a celebration of the Old Settlers Association.

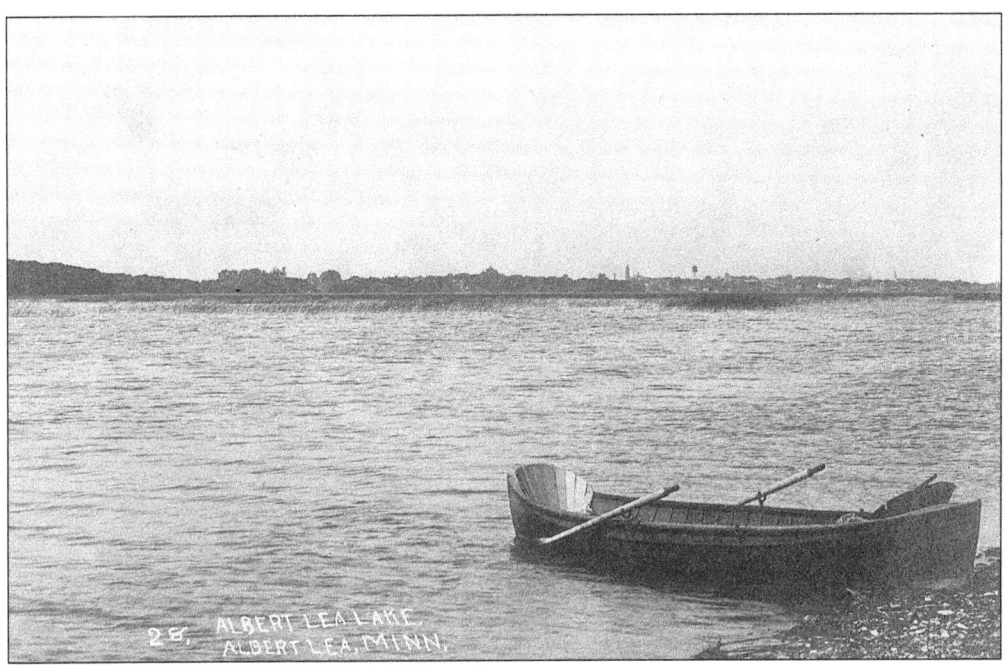

"Albert Lea, a beautiful lake about thirteen miles in length and varying in width from a quarter of a mile to three miles and situated in Freeborn County, Minnesota, is an attractive body of water to the sportsman . . . ducks, and geese visit Albert Lea in myriads. The elevation being great, the air is pure and the climate healthy. People seldom die there." (From the *Turf, Field and Farm*, May 22, 1874, New York.)

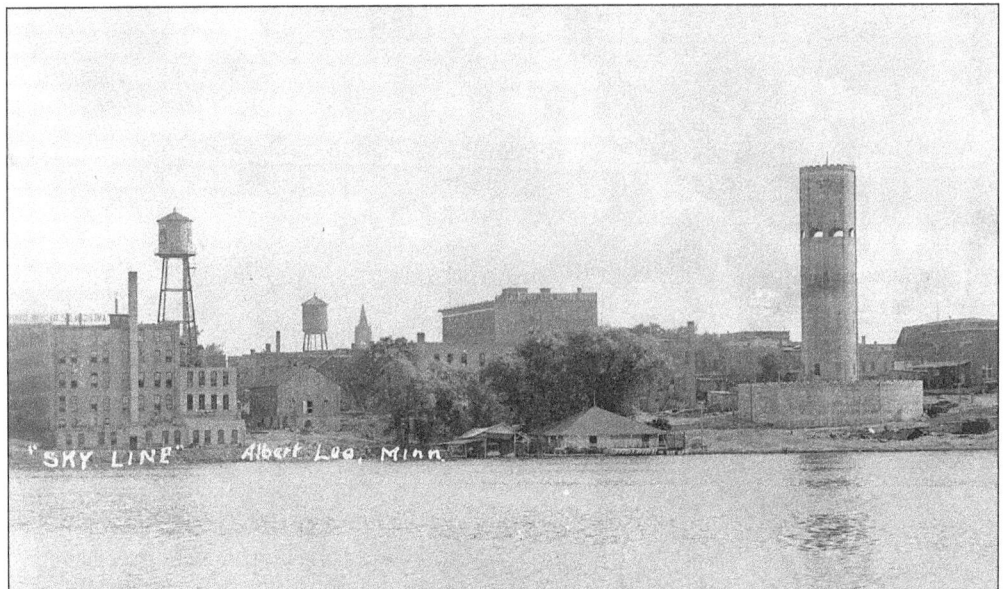

The City of Albert Lea surrounds beautiful Fountain Lake. This view shows the skyline as it looked prior to 1939. The cement water tower that did not hold water; the imposing six-story building, the Home Investment Building, which housed offices and stores; and the Casino/Dance Hall and boat rental are all a part of the heritage of the residents of Albert Lea, the county seat of Freeborn County.

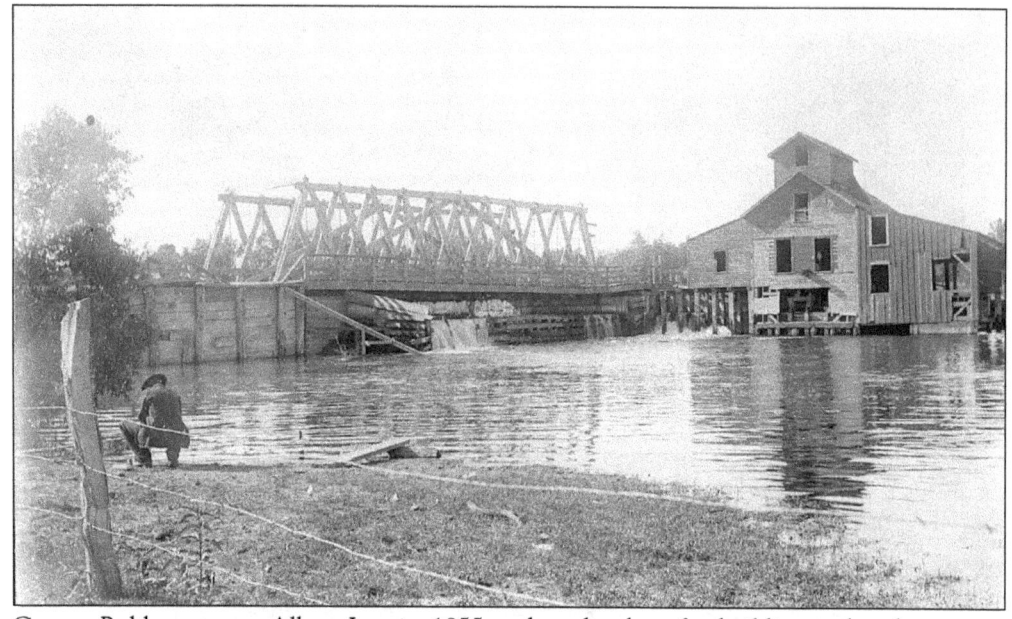

George Ruble came to Albert Lea in 1855 and made plans for building a dam between a wiregrass slough and Albert Lea Lake. He received permission from the Territorial Legislature to do so. A lumber mill was constructed, and a flouring mill was added. The site was destroyed by flooding in 1861. The photograph shows the Francis Hall flouring mill, built in 1867, north of the former mill.

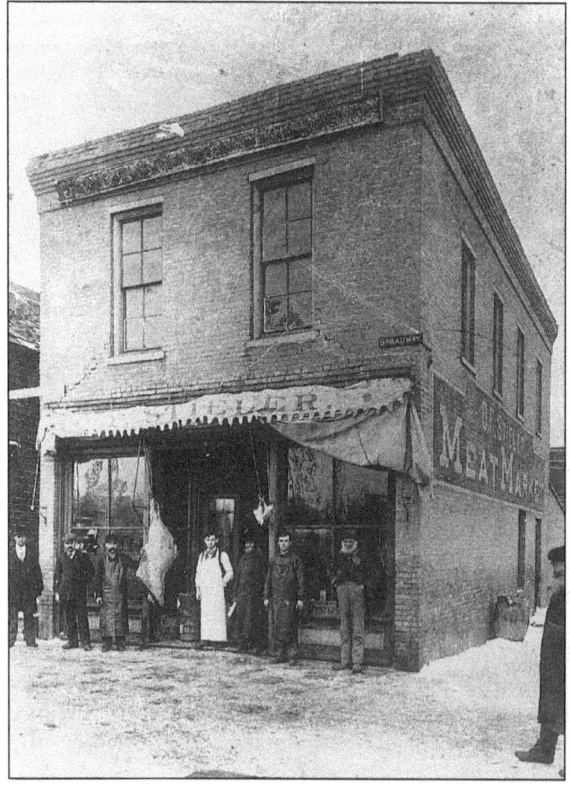

A beef carcass and two plucked chickens advertise the Stieler Meat Market on the southwest corner of Broadway and Main Street. The building was demolished in 1902. Before the meat market opened, Johnson and Nelson operated a grocery store in the building. Hugo Stieler is pictured here in the white apron. Among the others are D. Stieler, Helmer Kvame, and Dean Clark

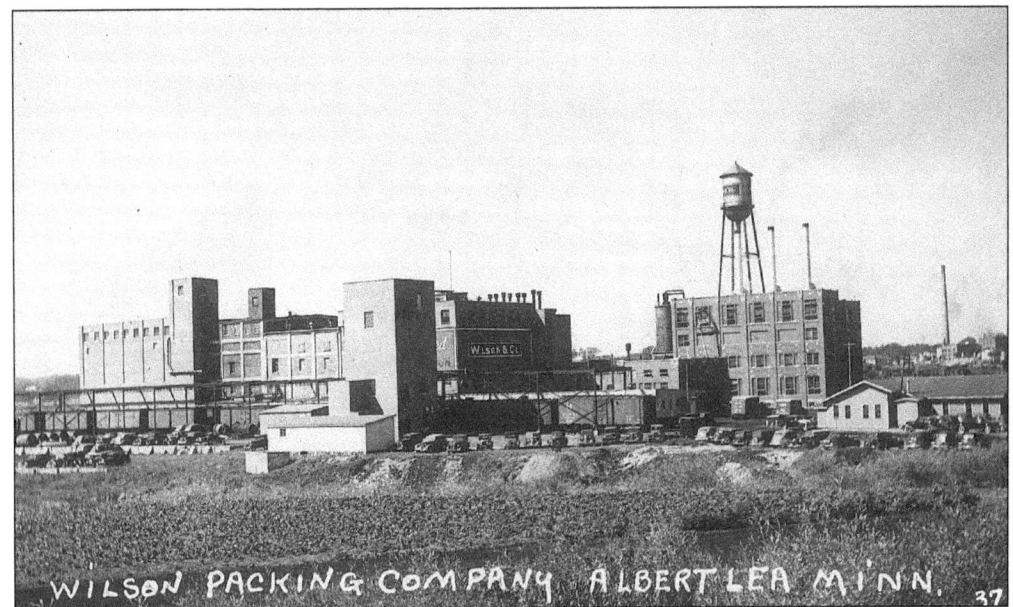

Wilson and Company looks busy and productive in this 1940s photograph. Early meat packing history in Albert Lea included such names as: Brundin Meat Packing Company, Albert Lea Packing Company, the Soth Packing Company, and Sulzberger & Sons Company. In 1916, the Wilsons decided to invest in the community, and thus began a successful expansion and employment pattern that continued almost 70 years.

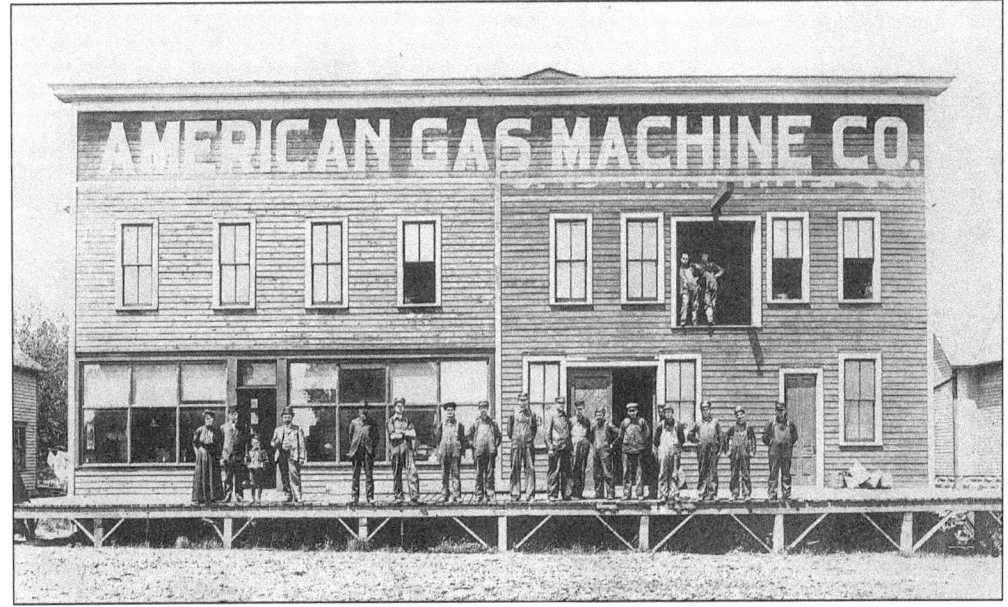

In 1894, H.C. Hansen began tinkering with gas lighting apparatus. With the help of local investors, his interest grew into the American Gas Machine Company, one of the largest employers in the city. This building on East William Street was soon outgrown, and in 1910 they moved to Clark Street, and in the 1920s to Front Street. Their manufacturing lines of items for cooking, heating, and lighting were sold world-wide.

Between 1855 and 1905, the Albert Lea Post Office was located in several different buildings, each dependent on the current postmaster. In 1905, this building was erected on Newton and William Streets. It was of light-gray brick with a stone foundation and was 67 by 45 feet. The *History of Freeborn County* states, "An iron railing has been provided for hitching teams near the east door. The cost of the complete building and grounds was $36,000."

Looking like European architecture of the Middle Ages, this building once housed the county sheriff and his family on the first floor and the jail on the second floor. Built in 1875, it stood on the corner of College and Newton. In 1886, a new jail addition was constructed on the east side, and the home's second floor was remodeled for family use. Meals for the prisoners were made by the sheriff's wife.

The Richardsonian-Romanesque style of construction, with its massive shape used in the building of the Freeborn County Court House, was a great source of pride to the community. The total cost of this building, in 1887, was $75,000.
In 1938, the courthouse custodian, when checking on the clock, was surprised to find the body of a man hanging in the tower. In spite of a thorough investigation, the dead man's identity was never discovered.

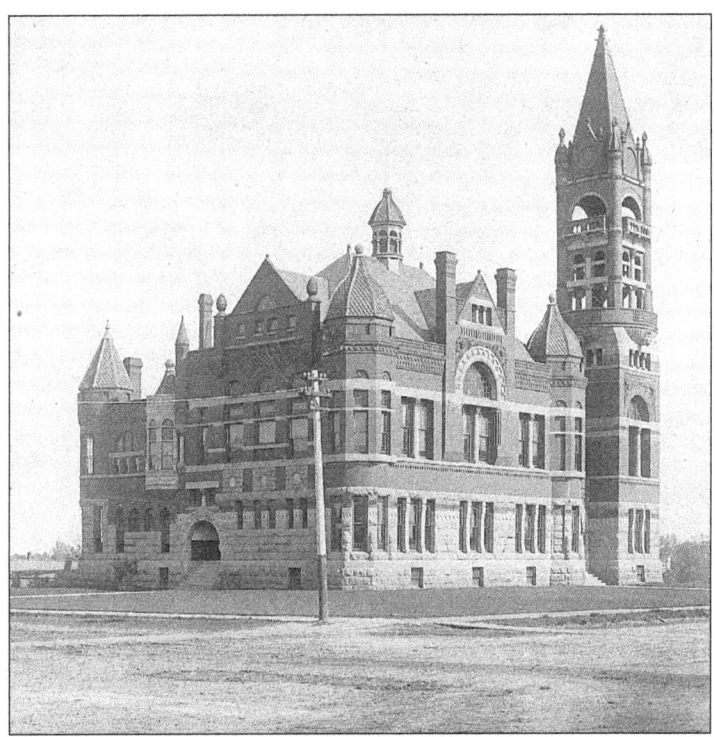

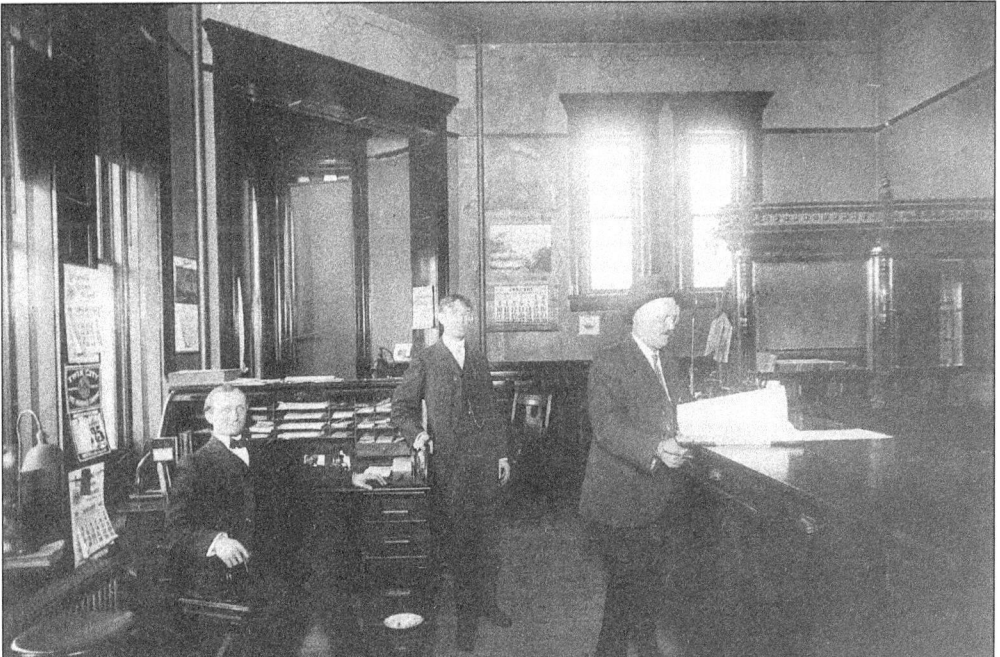

This photograph was taken in the county auditor's office in the Freeborn County Court House in 1913. The office was located in the northwest corner on the first floor. The auditor at that time was Charles E. Brainerd, probably the gentleman seated at the desk. He had previously served as city clerk. He was also active in many local organizations, was an assistant fire chief, and was an ardent Republican.

This photograph shows the northeast corner of Broadway and College as it looked in 1899. At that time, this was the site of Morin Law Office and Real Estate, and L.O. Greene & Sons Livery Stables. These buildings were then demolished for construction of the Hotel Albert. William A. Morin, whose father was one of the early successful financiers of Southern Minnesota, was instrumental in the development of the hotel corporation.

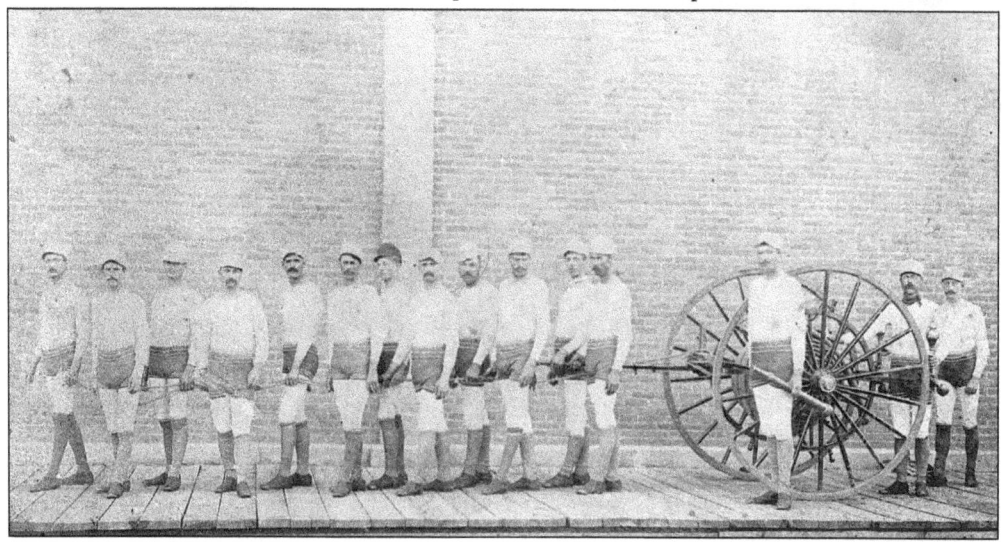

In 1879, Albert Lea residents were very proud of their fire department's "Running Team." They competed in an event in which a hose was attached to a make-believe water hydrant; the team ran 360 feet with the hose unreeling from the cart, and then a nozzle pipe was attached. The Albert Lea team came in second, losing only to the Red Wing team, whose time was 29 seconds, a United States record.

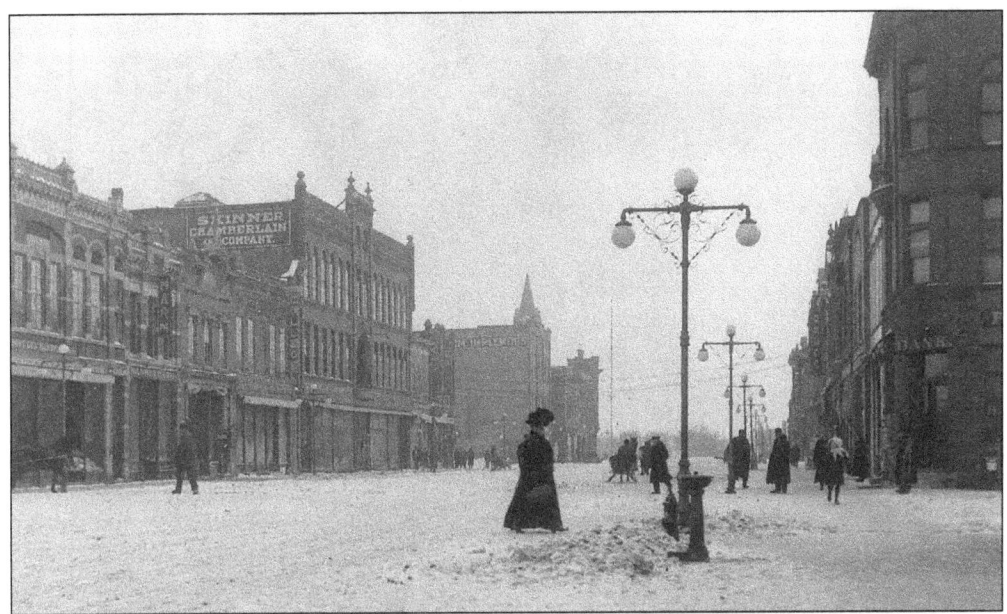

It looks like most Albert Leans on this winter day in about 1915 were home where it was warm, while a few hardy souls ventured out, intent on business. The lady in her broad brimmed hat, the ornately scrolled lamp posts, and the detailed roof tops of the buildings give a wonderful Victorian charm to the scene. The lady is crossing Broadway at the corner of William Street.

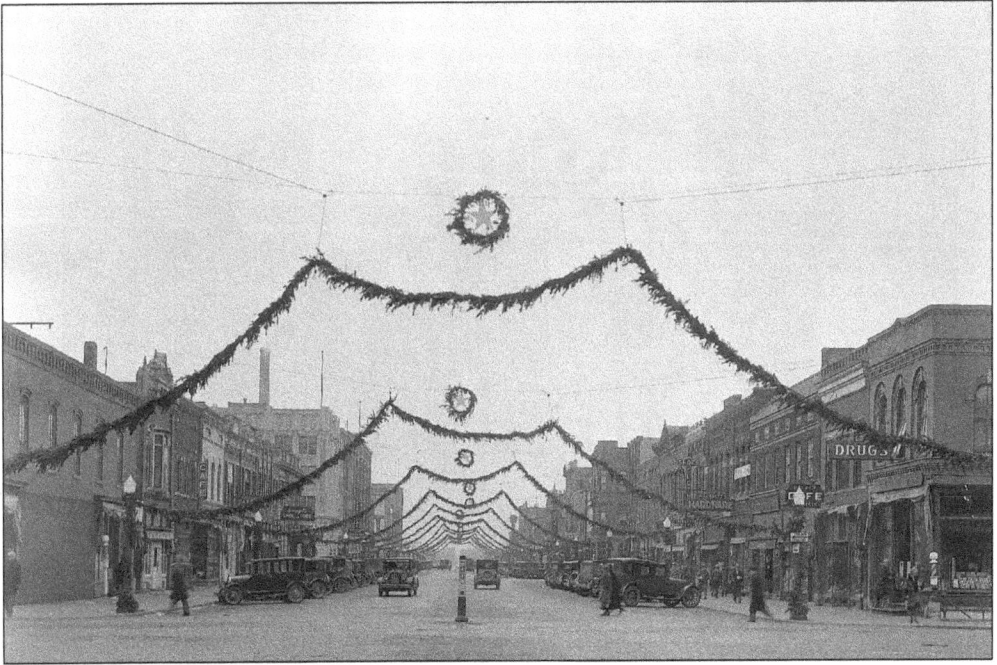

In the 1930s, national publicity was directed toward Albert Lea as a result of its Christmas display of wreaths. Each year, businesses and homes were decorated with streamers of green fir wound with colored lights, and wreaths were hung on the building tops and in windows. The number of automobiles and pedestrians seems to indicate a good atmosphere for business, as well as the holiday season.

Formed in January 1894, the Robson Post, Number 93, Women's Relief Corps had a charter membership of 45 ladies. They assisted the members of the G.A.R.—Grand Army of the Republic—in visiting the graves of those who had served in the military, and they remembered those in the soldiers' homes with special gifts.

The W.R.C. members are shown in this photograph near the monument built to honor the memory of the Freeborn County men who had served in the Civil War. The photograph was taken May 30, 1914, and the monument was dedicated on June 11th that same year. The bronze soldier and his musket stood atop a granite column on the northwest corner of the courthouse square. It was moved 100 feet to the south, in 1953, to make room for the courthouse addition.

Memorial Day services at Graceland Cemetery in 1947 included the dedication of a new monument honoring the Freeborn County men who gave their lives in the Spanish-American War, World War I, and World War II. Funds for the monument were raised by members of the American Legion, Veterans of Foreign Wars, and the Disabled American Veterans. Several years later, names were added of those who died in the Korean and the Vietnam Wars.

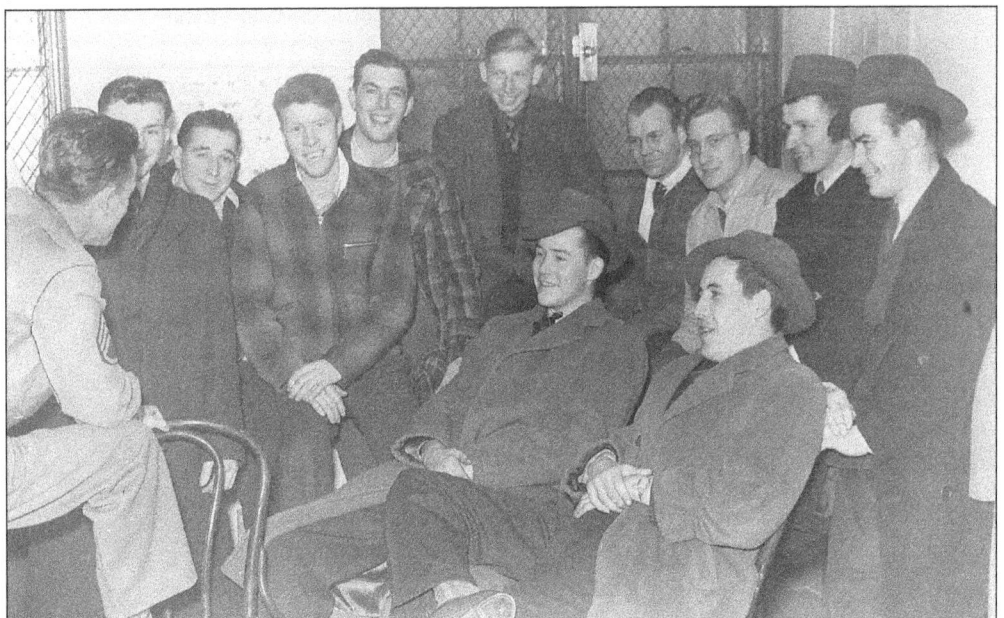

With determination and enthusiasm, these men left Albert Lea on a Rock Island train on December 27, 1941, for Fort Snelling and their training quarters. They are, from left to right: Harold Mork (Albert Lea); Damon Schulenberg and Orville Miller (Wells); Steven Prochniak (Fairmont); Gerald Weerts, Warren Shields, and William McClaim (Winnebago); Kenneth Jacobson and Kenneth Anderson (Albert Lea); Charles Bias (Wells); Leslie Brimacond (Austin); and Bernard Staubor (Fairmont).

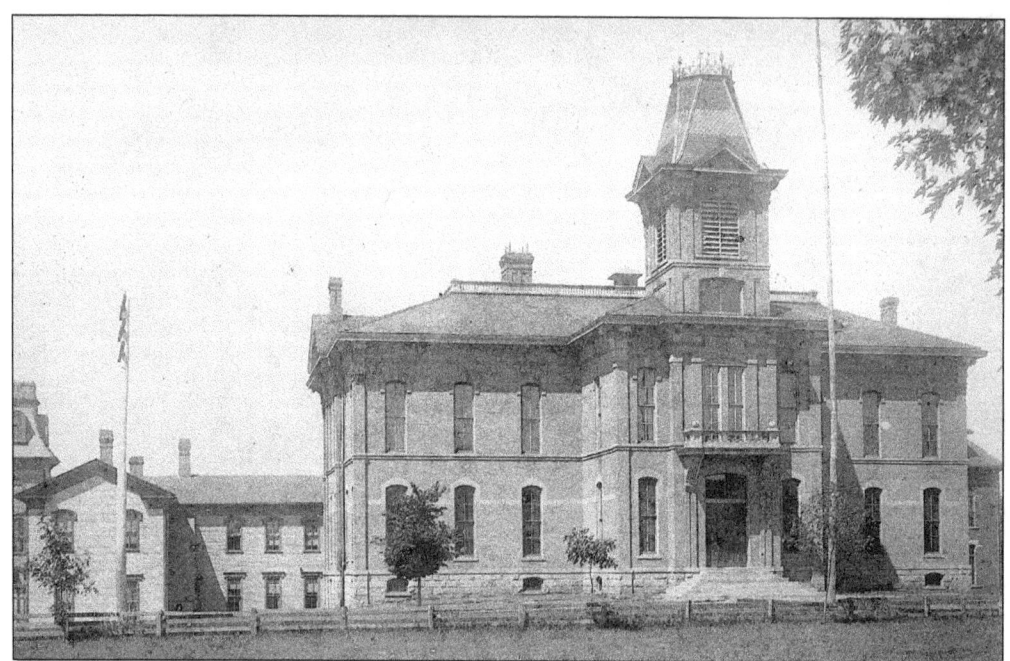

Beginning in 1857, school buildings, their sites, and their architecture, have varied considerably in Albert Lea. Central School was built in 1881 at a cost of $15,000. It was on West Avenue facing Central Park. In 1895, another brick building for high school classes was erected to the north, near Water Street. The wooden building on the south, on Clark Street, served as an elementary school.

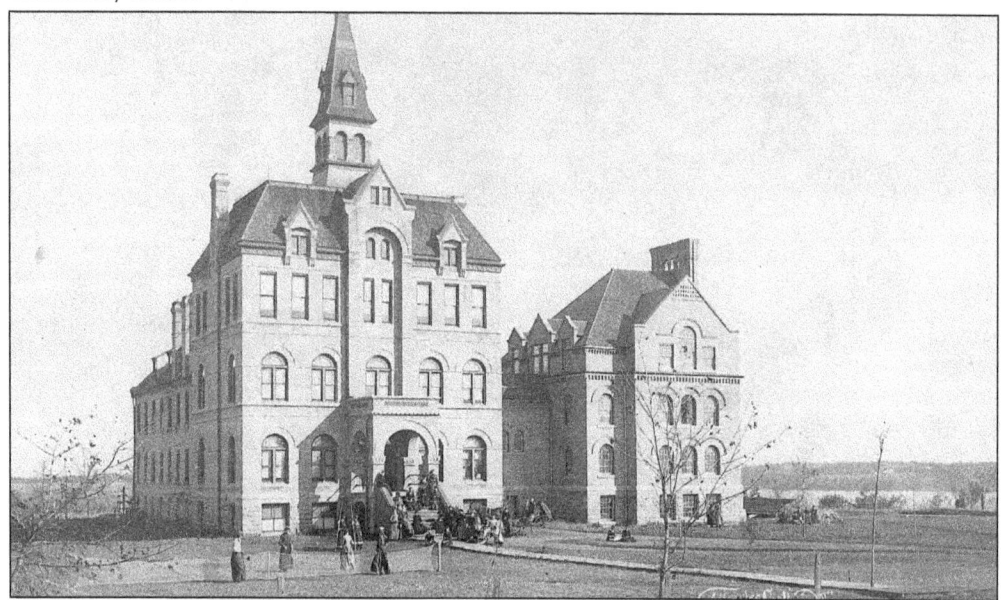

The Albert Lea College for women opened its doors on September 8, 1885, with an enrollment of 51. The building was designed to be constructed in three phases as expansion was needed, and was supported in part by the Presbyterian Synod. Classes included: German, French, Latin, history, science, mathematics, Bible study, sociology, English, physical culture, music, art, and home economics. The college closed in 1916.

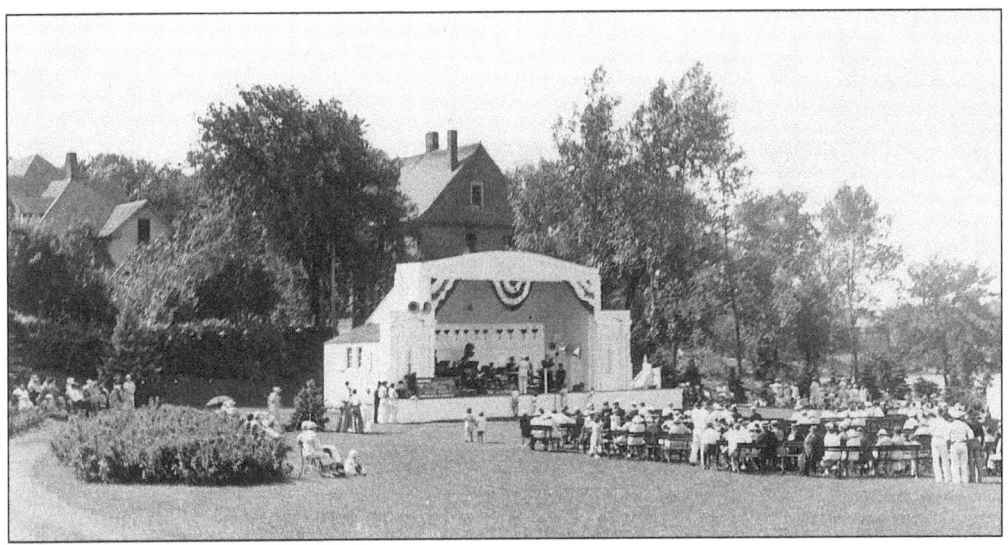

On the former location of the livery stable and an ice storage building, these 3 acres of lakeshore were transformed into a lovely park, dedicated in 1937. In 1933, the city purchased the Greene property and, later, a federal employment project—the Works Progress Administration (WPA)—provided the finances and the labor to build the park, bandshell, lakeside observation deck, and a turn-around lane on North Broadway next to the park.

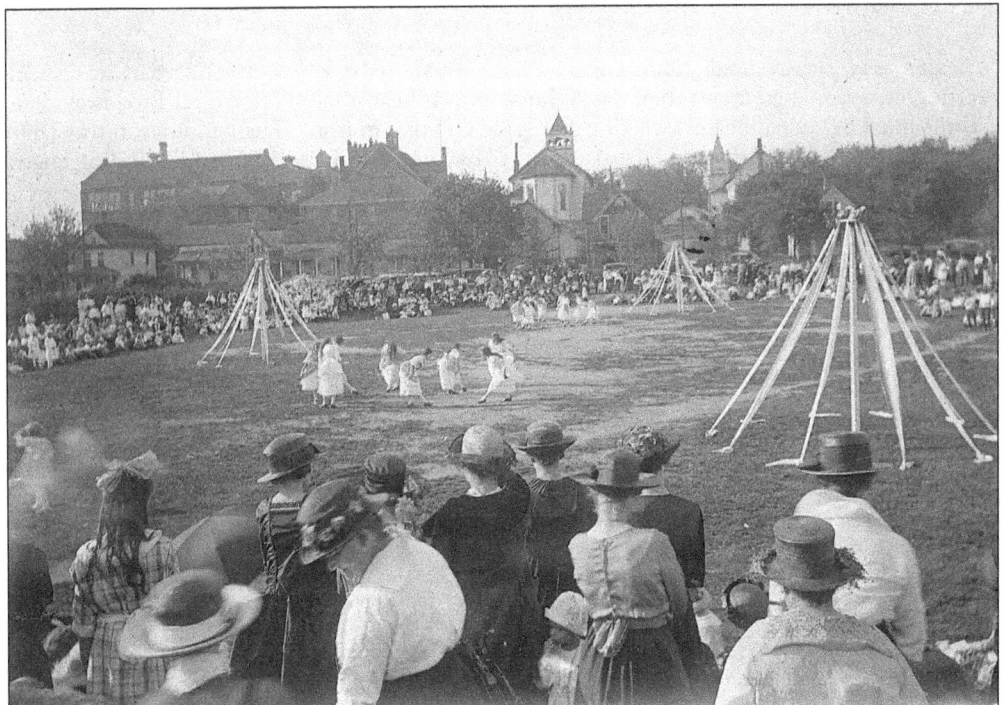

In this lovely park where maidens dance among the May poles, a shallow lake once existed where city residents tossed garbage and where it was said that "a team of horses once drowned." Around 1881, the lake was drained. Plans were later submitted to the state for suggestions on park and playground features. The name was changed from Spring Lake Park to Morin Park to recognize the donor.

As the townspeople go about their day, a horse-drawn hearse moves north on Broadway. It is accompanied by six pallbearers walking alongside and one in front. The buildings in this 1898 scene are, from left to right: the First National Bank, Times Printing Office, Charles Jorgenson Bakery (J.P. Colby building), and T.P. Jensen's Boots & Shoes (1895).

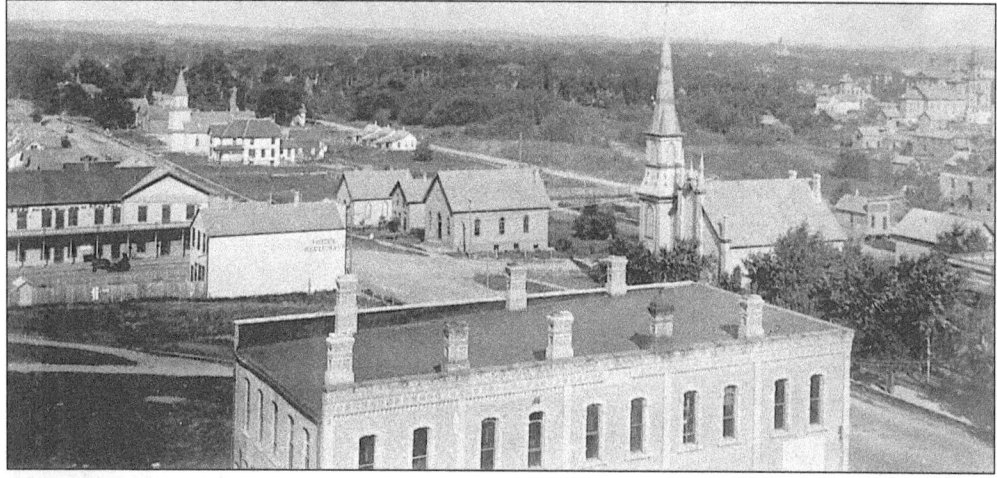

This aerial view of Albert Lea was probably taken from the courthouse tower. Looking to the northwest, we see in the foreground the Albert Lea Tribune building, and to the left the Gilbert House and the Central Hotel Restaurant. The street angling through the picture is West College, intersecting with South Washington. The four churches, as listed in the 1895 plat map, are, from left to right: Trinity Danish Lutheran, Swedish Baptist, Methodist, and Trinity Norwegian Lutheran.

Elizabeth D. Stacy was the first woman to graduate from the University of Michigan Medical School, thus being the third woman in the nation to become a doctor. She moved, with her husband, Judge Edwin C. Stacy, and their children to the Minnesota Territory in 1856. During much of the Civil War, she was the only physician in Freeborn County, riding all over the thinly-settled county helping the settlers with their medical needs.

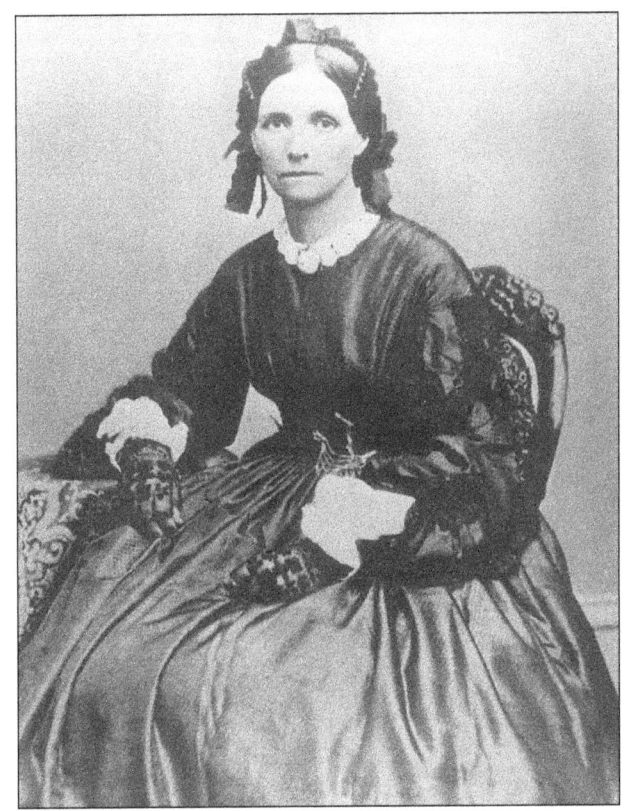

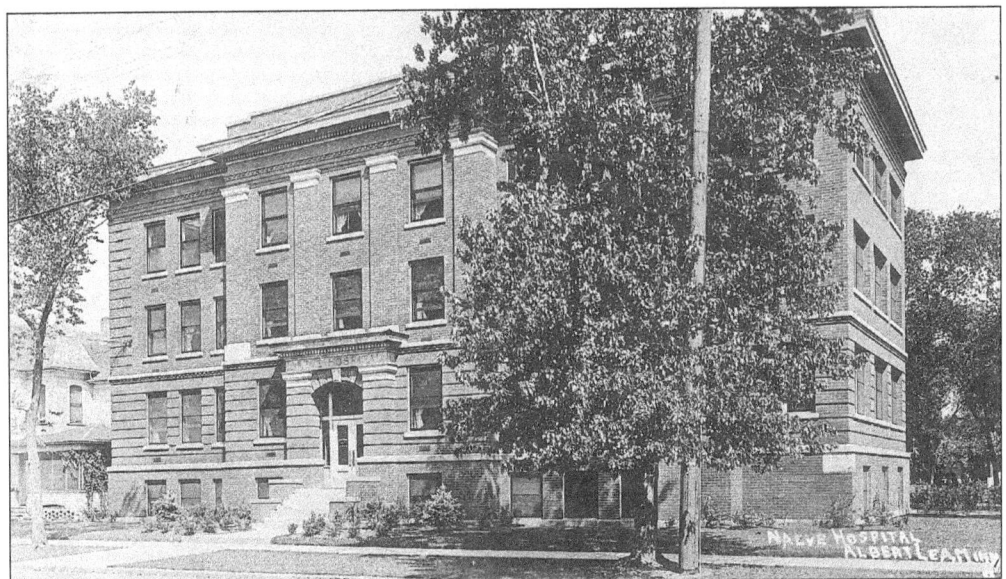

Hospitals in private homes, owned by doctors or medical associations, provided care in Albert Lea prior to 1910. While the need for a large, modern hospital was often discussed, it was not until the City and County Hospital Association was formed, and a sizable donation of land and funds was received from the Naeve and Soth estates, that the planning began in earnest for Naeve Hospital. The cornerstone was laid in May of 1911.

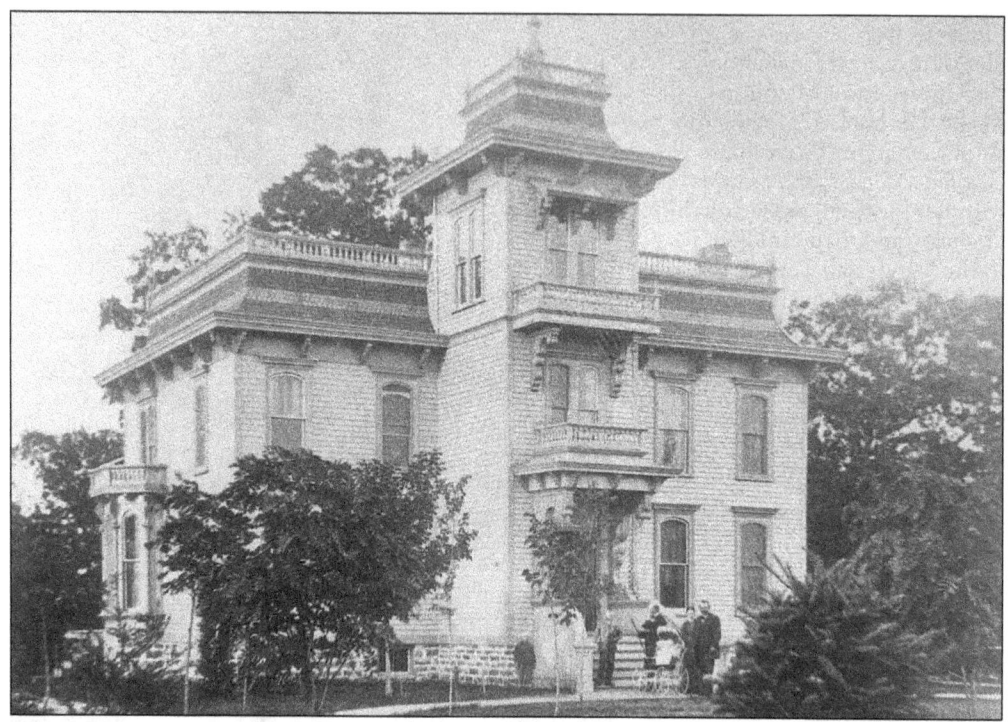

This image of the W.P. Sargeant home on Grove Street was taken from a stereopticon photo card. Sargeant and his family came to Albert Lea in 1871, where he purchased a lumber yard and a farm. In 1882 he was elected to the state senate. An earlier owner of this home was William W. Cargill, who operated a warehouse dealing in grain, hogs, and hides.

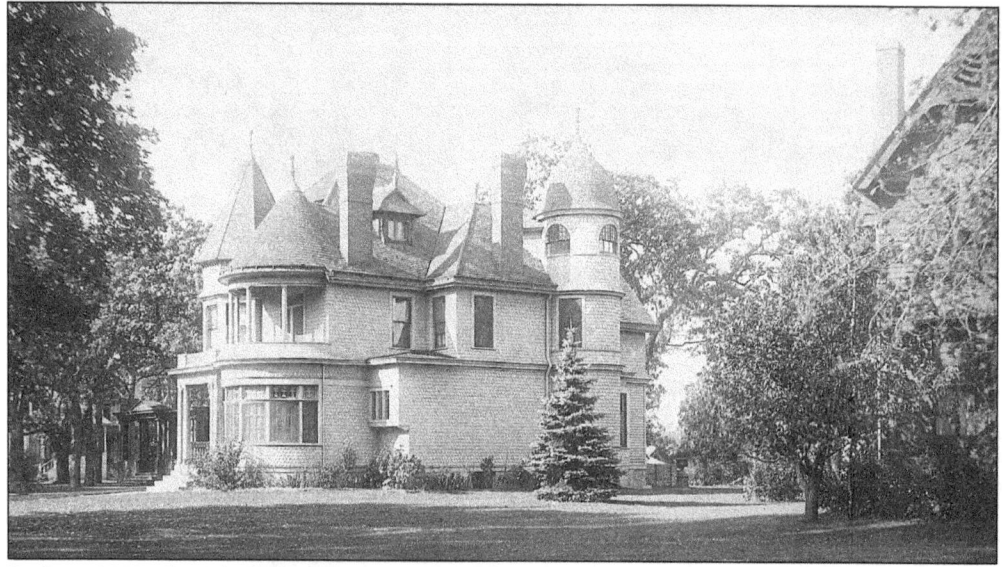

Built in 1889, the Charles Jorgenson-A.O. Watland home on Grove Avenue was an excellent example of Victorian Picturesque architecture. The Queen Anne style home was sided in both clapboard and shingles, and had several corner towers, dormers, and bay windows of leaded and stained glass. The home's interior contained several ornate fireplaces and a cherry wood buffet in the dining room. Jorgenson was a prominent businessman in Albert Lea.

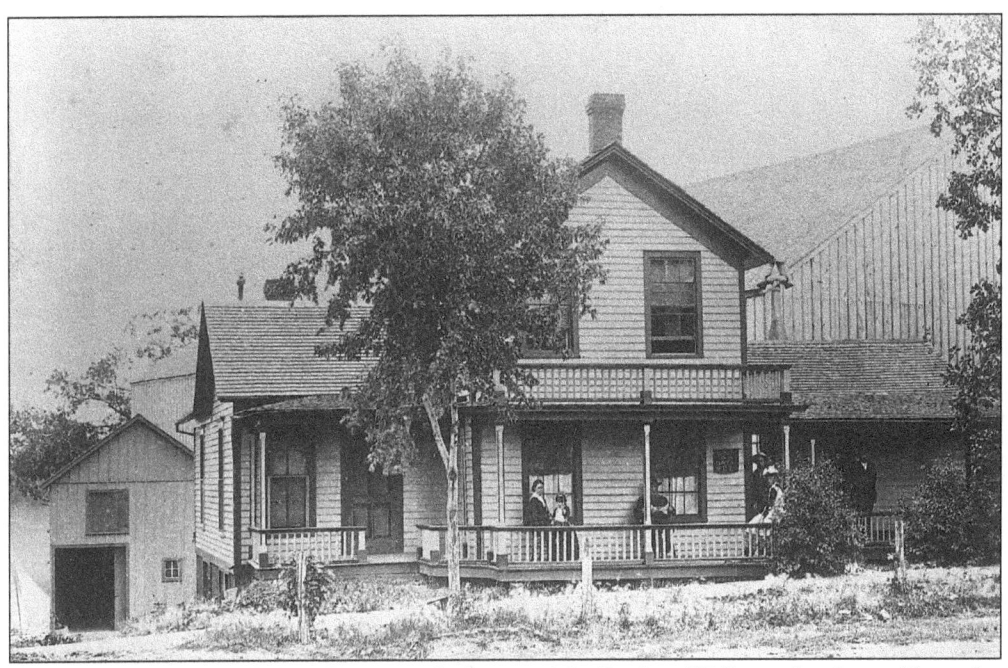

This residence on North Broadway was the home of the Reuben Williams family, and later the John Wing family. Both men had served in the Civil War, with Wing being one of the honor guards at the funeral of Abraham Lincoln. This photograph shows the Wing residence, c. 1890, with a sign on the house reading, "Boats for hire by day or week."

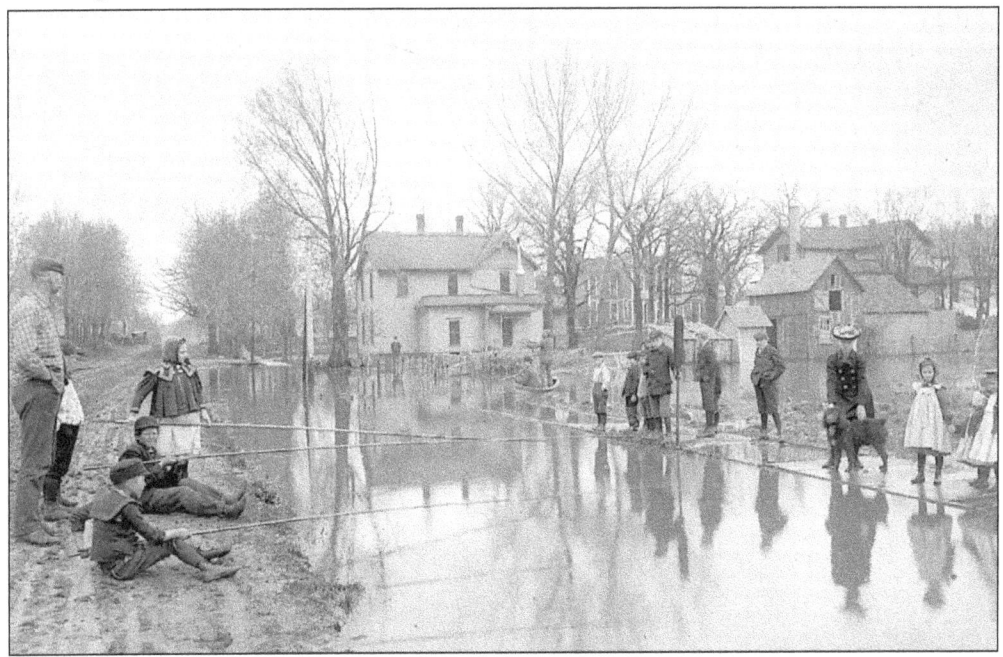

A warm spring day, with the accompanying muddy streets and flooding, must have brought frustration for the adults and joy for the youngsters in this scene at the corner of Euclid Avenue and Court Street. The children with cane poles, and the others standing on the sidewalk, seemed to enjoy posing for the photographer, c. 1912.

In the mid–1930s, Edward and Elsie Peal purchased a home on the Government Project located east of Albert Lea. One of Franklin D. Roosevelt's plans to help the U.S. out of the Depression, this homestead project provided 5 acres and a small home to qualified buyers. Daughters, Dorothy and Lois, are all ready for the Colonel Albert Lea Days celebration, which took place in 1940.

These identical homes were built by contractor Henry Engen on the 300 block of East William Street in Albert Lea around 1910. Known as worker's cottages, these homes provided inexpensive housing for families. The front porches were ideal for enjoying summer evening breezes and neighborhood visits. The Rock Island Railroad depot is in the background.

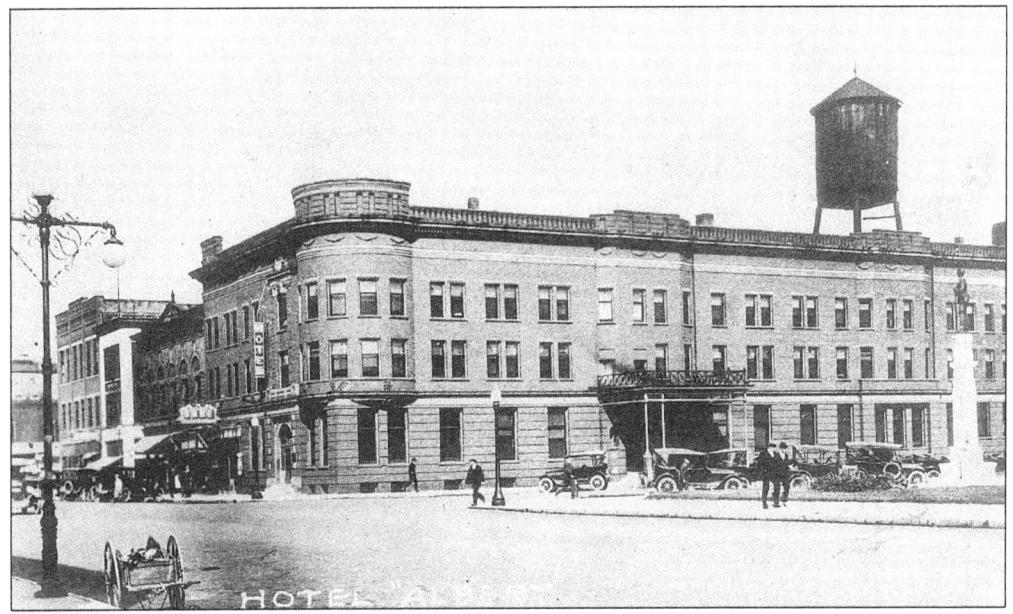

In 1899, the Hotel Albert was built by the Albert Lea Hotel Company. Shortly after, Charles Jorgenson bought out the other two stock holders, and within 20 years, it was the largest hotel per capita in the United States. Its 225 rooms, Spanish dining room, coffee shop, lounge, and elegant atmosphere provided respite for thousands of guests, including movie stars and prominent politicians, who traveled the Jefferson Highway.

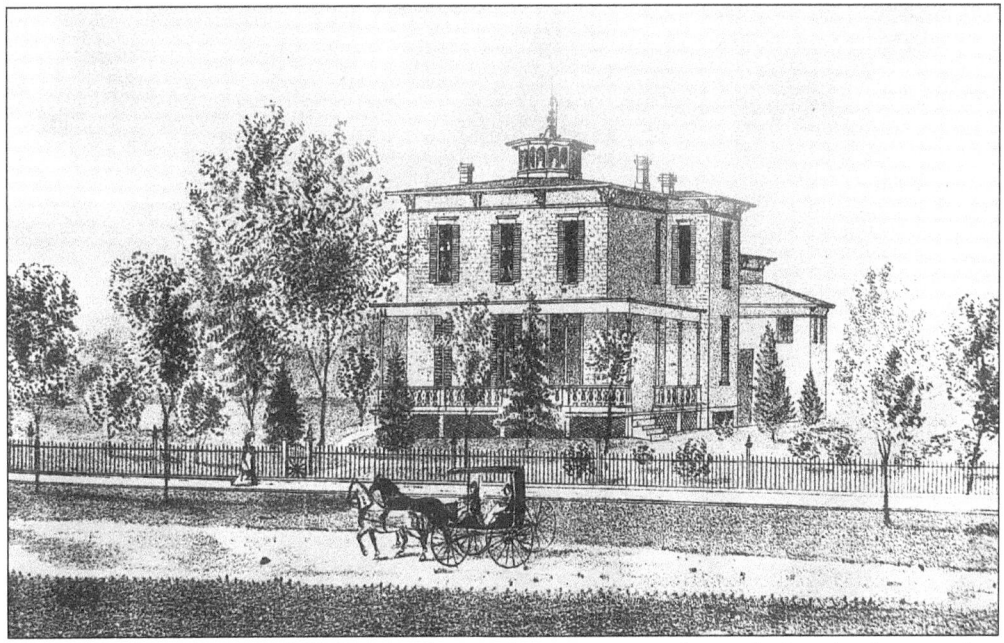

On October 14, 1865, Frank Hall wrote his purchasing agent to obtain the best lumber, window caps, door sills, and other materials. He knew the best materials would cost more, but he wanted to build a quality home. Hall served as Albert Lea's mayor, but he was a bank president and a merchant by trade. This home on East Clark Street eventually became the Hall House, later known as the Freeborn Hotel.

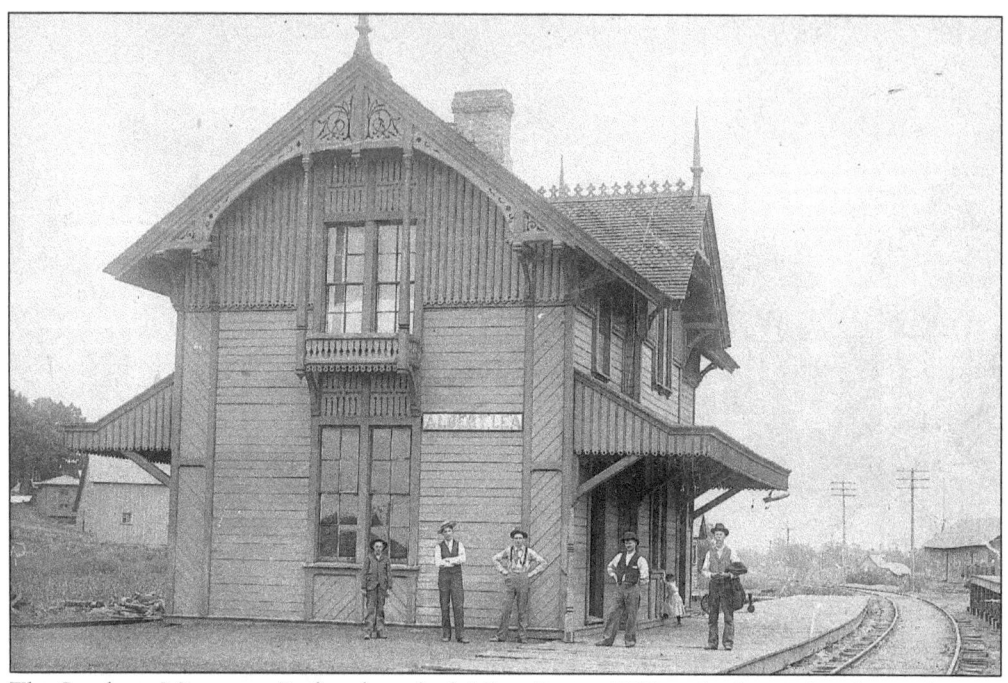

The Southern Minnesota Railroad reached Albert Lea in 1869 as the first railroad into the city. It was purchased by the Milwaukee Road in 1880. The depot just west of South Pearl Street, a good example of a Swiss Chalet style building, burned down in 1890. A new depot was built two blocks east, nearer Broadway.

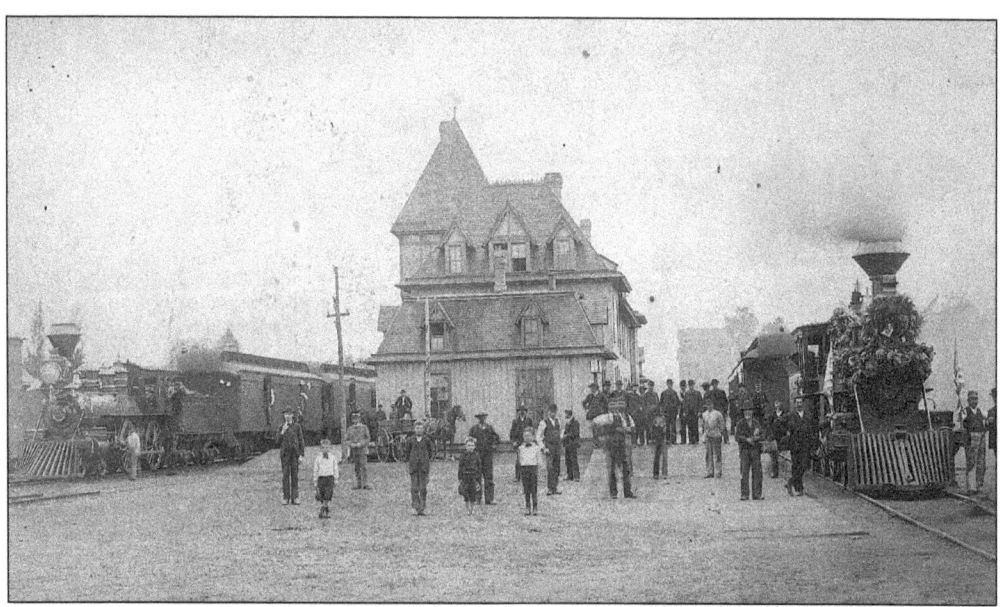

The Winslow House, a combination depot, restaurant, and hotel, served as the station for the Minneapolis & St. Louis and several other early railroads. This photograph shows the celebration in 1877, marking the arrival of two railroads, the M & StL and the Burlington, Cedar Rapids, and Northern, into Albert Lea. In 1880, there were about 40 arrivals every 24 hours, including eight passenger trains.

A Sunday afternoon drive and a visit with good friends—what a wonderful ending for our trip through Freeborn County! The folks in this photograph hope that you have enjoyed your journey, and that the bits of history that we have shared bring you a greater appreciation of our heritage and our home.

Interest in the preservation of Freeborn County's history surfaced periodically, with the Old Settlers Association in 1875, the Territorial Pioneers in 1899, and the Freeborn County Historical Organization in 1948. This effort led to the incorporation, in 1959, of the Freeborn County Historical Society. The community, generous with its volunteer hours, historical artifacts, and resources, has built a museum, library, and pioneer village complex at 1031 Bridge Avenue, Albert Lea. It is recognized as one of the leading historic sites in Minnesota. Shown in this sketch are, from left to right, as follows: FCHS museum, Big Oak School, Livdalen cabin, general store, and Norsk Evangelisk Luthersk Kirke. (By Beverly Piel Jackson, 1996.)

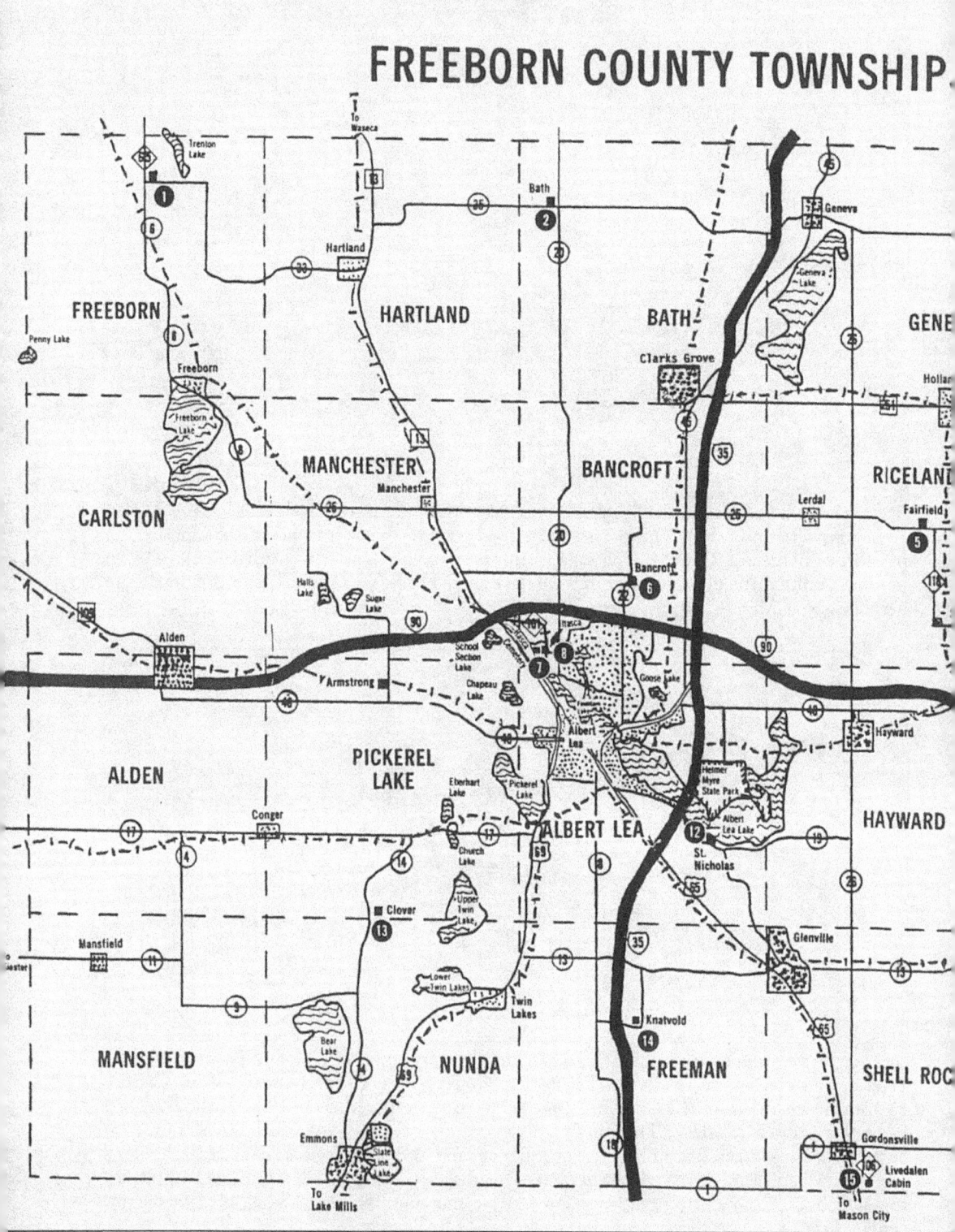

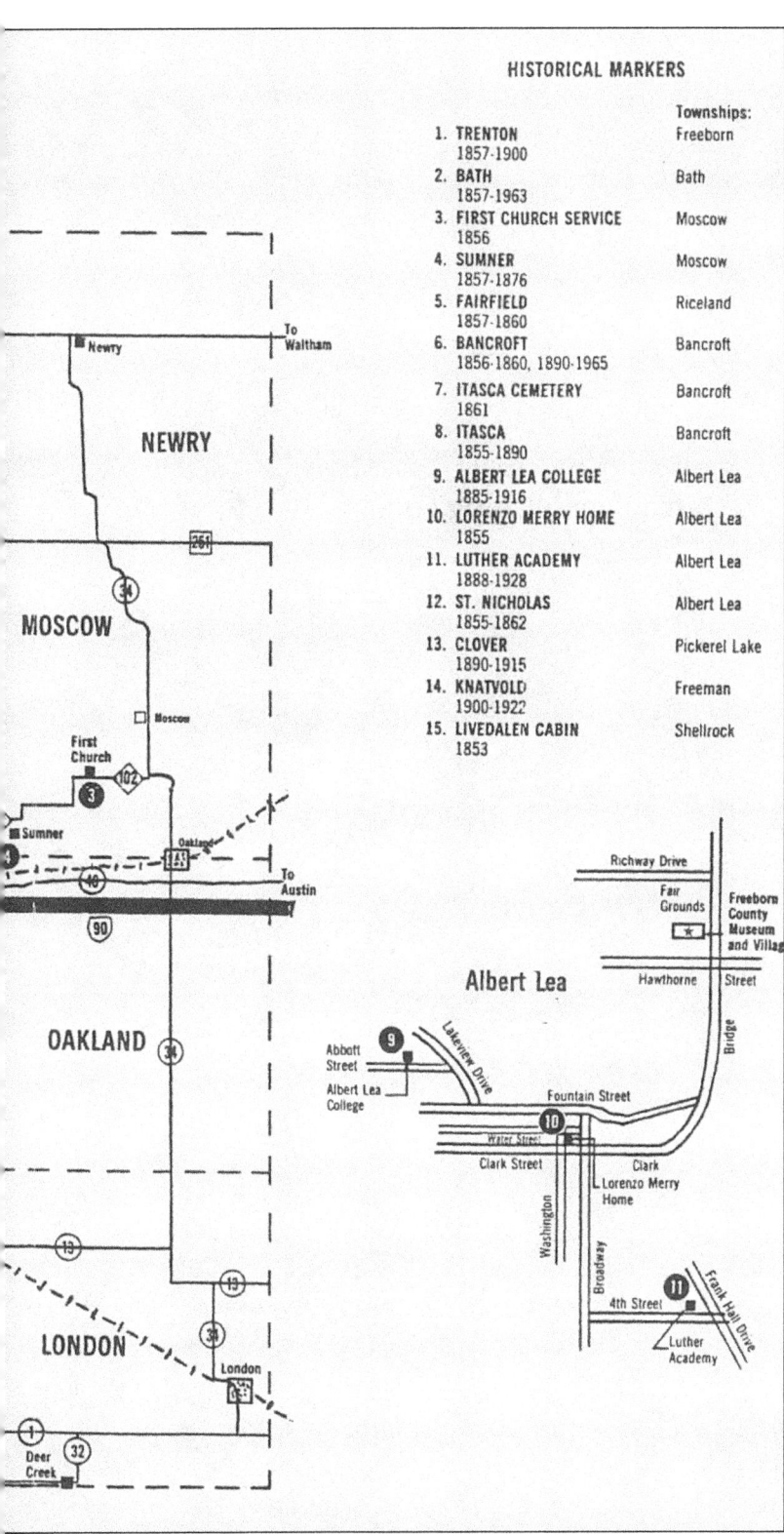

This is a map of Freeborn County, Minnesota.

Visit us at
arcadiapublishing.com

www.ingramcontent.com/pod-product-compliance
Lightning Source LLC
Chambersburg PA
CBHW080856100426
4281 2CB00007B/2055

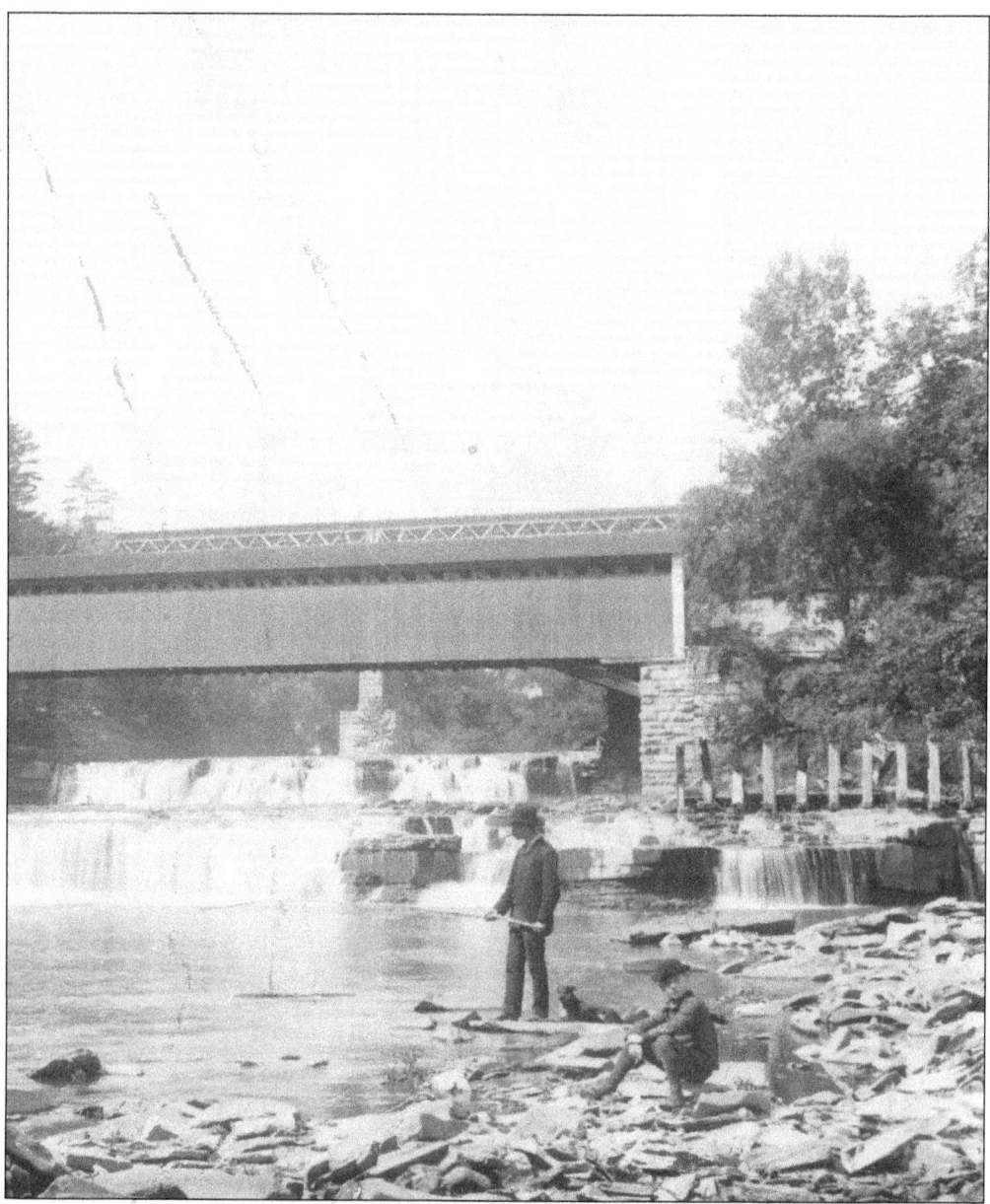

This 1880 scene, photographed at Frenchs Hollow, shows the covered bridge spanning the waterfalls and two Guilderland residents enjoying the sun and a little fishing. Swimming was a recreational treat in the cool, clean waters of the Normanskill.

IMAGES of America

GUILDERLAND
NEW YORK

Alice Begley and
Mary Ellen Johnson

ARCADIA
PUBLISHING

Copyright © 1999 by Alice Begley and Mary Ellen Johnson
ISBN 9781531600723

Published by Arcadia Publishing
Charleston, South Carolina

Library of Congress Catalog Card Number: 9960798

For all general information contact Arcadia Publishing at:
Telephone 843-853-2070
Fax 843-853-0044
E-mail sales@arcadiapublishing.com
For customer service and orders:
Toll-Free 1-888-313-2665

Visit us on the Internet at www.arcadiapublishing.com

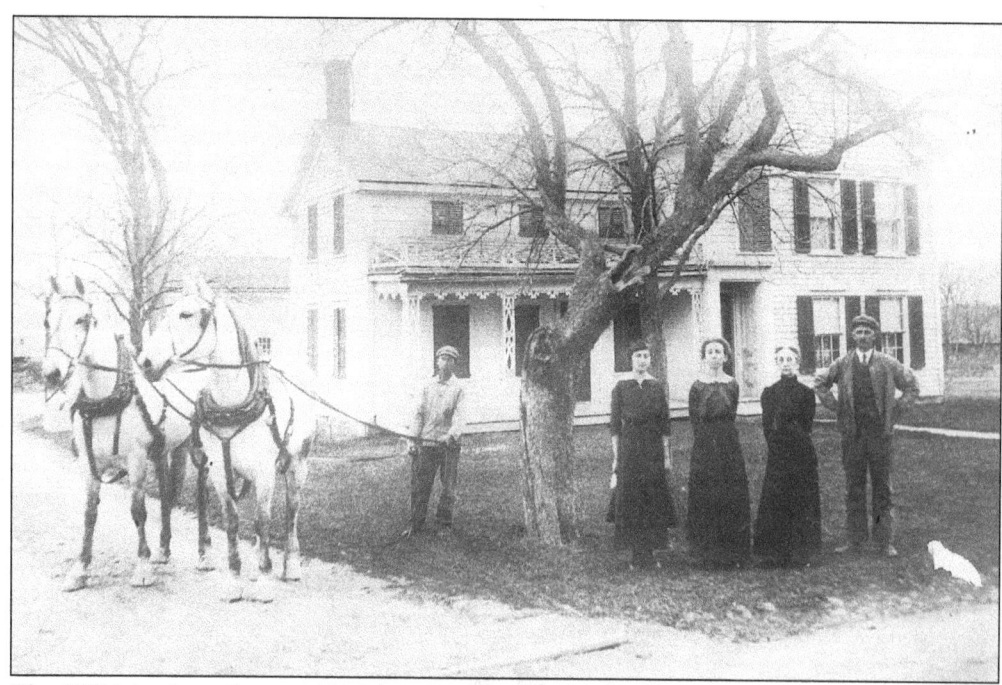

The Will Mynderse Farm at 151 Main Street in Guilderland Center was typical of the 1890s era. John Wormer stands with his team of horses while Mabel Tullock, Mrs. Tullock, Mrs. Shannon, and Andrew Tullock look on. The house still stands on Route 146, across from the Mynderse-Frederick House.

Contents

Introduction		7
1.	McKownville and Westmere	9
2.	Guilderland Hamlet	29
3.	The Great Western Turnpike	47
4.	Guilderland Center and Frenchs Hollow	65
5.	Altamont and Altamont Fair	85
6.	Back Roads and Country Byways	109
Acknowledgments		128

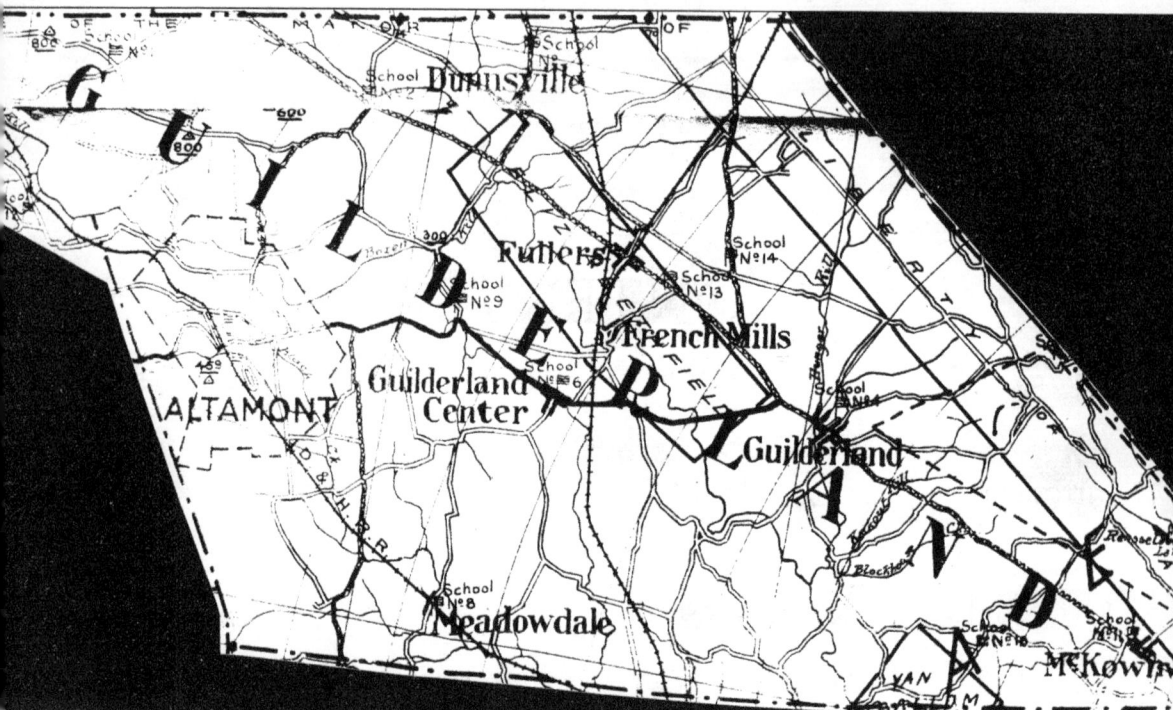

Shown here is an 1890 map of Guilderland, New York. Note that Meadowdale, Dunnsville, and Frenchs Mills were equally as important at that time as Altamont, Guilderland Center, and McKownville. Westmere was not in existence then.

Introduction

Winston Churchill wrote, "Without a sense of history, no one can truly understand the present." Looking at the town of Guilderland through photographic images brings to life the people and events that have shaped our town and allows us to visualize the time when simple farm areas and close-knit hamlets formed the landscape. This collection of photos from the Guilderland Historical Society and various other contributors permits us to present a different perspective of our town today. The photographs record Guilderland's history from the 1880s to 1960 and pay tribute to the people and achievements that have shaped Guilderland as we know it.

Hundreds of years ago, before Guilderland existed, bands of Mohican Indians camped and hunted along the Normanskill Creek. This turbulent stream harbored Mohican and Mohawk canoes as they slipped quietly downstream to the Hudson River to trade at the Dutch trading post. The resources of good soil, waterpower, and timber that could be found at the banks of the Normanskill and at the foot of the majestic Helderberg escarpment encouraged the Dutch magistrates to begin making land deals with the Mohicans. The area became a part of the Manor of Rensselaerwyck under the Patroonship of Killean Van Rensselaer. Throughout the Revolutionary War, sturdy pioneer families moved west to this outlying area, establishing farms along the waterway and paying rent to the wealthy patroon.

Since its pioneer days in the 1700s and its formal beginning in 1803, Guilderland has been a historic and unique locale. On February 10, 1803, Nicholas V. Mynderse proposed a petition to the State Assembly requesting that 58.67 square miles of land be separated from Watervliet, yet remain part of the Van Rensselaer Manor. The town was established on April 3, 1803, and named Guilderlandt after the Province of Gelderland in the Netherlands, the birthplace of the first patroon. Mynderse was elected as the first supervisor.

When the rural community organized itself into the first township of Guilderlandt, Thomas Jefferson was President and the Union flag boasted 15 stars and 15 stripes. The Louisiana Purchase was the first territorial expansion of the new nation, and Lewis and Clark had just begun their Northwest Expedition.

Historians note that the first improved highway heading west was the old Schoharie Road between Albany and Schoharie. It passed through Hamiltonville (Guilderland), Guilderland Center, and Altamont. Inns, taverns, and small farmhouses sprang up along this route that preceded the Great Western Turnpike, which was

completed in 1799.

In the 18th century, only a few people lived in the eastern section of Guilderland, an area of scrub pine and sandy soil laced by ravines and streams. William McKown, a later town supervisor, built a tavern on the border of the city of Albany, where the Kings Highway stretched through the Pine Bush toward Schenectady. The Palatine Germans marched from Albany southwest to Schoharie, crossed the Normanskill, forded the Black Creek, and headed toward the Helderberg escarpment, where many of them settled and built their farms at the foot of the "bright and clear mountain."

In the 19th century, Guilderland was rural America in microcosm. Agriculture replaced forest wilderness, and as turnpikes and railroads cut through the countryside, hamlets and crossroad communities developed. Town government and school districts were established, post offices opened inside general stores, and churches flourished. By the end of the century, Guilderland's 4,000 residents could read a weekly newspaper and attend an annual agricultural fair. A progressive town with small businesses, hotels, stores, and factories was in place. Yet life actually changed little in the 19th century. Children learned in the same one-room schoolhouses their parents had attended, travel was still by horse and buggy over dirt roads, families lighted their homes by kerosene, and there was a privy behind every house in town. Children born in the waning years of the 19th century, however, would grow old in a Guilderland far different from the one they experienced in their youth.

At the end of the 20th century, the western section of Guilderland remains mostly residential, with scattered farms and small businesses, though urban development is slowly changing the landscape. A State University of New York campus anchors the eastern end of the town adjacent to Albany, the state's capital city. That section of Guilderland has mushroomed into a growing commercial and residential suburb with a large shopping mall, several smaller shopping centers, business and apartment complexes, housing developments, and fast-food restaurants.

The Great Western Turnpike, which is referred to throughout this publication, is now more commonly referred to as Route 20. The old Schoharie Plank Road is now Route 146 from Route 20 to Altamont. We have attempted to begin the photo images at the eastern border of Guilderland and travel out the Western Turnpike to the town's other interesting communities, some of which have thrived while others have virtually disappeared.

One
McKownville and Westmere

McKownville derived its name from the John McKown family, who originated in Scotland, later moved to Londonderry, Ireland, and immigrated to America in the late 1740s. The first member, John McKown, leased the Five Mile Tavern near Indian Quad of the State University campus, built 200 years later. His son, William McKown, built a tavern in 1790 at a lonely crossroads (now Fuller Road and Western Avenue), anticipating the completion of the Great Western Turnpike in 1799. The turnpike became the main highway for travelers from the west to the Albany markets. The McKown family later donated land in Guilderland for the site of a church and school in the McKownville hamlet.

McKownville's proximity to the capital city of Albany destined it to become a hub of great business ventures. Although part of the hamlet retains its small community status, the boundaries of a metropolitan city and the New York State Northway and Thruway brought about its inevitable commercial and suburban destiny.

Westmere, on McKownville's western border, was a rural area with small cottages and isolated farmhouses dotting the landscape until returning World War II servicemen, looking for a "green spot" to raise their families, sought Guilderland's lush farmlands. One-family housing developments sprang up along the turnpike, renamed Route 20. Westmere, the hamlet connecting McKownville and Guilderland, is not noted in older history annals.

This 1960 aerial view of McKownville and Westmere shows Fuller Road (bottom), the Western Turnpike/Route 20 (upper-left), and Stuyvesant Plaza (bottom center), which opened in 1959. Also pictured is the New York State Northway (top).

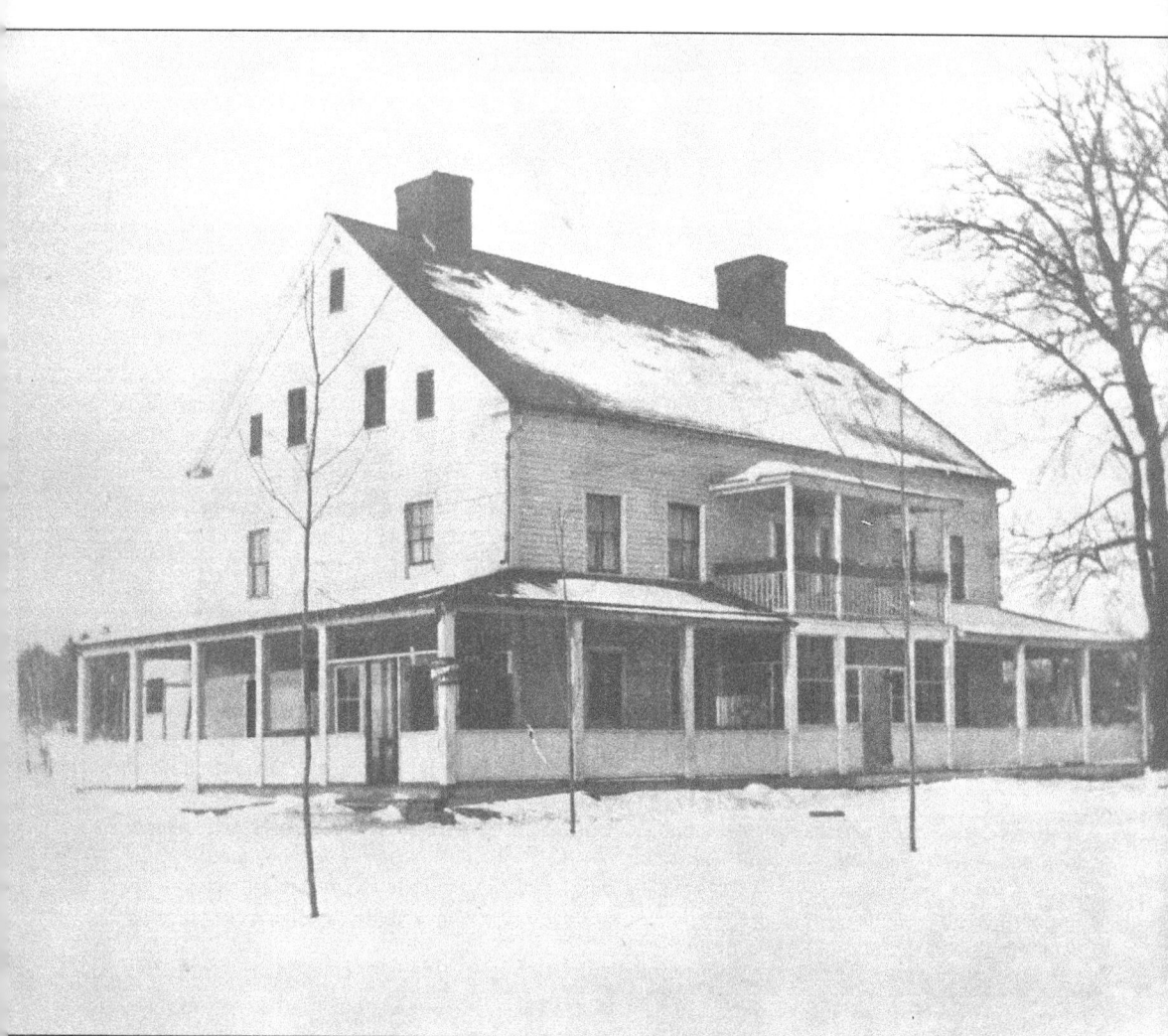

Over 200 years ago, "Billy" McKown built this tavern on a lonely dirt road leading west to feed hungry pioneer travelers. He cleared the land 5 miles west of the Hudson River, anticipating the construction of the Great Western Turnpike. McKown gave right-of-way to the Turnpike Company over a parcel of 600 acres. His tavern prospered, and the inn became a stopping place for New York State militia units, who camped on the tavern grounds on their way to Anti-Rent Wars in the Helderbergs (1839). McKown became the supervisor of Guilderland from 1813 to 1824. In 1884, William Witbeck bought the tavern, and it housed McKownville's post office until it was destroyed by fire in 1917. The King Shell Station then occupied the site. Today, fast-moving travelers stop at the same acre of land, at the busy intersection of Fuller Road and the Western Turnpike, to satisfy their hunger at a Burger King restaurant located on the historic site.

The McKownville Methodist Church was founded as a mission church for the Methodist Church in Hamilton, an early name for the village of Guilderland. The first structure of the McKownville Church was built in 1866 on land donated by John McKown, the son of William McKown. Rev. Edward Taylor was pastor. The original building, which still stands today, was erected on the Western Turnpike in 1898. At that time, Rev. Hamilton Allen supervised the building of the new church; it had a congregation of approximately 90 members.

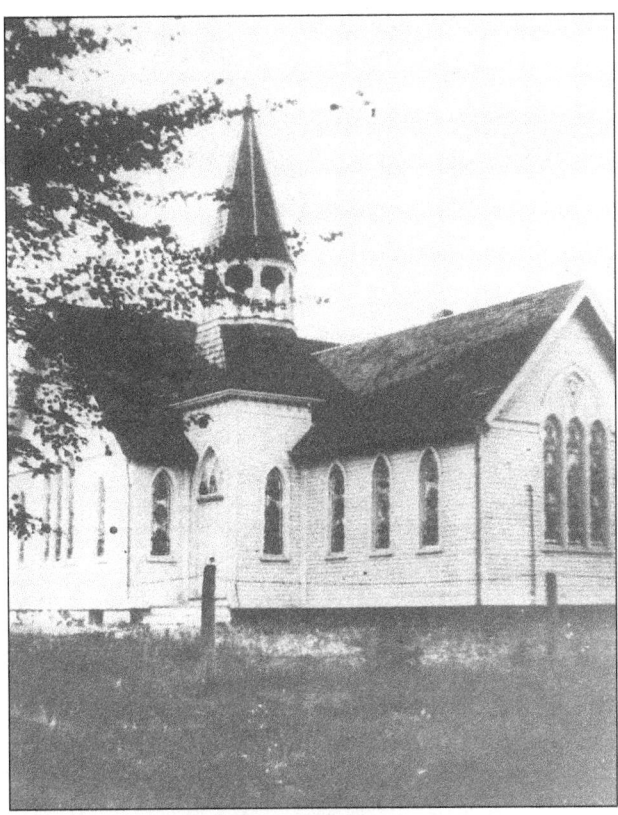

This system of hollow-log conduits, laid from the branch of the Krum Kill, served as McKownville's first water source in 1824. Sections of wooden pipes were 6 inches in diameter, and 6 feet long with a 2-inch bored hole. In order to fit together, one end of the pipe was pointed and the other was tapered. The water serviced the old McKown Hotel, the stock pens nearby, and several residences. The conduits were unearthed in 1969 near the McKownville Filtration Plant.

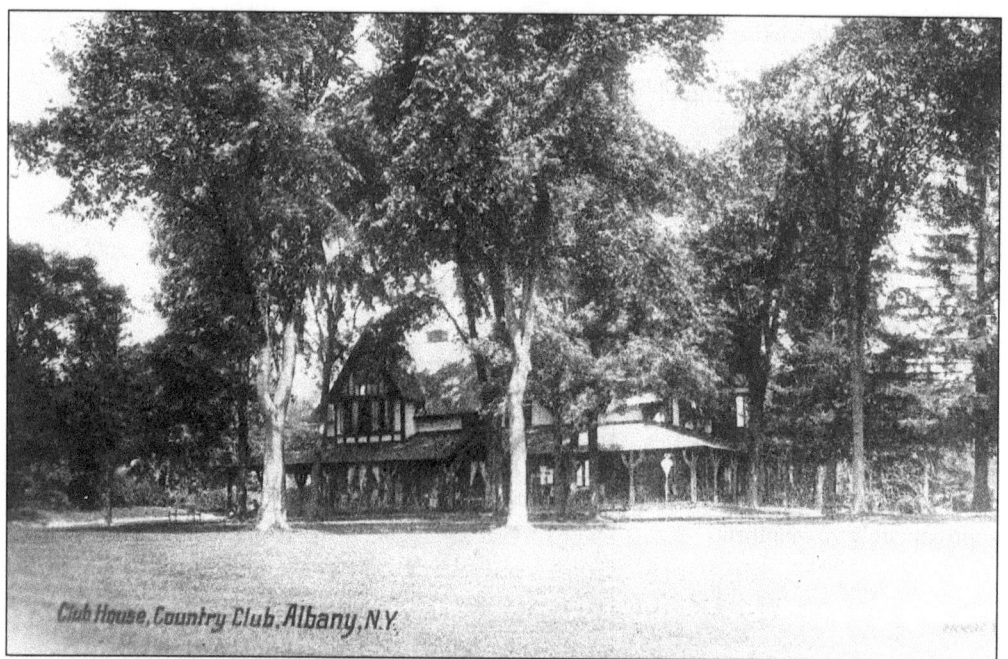

The Albany Country Clubhouse, set back from Western Avenue at the Guilderland/Albany City Line, was built in 1896. The King's Highway roamed through this scrubland in the mid-1700s for travelers heading west from Albany through the Pine Bush. The first tavern on the old road was the "Five Mile Tavern," built near the present site of Indian Quad on the State University of New York campus. The old road was obliterated by the Albany Country Club golf course and the university buildings. The clubhouse burned in February 1963.

In a woodland setting at the end of Waverly Street in McKownville, this baronial hunting lodge once housed political secrets at meetings of the "Barnes Machine." It was built in 1905 by William Barnes, who was the powerful chairman of the Albany County Republican Committee and the grandson of prominent politician and journalist Thurlow Weed. The rustic house, finished with wide-board teak flooring and a two-story main hall with a massive fireplace, became the Chapel House for the State University of New York. It was destroyed by fire in the summer of 1985.

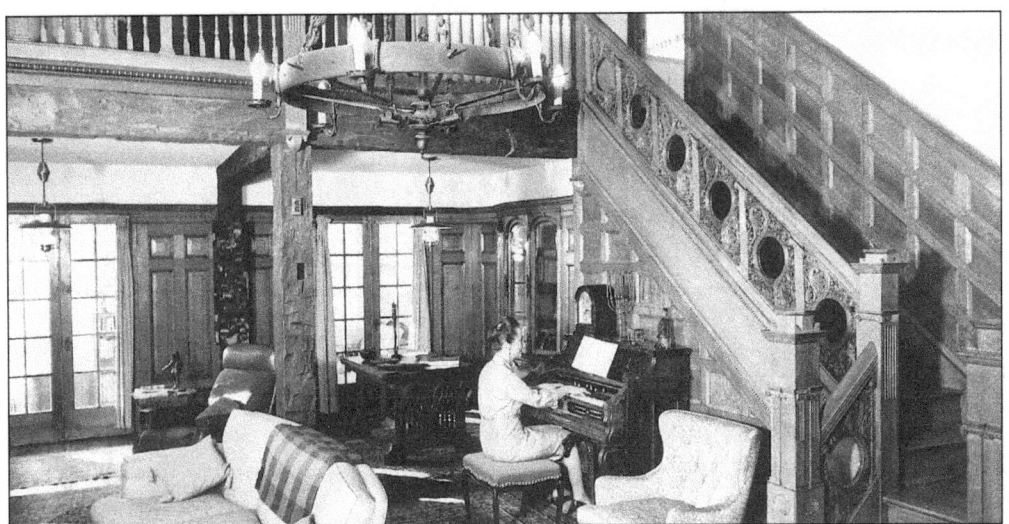

Albany attorney Thomas F. Wood built this early 1900s home, composed of bits and pieces of old Albany houses, as a wintering spot next door to the Barnes lodge. The living room was comprised of bits of the Brewery Inn. The oak cabinets and paneling came from the Myers and Whitney Houses, which once stood on Albany's Capitol Hill. Ceiling beams were from an ancient stable, and the chandelier was made from a wagon wheel and Civil War bayonets. Former University Dean of Students Mrs. Lois Gregg lived in the Wood House before it was demolished for university expansion.

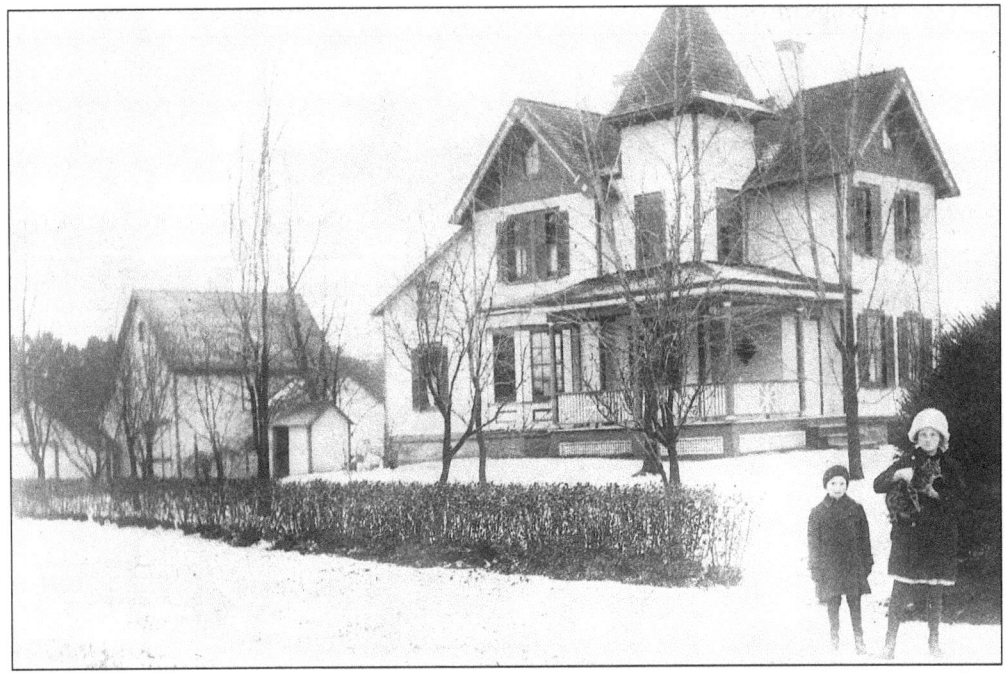

The George Manville residence, built in 1880 at 1438 Western Avenue, was located next door to the Tom Sawyer Motor Inn. Mrs. Manville was the organist at the McKownville Methodist Church from 1896 to 1951. The house was later occupied by the Crouse family. In 1980, it was converted into the Huckleberry Finn Pottery shop. The land is presently occupied by the Passonno Paint store.

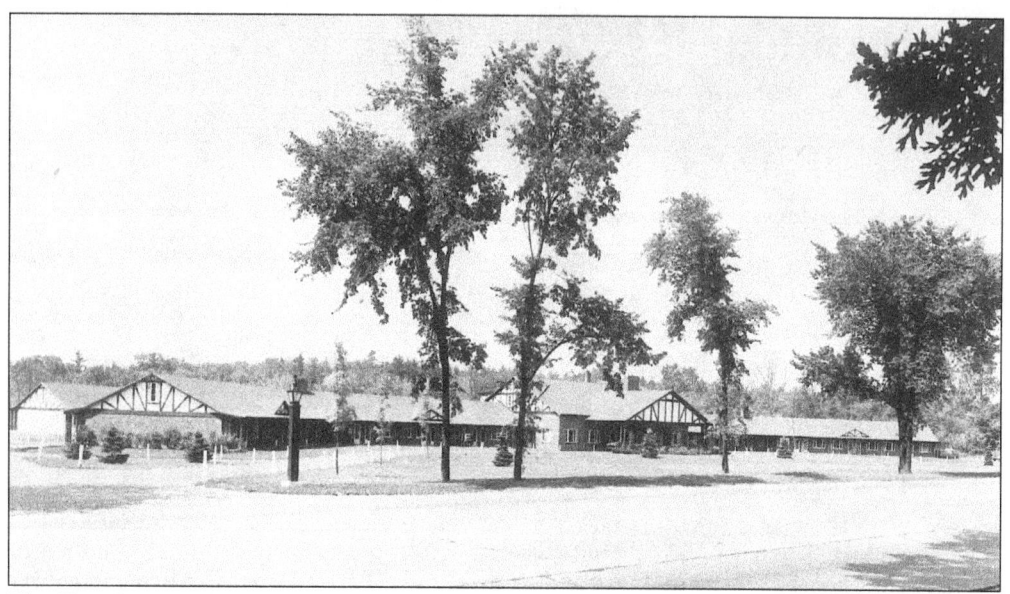

The Tom Sawyer Motor Inn on Western Avenue brought classy new traveler accommodations and elegant dining to Guilderland. Built in 1950, it became a popular meeting place for many community and business groups in town. McKownville's first traffic light was installed at Fuller Road and Western Avenue a year after the inn opened. A swimming pool was added on the front lawn several years after this picture was taken. A Holiday Inn Express and two medical offices now occupy this site.

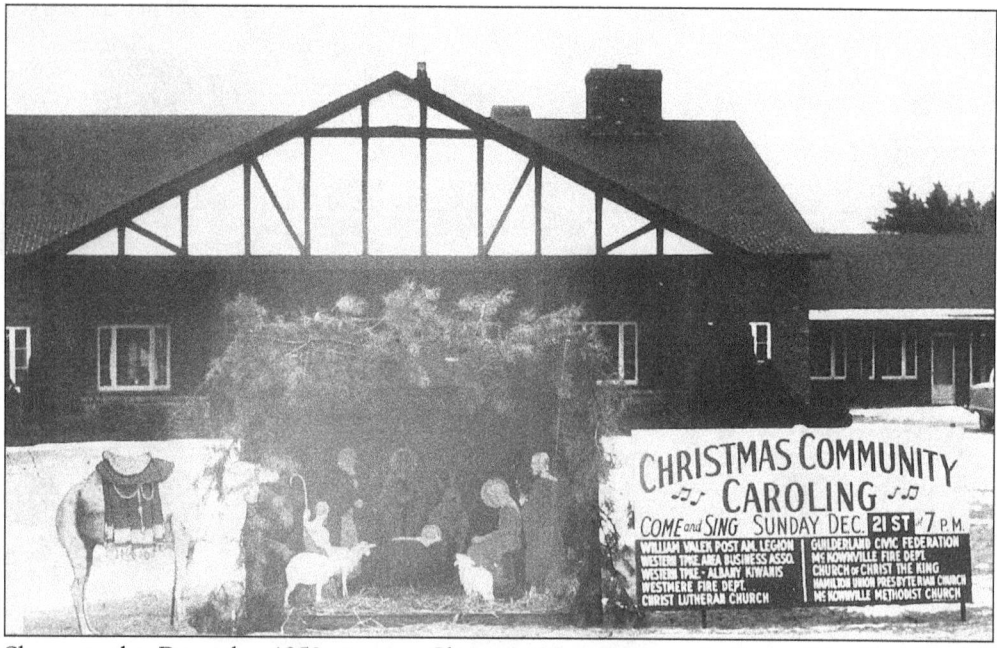

Shown in this December 1958 view is a Christmas Nativity scene in front of the Tom Sawyer Motor Inn. The scene was heralded by a community Christmas caroling that became a custom for many years. The event was sponsored by Western Turnpike Kiwanis, the Western Turnpike Rescue Squad, the Westmere and McKownville Fire Departments, the McKownville Fire Ladies' Auxiliary, the Westbrook Association, and the McKownville Methodist Church.

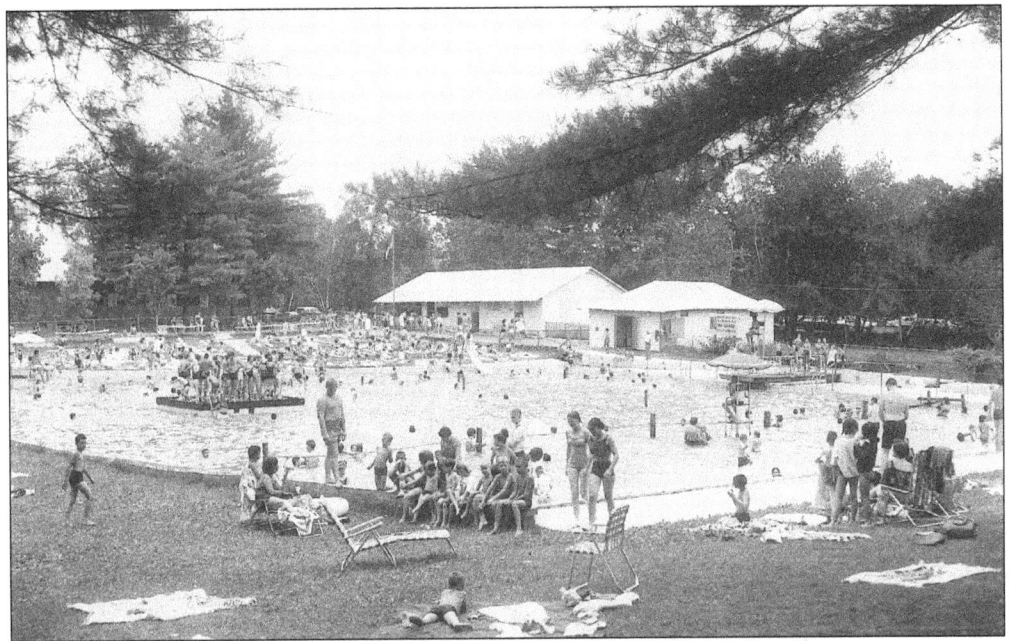

McKown's Grove was a favorite swimming spot in Guilderland for many years. It was opened in 1896 by William (Squire) McKown, grandson of the tavern-famous "Billy" McKown. The old swimming hole began at the dam of the water supply, causing the hamlet of McKownville to become a mecca for picnics, swimming outings, and clambakes. The Grove, situated on the land behind the Tom Sawyer Inn, was closed in 1980. A medical office building is presently located on the site.

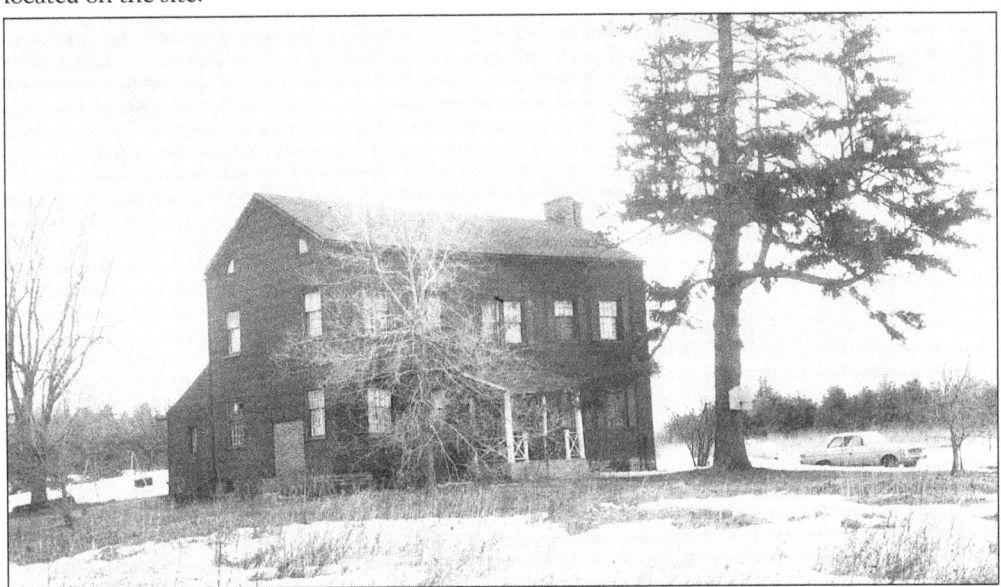

The John McKown Farmhouse, located on McKown Road beyond Short Street, was built c. 1815. The house and land, carved out of "Billy" McKown's land holdings, was most likely a wedding present to his son John and his son's bride, Catherine Hilton. The house had a fireplace in every room and a large kitchen fireplace in the basement, complete with a crane. It later became the residence of William and Margaret Knowles, before being demolished in 1970.

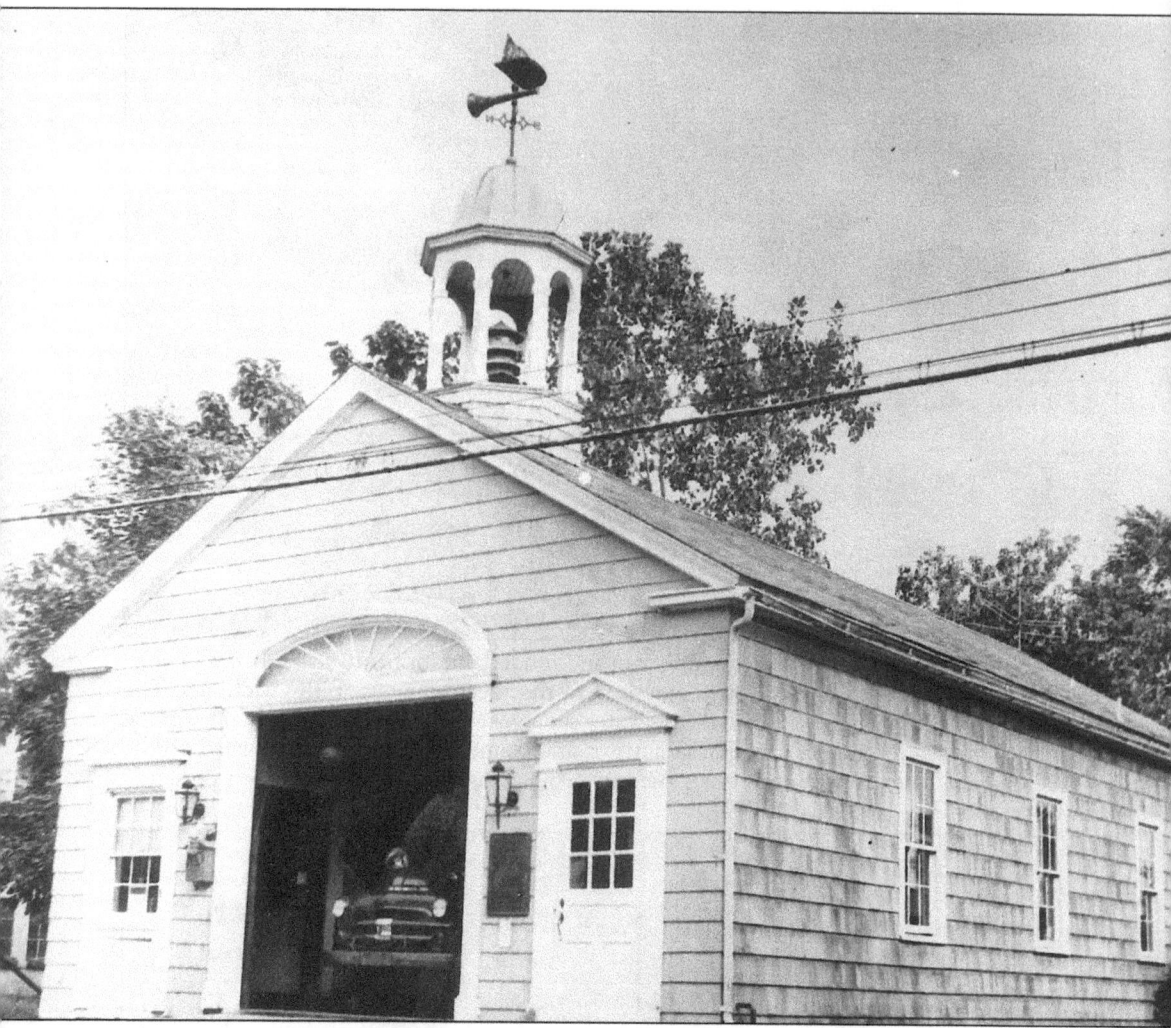

The McKownville Fire Company was established in 1918, after the opening of the Country Club Trolley Line. One early piece of fire equipment was a two-wheeled hose cart with a chemical tank housed in the carriage house behind the Witbeck (McKown) Hotel. The first alarm system was a locomotive tire hung outside the hotel that was hit with a sledge hammer in times of emergency. In 1933, on land offered by the Shell Oil Company, the Arcadia Street Firehouse was built for $10,850 and was dedicated on April 6, 1935. Today, the McKownville Fire Department has a three-bay firehouse on the Western Turnpike with three pumpers and a squad truck.

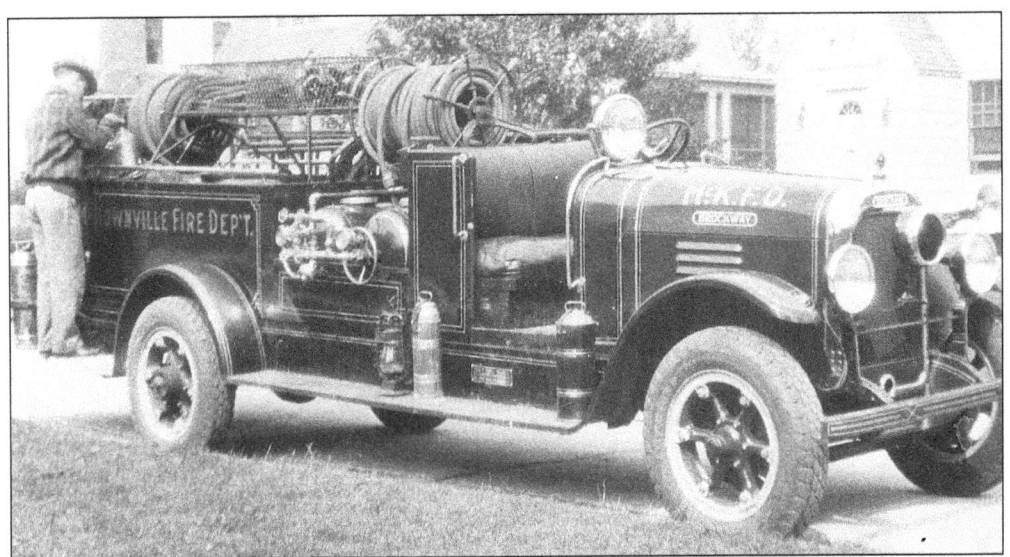

This Brockway fire truck was purchased by the McKownville Fire Department in 1931 for $1,825. It serviced the McKownville district until 1951, when it was retained as a second truck due to its small size and ability to get over narrow roads of the Pine Bush to fight brush fires. A new $20,000 Dodge fire truck was purchased in 1957, and the Brockway truck was sold to a New England amusement park for $150.

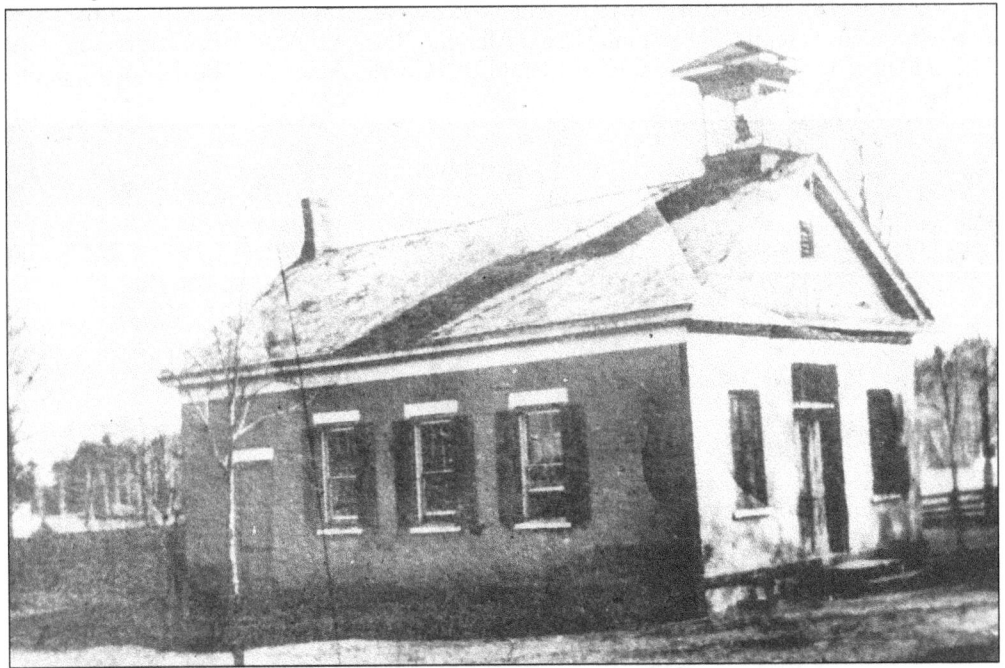

The one-room McKownville District School #11, located on the Western Turnpike at Schoolhouse Road c. 1877, had another room added at the turn of the century. Land for the school was deeded by the McKown family. The school was retired in 1954 when the Guilderland School District consolidated and the Westmere Elementary School opened. The John G. Myers Company opened a children's clothing store in the brick building, but it was destroyed by fire in the late 1950s. Albank is located on the premises today.

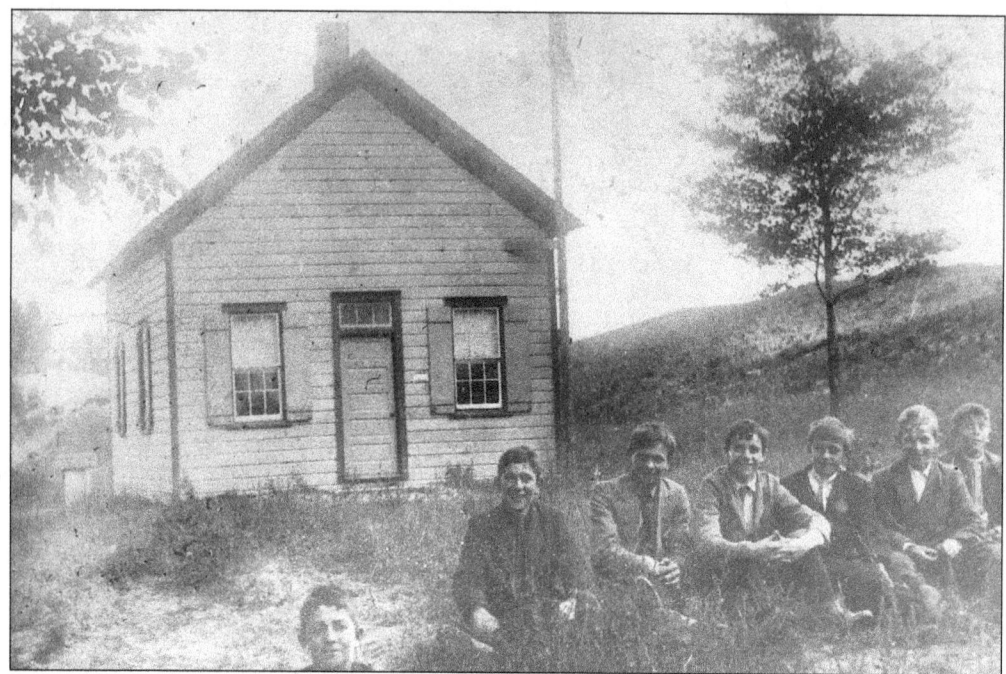

The McKownville Annex School #11-A was located on Johnston Road, opposite Veeder Road. It was built in 1887 and retired in 1953. The young Guilderland students pictured here are, from left to right, Joseph (John) Stahl, Harold Albright, Raymond Ableman, Charles Johnston, Arthur Manweiler, Floyd Johnston, Allen Gerald, and Charles Ableman. The date of this photo is unknown.

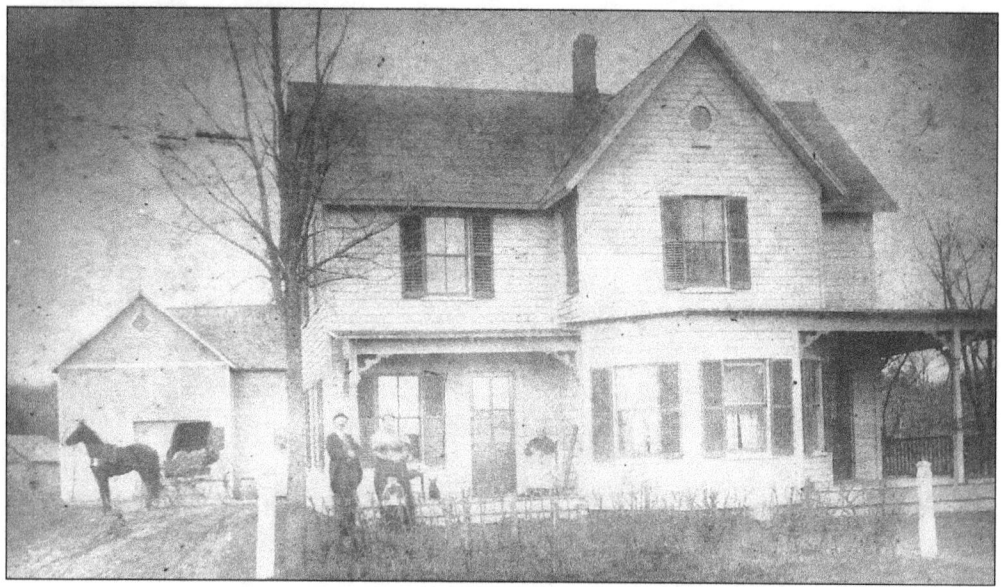

Unrecognizable as Western Avenue, this c. 1890s photo shows William and Hannah Knowles with their son William at their 1261 Western Avenue home built in 1884. Grandmother Knowles is seated on the front porch. William Knowles later resided in the John McKown Farmhouse on McKown Road. Note the horse and buggy on the dirt driveway (now Knowles Terrace).

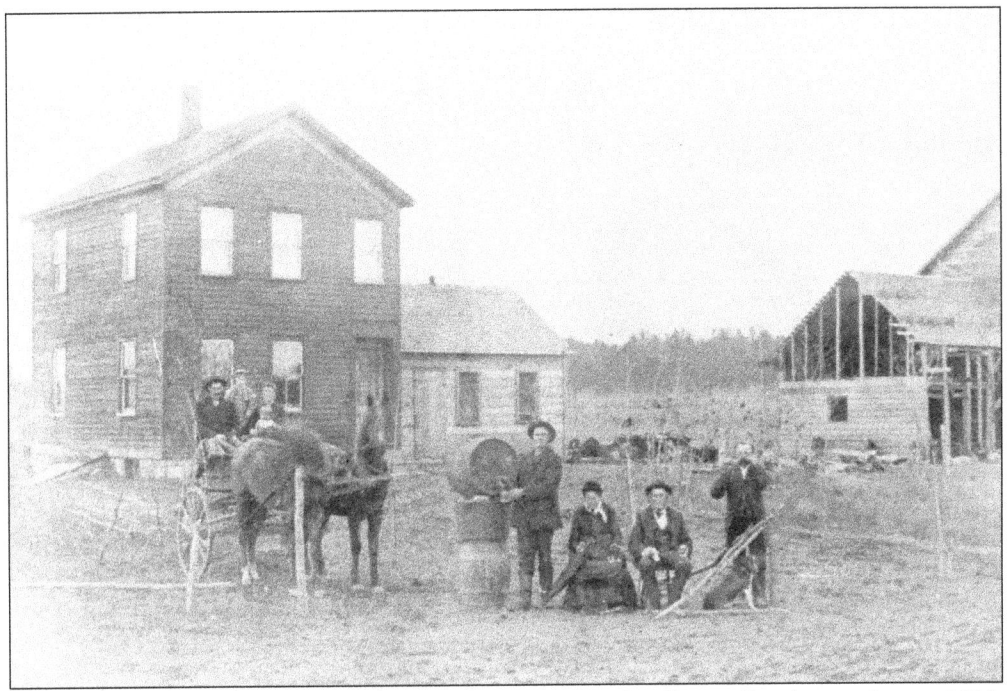

This image of the Gustave Ziehm House and barn on Schoolhouse Road was taken c. 1885. Ziehm and his wife, Marie, are in the wagon with their son Gus; seated in the yard are Ziehm's parents with neighbors standing by. The barn still stands, but it is now on the Woodlake Apartment grounds beside the tennis courts.

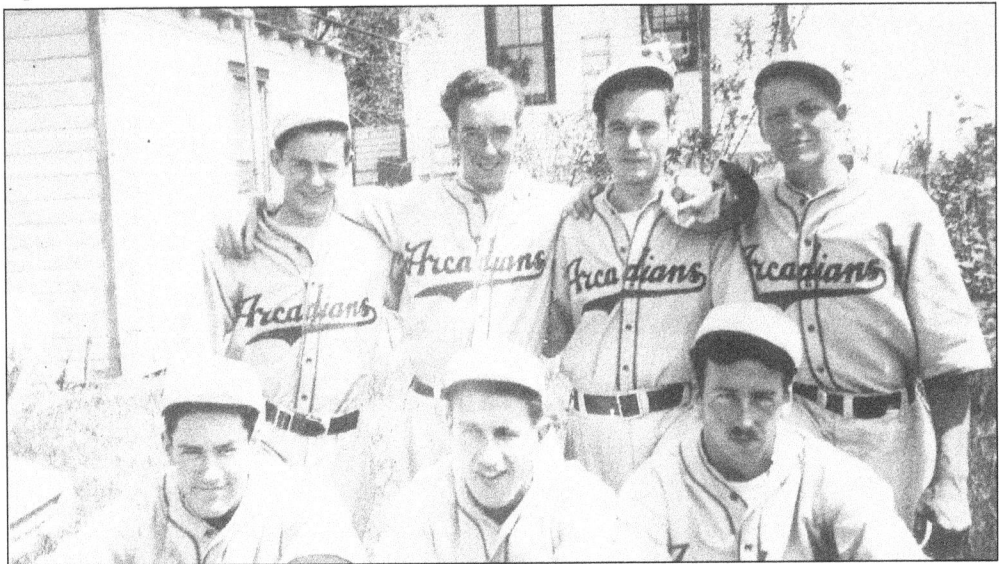

The McKownville "Arcadians" baseball team was named after the street most of the players lived on. The swampy and brush-filled playing field was located behind the Whitbeck Tavern. The team included Spencer Noaks, Ossie Gepfert, the three King brothers, Tom, Chet, and Jack, Ed Sickler, Bob Feldman, Stan Rice, Chuck Ebel, Fran Finegan, Clint Groves, Bill May, Fran Scanlon, Bill Thompson, Arn Volk, and others. The team disbanded when the Tom Sawyer Motor Inn was built on the Whitbeck Park land.

The electric trolley that serviced McKownville residents at the turn of the 20th century stopped at the Albany City line before it entered the hamlet. This transportation marvel was proposed to reach from Manning Boulevard in the city to the hamlet of Fullers, 7 miles out on the Western Turnpike in Guilderland. The proposal died, and a single track was laid from Manning Boulevard to the Krum Kill at Guilderland's border, where Sutter's Mill presently stands opposite the entrance of the State University at Albany.

The Christ Lutheran Church, located on the Western Turnpike at Highland Drive, was built in 1957. The roots of the church in the eastern end of Guilderland go back to 1928, when two Lutheran Seminary students canvassed the 4,000 residents of the town of Guilderland. First services were held in an apartment on the Western Turnpike in 1931. After several moves, the Church bought land under the auspices of the Reverend Arthur Gerhardt, whose ministry there spanned from 1944 to 1979. Reverend Gerhardt remains active even in retirement, serving as vacancy minister at several churches.

Dedication ceremonies for the 1964 opening of Whitney's Department Store at Stuyvesant Plaza drew a large gathering of Guilderland residents. Music was provided by the Guilderland High School Band. Officials in attendance included Town Supervisor Gordon Robinson and Lewis Swyer, the building contractor. Built on land that once housed the cattle of drovers staying at "Billy" McKown's tavern, the shopping center heralded a new era of business in the Guilderland township.

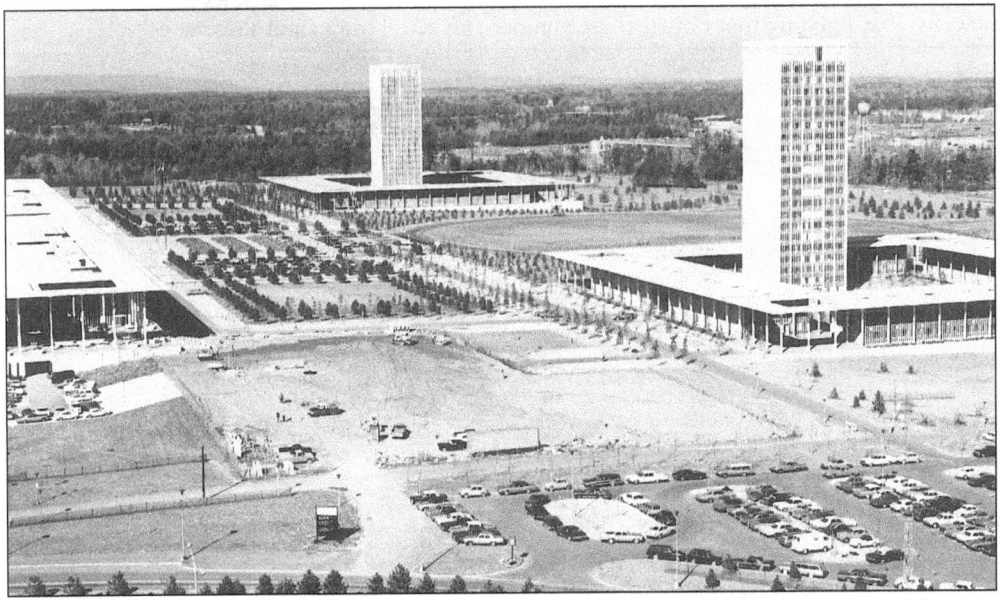

The changing face of McKownville in the town of Guilderland is depicted by two of the four SUNY student resident towers rising on the community landscape in the early 1960s. Today, additional high rise buildings join the changing scene to alter the view of the Helderberg Mountains on the horizon.

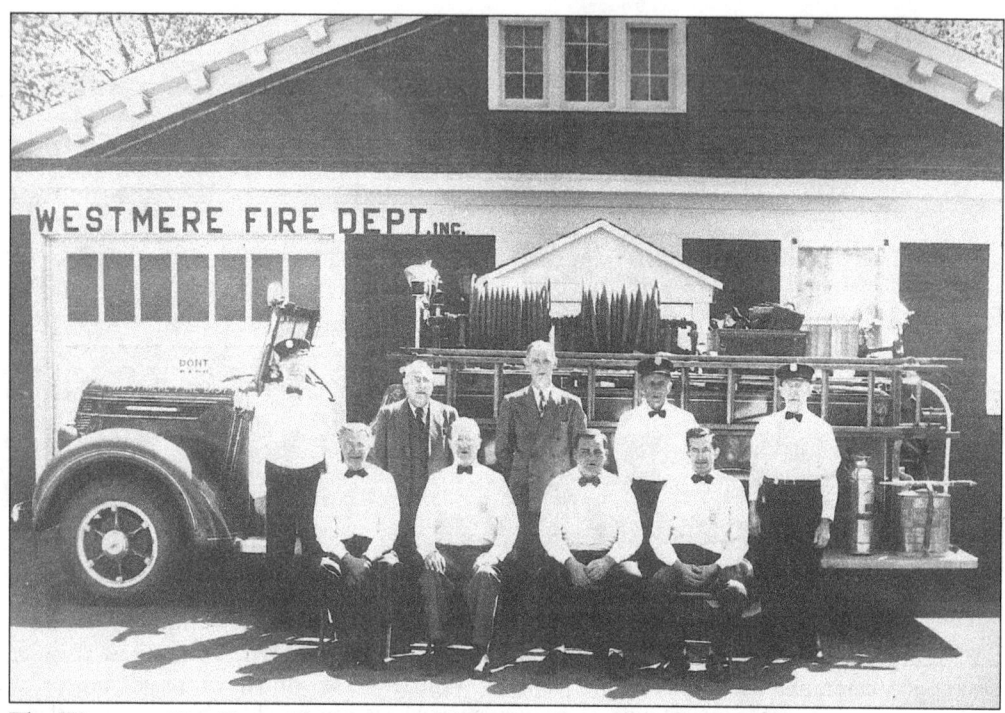

The Westmere Fire Department, organized in 1935, built a one-bay firehouse at 1690 Western Avenue. This photo shows a 1937 fire truck. From left to right are as follows: (seated) J. Fullenwilder, J. Clas, Ed Keller, and Howard Beebe; (standing) G. Trap, Ed Gladding, E. Hennessey, H. Sager, and C. Goodrich. The fire district population grew from 400 in 1937 to 10,000 in 1998. The department presently protects five shopping malls. Its facilities include a new, five-bay building that houses three pumpers, an aerial truck, and a rescue vehicle.

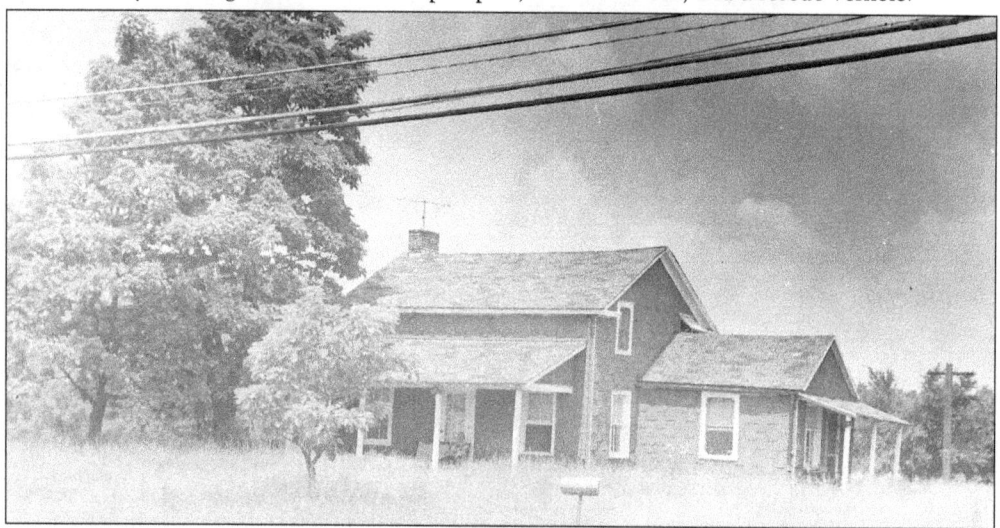

In the 1940s, the Leopold Stahl residence at 1745 Western Avenue included a 5-acre pig farm. Mr. Stahl was born in 1871 and operated this farm and a garden farm on Veeder Road off Johnston Road. The Pine Bush Little League played baseball games on his property. In 1955, a parcel of the Stahl land was acquired by the Westmere Fire Department for the building of a new firehouse. The Monroe Muffler Company now occupies part of the land.

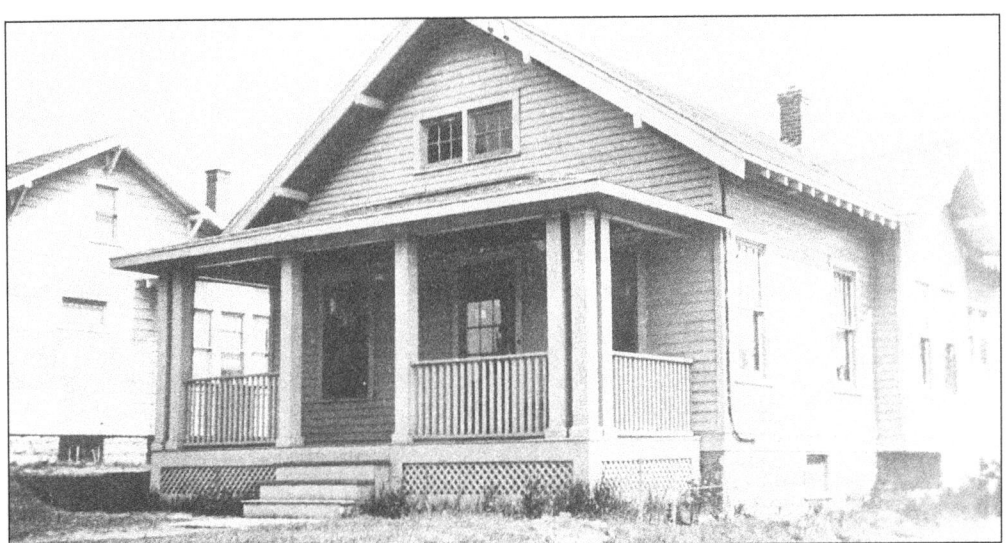

This is a typical 1935 bungalow along the Great Western Turnpike (now Route 20) in Westmere. Most of these cottage-type homes sprang up in what had been farmland in the post-World War I era. The name "Westmere" came into being in the 1940s with the post-World War II surge in building. There is little earlier history written about this section of the town of Guilderland.

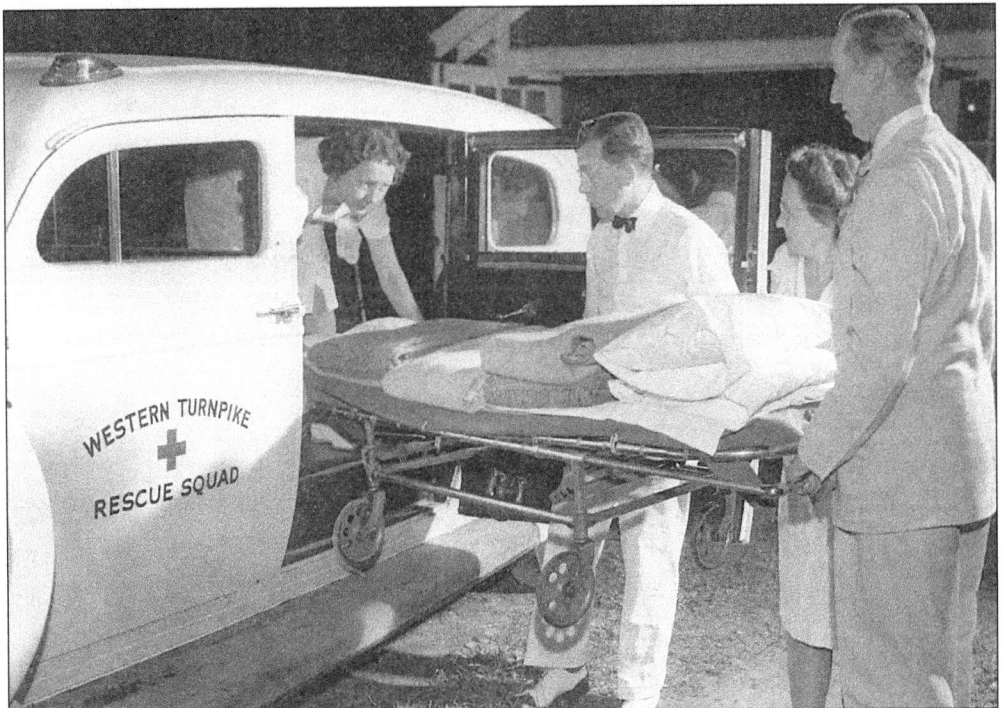

The Western Turnpike Rescue Squad was established in 1939 and was located on the Western Turnpike and York Road. In 1952, the squad had a budget of $2,856 and a total of 108 calls for the year. In 1997, the squad answered approximately 3,000 calls and had a budget of $150,000. The volunteer squad now has two buildings and three ambulances. This 1946 picture shows rescue squad workers with a 1939 Dodge ambulance.

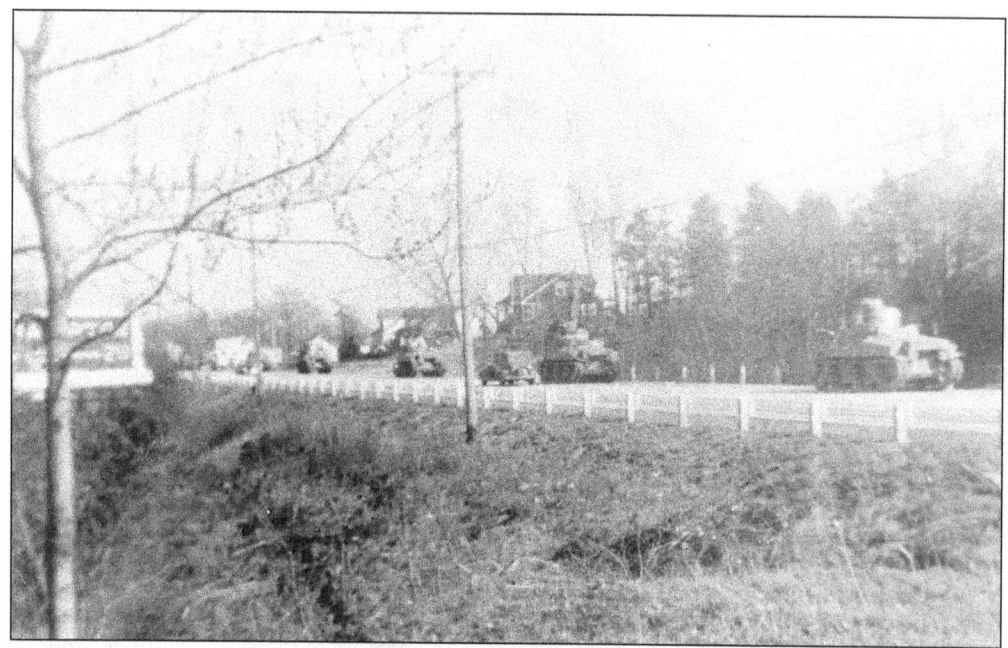

In this 1945 scene of the Western Turnpike, U.S. Army tanks make their way from the Voorheesville Army Depot. To the left of the photo (the north side of the road), near the sign, is the present-day Frame and Art Shop. The wooded area of the south side of the turnpike is now Cosimo's Plaza.

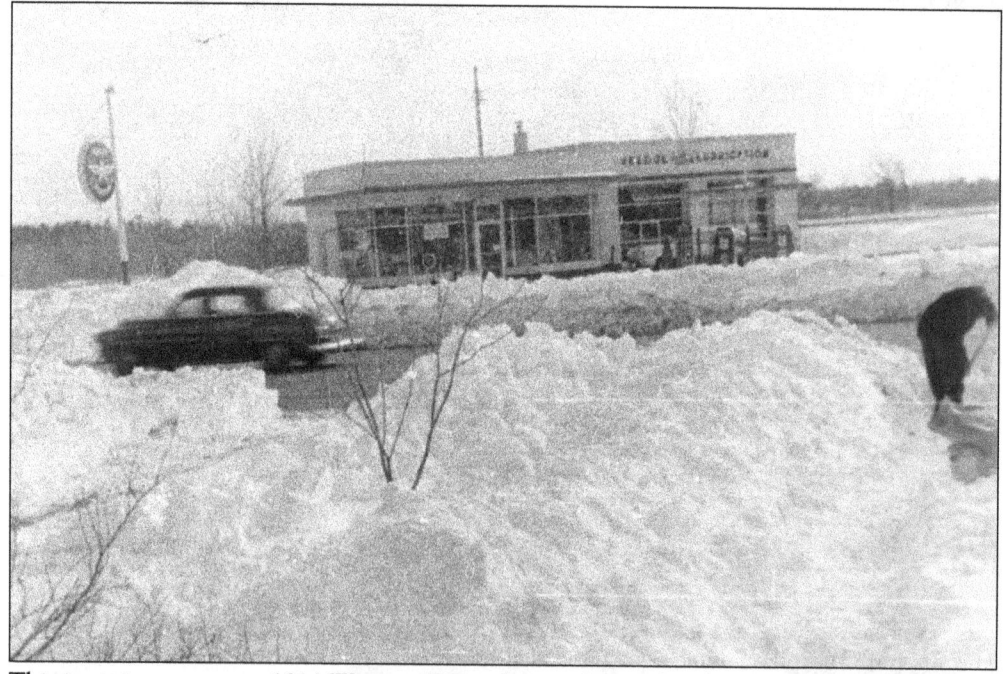

This is a winter scene at 1814 Western Turnpike, on the south side, where the Tydol Station was built in 1946. It was one of the first large corporation gas stations to be built in the area. Figliomeni's Restaurant is presently located there. Snowblowers were not a convenience as they are today. There were several 1935 bungalow-type houses in the area of the shoveler.

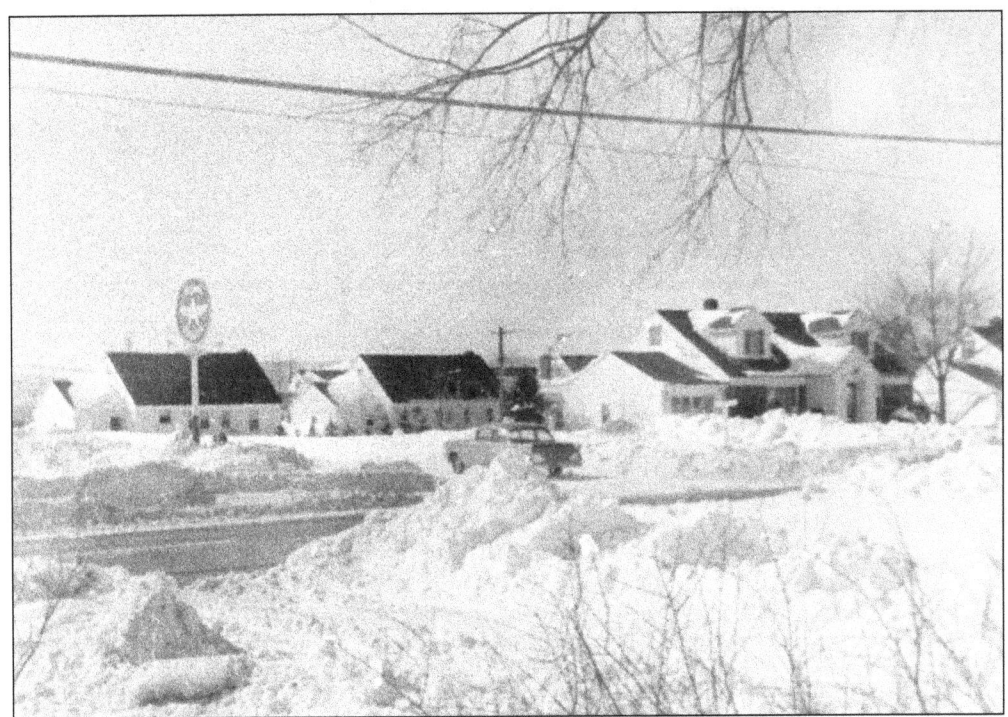

It is 12 years later (1958) in this snowy winter scene on the turnpike. A new town road called Kraus Terrace has been built next to the Tydol Station. In the era of returning World War II servicemen, Westmere had the fastest population growth in town. The population grew from 7,284 in 1950 to 14,989 in 1957.

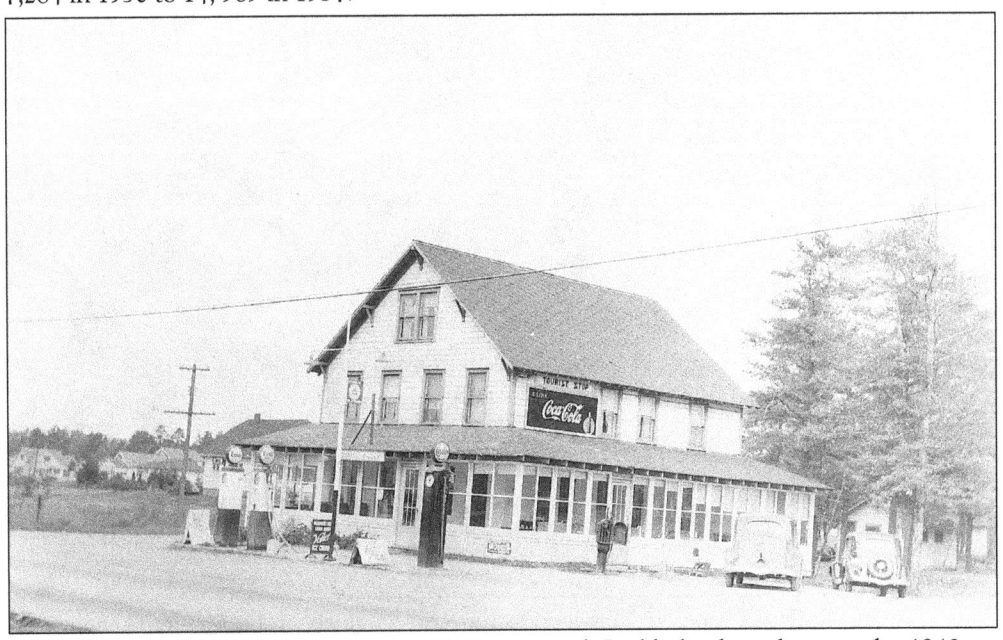

Dan Willey Sr.'s general store and gas pumps serviced Guilderland residents in the 1940s at the northeast corner of the Western Turnpike and Gipp Road. It was one of two grocery stores located between Fuller Road and Route 155.

One-room, wooden tourist cabins behind Dan Willey's grocery store housed travelers coming from the east or the west on the turnpike in the early 1900s. There were many of these simple types of accommodations along the westbound road. The "country" atmosphere even brought families from Albany for an overnight adventure in this rural region.

The Caroline Railroad, operated by conductor and engineer L.P. McGrath, delighted Guilderland youngsters with train rides on summer evenings and weekends. The 10¢ after-dinner rides, which took place on Willey Street near Gipp Road and the turnpike, came to a halt in 1969. According to the engineer, "revenue did not meet expenditures."

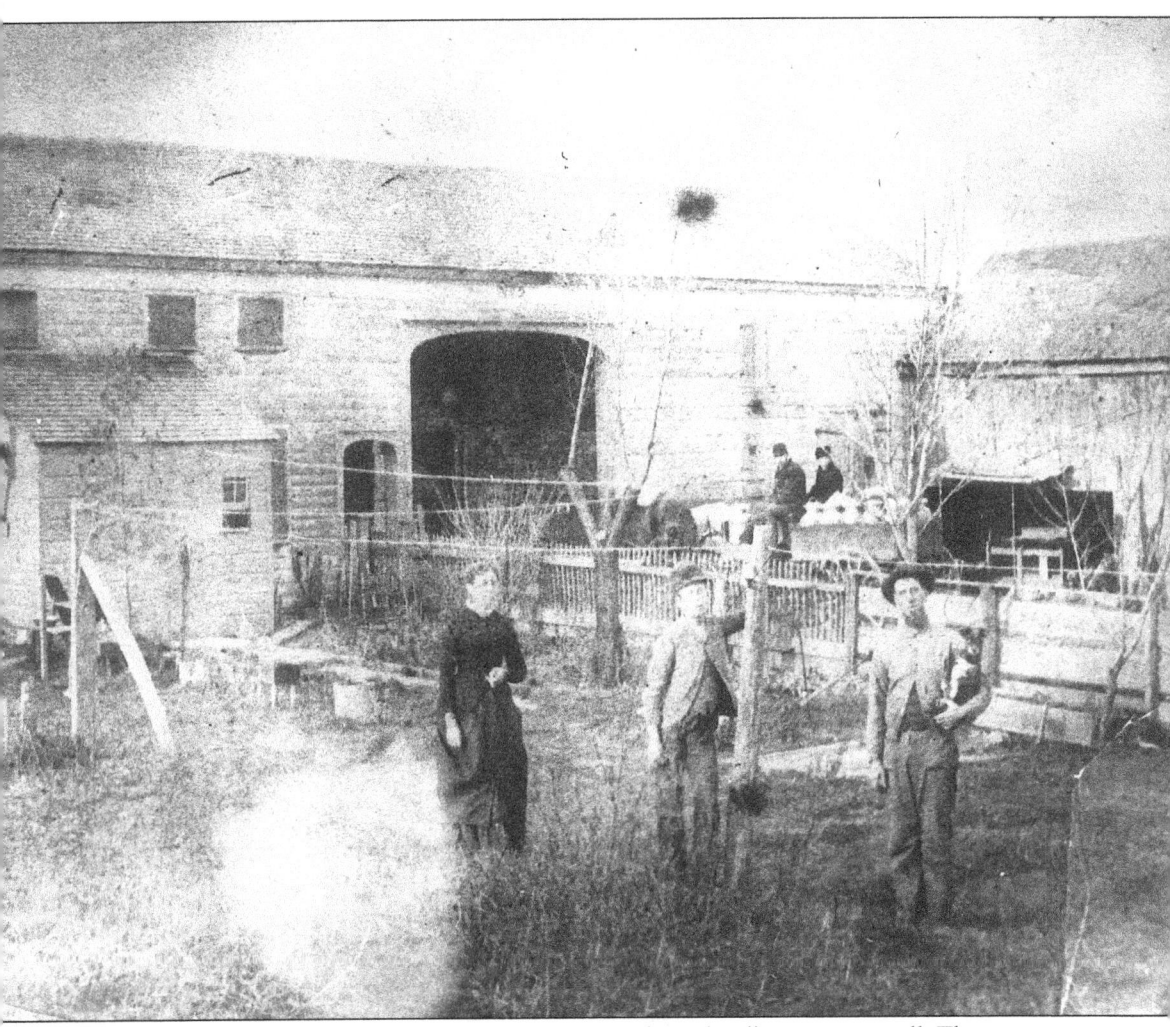

At the Great Western Turnpike Toll Gate No. 2, a westbound milk cart pays a toll. This is one of the very early images of Westmere, which was then a sparsely populated area. The tollkeeper's wife, Mrs. Williams, stands in the foreground. After the Revolutionary War, emigration to the west increased greatly. In 1796, three hundred sleighs or wagons passed through Albany and Guilderland on a westward journey, necessitating the need for better roads. In 1799, the Turnpike Corporation began charging tolls: 5¢ for each score of sheep or hogs, 12¢ for a horse with rider, and 25¢ for a wagon. The toll gate was located where the Turnpike Drive-In once stood, before the present-day Highwood Village complex was built. The toll gate building was moved in 1907.

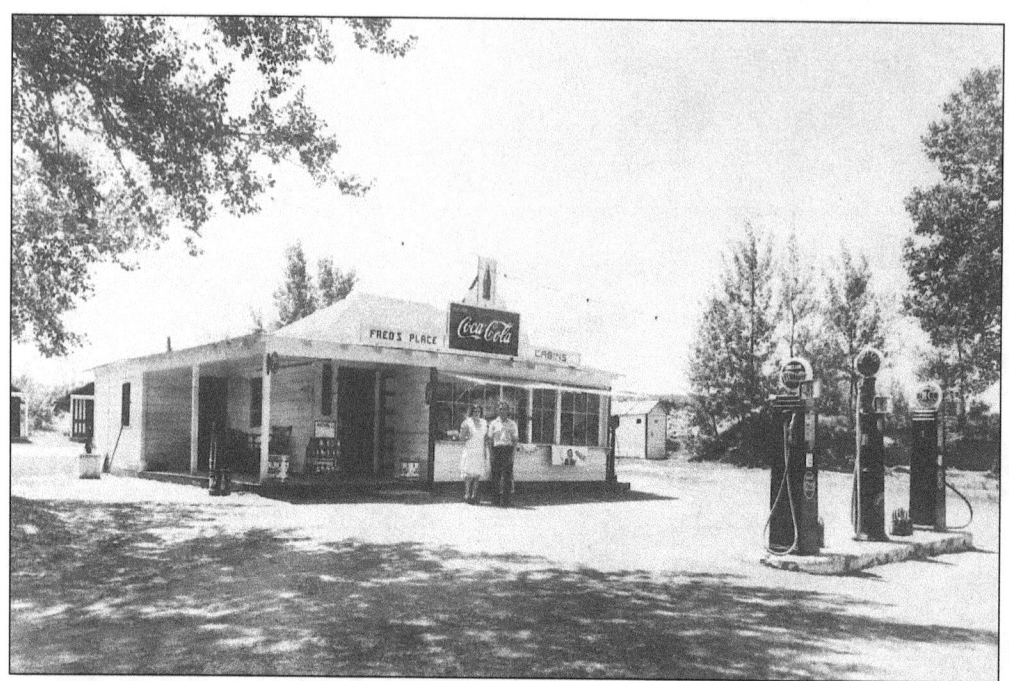

"Fred's Place," located on the two-lane Western Turnpike near State Farm Road, consisted of a gas station, snack bar, and tourist cabins. Owned by Emily and Fred Rudesheim from 1939 to 1970, the family-run business was on the site of the current Dunkin' Donuts at Star Plaza. Today, the heavily traveled intersection, with its multi-synchronized traffic light, is a far cry from when the small country business held forth on the turnpike.

A typical 1950s ranch-style house with a typical 1950s car parked in the driveway shows the new one-floor housing construction that replaced the cottage- and bungalow-style houses of previous years in Guilderland. Tract houses of this sort, if kept in original condition, will soon be considered "historic" and possibly eligible for the National Historic Register.

Two

Guilderland Hamlet

The hamlet of Guilderland was formed a number of years before the town of Guilderland was incorporated in 1803. Dutchman Leonard DeNeufville began a small glass factory in the tiny area 7 miles west of Albany, known as Dowesburgh, on the Great Western Turnpike. In 1797, the land around the glass factory was laid out in streets. The village was renamed Hamilton, after the U.S. secretary of treasury, and 54 community houses were built for the factory workers. In 1799, the Great Western Turnpike was built through Hamilton and many taverns and businesses sprang up. In 1815, the first official post office was established, and the village was renamed Guilderland. Prominent names like Van Rensselaer, Batterman, Schoolcraft, Veeder, and Sloan appeared on the tax rolls. A new foundry, a church, a school, and several taverns and inns were added, and the small village began to flourish. Today, the hamlet of Guilderland boasts a new library, a large elementary school, several historic houses, an addiction recovery center, a nursing home, and an apartment complex, and heralds the coming of a YMCA.

This panoramic view from the elevated height of Prospect Hill Cemetery scans the ever-changing face of Guilderland. The Jackson Tavern (pictured) was built in the early 1800s by Judge James A. McKown, grandson of "Billy" McKown. The building was dismantled in August 1996 and was moved near Cooperstown, where it will be re-assembled. The photo predates its present backdrop, the Regency Apartment Complex.

This is a 1950s view of the beautiful Victorian gateway that once adorned the entrance to Prospect Hill Cemetery on the Western Turnpike. The cemetery was chartered in 1854. Located high on the hill overlooking the town, it is the highest point on the turnpike, a fitting site for the historic heroes and heroines of Guilderland's past, and the view from it is euphoric. From this lofty burial ground, one can watch the changing face of Guilderland.

On the porch of the Victorian cottage in Prospect Hill Cemetery, Grand Army of the Republic Civil War veterans await dedication ceremonies in their honor on Memorial Day in 1910. A red-stone obelisk monument at the top of the entrance road in the cemetery also honors Civil War veterans.

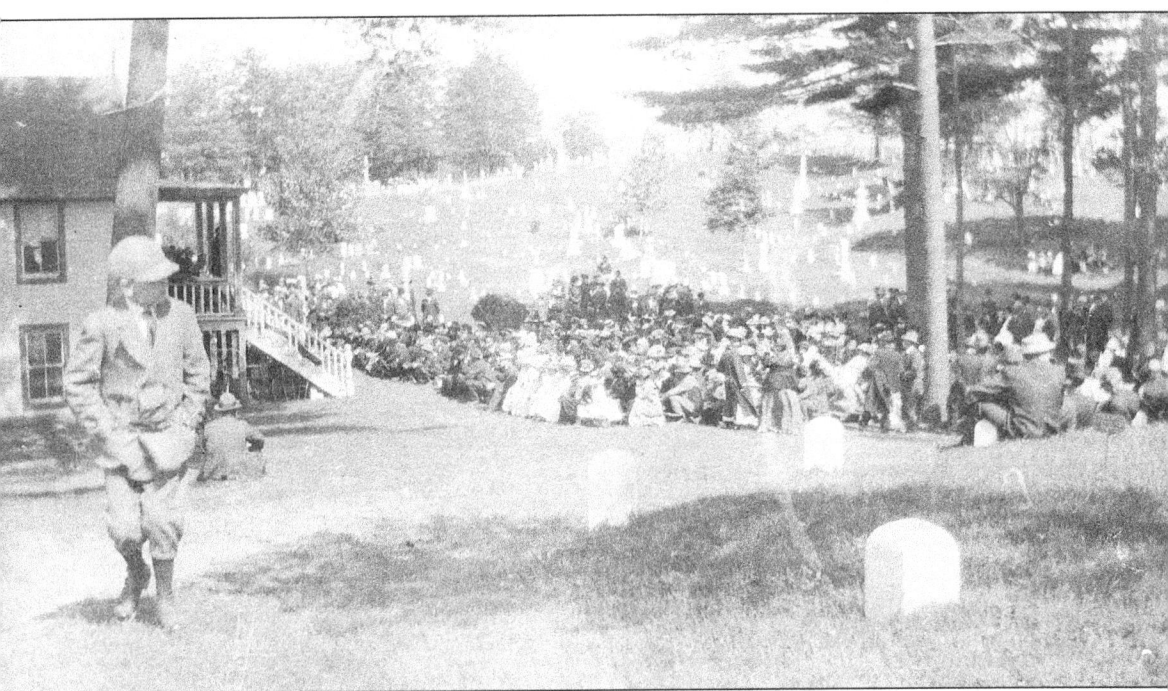

In the late 1800s and early 1900s, Prospect Hill was a gathering place for the living and the dead. It was customary for families to pack a picnic lunch and go to the burial grounds for an outing. From the porch of the small Victorian caretaker's cottage, dignitaries would assemble to give a speech and the town band would play. On Memorial Day in 1890, members of the Barkley Post, Grand Army of the Republic and townsfolk gathered to hear Guilderland poet Magdalene La Grange read her tribute to the fallen men of the Civil War. "We come today remembering the loved, the tried, the true, To deck the place where lie in peace, the boys who wore the blue." The Victorian cottage was demolished in the spring of 1998.

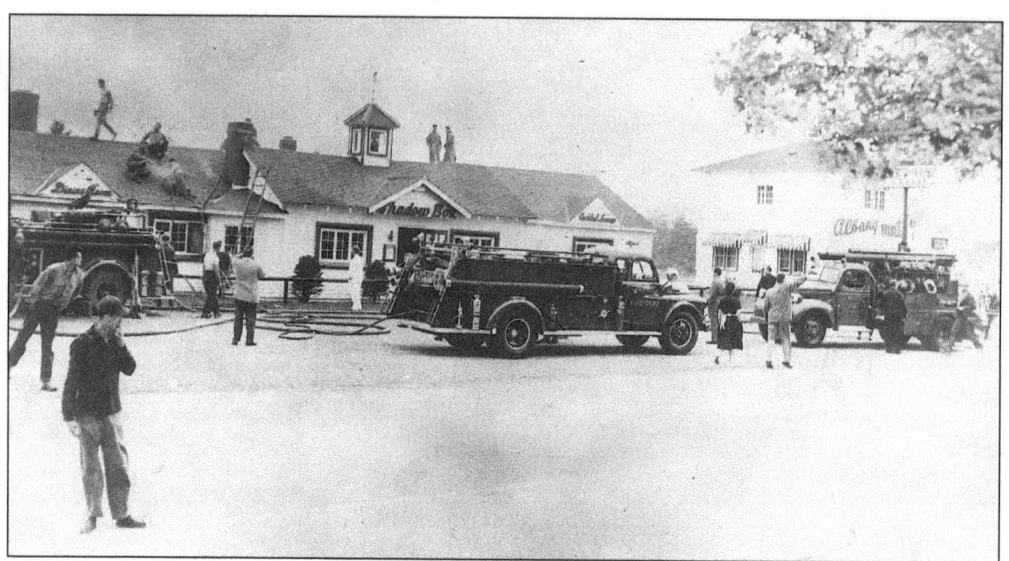

The McKownville, Westmere, Guilderland, and Fort Hunter Fire Departments answered a call on September 19, 1954, at the Shadow Box, a popular seafood restaurant and nightspot located across the Western Turnpike from Prospect Hill Cemetery. A second fire destroyed the building in 1976.

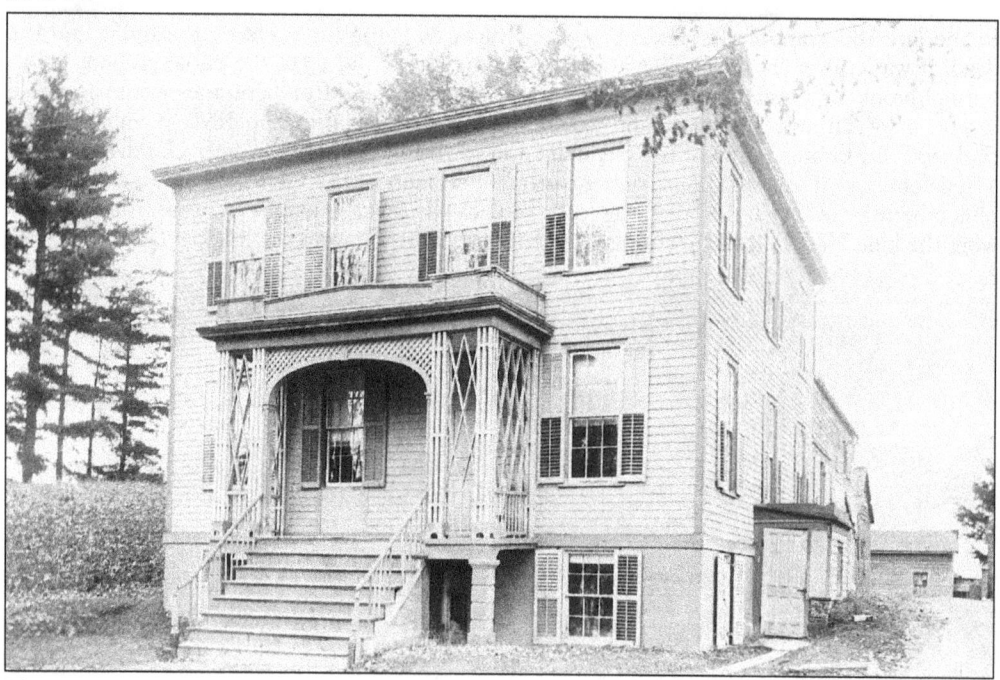

The impressive Rose Hill mansion has seen many changes on the Western Turnpike since it was built in 1842 by John P. Veeder. He was appointed during Lincoln's administration to investigate the U.S. Navy's scandals of the 1860s. Dr. Abraham DeGraff took the building's title from 1880 until the turn of the century, when it was let out to tenants. Schoharie County Doctor Miller Lee bought Rose Hill in 1945. The present owners, Drs. Lynn and Joseph Golonka, have kept the Federal-style historic house in mint condition. This photo was taken c. 1890.

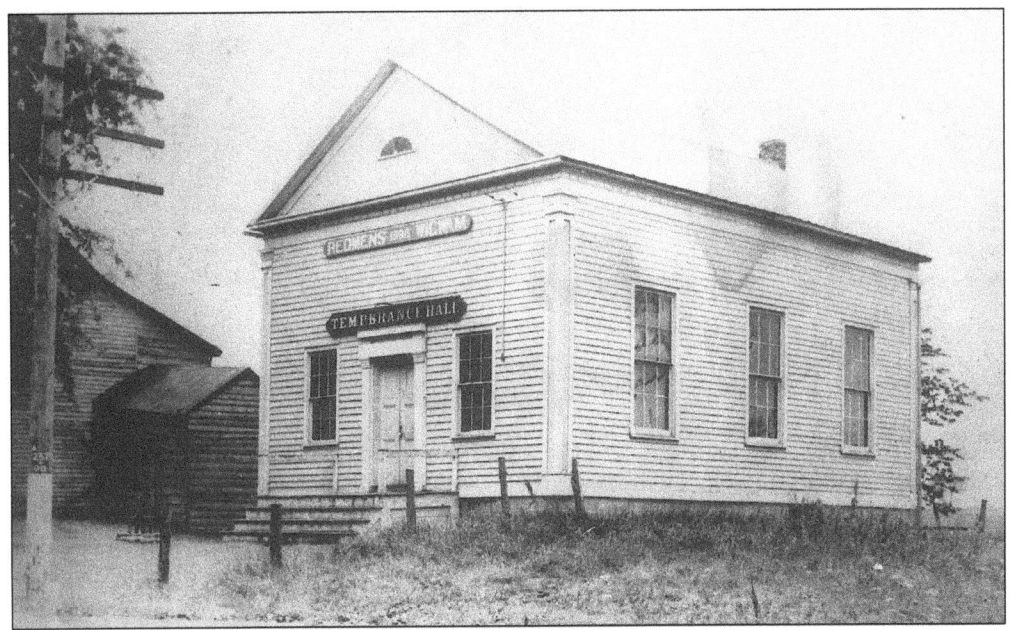

Once a pivotal place in the community, Red Men's Wigwam stood on the south side of Western Turnpike, east of Willow Street, from 1831 until it burned in 1967. A fraternity founded in 1765, the Red Men, earlier known as the Sons of Liberty, worked underground to help establish freedom and liberty in the colonies. This building was originally a Baptist church built on land donated by hotel owner Henry Sloan. It later housed a Catholic church, the Red Men, a temperance group, a polling place, and a work area for Red Cross women during World War II.

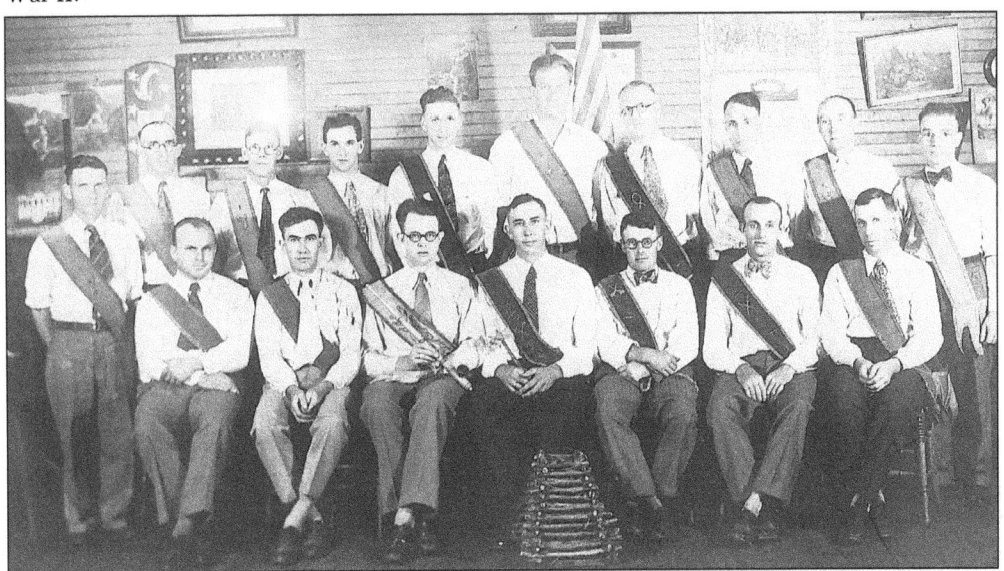

Guilderland "Red Men" of the Iosco Tribe #341 pose for a 1929 picture inside the Red Men's Wigwam, dressed in their ceremonial sashes. After the Revolutionary War, the Order of Red Men became a community-oriented, non-profit organization chartered by Congress. The national organization still supports flag recognition programs and observes a "Red Men's Day" at Arlington National Cemetery to honor soldiers fallen in battle.

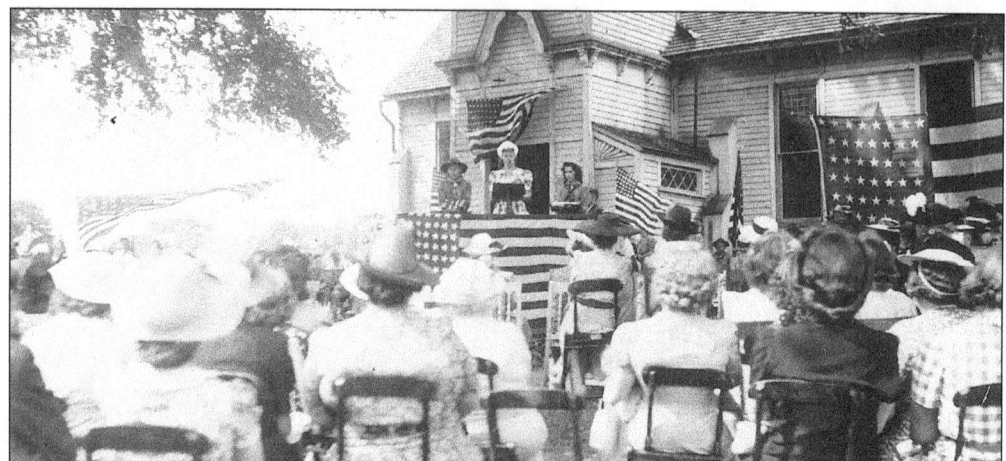

A dedication of the flag service on the Fourth of July in 1942 brought residents of the Guilderland hamlet to watch from the lawn of the Hamilton Union Presbyterian Church, located beside the Schoolcraft House. The church, established in 1812, was an octagonal structure that stood above a ravine and a stream east of the Batterman and Schoolcraft taverns. The building also became a superior preparatory academy for boys.

The John L. Schoolcraft House is a unique local landmark on the Western Turnpike. The early Gothic mansion was built in the 1840s by Congressman Schoolcraft, a wealthy banker and wholesale merchant. The house was purchased by Guilderland Historical Society and the Town of Guilderland in 1994 to be restored for use as a community cultural center. Pictured are the turn-of-the century residents of the house, sisters Alice, Edna, and Nellie Magill.

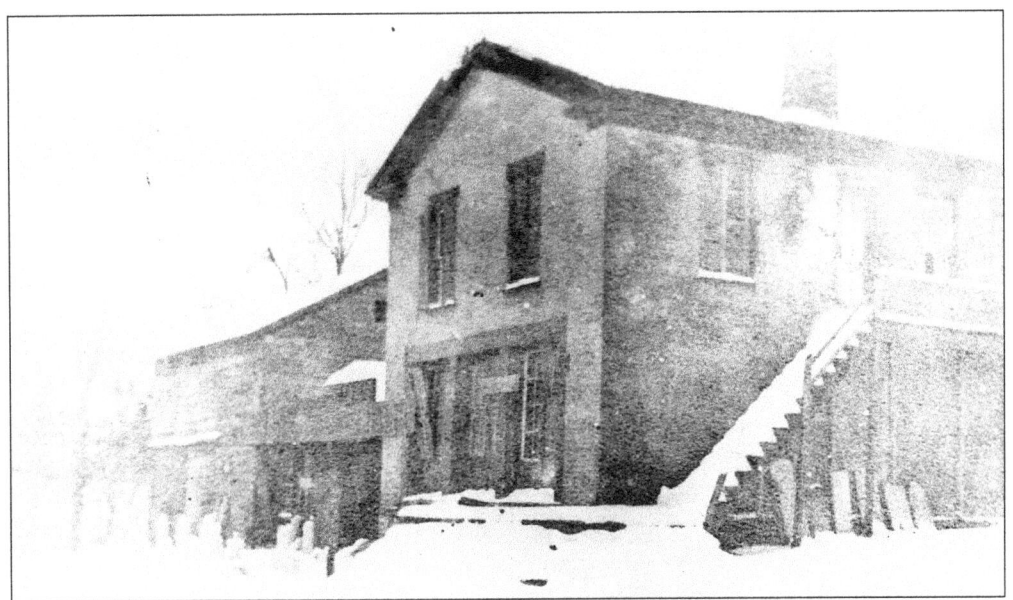

The two-story brick building at the corner of Schoolcraft Street and 2301 Western Turnpike was once the carriage and harness repair shop of Christopher Batterman, Guilderland supervisor from 1833 to 1839. Batterman created Mill Pond, located west of Hamilton Street, for his gristmill. In 1951, the building became the first firehouse for the hamlet, housing a 1937 Mack Jr. truck. The restored building is now occupied by InfoEd International Systems and Support Services.

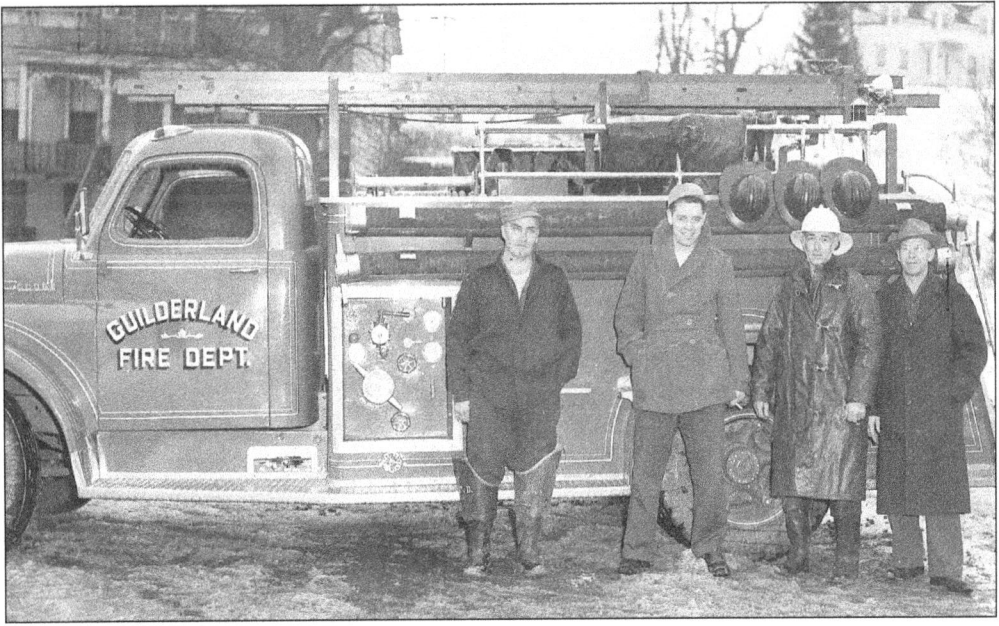

Four volunteer members of the Guilderland Fire Department pose in front of their 1951 Engine 25 Dodge pumper in this c. 1952 view. From left to right are Ross Mesick, Ken Cunningham, Tom Van Wagenen Sr., and Earl Kisby. The photo was taken on Foundry Road in front of the white Pruskowski House on the hill. A new, three-bay firehouse was built on the turnpike in 1994, housing four new pieces of fire apparatus. The old 1951 pumper is still used for parades.

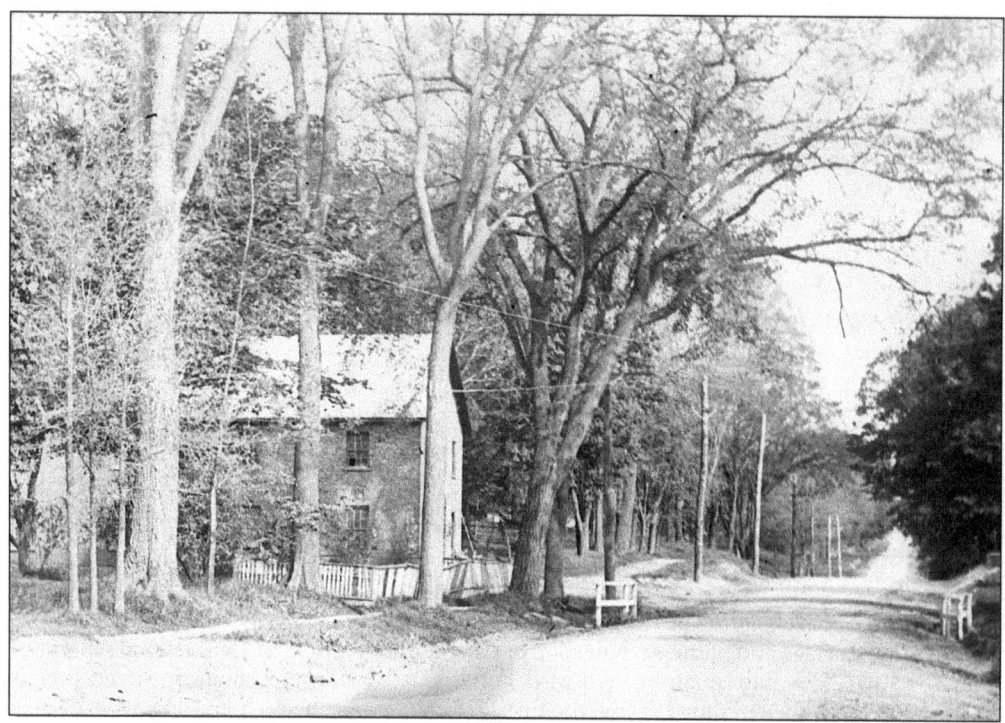

This peaceful-looking country road is today a busy thoroughfare. Driving east from this point on the Western Turnpike toward Schoolcraft Street in this decade, you would have just passed a traffic light and, perhaps, read the informational sign in front of the new Guilderland Firehouse on your left. The brick building was Batterman's Carriage Shop and the original firehouse in the Guilderland hamlet.

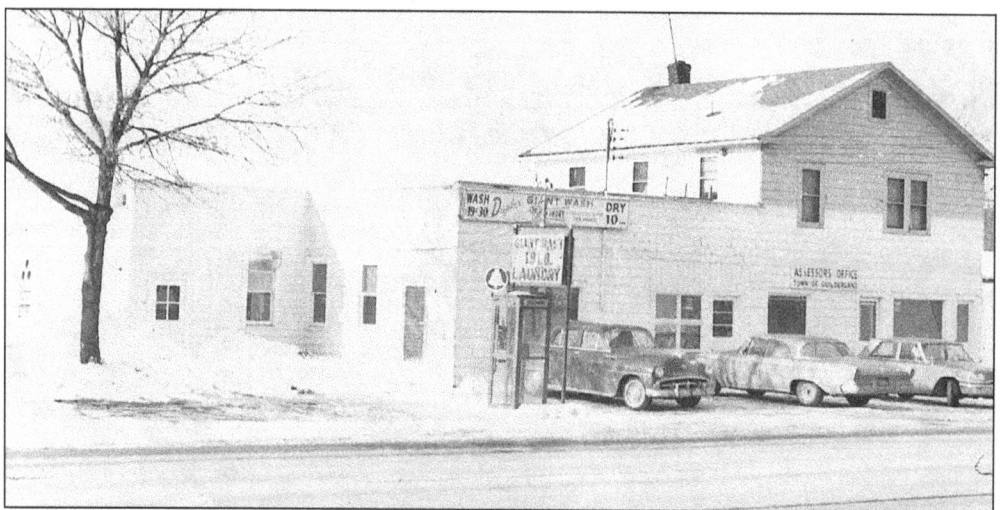

After a short life of 27 years, this building on the Western Turnpike across from Willow Street burned to the ground. Beginning in 1942, it housed Wells' gas station, a repair shop, restaurant, residence, laundromat, and a bus shelter. From 1950 to 1956, the Town of Guilderland held all of its meetings in rooms on the east end of the structure. Supervisor John J. Welsh moved town offices to the old schoolhouse on Willow Street in 1956. The Guilderland Free Library was also housed here from 1959 to 1961.

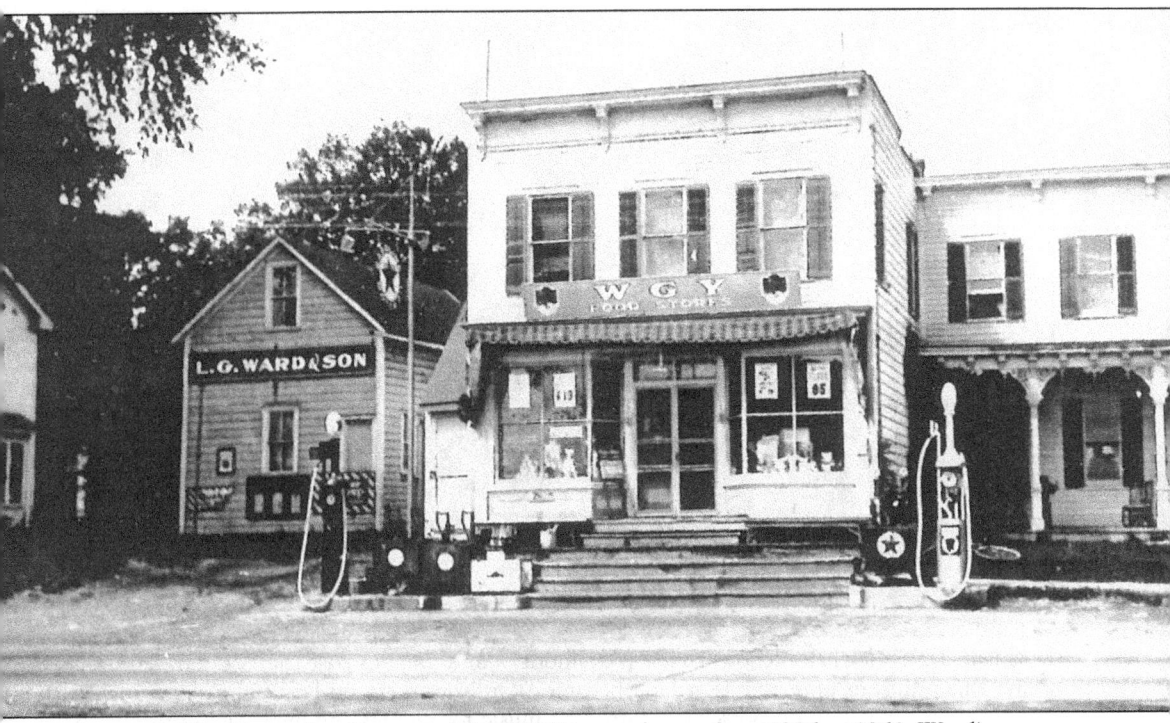

Thomas B. Ward owned and operated the WGY general store from 1926 to 1960. Ward's store, located on the Western Turnpike between Schoolcraft and Willow Streets, was a favorite gathering place for the folks in the small hamlet and was where they paid their town taxes in the 1930s. Ward also sold gasoline at his store and delivered groceries through the Pine Brush by horse and carriage. He served as postmaster from 1927 to 1965. Note the two-lane road very close to the entrance steps. A second-hand clothing store, Unique Boutique, presently occupies the building.

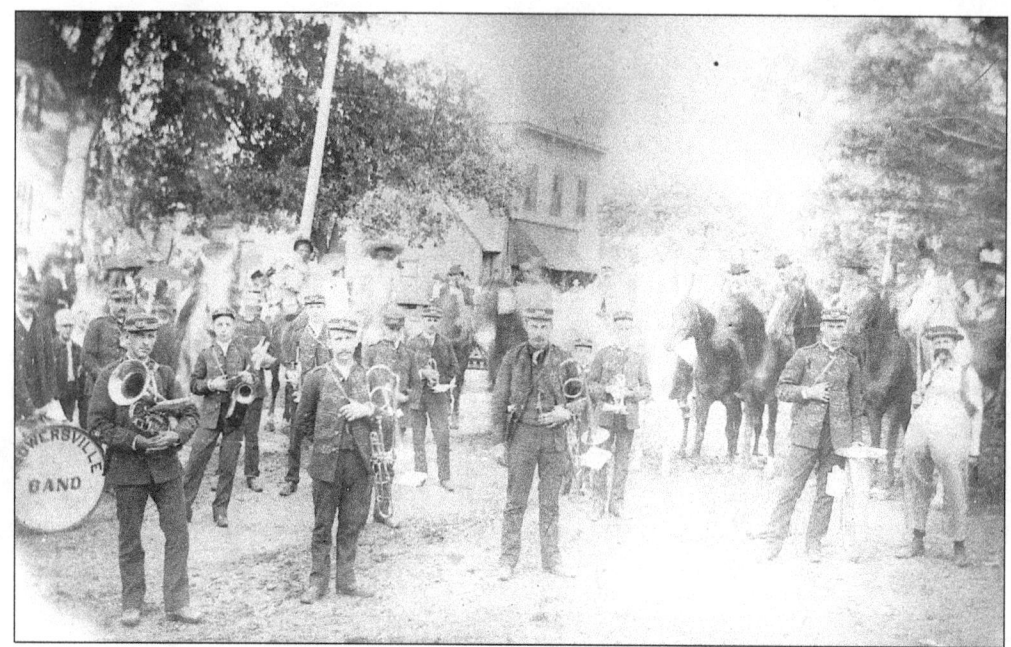

In this c. 1890 view, the Knowersville (Altamont) Band parades past the Western Turnpike Plank Road in front of a store that later became Ward's Market and Post Office. The spirited band, led by a marshall on horseback, furnished music for picnics and memorial services. The band had been playing for a Memorial Day service at Prospect Hill Cemetery. Note the dirt road with one strip planked.

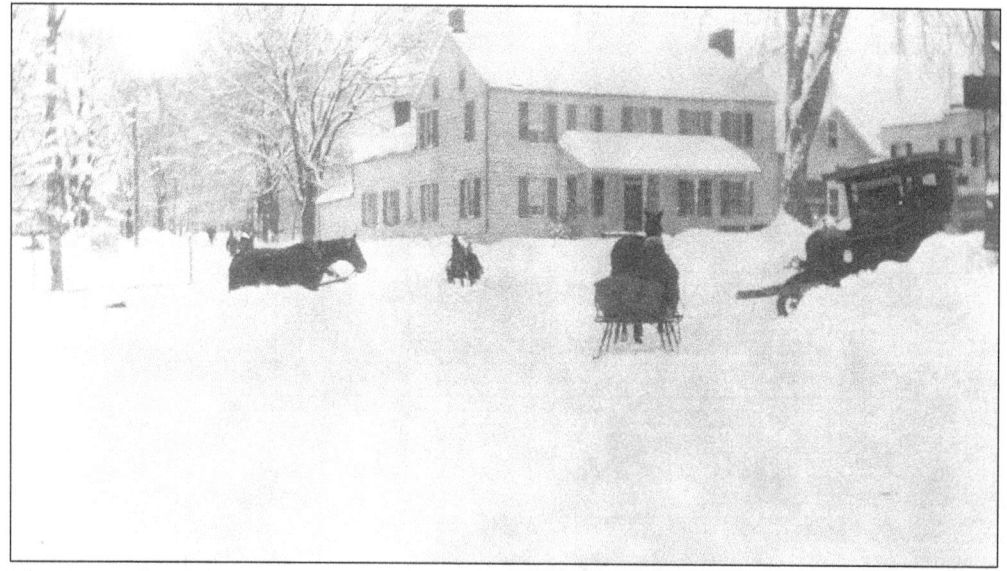

This is a turn-of-the-century winter scene looking from Foundry Road across the Western Turnpike to Willow Street. Note the horse-and-sleigh transportation; the new, horseless carriages were made immobile by the weather. The building pictured is now Capital Costumes, located at 2319 Western Turnpike.

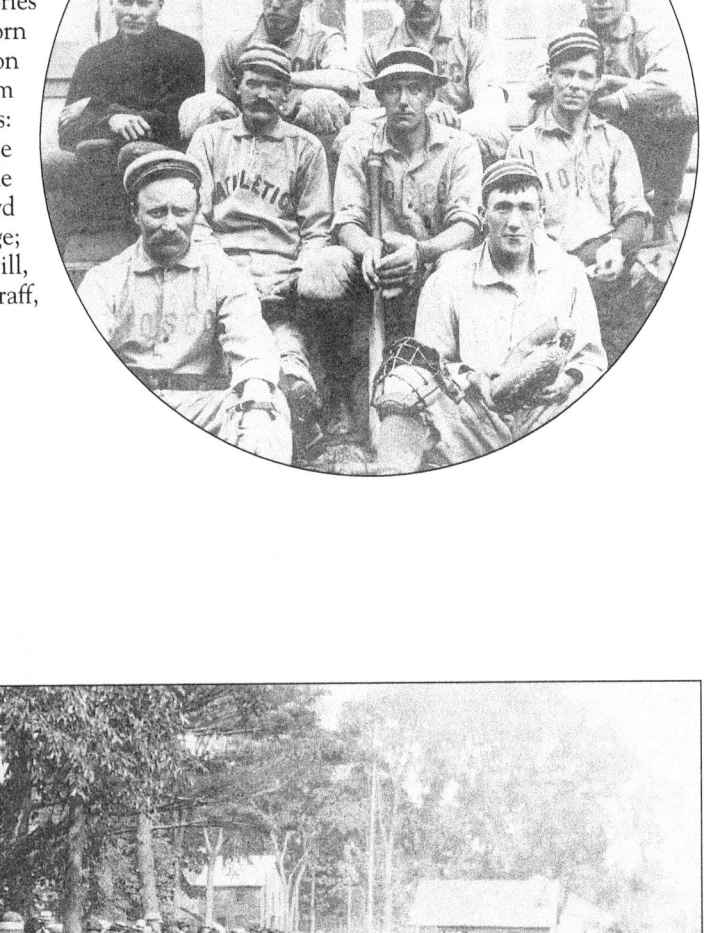

Men of Guilderland's 1899 Iosco baseball team are seated on the store steps at the corner of Foundry Road and the Western Turnpike. Iosco was the name used by Henry Rowe Schoolcraft, writer of Native-American legends and poems that included memories of his hometown. He was born in a house that still stands on Willow Street. Pictured from left to right are as follows: (first row) William Mynderse and DeWitt Main; (middle row) James Clark, Lloyd Coss, and Albert Talmadge; (back row) Walter Magill, Thomas Holmes, Fred Degraff, and Jesse Wood.

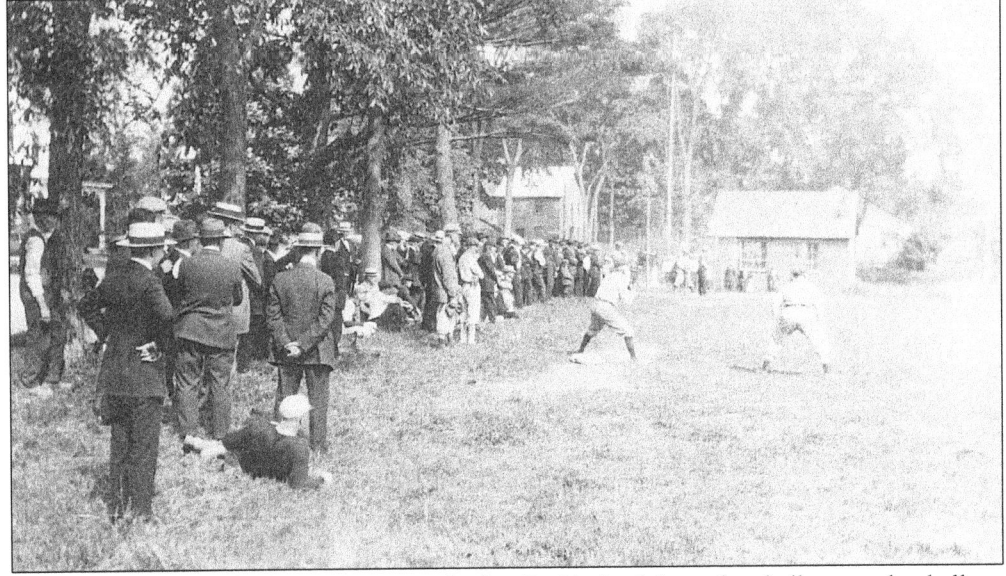

Turn-of-the-century town residents watch the Guilderland Iosco baseball team play ball on Iosco field, on the south side of the Western Turnpike. Perhaps it was a Sunday after church. Note the straw hats and suits of the male spectators.

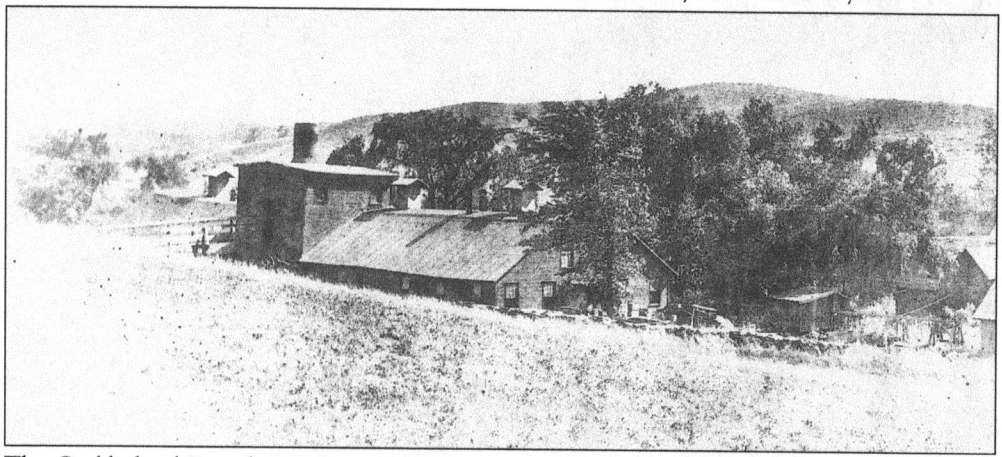

This 50¢ script from the Hamilton Glass Works of Foundry Road in Guilderland hamlet is dated 1815. In a wilderness about 7 miles west of Albany, with natural resources of sand, potash, wood, and waterpower, Leonard DeNeufville established the Dowesburgh Glass Works in 1785. By 1813, the small factory was outputting 500,000 feet of window glass per year. Competition from English manufacturers cut the life of the Guilderland factory short after 30 years.

The Guilderland Foundry on Foundry Road was previously a hat factory turned into an iron-casting business by owners George Chapman and Jay Newberry in the 1860s. The foundry, once the site of the old Hamilton Glass works, produced brackets for the Castleton piano factory, manhole covers, and sash weights. It is believed that the decorative iron finials adorning the Schoolcraft House may have been made at the foundry.

In this view, Dr. Abram DeGraff stands in front of his medical office on Foundry Road. The doctor and his wife, Mary Francis Veeder, lived at Rose Hill across the turnpike. She was the daughter of the original owner of Rose Hill.

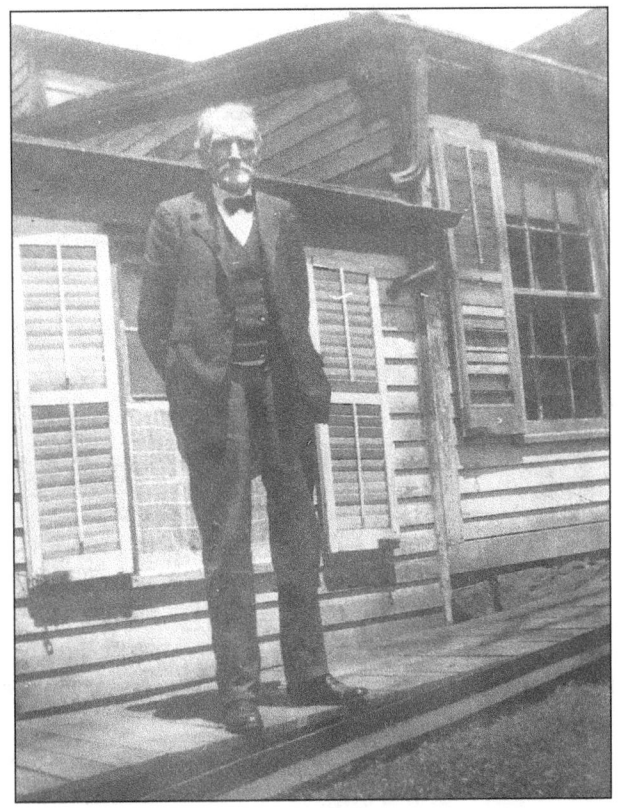

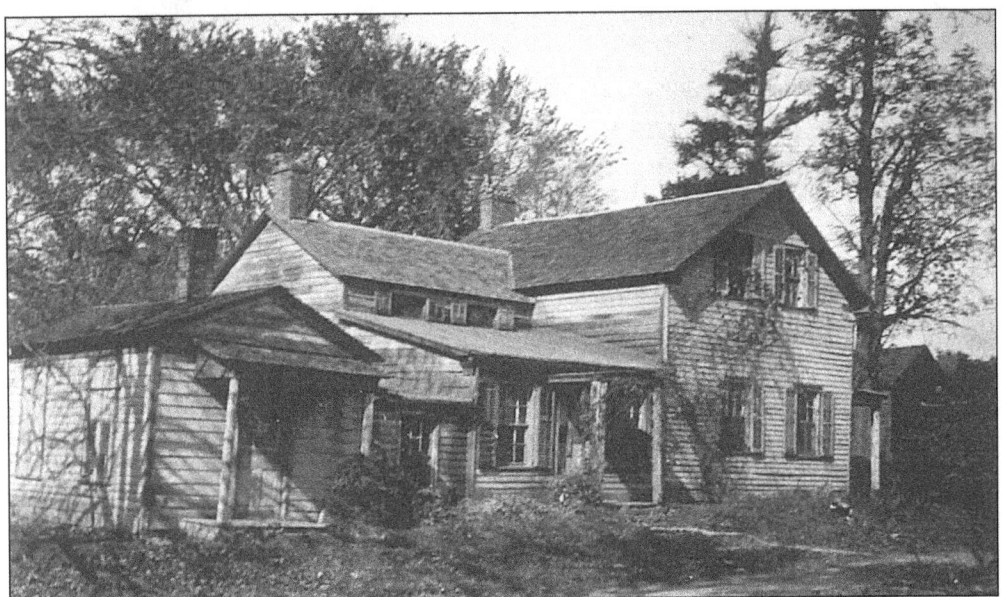

It is difficult to envision that this 1922 photo is at the corner of the Western Turnpike and Foundry Road. The little building on the left was the office of Dr. Abram DeGraff. The old house still stands today.

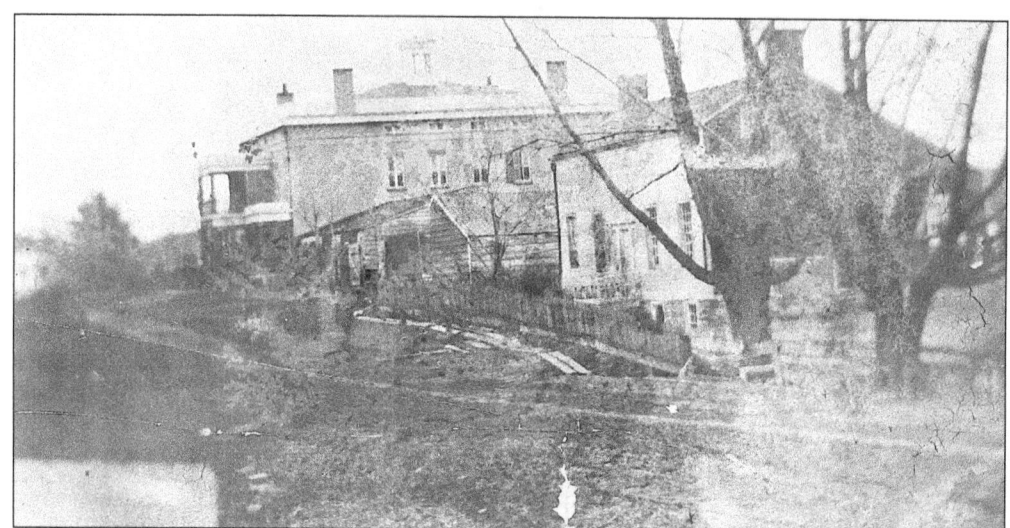

Christopher Batterman built and operated a large, brick hotel on the south side of the Western Turnpike, west of the Schoolcraft House. When Henry Sloan married Batterman's daughter, he took over the hotel and named it Sloan's. Note the single-lane road that was the beginning of the turnpike. History notes that Theodore "Teddy" Roosevelt stayed here on his way west. The hotel burned in 1900. The house in the foreground was the Rheinhardt residence.

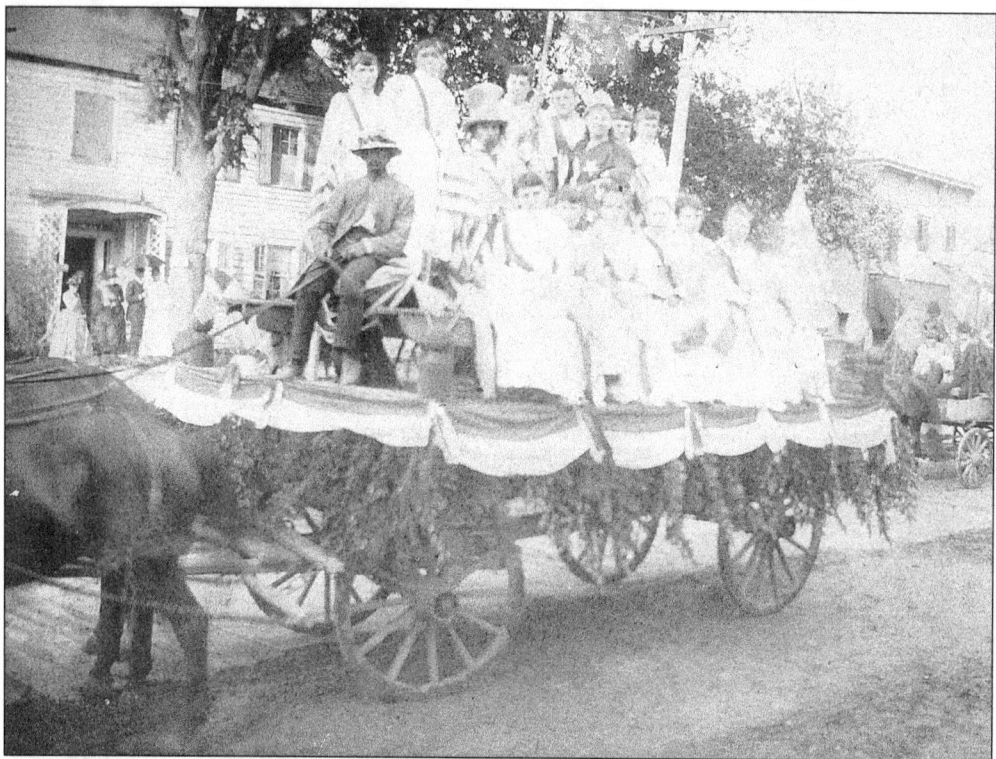

A Fourth of July celebration, c. 1890, shows schoolchildren on a parade wagon with Uncle Sam and Miss Liberty. The photograph was taken at the Willow Street intersection. This indicates the kind of community events in which the whole hamlet participated. Note two familiar buildings in the background and the wooden plank turnpike.

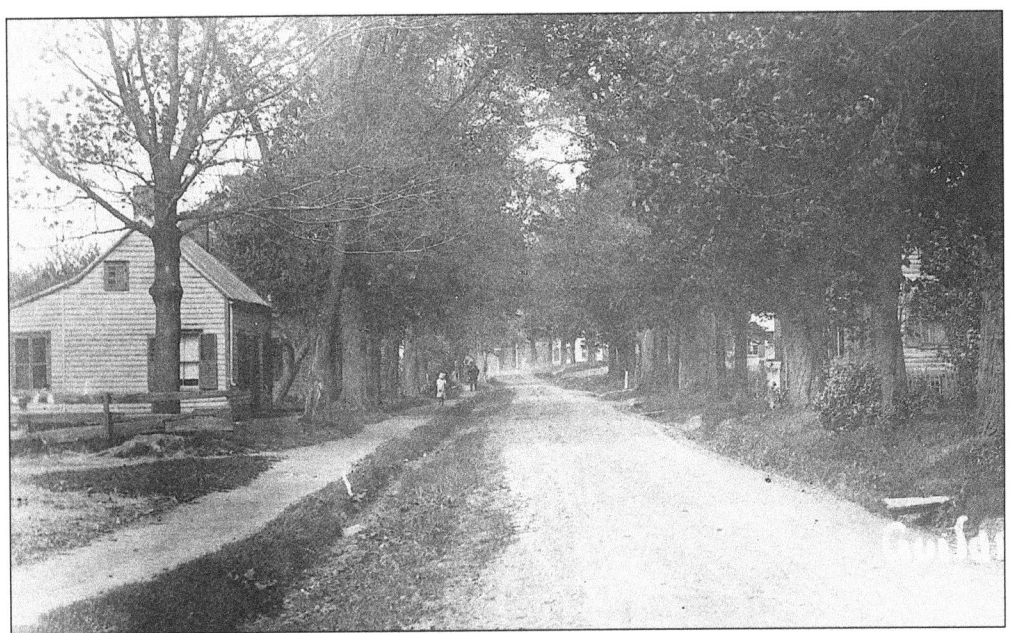

This is a c. 1900 view looking north on Willow Street, in front of District #4 Schoolhouse. It became the town hall in 1956 and is presently the New York State Troopers' barracks in Guilderland hamlet. The unpaved road and lines of trees are evidence of the rural nature of the village.

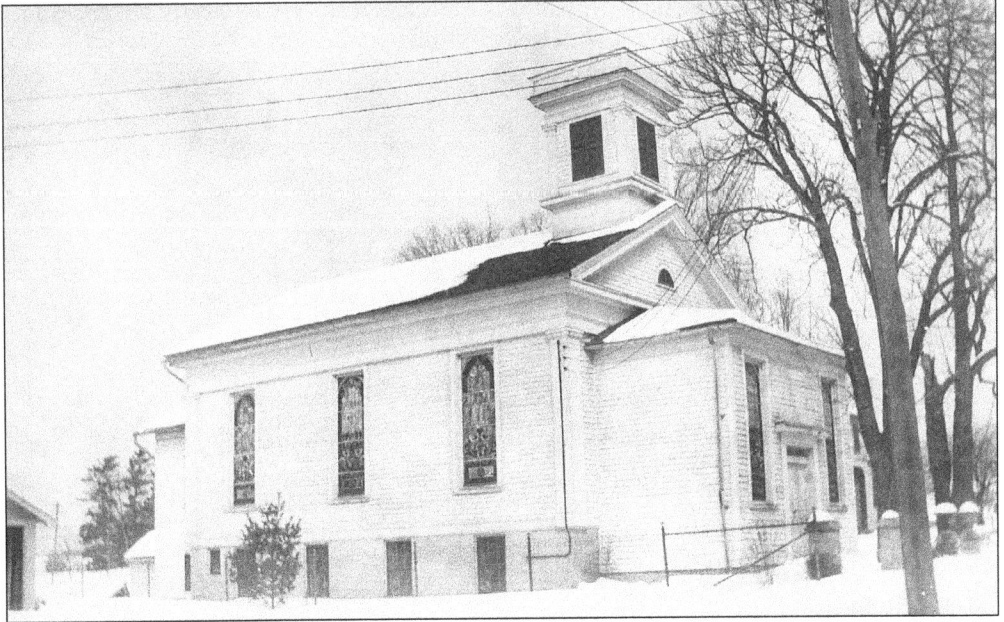

Methodism appeared in Guilderland as early as 1845, when a congregation called the Guilderland Methodist Episcopal Church was organized near the site of the glass factory. The church was built in 1852 on Willow Street. After 90 years, and with a diminishing congregation, some members merged with the Hamilton Union Presbyterian Church, while others joined the McKownville Methodist congregation in eastern Guilderland. The building was demolished in 1942.

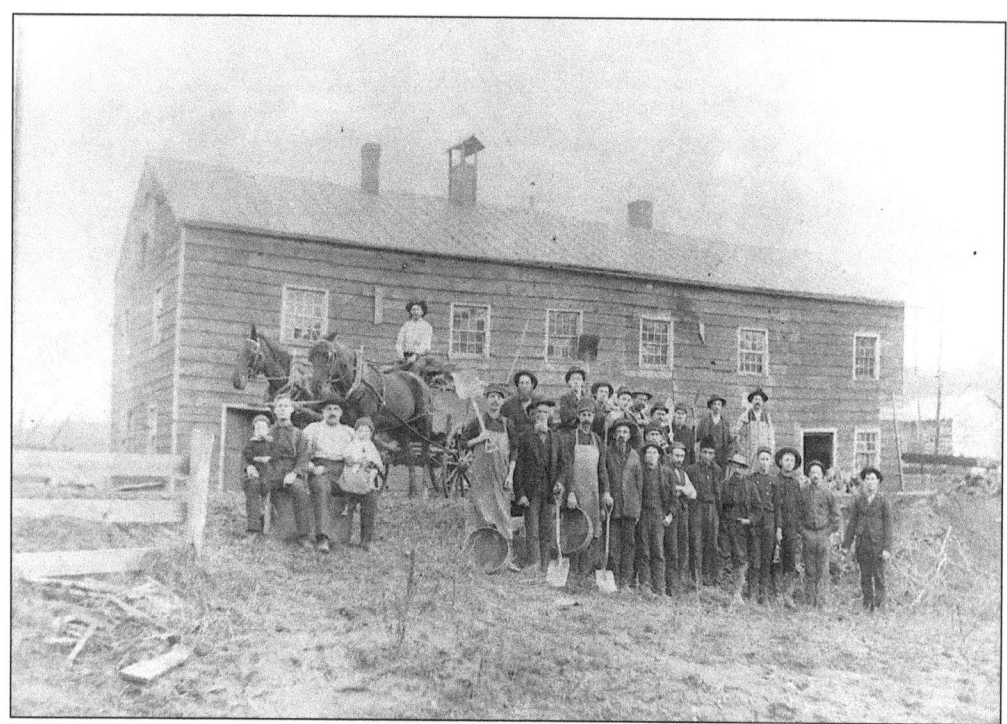

Employees of the hat factory on Foundry Road pose in this c. 1886 view wearing the results of their labor. George Chapman sits with Arnold on his lap, while Jay Newberry holds George. They were co-owners of the business. Will Kelly is sitting on the wagon.

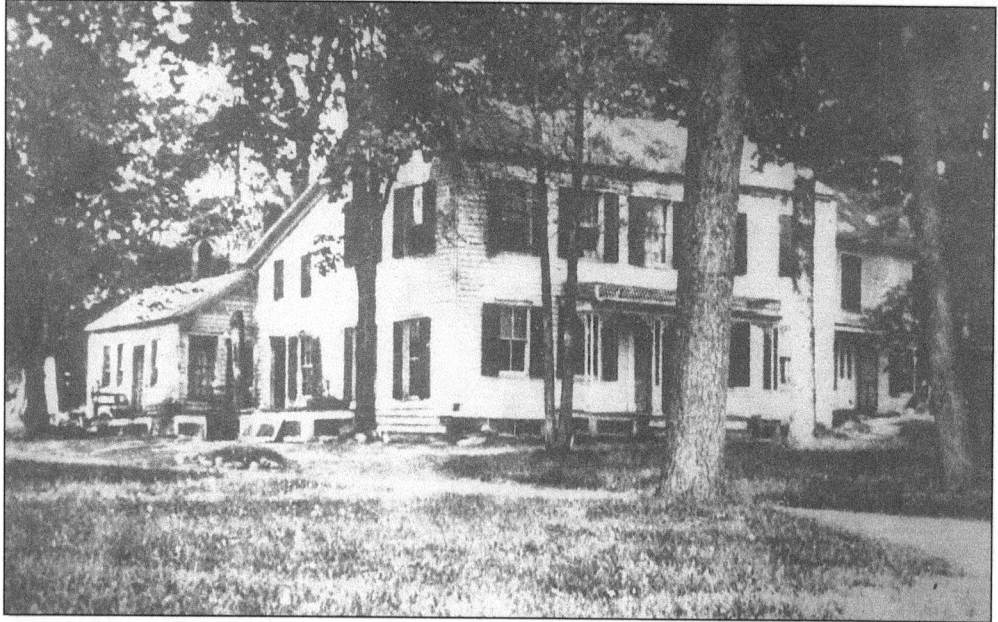

The Case Homestead, built in 1796, was a famous Guilderland tavern and inn. Much of the window glass was from the Glass Works one-quarter mile east on the Western Turnpike. This historic home burned in 1950, after eight generations of the Russell C. Case family had lived there.

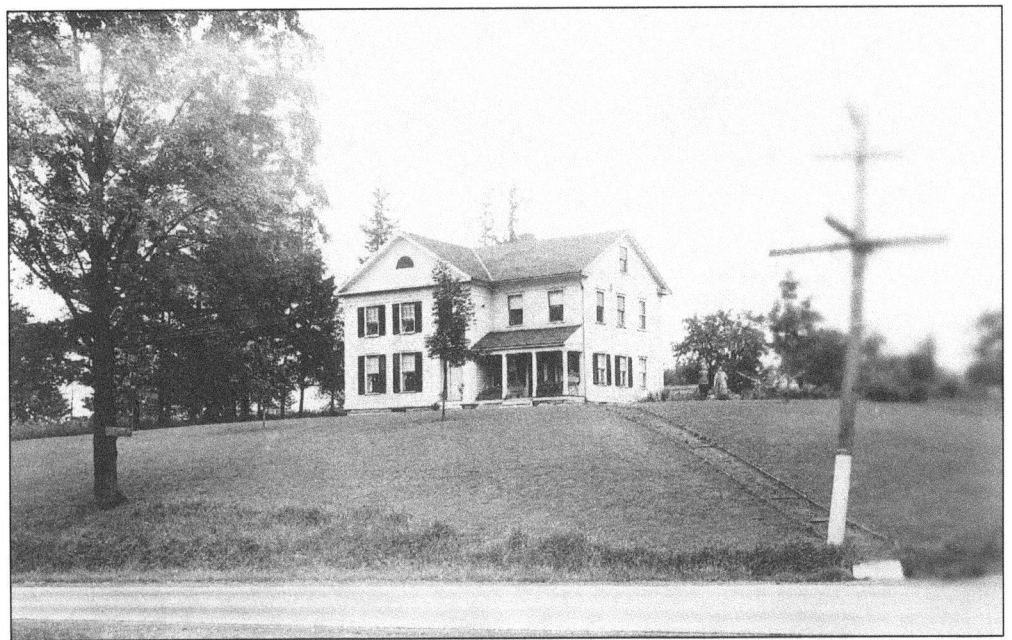

One of Guilderland's lovely old houses is situated on a hillock rising above the Western Turnpike at Hamilton Street. Floyd and Stella Bradt bought the house from Marjory Siver in 1924. It was owned by Helen and William Borden in the 1950s. The present owners have restored a grand look with new, white siding, blue shutters, and blue wicker porch furniture.

Wild ducks nest among the cattails and purple loosestrife in Mill Pond next to the Borden House on the turnpike. Older residents recall skating on the pond in the 1950s or watching as men chopped ice squares to sell in town. The pond was created by Christopher Batterman, who dammed up the land in 1841 for power to operate his gristmill. He sold the pond and 108 acres of land in 1853 to John L. Schoolcraft, who deeded it over to Henry Spawn in 1857. The town took possession of the land in the early 1900s. Mill Pond, one of Guilderland's prettiest assets, is also known as Glass House Pond and Batterman's Pond.

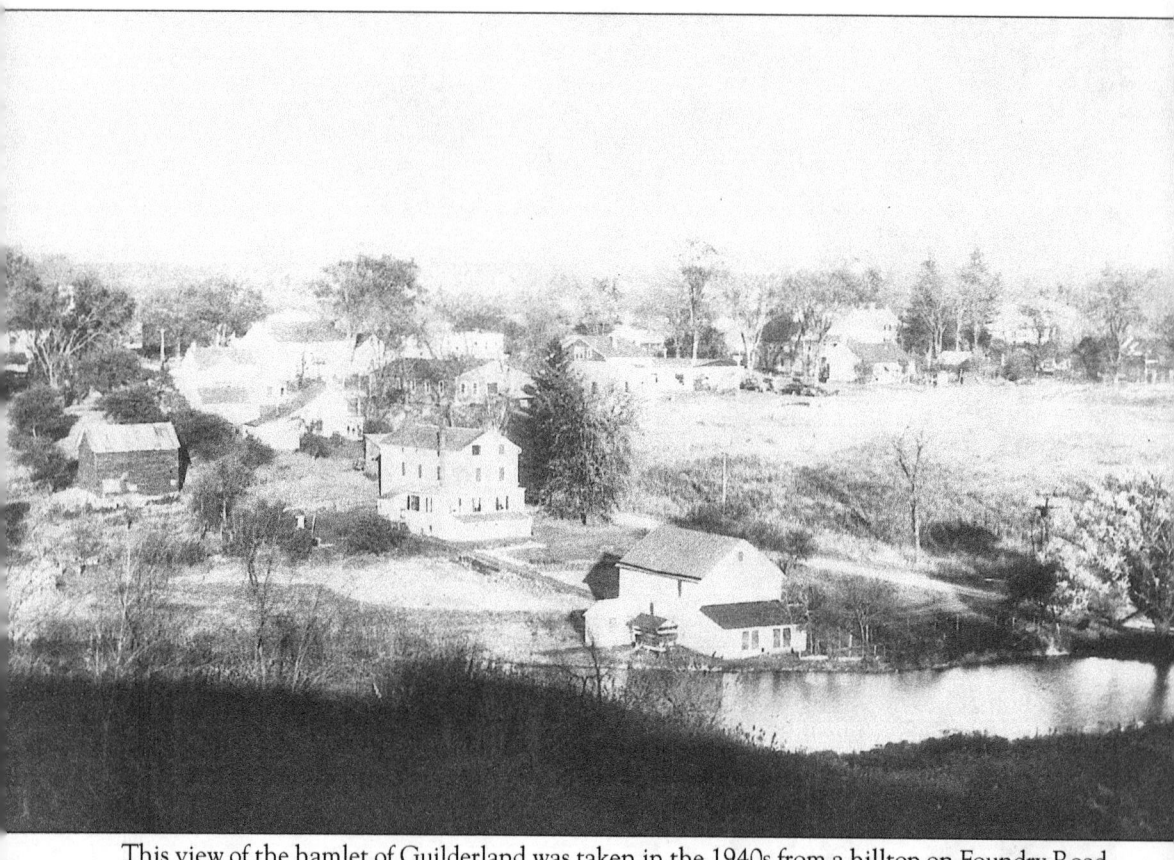

This view of the hamlet of Guilderland was taken in the 1940s from a hilltop on Foundry Road, looking north toward the Western Turnpike. It is a typical rural scene of past years. Foundry Road is visible in the foreground. The pond is made up of run-off waters from the Hungerskill. The Schoolcraft House can be seen in the background.

Three

THE GREAT WESTERN TURNPIKE

After the Great Western Turnpike was cut through the unsettled western part of Guilderland, taverns appeared and were soon followed by small clusters of farms and homes along the way.

The hamlets of Dunnsville and Fullers each began with an early tavern as the nucleus. Fullers became larger and more prosperous when the railroad came through and located a West Shore depot there. By the end of the 19th century, both Dunnsville and Fullers had their own post office, one-room school, blacksmith, general store, and other businesses. At that time, these hamlets had twice the population of the McKownville and Westmere areas.

Other locations along the Western Turnpike developed around intersections and became designated "corners." The corner around where the Schoharie Plank Road (later Route 146) turned south from the turnpike became Hartmans Corners, while to the west, McCormacks Corners was named after a store and early gas station at the intersection of Carman Road and the Western Turnpike. Today, the town hall's address is McCormacks Corners. Continuing west past Fullers was Sharps Corners at the intersection of the road to Schenectady (now Route 158) and the Western Turnpike.

These names show up on modern maps, but the people who inspired them and the sense of identity these areas once had are gone.

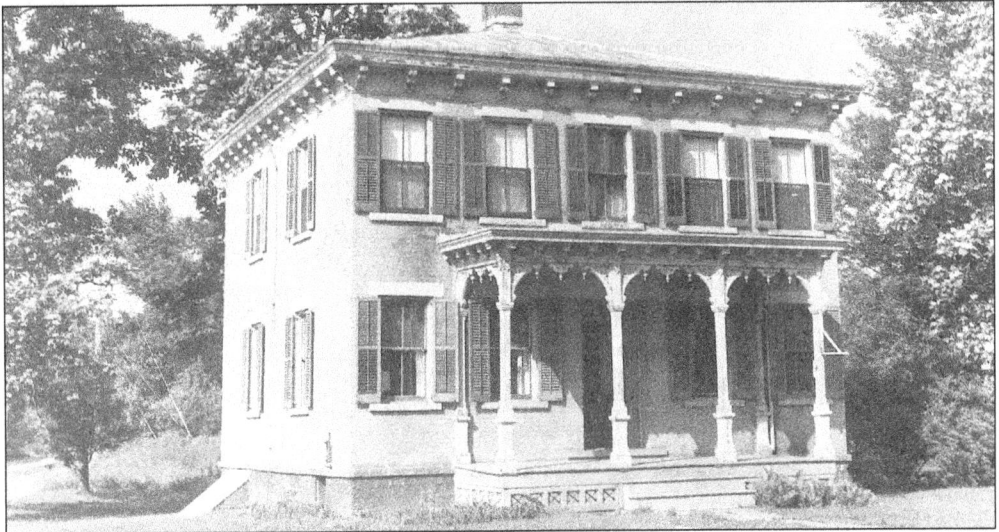

The intersection formed where the Schoharie Plank Road branched off from the Western Turnpike was designated Hartmans Corners, after the family who lived in this 1849 brick house. The Hartman house was razed in the 1960s to make way for a Texaco station, which in turn was demolished for Stewart's Shop at the corner of Routes 146 and 20.

The first roadside stand along this section of the Western Turnpike was opened in 1920 by Harold Fonda. Selling hot dogs, ice cream, smokes, and soda proved so profitable that by 1925, he added one of the first gas stations on the turnpike. From the mid-1960s until 1997, Polito's Tavern operated in the same location on the corner of Routes 20 and 146.

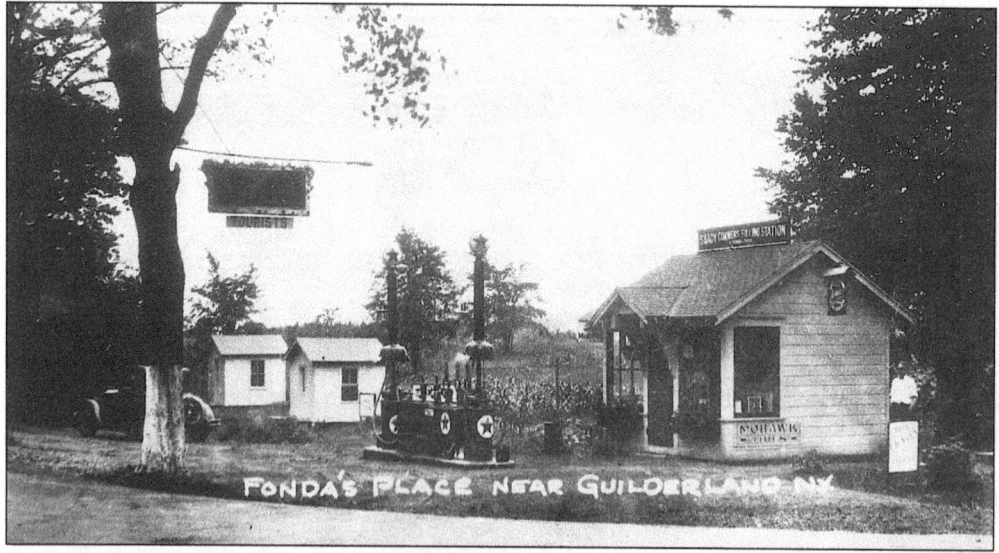

Fonda was an entrepreneur who took advantage of the increased auto traffic passing through Guilderland in 1926 to add a "cabin camp" to the roadside stand and a gas station he already operated. The number of cabins increased, and he eventually added a motel. Fonda remained in business until 1959. During those years, the intersection was often called Fonda's Corners.

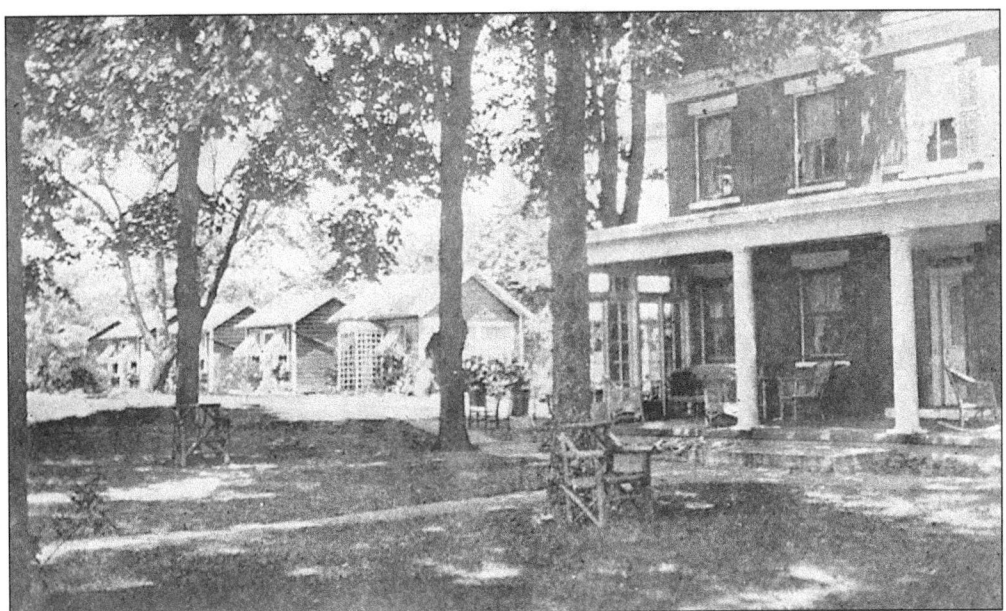

The large, old brick house opposite the Hartman House became a tourist home, the 1920s version of a bed and breakfast. Cabins were added in the side yard, as shown in this 1934 postcard, when Mr. and Mrs. J.J. Thearle were the proprietors. Later, a modern motel replaced the cabins. The house and motel unit still stand opposite Stewart's on Route 20.

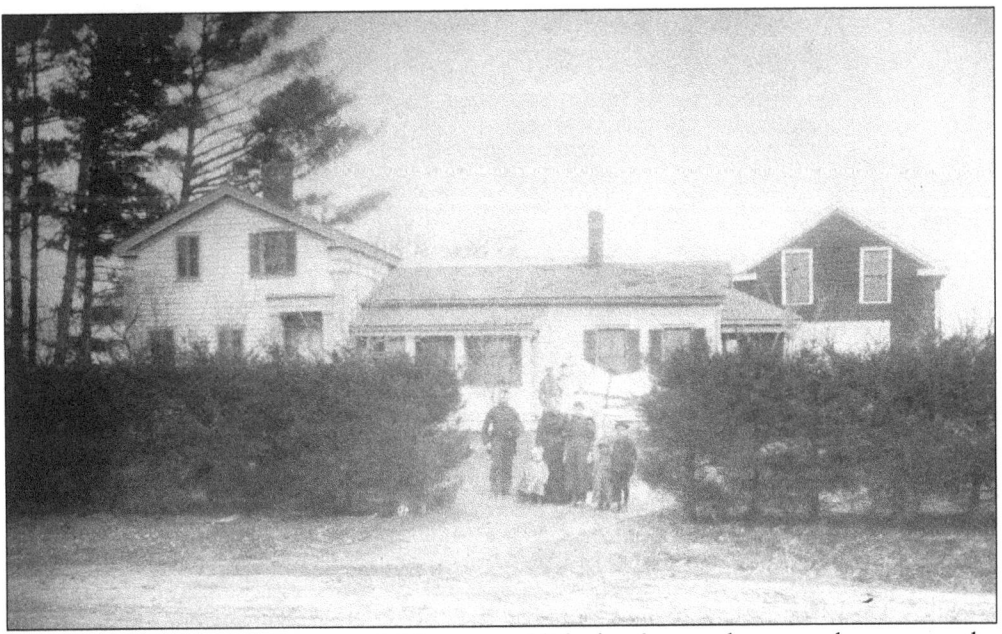

Evert Bancker, the third mayor of Albany, established a farm and country house near the Normanskill, regularly traveling by canoe to get there. The photo shows the house as it was c. 1895. Some time after this, the house burned and was replaced by the present one. However, the dark building at right survived and remains today. Its location is on Route 146, one-half mile south of Hartmans Corners.

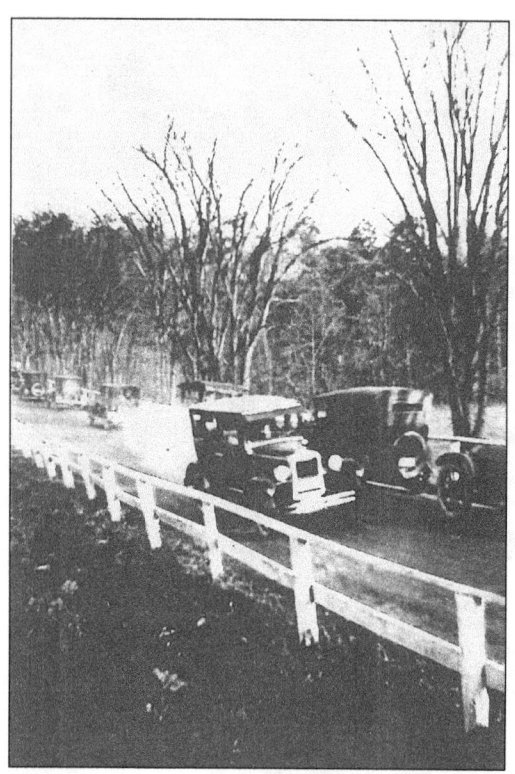

Unusually heavy traffic was crossing the Normanskill Bridge when this photo was shot in 1926. The Evert Bancker Farm was nearby, and over the years, local people corrupted the name to "Bunker" for both the bridge and for the long hill Route 146 climbed on its way to Guilderland Center. Occasional floods on the Normanskill washed out successive bridges, including a covered bridge and an iron bridge, once resulting in a fatal accident.

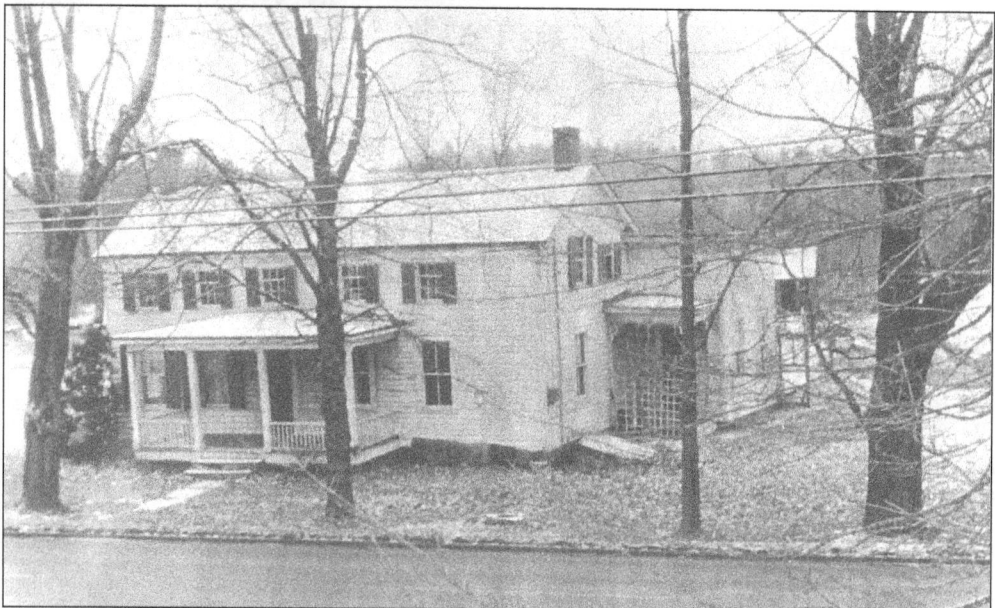

Established in 1876, the Gade Family Farm had the distinction of receiving one of New York's Century Farm awards, for having been worked by several generations of the Gade family for over 100 years. The original part of the farmhouse was constructed in the early 1800s. Seen in this c. 1950 photo, the house was dismantled for restoration on another site in 1984. Customers of Gade's Farmstand park on the site of the farmhouse, which stood along the Western Turnpike.

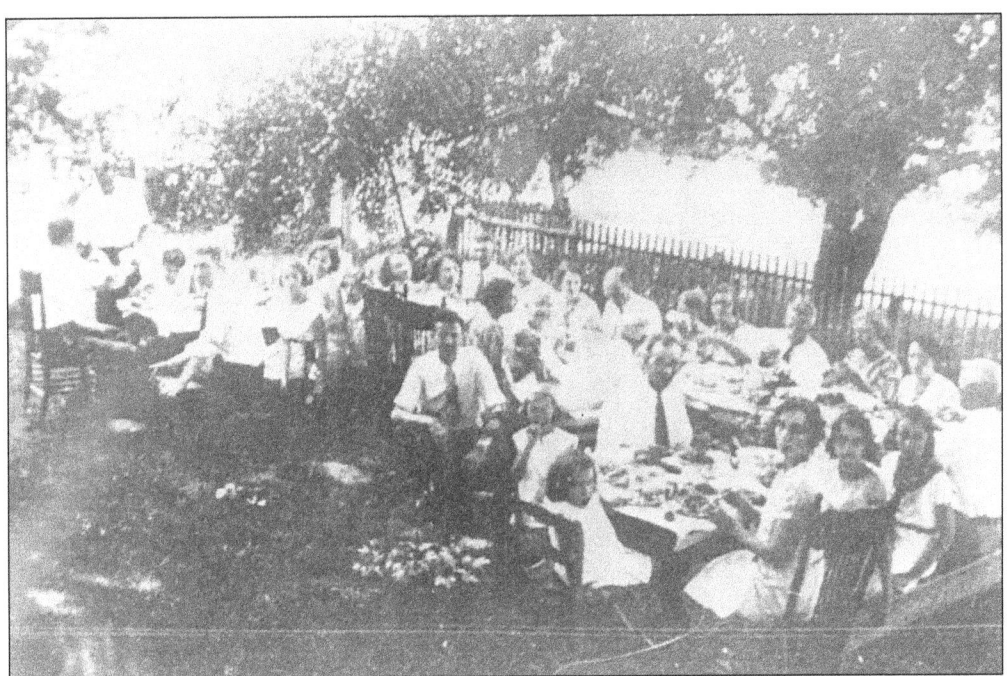

Summer picnics brought together family and friends, providing a welcome break in the usual routine. Here, members of the Gade family enjoy a clam bake in August 1932. With Peter Gade, founder of the family, raising 11 children on his farm, there was no shortage of relatives to join in on the fun.

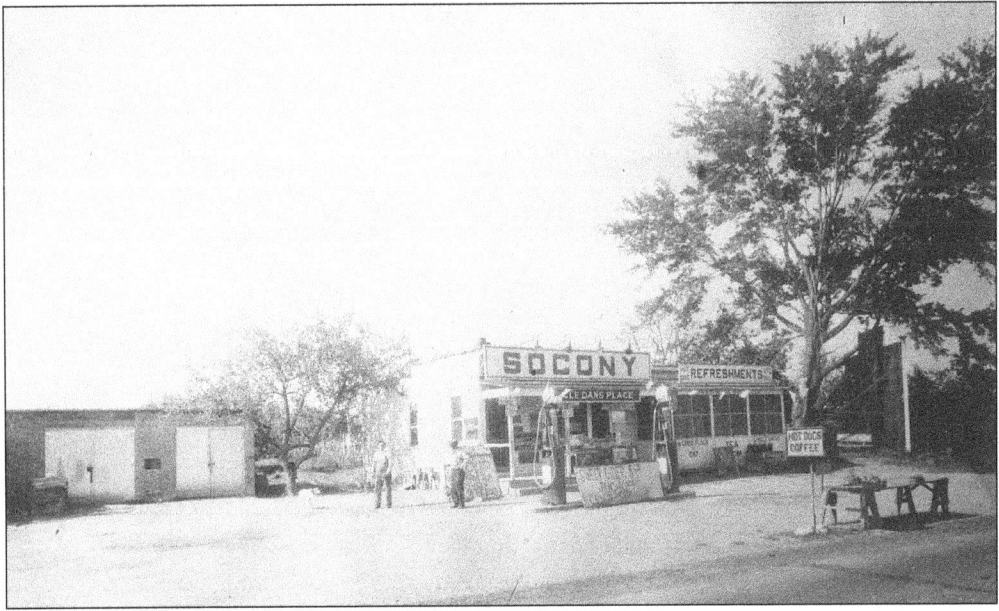

The road may have remained the Western Turnpike to local people, but to the ever-increasing number of auto travelers in the 1920s, the highway was called U.S. Route 20. Uncle Dan's Place, near McCormacks Corners, was one of any number of roadside businesses that sprang up to serve the traveling public. Uncle Dan could fill your tank with gas for 19¢ per gallon and fill your stomach with the "best coffee and sandwiches on the road."

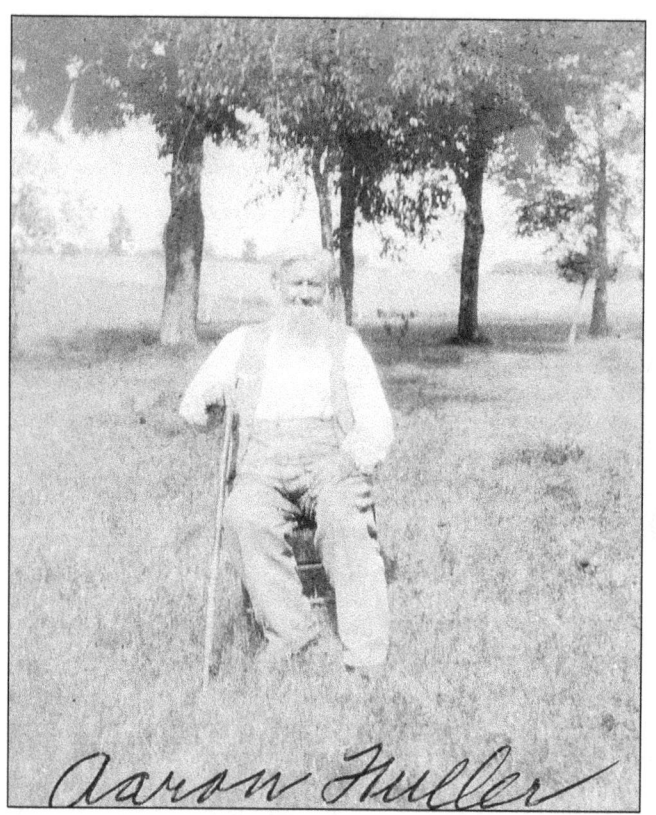

Aaron Fuller, one of Guilderland's most prominent citizens, sat for this photograph in 1900. He was an elderly man able to reflect on a productive life as a farmer, businessman, and politician. Because of his foresight in convincing the West Shore Railroad to build a station there, the hamlet of Fullers, west of McCormacks Corners on the Western Turnpike, grew prosperous. Fuller developed a thriving hay and produce business and was the only Democrat elected to the position of town supervisor for over a century.

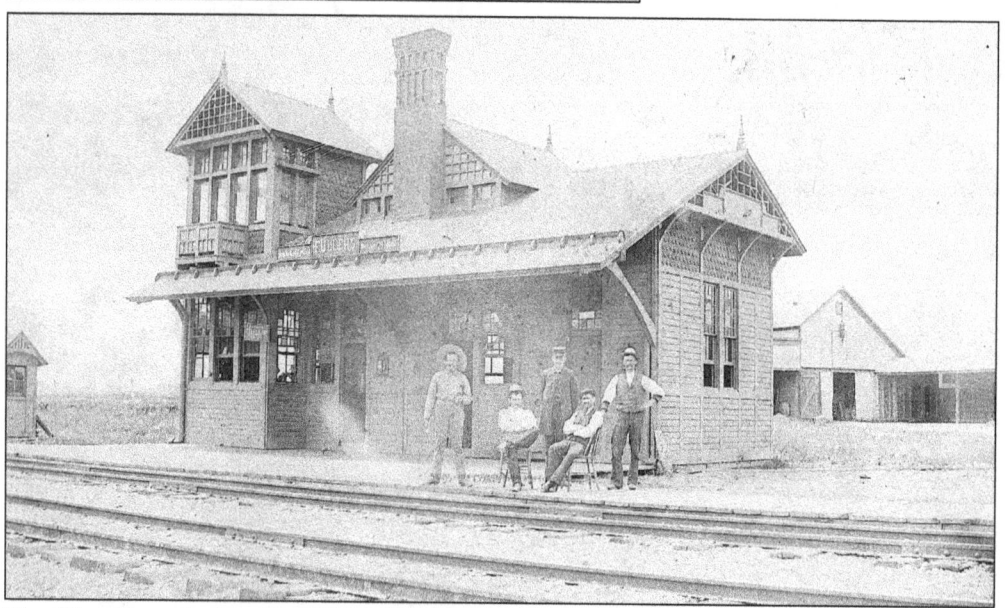

The West Shore Railroad's depot at Fullers was built in 1882 on Fuller Station Road, southwest of the Western Turnpike. Rail traffic was heavy enough through this small hamlet for incoming and outgoing mail twice daily. Students commuted for $7.50 monthly to Ravena High School at their own expense. Removal of the station became necessary in 1927, when the tracks were built above the level of the Western Turnpike.

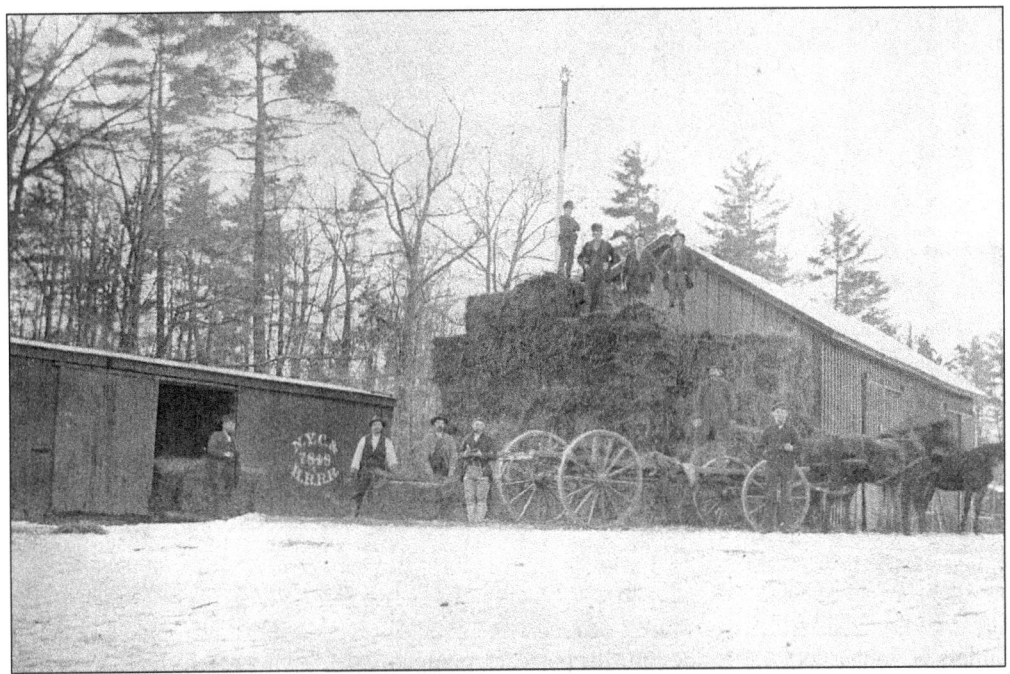

Behind Fullers Station was a huge hay barn. At Fullers, Aaron Fuller and the firm of Tygert and Martin each had a "hay press," a business that purchased hay from local farmers, then compacted the hay into bales so the maximum amount could be shipped out in boxcars to meet the huge urban demand in the horse-and-buggy era. The process of pressing and loading hay provided seasonal work for many men.

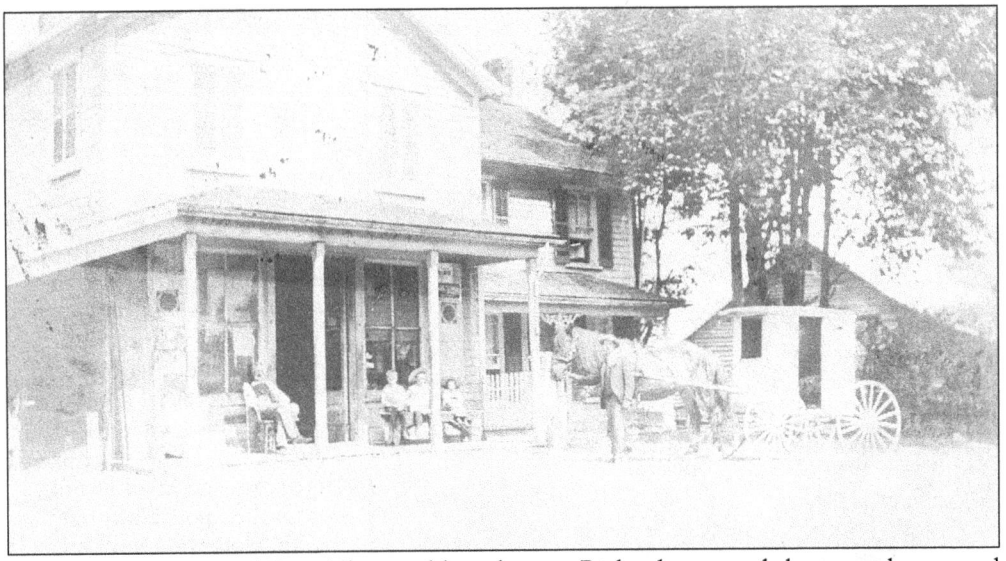

For many years, Samuel Van Allen, and later his son Richard, operated the general store and post office at Fullers. The store, shown here on a 1907 postcard, was located southwest of the Western Turnpike on Fuller Station Road. The post office was discontinued in 1918, and when the store closed, the building was converted into a home that remains standing today.

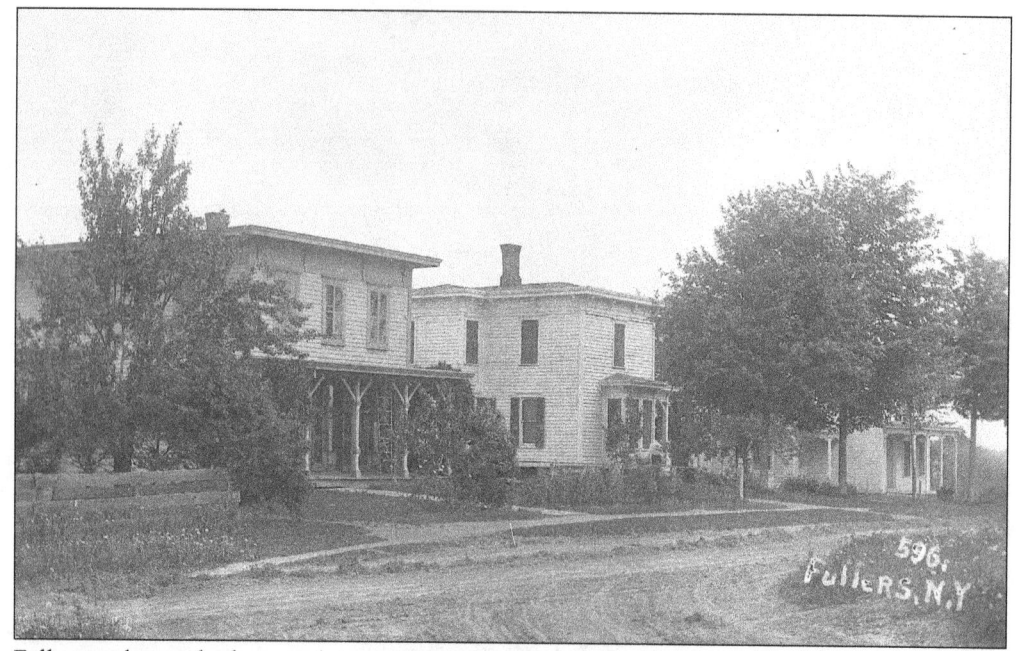

Fullers no longer looks as it does on this postcard stamped 1914, a time when the hamlet still had a store, post office, and school. The houses remain, but Route 20 was lowered in 1927 from the level it had been as the Western Turnpike At that time, the West Shore "flyover" was created to do away with a dangerous grade crossing, resulting in a very high retaining wall separating these houses from the road.

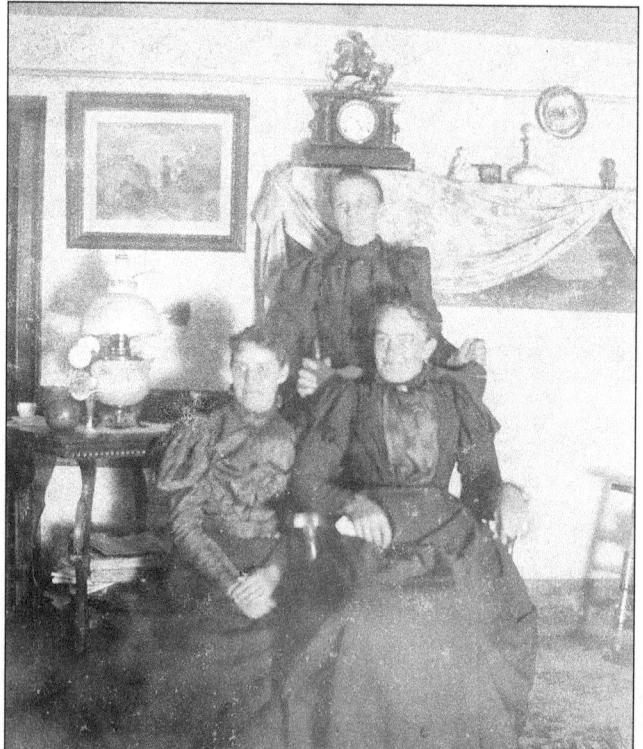

Major John Fuller, and later Aaron Fuller, presided over a tavern situated on the Western Turnpike at the northwest corner of Fuller Station Road. Later in the 1800s, it became a private home where, a century ago, Emma Van Allen, Sate Coss, and Ella Blessing sat for their portrait in the parlor. Note the Victorian knickknacks, fancy kerosene lamp, and draped mantle added to the Federal-period house to make it look more "modern."

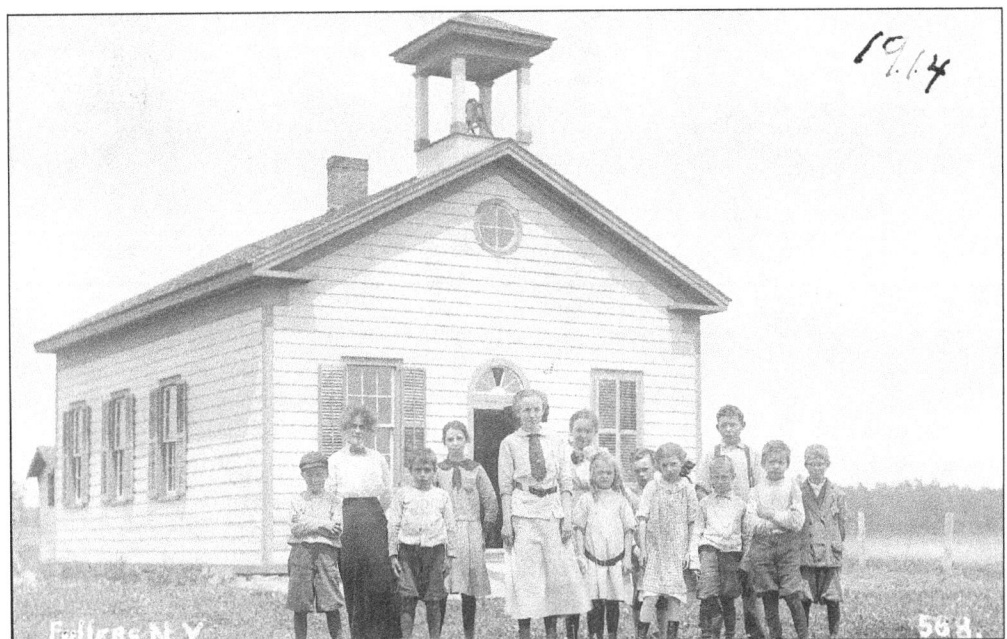

Among the students who lined up with their teacher in 1914 near the Fullers District #13 School on the Western Turnpike was Anna Blessing Anthony (sixth from left). After graduating from Ravena High School, she attended a summer session at the Oneonta Normal School. That fall, at the age of 18, she was paid $15 weekly to teach at the Dunnsville School. On her first day, the children tested her mettle by stuffing a dead mouse in her desk drawer.

The Ladies' Social Union, a women's organization of the Helderberg Reformed Church that met at various members' homes, gathered at the Coss House in Fullers. The ladies appreciated the opportunity for a visit and leisurely chat, but had the more serious purpose of raising funds for their church. Note the c. 1900 interior, especially the parlor stove.

Perhaps unsettling to the eyes of squeamish modern viewers, this c. 1915 scene of slaughtered pigs hanging on the Blessing Farm, waiting to be cut up and smoked in the farm's smokehouse, was a common sight in late autumn on Guilderland's farms. Local farm families supplied most of their own foodstuffs, and the hams, bacon, sausages, and headcheese were welcome additions to their diet.

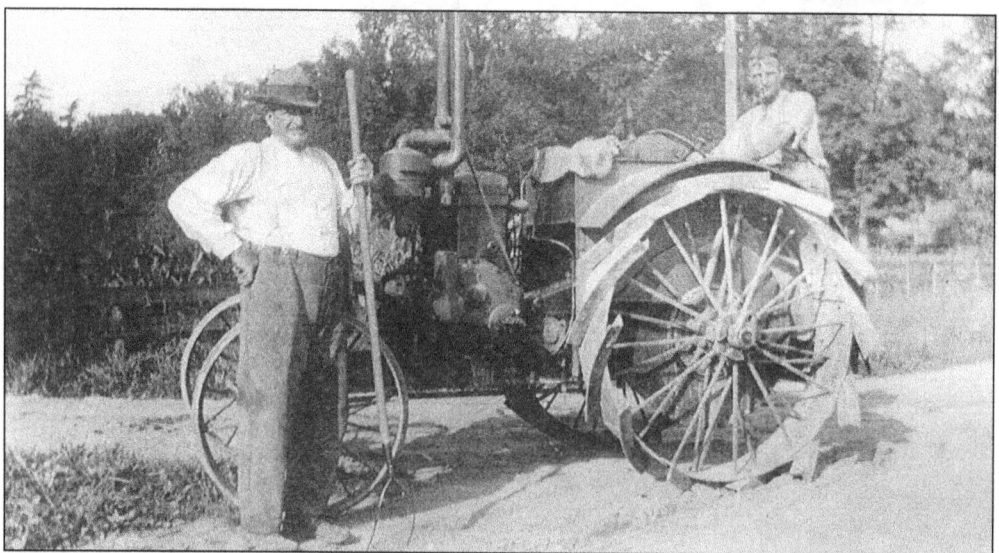

The old and new are evident in this picture taken on the Blessing Farm in Fullers. Martin Blessing (on the left) clings to his pitchfork, an implement used by generations of local farmers, while his son Jake stands ready to use their early tractor to quickly do chores that would have taken hours with a horse or by hand.

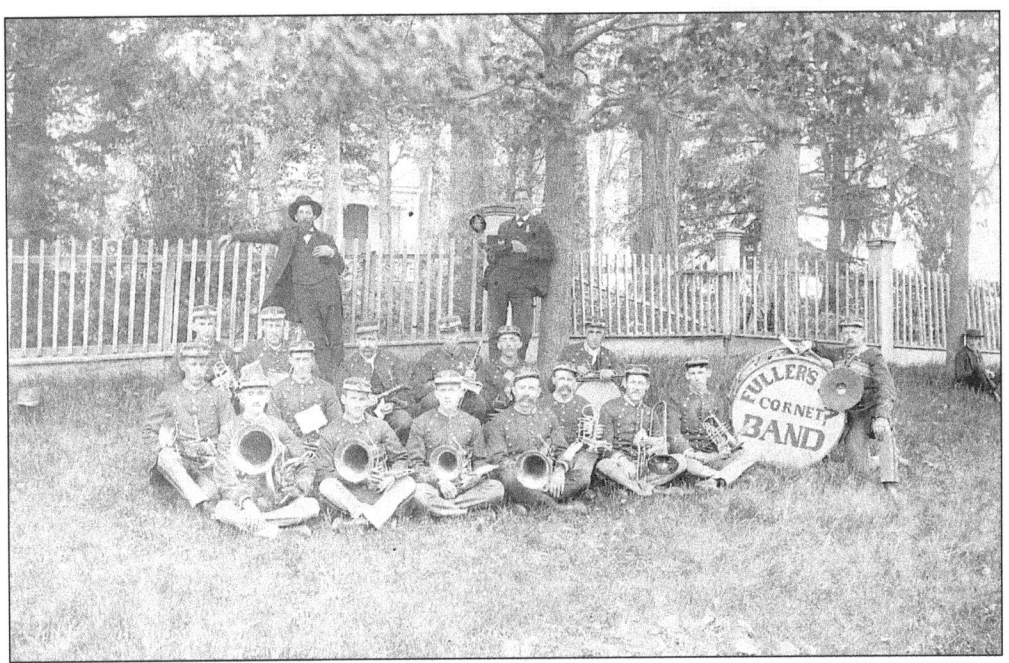

Guilderland's town band tradition got its start in the 19th century with the formation of cornet bands in Fullers and Knowersville. They performed at patriotic events and parades on Memorial Day and July Fourth.

The grade level crossing at Fullers became extremely dangerous with increased auto traffic in the 1920s. In 1927, a trestle was constructed and the highway was lowered to alleviate the problem. Within a few years, the second high trestle was erected, supposedly to aid locomotives pulling heavy trains up the steep grade at Frenchs Hollow.

Col. Abraham Wemple's farm, located back from the turnpike west of Fullers, was nestled on the fertile flats bordering the Normanskill. Wemple, an esteemed Revolutionary War hero, was a prosperous farmer. His home was constructed in 1760 from bricks made of clay dug from the nearby banks of the Normanskill. When the Watervliet Reservoir was created, the house was demolished and the once productive fields were flooded.

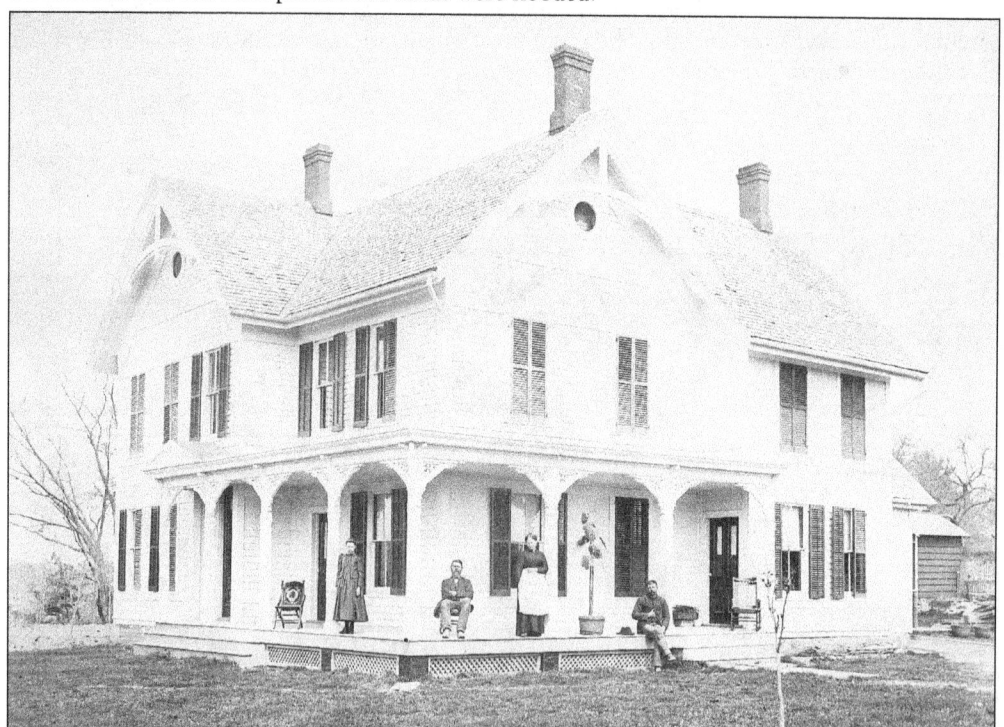

Sharps Corners was the name given to the intersection where the Western Turnpike crossed the road to Schenectady, now Route 158. Members of the Sharp family owned houses near each corner. The one pictured here is the Sharp-Jeffers House, standing west of the corners. It was one of many Guilderland homes photographed with their owners by the Northern Survey Company of Albany during the last quarter of the 19th century.

By the 1920s, Sharps Corners was on a heavily traveled east-west route. It was crossed by a well-traveled local road that was the perfect location for a gas station. Al and Eleanor Folke opened this Texaco station on the northeast corner of the intersection in 1925. In this early view, Folke poses by a gas pump shortly after the station opened.

Folke's gas station prospered so that within a few years it was expanded with a restaurant and cabins. The rose-covered trellis and flowers added a homey touch. The Folkes operated their business at this location for over 40 years. The building has been converted to a residence at the northeast corner of Routes 20 and 158, and some cabins still remain.

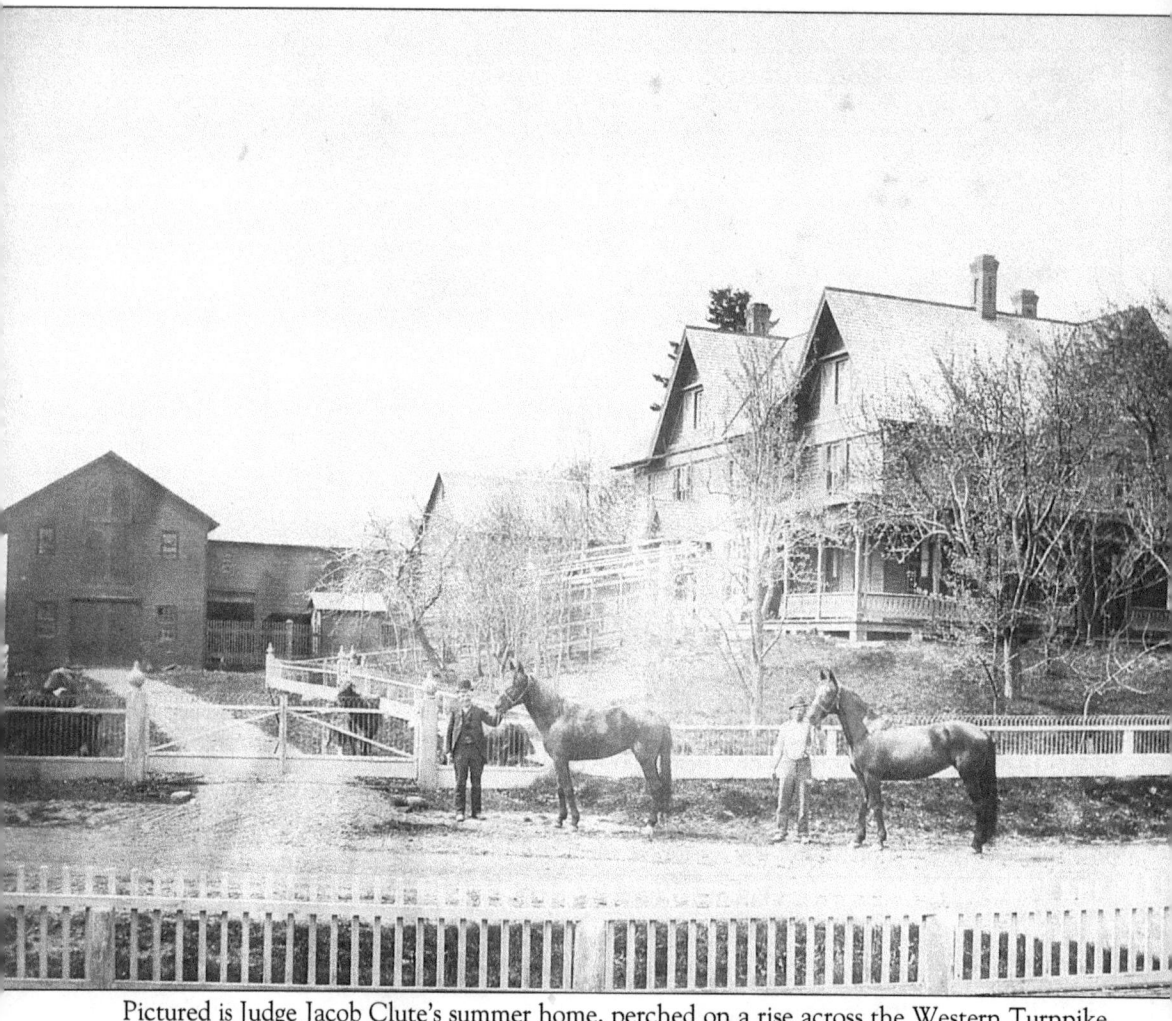

Pictured is Judge Jacob Clute's summer home, perched on a rise across the Western Turnpike. Judge Clute raised fine carriage horses on this working farm, which was run year round by his brother-in-law, Billy Moran (right). Charles Decker Sr., a neighbor, stands at left. Judge Clute's niece, Ina Clute, married a member of the Sharp family and eventually inherited the property. The house and barns survive today on the south side of Route 20.

Early in the 19th century, a covered bridge carrying the Western Turnpike over the Normanskill was constructed just west of Sharps Corners. Road machinery and supplies were stored in the narrow half. Here, the view is to the east, toward Fullers, and the house on the left is the Sharp-Jeffers House. The bridge was removed c. 1922 to accommodate the trucks and buses that had begun to use the road.

Living among Guilderland's many prosperous farmers and successful businessmen and craftsmen were those who had difficulty making ends meet. Their dwellings were seldom recorded and have long since disappeared, along with memories of their owners. This man, however, did have one precious possession: his little dog, which he carefully leashed. The house was located west of Sharps Corners, along the Western Turnpike.

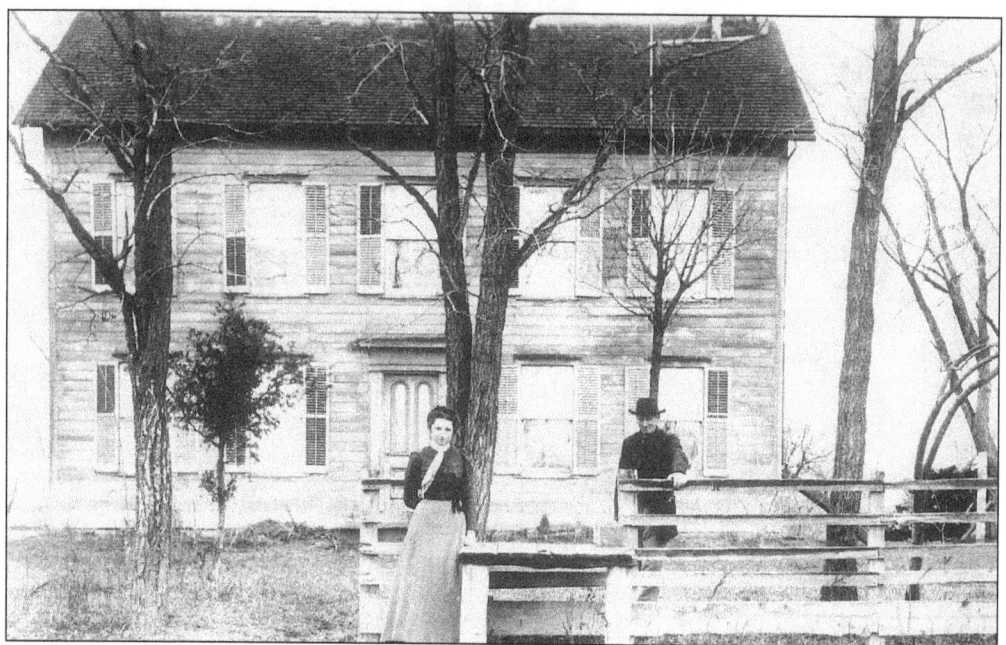

Miss Belle Davis, a teacher in the Dunnsville District #2 School, poses with her father in front of their home, located on the turnpike, one mile east of Dunnsville. When the house burned in 1912, a valuable landmark was lost; the building was an inn built many years before, when the Western Turnpike was a heavily traveled route to the west.

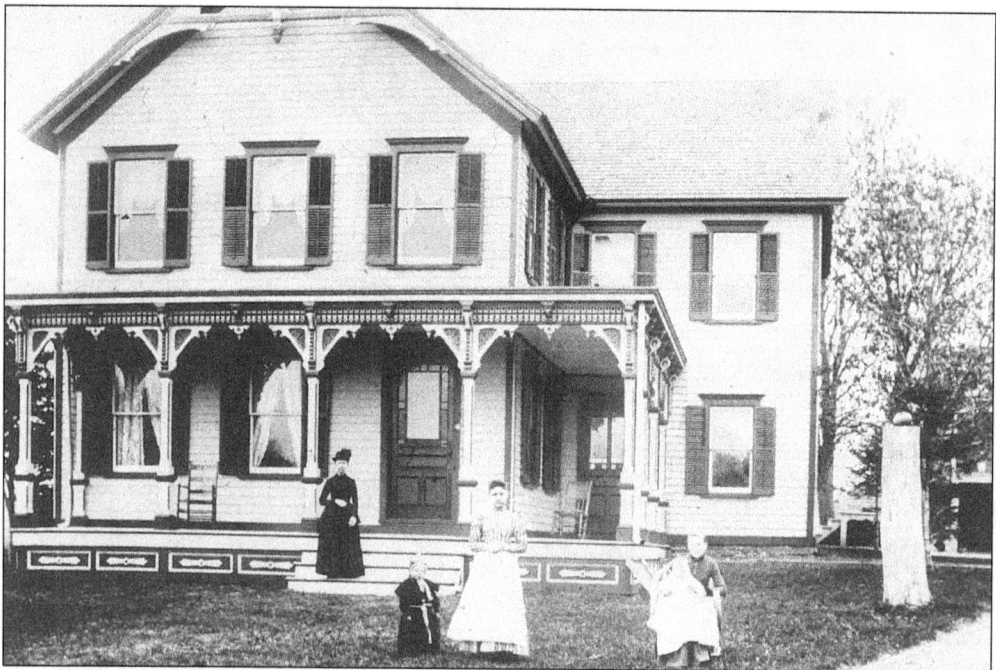

Casper Wagner's farmhouse was rebuilt in 1872, giving it what was then an up-to-date Victorian look, sporting elaborate millwork and trim. There was obviously a multi-color paint scheme, which was typical of the time. The house and farm were located on the Western Turnpike, east of Dunnsville Road.

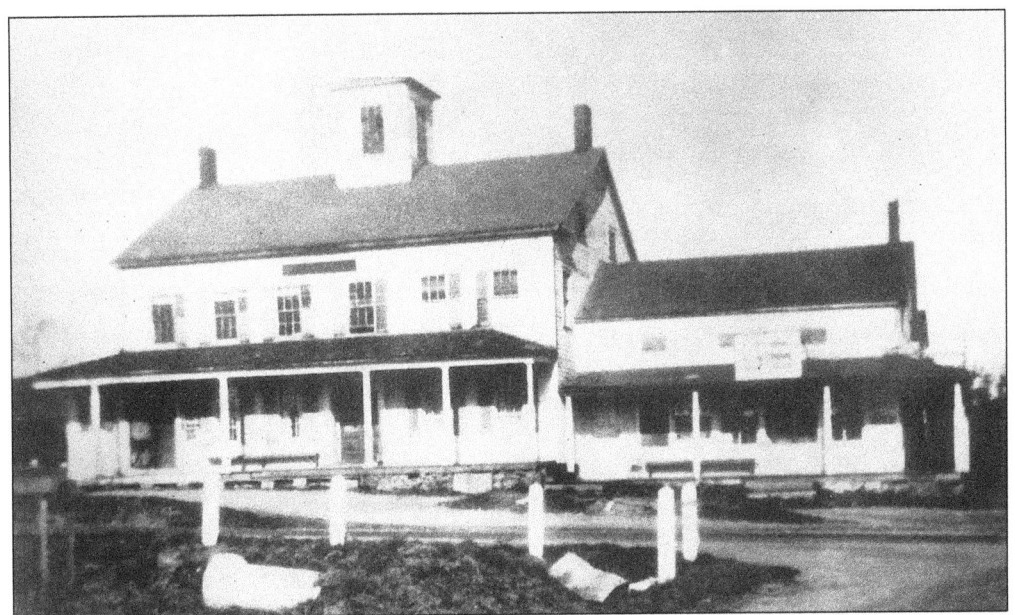

Christopher Dunn, an early landowner in the western part of Guilderland along the turnpike, was not only a tavern keeper, but gained statewide recognition as a progressive agriculturist in the 1830s. The small hamlet that developed in this area became known as Dunnsville and boasted two taverns, a store, two blacksmiths, a school, a post office, and a doctor's office by the end of the 19th century. Pictured is the Dunnsville Hotel, built in the mid-1800s. It was later used to house the Gifford Grange Hall.

Couples traveled for miles to dance to the latest tune at the Air-O Dance Hall after its opening in 1930 on the Western Turnpike in Dunnsville. Unknowns such as "The Commanders" as well as popular musicians Rudy Vallee, Benny Goodman, and Jimmy Dorsey played at the crowded night spot. Wartime gas rationing closed the dance hall, but it later reopened as the Swiss Inn and stayed in business until it was destroyed by fire in 1972.

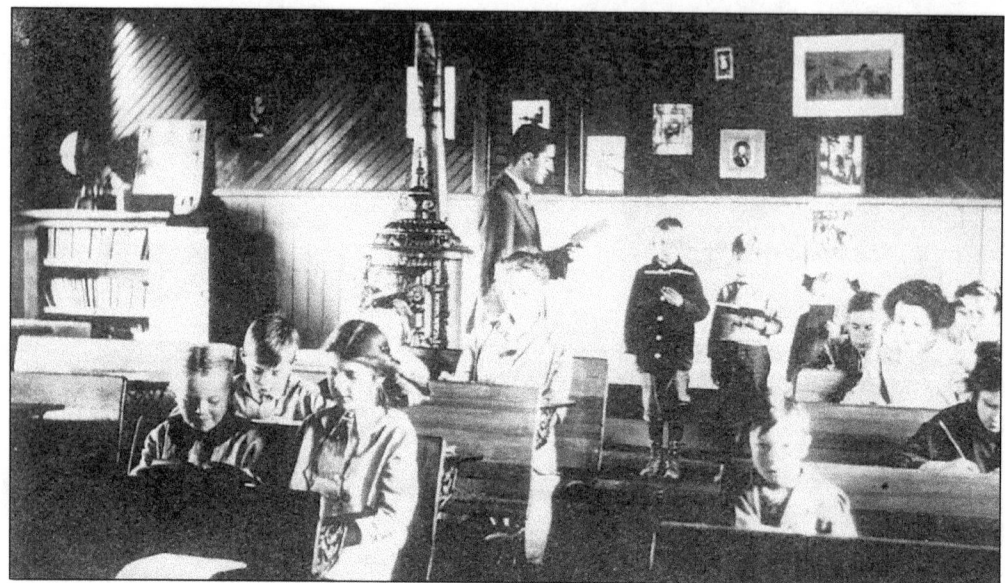

In a one-room school, c. 1915, self-discipline was expected of children regardless of age. Here, students at Dunnsville District #2 School quietly occupy themselves while the teacher works with small groups of children of varying ages and abilities. Equipment was simple: a pot belly stove, desks bolted to the floor, a blackboard, and a single bookcase that held the entire school library.

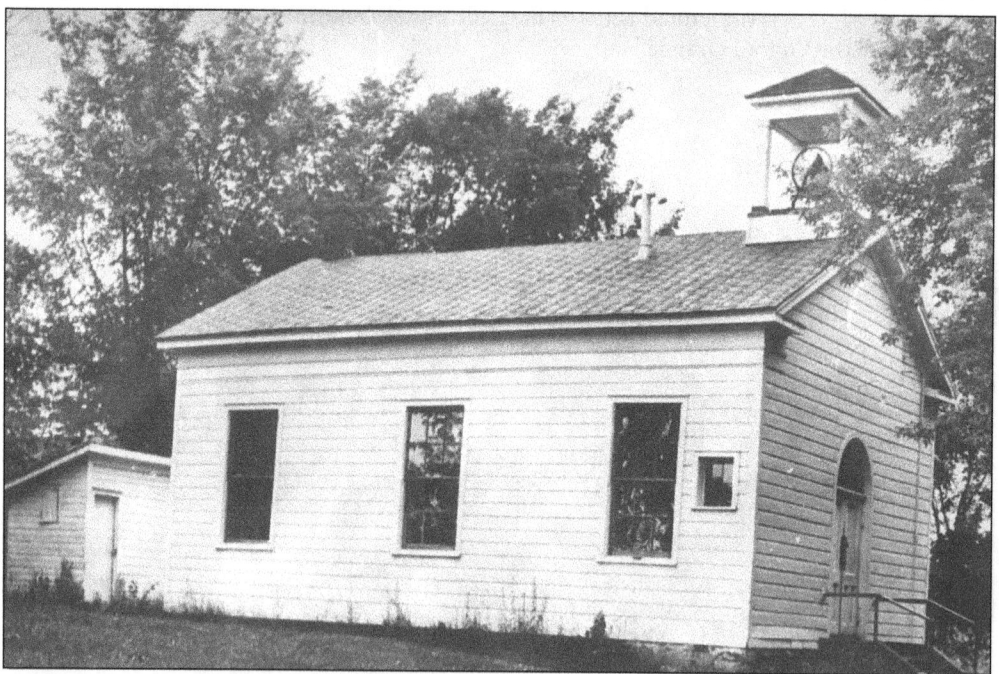

By 1876, Dunnsville's school had been relocated across Dunnsville Road from its original site. It remained in use at the new site until 1953. A teacher there for the last quarter century, Mrs. Ruth Lawyer, remembered modern technology coming to the one-room schoolhouse: "a radio to get educational programs, a victrola for music appreciation, a slide machine to help us learn of other countries." After 1953, the building became a private residence.

Four

GUILDERLAND CENTER AND FRENCHS HOLLOW

Few who drive Guilderland Center's Route 146 can visualize it as Schoharie Road, the dirt path trekked by German Palatines on their way to Schoharie in the 1750s, or later as the improved Schoharie Plank Road, traveled by stagecoaches and wagons. By the close of the 19th century, the road had simply become Main Street, lined by residences, a school, two churches, taverns, and various businesses, including a cigar factory. Building a railroad in 1865 helped spur the growth of the community.

By then, Guilderland Center was a respectable hamlet, unlike earlier times when people called it "Bangall" due to the "influence of rum, horse racing, and rough manners, once too prevalent there." Today "Bangall" has become an affectionate nickname for what is now a quiet, residential community. The dirt path through the wilderness has become the heavily traveled Route 146, but the old buildings on either side still retain a flavor of the past.

Nearby, over Frenchs Mills Road, was Frenchs Hollow, site of Peter Broeck's 1795 cloth works. Some other mills were built, and for a brief time, the area showed promise as an early-19th-century manufacturing center. Years of slow decline followed, and no trace remains of this early settlement.

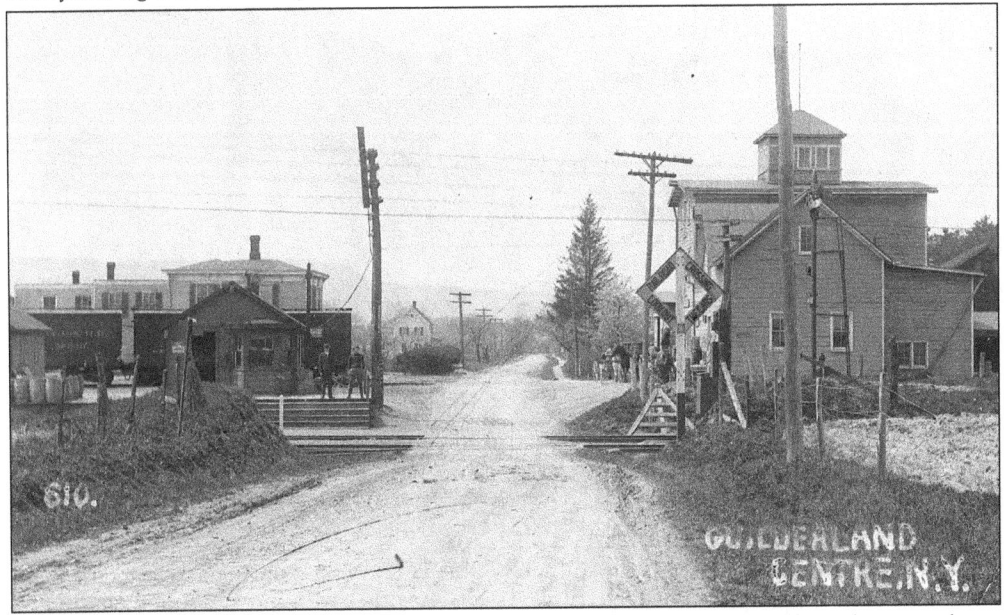

Travelers entered Guilderland Center on Wagner Road, crossing the West Shore tracks at grade level. After several auto fatalities at this crossing, the road was realigned and the Route 146 overpass was constructed in 1927.

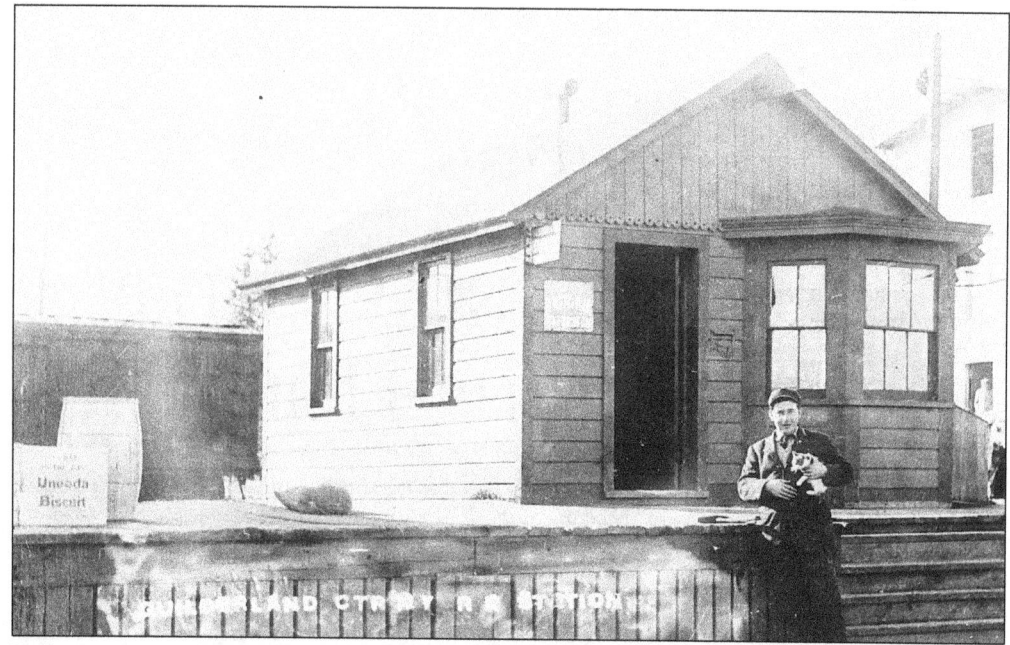

Perhaps young Edmund Witherwax had just laid a penny on the track and was waiting for a freight to come through to flatten his coin; this was a favorite activity of young fellows in his day. Even though Guilderland Center was on the mainline of the West Shore, it rated only the small station shown here c. 1910, where through the bay window observers could watch the telegrapher at work. Hurst's feed mill is visible on the right, across the main road.

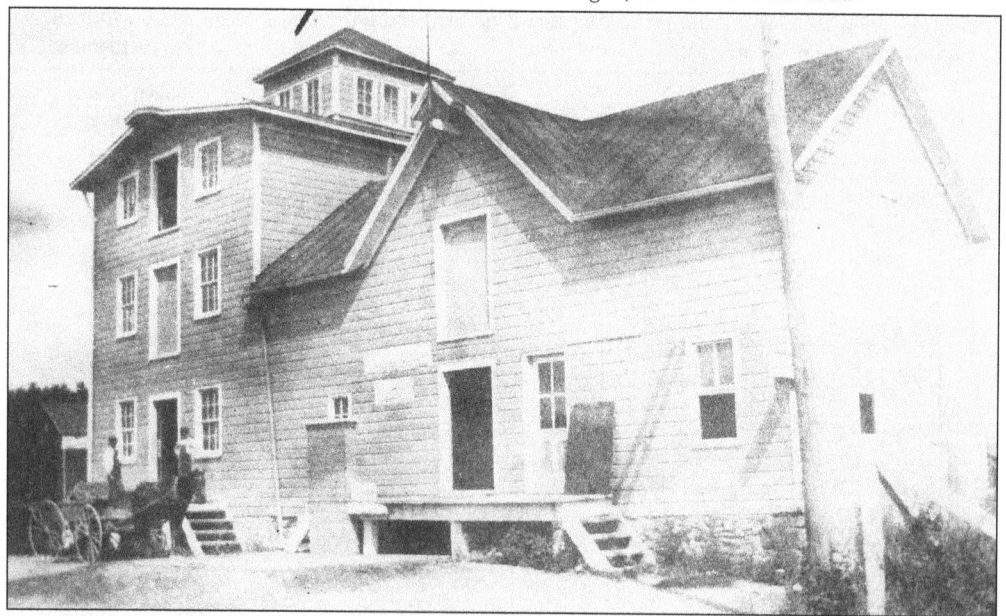

C.J. Hurst's feed mill was one of several mills in Guilderland, and it found a ready market among farmers who needed the animal feed, fertilizers, seed, and other farm supplies sold there. By the 1920s, Hurst also advertised coal, asphalt roofing, tires and tubes, oil and grease, and Overland Automobiles. When the mill burned in a spectacular fire one night in August 1926, witnesses said the glow could be seen for miles. The Route 146 overpass was built over this site.

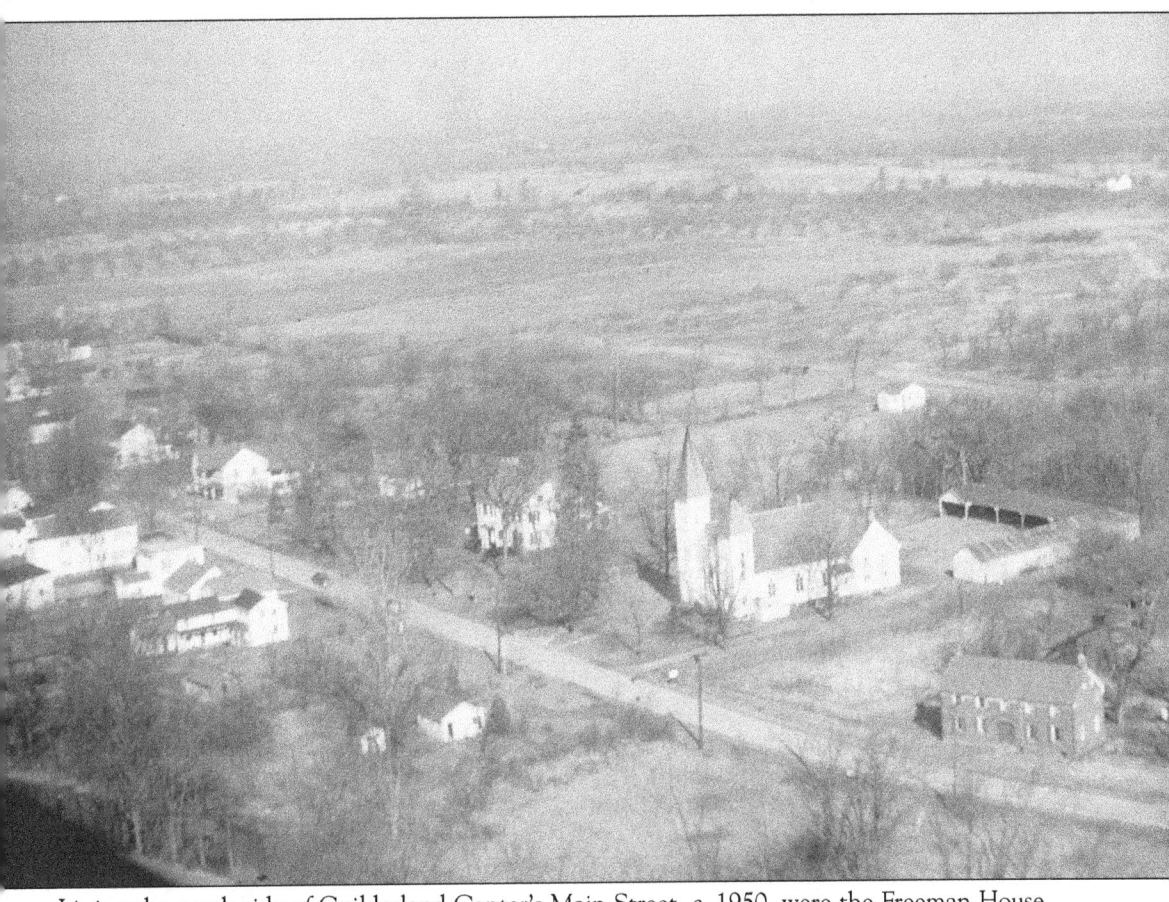

Lining the north side of Guilderland Center's Main Street, c. 1950, were the Freeman House, the Helderberg Reformed Church (with the horse sheds still intact), the Mynderse-Frederick House, Joe Banks' tavern, private homes, and, at the far left, St. Mark's Church. Across the street from the Reformed church was a gas station, then private homes. The peak of Empie's store can be seen beyond the large, rectangular house, which was moved around the corner to School Road when the store was demolished. It was replaced by a gas station in the early 1970s.

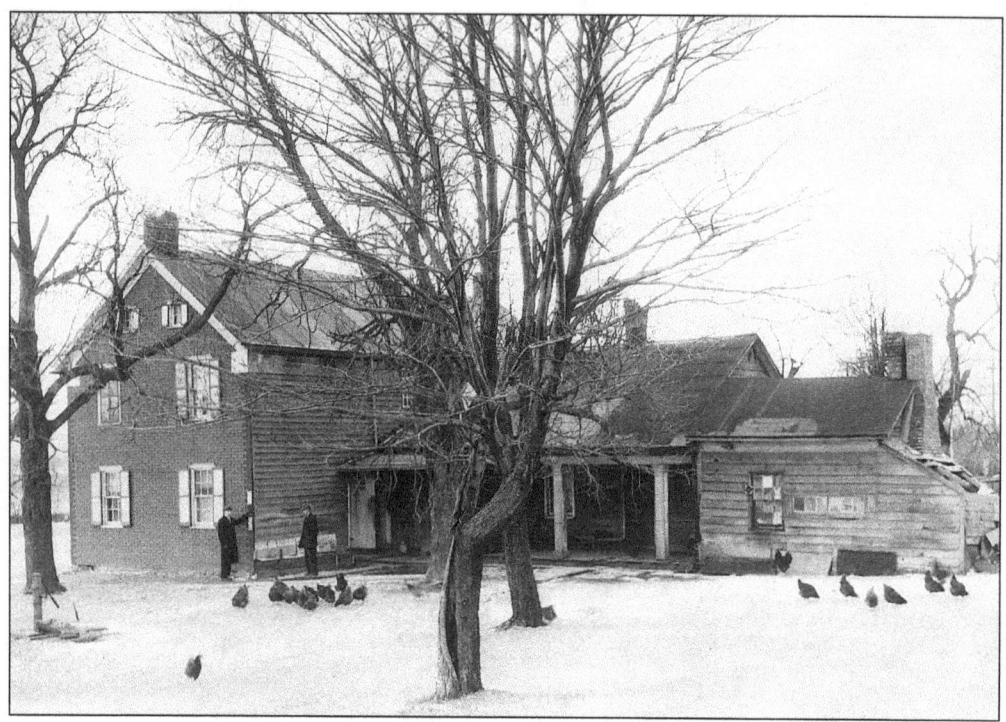

The oldest existing frame building in Guilderland is the red clapboard Freeman House, which was built c. 1734 at 429 Route 146. In this 1937 view, Edward P. Crounse stands to the right of his farmhouse while it is being recorded for the Historic American Buildings Survey. Since restored, the Dutch door in front is just one of its many original architectural details.

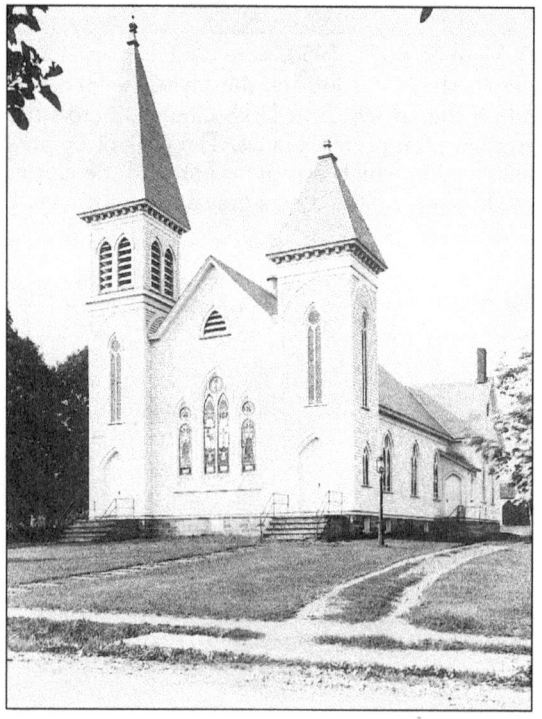

The Helderberg Reformed Church, seen here c. 1910, opened its doors in 1896 when it replaced the Gamble Church at Osborn Corners. Stained-glass windows, the chandelier, and the bell given in 1845 by the Ladies Benevolent Society were incorporated into this building. It burned in 1986 and had to be razed. The bell survived the flames to ring again in the new church.

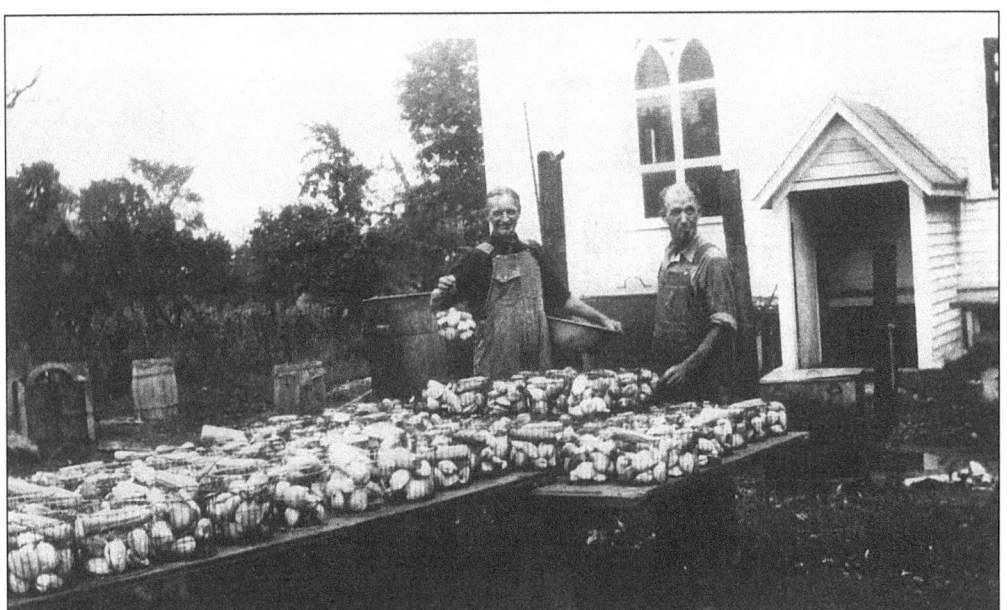

Both the St. Mark's Lutheran and Helderberg Reformed Churches sponsored events such as ice cream socials and dinners. Helderberg's dinners were described in the *Altamont Enterprise* in 1912 as having "a wide reputation owing to the excellent spreads they set up," and their famous clam bakes drew large crowds. In this c. 1932 view, Jacob Blessing (left) and Lloyd Coss are set to steam baskets of clams and corn in huge vats behind the church.

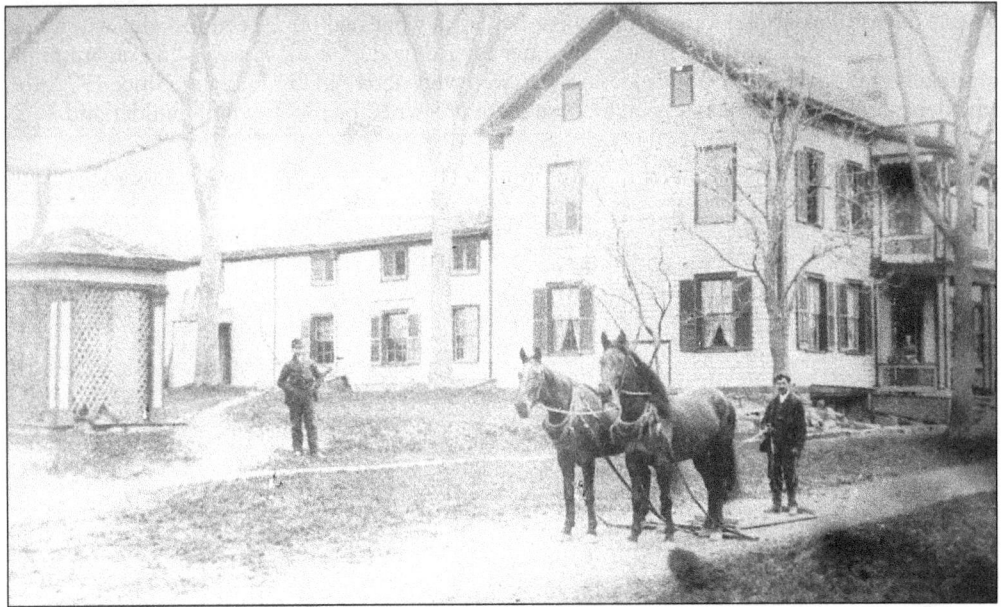

The Mynderse-Frederick House, one of Guilderland's early taverns, was built on the Schoharie Road in 1802 by Nicholas Mynderse. Three generations of the Frederick family continued tavern operations here until 1917, when the building became their private home. William Frederick and William Frederick Jr. are pictured in this c. 1890 photograph. Note the Victorian porches and the latticed well house, both since removed. The entrance to the tap room is to the left of the porch.

The Mynderse-Frederick House still retains the bar in what had once been its cellar tap room. Above the bar, for many years, hung the banner carried by the "Wide Awakes," an organization of backers of Lincoln in the 1860 election who were very active in Guilderland. Since 1972, the Mynderse-Frederick House has been a house museum owned by the Town of Guilderland.

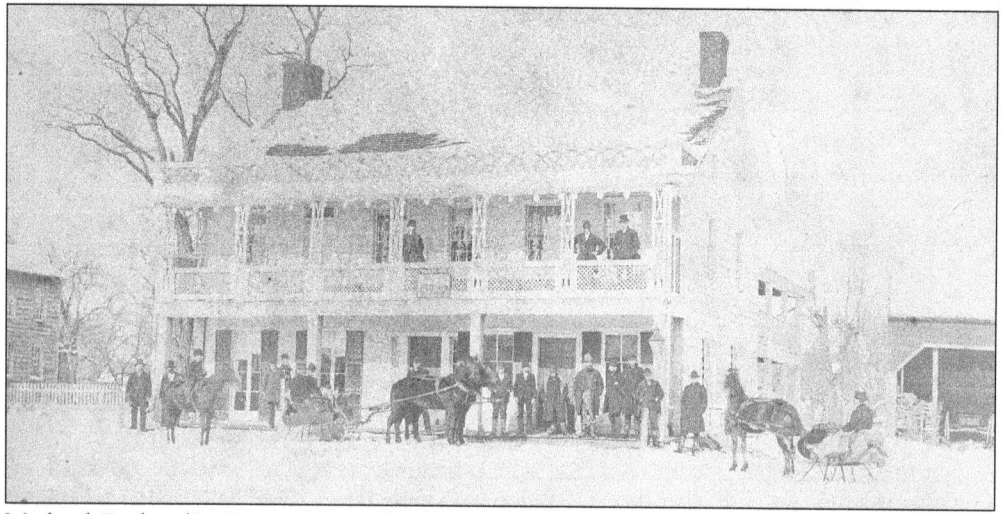

Michael Frederick's Center House, built c. 1849, was a popular rest stop for Schoharie and Albany Stage Coach passengers traveling the Schoharie Plank Road. A convivial gathering place, the bar was occasionally the scene of the fisticuffs that gave "Bangall" its reputation, while in the spacious upstairs ballroom, partygoers often had lively dances. The tavern, shown here c. 1890, continued to be a center for local social life for another 80 years.

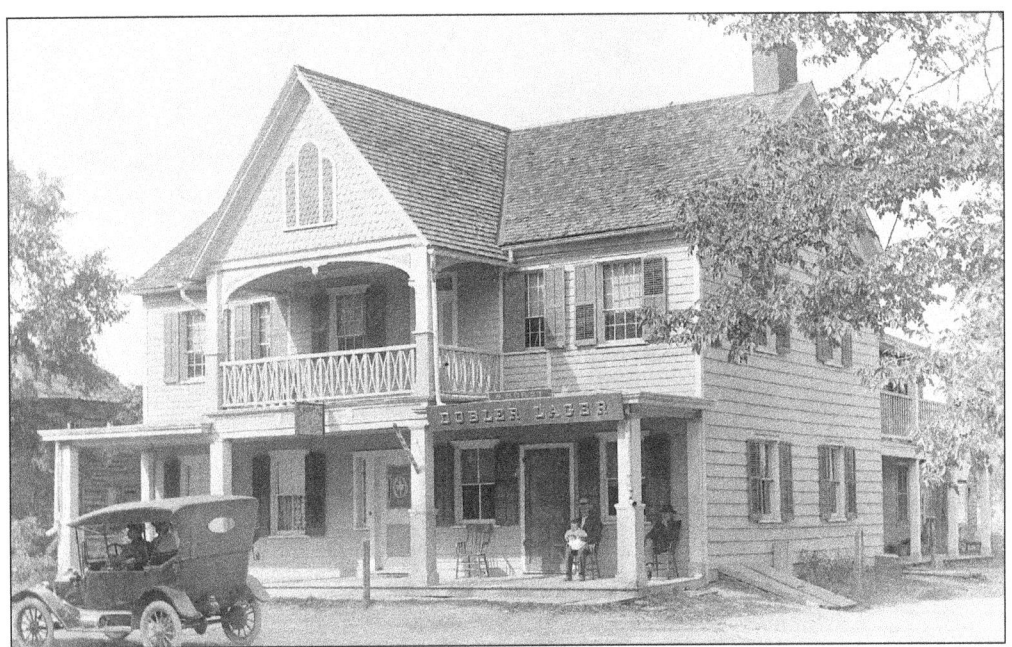

Remodeled and modernized early in the 20th century, the Center House continued to be a tavern until c. 1970. Seymour Borst was its proprietor in the 1920s when this photograph was taken; in the 1930s, the tavern was owned by Joseph Banks. Under his management, the tavern attracted not only the local residents, but out-of-towners for parties and dances. The tavern was demolished by a developer, and Park Guilderland's entrance is located on the site today.

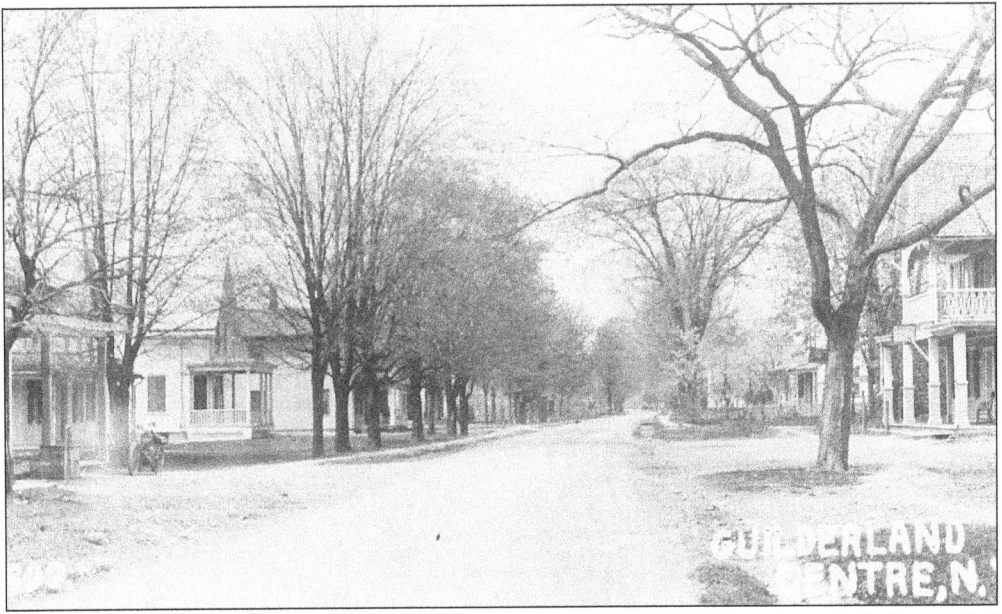

In this c. 1915 view looking toward Altamont, Main Street is little more than a lightly traveled dirt road. Borst's Hotel, later known as Banks' Tavern, is on the right. At the far left are the porch columns of Petinger's General Store, which is the present site of a gas station. The motor cycle is parked where School Road (County Route 202) leads to Guilderland High School. The houses located west of School Road remain.

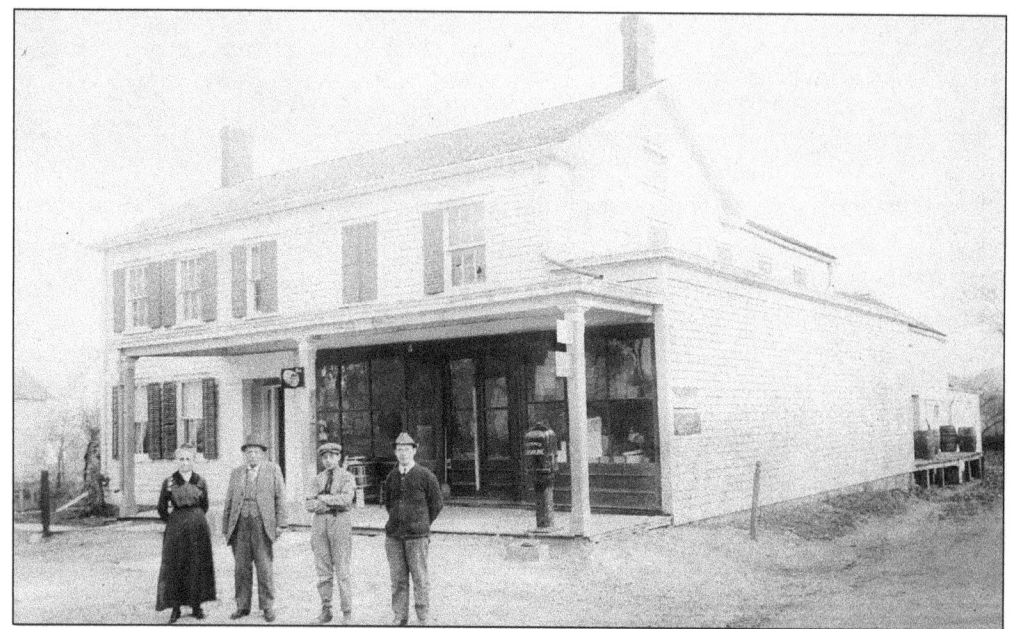

Petinger's General Store was a fixture on the southeast corner of Main Street and School Road. It was the first gas station in Guilderland Center. The gas pump at the end of the porch served the two or three cars that passed by daily when this picture was taken c. 1915. Gasoline was brought from Albany in a wagon pulled by a mule team. Helen, Philip Sr., Philip Petinger III, and John Ladd are in pictured in front. In later years, Luther Empie ran the store.

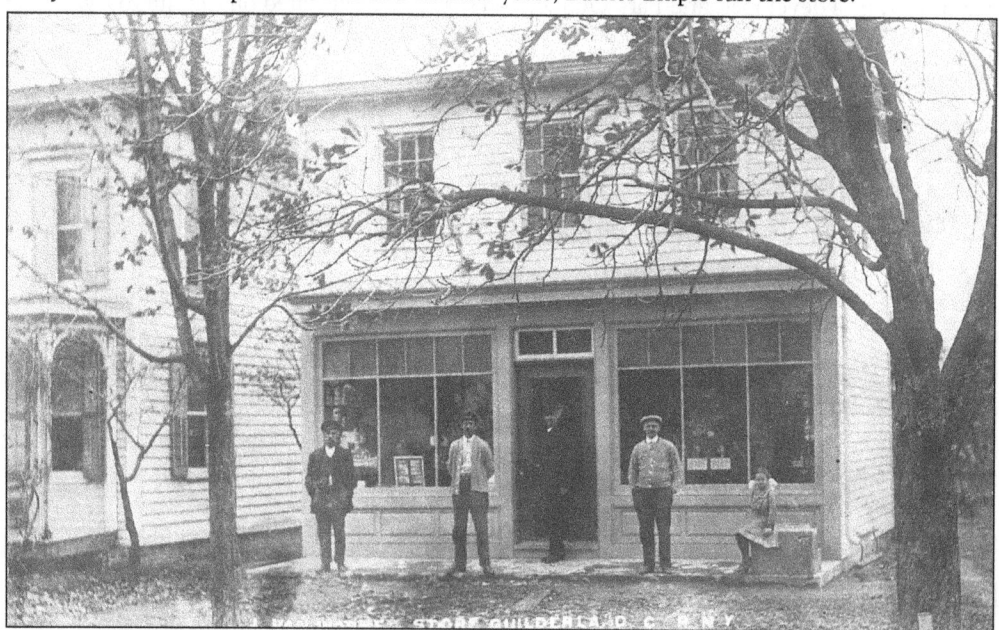

Early in this century, Guilderland Center's other general store was owned by Fred and John Van Wormer. In those days of postal patronage, when a Democratic president was elected, the post office moved to their store. Otherwise, it was up the street at Petinger's store. The men in this view are unidentified. The little girl is Margaret Moak. The building, presently a residence at 468 Route 146, has changed significantly since the time of this picture.

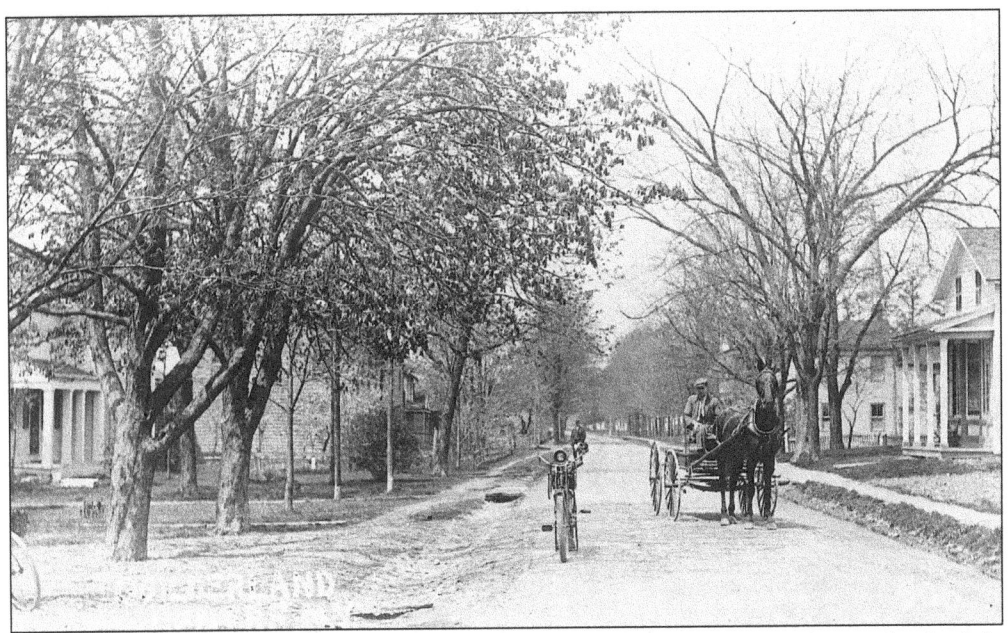

Eyeing a snazzy motorcycle, Leon Van Wormer is seated in his rig on Main Street. On the left, just down the street, is the "old town hall." Acquired by the Town of Guilderland in 1915, it was never used for town offices; in those simpler days, office holders worked from their homes. The small shop on the right was formerly a shoe shop. In the distance is St. Mark's steeple.

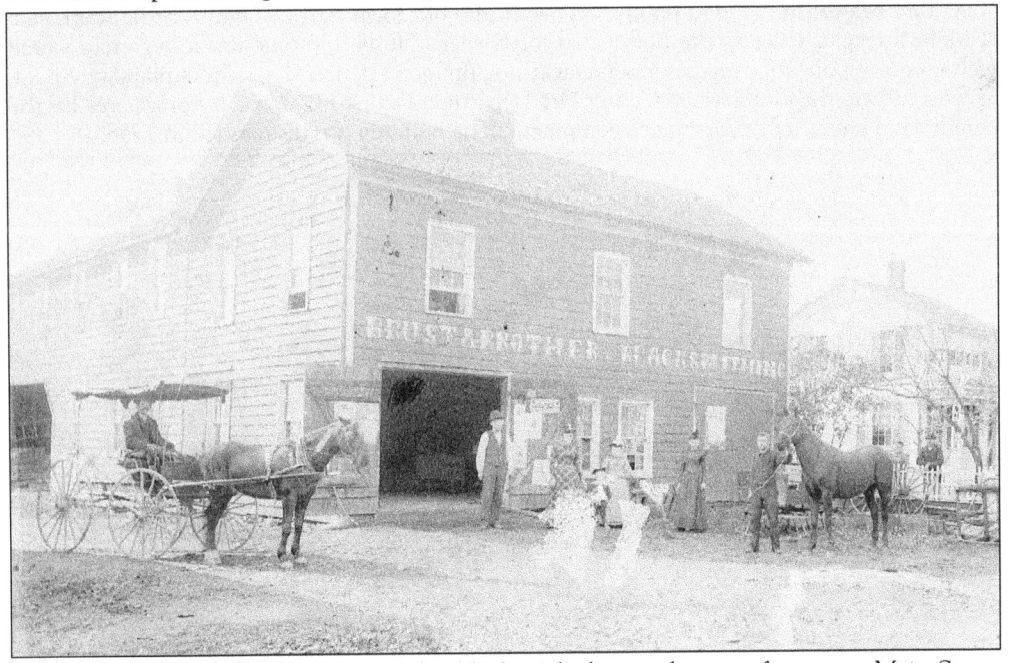

Charles Brust and his brother owned this blacksmith shop and wagon factory on Main Street c. 1885. Later, the building was used for auto dealers and their repair shops until it was removed c. 1920. The lane at the left of the building led from Black Creek to the farmhouse on the opposite bank. The house on the right burned in 1963. A newer home, located at 482 Route 146, presently stands at the former site of Brust's shop.

A century before this c. 1950 photo was taken, the old town hall was built on the south side of Main Street to serve as the horse shed for Fowler's Hotel. Upstairs was a large hall where such events as political caucuses, public meetings, firemen's dances, and school plays were held. Downstairs was the Guilderland Center Fire Department's first home and a storage area for the Guilderland Highway Department's equipment. The building was dismantled in 1958.

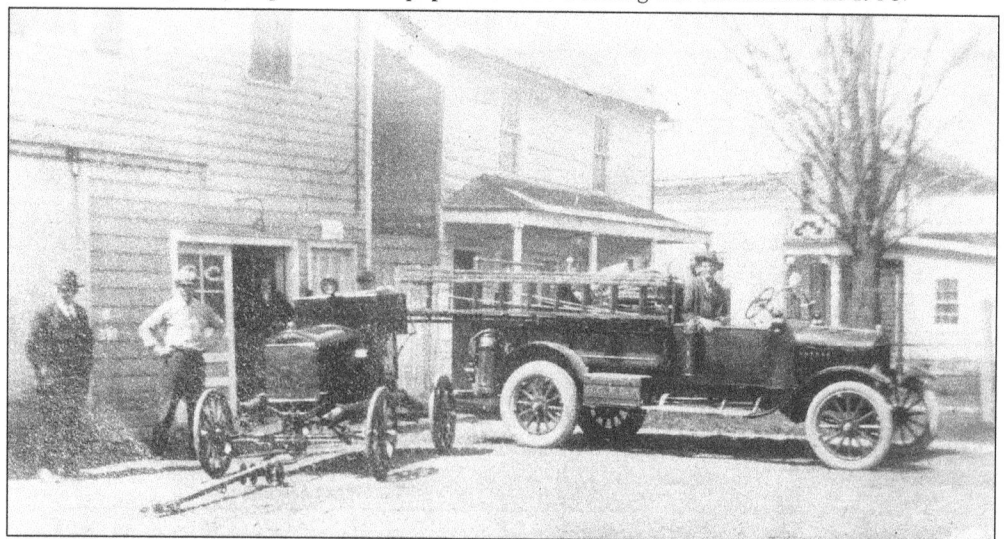

Founded in 1918, the Guilderland Center Fire Department's first piece of equipment was a two-wheeled chemical tanker cart, which firemen had to pull to the fire scene when signaled by the clanging of a sledge hammer against a locomotive tire. Here, in the mid-1920s, Chief John York stands beside the 1923 Village Queen pumper with a 1924 Model-T parked nearby.

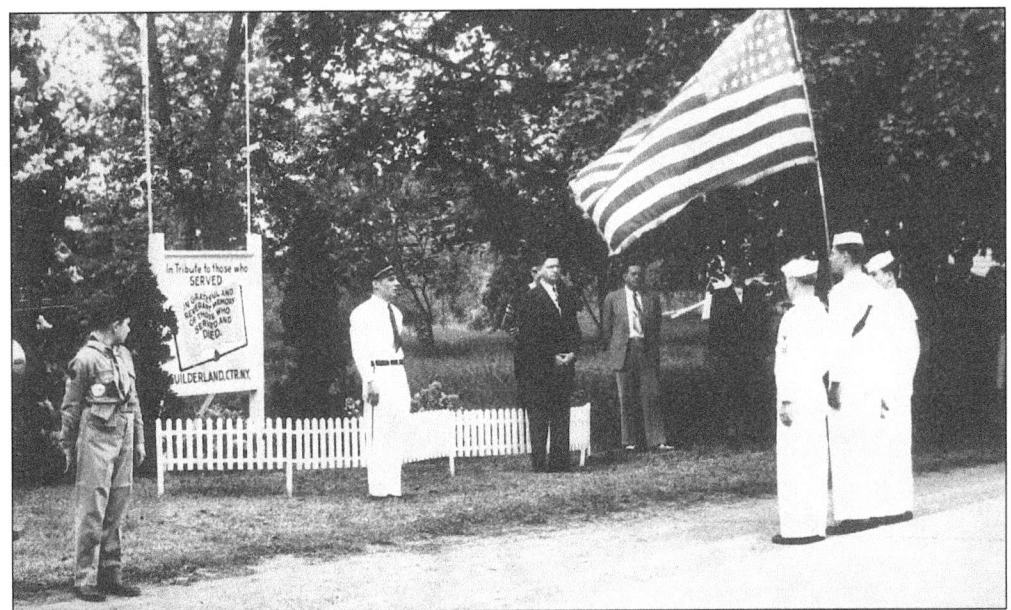

Traffic halted on Main Street in May 1949 for the dedication of Guilderland Center's World War II Memorial and Honor Roll. Pictured from left to right are unidentified scout, Donald Lawton, Rev. Floyd Nagel, and Charles Miller. John Martin is at left in the Honor Guard. The others are unidentified. A private home, located at 475 Route 146, stands today at the site of the memorial.

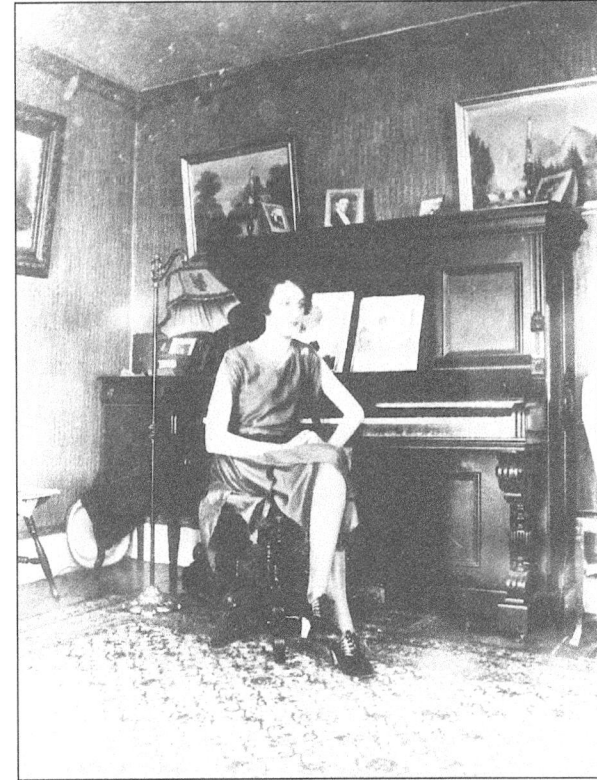

Helen Hurst posed for this photograph at a local Halloween party in 1925. Note the typical mid-1920s interior of the living room in George Hurst's home. The house still stands on Route 146.

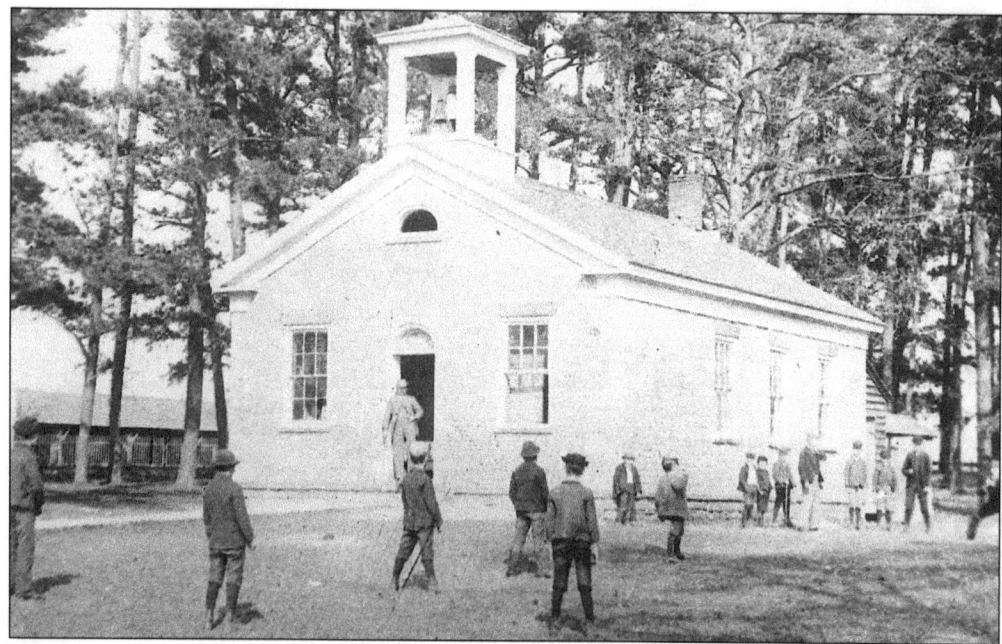

Children play outside the District #6 Cobblestone School under the watchful eye of their teacher in this c. 1900 view. Constructed in 1860, the building served as Guilderland Center's schoolhouse until 1941, when students began attending classes in Voorheesville. The building is located on the north side of Main Street and is still owned by the Guilderland Central School District.

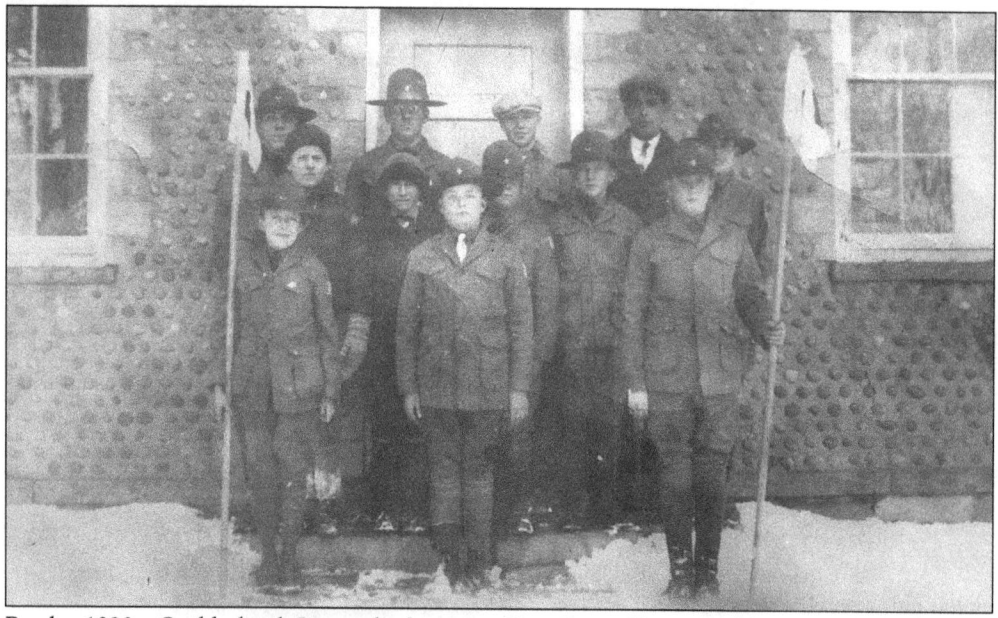

By the 1920s, Guilderland Center had its own Boy Scout Troop, led by scoutmaster Raleigh Moffett. Standing at attention in front of the Cobblestone School in this view are the following, from left to right: (front row) Roland Van Wormer, George Wedekind, and Bob Hurst; (middle row) unidentified, Arthur Frederick, unidentified, and Harold Gillespie; (back row) Curtis Doxsee, Moffett, Roy Frederick, Leland Van Auken, and Earl Doxsee.

St. Mark's Lutheran Church and horse sheds were new when this view was taken in 1875. Dedicated in 1872, the church, along with St. John's of Altamont, were successors to the old St. James below the Hellebergh, which had been located near the modern entrance to Fairview Cemetery. St. Mark's served the Lutherans until 1973, when the town leased it as a community center. The Berean Baptist congregation has returned the building to its original use as a church.

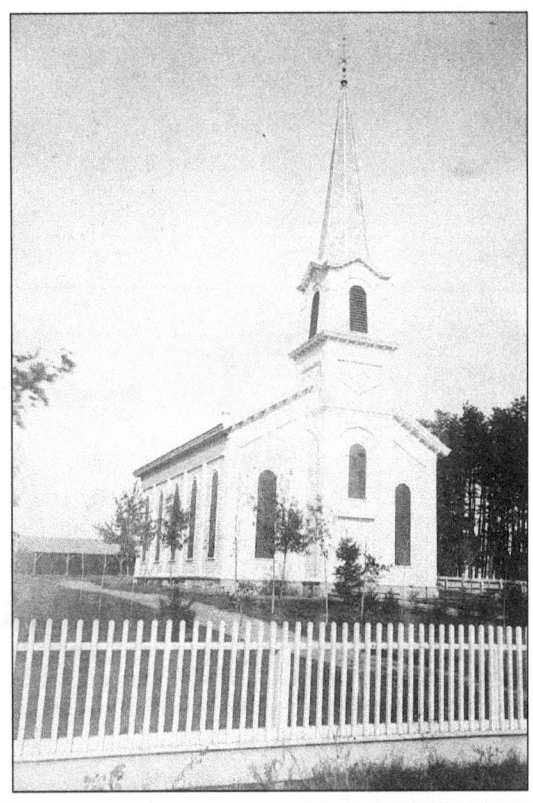

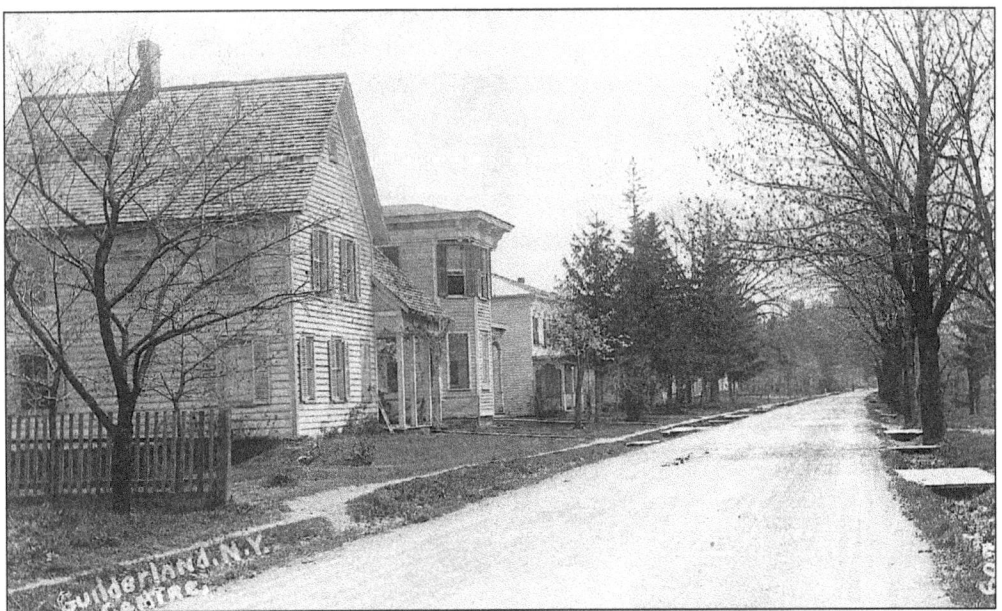

These three houses on the north side of Main Street look almost the same today as they did in 1910. When the Helderberg Reformed Church moved to Guilderland Center in 1896, the center house became the parsonage. Eventually, after being drastically remodeled, Hazel Reed began the Guilderland Center Nursing Home there in 1955. The current owner has returned it to its original architecture. These houses are at 495, 497, and 499 Route 146.

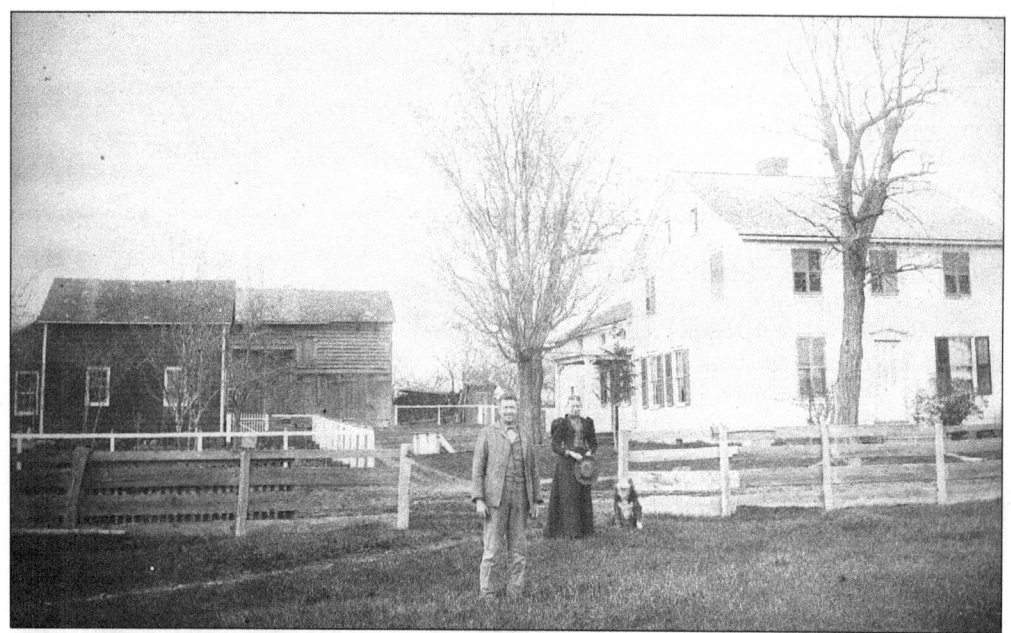

Mr. and Mrs. Charles Fares and their dog pose for a photographer in front of their farmhouse and barns on the north side of Main Street c. 1880. This was one of three working farms on that road in the hamlet. Note the privy beyond the tree; every house had one of those necessaries out back. The house and barns are located at 515 Route 146.

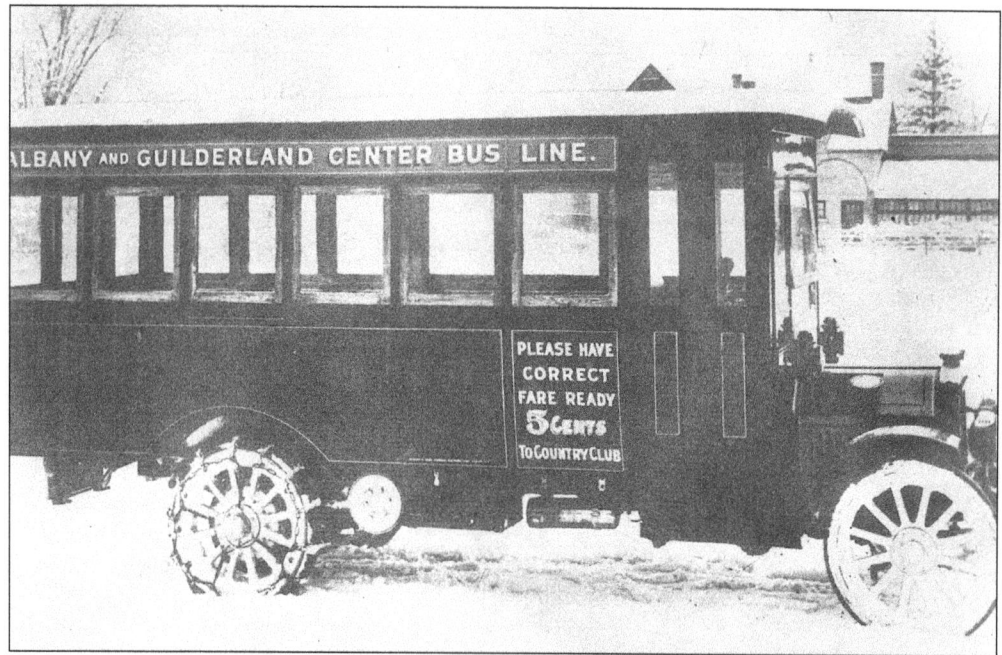

Since the West Shore Railroad did not go directly to Albany or Altamont, the introduction of bus service made life more convenient for Guilderland Center residents. DeWitt Main ran buses between Albany and Fonda's Corners, soon extending the route into Guilderland Center and Altamont. In this 1913 winter scene, note the chains on the back wheels, which were necessary to climb the hills to Altamont in the snow.

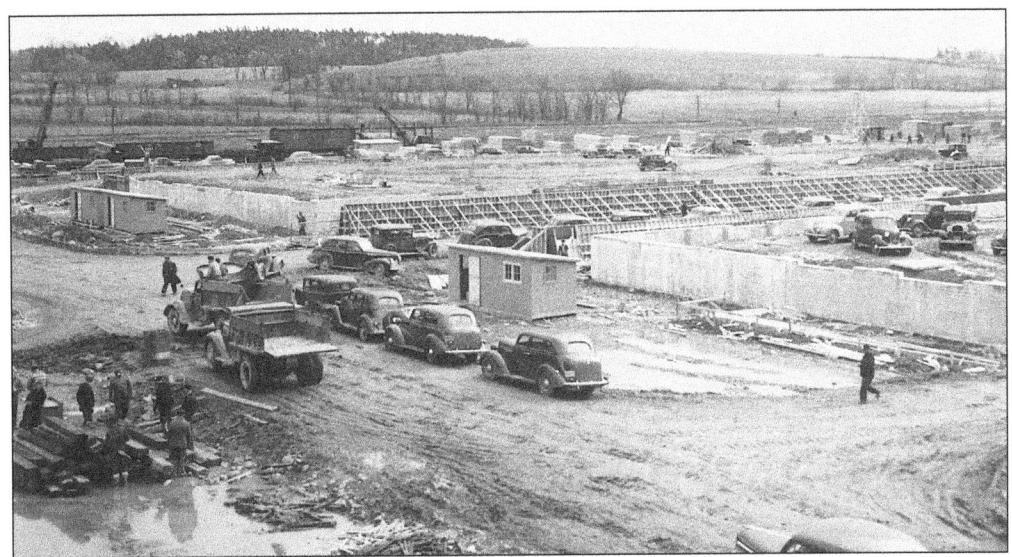

In the late 1930s, with the threat of possible U.S. involvement in the war growing more serious, the government began to establish military depots for storage and shipment of war materiel. After acquiring a large tract of farmland between Guilderland Center and Voorheesville along the West Shore tracks in 1941, construction began on the U.S. Army Engineering Depot, a National Defense Project. Here, warehouse three and four are taking shape. Expanded during the Korean War, the depot later became Northeastern Industrial Park.

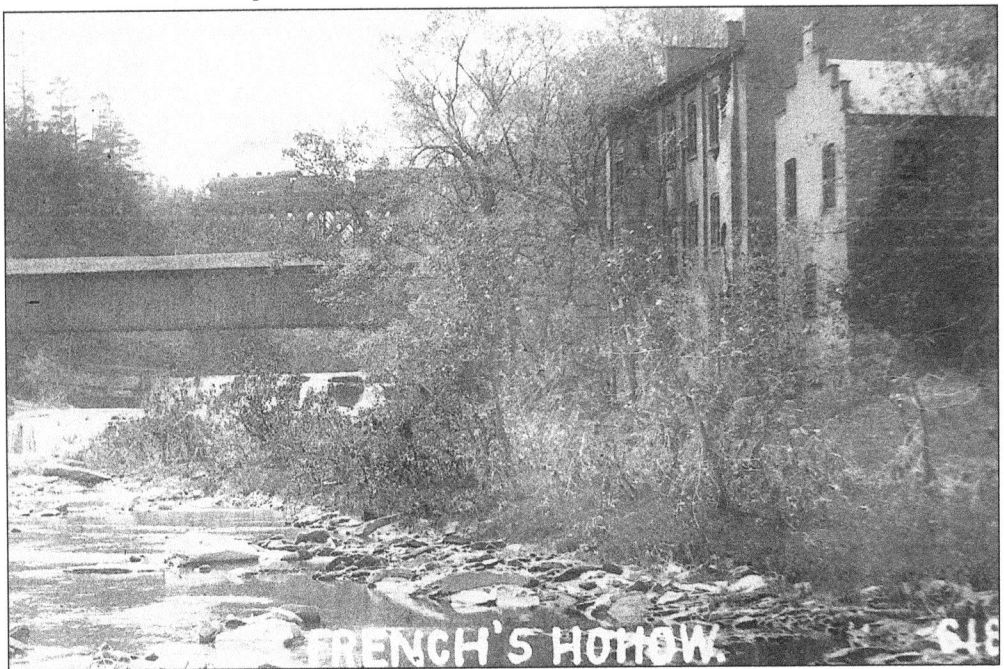

Frenchs Mills was a ghost town c. 1910. Long ago a thriving manufacturing settlement along the Normanskill at Frenchs Hollow, not far from Guilderland Center, it once had a gristmill, sawmill, covered bridge, and the large cloth factory seen here. When the railroad was built in 1865, it bypassed the Hollow, crossing on a trestle. The old mills and covered bridge were demolished one by one. By 1933, all were gone.

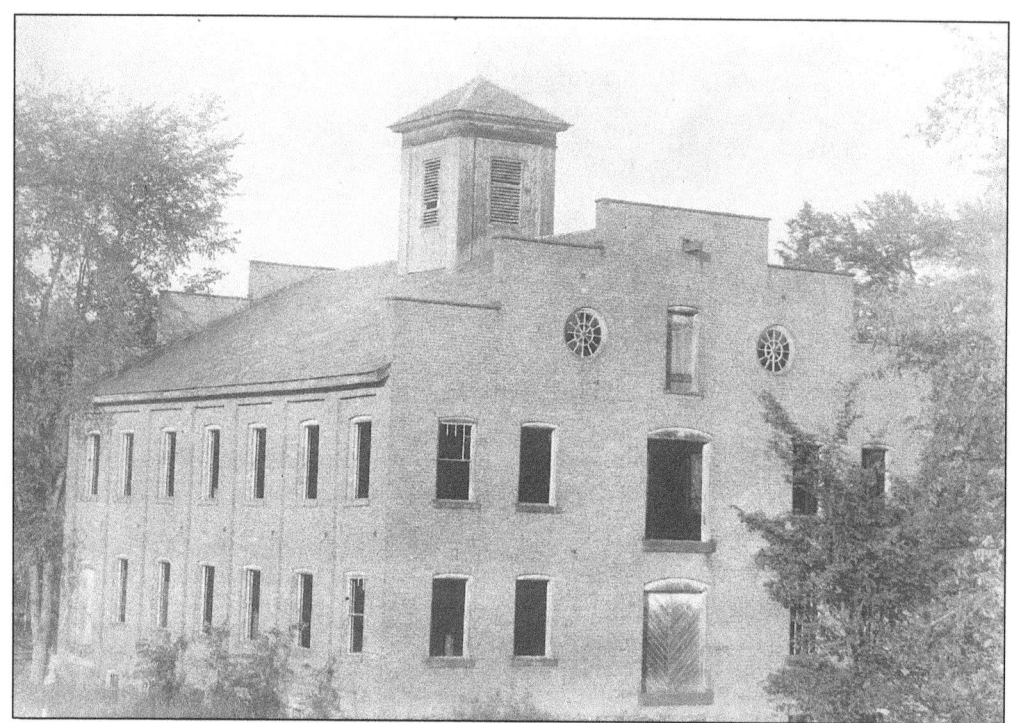

Utilizing the power of the rushing Normanskill, Abel French built this woolen mill c. 1800. By the 1860s, the factory was no longer in production. For many years, however, the community made use of the building for church suppers, dances, early Methodist meetings, and other gatherings. Derelict by the time this photo was taken c. 1890, the building was razed in 1917 (when the Watervliet Reservoir was created) and it became the site of the pumping station.

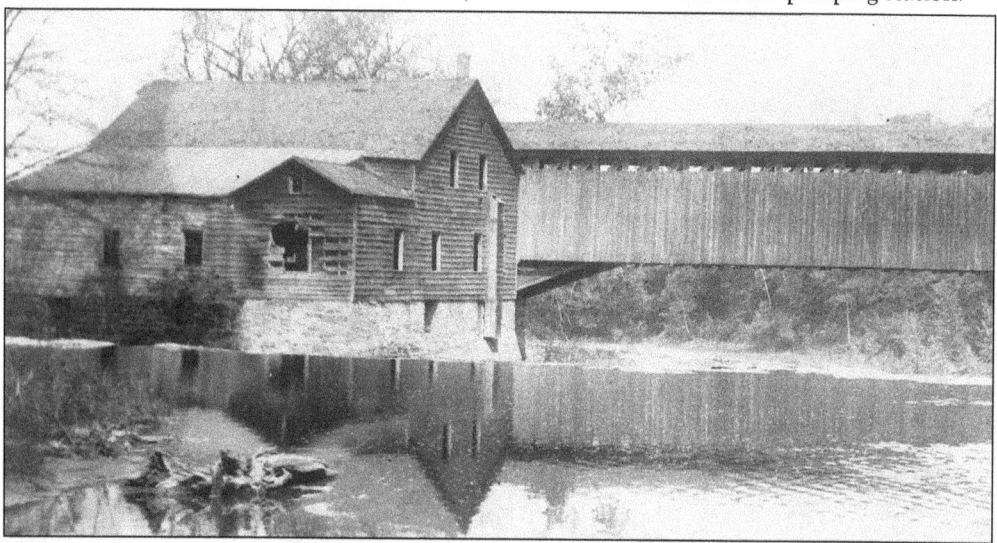

The sound of mill wheels grinding grain into flour at the Globe, later Spawn's Grist Mill, once echoed down the Hollow. Competition from cheap Midwestern flour forced local mills out of business so that by the time this photo was taken c. 1900, the mill had been abandoned for years. The old building was dismantled in 1925, and the new bridge was erected in 1933. It crossed the Normanskill over the site of the old mill.

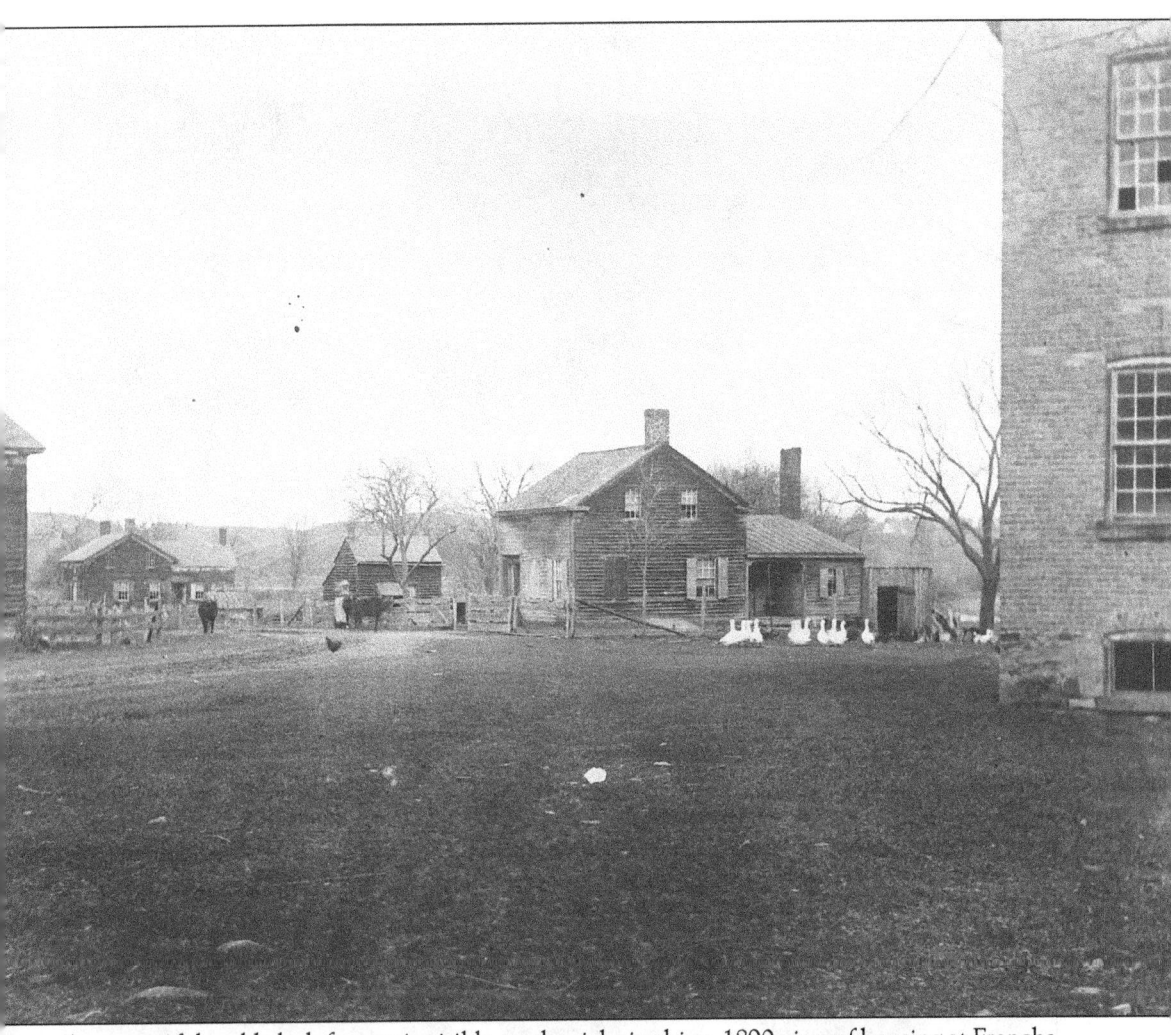

A corner of the old cloth factory is visible on the right in this c. 1890 view of housing at Frenchs Mills. Children living here hiked out to the Fullers School while churchgoers either attended Guilderland Center churches or went to the Parkers Corners Methodist Church. All of these buildings along Frenchs Mills Road had disappeared by 1917, when the reservoir pumping station was built.

The interior structure of Frenchs Hollow covered bridge magnified the sounds of horses' hoofs and wagon wheels to reverberate like thunder; it was a sound that could be heard some distance away. Henry Witherwax built the 162-foot, 8-inch span to carry Frenchs Mills Road over the Normanskill in 1869. Still in fine condition when it was dismantled in 1932, the bridge had become inadequate for the increasing auto traffic.

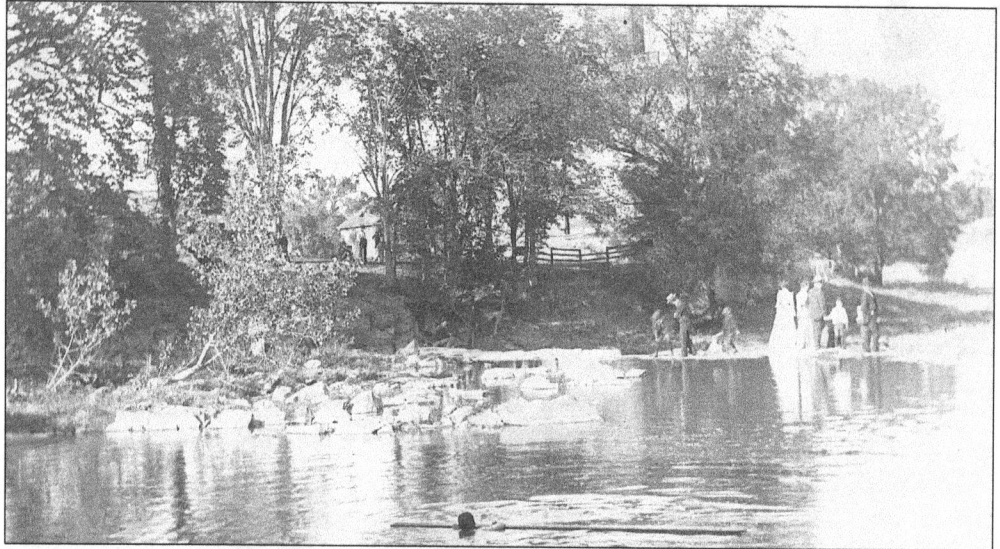

Until well into the 20th century, folks came from miles around to swim, fish, and picnic at Frenchs Hollow. When this photo was taken c. 1910, casual dress was still quite formal. Note the tower of Frenchs Mill behind the trees.

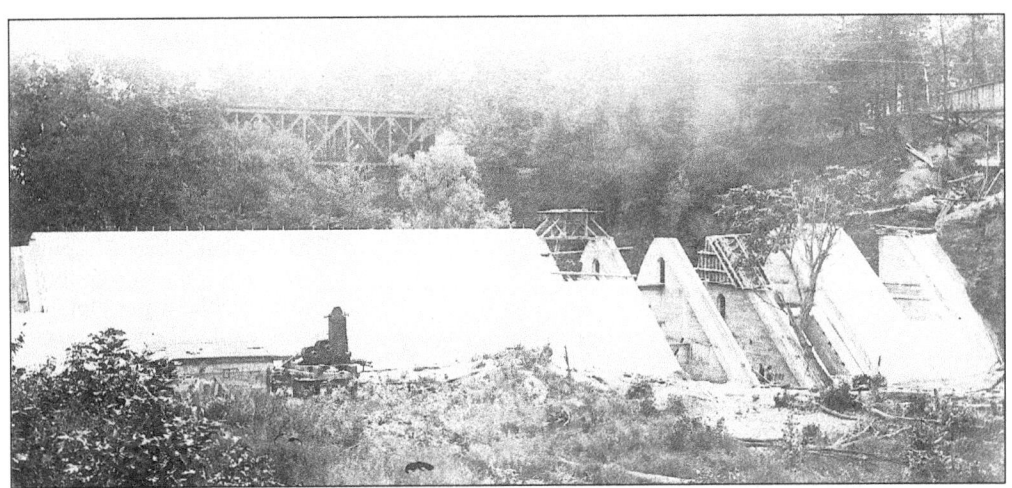

Shortly after Watervliet Reservoir was created by damming up the Normanskill in 1917, all vestiges of the Frenchs Mills 19th-century manufacturing settlement disappeared. The dam was located upstream from the West Shore Railroad trestle, which can be seen in the background of this picture of the dam under construction. Beyond the trestle would have been the abandoned gristmill, covered bridge, factory building, and old houses. Water from the reservoir still supplies Watervliet and provides part of Guilderland's town water.

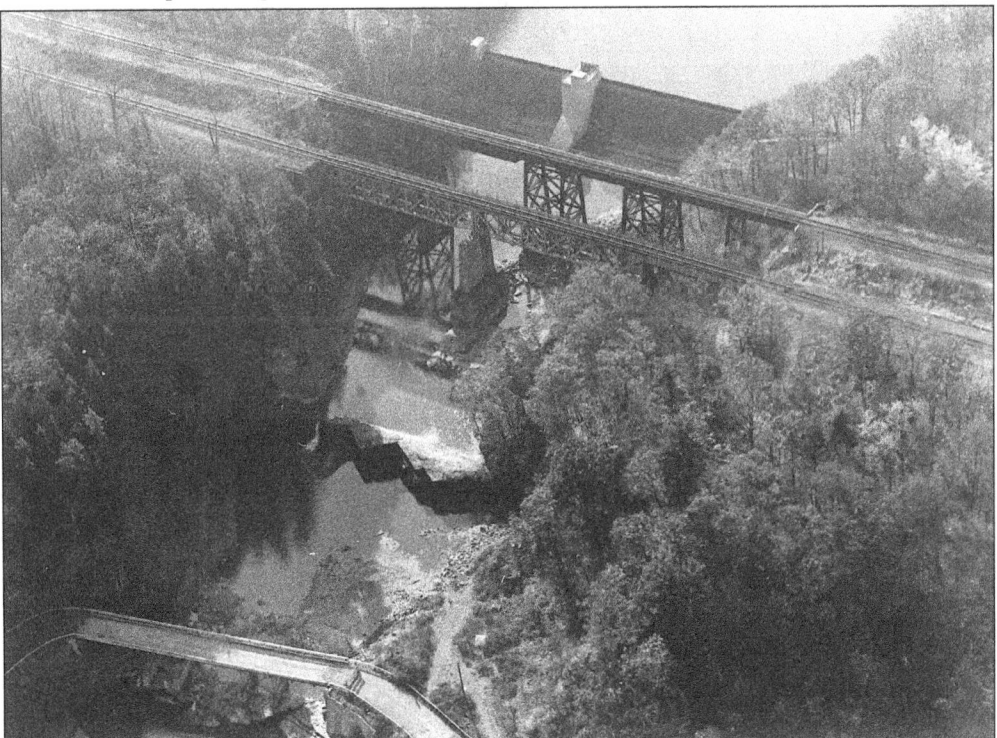

This aerial view of Frenchs Hollow ravine shows the area as it has been for many years. Upstream, much farmland was flooded when the Normanskill was dammed in 1917. Heavy freight trains cross the sturdy trestles that replaced the original wooden one erected by the Saratoga and Hudson Railroad in 1865. The 1933 Frenchs Mills Road Bridge has been declared unsafe and is now closed to traffic.

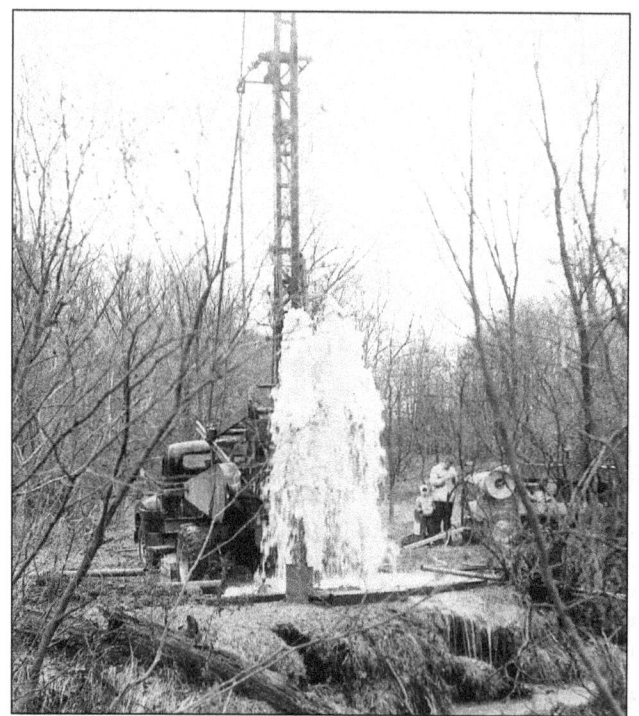

This well was described as a "gusher" when well driller Richard Ferriaoli first tapped into an underground water channel near Frenchs Mill Road in October 1964. Town officials were elated when it produced 540 gallons per minute, hoping this would be a major step in creating a public water supply. Unfortunately, when test results were in, the water proved to have a high iron content with additional minerals, making treatment and public use impractical.

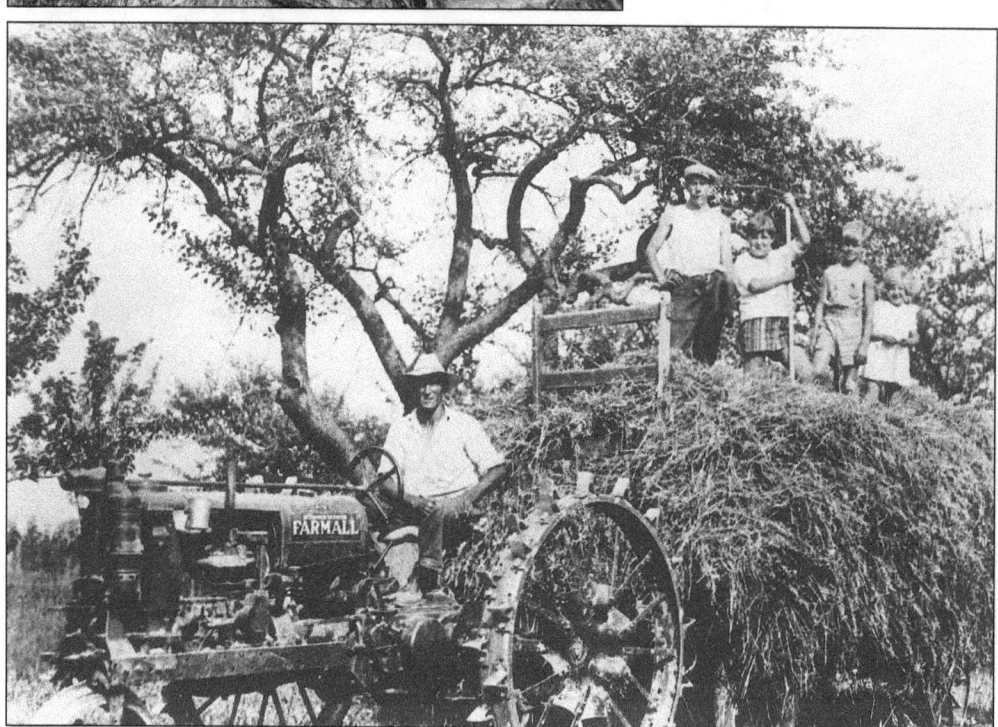

One of the old family farms in the Frenchs Hollow area was the Brandow Farm on Frenchs Hollow Road. Getting a lift atop a hay wagon was always a treat for farm children. Pictured from left to right in this 1936 snapshot are Eleanor Smith, William Henry Brandow Jr., and Helen Brandow Coughtry. The two men are unidentified.

Five

ALTAMONT AND ALTAMONT FAIR

The significant historical background of Altamont is an important part of the town of Guilderland's history. The notations on the earliest Palatine settlers in the 1740s, the Anti-Rent Wars of the 1830s, the village railroad history, and the beginnings of an agricultural fairground make the small hamlet that has had seven names unique.

The Manor of Rennselaerwyck, Helleberg, West Manor, West Guilderland, Knowersville, Knowers, and finally, in 1887, Altamont has retained its early American heritage. A main street lined with gracious Victorian homes, a railroad station with tracks that run through the middle of the village, and a fairground that has seen the horse and carriage give way to the many-hued motor cars that fill the parking lot every August are reminders of Altamont's history.

The incorporation of Altamont in 1890, under the direction of the village's first mayor, Hiram Griggs, named specific boundaries. Historic houses such as the Knower House and the Inn of Jacob Crounse, located in the "old village" of Knowersville, and a section of the Altamont Fair Grounds are not included within the village boundaries. They are included in this chapter because of their close proximity to the village.

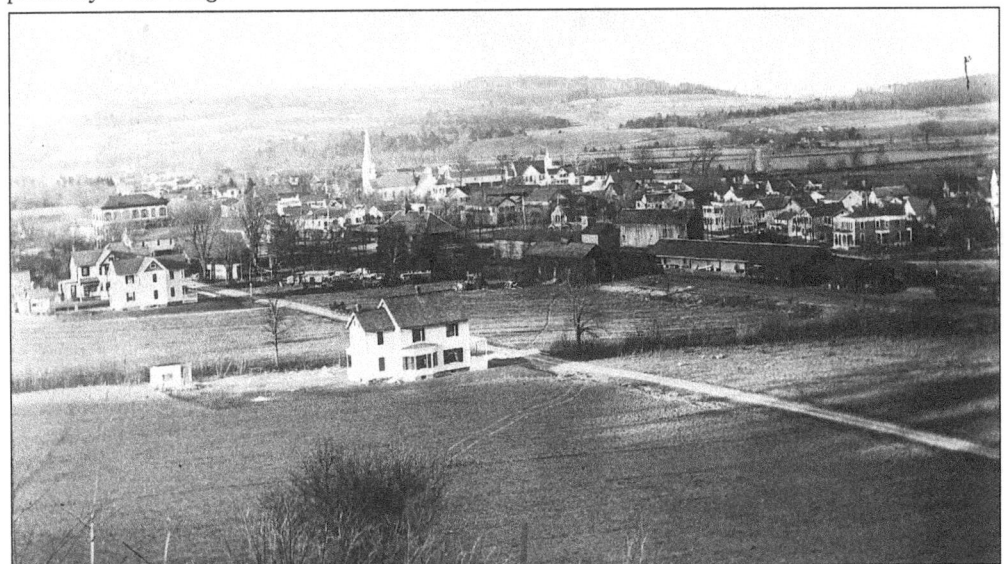

An idyllic small village, Altamont represents typical Americana c. 1900. The steeples of St. John's Lutheran Church and the Altamont Reformed Church can be seen. The building with seven windows on the top floor is the old Altamont Hotel. In the center is the newly erected gazebo on the village green.

The Inn of Jacob Crounse, built in 1833 on Route 146 in Altamont, was once a halfway house and tavern where pioneer guests found bed and board and where horses were changed on the Schoharie-Albany mail and stagecoach run. Jacob's Inn was built on a foundation of bluestone from Howe's Cavern and lumber from the Helderberg forests. Located in the "old village of Knowersville," an antique shop run by Charles and Gigi Mealy now occupies the historic inn.

Pictured in this c. 1915 view is the Knower House, located on Route 146 north of Gun Club Road. In "old Knowersville," it has been an historic landmark since 1800. Benjamin Knower began his business as a hatter and a mechanic. His fashionable "Knower hats" were waterproofed by a secret process of immersion in the Bozenkill Creek behind his mansion. Through his personal integrity, he became a bank president and the secretary of the New York State Treasury. The wedding of Knower's daughter Cornelia to Gov. William L. Marcy took place on this historic site.

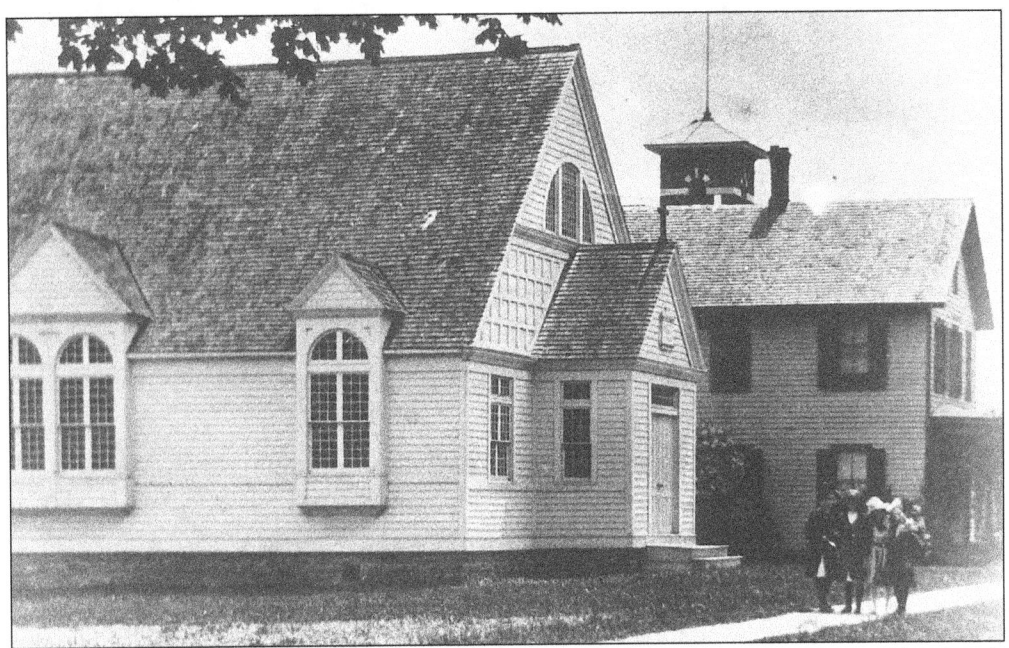

Youngsters gather outside St. Lucy's Church on Grand Street in this 1905 photo. The church was built in 1888 through the efforts of Mrs. William (Lucy) Cassidy, who owned a large mansion on the hill above Altamont. The name was going to be St. Anthony's, but it was changed to honor the founder's patron saint. History records also reveal that Mrs. Cassidy was instrumental in having the name of Knowersville changed to Altamont. The Altamont School tower can be seen in the background.

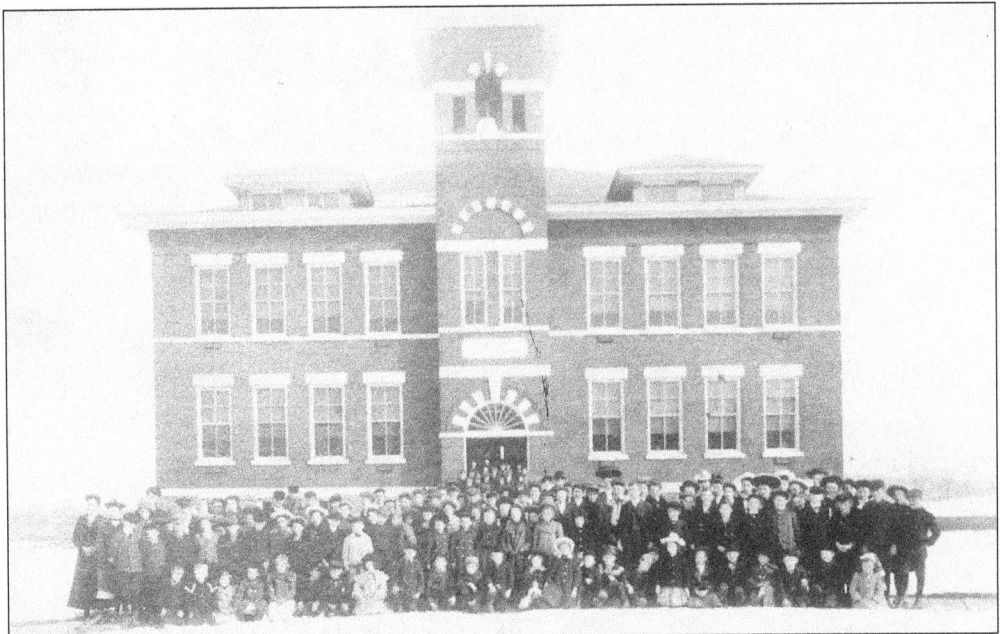

Built in 1902, the new Altamont High School on Grand Street had its first year of classes in 1903. The building, demolished in 1955, once stood in front of the site of the present Altamont Elementary School.

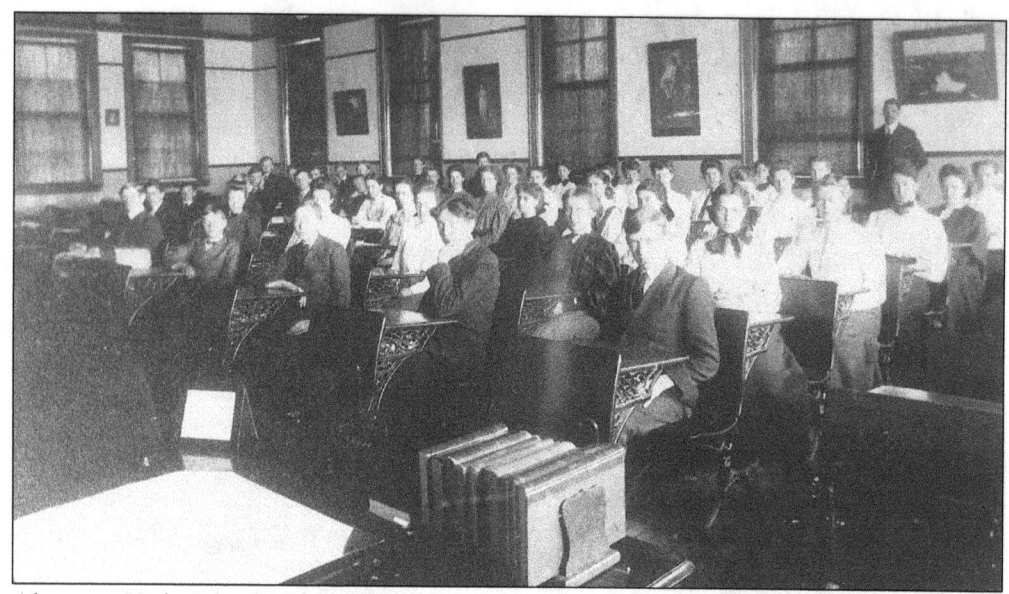

Altamont High School had been open just two years when this photo was taken in 1904. Principal Arthur Boothby and students pause from their studies for the camera to record a moment in history. Because it was the only high school between Albany and Schoharie, it attracted a number of students; out-of-town students often boarded with Altamont families, while commuters purchased $3-per-month tickets to ride the D&H train from Voorheesville or Delanson.

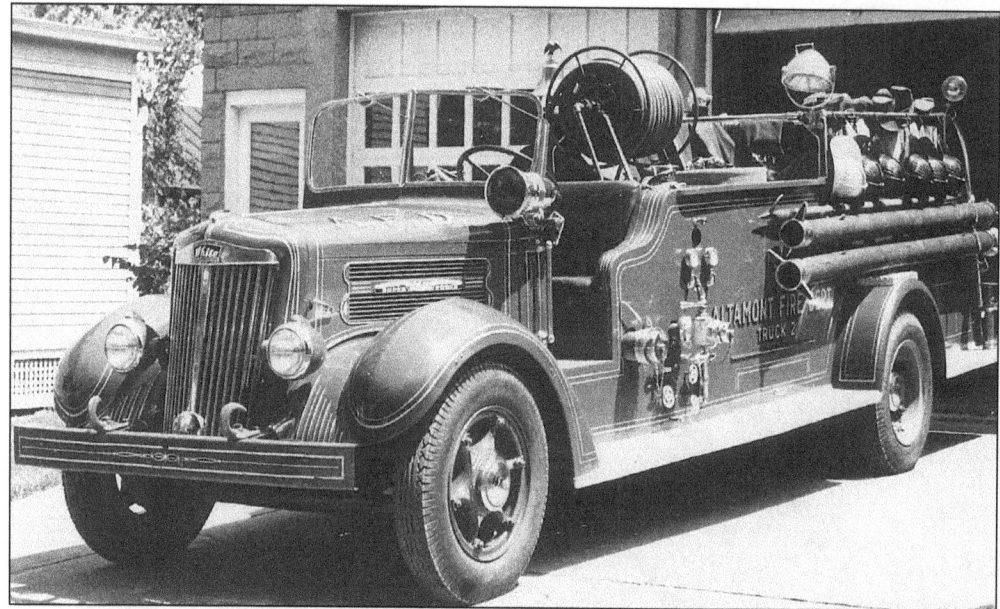

This 1941 White Fire Engine with a water pump was Altamont's first "modern" fire-fighting apparatus. The department was created in May 1893, and the pumper was housed on Maple Street. Altamont's first big fire occurred in 1886, when six buildings on Maple Avenue burned to the ground. A group of town residents fought the blaze with buckets, wet blankets, and shovels. Today, the fire company operates with its new equipment from a new building on Main Street.

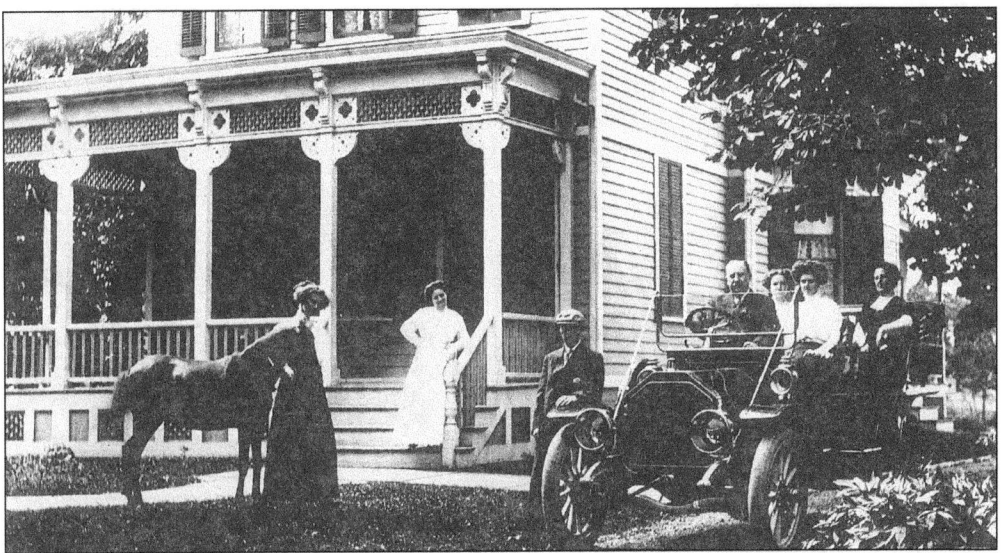

James Keenholts, seen here at the wheel, shows off his new Buick in the driveway of his 174 Main Street home. In this 1909 photo, Anna Keenholts (Hilton) sits behind her "Papa" with her Aunt Myra. Mrs. Edna Poland is seated beside Mr. Keenholts. Ella Keenholts (Vanderpool) stands by the pony, "Fanny," while her mother, Mrs. James Keenholts, is on the front steps. The family chauffeur, Mr. Kaley, stands by the car. Records tell us that Mr. Keenholts, who never learned to drive, ran a livery and boarding stable on Prospect Avenue, at the present location of Agway.

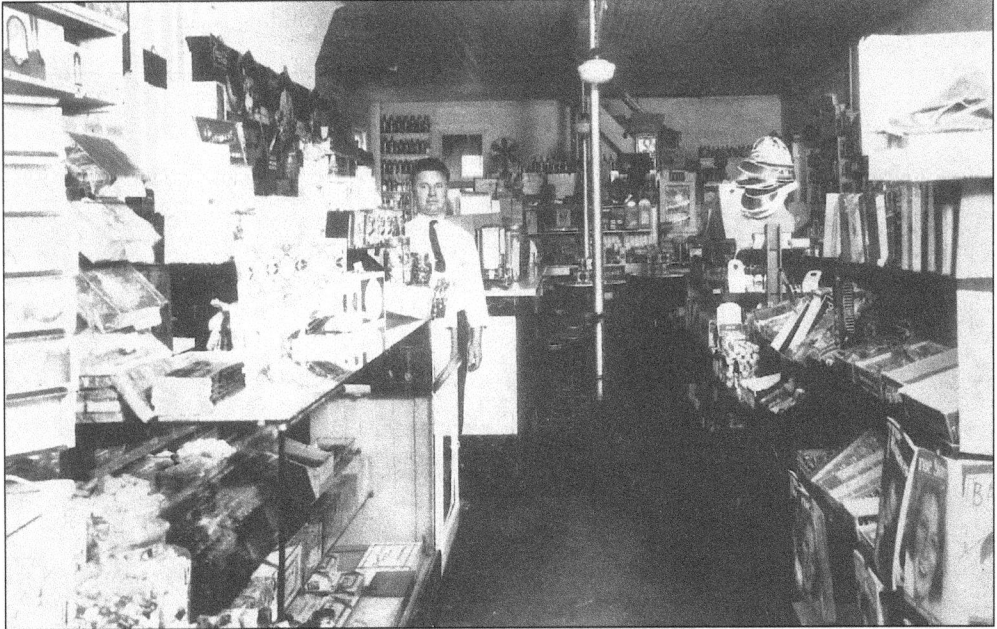

Stephen A. Venear owned and operated the Altamont Pharmacy on Main Street from 1926 to 1954. The pharmacy was the oldest in the area, dating back to 1888, when George Davenport and Cyrus Frederick were the owners. In addition to prescriptions, the pharmacy was a mainstay for Altamont residents; it also carried magazines, candy, sundries, and served treats at the ice cream and soda counter.

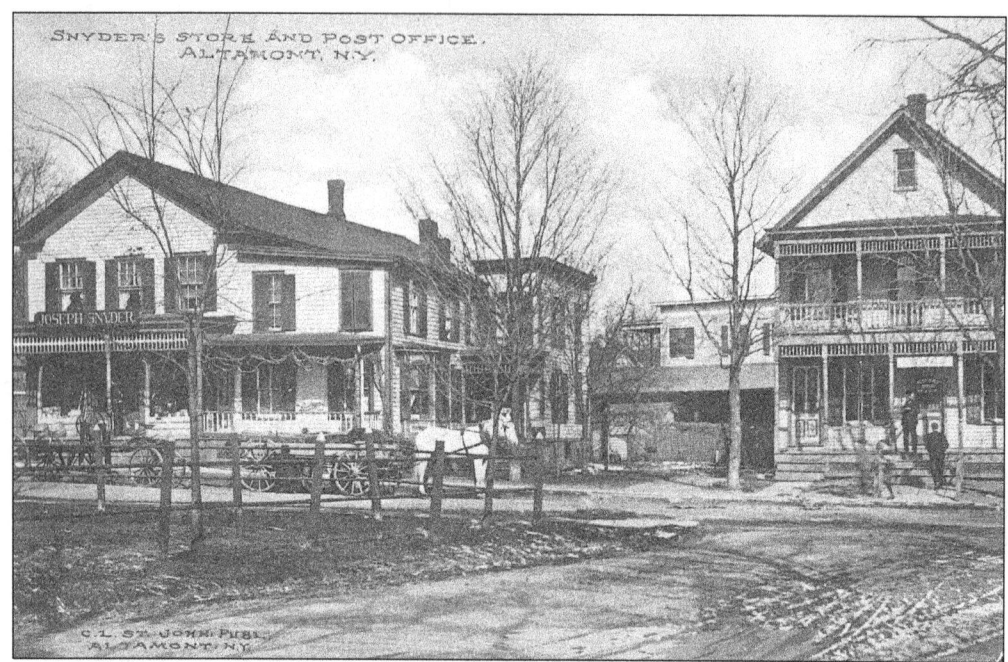

Snyder's store on Main Street gives full visual meaning to Altamont's early days. Note the team of horses used for deliveries. Snyder's became the A&P food store, and then passed through several owners. Today, the Hungerford Bagel Shop occupies the building. The building on the right once housed, at different times, the *Altamont Enterprise*, the Altamont Post Office (from 1901 to 1914), and the Altamont Pharmacy. The building is currently owned by Gilbert DeLucia.

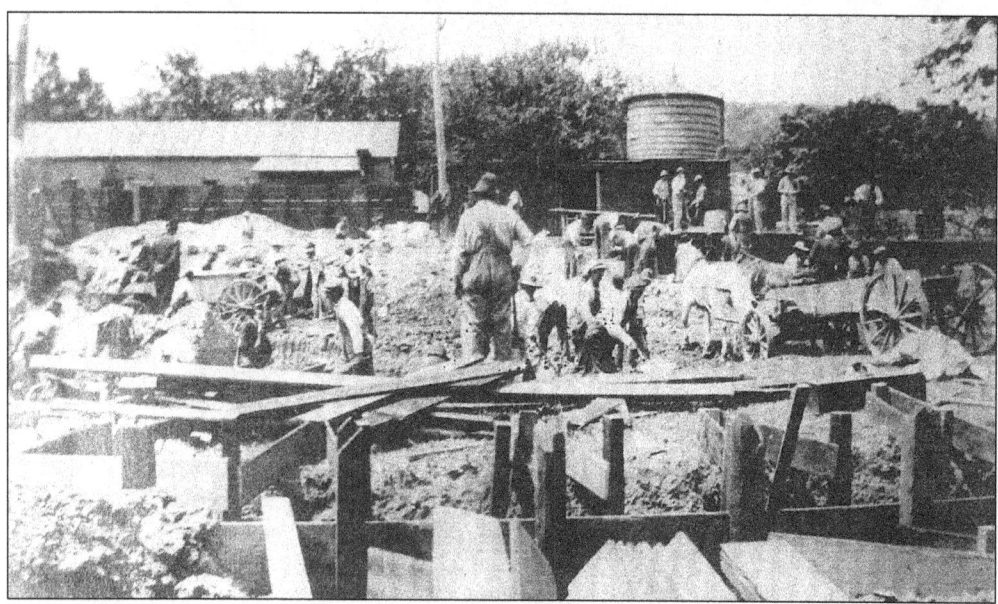

In this *c.* 1890 view, village workers assist D&H Railroad men in building the turntable that led the Altamont "Scoot" through the D&H Engine House and back on tracks for a return trip to Albany via Meadowdale and Voorheesville. The turntable was on the site of the present Altamont Post Office.

...THE...
Delaware and Hudson
COMPANY.

TIME TABLE OF TRAINS
BETWEEN
**ALBANY,
ELSMERE,
DELMAR,
SLINGERLANDS,
FONT GROVE,
VOORHEESVILLE,
MEADOWDALE and
ALTAMONT,**

In Effect January 3rd, 1909

J. W. BURDICK, Passenger Traffic Manager
A. A. HEARD, General Passenger Agent.

TICKETS
FOR TRAINS NAMED HEREIN ARE ON SALE BETWEEN THE FOLLOWING POINTS AT RATES NAMED:

BETWEEN ALBANY AND	One way Fare	Round Trip Fare	60 Trip Monthly Commutation Tickets	50 Trip Family Commutation Tickets	46 Trip Monthly School Tickets
†Elsmere	.15	.25	$4.25	$5.00	$2.30
Delmar	.18	.31	4.50	5.25	2.50
Slingerlands	.20	.35	4.75	7.00	2.75
Voorheesville	.33	.61	5.50	9.65	3.50
Meadowdale	.42	.79	6.75	12.25	3.75
Altamont	.50	.95	7.00	15.75	4.00

† On sale at Albany only.

60 trip monthly commutation tickets and 46 trip school tickets are good for one month and only for the individual use of the person in whose name they are issued.

50 trip family ticket is limited to four months from date of sale and is good for the passage of the person in whose name it is issued, any dependent member of his or her family, any visitor to the family, or domestic servant employed therein.

Purchasers of commutation tickets will find the ticket office established in the D. & H. building a great convenience and are recommended to secure their monthly tickets. If purchased in Albany, there, so as to relieve the congestion at the Union Station.

12-23-1908-5M-1138

This is a copy of a D&H Railroad timetable.

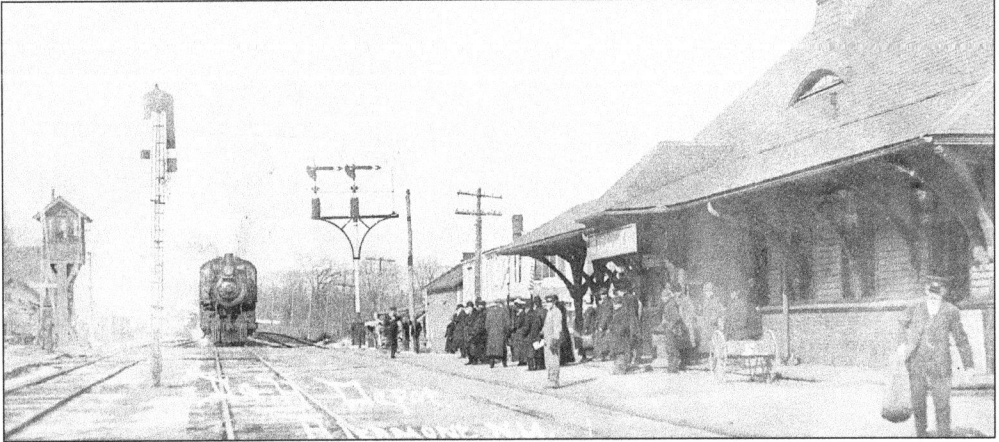

From the D&H Railroad Station in Altamont, 10 trains traveled daily to Albany via Meadowdale, Voorheesville, Slingerlands, and Delmar. Commuter trains turned around in the village roundhouse on the site of the present post office. Note the switchman's square, wooden shelter with windows on all sides and perched on a tower. It protected the switchman from inclement weather as he engineered oncoming trains to sidings to unload freight and passengers, in order to keep the main track clear for express trains. The switch hut is being restored and was displayed at this year's Altamont Fair.

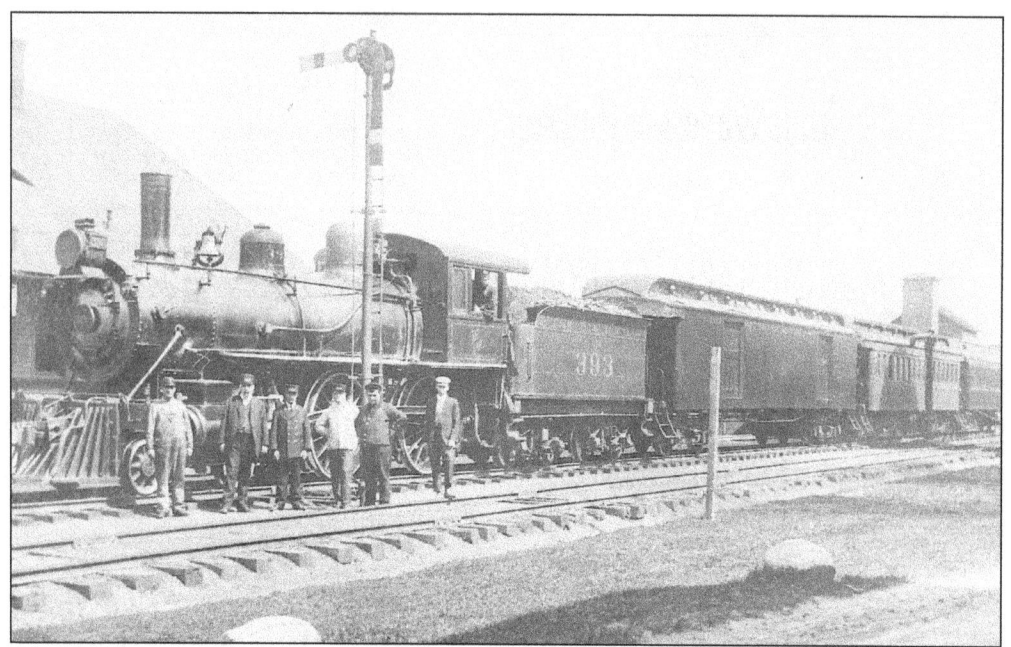

The old Altamont "Scoot" roared up the tracks into the village, gave a blast of its whistle, and drew into the train station to discharge passengers from four wooden coaches each day at 5:45 p.m. Engine #393, built by the Dickson Locomotive Works in 1895, and the crew were a familiar sight to town residents. The train, which had carried commuters from the little town at the foot of the Helderbergs daily to their work in Albany, made its last run on April 30, 1930.

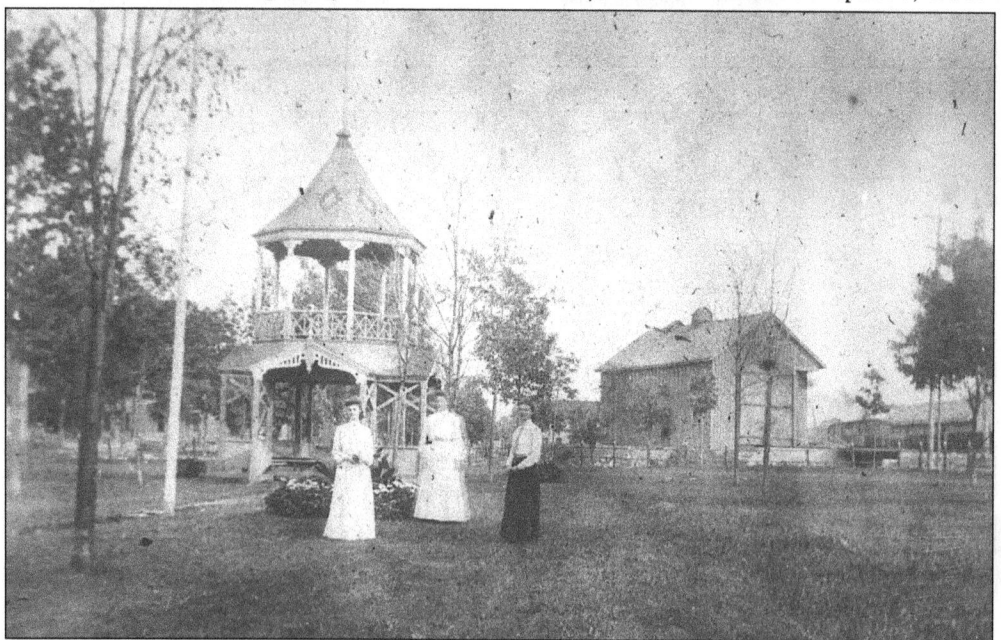

The Altamont Village Park with its ornate pagoda and bandstand create a lovely Victorian scene. The park was completely enclosed by an iron-pipe fence (background) and was the property of the D&H Railroad until deeded over to the village. The D&H Engine House in the background was built c. 1895. The three ladies enjoying the day remain unidentified.

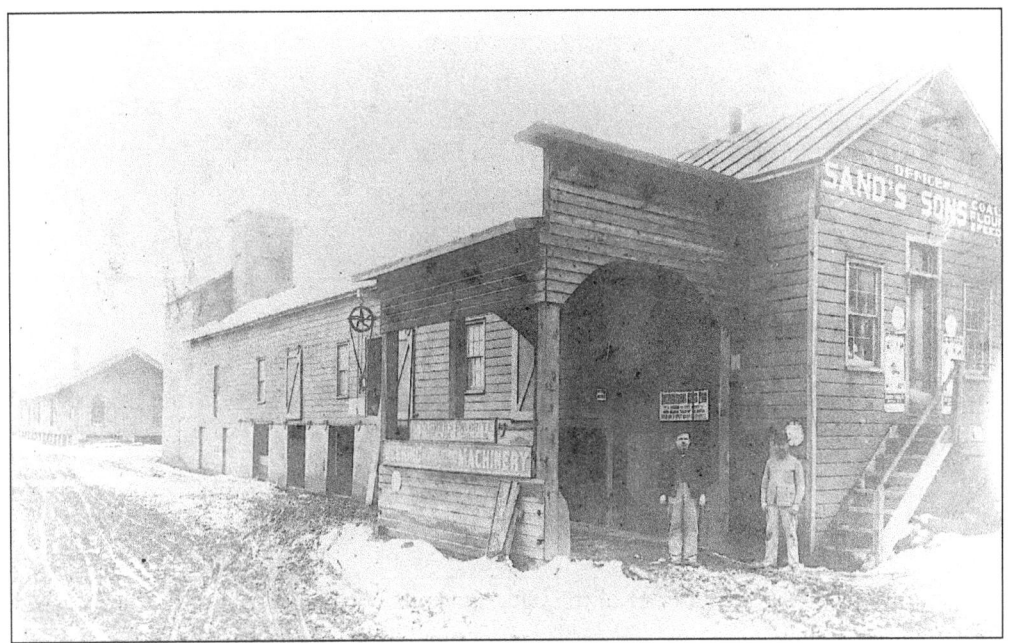

The Sand and Son Coal, Flour, and Feed Mill was operated by the Sand Brothers, who owned the feed and grain mill, a soda manufacturing company, and an automobile sales venture in Altamont. Montford Sand, a one-time village mayor, was one of the leaders in the village's incorporation and the owner of the Altamont Illuminating Company, which brought streetlights to Altamont c. 1902.

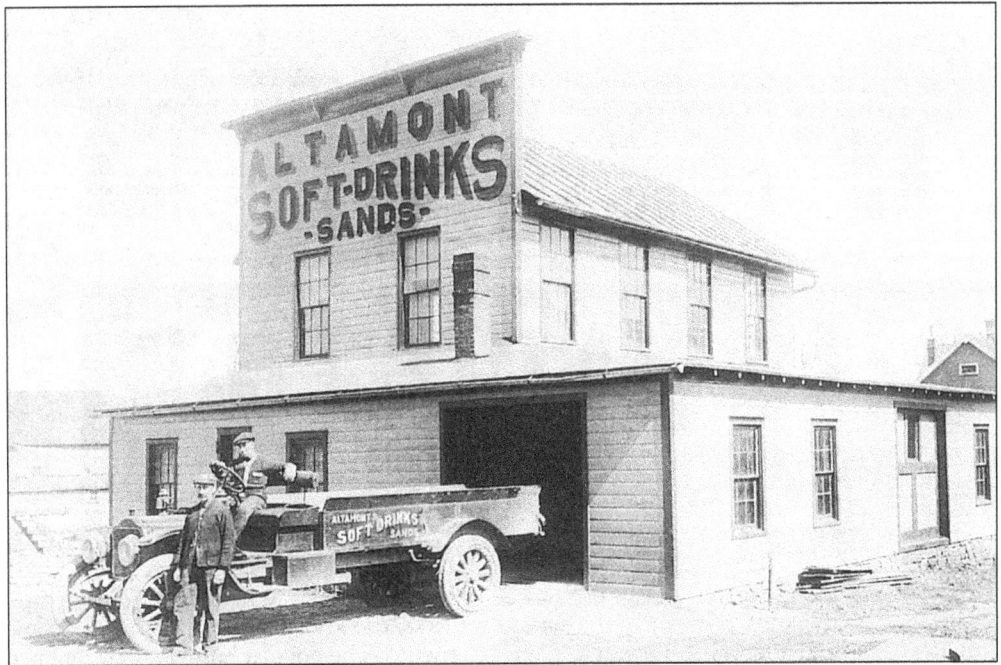

Previously a shirt factory, the Sand's Bottling Works was a thriving turn-of-the-century soda and sarsaparilla business. Owned by Montford Sand, the building was located at the end of Park Street and housed a dance hall upstairs, over the bottling works.

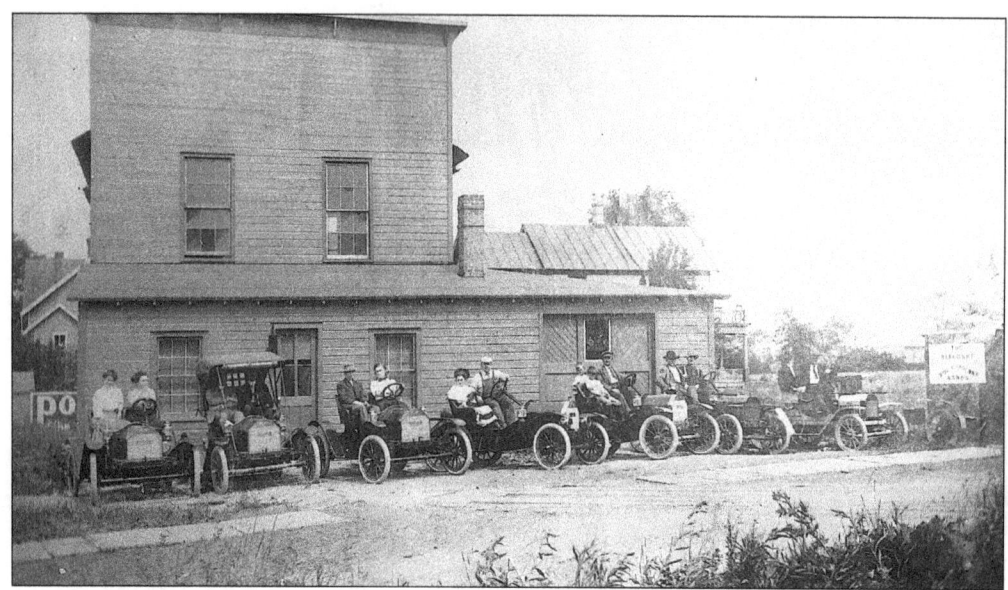

A line of Brush Runabouts in front of the Old Altamont Bottling Works, near the corner of Fairview Avenue and Park Street, get ready for a drive through the village in 1910. Brush cars were built from 1907 to 1912, with the Runabout a favorite model that sold for about $480 to $750. Late town historian Roger Keenholts wrote that Altamont residents used their Runabouts for delivering groceries and, weather permitting, the mail.

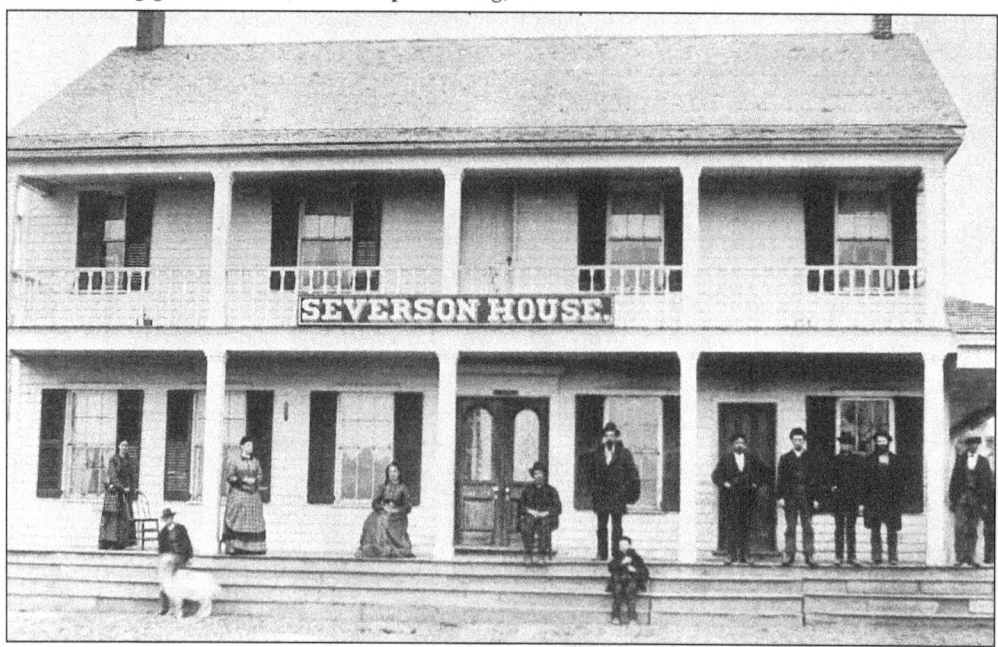

This hotel, erected in the new village of Knowersville (Altamont), was built in 1867 by George Severson, a great-grandson of one of the earliest settlers. Also known as the Union Hotel, and later the Commercial Hotel, it was run by Dutch Cornelius. The popular hostelry drew summer boarders from Albany and surrounding areas who sought the fresh air of the Helderbergs. The new D&H Railroad line near the hotel added to the mushrooming growth of the village and neighboring areas.

Mr. and Mrs. Charles Beebe pose for a formal photograph in their turn-of-the-century Altamont home. This rare interior photo with a piano and many wall hangings depicts the well-to-do status of the inhabitants. Mr. Beebe owned and operated Beebe's Harness Shop in the village.

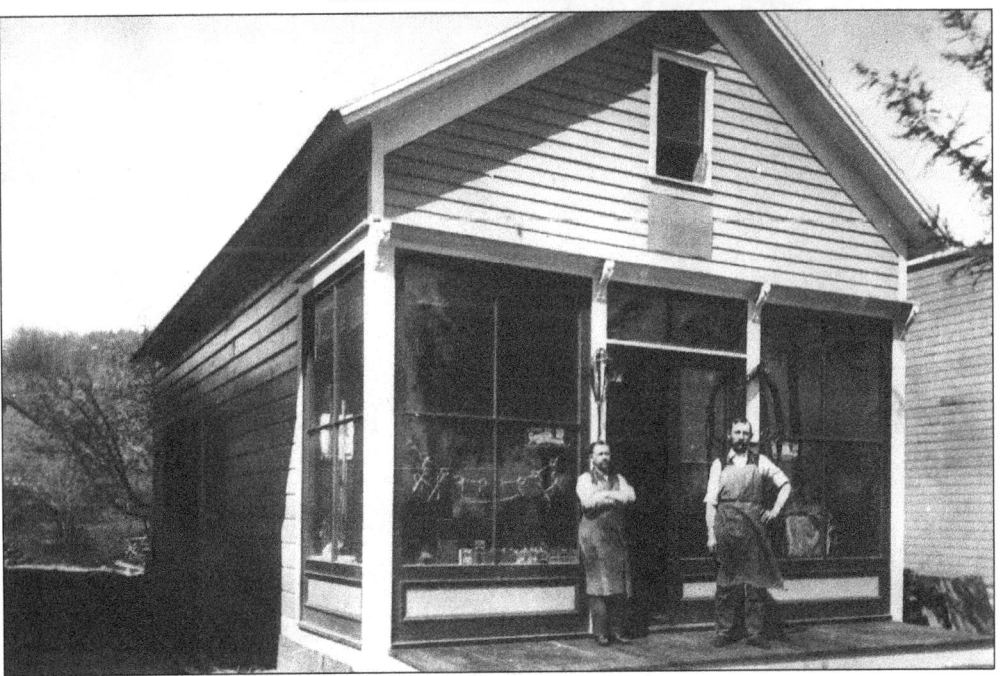

Frank Cowan, employee, and Charles V. Beebe, owner, pose for the camera in front of Beebe's Harness Shop at 119 Maple Avenue in 1895. Harnesses and riggings were repaired here, and carriages were repaired in a large barn-like building in the rear, also owned by Beebe. With the advent of the horseless carriage, the building housed the Keenholts Insurance Agency, operated by late town historian Roger Keenholts.

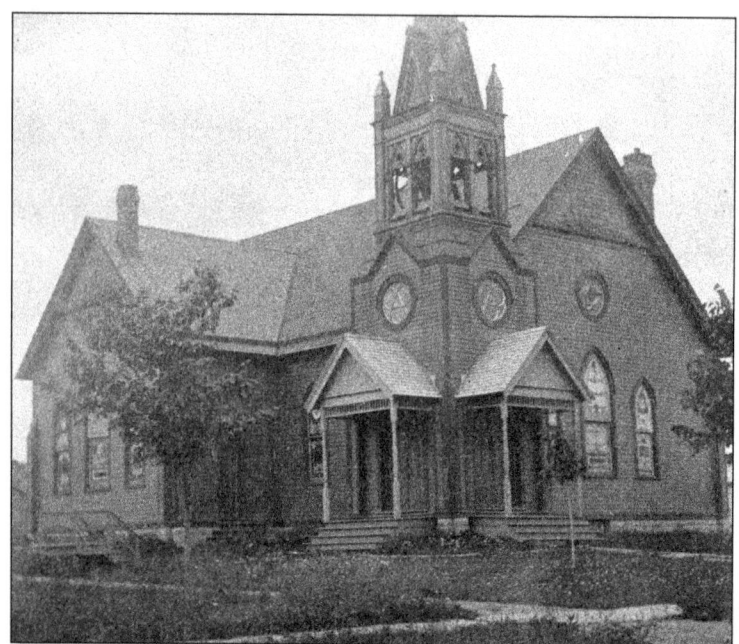

The Reformed Church began as a mission church in 1888 for summer residents, with services held by the Helderberg Reformed Church ministers. With a growing congregation, the Altamont Church split with the Helderberg Church in 1896 and built their church on Lincoln Avenue.

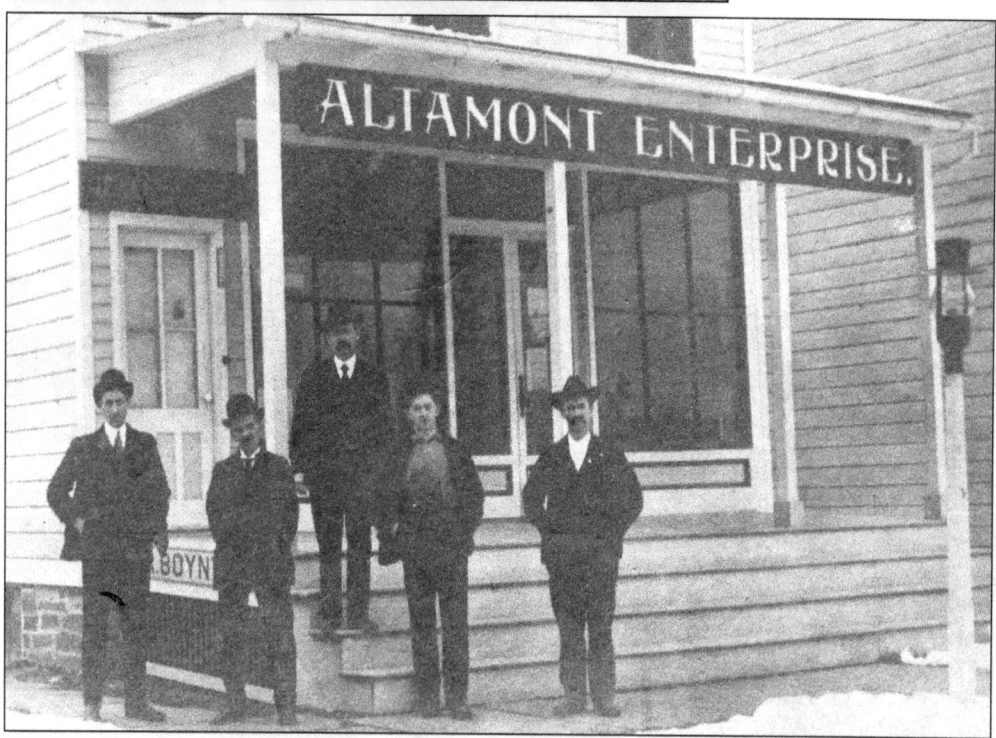

The Altamont Enterprise building at 123 Maple Avenue has seen many changes since this early 1900s photo. On July 26, 1884, the first edition of the *Knowersville Enterprise* was published by editor David H. Crowe. Crowe sold the paper to Jay Klock and J.B. Hilton within a year. Three years later, ownership came to John D. and Junius D. Ogsbury. When the village changed its name to Altamont, so did the paper. It became the *Altamont Enterprise*. The men in this photo are unidentified.

A 1960 photo at the *Altamont Enterprise* shows Marvin Vroman, part owner of the newspaper, seated at the hot-metal typesetting machine while James Gardner, typesetter, and James Pino, part owner, look on. James Gardner is now the owner and publisher of the weekly paper, which has been published continuously since 1884.

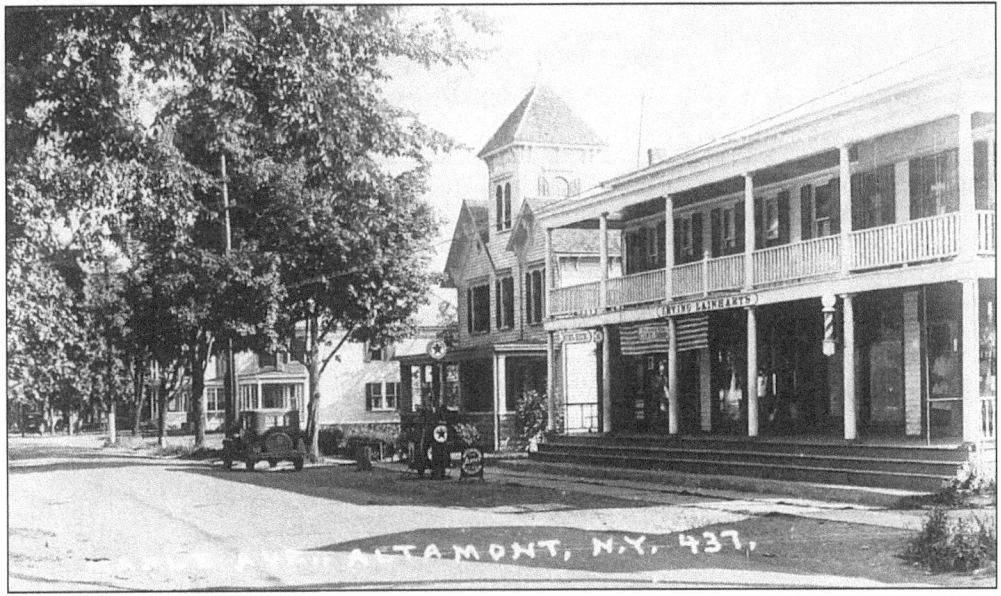

The Lainhart Building on Maple Avenue could be called Altamont's first "strip mall" of the early 1900s. It featured a news room, a barber shop, and an all-purpose general store. It became the social gathering place of the times. Next door, at 118–120 Maple Avenue, was the Joseph Gaglioti House. His descendants built and opened the Maplewood Restaurant on the adjoining property.

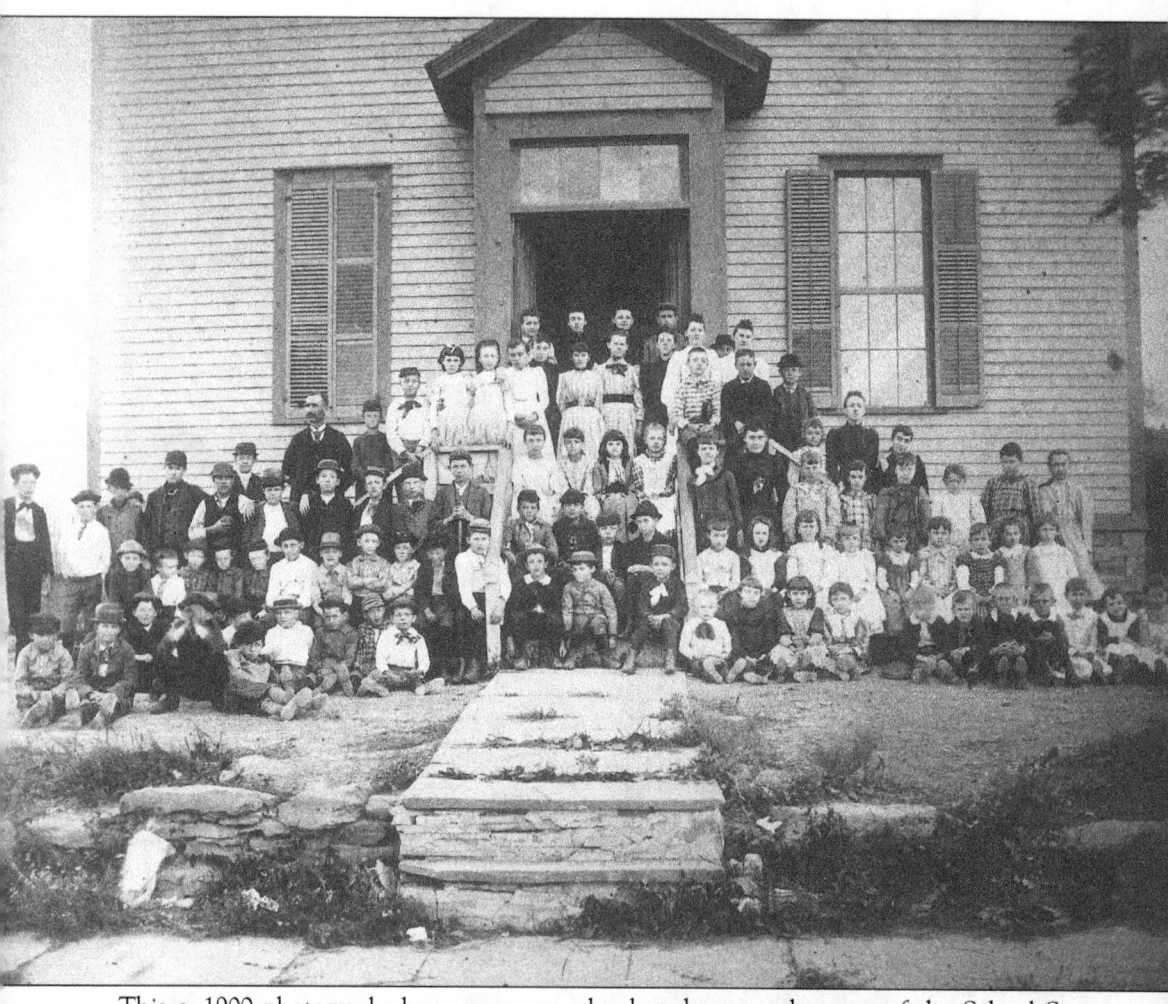

This c. 1900 photograph shows grammar school students on the steps of the School Street (Lincoln Avenue) public school building, located between the Temperance Lodge and the Altamont Reformed Church. In 1901, when the Altamont High School was to be built, the school was moved to 131 Maple Avenue. The structure now houses apartments. The teacher is unidentified.

Soon after the Revolutionary War, the seeds for the beginnings of the Lutheran Church were sown in Altamont. The mother church, St. James, was founded by German settlers, and their first church was built in 1787 near Fairview Cemetery. After 100 years, with a growing congregation, St. John's Lutheran Church was built on Maple Avenue in the village. St. John's celebrated its 125th anniversary in 1997.

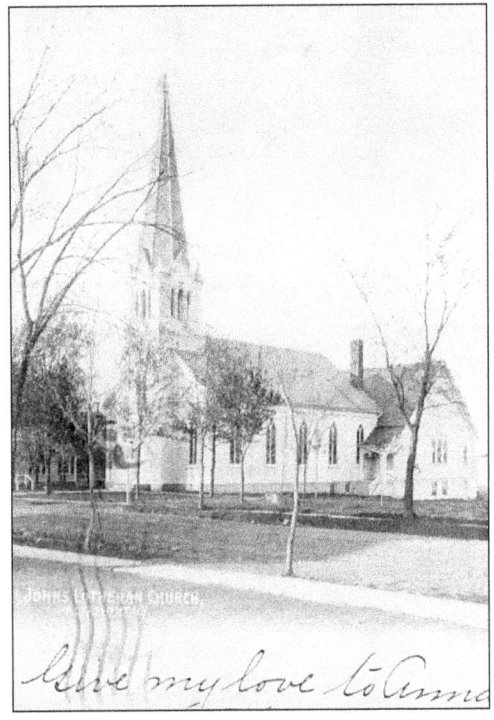

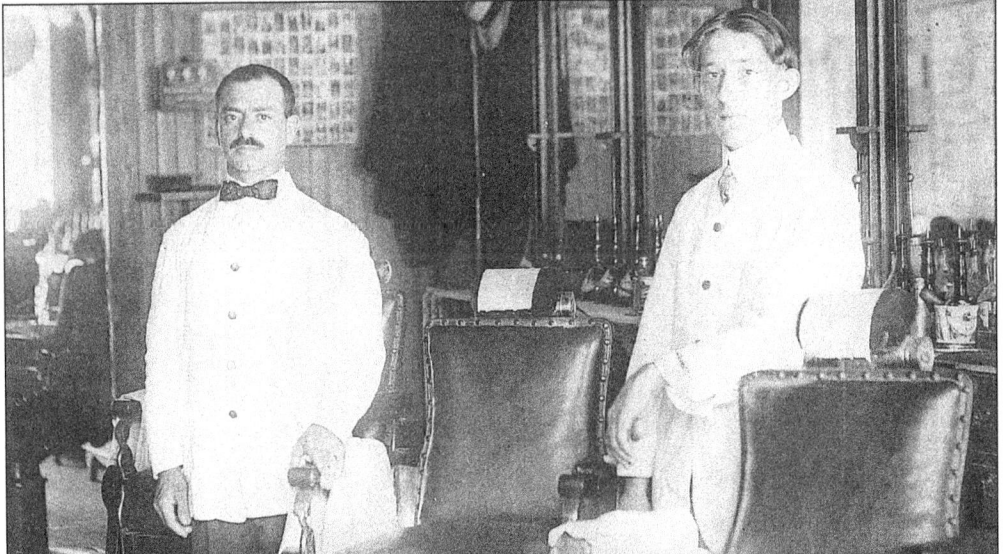

Joseph Gaglioti (with mustache) awaits customers in his barber shop in the Lainhart building. In the 1890s, when the Village of Altamont was incorporated, there were many thriving businesses, including a shoemaker, blacksmith, framer, cabinet maker, carriage repair shop, steam mill, drug store, furniture store, and undertaker. There were also several dry goods stores, a meat market, a fish store, two doctors, and a lawyer. The carriage maker, the shoe maker, and the blacksmith enterprises disappeared, along with other businesses that succumbed to competition. Yet the ambiance has never left the tiny Victorian village, and though most residents commute to make a living, they chose to return to the delightful homespun atmosphere of the village nestled at the foot of the "clear and bright" Helderberg Mountain.

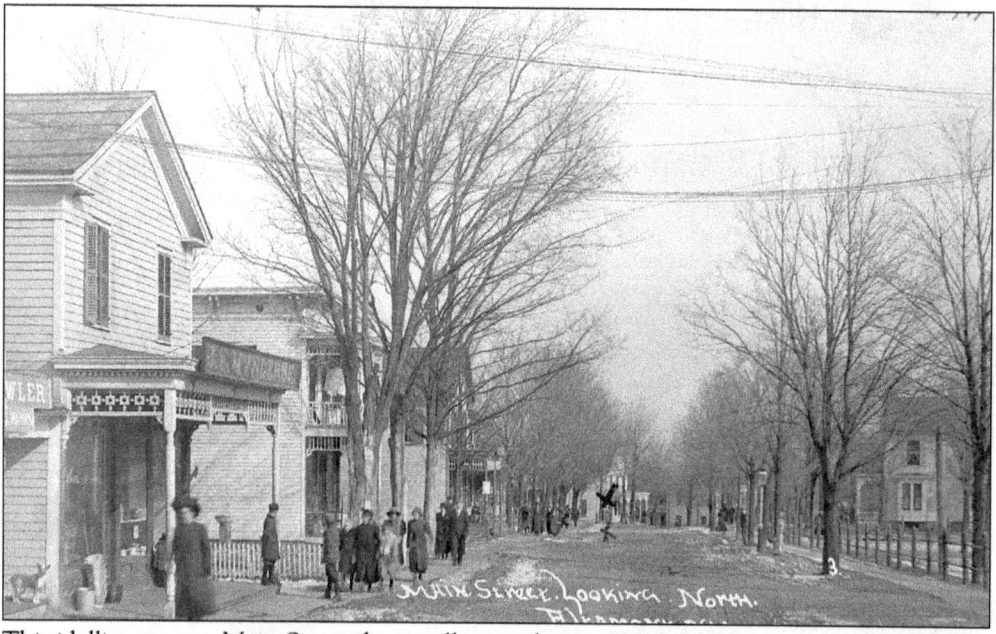

This aerial view, looking north over the Helderberg Roller Flour Mill near the D&H Railroad tracks, was photographed c. 1905. The mill was the second one on that site. The building on the left with an awning was a shirtwaist factory. It later housed the Altamont Soda Works.

This idyllic scene on Main Street shows villagers who were probably coming back from church on Sunday morning. Note the ladies' hats and men's suits. This early 1900s photo was taken looking north from the railroad tracks. Also note the post fence circling the village green.

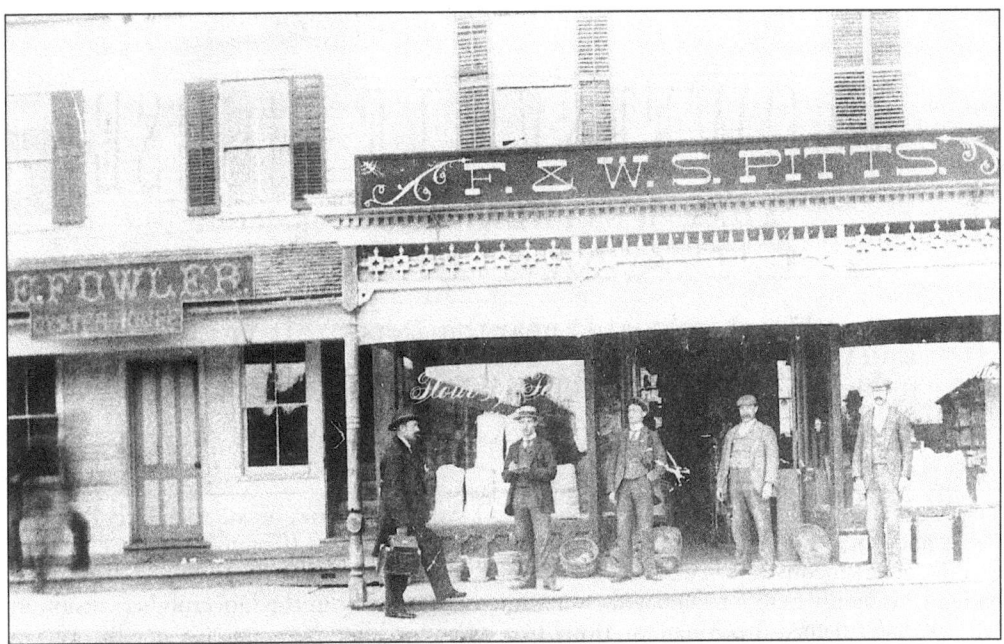

This is reported to be the oldest commercial building in Altamont. In the style of the times, part of the building was set back. Built on Main Street next to the railroad tracks in 1864, one side of the building housed various grocery stores, including Grand Union. The other side was an oyster bar and tavern. Today, the Home Front Cafe and Cindy Pollard's Second-Hand Store operate from there.

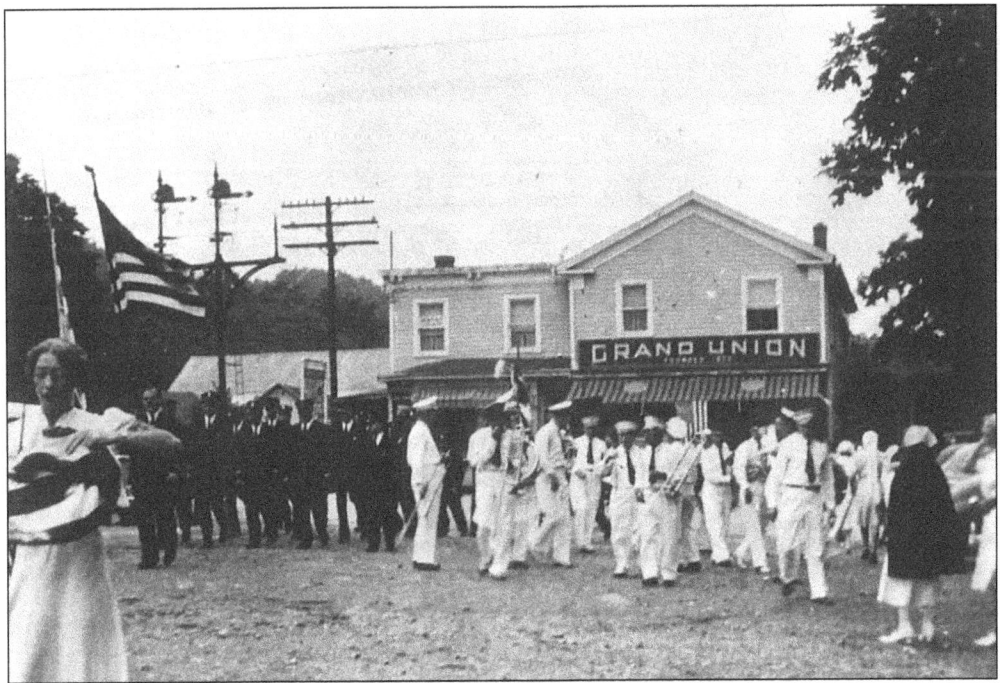

Getting set before the parade and Memorial Day ceremonies are a visiting group of firemen and a band. Grand Union (background) is now a second-hand thrift store.

KNOWERSVILLE HOUSE,

ADAM WEATHERWAX, Proprietor.
ALTAMONT, N. Y.

This Hotel is located near the Depot. It is the largest and most convenient Hotel in the village. Terms reasonable. Special inducements to Summer Boarders and Commercial Travelers.

GOOD STABLES CONNECTED. CARRIAGES ALWAYS READY.

The Knowersville House was built in 1874 by J.O. Stilt, proprietor, beside the D&H Railroad tracks and across the street from its competitor, the Union Hotel (Commercial Hotel). Plans for Altamont's incorporation were made here in 1890. Historians note that Theodore Roosevelt brought his family here for Sunday dinner while he was living in the Governor's Mansion in Albany. Later named the Altamont Hotel by new owner Julius Voss, guests came by train to enjoy the hospitality offered at $8 per week for room and board. The hotel burned in 1928, and Ketchum's now occupies the site.

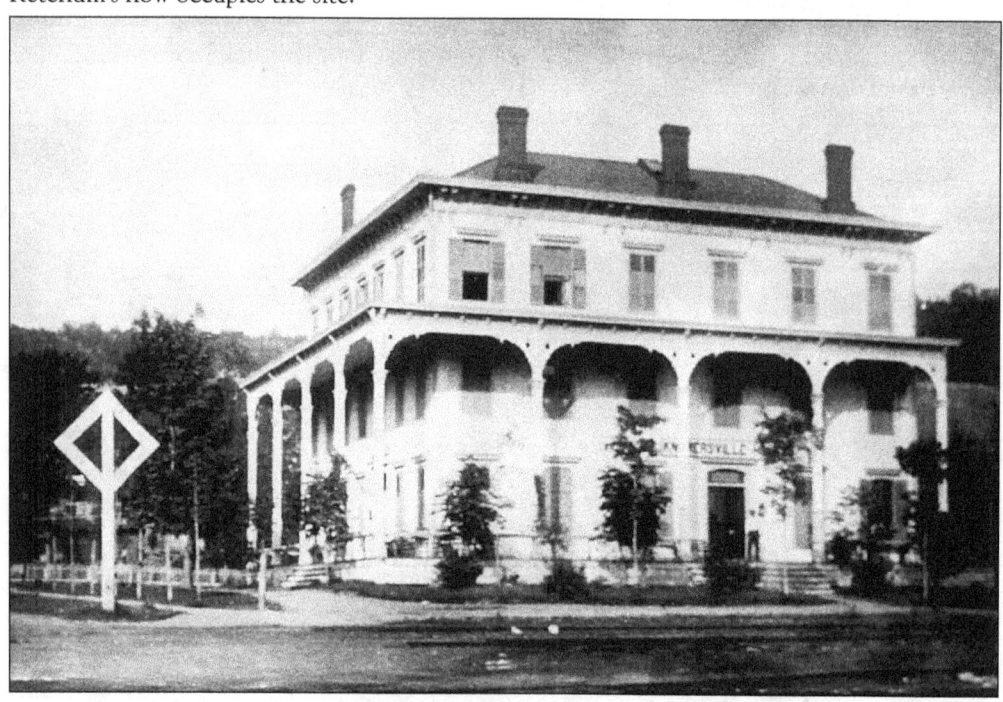

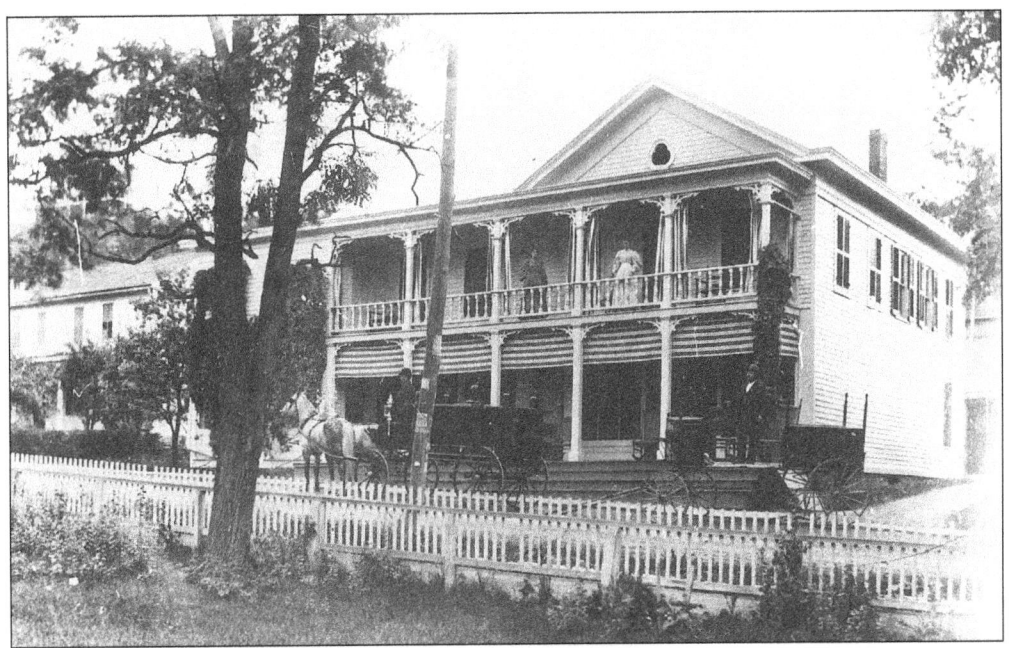

The Fredendall Funeral Parlor on Helderberg Avenue dates back to the middle of the 19th century. M.F. Hellenbeck served villagers with a furniture and undertaking establishment from 1886 to 1895, when his apprentice, Harry Fredendall, purchased the business. Horse and hearse were standard operating equipment until Fredendall made changes by discontinuing the furniture and adding new motor hearses. James Yohey is the present owner.

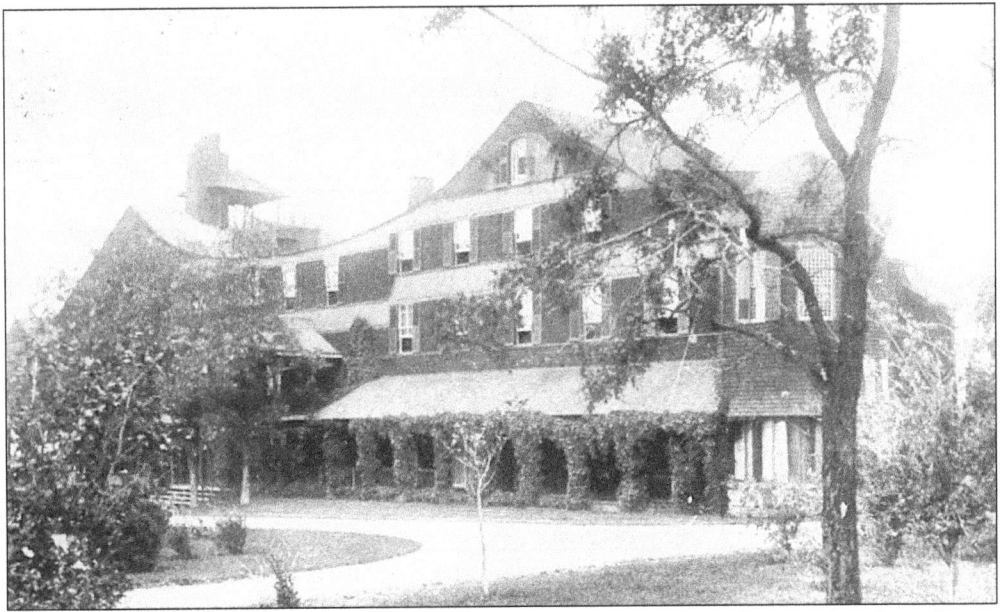

The Kushaqua Hotel (Helderberg Inn) was built in 1886 by Col. Walter S. Church on Route 156, overlooking the village of Altamont. Once owned by the Van Rensselaer landlords, the site is said to have been an ancient Native-American burial ground. In 1918, it was owned by Sisters of Mercy, and was then sold in 1928 to LaSallette Fathers for a seminary. The Peter Young Rehabilitation Center was later built on the site.

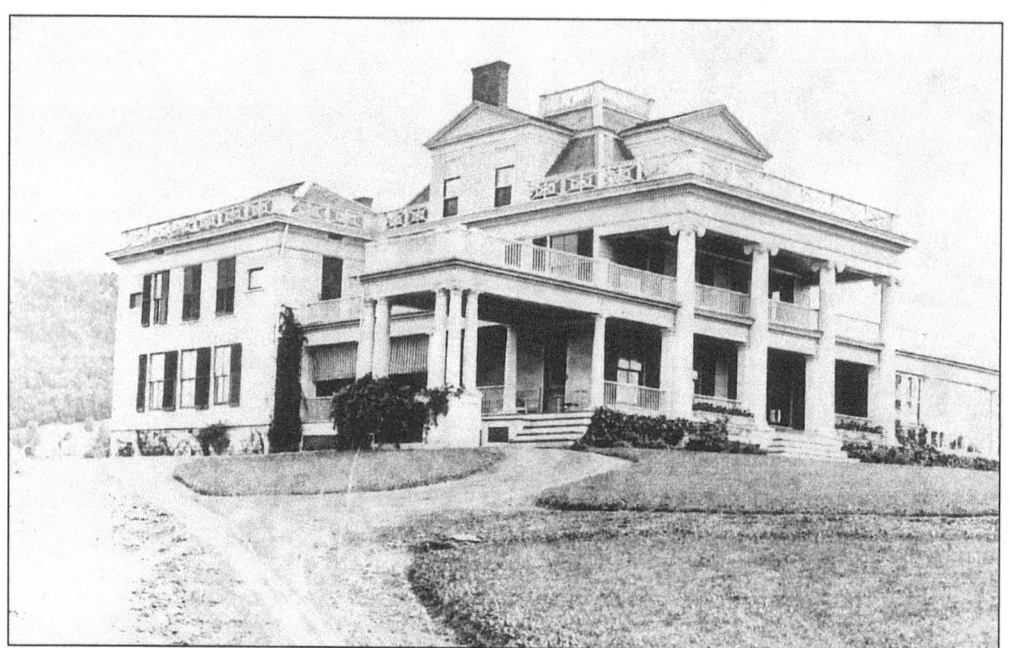

The elegant John Boyd Thacher summer mansion sat high on the Helderberg Mountains overlooking Altamont. It was built c. 1886. Mayor Thacher and his wife entertained dignitaries from the political scene at this handsome mountain retreat. The house was burned in January 1965 as a fire department exercise.

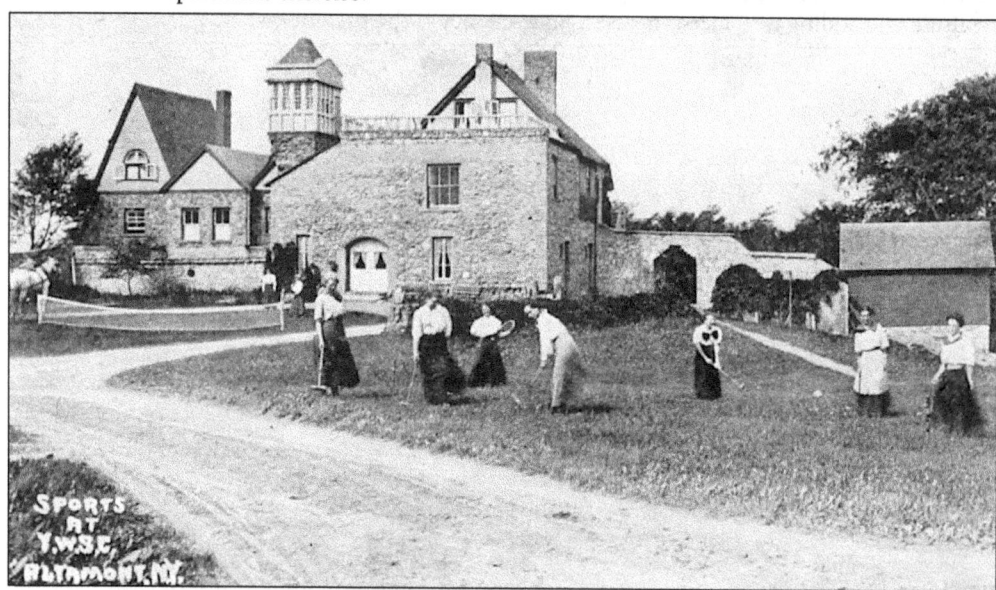

The famous castle of Albany architect Edward Cassidy was built in 1899. After touring France, Cassidy created his castle on the highest part of his estate in the Helderbergs. Built of Oriskany stone, the castle was a national tourist attraction. A hotel was built to house those who came to enjoy the game-cock matches, the quarter-mile race track that featured Cassidy's colts, and to breathe the exhilarating mountain air. After several owners, the castle and several acres of ground were turned over to the Salvation Army, and a Fresh Air Camp was conducted there until the structure burned in 1949.

Governor's Day, held on August 17, 1903, was a special opening day at the Altamont Fair Grounds off Grand Street. Note the fancy gowns and hats on the ladies and the men dressed in suits and straw hats. Hundreds of carriages carrying fun-loving fair-goers filled the parking area. Horse sheds can be seen in the background. The first Altamont Fair was held in September 1893.

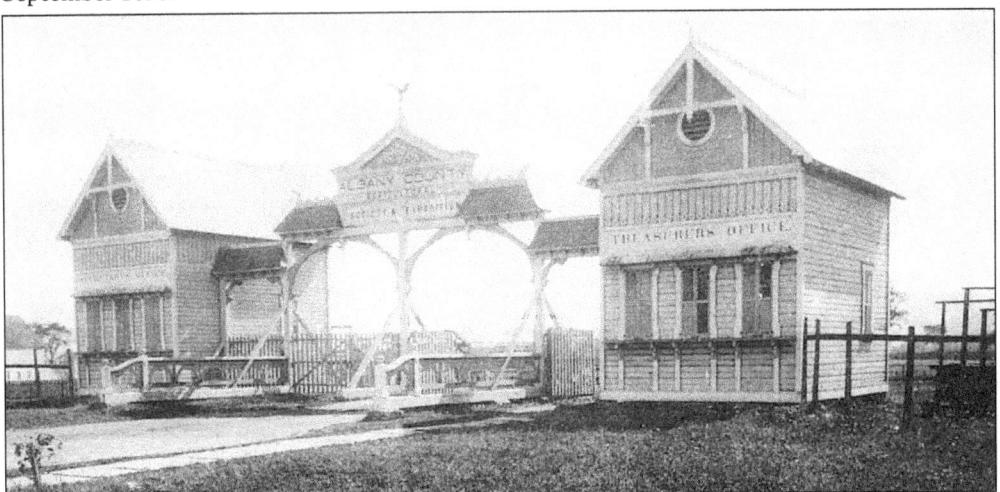

The ornate entrance gate to the Grand Street Altamont Fair Grounds was built in 1905. The small buildings to the right and left outlived their usefulness as offices. Today, they are used as rest room facilities.

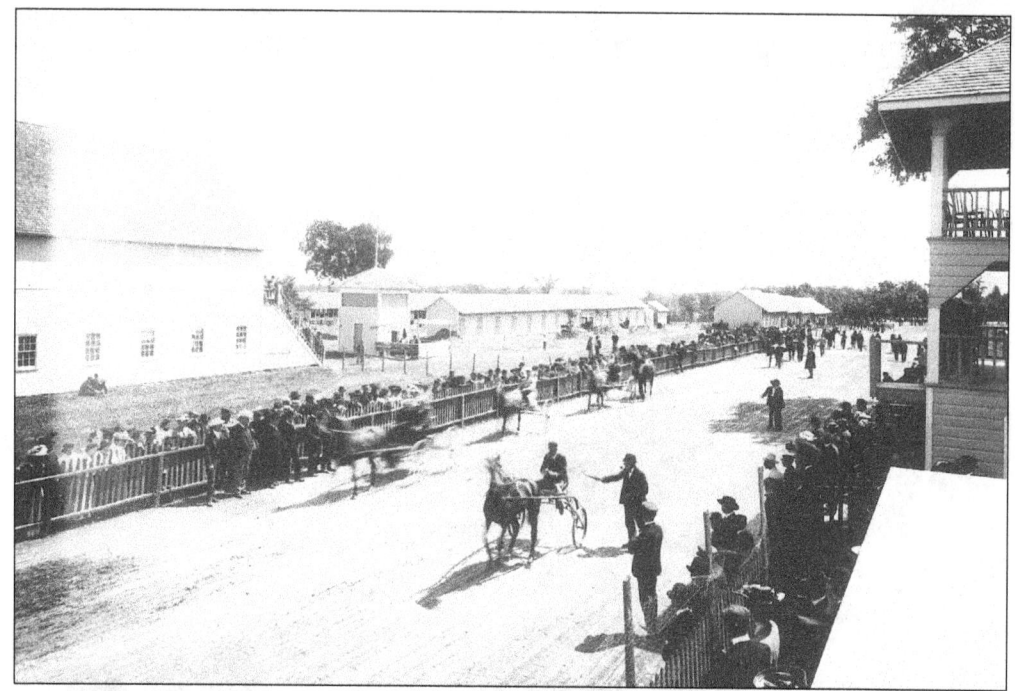

Harness racing at Saratoga brought an end to the harness racing in Altamont. Many of the wealthier local residents participated in this sport. Millard Hellenbeck, a furniture store owner and undertaker, was a popular driver in his cart around the dusty track. This c. 1900 photograph shows the newness of the buildings and the wooden fence at track side.

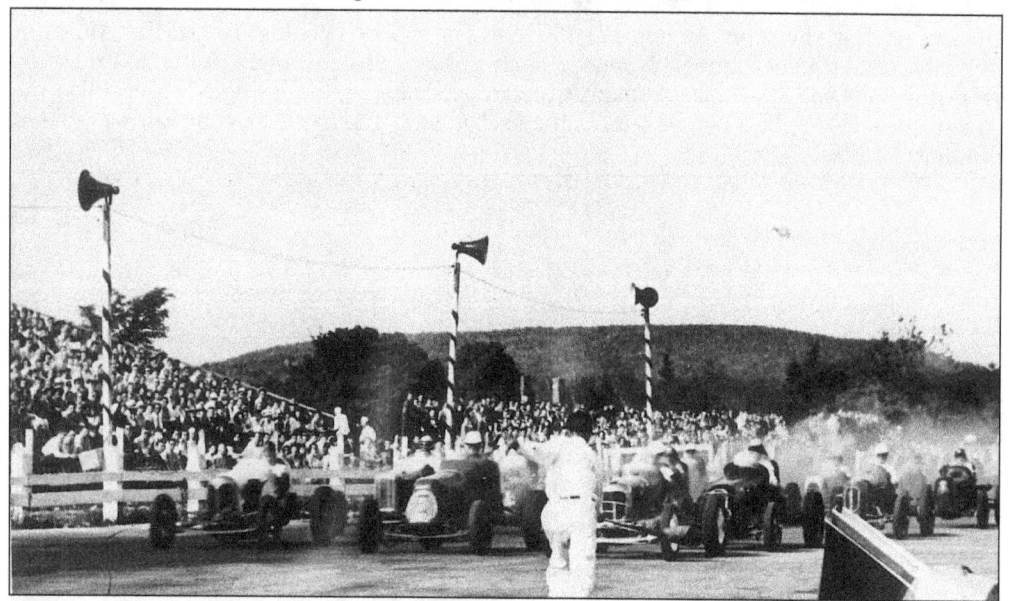

Car racing, livestock shows, and the midway were always big attractions at the fairgrounds. This photo shows the start of the Spring Championship 30-lap race on Memorial Day 1948. The heyday of auto racing was in the 1930s through the 1940s. The one-half-mile clay track was touted as being one of the best tracks in that era. Lee Wallard, the 1951 winner of the Indianapolis 500, rode at the Altamont Fair Grounds track.

Invented in 1892 by Frank W. Ferris, this was one of the earliest Ferris wheels and was one of the biggest attractions at the local Altamont Fair. Today's wheels are much more sturdy than the spindly one pictured in this *c.* 1899 photo.

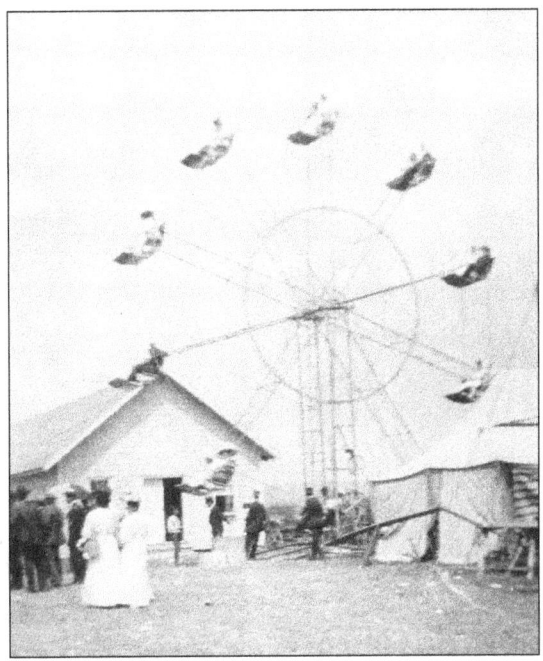

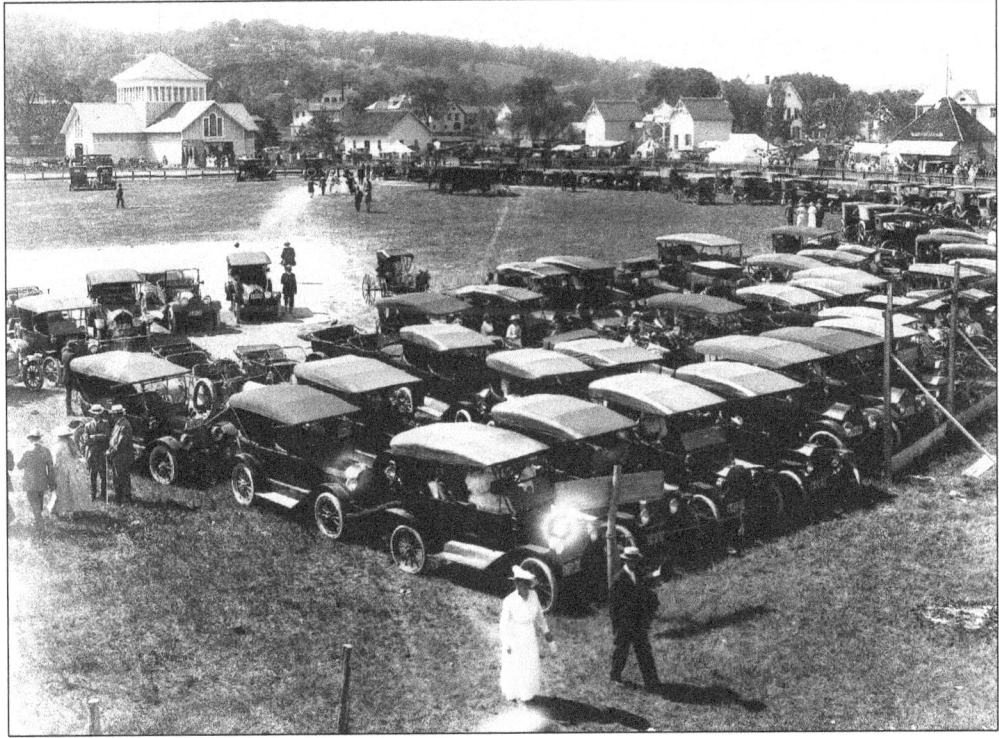

Thirteen years have changed the look of the fairgrounds' parking lot. This 1916 scene shows that the new gas-driven motor cars have replaced the horse and carriage. Yet the ladies still cling to their long dresses and large hats, and the men still wear their straw hats. The Flower Building is in the background, and Albany Mayor John Boyd Thacher's elegant home, now demolished, stands high on the hill on what is presently Leesome Lane.

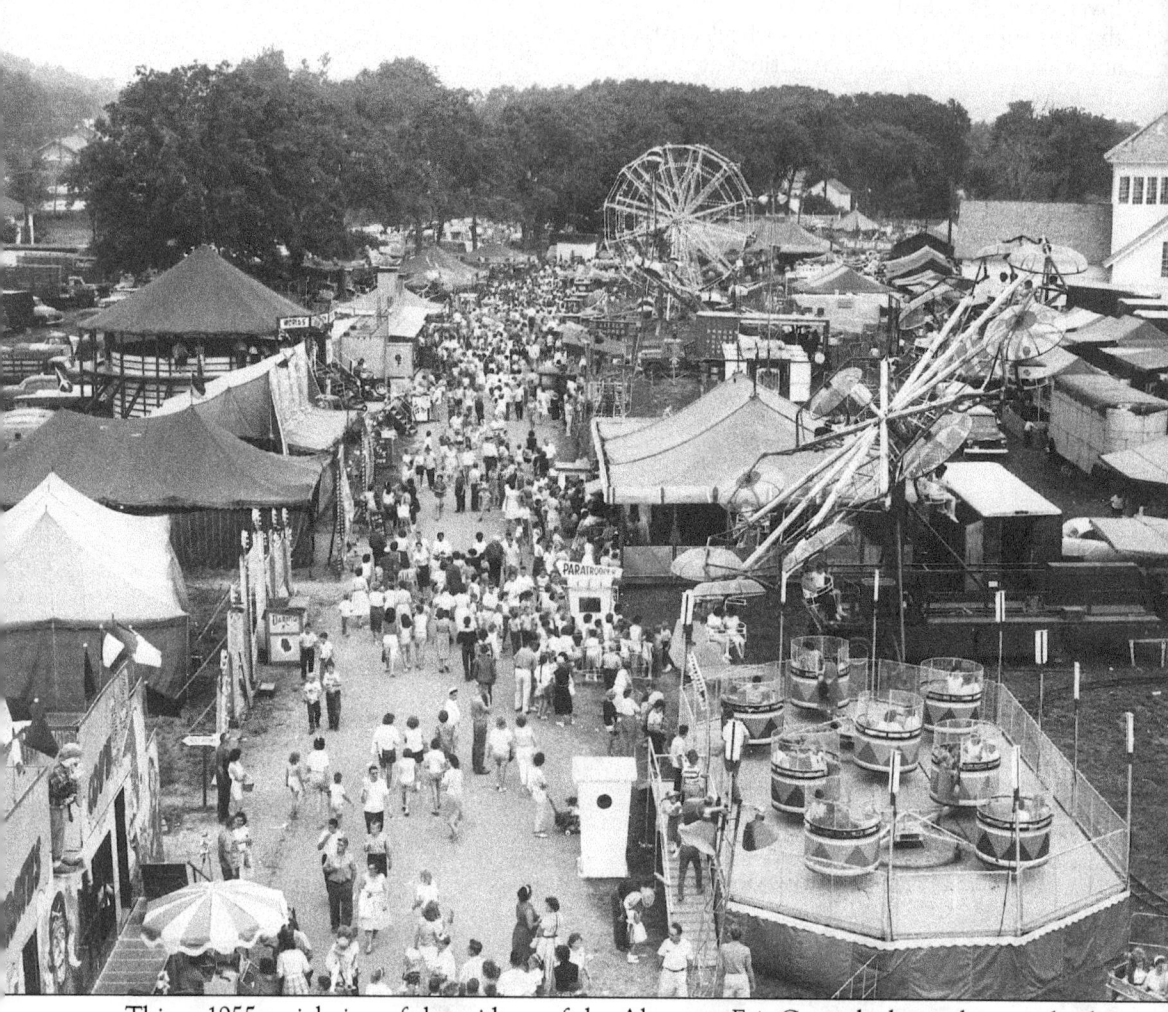

This c. 1955 aerial view of the midway of the Altamont Fair Grounds shows the crowds, the Ferris wheel, the merry-go-round, and other attractions that continue to draw huge crowds from all over the state to Altamont for a week in August every year. In the early years, the fair was only open for three or four days. In the 1920s, the fair remained open for two extra evenings by adding electric lights and, shortly after, fireworks.

Six

BACK ROADS AND COUNTRY BYWAYS

Guilderland's outlying areas often had names and identities unfamiliar to most people today. Osborn Corners is the intersection of Routes 146 and 158 west of Guilderland Center. Originally, the corners were just to the east, where the Schoharie Road passed Osborn Road. First called McChesney Corners, after the family who owned the Appel Inn from 1869 to 1904, the name changed after the property was purchased by Calvin Osborn.

To the northwest of Altamont is Settles Hill, once called Settlesburgh after the 18th-century Sittle or Settle family, who were among the earliest settlers there. Ostrander and Wormer Roads are southwest of Guilderland Hamlet. Fort Hunter is the Carman Road area that was once farmland. In colonial days, Fort Hunter Road began at Old State Road, then followed the route of modern-day Carman Road until it left Guilderland in the direction of Fort Hunter in Montgomery County.

Parkers Corners is the area of Old State Road and Route 158, taking its name from the Parker family, who once lived there. Meadowdale, formerly a thriving community east of Altamont, developed when the Albany and Susquehanna Railroad located a station there to attract tourists to the Helderberg scenery and healthy surroundings.

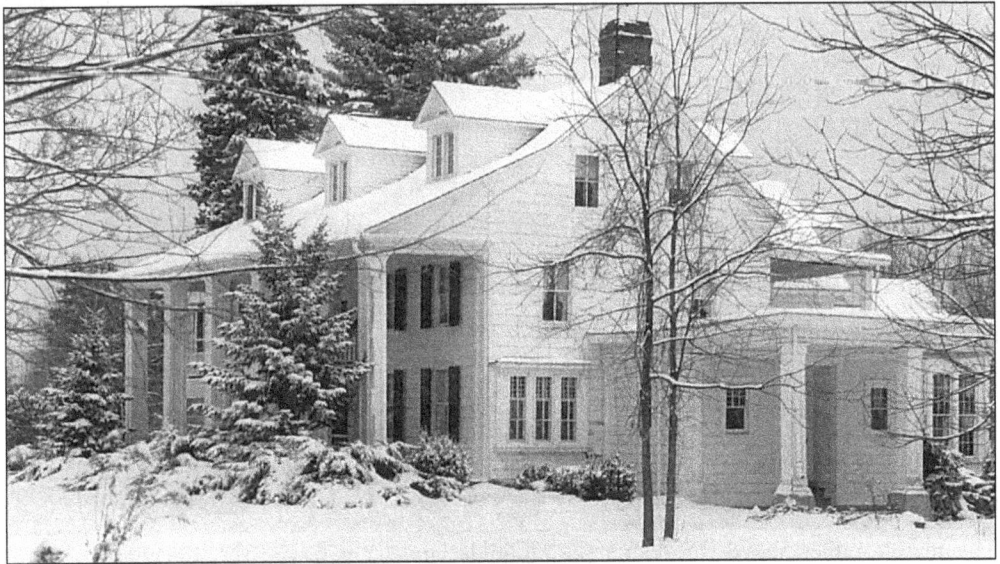

Beginning in the 1760s, Hendrick Appel's tavern was a welcome sight for tired Schoharie Road travelers, who would quaff his famous warming apple toddy. Guilderland's town fathers met here in 1803 to establish a town government. In the 1930s, the building became a restaurant called the Hawthorne Inn and is today a bed and breakfast called the Appel Inn.

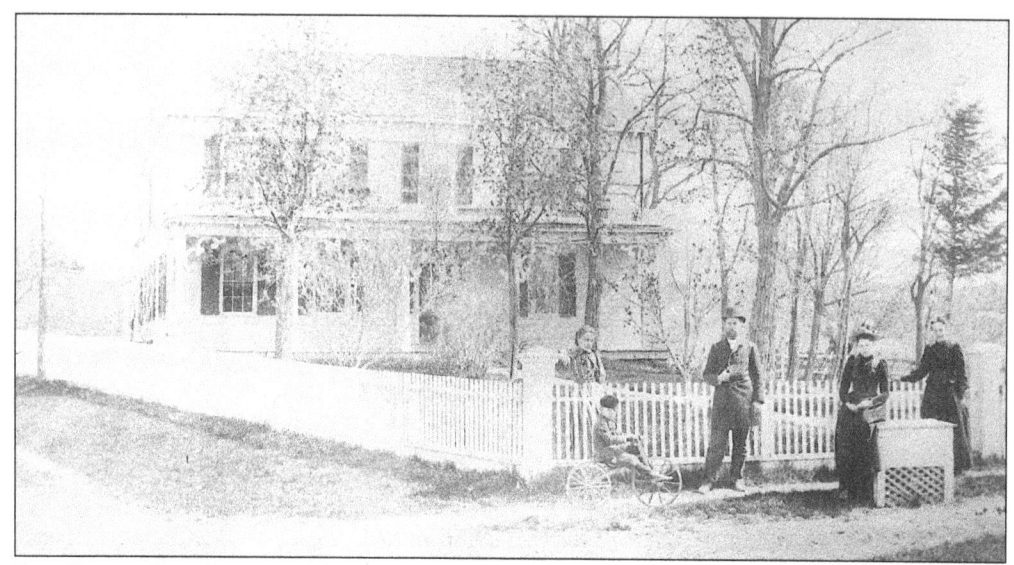

Rev. Bergen Staats, pastor of the Helderberg Reformed Church, poses with his family in front of the parsonage on Osborn Road c. 1890. The late-18th-century house served as a parsonage until 1896, when the church moved from Osborn Corners. Occupied as a private residence until the 1950s, it was then abandoned. Under the supervision of three local fire departments, the vacant house was burned in 1967.

The marble tablet above the door reads, "Guilderland Cemetery, 1872, Receiving Vault." This vault is one of five cobblestone buildings erected in Guilderland in the 1860s and 1870s, probably all constructed by R.E. Zeh, the mason documented as the builder of the Guilderland Center Cobblestone School. Located just off Osborn Road, the cemetery itself dates to at least 1849, when a portion of church land was set aside as a burial ground.

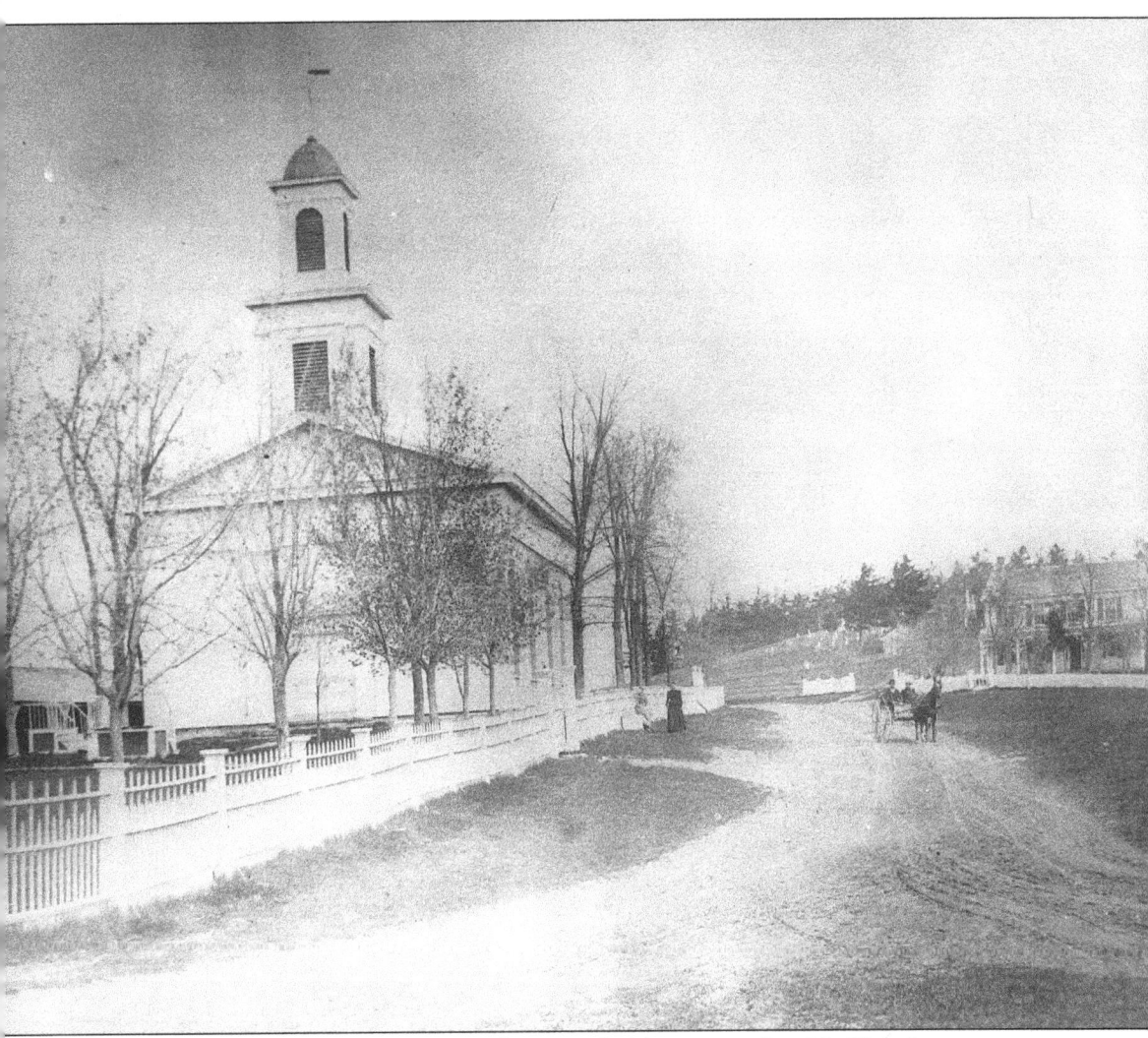

As Schoharie Road travelers approached Osborn Road, the imposing Gamble Church came into view. Across Osborn Road were the parsonage and cemetery shown in this c. 1890 photograph. The church was the third Helderberg Reformed house of worship located on this site since the 1760s. First a log "prayer house," then, as the congregation grew, the "Old Red Church" served worshippers. By 1834, a third church was necessary; it was expanded in 1852 so that several hundred church-goers could be accommodated. Large horse sheds (left of the church) sheltered horses and wagons. So popular and influential was Rev. Samuel Gamble, pastor during the 1870s and 1880s, that the 500-member congregation began to call their church the "Gamble Church." In 1896, the congregation split amicably into the Altamont and Helderberg Reformed Congregations, and each built a new church. The old Gamble Church was demolished. Today, underbrush and trees grow on the site where this beautiful church and parsonage once graced the landscape.

Standing behind the Gamble Church was the District #9 one-room cobblestone school. Lost to fire in 1894, it was replaced by the white frame building shown in this c. 1918 photograph. Students attended the Osborn Corners School until 1942, when district residents voted to send their children to Altamont schools. The building continued to be used for community activities until 1953. A year later, the old school building was converted into a residence; it burned in 1969.

Proudly displaying an American flag outside the Osborn Corners School are Doris Cochrane, Nellie Relyea, Anna Smith, Margaret Hay, Donald Smith, and an unidentified boy. Attendance at the one-room schools not only included the three Rs for the students, but also such highlights as Christmas festivities, Arbor Day celebrations, closing exercises with a class picnic, and participation in patriotic events such as Memorial Day.

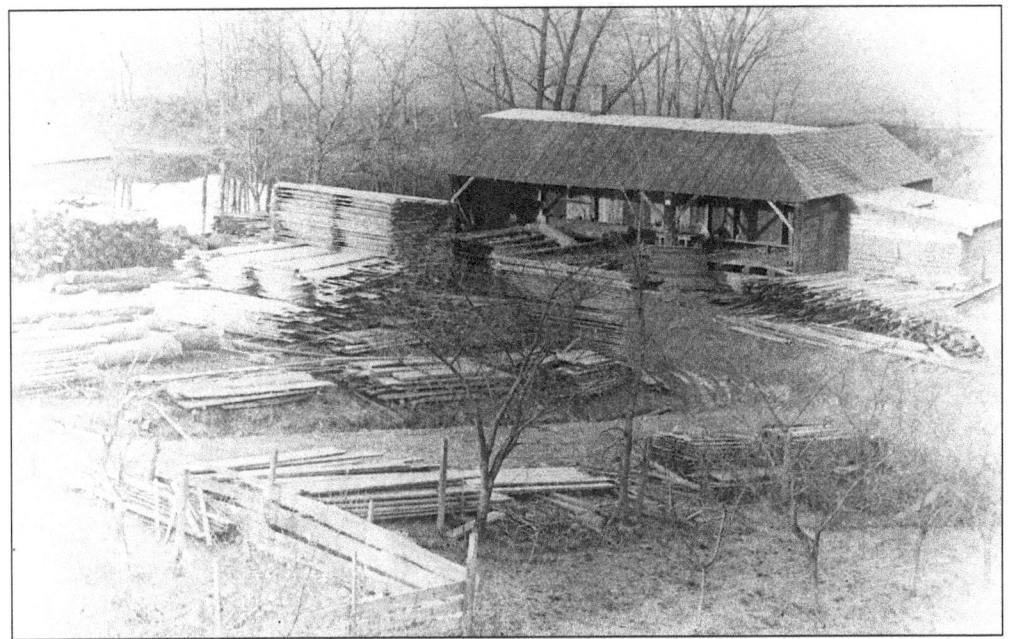

Located on Route 158 north of Osborn Corners, this sawmill first utilized water power from Black Creek, then steam power. Built by Rev. Adam Crounse c. 1833, its owner by the 1880s was A.J. Tygert, who was described as a "manufacturer of sash, blinds, and doors, and proprietor of a planing mill." His son Peter continued the business. In 1913, the sawmill burned.

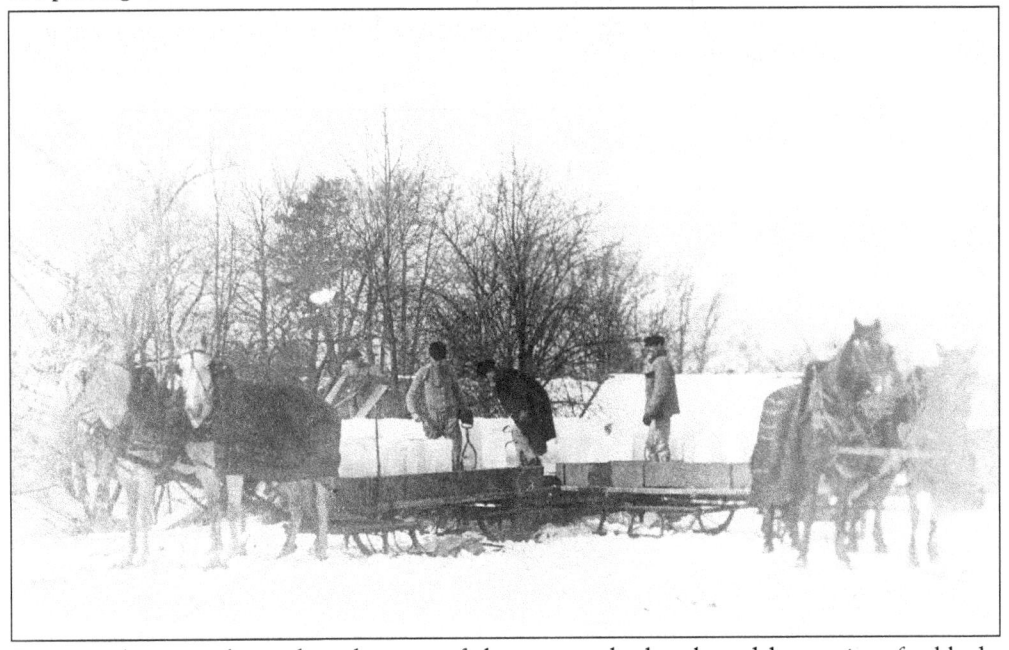

To meet the great demand at the turn of the century by hotels and housewives for blocks of ice to cool their ice boxes, the Tygerts hired men to cut ice from Black Creek, near their sawmill. After being cut, the blocks were piked to the edge and hoisted out by means of a drag. Here, ice blocks are being loaded on a cutter to be transported to the nearby ice house and packed in sawdust.

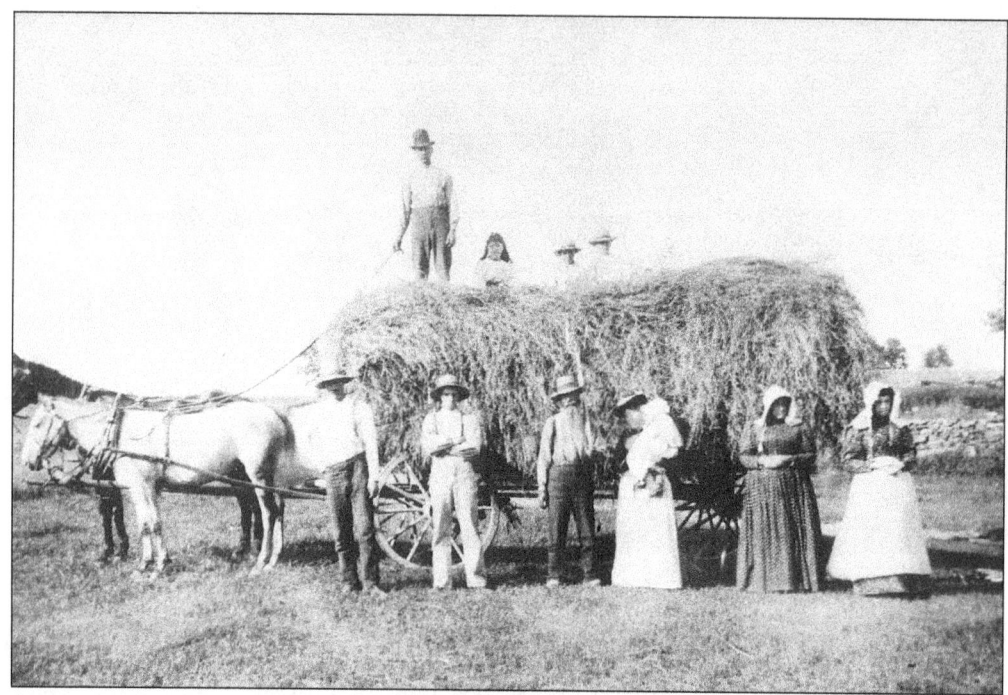

On the Lainhart Farm in the Settles Hill area of town, family members pause after completing the hot, hard task of cutting hay and loading the hay wagon, a job done by hand a century ago. Note the pitchfork. A major source of income for Guilderland farm families was the sale of hay to dealers who paid farmers for their hay by the pound and then shipped it to nearby cities from one of Guilderland's four railroad stations.

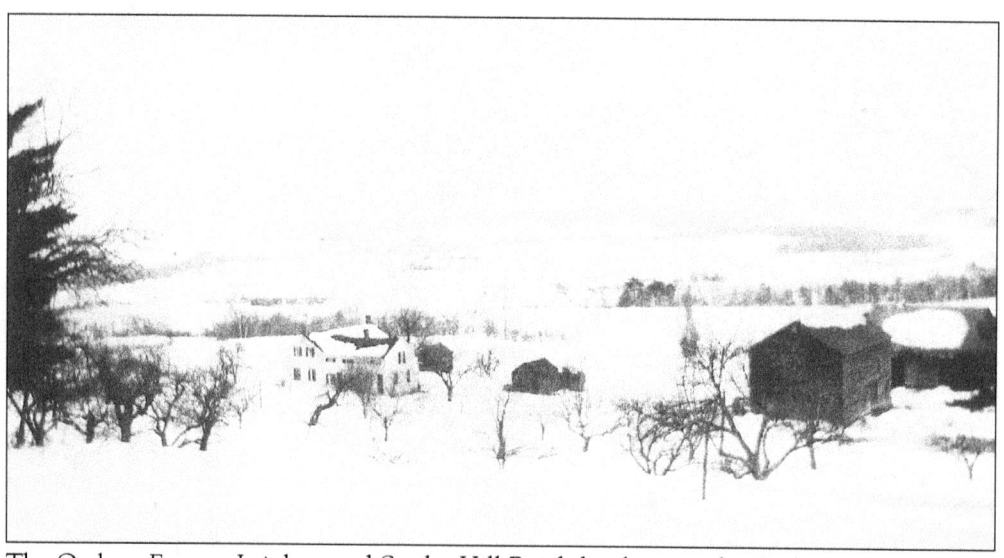

The Ogsbury Farm at Lainhart and Settles Hill Roads has been in the Ogsbury-Frederick-Rau family since 1799. Wheat was the original cash crop raised on this farm, but later rye, oats, and hay were grown for sale. By the early 20th century, the farm had become a dairy farm, a transition typical of local farms. A Dutch barn remains on the property. This wintery scene shows that much of Guilderland was still open farmland in the 1930s.

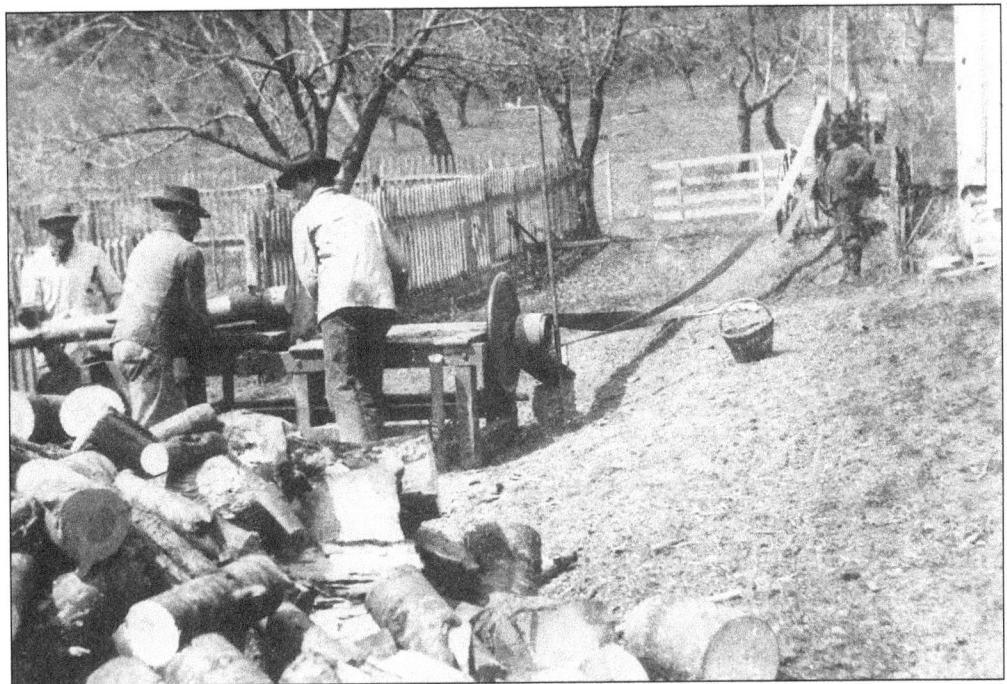

Each autumn, farmers had to be sure that enough firewood was cut to last through the winter. In the Settles Hill area, a farmer named Gray owned a buzz saw powered by an early "hit and miss" gasoline engine, which he took from farm to farm cutting firewood for a fee. Here, on the family farm c. 1915, Peter and Willard Ogsbury (left) assist in sawing logs. The two men on the right are unidentified.

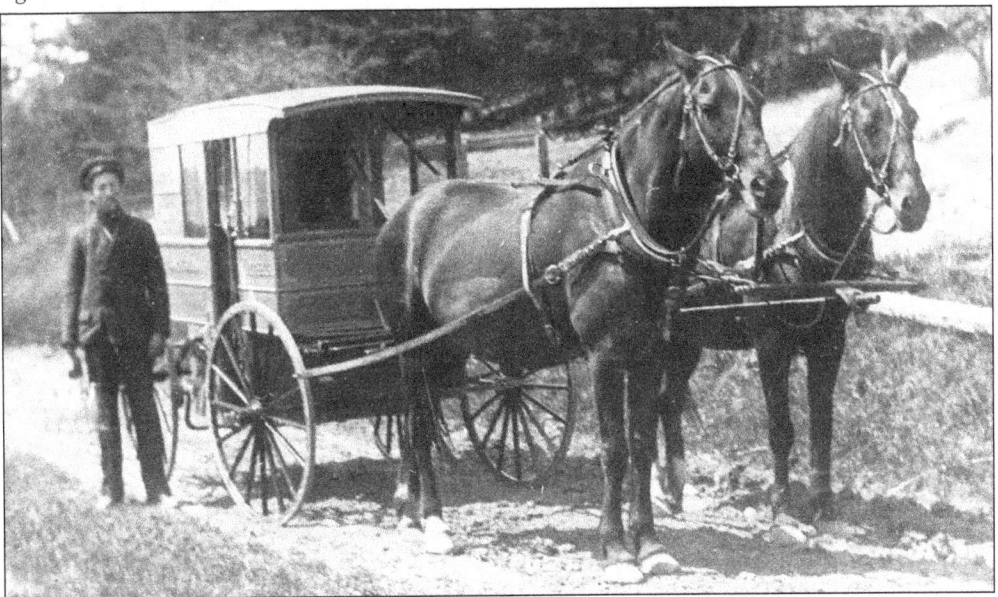

Willard J. Ogsbury stands by his horse-drawn milk delivery wagon, near his farm on Lainhart Road c. 1910. At first, as he made his rounds, he carried bulk milk that he dipped out with a ladle into one- or two-quart milk cans. Later, the milk was bottled for delivery. He also sold eggs and butter, and fed the skim milk to the pigs.

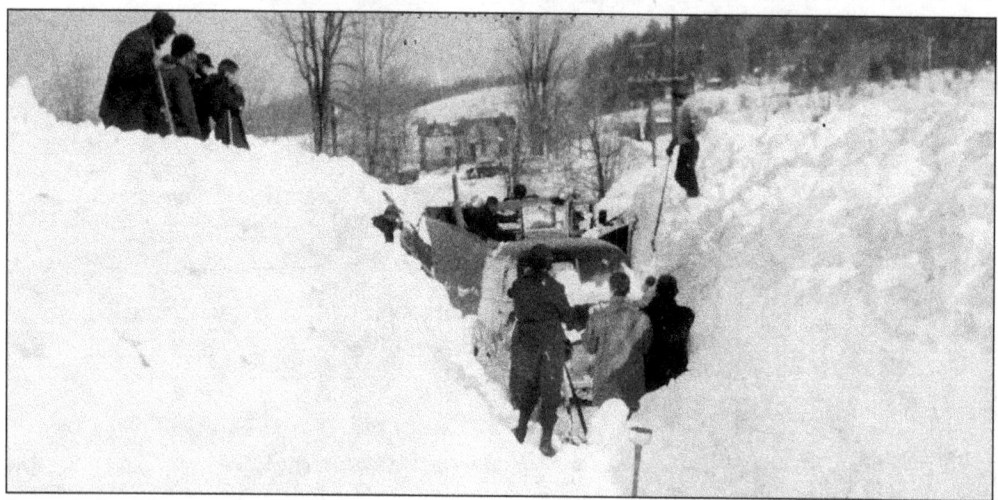

The Settles Hill District #1 School, located at the northeast corner of Settles Hill and Gray Roads, was built in 1854. The teacher and students in this c. 1890 photo are unidentified. In 1891, the Settles Hill District #1 was one of 14 separate common school districts in Guilderland, each with its own schoolhouse. Nineteen teachers were employed to instruct 658 students.

During the Blizzard of 1958, howling winds whipped over 20 inches of powdery snow into huge drifts, making roads impassable, often for days. Schools closed down for a week after the February 16–17 storm and snowmobiles and helicopters had to be used to help people who were stranded. Here, on Gray Road, the Guilderland Highway Department and neighbors attempt to dig out an abandoned car.

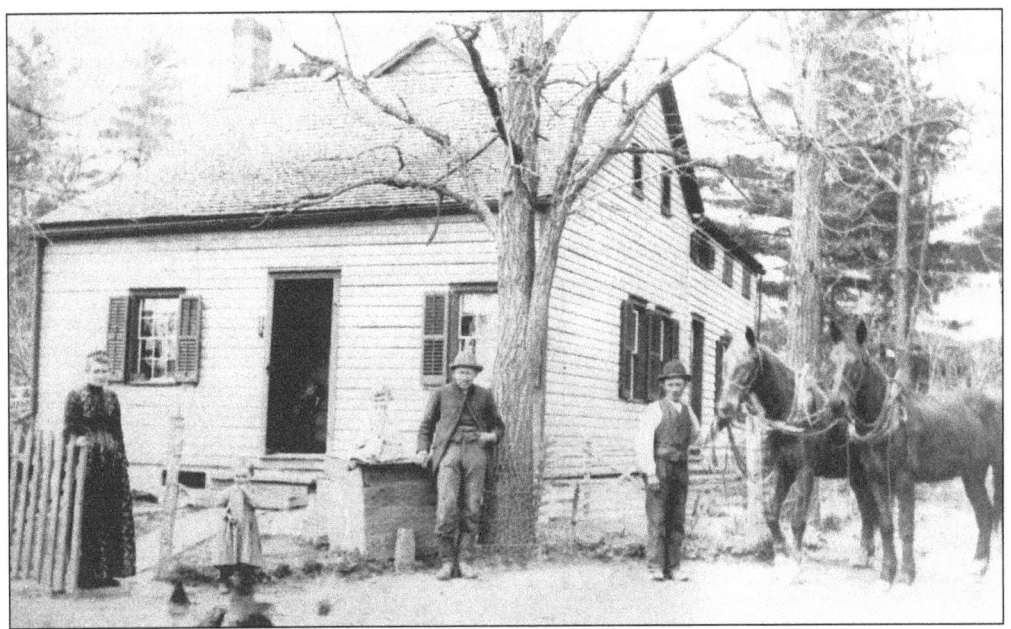

The La Grange family, one of the oldest in this area, established a large farm on Ostrander Road. Seen here in 1891, Myndert La Grange Jr. gathered his wife, Catherine, and his children, Viola and Schuyler, in front of their home. He was a breeder of Morgan horses. His hired hand displays a pair of his prized purebreds.

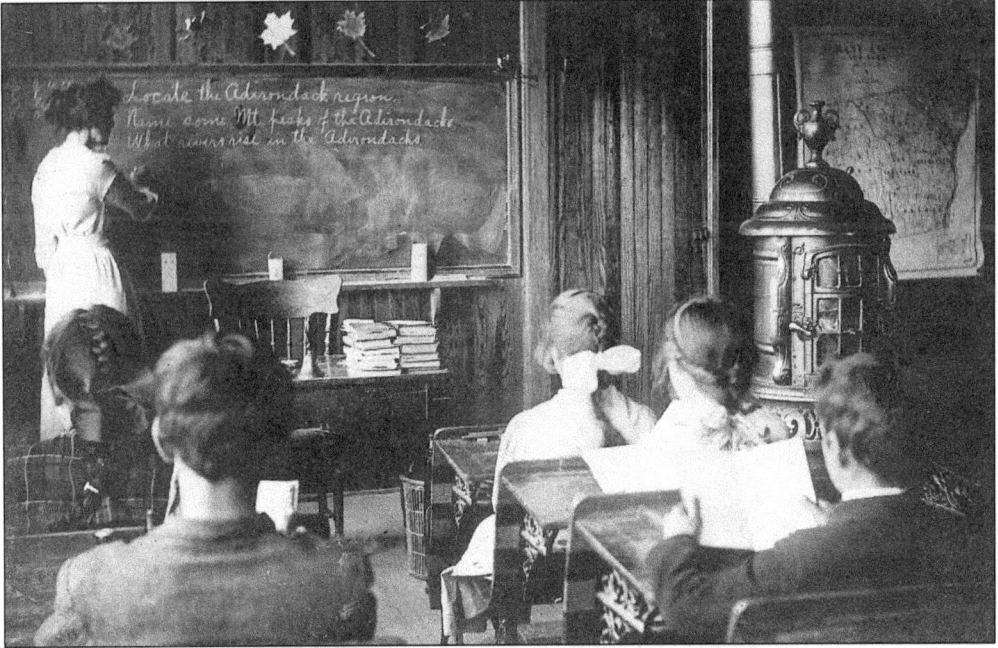

Students at the Wormer Road District #5 School are very attentive as their teacher writes exercises about Adirondack geography on the board. In 1891, Guilderland residents paid a total of $6,074.33 in local school taxes and received an additional $2,658.18 in state aid. That was all that was necessary to run these simple, one-room schools. This one was located at the northeast corner of Route 155 and Wormer Road.

Guilderland's unsung published poet, Magdelene La Grange (Merritt), was born in 1864 near Voorheesville. Her two books of poetry published in 1895 were *Songs of the Helderbergs* and *Helderberg Harmonies*. Magdelene's poems describe her life in Guilderland before the turn of the 20th century. Her poem, "The Drill," depicts delightful scenes of a social gathering at old Frenchs Mill.

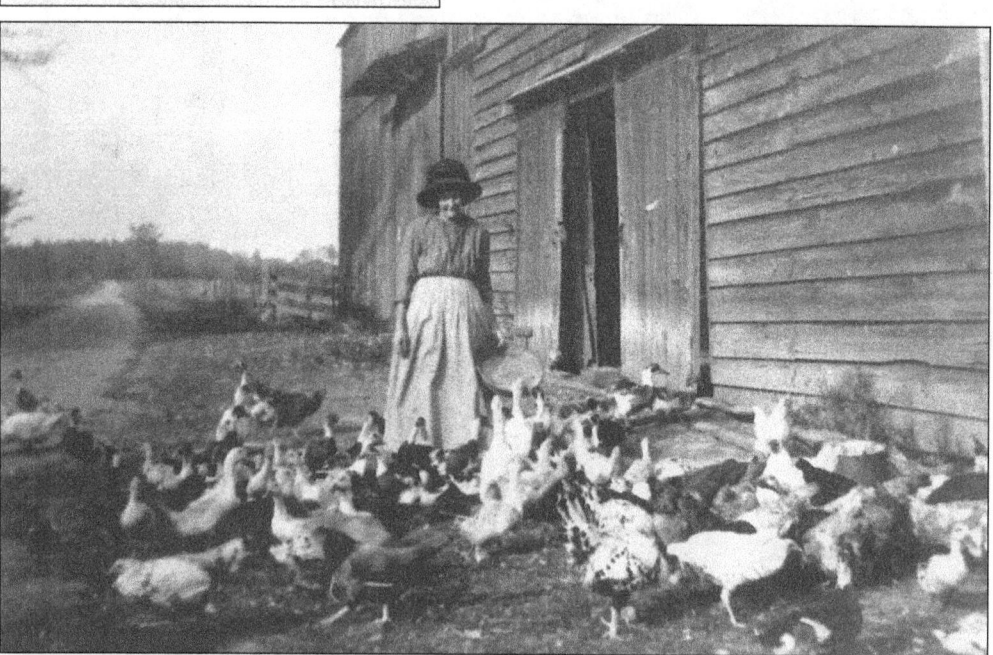

Catherine La Grange is shown here c. 1915 on the La Grange Farm, located on Ostrander Road, doing one of farm women's many chores—feeding the fowl. In addition to ducks, geese, and chickens, farmers often kept guinea fowl, whose raucous cries warned them when intruders were in the hen house.

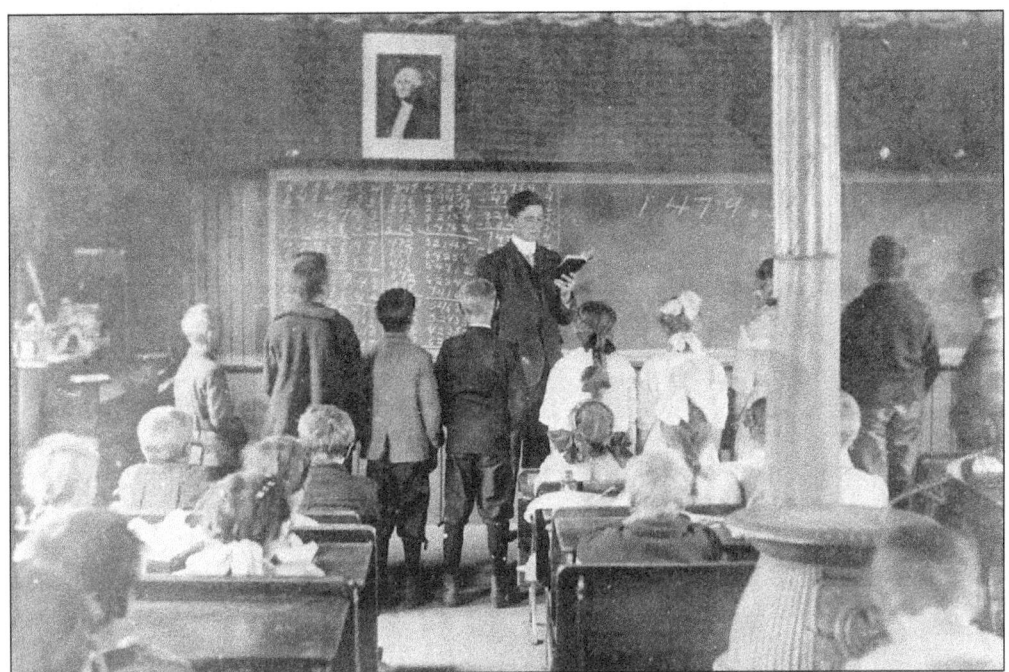

John Gade Sr. listens to recitation by some of his students at the George Bigsbee School District #14 in this 1913 view. In use until 1935, when the Fort Hunter School opened, Bigsbee School was located on the opposite side of Carman Road, west of the later school. Bigsbee's 1876 attendance register still exists, recording winter and summer sessions. The children were out of school in late spring and early fall to help their families with planting and harvesting.

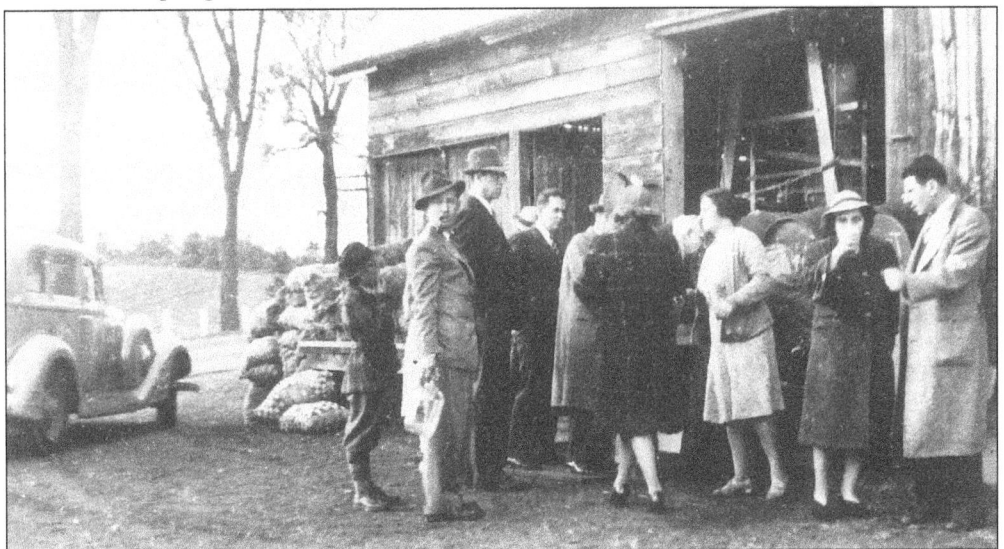

Lovers of pure, tasty apple cider still miss Leininger's Cider Mill on Carman Road, north of Old State Road. Carl and Edith Leininger bought the property in 1942 from Eli Van Wagener and started producing 1,500 gallons of cider a year. By 1949, they were making 48,000 gallons. Albert Leininger continued the family business until 1986, when Indian Ladder Farms took over the mill. The cider mill was torn down in 1989, and Dr. William Tetrault opened a medical practice at the location.

The St. Madeleine Sophie parish dates to 1939 when "George's Place," a Carman Road dance hall, was converted into a chapel. Originally a mission parish, its first pastor was assigned in 1947. Expansion became necessary, and the church was dedicated in 1951. Pictured is the church and its first rectory (left) in the mid-1950s, prior to the construction of the school, convent, present rectory, and parish center.

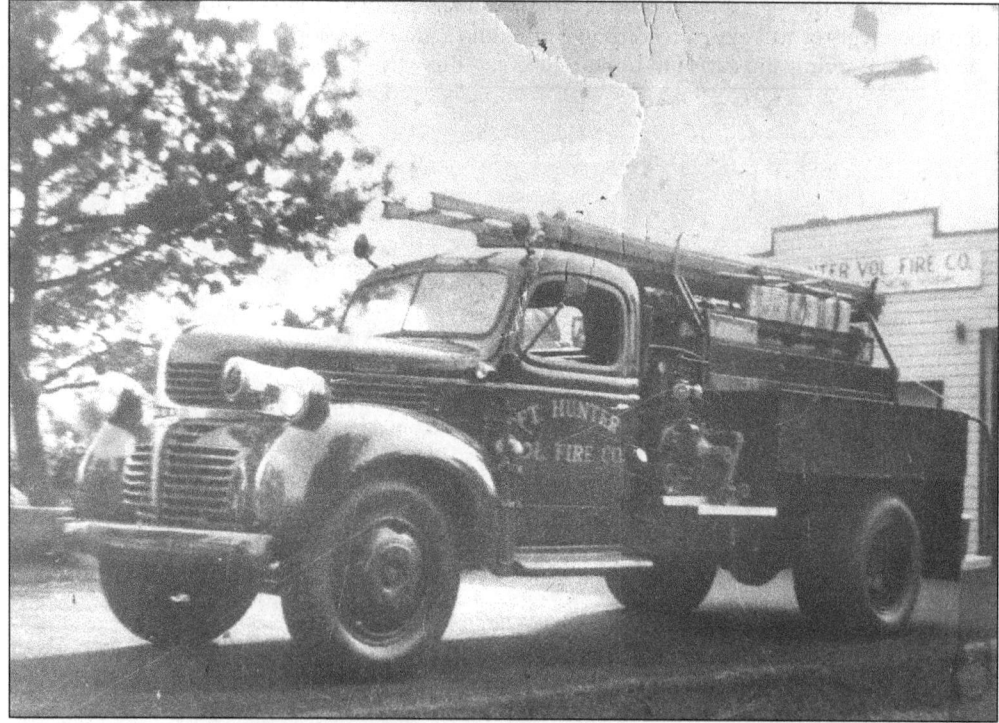

The Fort Hunter Fire Department's first new firetruck, a late 1930s Dodge rebuilt as a fire apparatus, is shown parked in front of the original firehouse on Carman Road. The fire department was founded in 1950.

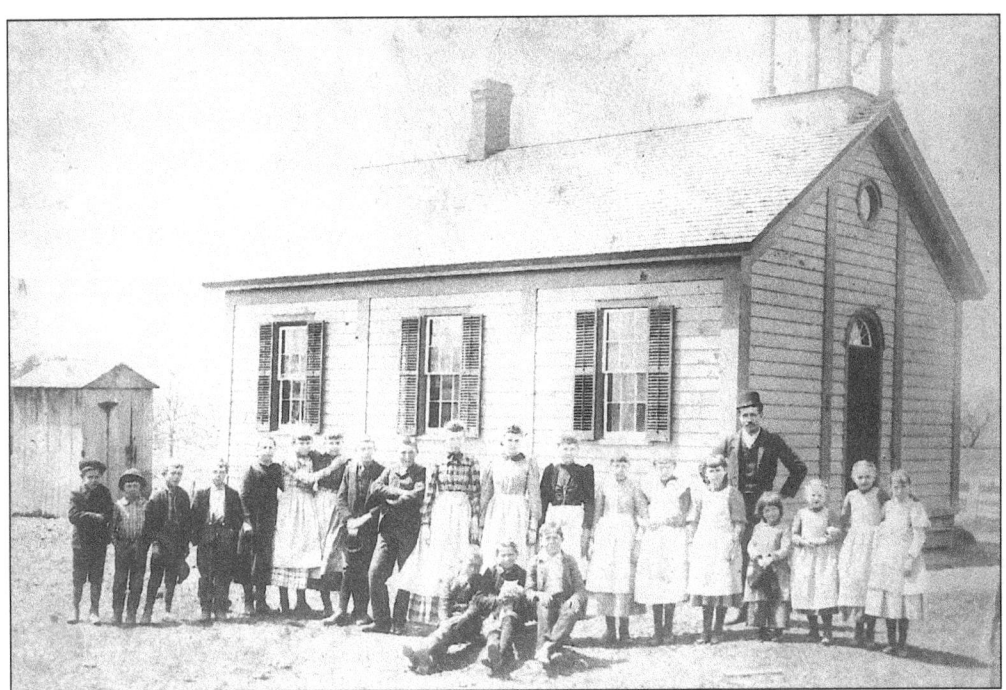

Teacher Jacob Frederick joined his students outside Parkers Corners District #3 School on Old State Road to have this photo taken c. 1890. Behind the school stands the privy, the only rest room facility these one-room schools had well into the 20th century. After the school burned c. 1935, children attended classes at the State Road Methodist Church until centralization in the early 1950s. Then they were bussed to the Fort Hunter Elementary School.

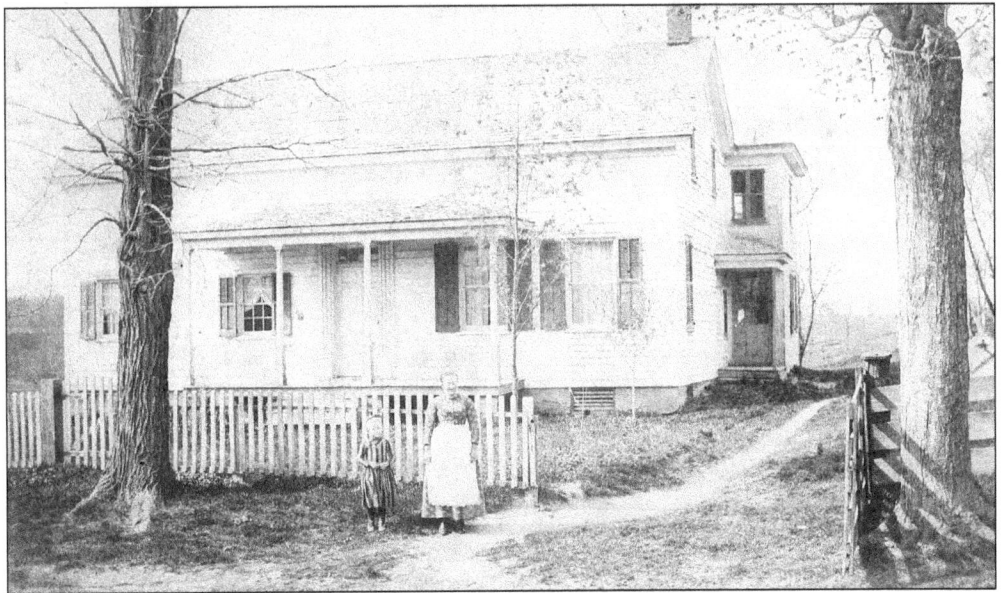

Mary Clute, wife of Parkers Corners' farmer George Clute, and their daughter Ina stand in front of their farmhouse on Old State Road. Mrs. Clute is wearing the typical farmwife's attire of the time: a long dress and apron, uncomfortable for doing household chores on a hot, summer afternoon.

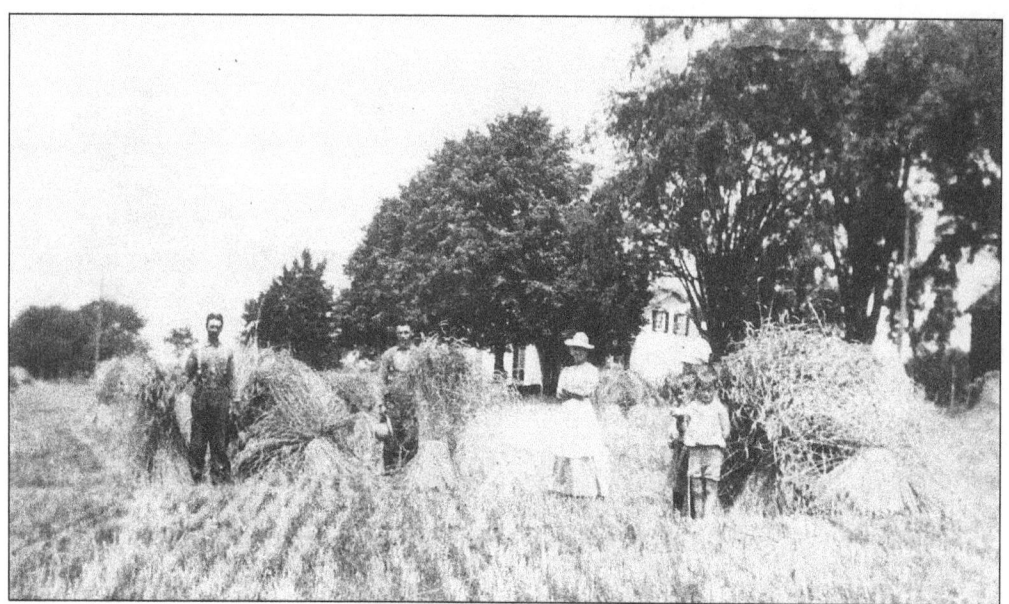

Harvest time meant farmers prayed that the weather cooperated when it was time to take in their ripened crops. Here, members of the Chapell family of Parkers Corner stand in their field c. 1910, content that their grain has been harvested and neatly tied in sheaves, ready to be taken to the barn. Their farmhouse stands in the background.

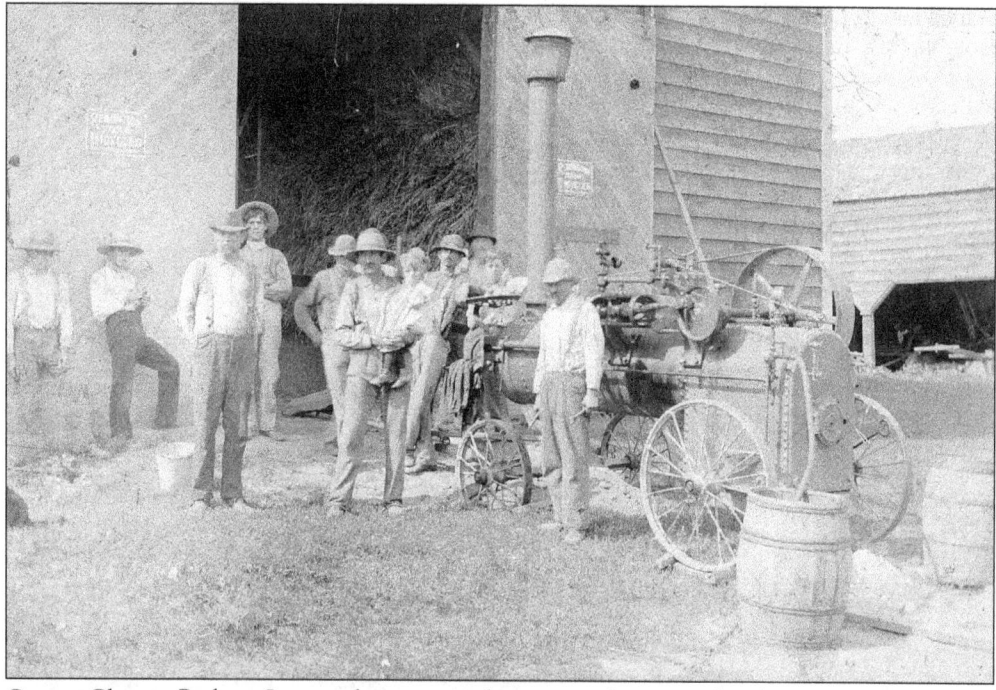

George Clute, a Parkers Corners farmer, was the owner of a steam-threshing outfit, a machine capable of efficiently separating grain from chaff and straw. At harvest time, he hired out to local farmers to thresh their harvested grain, here piled high in Andrew Tullock's barn on Old State Road. In this c. 1900 view, Clute poses in front of his machine while Andrew Tullock, along with neighboring farmers and hired hands, leans against it.

"Mud season" plagued country folk each spring, when the snow melted and the thawing ground turned roads to deep mud. These stranded fellows were bogged down at Parkers Corners somewhere in the area of Old State Road and Route 158. Planks laid down on both the Western Turnpike and the Schoharie Turnpike were an unsuccessful effort to overcome the problem.

Four young women graced a span called Clute's Bridge on a summer afternoon. Old State Road crossed the Normanskill on this bridge. Postcards such as this were an inexpensive means of communication in the days before the telephone, when mail trains ran frequently. Many of the old scenes of Guilderland that have survived were originally postcards.

The hamlet of Meadowdale grew around Meadowdale Road, near the railroad crossing. It is pictured in this view looking west toward Helderberg Escarpment. In addition to the railroad station, other businesses included Schoolcraft's general store and post office, two dealers in hay and straw, and George Lauer's blacksmith shop (fourth building from the left.) The station and store stood diagonally from each other, on either side of the tracks.

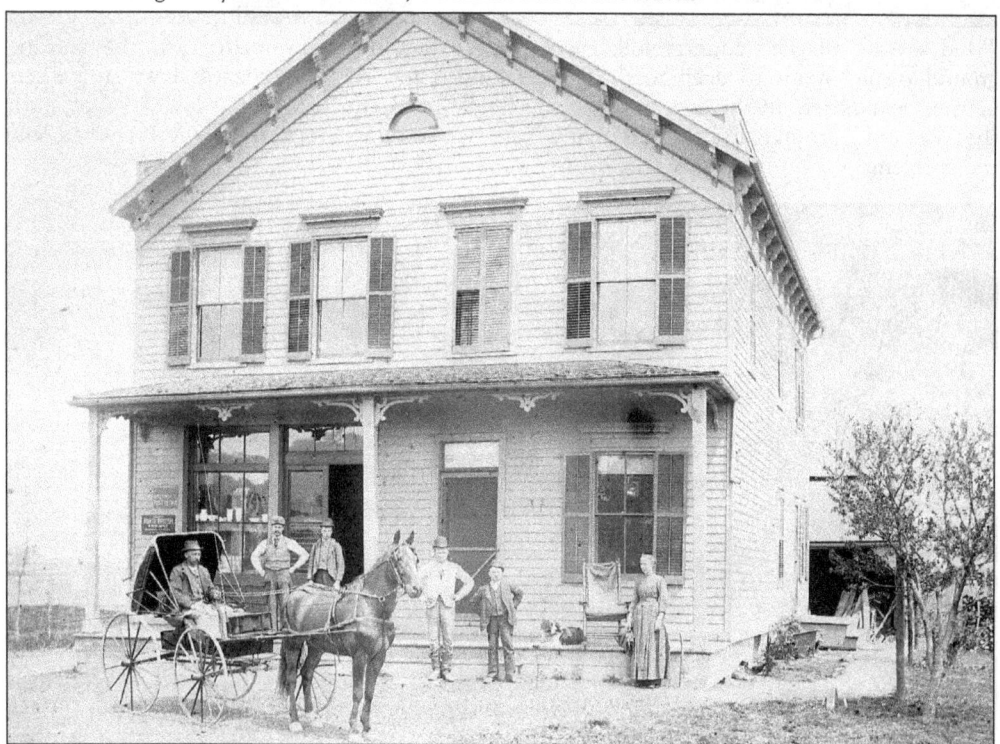

Near the D&H tracks was William Schoolcraft's general store. Mrs. Schoolcraft helped run the store when her husband made his regular circuit of outlying farms, peddling groceries to farmers' wives from a covered wagon pulled by two horses. Until 1926, when it was discontinued, the post office was also located inside this store. It was eventually torn down and the building materials were reused for house construction in Voorheesville.

Weekends and holidays were especially busy at Meadowdale Station when picnickers got off the D&H local to visit the scenic Helderbergs. Most walked up Indian Ladder Road and climbed the ladder to the top, while others hired a horse and carriage similar to the one pictured on this 1907 postcard. Lester Hill's Altamont Livery Stable regularly sent carriages to meet the trains. At day's end, tired from their outing, visitors headed back to Meadowdale Station for the ride home.

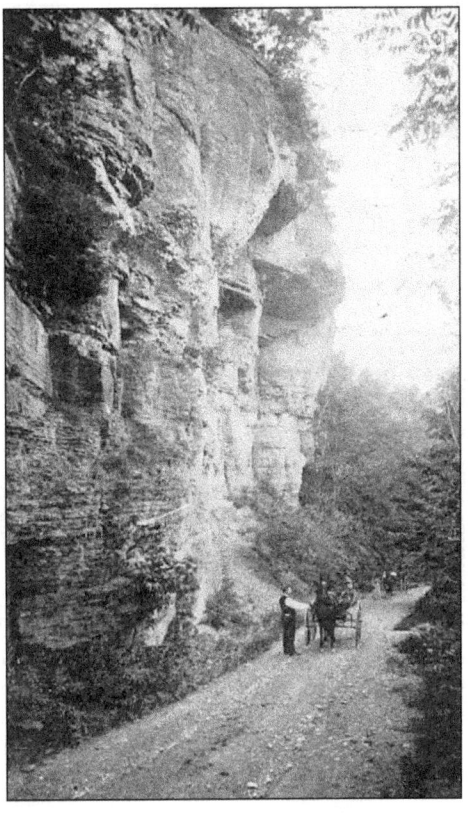

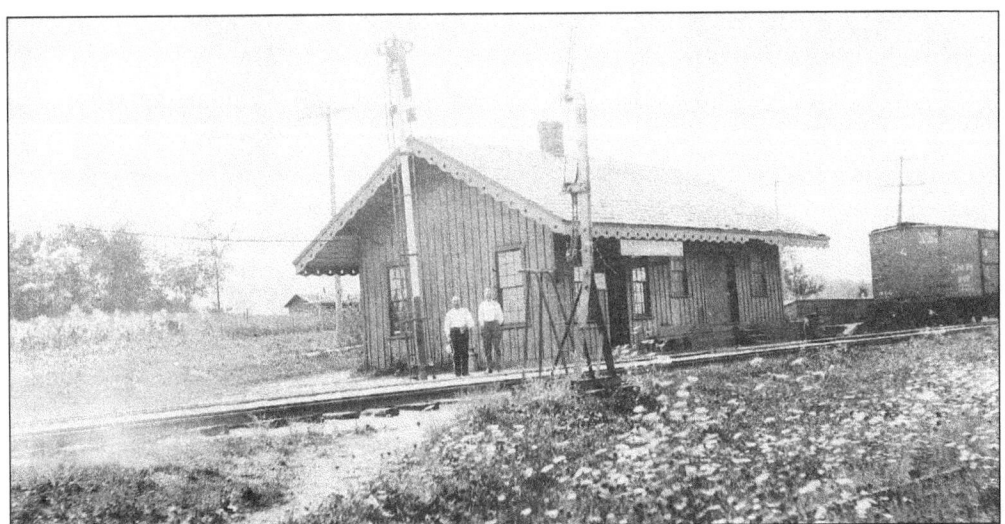

Meadowdale Station was erected in 1864 by the Albany and Susquehanna Railroad; it was a typical country station with a pot-belly stove in the waiting room, a ticket window, and a freight office. Hay wagons could pull up on the platform to the right to unload directly into freight cars. The crane across the tracks enabled passing trains to transfer mail quickly. There were extra sidings and a water tank nearby to supply steam locomotives. After 1931, when D&H ended local train service, the station was demolished.

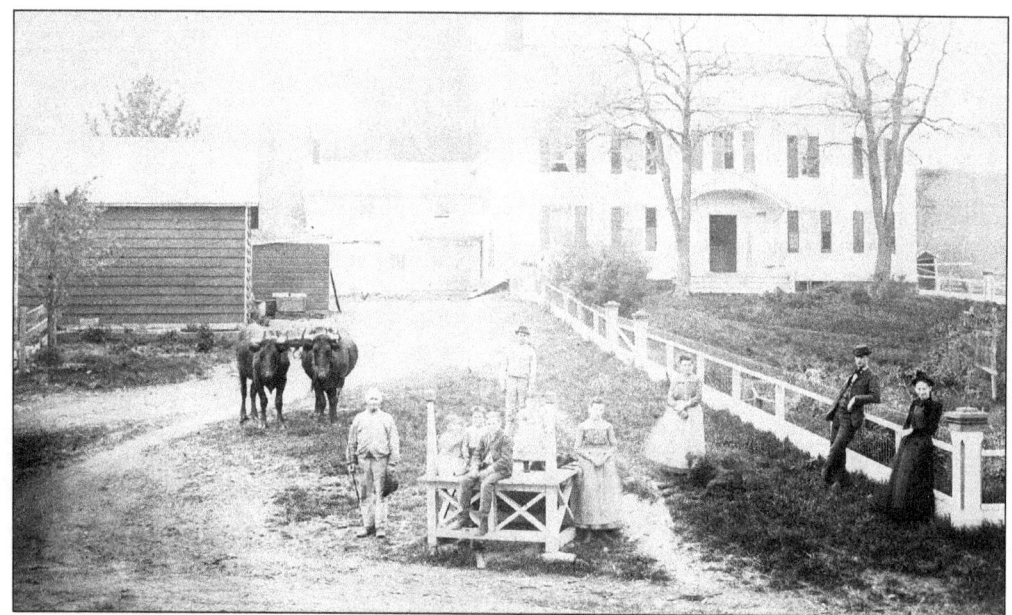

Crounse family members stand in front of their ancestral farmhouse, which was built in 1803 on Route 156 near Brandle Road. Frederick and Elizabeth Crounse, 18th-century Palatine Germans traveling through Guilderland on their way to Schoharie, got no further than the foot of the Helderbergs because, tradition says, the exhausted Elizabeth could not go on. Their farm was established in 1754, and remained in the family for generations. The house still stands today.

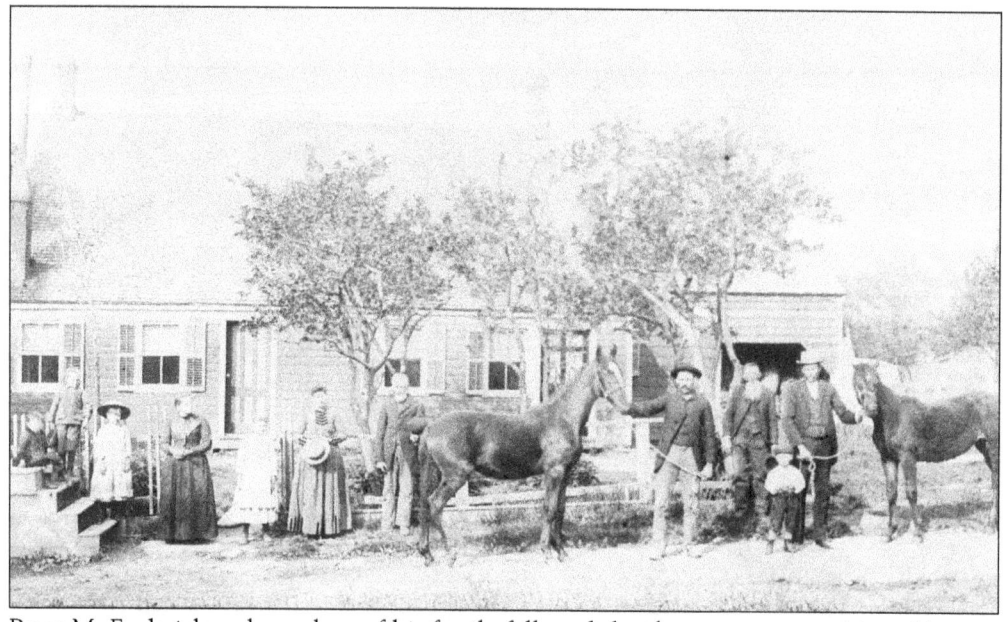

Peter M. Frederick and members of his family followed the then-common practice of having a family portrait taken in front of their home when they lined up beside their farmhouse on Frederick Road c. 1890. Frederick had inherited the house, a 19th-century alteration of the original structure, and a remainder of the Frederick Farm, which was first settled c. 1738 by Michael Frederick and his wife, Gertrude.

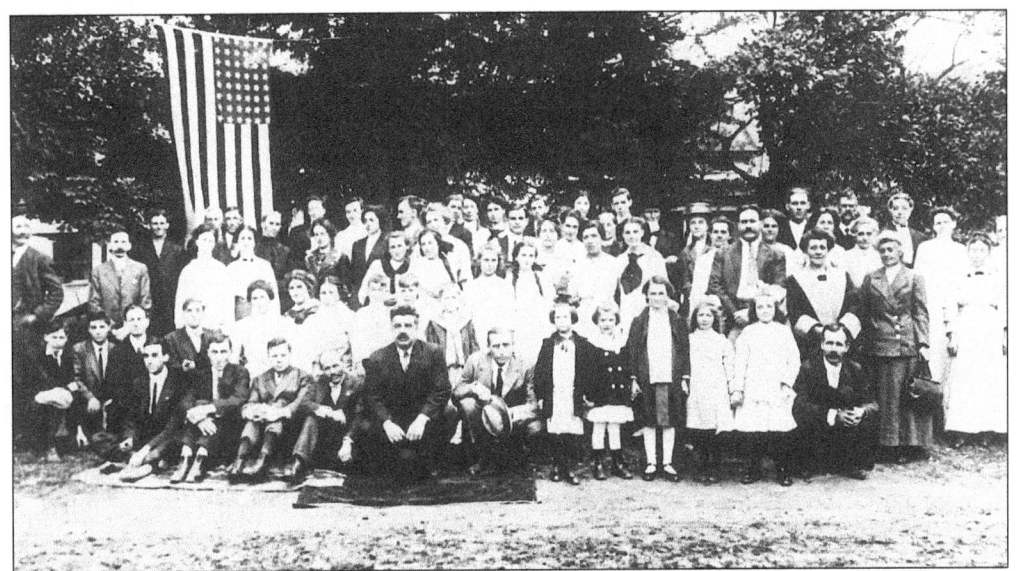

Early in the 20th century, Tebalt Frederick's descendants began meeting for lively family reunions complete with good food, contests, and games. Here they pose on Labor Day 1912 at the Tebalt Frederick Homestead, located on Route 156 at Gardner Road. Tebalt, the youngest of Michael Frederick's three sons, died weeks short of his 100th birthday in 1838; he wasn't quick enough to escape over a fence and was gored to death by a rampaging bull.

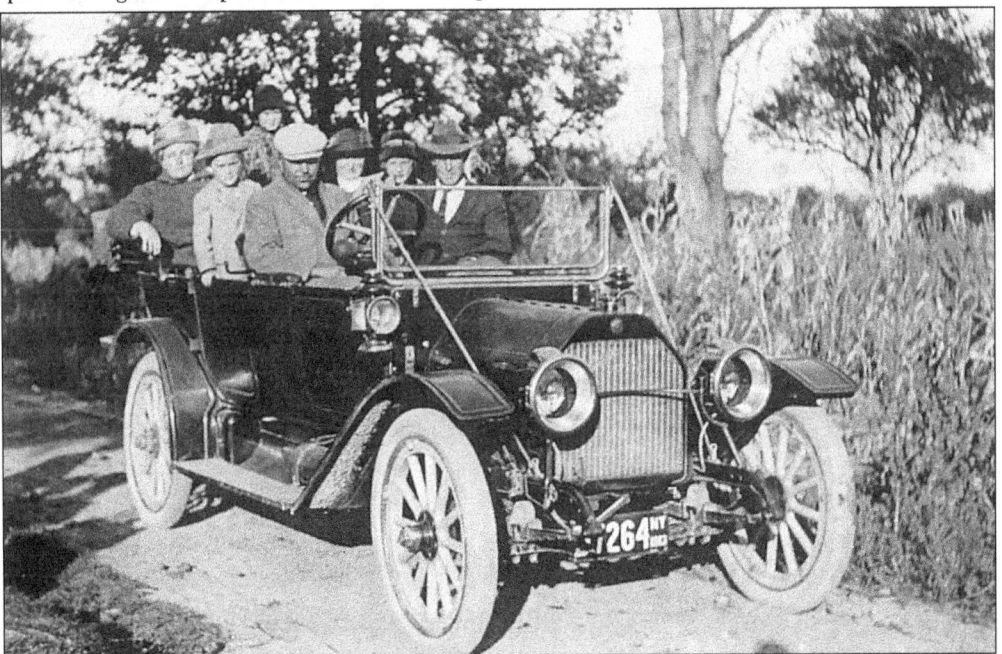

Enthusiasm for the horseless carriage spread quickly. Sitting proudly in their automobile are, from front to back, as follows: Chester Abram and Effie Oliver; (right) Oakley, Marshall, Blanch, and Austin Crounse of Meadowdale. Note the 1913 license plate. At that time, D.H. Whipple of the Altamont Carriage Works advertised Regal Cars in the *Altamont Enterprise*, offering the choice of a five-passenger touring car, fully equipped, for $1,025, or a roadster for $975.

Acknowledgments

The authors would first like to extend deep appreciation and thanks to late historian Fred Abele, for his insight in beginning the photo archives for the Guilderland Historical Society, and to the Society, who made the photographic images available to us. Images from the collection of former town historian Roger Keenholts are included. This book could not have been published without the photos from these valuable collections.

Many people all over town have shared their photographs and memories of Guilderland's past. We extend our thanks to Louise and Henry Adams, Shirley Carman, Roberta Chesebrough, Arnold and Hazel Crounse, Kenneth Frederick, John Gade Sr., Jim Gardner and Bryce Butler of the *Altamont Enterprise*, the Leininger family, Vera Lund, Reid Northrup of the Altamont Fair Office, Everett Rau, representatives of all the town fire departments and churches, Altamont Village Clerk Kathy Adams, and the many other town residents who answered our calls with information. All either loaned photographs or contributed information.

Finally, we would like to thank the editors at Arcadia Publishing for their counsel and generous patience in guiding us through this exciting experience.

—Alice Begley and Mary Ellen Johnson

www.ingramcontent.com/pod-product-compliance
Lightning Source LLC
Chambersburg PA
CBHW080857100426
42812CB00007B/2067